# AMERICAN PAINTINGS AND WORKS ON PAPER IN THE BARNES FOUNDATION

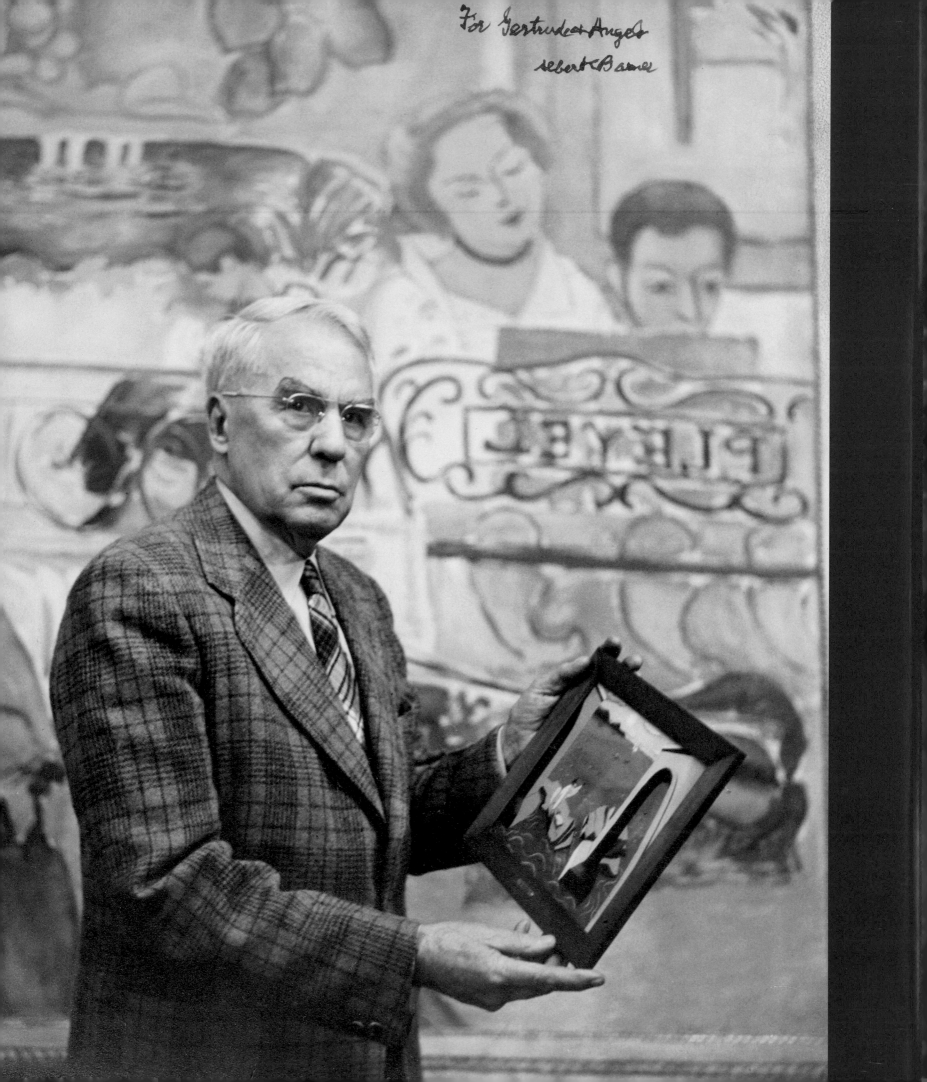

For Gertrude Angels
Robert Barnes

# AMERICAN PAINTINGS AND WORKS ON PAPER IN THE BARNES FOUNDATION

Richard J. Wattenmaker

The Barnes Foundation, Merion, Pennsylvania,
in association with Yale University Press, New Haven and London

Published in the United States of America by the Barnes Foundation, Merion, Pennsylvania, in association with Yale University Press, New Haven and London, 2010

Edited by Kristin Swan
Proofread by Laura Iwasaki
Index by Enid L. Zafran
Designed by Zach Hooker
Typeset in Kepler, with display type in Cronos, by Susan E. Kelly
Color management by iocolor, Seattle
Produced by Marquand Books, Seattle
    www.marquand.com
Printed and bound in China by C&C Color Printing Co., Ltd.

Library of Congress Cataloging-in-Publication Data
    Barnes Foundation.
    American paintings and works on paper in the Barnes Founda-
    tion / Richard J. Wattenmaker.
        p. cm.
    Includes index.
    ISBN 978-0-300-15877-9
    1. Art, American—20th century—Catalogs. 2. Art—Pennsylvania
    —Merion—Catalogs. 3. Barnes Foundation—Catalogs.  I. Watten-
    maker, Richard J. II. Title.
    N6512.B276 2010
    759.13074'74812—dc22                          2010008852

The paper in this book meets the guidelines for permanence and durability of the Committee on Production Guidelines for Book Longevity of the Council on Library Resources.
10  9  8  7  6  5  4  3  2  1

Jacket illustrations: (front) William J. Glackens, *Race Track*, 1908–09, oil on canvas, 26⅛ × 32¼ in. (66.4 × 81.9 cm), The Barnes Foundation, BF138; (back) Charles Demuth, *In Vaudeville: Two Acrobat-Jugglers*, 1916, watercolor and graphite on wove paper, 11³⁄₁₆ × 8 in. (28.4 × 20.3 cm), The Barnes Foundation, BF602

Frontispiece: Dr. Albert C. Barnes (1872–1951), c. 1945, in Gallery XIX holding Angelo Pinto's *Icarus* (BF744). Photograph by Angelo Pinto

*For Barton Church, artist-painter, teacher, mentor, friend*

# CONTENTS

ix    Director's Foreword   *Derek Gillman*

xiii    Preface and Acknowledgments

xix    General Notes on Documentation

1    Introduction

11    Albert C. Barnes and The Barnes Foundation

63    CATALOGUE

65    William J. Glackens

71    Works

127    Alfred H. Maurer

133    Works

143    Maurice B. Prendergast

149    Works

171    Charles Prendergast

175    Works

183    Ernest Lawson

188    Works

195    Jules Pascin

201    Works

247    Marsden Hartley

252    Works

259    Charles Demuth

268    Works

305    Horace Pippin

311    Works

318    Additional Works by American Artists

373    Index

381    Photograph Credits

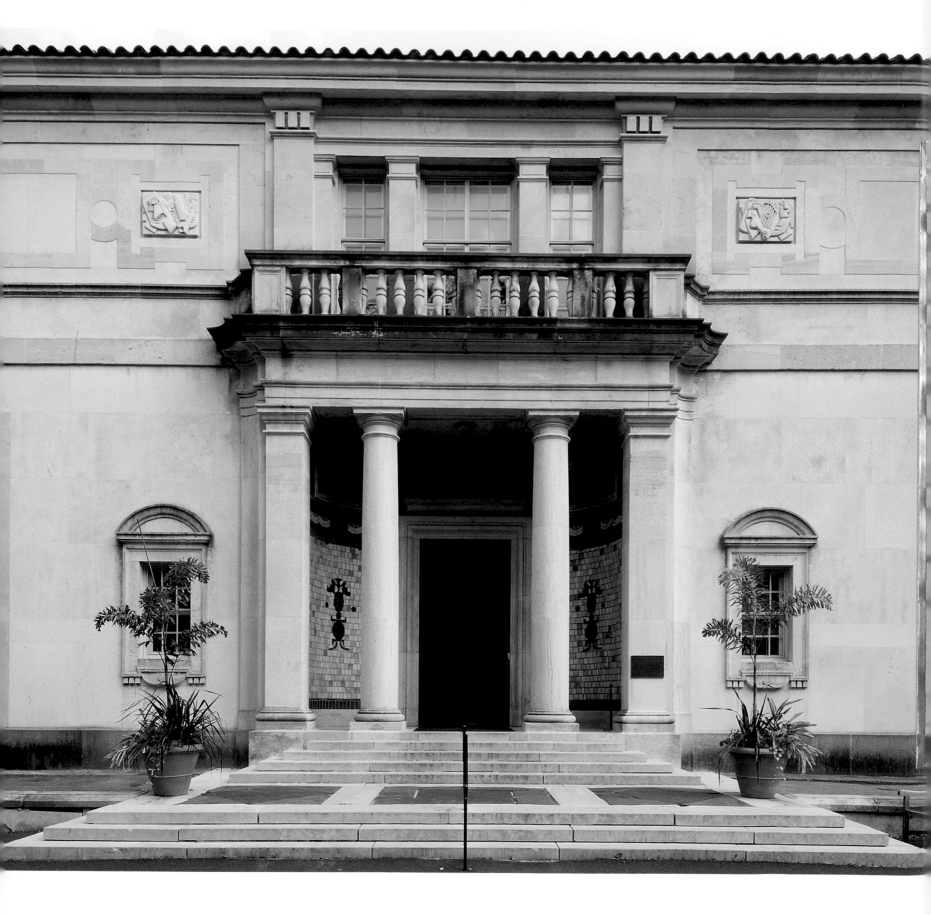

# DIRECTOR'S FOREWORD

The Barnes Foundation's collection is rich in American art. Approximately a quarter of all the paintings in the galleries were created by American artists, a fact that might surprise many scholars and visitors who know the collection solely for its celebrated holdings of Modern European art. Albert C. Barnes was most definitely an American collector, in the largest sense.

As Richard Wattenmaker makes evident in this important volume, Barnes's taste was shaped not only in Paris and London but also in his own Philadelphian environment and by his friendships with forward-looking American artists. Indeed, it is hard to appreciate quite how this collection was assembled without understanding the passion that Dr. Barnes had for his own country and his aspirations to further its political and educational development. There are many myths and half-truths about Albert Barnes. It is the intention of Dr. Wattenmaker to clarify details of Barnes's life as well as his lifework of educating the underprivileged and seeking to place the study of art on an objective footing, to the extent that it was possible—a task that the author splendidly achieves in *American Paintings and Works on Paper in the Barnes Foundation*.

This volume illuminates not only the work of such artists as William Glackens, a member of "The Eight" and an especially significant figure for Barnes, but also that of lesser-known members of the flourishing Philadelphia arts community in the early years of the last century, including Angelo and Biagio Pinto, Luigi Settanni, and Francis McCarthy. To understand Barnes, we must bring together the breadth of the international avant-garde and the specificity of his Pennsylvania birthplace, as Dr. Wattenmaker has done with utmost seriousness and almost unrivaled scholarship.

This is a momentous time for the Barnes Foundation as the collection moves to central Philadelphia, to a building that can accommodate more scholarly and educational activities, serving constituents that Barnes himself wished to reach. It is appropriate that this landmark catalogue of the American works, which presents so much original material on Albert Barnes himself, should inaugurate a new generation of scholarly publications at the Foundation. With this volume begins a projected series, produced in collaboration with Yale University Press, that will illuminate various aspects of the collection. These books are the first to be issued by the Foundation since Barnes and his colleague Violette de Mazia wrote their volumes on Matisse, Renoir, and Cézanne in the 1930s, excepting the catalogue *Great French Paintings from the Barnes Foundation: Impressionist, Post-Impressionist, and Early Modern*, which accompanied the world tour of selected works during the mid-nineties, and to which Richard Wattenmaker also contributed.

Front entrance of the Barnes
Foundation Gallery with reliefs
by Jacques Lipchitz and ceramic
decoration by Enfield Pottery
and Tile Works

Dr. Wattenmaker joins me in thanking our professional staff for their exemplary research, especially Katy Rawdon, Archivist and Librarian; Barbara Buckley, Head of Conservation; Renee Bomgardner, Registrar; Deborah Lenert, Visual Resources Manager; Andrew Stewart, Director of Marketing and Public Relations; Barbara Anne Beaucar, Assistant Archivist; Adrienne Pruitt, Processing Archivist and Assistant Librarian; P. Timothy Gierschick II, Art Handler and Collections Assistant; Emily Croll, former Project Director for the Collections Assessment Project; and Sarah Noreika, former Collections Information Manager. I extend my deep appreciation to photographers Tim Nighswander and Rick Echelmeyer, whose excellent work is reflected in most of the illustrations in this volume. I would also like to thank Zach Hooker, Marie Weiler, Adrian Lucia, and Sara Billups of Marquand Books, and especially Ed Marquand for his enthusiasm for the project and his unerring sense of design.

Most importantly, I acknowledge here the coalition of munificent institutions whose contributions in support of the present generation of Barnes Foundation scholarship cannot be overestimated. I am grateful for the splendid support given by the Trustees of the Andrew W. Mellon Foundation, and especially Angelica Zander Rudenstine, Program Officer for Museums and Art Conservation at the Mellon Foundation, whose funding for scholarly work at the Barnes Foundation for the better part of a decade has been absolutely vital to the success of this project. Crucial financial assistance for the earliest stage of this research was also provided by the J. Paul Getty Trust, the Pew Charitable Trusts, and the Henry Luce Foundation, and this volume builds on the work they nurtured. In addition, in 2004, the Henry Luce Foundation awarded the Barnes Foundation a grant specifically to underwrite the American catalogue, and the National Endowment for the Arts and the Von Hess Foundation supplied additional grants to help fund the project. The Dolfinger-McMahon Foundation generously contributed support for the digital reproduction of the paintings. This magnificent book is a testament to their generosity.

I would also like to thank my predecessor as Director, Kimberly Camp, for her dedication to the scholarly ambitions of the institution; Joseph J. Rishel, the Gisela and Dennis Alter Senior Curator of European Painting before 1900 at the Philadelphia Museum of Art, for chairing the Curatorial Advisory Committee for the Collections Assessment Project at the Foundation and for providing endless wise counsel; and, not least, the members of the Barnes Foundation Board of Trustees, who believe that this new century will bring to fruition many of Albert Barnes's ambitions in the field of education.

Finally, I am deeply grateful to Richard Wattenmaker for his years of devoted attention to the Barnes Foundation, to its founder and his mission, to the works that constitute its extraordinary collection, and to its educational program. Through this splendid book, he greatly enriches our understanding one of the most remarkable collectors in American history.

Derek Gillman
Executive Director and President

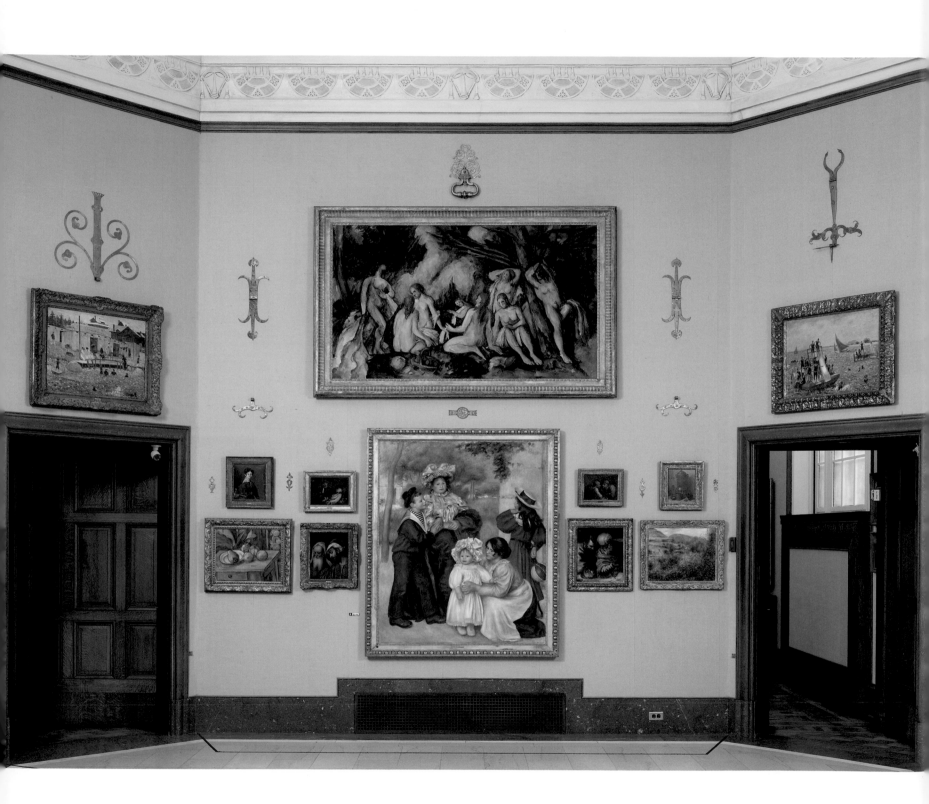

# PREFACE AND ACKNOWLEDGMENTS

This book has had an extended period of gestation, and I hope the work, so long in coming, does justice to the unique importance of the Barnes Foundation. I enrolled as a student in the Art Department of the Foundation in 1959. In the next seven years I took both the first- and second-year classes—the first year was taught by Violette de Mazia, Director of Education of the Art Department, Trustee, and co-author with Dr. Barnes of four of the textbooks used in the classes, and the second was taught by Barton Church, one of three teachers in the Art Department (the painters Angelo Pinto and Harry Sefarbi were his colleagues). In addition, from 1961 to 1966, I was a member of a seminar group under the supervision of Miss de Mazia. All of these classes were conducted in the galleries of the Foundation. We studied the paintings and objects in the collection directly and were encouraged to familiarize ourselves with museum collections in the United States and abroad. The aim of this method is one that, I have always found, pays dividends in all realms of human endeavor: to develop one's own perceptions through firsthand experience.

At the Barnes Foundation, students and visitors alike are initially struck, even overwhelmed, by the concentration of major works by artists such as Paul Cézanne, Pierre-Auguste Renoir, Henri Matisse, Pablo Picasso, Chaim Soutine, and Amedeo Modigliani. As I progressed in my studies and my feelings of awe subsided, I began to notice as well the collection's American paintings, work I had never seen. I was especially impressed by the unique concentrations of works by William Glackens and the Prendergast brothers, Maurice and Charles, as well as paintings, drawings, and watercolors by artists such as Alfred Maurer, Ernest Lawson, Charles Demuth, Jules Pascin, and Horace Pippin.

During my seven years at the Barnes Foundation, I concurrently pursued and received a B.A. in the History of Art from the University of Pennsylvania in 1963 and an M.A. from the Institute of Fine Arts, New York University, in 1965. As I began research on my doctoral dissertation, *The Art of William Glackens* (1972), early-twentieth-century American painting—an interest spurred by my work at the Barnes Foundation—became one of my fields of specialization.

By 1988, I had spent more than twenty years as a curator and museum director, with the usual portfolio of duties—building campaigns, dozens of exhibitions of both European and American fine and decorative arts, articles, books, installations, framing, auctions, fund-raising, trustees—but I consistently continued my study of the paintings and concepts of Albert Barnes. In order to understand better the relationship and reciprocal exchanges of ideas between Dr. Barnes and John Dewey, I read the greater part of letters (1917–51) between Dr. Barnes and John and Alice Dewey preserved at

The Barnes Foundation Main Gallery, east wall, with Pierre-Auguste Renoir's *The Artist's Family* (*La Famille de l'artiste*, BF819), Paul Cézanne's *Large Bathers* (*Les Grandes baigneuses*, BF191), and, over doors, William Glackens's *The Bathing Hour, Chester, Nova Scotia* (BF149) and *The Raft* (BF701)

the Center for Dewey Studies at Southern Illinois University Carbondale (SIUC). In 1991, I was invited to teach at the Foundation and was commissioned to write the introductory essay in the catalogue of the exhibition Great French Paintings from the Barnes Foundation (1993) organized by the National Gallery of Art, Washington, D.C. For that work I had access to the Foundation's archives and also used documentation assembled and referenced in the course of my dissertation research. The show drew millions of appreciative viewers as it made a triumphant tour to cities around the world, and the catalogue was translated into French, Italian, German, and Japanese.

In the seventeen years since that tour revealed to the world in so notable a way something of the Foundation's important collection, much has been accomplished. Early in 2001, Kimberly Camp, then Executive Director and CEO of the Barnes Foundation, established a Collections Assessment Project (CAP), an effort initially funded by the J. Paul Getty Trust, the Pew Charitable Trusts, and the Henry Luce Foundation, to document the entire collection of the Barnes Foundation. As a member of the Curatorial Advisory Committee for the Collections Assessment Project (which was chaired by Joseph J. Rishel, Gisela and Dennis Alter Senior Curator of European Painting before 1900, Philadelphia Museum of Art), I conducted a comprehensive, detailed study of all the American paintings and works on paper as well as the more than one thousand wrought iron objects assembled by Dr. Barnes. The present catalogue, *American Paintings and Works on Paper in the Barnes Foundation*, is an extension of my research for that project, and I am very grateful to Ms. Camp for initiating the Collections Assessment Project and the American catalogue.

Concurrently, in 2001, Ms. Camp appointed professionals in the fields of archives, conservation, and collections management, who were subsequently funded by the generous support of the Andrew W. Mellon Foundation from 2001 through 2009. Additional support for the project has come from the National Endowment for the Arts, the National Endowment for the Humanities, the Institute of Museum and Library Services, the Pennsylvania Museum and Historical Commission, and West Whiteland Township.

Since then, Archivist and Librarian Katy Rawdon and her staff have processed and catalogued the papers of Dr. Barnes and his associates as well as many of the historical records of the Foundation, which greatly facilitated my access to the documents required to conduct my investigations. Registrar Renee Bomgardner has created, computerized, and continues to update object records for the entire collection, comprising more than six thousand works. Head of Conservation Barbara Buckley oversaw a conservation assessment of the collection including general overview and item-specific surveys, environmental remediation, and storage projects. The conservation survey work was completed by eighteen consulting conservators, with contributions from staff conservators, assistants, and art handlers. Collectively, this noteworthy work has provided much of the technical data published in this catalogue.

In 2004 the Henry Luce Foundation and the National Endowment for the Arts both provided substantial grants specifically to fund the production of the catalogue of American works. That same year I was contracted to write the catalogue. I am extremely thankful for the support of these organizations.

Over the years, my knowledge of Dr. Barnes and his endeavor has been enriched by talks with numerous artists, former teachers, and students at the Barnes Foundation, and with others who knew Dr. Barnes in various contexts, including art and antiques dealers. The most notable of these was the artist and photographer Angelo Pinto, a student and teacher at the Foundation for fifty-five years, who worked closely with Dr. Barnes and other staff members and whose insights were instructive and highly valuable. Among others who related their experiences with Dr. Barnes were Ira Glackens, son of William and Edith Glackens, James Johnson Sweeney, Antoinette Kraushaar, Henry Pearlman, Francis McCarthy, Harry and Ruth Sefarbi, Hugh Mesibov, Abraham Hankins, Alo Altripp, Abram Lerner, Zero Mostel, Charles F. Montgomery, Titus C. Geesey, Henry Moore, Paul Moses, Claude Clark, Humbert Howard, Kenneth Lochhead, Luigi Settanni, Milton Avery, and Christabel Aberconway.

I am indebted to the following individuals for their cooperation, assistance, insights, suggestions, and cautions.

Derek Gillman, Executive Director and President of the Barnes Foundation, has graciously extended every courtesy to me in the course of my work in Merion; Michael Gilligan, President, and Ellen Holtzman, Program Director for the Arts, the Henry Luce Foundation, generously funded this project; and Sheila Burke, Former Deputy Secretary and CEO, Smithsonian Institution, made it possible for me to devote myself exclusively to research on the catalogue as Senior Scholar, Archives of American Art, in 2005–06.

I am grateful to Barton and Mary Jane Church, whose unique, substantive, and all-encompassing knowledge of Albert Barnes's collection, educational program, and teaching method has guided me for fifty years; to Bob and Sandy London, whose unflagging encouragement, deeply informed knowledge, and indefatigable support has been absolutely indispensable to every aspect of this project; and to William D. and Nancy Coe Wixom, whose invaluable experience, wise counsel, and insight spurred me to formulate balanced judgments with respect to Dr. Barnes and his unique experiment.

Darcy N. Tell offered her editorial opinion on the initial draft, and, especially, Gwendolyn M. Wells worked with me to shape the manuscript into its present form. Their creative editorial work was essential to structuring the book. Kristin Swan, Editor, and former Project Assistant to the Collections Assessment Project, has masterfully and subtly edited the entire text in all of the complex phases of the book. Her painstaking and patient guidance has been substantial and invaluable.

The Barnes Foundation staff has worked tirelessly with the highest degree of professionalism, and I am deeply appreciative to them for their multiform contributions to this project. Andrew Stewart, Director of Marketing and Public Relations, ably oversaw the project from its inception and served as liaison between the Foundation and Marquand Books; Katy Rawdon, Archivist and Librarian, and her colleagues Adrienne Pruitt, Processing Archivist and Assistant Librarian, and Barbara Anne Beaucar, Assistant Archivist, have contributed substantially to my research. Without their individual and collective devotion to locating and providing much of the primary documentation in a timely and comprehensive fashion, this book would not have been possible. Barbara Buckley, Head of Conservation, has provided her intimate and reliable expertise on all matters pertaining to the collection, and her thoughtful and generous collaboration has been critical to my work. Renee Bomgardner, Registrar, has offered valuable support through her thoroughgoing attention to detail and comprehensive knowledge of the collection. Deborah Lenert, Visual Resources Manager, has painstakingly assembled and coordinated the images published herein.

Former members of the Barnes Foundation staff Emily Croll, Project Director for the Collections Assessment Project, and Sarah Noreika, Collections Information Manager, were of considerable assistance at the outset of my research and participated in the lengthy but essential process of fact-checking my draft manuscripts together with Katy Rawdon, Renee Bomgardner, Barbara Buckley, Adrienne Pruitt, and Barbara Anne Beaucar.

Martha Lucy, Associate Curator and former Andrew W. Mellon Fellow in Renoir Studies at the Barnes Foundation, and Karen Butler, Associate Curator, Mildred Lane Kemper Art Museum, Washington University, and former Andrew W. Mellon Fellow in Matisse Studies at the Barnes Foundation, graciously extended assistance. Other Barnes staff who have helped in a variety of ways include P. Timothy Gierschick II, Art Handler and Collections Assistant; Lara Kaplan, Contract Objects Conservator; Jacob Thomas, Director of the Arboretum; Joan Taylor; and Marge Sarajian.

I wish to express my thanks to Esther Van Sant, late Trustee, Violette de Mazia Trust, along with Marcelle G. Pick, President, and Ross L. Mitchell, Executive Director, the Violette de Mazia Foundation.

Edward Dixon and his late mother, Jane Nulty Dixon, daughter of Albert Nulty, provided important insights into Dr. Barnes's character.

Infinitely helpful and patient in assisting me in locating documents without which this study would not have taken its present form were my former colleagues and present staff at the Archives of American Art, Smithsonian Institution, Marissa Bourgoin, Head of Reference Services; Susan Cary, Registrar; Elizabeth Botten; Wendy Hurlock Baker; and Tessa Veazey. Current and former staff of the American Art Museum and National Portrait Gallery Library at the Smithsonian Institution, Cecilia

Chin, Head Librarian; Alice Clarke, Technology Librarian; Stephanie Moye, Serials Librarian; Glenn Juchno, Librarian Technician, Acquisitions; Douglas A. Litt, Senior Reference Librarian; and S. Scott Scholz and Patricia Lynagh, were painstakingly supportive and creative in responding to all my requests for often obscure and difficult-to-locate citations.

For their contributions I am indebted to Dennis O'Connor, Former Provost, Smithsonian Institution, and Professor of Biology, University of Maryland, and, at the National Portrait Gallery, Smithsonian Institution: Ellen G. Miles, Curator of Painting and Sculpture; Patricia H. Svoboda, Research Coordinator; Linda A. Thrift, Center for Electronic Research & Outreach Services; and Susan Foster Ganton, Catalogue of American Portraits. Also of help at the Smithsonian Institution were Harry Rand, Curator of American History; Dianne G. Neidner, Senior Program Officer, Office of the Undersecretary for History and Culture; and John Lapiana, Chief of Staff, Office of the Regents.

I received meaningful research assistance from Larry A. Hickman, Director; James G. Downhour, Assistant to the Director; and Harriet Furst Simon, Textual Editor, all at the Center for Dewey Studies, Southern Illinois University Carbondale; along with Randy L. Bixby, Manuscript Curator/Archivist, and Marta Davis, Education Librarian, both at the Morris Library Special Collections, SIUC. David Frankfurter, Professor of Religious Studies and Literature, University of New Hampshire, kindly authorized me to quote from the transcript of his grandfather Thomas Munro's Oral History at the Center for Dewey Studies.

Directors, curators, archivists, librarians, collectors, art dealers, and other individuals who have graciously assisted me include Maria Pinto Carland and John M. Carland, Jody Pinto, and Anna Pinto; Carole Pesner and Katherine Degn, Kraushaar Galleries; Irvin Lippman, Executive Director, Jorge Hilker Santis, Curator and Head of Collection Research, Stacy Slavichak, Collections Manager, and Rachel Talent Ivers, Head Registrar, Museum of Art Fort Lauderdale, Nova Southeastern University; Cheryl Leibold, Archivist, Pennsylvania Academy of the Fine Arts; Linda Eaton, Curator of Textiles, Catherine E. Cooney, Senior Librarian, and Jeanne Solensky, Librarian, Joseph Downs Collection of Manuscripts & Printed Ephemera, Winterthur Museum, Garden & Library; Ellen Glavin, S.N.D., Professor of Art, Emmanuel College; Nancy Mowll Mathews, Eugénie Prendergast Senior Curator of Nineteenth and Twentieth Century Art, Williams College Museum of Art; Heather Campbell Coyle, Associate Curator, and Jennifer M. Holl, Registrar, Delaware Art Museum; Patricia C. Willis, former Curator of the Yale Collection of American Literature, Beinecke Rare Book and Manuscript Library, Yale University; Nancy R. Miller, Public Services Archivist, and J. M. Duffin, Technical Services Archivist, the University Archives and Record Center, the University of Pennsylvania; Robert A. Sanders, Archivist, Central High School, Philadelphia; Jeremy E. Adamson, Director for Collections and Services, and Ingrid Maar Adamson, former Curator of Exhibitions, Library of Congress; Jennifer Sharp, Seeley G. Mudd Manuscript Library, Princeton University; Sarah J. MacDonald, Public Services Librarian, University Libraries, the University of the Arts, Philadelphia; Karen O'Connell, Preservation Coordinator and Rare Book Librarian, Georgetown University Library; Michael R. Taylor, the Muriel and Philip Berman Curator of Modern Art, and Mark D. Mitchell, Associate Curator of American Painting and Sculpture, Philadelphia Museum of Art; Robert Smogor, Registrar, the Snite Museum of Art, University of Notre Dame; William Adair, Gold Leaf Studios; Ben and Gayle Brown; Martin Kotler; Col. Meryl Moore; Irving Burton; Paul-Louis Durand-Ruel; Betsy Fahlman, Professor of Art History, Arizona State University; Jan and Michiko Firch; Alan and Elaine Kolodkin; Hope and Paul Todd Makler; David McCarthy, Professor of Art History, Rhodes College, and Marina Pacini, Chief Curator, Memphis Brooks Museum of Art, who generously donated the Argyrol advertisement reproduced on page 14; Thelma McCarthy; Lillian Morris, S.N.D., Emmanuel College; Harry and Irene Pepp; David G. Tell; and Hannah Wong, Department of Art and Art History, University of Texas at Austin.

Lastly, my special appreciation to Eva, Adrian, and Barnaby Wattenmaker, for their forbearing patience and unwavering support.

R. J. W.

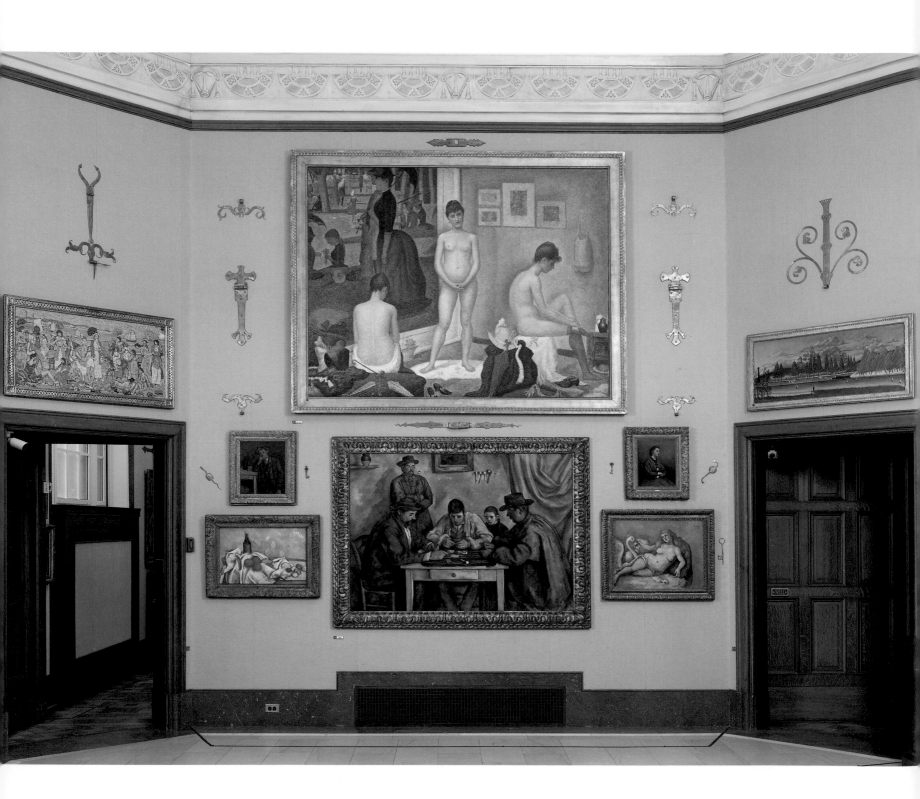

# GENERAL NOTES
# ON DOCUMENTATION

Every effort has been made to credit sources and rights holders for texts cited in this volume. If there are omissions, please contact the Barnes Foundation so that corrections can be made in any subsequent editions.

This book relies extensively on records from the Barnes Foundation Archives in Merion, Pennsylvania, abbreviated in citations as "BFA." Unless otherwise specified, letters from or to Dr. Albert C. Barnes quoted or cited in the text are found in the Albert C. Barnes Correspondence, hereafter abbreviated as "ACB Corr.," in the Foundation's archives. The Barnes Foundation Financial Records, discussed in detail below, are cited as "BFFR."

Page references to Albert C. Barnes's *The Art in Painting* are to the first edition (Merion, Pa.: Barnes Foundation Press, 1925) unless otherwise specified. The *Journal of the Art Department*, published by the Barnes Foundation from 1970 to 1978, is abbreviated *BFJAD* throughout the catalogue entries. The *BFJAD* was succeeded in 1979 by *Vistas*, published by the V.O.L.N. Press, Merion, Pennsylvania, until 1989.

The "BF" numbers corresponding to works of art in the collection of the Barnes Foundation were not assigned according to any given system and should not be considered to have any particular chronological or organizational significance.

Preserved in the archives of the Barnes Foundation are certain documents that, while of historical interest and sometimes useful, are not necessarily complete or accurate. One such document is a partial photocopy of an inventory created between 1922 and 1924 (hereafter referred to as "1922–1924 Inventory") prior to the transfer of any works to the newly constructed Gallery or administration building, which then served as the Barneses' residence. This inventory consists of typewritten Arabic numerals 1 through 735 and a handwritten record of the artist, title, dimensions, and location of each work in the collection. Numbers 76 through 100 (page 4) and 301 through 349 (pages 13–14) are missing from this twenty-nine-page photocopy, and numbers 674 through 708 (ten items on page 27 and all of page 28) have been left blank. The list might have had additional pages and numbers beyond 735, but is extant in the Barnes Foundation Archives only in photocopy form, the original presumably being lost. This inventory was begun in the latter part of 1922, at which time Barnes transferred ownership of his collection to the newly chartered Foundation. It was drawn up room by room (for example, "reception room," "dining room") in Lauraston, Dr. and Mrs. Barnes's home. It also includes works that were hung in the offices of the A. C. Barnes Company, since a number of pictures on the list are bracketed as "Nelle" (Nelle E. Mullen), "Jane" (Laura V. Geiger, Barnes's secretary and subsequently Recording Secretary of the Barnes Foundation), and "Dr.,"

The Barnes Foundation Main Gallery, west wall, with Paul Cézanne's *Card Players* (*Les Joueurs de cartes*, BF141), Georges Seurat's *Models* (*Poseuses*, BF811), and, over doors, Maurice Prendergast's *The Beach "No. 3"* (BF359) and Henri Rousseau's *The Canal (Landscape with Tree Trunks)* (BF583)

which probably indicates pictures hanging in Dr. Barnes's office at the company when the inventory was begun. In 1923 and 1924 individual items were added to this list, but it is not comprehensive, since financial and other records at the Foundation indicate numerous other purchases in 1923 and 1924 that were not included on the list.

At the time this inventory was drawn up, small, perforated-edged, gummed labels, each also typed with a number, were affixed to the verso of each corresponding work. The numbered twenty-nine-page inventory list and the labels were created as part of the same process. Some of the paintings that were recorded on the now missing pages of the inventory have been identified through their labels, which were noted during conservation surveys examining the works in the collection. In some cases the labels appear to have dried out and fallen off or have been obscured by conservation procedures. This labeling system was discontinued prior to the opening of the Foundation Gallery in March 1925. A new, but equally arbitrary, numbering system was created, whereby all works acquired had small, numbered brass tags affixed to their frames or, in the case of sculpture, their bases. It is not certain at what date these tags were first affixed, but this system was probably instituted between 1923 and 1926, for installation photographs made at the time of the April–May 1923 PAFA exhibition of works from the collection do not reveal tags on any of the frames.

The current numbering system (BF1, BF2, BF3; or, for sculpture, A1, A2, A3, and so on) corresponds to the numbers embossed on these metal tags and to the number assigned to each work in this catalogue. In at least thirty-five instances, current Barnes Foundation inventory numbers (for example, BF37, Vincent van Gogh's *The Postman [Joseph-Etienne Roulin]*; BF138, William Glackens's *Race Track*; and BF719, Henri Matisse's *Joy of Life [Le Bonheur de vivre]*) were retained from and correspond to the numbers on the 1922–1924 Inventory. However, Barnes did not intend these numbers to be the basis for a chronological catalogue of the collection, nor do they reflect the order in which the works were acquired. For example, Pierre-Auguste Renoir's *Woman with Black Hair (Jeune femme avec cheveux noirs*, BF1), acquired in 1915, was not the first painting purchased by Barnes and does not correspond to number 1 on the 1922–1924 Inventory.

A second, seventeen-page photocopy of a "List of Paintings in The Barnes Foundation" typewritten on Barnes Foundation letterhead and dated 1926, which numbers 792 paintings and works on paper (no sculpture is recorded), is held in the archives of the Barnes Foundation. The List (hereafter referred to as the "1926 List of Paintings") comprises numbers 1 through 777 and 801 through 815 (numbers 778 through 800 are omitted). The 1926 List of Paintings is divided into three columns: the first is entitled "Catalogue Number"; the second, "Artist"; and the third, "Description," and this last column provides the medium for works on paper, drawings, watercolors, and pastels without any specific description or title. No dimensions are given and, unlike the 1922–1924 Inventory, which was compiled before the works were installed in the Gallery, on the 1926 List no locations are indicated. This List appears to have established (or confirmed) the basic system of numbering, however random, by means of the numbered brass tags that continued to be affixed to works in the collection until 1951. Although the numbers on the 1926 List do not always correspond to those on the 1922–1924 Inventory, with respect to the American works, the numbering on the later List corresponds in fifty percent of cases to the numbers on the brass tags and the BF numbers in use today and cited in this publication. *It is important to note that the 1926 List of Paintings records only paintings and works on paper, European and American, that were in the Gallery at the time in the latter part of 1926 when the list was compiled.* For example, Glackens's "A. C. Barnes" oil portrait of Dr. Barnes appeared on the 1922–1924 Inventory (no. 367) but is not found on the 1926 List of Paintings. Many other pictures owned by Barnes, such as John Sloan's *Nude, Green Scarf* (BF524) and Guy Pène du Bois's *The Politician* (BF270), do not appear on the 1926 List and were probably never displayed in the Gallery but remained in the collection as they do today with a number of works Barnes sought to dispose of until his death in 1951. Yet others, such as the collection of Japanese colored woodcut prints, never hung in the Gallery and served as teaching tools in the Foundation's classes.

By comparing the 1922–1924 Inventory with the 1926 List it can be determined both that there was a greater total number of American works on the earlier inventory, and that the numbers of works by the major artists—William

Glackens, Maurice and Charles Prendergast, Ernest Lawson, Jules Pascin, Alfred Maurer, Marsden Hartley, and Charles Demuth—do not tally. Some of the works by those artists not enumerated on the 1926 List were installed at that time in the administration building (the Barneses's new domicile) and in the offices of the A. C. Barnes Company, where many American pictures had customarily hung since 1912. As new acquisitions mounted, there were many changes to what hung in each of these locations, and some works were also held in storage. With regard to the Additional Works by American Artists listed in this catalogue, the majority of which were purchased after 1926 and sometimes assigned tags and BF numbers that can be identified on the 1926 List as having been transferred from works subsequently deaccessioned, 14 out of 117 carry over the numbers assigned to them on that List and remain so designated today: Mary Cassatt's *Woman with Nude Boy at Her Right* (BF321) and *Woman with Nude Boy at Her Left* (BF323); Arthur B. Davies's *Flora* (BF527); Edith Dimock's *Country Girls* (BF352), *Country Girls Carrying Flowers* (BF353), and *The Sunday Walk* (BF354); Lenna Glackens's *Two Figures—Sphinx* (BF758) and *Woman and Dog Under Tree* (BF759); George B. Luks's *The Blue Churn* (BF391); Jerome Myers's *Street Shrine* (BF526); James Preston's *Trumbull, Connecticut* (BF747); Paul Rohland's *Flower Piece (Zinnias)* (BF721); and Maurice Sterne's *Deer* (BF646) and *Reclining Figure* (BF669).

From the outset in 1912, Barnes's collection was continuously developing. Prior to the 1922–1924 Inventory list and after the establishment of the numbered tag system, many works were sold, traded, or gifted. All paintings and objects acquired from 1926 to 1951 were randomly assigned either new numbers or numbers reassigned from previously owned works.

File cards kept by the Foundation often contain valuable information, such as purchase date and cost, source, dimensions, variant titles, and in some cases bibliographical citations or references. It is uncertain at what date these cards were created, but they predate 1935 and record information concerning purchases and deaccessions dating back to 1912, and were made for all acquisitions until 1951. Especially in cases in which there is no other documentation, information on the cards has been taken into account in compiling the catalogue entries, but readers should be aware that because the information on these cards was added both before and after 1951, they are sometimes inaccurate, imprecise, uncorroborated, or otherwise misleading. Conclusions regarding titles, approximate dates, published and unpublished references, and reproductions of all works in the collection are those of the author or an otherwise acknowledged source or sources consulted by the author.

Documentation of purchases is found in Barnes Foundation Ledger A–O, 1922–1950, and Barnes Foundation Ledger P–Z, 1922–1950, Barnes Foundation Financial Records (hereafter, BFFR), in the Barnes Foundation Archives. The Financial Records also contain invoices from, and canceled checks in payment to, artists or dealers; these are listed in the catalogue entries when they can be associated with specific transactions. In only a limited number of cases the name of a specific work appears on the check, or on its accompanying stub, issued in payment. Despite these invaluable sources, not all works are documented. For some pre-1922 acquisitions, the dates and amounts of purchases or precise identifications of works obtained in particular transactions cannot always be confirmed. In many of these early transactions, a dated check to an artist or dealer does not specify the name of the work. In other instances, letters from Barnes to a given artist or dealer, or an invoice from the dealer, provide some or most of the data and have been cited in the individual entries. In some cases in which Barnes acquired works directly from the artist, there is no record of the purchase.

With regard to frames: in many instances, payments for frame commissions to Charles Prendergast, Robert Laurent, and Max Kuehne cannot always be distinguished from purchases of their own works in various media, nor have all of their commissioned frames remained with the works by other artists for which they were originally intended. The initial design and finish or patina of these frames were frequently a collaboration between the collector and the fabricator. However, as the collection evolved between 1912 and 1951, some frames were transferred to different paintings and others were sized and reused. Therefore, identification of a frame as the creation of a specific artist-craftsman does not always guarantee that it was designed for the work it presently protects.

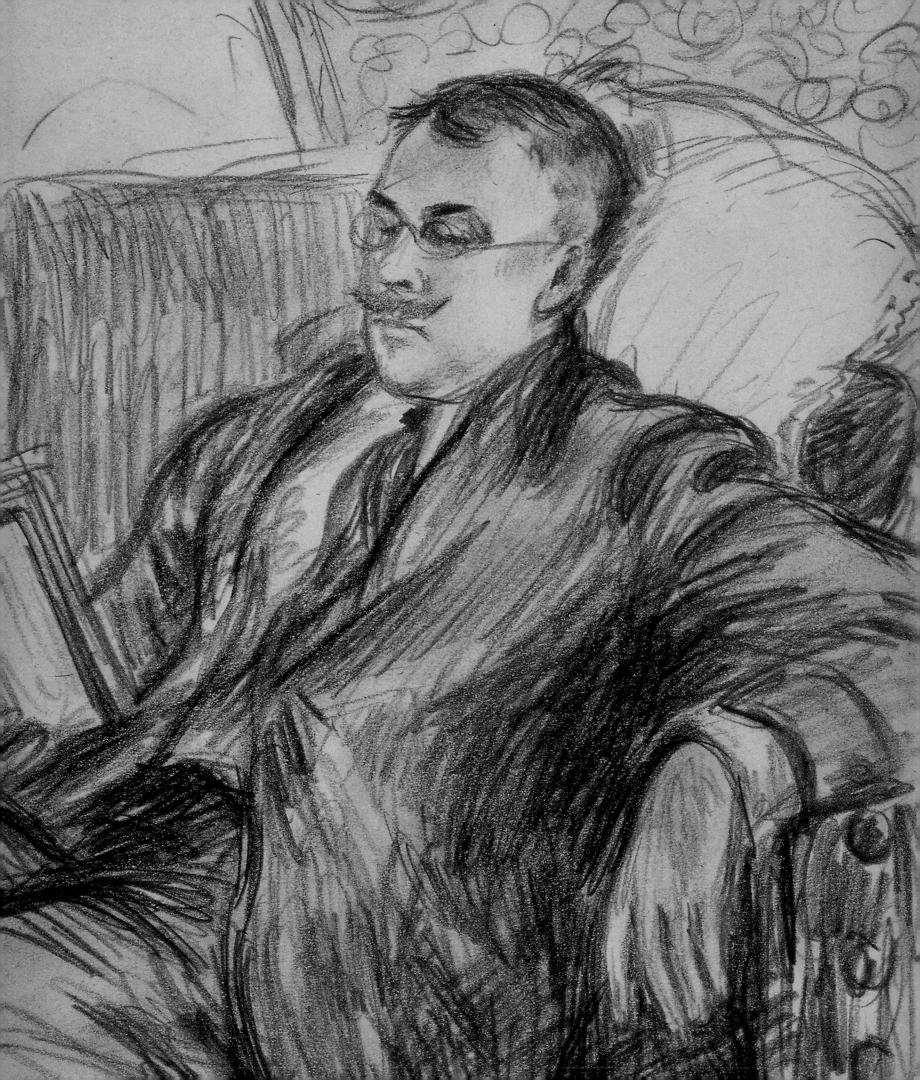

# INTRODUCTION

No adequate conception of the work of the Barnes Foundation can be formed without an account of the tiny roots from which it grew in a small chemical factory in Philadelphia, thirty years ago. The venture was a shot in the dark, an experiment with very dubious material, namely, unskilled workers with but little early schooling. The object of the experiment was to test the practical value of John Dewey's principles of education. . . . Dewey's conceptions are both simple and sensible. Education, he says, is the full and free development of all the capacities with which a person is endowed at birth. The function of the teacher is to direct, but not control these capacities. Education is not primarily preparation in youth for the future, but is a constantly developing process that covers the whole span of life. Its goal is to make what happens to us more understandable, more significant, by stimulating the initiative and inventiveness of every individual. Education is a social process. It becomes a potent force in democracy when the interests of a group are shared by all its members, and when a group with a particular interest interacts fully and freely. . . . In that chemical factory . . . we put democracy into our plan for the education of our employees, not by watering down knowledge, nor by relaxing the standards of intelligence, but by making the whole process a cooperative affair, free from any authoritative control.

—Albert C. Barnes, radio address, 1942

The need of education flows from many sources. . . . They spring from the disposition of artists or at least "connoisseurs," to set art on a pedestal, to make out of it something esoteric, something apart from values inherent in all experiences of things in their full integrity, and something apart from the constant needs of everyday man. . . . The existence of the Foundation and the book which presents its leading ideas of method are a challenge. They assert that aesthetic appreciation inspired and directed by art is a rightful and imperatively urgent demand of the common man; they assert that method, intelligence, may be employed not just by a few critics for the delectation or information of a small circle, but so that everyone may be educated to obtain what art in paintings has to give.

—John Dewey, response to a review of *The Art in Painting*, 1926

*The collection of Albert C. Barnes (1872–1951)* (fig. 1) and the institution he founded as an educational experiment in 1922 form a vital chapter in the cultural history of the United States. Beginning in the second decade of the twentieth century, Barnes systematically amassed what is acknowledged to be the foremost collection of late-nineteenth- and early-twentieth-century Modern art in the world. Extraordinary by any standard, the collection was primarily intended to serve an extraordinary project, the educational program of the Barnes Foundation. There, by bringing a scientific approach and democratic

principles to the teaching of aesthetics, Barnes and his associates sought to counter the prevailing elitism surrounding art and to equip ordinary men and women to grasp its profound meanings and human significance. All too often, regrettably, Barnes's achievements and the magnitude of his vision have been eclipsed by the notoriety that has come to surround Barnes the man.

In his lifetime, a cataract of words was written about Barnes, in art periodicals, newspaper articles, and popular magazines. Some of these articles were the result of discussions or interviews with the collector, but all were based on insufficient access to essential corroborative documentation, and in many of them sensationalism prevails over accuracy. After his death, a number of books were written, several by people who knew Barnes peripherally, and many articles were penned by those who had worked for him or had been students in classes at the Foundation during and after his lifetime. This torrent has continued unabated, and in its course fundamental factual and interpretive misconceptions concerning his life and work have grown up. It would be disingenuous to ignore the persistent legacy of hostility toward Barnes and his enterprise borne by generations of art historians, museum curators, journalists, and biographers, whose grievances were based upon an assumption of proprietary access to what they held to be a museum. But Barnes did not found a museum; he envisaged the Foundation in a strictly educational light and likened the Gallery of the Foundation, with the collection as its instructional tool, to laboratories at universities that were never indiscriminately open to the public. Barnes merits an objective consideration of the full facts and context of his life's work, insofar as these can be determined. This is a prerequisite for a truly thoughtful assessment of his ideas and the purpose for which the Barnes Foundation was created.

Ira Glackens, son of Barnes's closest friend and early mentor, William J. Glackens, in 1957 wrote, "during his career as a collector of art, Albert C. Barnes became celebrated for many things, and since his death . . . his figure has continued to grow into a colossal legend. The highly colored stories and anecdotes about him have overshadowed his achievements. . . . This is perhaps not surprising, for his character lent itself to legend, but it is unfortunate. Albert Barnes was a genius, and the true story of his life

will probably never be told."[1] These remarks were well justified, for when Ira Glackens wrote his memoir about his father, even he was denied access to the archives of the Barnes Foundation. He was therefore unable to detail fully Barnes's relationship with his father and the essential role that William Glackens played in the formative stages of Barnes's collection of Modern European and American paintings, in particular the painter's trip to Paris in 1912 to purchase a group of important paintings on Barnes's behalf.

From the outset of his pursuit of Modern paintings early in 1912, Barnes was passionate about contemporary American art. Not only did he acquire numerous paintings by artists such as Glackens, Maurice B. Prendergast, Alfred H. Maurer, Ernest Lawson, Charles Demuth, Jules Pascin, Marsden Hartley, George Luks, John Sloan, Robert Henri, Jerome Myers, Guy Pène du Bois, and Arthur B. Davies, but he also vigorously promoted them, urging dealers to exhibit and journals to publish articles on and reproductions of their work. Barnes consistently hailed the Americans as worthy peers of their European contemporaries. Most important in the development of his collection, Barnes learned much of what he knew about their work, as well as that of Europeans he was buying, through intensive questioning and listening to the artists' reasons for painting the way they did.

The majority of the American paintings, drawings, watercolors, and prints in the collection today were bought directly from the artists during the first decade of his activity, between 1912 and 1922, at the same time he was acquiring Pierre-Auguste Renoir and Paul Cézanne in quantity, and he continued to buy the work of American artists until his death in 1951. Barnes did not in fact segregate painters by national origin nor hang pictures in chronological sequence.[2] Rather, he interspersed the Americans among his European holdings, so as to underscore his confidence in their equal status. It may surprise even those familiar with the collection that *every room in the Barnes Foundation Gallery has at least two American works.* The artists were invited to Merion, where they could take pride in the fact that their work was juxtaposed with the finest examples of the major nineteenth- and early-twentieth-century Europeans from whom, in large measure, they had derived.[3] Thus, for example,

when Demuth visited, he could see his Cubist-inspired landscape watercolors placed with Cézanne watercolors. Likewise, when Maurice Prendergast visited Barnes's home and office, he could see his paintings hanging with works by Paul Gauguin, Camille Pissarro, Paul Signac, and Cézanne, artists he admired and learned from, and Glackens could do the same with Édouard Manet and Renoir as well as his American confreres throughout the gallery.

These intentional contextual relationships not only were meaningful for the artists themselves but were intended to lead students at the Foundation, a great many of them young artists, to study their American and European predecessors and contemporaries, enabling them to make connections they might never have imagined when they began to explore pictures firsthand. In classes at the Foundation, under the guidance of experienced teachers, students explored basic aesthetic values, a process that in Barnes's approach focused on the fundamentals of painting and not on the symbolic, iconographic, classificatory, and literary inquiries stressed by art historians. To this end, the interspersion of dissimilar cultures and traditions, Old Masters and Modern pictures, furniture, wrought ironwork, and pottery, often in stimulating juxtapositions intended to draw out unsuspected aesthetic relationships, was refined to a greater degree in Barnes's collection than in any presentation before or since, and this remains a guiding principle of the Foundation's classes today, more than eighty-five years after the educational program was begun. Henri Matisse, who instantly grasped what Barnes had achieved, best summed it up after a visit to the Foundation in 1930: "One of the most striking things in America is the Barnes collection, which is exhibited in a spirit very beneficial for the formation of American artists. There the old master paintings are put beside the modern ones, a [Henri] Douanier Rousseau next to a Primitive, and this bringing together helps students understand a lot of things that the academies don't teach. This collection presents the paintings in complete frankness, which is not frequent in America. The Barnes Foundation will doubtless manage to destroy the artificial and disreputable presentation of the other collections, where the pictures are hard to see. . . . The vogue for modern painting in America is certainly a preparation for a flowering of American art."[4]

By 1920, Barnes owned approximately one hundred Renoirs and thirty Cézannes when Marsden Hartley wrote him what is perhaps the clearest articulation of what Barnes's collection held for American artists at a time when examples of the work of these two masters—and all Modern painting—were not common in this country:

My mind surges and swells with [the] splendour in your home, still. I can't think of any greater experience for a painter than to be in on the great triumphs adjusting two centuries. It is splendid to me—two great innovators showing great comprehension of reality. It is like stepping from one great ship to another great ship to plow another majestic ocean. I often wonder what those who do not paint receive from such benefits as are to be derived if one is acutely conscious of technical processes. I know that painting will never be the same again since the apotheosis of these two great artists. The new ones now and to come will have to walk into the new era if they expect to arrive logically and it must be done with comprehension and not in the spirit of copy. . . . But the eye is too near even to Renoir and Cézanne to comprehend. I wonder if the talking ones really get them. . . . The critic places and displaces through self dissatisfaction mostly. It is the painter who must comprehend and care. When a working artist understands what Courbet, Renoir and Cézanne have done for our century, he is a long way toward intelligence. They have done what Rubens and Michelangelo can never do for us. They have eliminated metaphysics and that alone is a superior gift. If I were nearer I should be tempted to ask for a monthly entrée into the real American Louvre of modern art. . . . I have the wish to take the same attitude toward your collection that Cézanne took toward the Louvre. . . . It is all there for us who care for modern masters. I am still in a state of breathlessness intellectually to catch up with these great ones and feel them calmly. Pictures are for the right mind what athletics are to the body. They make the mind operate—and give it gesture. Thanks sincerely for the great privilege.[5]

The present study is neither a full-scale biography nor a comprehensive review of the vast secondary Barnes literature. Crucially, however, it draws from an important store of documents brought to light during recent efforts to organize systematically and modernize the archives of the Barnes Foundation. New information and biographical elements from the archives and other previously unpublished and uncited sources have been here integrated with known facts, and the whole has then been presented within a chronological framework that concentrates on Barnes's manifold goals and accomplishments. My generous incorporation of primary documents is meant to allow Barnes and his contemporaries, to an unprecedented degree, to speak for themselves, to tell the story in their own words. Where I interpret due to sparse or nonexistent documentation, conclusions drawn from inference are made explicit. This approach provides a more complex and nuanced picture of Barnes's outlook and activities than has heretofore been possible—one that counteracts many of the colorful, even fantastic, but more often than not unsubstantiated anecdotal and exaggerated tales that, taken in isolation, have tended to obscure and diminish the serious purpose of Barnes's work and the extent of his pioneering achievement. I have elected not to dwell at length upon the oft-repeated sagas of Barnes's battles with the Philadelphia public schools, the University of Pennsylvania, the Philadelphia Museum of Art, the *Saturday Evening Post*, and the Pennsylvania Academy of the Fine Arts and numerous other controversies that have perpetuated a disproportionately negative and largely superficial idea of this prodigiously gifted intellectual.

Barnes was an irrepressibly provocative man, a fierce polemicist who was sometimes as aggressive with his friends as he was with those he perceived as enemies as he wrestled on many fronts—in his business and, after the early 1920s, in his educational project—to mitigate ignorance and prejudice. He was devoted and generous to his co-workers, to students of the Foundation, and to his friends and their families, who comprised people from all strata of society. Several of his closest associates were women who held executive decision-making positions in his company and at the Foundation. His wide-ranging charitable benefactions, both institutional and individual,

were for the most part anonymous. Barnes's political views were those of a progressive liberal. He understood the deep-rooted racism that disenfranchised large segments of society, notably African Americans, and actively engaged in combating it. He was supportive of the labor movement and held that labor and management working together would solve many of the intractable problems of social injustice, which he firmly believed could be overcome by applying scientific method to education. His belief in democracy coincided with John Dewey's; he considered communism undemocratic and unworkable and its adherents intellectually untrustworthy. Barnes was under no illusions as to human fallibility and inertia, yet he was fundamentally optimistic about the possibility of reform and the melioration of societal ills.

Barnes enjoyed reminiscing and often recounted episodes from his student days and early professional career. Throughout his life—in letters, interviews, articles, public lectures, and radio broadcasts—he varied his recollections considerably depending on the audience he was addressing. He was urged to write his memoirs but declined. Barnes presumably realized that he was making it difficult during his lifetime for would-be biographers when he told multiple renditions of the same well-rehearsed stories about his schooling, his travels, and the formation of his collection. He loosed a veritable carpet of anecdotal caltrops to hinder attempts to make of his early life a variation of the Horatio Alger pattern, yet at the same time he was himself fostering that very image with hyperbolic accounts of his boxing, baseball, and racetrack gambling exploits. Although the subject of considerable speculation, his motives for this somewhat contradictory behavior cannot be entirely known. This is not to say, however, that Barnes did not realize that biographers would eventually see his voluminous correspondence with John Dewey, for in 1946 he turned over copies to Joseph Ratner, who was writing a biography of the philosopher.[6] Because he sent so many copies of his letters to various individuals, Barnes must have been equally aware that his correspondence with artists, dealers, critics, educators, and others would find its way into repositories, public and private, as the recipients placed them in the public domain. He made it abundantly clear that he wished to be remembered for his school and the

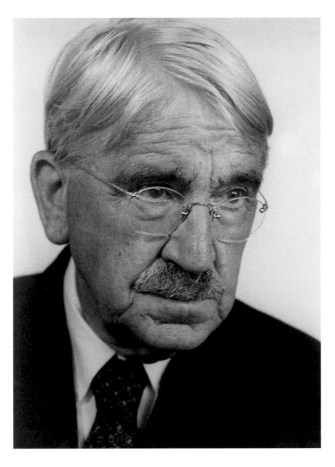

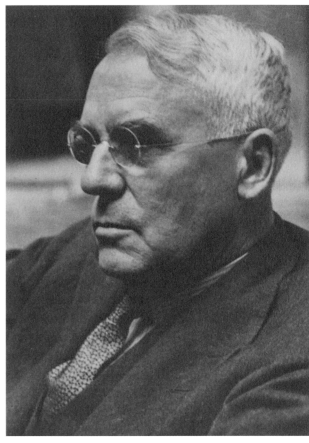

educational method he put into practice therein, for his writings, and for the collection he so purposefully and determinedly assembled to make that work possible.

The formidable range of Barnes's knowledge, curiosity, reading, and network of acquaintances in numerous fields revealed in his correspondence is imposing. The letters exchanged between Dewey (fig. 2) and Barnes (fig. 3) over a period of nearly thirty-five years, from 1917 through 1951, express their mutual respect and reciprocity in sharing ideas on psychology, aesthetics, educational method, and numerous other topics, including politics, labor, and race relations—all subjects of primary interest to Barnes. These often lengthy exchanges articulate the wide-ranging intellectual rapport between the two men and document an essential part of Barnes's outlook. They disclose Dewey's unfailing support for Barnes's educational approach and of the goals he envisaged for his

experiment in education. Dewey often acted as a sounding board for his friend's ideas and projects; he was steadfast even when he did not wholly sanction Barnes's confrontational (and often counterproductive) behavior, notably in relation to institutions of higher learning that might have helped him achieve more fully his ultimate goal of bringing scientific method based on modern psychology and firsthand experience into the classroom. Thomas Munro (1897–1974), a student under Dewey from 1915 to 1920 who taught in the philosophy department at Columbia University from 1918 to 1924, was a close associate of both men in the formative years of the Foundation and thus was an intimate observer of the Barnes-Dewey relationship, which he characterized as follows: "In 1924 I went to the Barnes Foundation and it was Dewey who recommended me to Dr. Barnes for the position as Associate Educational Director. Barnes had been studying with

Dewey, had taken courses on Dewey's general philosophical approach, his democratic views of education, and his experimental approach to problems. Barnes was tremendously impressed by Dewey as an intellectual leader and always remained so. Dewey was one of the people with whom Barnes never did quarrel and with whom he remained on good terms. They were always friendly and respectful toward each other."[7] Robert B. Westbrook has also noted "the genuine affection that developed between the two men, an affection that led each to withhold sharp criticism from the other when they disagreed. . . . The most important bond between the two men was that they learned a great deal from each other, and this, more than anything else, held them together. . . . No one did more than Barnes to help him understand the character of the artful experience that he believed made life most worth living."[8] Steven C. Rockefeller concurs, observing that "[Barnes] and Dewey formed a lasting friendship built around their common interests in art, education, and philosophy. Dewey, who had long enjoyed poetry and who had no ear for music, set out at this time [1917] to deepen his appreciation of painting, and he found Barnes immensely helpful. . . . He found Barnes to be possessed of good critical judgment in matters of art and to be a stimulating influence as he worked to clarify the nature of aesthetic experience and to give it a central place in his philosophic vision."[9] Ten years into their friendship their salutations evolved from "Dear Mr. Dewey"/"Dear Mr. Barnes" into "Dear Jack"/"Dear Al." Those commentators who claim that the Barnes-Dewey relationship was exploitative have missed the essential candor and trust that characterized their friendship from the outset. Barnes's letters to Dewey are exuberant, expansive, and optimistic, if frequently critical of persons and institutions; they are also from time to time reflective and confessional. They provide unique insight into Barnes's ideals and plans, realized and unrealized, and they lay bare his disappointments.

Despite widely held opinion to the contrary, Barnes was well aware of his own foibles and limitations. On September 20, 1920, in a remarkably candid and revealing letter to Alice Chipman Dewey, he wrote,

I came into the world maladjusted—and I'm still that. I saw my trouble when I was about twelve years old and at about fourteen I began the study of psychology from a deep interest, which probably had its origin in an unconscious need. Even at that age, I was an inveterate experimenter and nothing I ever came in contact with did I accept as standard or right or ultimate. I wanted to change the status of everything in my boyhood world. You can imagine the trouble I was to my parents, teachers, companions but I don't regret it because it taught me to fight and it was always for an ideal—of course, a disbalanced, youthful, stupid ideal in many cases. At about sixteen, I had pat most of the stuff the formal psychologists were writing about and I knew the essence of Freudian theory by personal knowledge of myself and others, long before Freud had even begun to earn a living. In short, I was living by experimenting with what made up human nature. From eleven, I've made my own bread and butter and never had to struggle to do it because I simply did—that is really did—what I thought was the fitting thing to do under the circumstances. Sometimes the difference of opinion as to the fitness of particular things had bad effects on me; I was stabbed once, have been locked up for fracturing a disreputable person's skull, have slept two nights in the public square at Antwerp because I didn't have the price of a bed, and once worked my way home from Europe on a tramp steamer. But all of these things were simply accidents that were the result of intelligent efforts to change a bad social order. The gains were some things worthwhile—a college education, fine character-making friendships with teachers at Berlin and Heidelberg, about fifteen trips to Europe before I was thirty, and after that age considerable money and the things that money can buy.[10]

As a result of his combative idealism Barnes antagonized and alienated many who might have been his allies in carrying out serious educational work. Gilbert M. Cantor

rightly summed up these constituents of this complex personality when he wrote, "Not all the perfumes of Arabia will make a saint out of Dr. Barnes."[11]

Barnes, whose training as a scientist is often overlooked, deeply admired Dewey's scientific methods and pragmatic approach. He shared Dewey's view of education as a lifelong process whose aim is to enrich each individual's experience by instilling the spirit of individual initiative and inventiveness that are fundamental to a liberal democratic society, just as he shared the philosopher's conception of culture as an evolving response to experience in the world. From the conception of the Foundation, Barnes adapted and applied Dewey's methods in his ongoing efforts to expand its programs and broaden its impact. Munro observed:

> Being a scientist by training and temperament, [Barnes] was not satisfied just to collect [pictures]; he wanted to study them scientifically and to use them as a means of education. Dewey's advice helped him on all those problems. . . . Barnes wanted to develop his educational approach more fully by establishing a regular teaching program in the Barnes Foundation Gallery. He had been, was then and remained, a friend of Glackens . . . and Glackens helped him start understanding and collecting modern art; but Barnes's decisions to purchase or to praise one artist rather than another were largely or wholly his own. He learned something from many people. He learned nothing about visual art from Dewey. . . . Barnes wanted to set up a program which would be on the university level; not just for . . . superficial dilettanti, but for students who wanted to go ahead and study the philosophy, criticism, and history of the visual arts in depth. Barnes asked that Dewey, himself, take charge of working out the program, and he decided that Dewey should be educational director of the Barnes Foundation, while I was associate educational director. . . . He was to advise on educational policies, which he did. . . . I worked as a sort of go-between there, and I saw both men.[12]

The significance of Barnes's educational experiment and of his philosophical affinities with Dewey has perhaps not yet been apprehended in the larger context of the history of American liberal education.

As Dewey himself often acknowledged, most notably in his foreword to Barnes's and Violette de Mazia's *The Art of Renoir*: "Since my educational ideas have been criticized for undue emphasis upon intelligence and the use of the method of thinking that has its best exemplification in science, I take profound, if somewhat melancholy, ironic, satisfaction in the fact that the most thoroughgoing embodiment of what I have tried to say about education, is, as far as I am aware, found in an educational institution that is concerned with art."[13]

Although he was often refractory, Barnes tirelessly channeled his idealism into overwhelmingly positive accomplishments. In the above-quoted letter to Mrs. Dewey, Barnes also stated, "The ability to make lots of money does not entitle its owner to talk on the successful life. Money as an end has never been a pursuit with me. . . . My greatest esteem is for the persons with the highest ideals who strive to realize them with an intelligence that merits approval when analyzed." Barnes strove with remarkable energy to realize his own ideals. He was a benefactor of humanity who conceived and successfully marketed a drug that alleviated suffering, a proud self-made man who deployed his wealth according to his interests in a unique experiment that began as an enlightened workplace relationship with his employees. He considered the collecting of art not as a pastime or a speculative investment, nor as an emblem of social status or prestige, but rather as an effective tool for teaching a sound practical method of understanding the profound *aesthetic* meanings of what artists throughout the ages and in diverse cultures have accomplished. Above all, he cannot be understood without a comprehensive knowledge of the scope and high quality of his unique collection.

## NOTES

Epigraphs. Albert C. Barnes, "Dr. Barnes of Merion Tells His Story," radio address broadcast on station WCAU, Philadelphia, April 9, 1942, transcript BFA. John Dewey, "Art in Education—and Education in Art," *New Republic*, February 24, 1926, 11–13, in response to Leo Stein, "The Art in Painting," review of *The Art in Painting* by Albert C. Barnes, *New Republic*, Winter Literary Section, December 2, 1925, 56–57.

1  Ira Glackens, *William Glackens and the Ashcan Group* (New York: Crown, 1957), 161.

2  The sole exception is Gallery XII, limited to American artists; this ensemble represents a special homage to the Americans, including three, Maurice Prendergast, Lawson, and Pascin, who were not native born.

3  This was important to the artists and not a new idea. As early as 1904, a group of New York patrons, calling itself the Society of Art Collectors, organized the Comparative Exhibition of Native and Foreign Art. "The . . . group of art lovers . . . patriotically, but perhaps too boldly, resolved to hold . . . a Comparative Exhibition of two hundred paintings, to consist of an equal number of the best modern European paintings that could be procured and of the best American works obtainable. . . . Native and foreign paintings should be interspersed or hung side by side, thereby affording for the first time on a large scale an opportunity to compare American with European paintings on even terms." "Introduction" [unsigned], in *Comparative Exhibition of Native and Foreign Art 1904* (New York: American Fine Arts Society, 1904). Americans such as Ralph Albert Blakelock, William Merritt Chase, Arthur B. Davies, Childe Hassam, Winslow Homer, William Morris Hunt, George Inness, John La Farge, Theodore Robinson, Albert Pinkham Ryder, Abbott H. Thayer, John Henry Twachtman, and James McNeill Whistler were hung side by side with such Europeans as Eugène Boudin, Jean-Baptiste-Camille Corot, Gustave Courbet, Charles François Daubigny, Edgar Degas, Eugène Delacroix, Narcisso Virgilio Diaz de la Peña, Théodore Géricault, Johan Barthold Jongkind, Jean-Baptiste Millet, Claude Monet, Adolphe Monticelli, Pierre-Auguste Renoir, and Alfred Sisley, among others. Some of these were lent by Paul Durand-Ruel. Glackens doubtless saw this show.

4  Quoted in "Statements to Tériade, 1929–30," in Jack D. Flam, ed., *Matisse on Art* (London: Phaidon, 1973), 63. See also John Russell, *Matisse: Father and Son* (New York: Harry N. Abrams, 1999), 61: "To quote from Matisse's pocket diary—'the only sane place' for the display of art that Matisse had as yet seen in America."

5  Letter, Marsden Hartley to Albert C. Barnes, n.d. (1920), typed transcription, ACB Corr., BFA. Hartley probably saw the thirteen Cézanne landscapes and still lifes from the Hoogendijk collection that Barnes had acquired in 1920, which arrived in Merion in August. See Barnes's letter to John Dewey, May 14, 1921, ACB Corr., BFA: "In the last two years, I must have bought a score or more of Renoirs . . . and now have over a hundred of his works, and over 30 Cézannes."

6  Ratner had edited *Intelligence in the Modern World: John Dewey's Philosophy* (New York: Random House, 1939), including a 240-page "Introduction to John Dewey's Philosophy." His biography was never completed. These copies belong to the Center for Dewey Studies, Southern Illinois University, Carbondale. They can also be found on a CD-ROM, *The Correspondence of John Dewey, 1871–1952*, 2nd rev. ed. (Charlottesville, Va.: Intelex, 2005).

7  Thomas Munro, oral history interview, April 26, 1967, transcript, Special Collections Research Center, Southern Illinois University, 6. Hereafter cited as Munro oral history, 1967. Munro received his bachelor's, master's, and doctoral degrees at Columbia and "heard all his courses" (Munro oral history, 1967, 1). Munro was subsequently curator of education at the Cleveland Museum of Art and professor of art at Case Western Reserve. He published numerous books, including *Scientific Method in Aesthetics* (1928), *Evolution in the Arts and Other Theories* (1963), *The Arts and Their Interrelations* (1967), and *Form and Style in the Arts: An Introduction to Aesthetic Morphology* (1970) and was a founder of the American Society of Aesthetics. While teaching at the Barnes Foundation he wrote (with Paul Guillaume as co-author) *Primitive Negro Sculpture* (New York: Harcourt, Brace & Co., 1926), illustrated with objects from the Barnes Foundation, with a chapter devoted to the relations of African sculpture to contemporary art. See "Albert C. Barnes and the Barnes Foundation," page 57, note 128.

8  Robert B. Westbrook, *John Dewey and American Democracy* (Ithaca, N.Y., and London: Cornell University Press, 1991), 389–90.

9  Steven C. Rockefeller, *John Dewey: Religious Faith and Democratic Humanism* (New York: Columbia University Press), 345.

10  Letter, Barnes to Alice Chipman Dewey, September 20, 1920, ACB Corr., BFA.

11  Gilbert M. Cantor, *The Barnes Foundation Reality vs. Myth*, 2nd ed. (Philadelphia: Consolidated/Drake PRS, 1974), 78.

12  Munro oral history, 1967, 6–7.

13  John Dewey, foreword to *The Art of Renoir*, by Albert C. Barnes and Violette de Mazia (New York: Minton, Balch, 1935), x. A typical example is found in Dewey's letter to Barnes, September 18, 1933, ACB Corr., BFA: "I have had the same question you raise to deal with constantly in writing up my lectures. There are no chapters and not many, if any, pages that don't owe something to you. Where I have quoted directly as I have a few times I can of course make the reference specific. But mostly the indebtedness is in helping form my entire mode of approach. And so I feel as you do that the material as a whole is mine—in other words that I have taken in what you have given me and made it a part of my own 'mind'. Well, the way I have decided to meet the question is not to encumber the pages with repeated acknowledgments, outside the cases of definite citation, but to make a general acknowledgment in the preface."

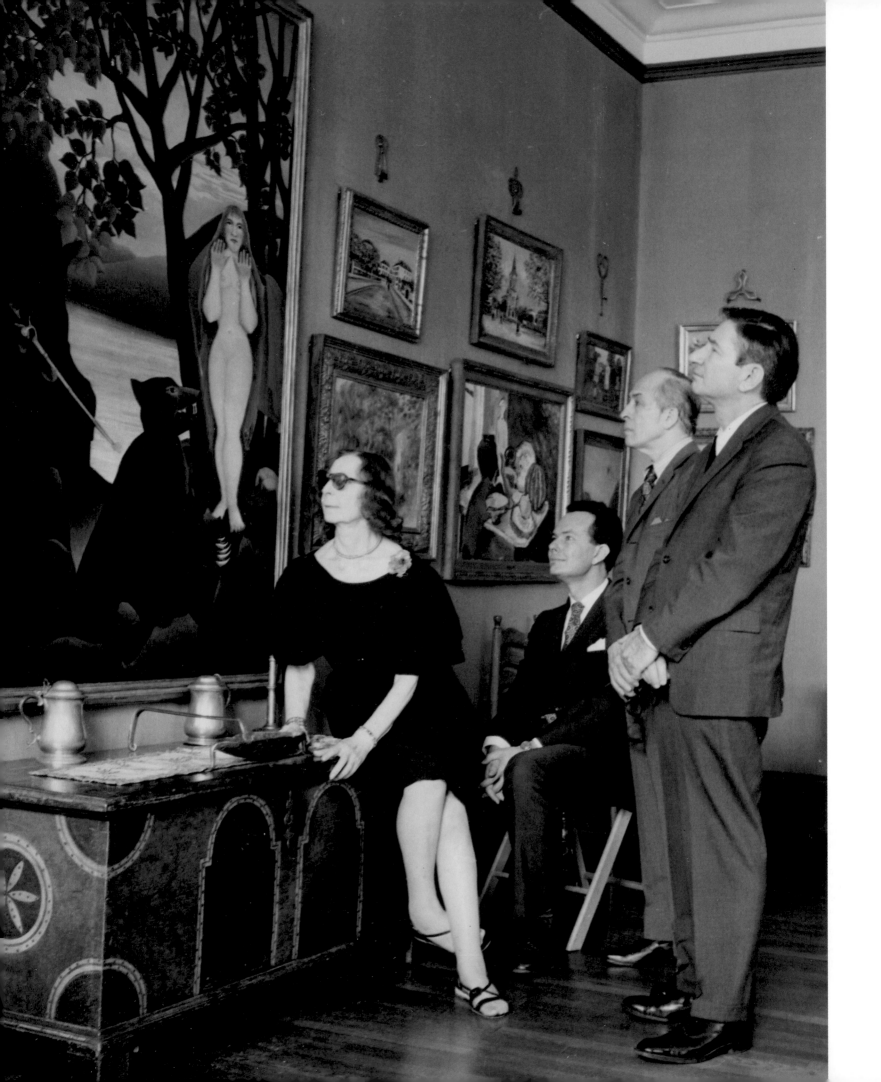

# ALBERT C. BARNES AND THE BARNES FOUNDATION

Objects of art contain myriads of elements of form on different levels, knit together in more and more complex systems, till the feeling which they demand is such as to occupy the whole powers of the greatest mind, and more than these if they were to be had.

Bernard Bosanquet, *Three Lectures on Aesthetic*, 1915

*Albert Coombs Barnes (1872–1951)* assembled a collection of Modern paintings unrivaled for quality in the twentieth century. What sets Barnes apart from other great collectors is his conviction that these works of art could be used as tools in an educational experiment begun with his employees in the early years of the twentieth century and crystallized in 1922 in the school of the Barnes Foundation (fig. 4).

Barnes was born January 2, 1872, in Kensington, a working-class neighborhood in Philadelphia. In 1867, his father, John J. Barnes (1844–1930), a Civil War veteran, had married Lydia A. Schaffer (1846–1912), a devout Methodist of Pennsylvania-German origin. On his father's side, Barnes was descended from Quakers and Presbyterians. In response to an inquiry about one of his ancestors, Barnes wrote to Henry Francis du Pont,

> Yes, the guy was one of my ancestors—& he was a renegade—i.e. When Penn's boat landed here in 1682, it was with a big bunch of my forebears—every damned one of them an orthodox Quaker. Sometime before 1700, they had a fight about religion & part of them went to the Presbyterian Church in Abington [Pennsylvania], & the gravestones there give the dates of their birth & burial. The faithful ones are buried in the Abington Quaker burial ground, just around the corner from the Abington church. I carry water on both shoulders by never visiting one cemetery without going to the other. They were all honest workmen—one a wheelwright, another the maker of some Windsor chairs that Stog[dell] Stokes owned. My grandmother Coombs, (Coombs Alley is named for the family & so am I) was a quaker, so was very grounded; my mother was a Methodist—& that makes me a mugwump. Never mind—I'll see them all later.[1]

Concerning his parents, Barnes recalled in a letter to Alice Dewey, dated September 20, 1920, "I had a marvelous mother, one endowed with a keen, penetrating intelligence and a courage equal to Roger Baldwin's, but best of all, she had poise and balance. Unfortunately, I needed a father and while he had a good intelligence and tremendous energy, he lacked the balance to use them right to achieve that composite we call character."[2]

FIG. 4

Faculty of the Art Department of the Barnes Foundation, 1972, in Gallery XXIII, facing Henri Rousseau's *Unpleasant Surprise* (*Mauvaise surprise*, BF 281). L–R: Violette de Mazia (1899–1988), Director of Education, Barton Church (b. 1926), Angelo Pinto (1908–1994), and Harry Sefarbi (1917–2009), instructors, London Collection. Photograph by Angelo Pinto

And about his maternal grandmother, he wrote to John J. Cabrey on November 29, 1950, "My interest in the Pennsylvania Dutch, comes naturally for my grandmother was one of them, and early in life I became acquainted with their furniture, their cooking, and their wonderful houses and gardens."[3]

Barnes often reminisced about his early life, and the passions and temperament that defined him as an adult were already apparent in childhood—at least as he reconstructed it in memory. In one interview he stated, "I have always been interested in painting, and painted as a boy from the age of 6 until I was 28."[4] He and his brother, Charles, bought boxing gloves and practiced in the cellar, attending local matches and honing their technique in order to defend themselves against neighborhood bullies.[5] He told John Dewey in 1946, "I learned more about painting, music and how to go about doing things in a practical world from my experiences on the baseball field and in the boxing ring."[6] Combativeness would prove to be a basic constituent of Barnes's psychological makeup.

In his autobiographical reflections Barnes often evoked his early contact with African Americans and the decisive influence black culture had on his life. At the age of eight, he attended a camp meeting in Merchantville, New Jersey, where he was captivated by the crowd's movements, vocalizations, and other expressions of deeply felt faith. This experience, he said, influenced his whole life, not just by exposing him to African American religious life, "but in extending the aesthetic phase of that experience to an extensive study of art in all its phases, and particularly the art of painting."[7] The singing of spirituals, in particular, thrilled him.

In 1926, he wrote to Charles S. Johnson, editor of the National Urban League's publication *Opportunity: Journal of Negro Life*, to arrange a visit of the glee club from the Manual Training and Industrial School for Colored Youth in Bordentown, New Jersey. "I'd like . . . to have the chorus give a couple of the real spirituals—the crooning, exhortation, confession, etc., etc. that I've heard many times in camp-meetings and churches and have heard slaughtered so often . . . on the concert stage not only here but in Paris."[8] The chorus, under the direction of Frederick J. Work (1880–1942), the leading scholar who transcribed and published many of the spirituals, performed annually in the Main Gallery of the Barnes Foundation from 1926 until 1942.[9] Barnes invited the singers again in 1950, writing to W. R. Valentine, principal of the Bordentown school, of his dual purpose for the concerts:

> When your glee club sang at the Foundation for the first time, there was a definite prejudice against the Negro as an equal and integral part of the American idea of democracy. I mean by democracy the sharing of all classes of people of the special contributions of any one section of the community. As your boys and girls sang the Spirituals, the audience was gripped by something new, deep feeling that gave them a new and enriched experience. At the end of even the first performance, the first steps toward breaking down the prejudice were accomplished. . . . When the average Negro is treated on terms of equality and is given a job that requires the mentality which supposedly is exclusively the property of the white man, the Negro can do that job just as well as the white man. . . . I think their appearance at the Foundation would give me an excellent opportunity to bring this idea home to the kind of audience that we have and it would do most good in the advancement of the idea that the Negro has the qualities that entitle him to an equal place in American life with the white man. . . . I would make it a point to have present not only the best of our student body, but some of the most distinguished leaders in the various fields of community life.[10]

After graduating from the William Welsh Elementary School, in June 1885, Barnes entered Central High School, one of the preeminent public high schools in the United States. Chartered in 1836, the school was empowered in 1849—and still is—to grant advanced degrees to its graduates.[11] The academic program was rigorous; it offered a full curriculum of sciences and general humanities, including courses in algebra, trigonometry, calculus, chemistry, physics, Latin, German, economics, history, English, and literature. Barnes progressed smoothly through the program at Central, graduating in June 1889 at the age of seventeen.

It was at Central that Barnes met William J. Glackens (1870–1938), who would become a lifelong friend.[12] The

two shared an interest in sports, and by all accounts they were active and popular students. As recalled by Barnes, Glackens was renowned among his peers for his satirical drawings of teachers, which were circulated among students "with results disastrous to book learning but very illuminating of life as it exists. . . . Nothing could have saved him from expulsion except his obviously great intellectual endowment, a personality universally loved and respected and a sense of humor so contagious that it disarmed the justifiable wrath of his teachers when the question arose as to whether he should be banished from the school."[13]

In September 1889, Barnes was enrolled in the University of Pennsylvania Medical School. Following his graduation three years later, in 1892, he served as an intern in the Polyclinic Hospital and at the Mercy Hospital of Pittsburgh. He recalled, "This experience led me to believe that I was not cut out for the practice of medicine. What interested me most was, in a broad general way, science, and particularly that branch of chemistry that was related to physiology. By various means I scraped together enough to go to Europe to get the proper training and managed to spend three years over there taking courses at the University of Berlin and later at Heidelberg University. . . . I turned my attention to another branch of science which concerned the relationship between chemical constitution and physiological activities. In the course of this investigation, I developed many new products, one of which, Argyrol, turned out to be of considerable clinical value and incidentally, the means of providing me with a lot of money."[14]

A critical element of Barnes's intellectual formation was his passionate lifetime study of modern psychology, still in those years a relatively new discipline. On December 11, 1915, he wrote to the editor and critic Charles FitzGerald, "More than twenty years ago I came to the conclusion that the three most important sciences in the world are mathematics, psychology and chemistry. Of mathematics I know practically nothing, chemistry not as much as I would like to know, but I have attained a fair knowledge of normal psychology from twenty years continuous reading in that subject, a practical laboratory training therein, and many years experience in applying the principles of psychology to every day life."[15]

Specifically, Barnes was an early exponent of Sigmund Freud's analytical method. A few days before, on December 6, he had written FitzGerald, "I am a Freud enthusiast and have been for a long time. . . . But the Freud system needs the study of good psychologists who are not apparently as blind as Freud has been in their devotion to a principle that is sound at the bottom, monumental in conception, but not yet fully proved."[16] On December 11, he elaborated to FitzGerald, "I do not accept all that Freud claims, but I have never found anything which he stated which could be successfully controverted by the presentation of sound psychological principles. I like the arbitrary, dogmatic stand he has taken, because he is a man who thinks straight and original in a domain in which he is familiar with what scientists have developed."[17] Barnes prided himself on his abilities as a lay analyst and sometimes consulted on cases referred to him by medical colleagues. His self-confidence in this respect was perhaps exaggerated, but his efforts as a lay analyst were grounded in serious study, for, as he wrote to critic Leo Stein on February 26, 1916, "I tackled that problem [Freud] the same as I do any other one that I think is important for my life—that is, I got all of the works of Freud himself, and have spent the time since last June practically every day for several hours in association with a fellow who has studied it for years, in trying to get at the meat of the thing, and reconcile it with the straight goods in psychology as I have learned them from study and personal interpretation."[18]

Upon his return from Berlin around 1897, Barnes worked a brief stint as "quasi-consulting chemist" at H. K. Mulford & Company. He then returned to Germany in 1900 to study at Heidelberg.[19] It was here that Barnes conceived of the idea for the drug that would earn him a fortune. Barnes was aware of the uses of silver compounds in previously developed drugs, but to realize his product he needed someone more skilled than he in chemistry. In Heidelberg he recruited and hired a young German Ph.D. in chemistry, Hermann Hille (1871–1962), who also had a diploma in pharmacy, to work for Mulford as a research chemist. Hille referred to Barnes as "advertising or sales manager of Mulford."[20] During this time he worked on developing new products for the company and also, on the side with Barnes, on ideas for other new preparations. While still in the employ of Mulford, Barnes

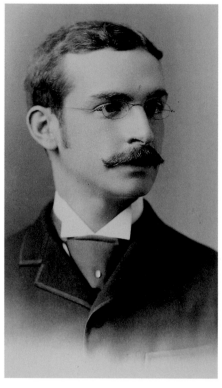

FIG. 5

Pharmacy sign advertising the sale of Argyrol, c. 1908–29, The Barnes Foundation Archives, Gift of David McCarthy and Marina Pacini in honor of Ruth McCarthy

FIG. 6

Albert C. Barnes, c. 1900, The Barnes Foundation Archives

FIG. 7

Laura L. Barnes (1875–1966), c. 1901, The Barnes Foundation Archives

and Hille created a silver compound they later named Argyrol. They described the new drug, demonstrated to have therapeutic benefits in the treatment of ophthalmic infections, particularly infant gonorrhea, in a paper read at the third annual meeting of the American Therapeutic Society in New York (May 14, 1902) and published in the *Medical Record* of May 24, 1902.[21]

Immediately thereafter the partners left Mulford and established their own business, Barnes and Hille, Manufacturing Chemists. They conceived, created, and successfully marketed Argyrol and other new products (fig. 5). Hille was in charge of production, and Barnes was highly successful in marketing the new drug directly to physicians, and the company established offices in London and Sydney. Although the enterprise prospered, from the outset the two men clashed. Less than a year after the initial partnership agreement had been signed, it was scrapped, and the two men signed a five-year contract as of April 30, 1903, creating the Barnes and Hille Company. Laura Leggett Barnes (1875–1966), the daughter of a prosperous Brooklyn family whom Barnes had married in

June 1901, kept the books (figs. 6 and 7).[22] Two employees were engaged, Nelle E. Mullen (1884–1967) and her sister Mary (1875–1957), who remained Barnes's lifelong associates and played major roles in all of his business affairs and educational projects. Both women later held important positions at the Barnes Foundation (fig. 8).[23]

By 1907 relations between the two partners had deteriorated completely. With one year remaining on their five-year legal agreement of 1903, Barnes brought a bill in equity against Hille and subsequently prevailed in his bid to buy his partner out.[24] Barnes reorganized the company as the A. C. Barnes Company and registered the trademark Argyrol in June 1908.[25]

This move secured Barnes's already strong financial position, enabling him to accelerate an educational experiment that had been under way since around 1902. The evolving project in effect fused his business interests, idealism, knowledge of psychology, and passionate devotion to the cause of equal rights and progress for black citizens. The factory of the new A. C. Barnes Company, located at 24 North 40th Street, adjacent to the University

of Pennsylvania campus, was fitted out with a laboratory, but the offices had the character of a residence. It was here that innovative seminars were conducted for the benefit of Barnes's employees.

Barnes offered a useful description of the spirit and impetus of his first educational venture—the seminars at the laboratory—in a 1942 radio address and, as always, stressed the continuity between them and the classes held after 1925 at his new Foundation: "The educational program of the Barnes Foundation is basically a continuation on a larger scale of the experiment made with the humble factory workers," he began. "[The first seminars constituted] an experiment with scientific method applied to the study of art, particularly paintings, a large collection of which I had accumulated, studied, and written about, over a period of many years. And what I had learned [myself], I [later] applied to the training of the Foundation's teaching staff."[26] Barnes assigned Mary Mullen to lead the factory seminars, based on her thorough grounding in Dewey's principles and her knowledge of psychology.[27] The worker-students were encouraged to

view themselves as equal partners in the learning process. After the opening of the Foundation in 1925, classes continued at the company. "The gallery class is merely substitution of material for the words which Mary Mullen uses in another class held in our laboratory in which *Democracy and Education* is the text followed."[28]

In a piece written for the *New Republic* in 1923 to describe the origins and announce the purpose of the Foundation, he emphasized the self-determination enjoyed by his student-employees at the A.C. Barnes Company and the group's diversity in terms of race and educational level. The article goes on to describe the company's unique business ethos and methods in a passage that sheds light on his developing system of experience-based education, its origins in the factory seminars, and the intellectual underpinnings it shared with the earlier classes:

The business [Barnes and Hille] was started in 1902 with only enough capital to last about three months, if luck had gone against us. We never had a salesman or traveling representative and we do not advertise in the technical journals, because we found in the psychology of William James' principles which enabled us to dispense with those luxuries. From his and similar books we developed a business plan which in two years was financially profitable. In 1908 we reorganized the business on a cooperative basis worked out during the next four years on lines that were merely adaptations of the principles of psychology to our business, educational and social needs in their larger conception. A good part of those four years was consumed in efforts to unify to a common purpose the diverging temperaments of the principals. We were fortunate in having as universals a spirit of adventure and a common respect for the personality of each individual. The business never had a boss and has never needed one, for each participant had evolved his or her own method of doing a particular job in a way that fitted into the common needs. We found that no business day need be longer than six hours of actual work, but we had to concede to the tradition that eight hours at the place of business were necessary. That compelled us to face the problem

of utilization of leisure and it was natural that we should turn to the men in whose writings we were genuinely interested, and whose ideas had been good money-makers for us. We started a seminar with one of the women [Mary Mullen], who had a flair for psychology, at the head of it. Two years were devoted to William James, starting with his *Talks to Teachers*, then progressing through his *Principles of Psychology, Pragmatism, Varieties of Religious Experience*, most of which was found comparatively easy going. We foundered on his *Radical Empiricism*. About that time [1910] Dewey's *How We Think* was published and it brought a means of clarifying and adapting what we had read to the needs of most of the other employees. The seminars interested a number of people outside of the business, and additional meetings were conducted at the homes of two of the women principals. Bertrand Russell won their hearts with his *Free Man's Worship* and [George] Santayana was soon in the ascendancy with his *Sense of Beauty*, the pretty thorough study of which was responsible for our trying to learn something about painting by hanging in our building good examples of the work of [William] Glackens, [Ernest] Lawson and [Maurice] Prendergast. This interest grew and for about ten years we have had constantly in the building modern pictures that would stand examination in the light of what we learned from Santayana's *The Sense of Beauty*, his *Reason in Art*, and from other books like Roger Fry's *Vision and Design* and [Percy Moore] Turner's *Appreciation of Painting*.[29]

In an article published in *Opportunity: Journal of Negro Life* in 1926, Mary Mullen provided her own clear description of the class sessions:

The experiment sketched herewith was carried out in a chemical factory that employs about a dozen Negroes. . . . Because of the shortness of the working day, it was possible to devote an hour several times a week to a systematic study of problems intimately related to the Negro's life, both business and personal. . . . Membership in the classes was and always has been voluntary, but the interest aroused was such that all the employees attended them regularly. . . . The *esprit de corps* has always been so good, and the desire to advance in understanding so genuine, that the discussion has always gone on under its own impetus. The object of education is to find one's self in the world and to make one's self at home there. Hence the first topics of discussion were psychological. Psychology, however, was presented without any unnecessary technicality, and simply as a study of the impulses, the instincts, which constitute the ultimate sources of behavior, the organization of these impulses into habits, and of habits into the personality as a whole. . . . Every effort was made to leave no general principle unattached to specific facts in experience, and to point out the bearing of all principles upon specific personal problems. . . . Since all labor is an affair of cooperation, the conditions under which cooperation becomes effective and personally satisfactory were dwelt upon. . . . The problem of extending personal activities into other spheres led at once to the study of social conditions in general. At this point Bertrand Russell's *Why Men Fight* was found illuminating. Since understanding of the social system as it exists requires knowledge of the past, history came next under consideration, and [H. G.] Wells' *Outline of History* was studied and extensively discussed. From this it was but a step to the nature of evolution, and from that to scientific method in general. . . . Parallel to the discussion of the world of objective fact, a study of the world of art was carried on. After the aesthetic phases of the everyday life of affairs had been explored, attention was turned to the fine arts themselves. A large collection of pictures belonging to the chemical company had always been exhibited in the factory buildings, and these pictures provided material for unending comment and debate. They were treated, in accordance with the Barnes Foundation's general educational program, from a point of view strictly plastic: discussion was always directed to the qualities that make a picture a work of plastic art rather than a literary or historical document. . . . Not pictures only, however, but music, poetry, the drama, were

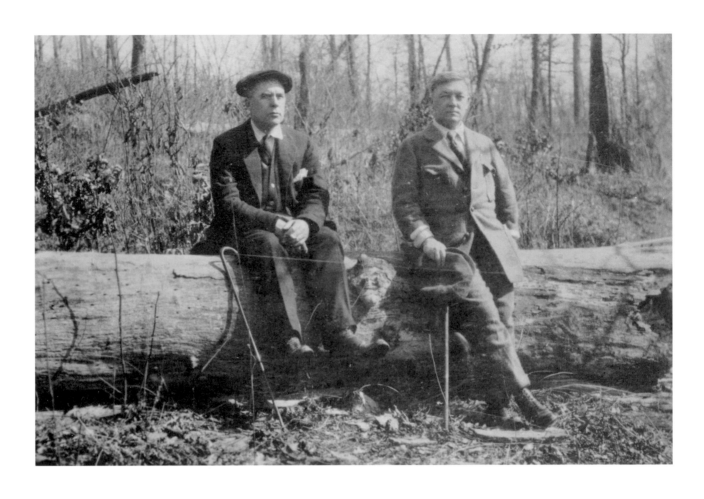

analyzed in the light of aesthetic principles; their source in human nature was kept constantly in view, and the psychological factors in aesthetic appreciation were at all times shown in relation to the objective facts in the work of art itself. . . . Because of the fact that the members of the class were Negroes, particular attention was paid to race problems, to the social and economic handicaps under which the Negro suffers, their cause and their cure. These problems were naturally in the center of the men's consciousness, the questions arising were those which they most desired to find answers to, and the coordination of particular facts with general principles was easiest in this field.[30]

From an inventory drawn up in 1922–1924,[31] we know that prior to the move from his home to the gallery of the Barnes Foundation in the latter part of 1924, Barnes's residence and factory were bursting with pictures. More than seven hundred works were transferred to the gallery of the Foundation, and Barnes continued to acquire new works to support the activities of his school.

In the latter part of 1911, Barnes reestablished his friendship with his old school friend William Glackens (fig. 9). In the next few years the cordial, but somewhat formal tone of their early letters of this period quickly gave way to the old familiarity, and through Glackens, Barnes gained contacts that became vital as he immersed himself in Modern painting. Barnes visited Glackens, looked at his work, and discussed it. Glackens also introduced Barnes to some of his colleagues, including Ernest Lawson, John Sloan, and Robert Henri. The fledgling collector visited their studios as well and began to purchase their work and that of other contemporary Americans.[32]

On January 19, 1912, Barnes wrote to Glackens, "Dear Butts: I want to buy some good modern paintings. Can I see you on Tuesday next in New York to talk to you about it?"[33] Glackens responded, "Dear Barnes, Why not call for me at my apartment at the above address [29 Washington Square]. We can have lunch at the Brevoort and talk it over."[34] During this visit to Washington Square, Barnes purchased a canvas by Glackens, *Mahone Bay*, painted in Nova Scotia in the summer of 1910. He wrote to Glackens on the 24th, "I enclose a check for $300.00 in payment for the painting of Mahone Bay, Nova Scotia. When you have had this painting framed, please send it to me by express to my residence."[35]

On January 30, Barnes wrote to Glackens about the proposal he had made earlier in the month:

I believe that your mission to Paris in search of Renoirs, [Alfred] Sisleys, and others of the modern painters discussed by us, will be facilitated if you are provided with spot cash to pay for the entire lot. I know the keenness with which Europeans look upon ready money, and I am confident that you would be able to drive better bargains if you are in a position to say that you are ready to pay spot cash for the paintings, and have them packed and shipped under your own observation. I am ready to furnish you with [a] letter of credit sufficient to buy several Renoirs, two or three Sisleys, and others discussed by us at the prices which we thought would prevail in Paris. If you decide to go, as I hope you will, I suggest that you see me in Philadelphia on next Saturday morning . . . and we can arrange the financial part as above outlined. There is a North German Lloyd steamer sailing next Tuesday which would get you in Paris about Feb. 14th or 15th, give you a couple of days to get a line on what you want, and still allow two weeks for selecting the paintings, and enable you to be back in New York by the middle of March. I suggest that you get in touch promptly with [James B.] Moore and talk the situation over with him; but I do not think that it would be wise to depend absolutely upon one man's statements that such paintings as we want to secure are not immediately available, because the personal

equation which enters so much into the matter makes a pre-judgment practically impossible. I feel sure that you could get what you go after.[36]

On February 3, Glackens sent a message from onboard the *Rochambeau* to Barnes: "Dear Barnes, Am off and primed for the fray. Yours, Butts."[37]

Glackens was accompanied on the voyage across and in Paris by Alfred H. Maurer, an old friend and colleague who had lived in France since 1897 and whom Glackens and his wife had visited on their trip to France in 1906. Maurer was friendly with Leo and Gertrude Stein, had known their collection from its inception, and was familiar with the most progressive contemporary art in Paris.

A comprehensive chronology of Glackens's activity in Paris is preserved in the form of letters home to his wife, Edith Dimock, letters to Barnes, and two notebooks in which Glackens recorded which dealers he visited, the pictures he saw at each, and their prices in francs.[38] From the ship, Glackens wrote his wife on February 13, 1912, "Arrived in Paris last night 11 o'clock. . . . The weather is delightful. . . . I am to meet Alfy at one o'clock and he is going to introduce me to Mr. [Leo] Stein a man who collects Renoir, Matisse, etc."[39] On the 16th, Glackens wrote his wife, "I have been through all the dealers places and have discovered that Mr. Barnes will not get as much for his money as he expects. You can't touch a Cézanne under $3,000 and that for a little landscape. His portraits and important pictures range from $7,000 to $30,000. I got a fine little Renoir at Durand Ruel a little girl reading a book, just the head and arms, in his best period [*Child Reading* (*Enfant lisant*, BF51)]. I paid seven thousand francs for it. They asked eight but came down. I consider it a bargain. This is all I bought so far. Am still looking around. . . . Hunting up pictures is not childs play."[40] On February 24th, Glackens wrote Edith, "I have six more days of Paris and then I start for New York on *Le Provence* from Havre. . . . Poor Alfy will doubtless be glad to see me go as he has been with me every day assisting with his fluent French. He has been awfully nice."[41]

On March 1, after a successful two weeks at the dealers in Paris, Glackens wrote to his wife, "Everything is settled up here and the pictures being boxed. I am mighty glad it is finished and I am sick of looking at pictures and asking

prices. . . . I suppose I will have a devil of a time with the customs people over the pictures. I am loaded down with invoices and consular certificates."[42] The same day, Glackens summed up the trip in a letter for Barnes:

> Everything has been finished up and the pictures are being boxed and packed by a first class packer. . . . I am bringing you a fine collection of pictures nearly everything I started for. Some I decided not to take, a Gauguin, and a Matisse. I had no selection only three in Matisses and as I had seen better ones I thought it better to wait. Degas too expensive. Manet also. Have got a fine Morrisot [*sic*]. As for the younger men you would have to be here in Paris to see for yourself what they are doing. You would scarcely believe your eyes. I will try to bring back some photograph[s] to show you. Art is in a strange state at present among the youth. A series of convulsions apparently and as you made certain discoveries with regard to convulsions if I remember correctly you may be able to explain what is the matter with art. I confess that lots of things I have seen over here are incomprehensible to me as art. Cézanne is supposed to be the fountain head of all this but the fact of the matter is they didn't understand him. I have seen quite a number of them. He was undoubtedly a mighty big man. I am bringing a Cézanne landscape one that was owned by [Théodore] Duret ["the art critic" crossed out]. I didn't need the $3000 after all and am bringing it back. The best thing I could do for you would be to put it in another Renoir ["or Cézanne" crossed out] but as there will be a lot of Renoirs coming back from St. Petersburg and Munich where there have been exhibitions, some time toward the end of this month it would be better to wait. And you can decide whether you want one or not. As for Monet it would be advisable to wait for some sale. I am told they do not always bring high prices. You certainly have to pay good prices to the dealers. There will be duty to pay on some of these pictures. I suppose you will be at the dock.[43]

Glackens had selected and purchased for Barnes a total of thirty-three works.[44] His notebooks and correspondence have made it possible to reconstruct, for the first time, a complete inventory giving the names of the artists, titles and or descriptions of the works, their purchase prices, and the dealers from whom they were purchased. As Glackens visited dealers in Paris in 1912, he recorded the asking prices of works that interested him in a notebook inscribed "BARNES Pictures" at the bottom of the front cover. It is evident by comparing the numerous notations of artists, titles, and prices throughout the notebook to the final list of purchases Glackens made (fig. 10) that he bargained successfully with the dealers for lower prices. The final list, which documents all of his Paris acquisitions for Barnes, is transcribed below, with Glackens's descriptions enclosed in quotation marks. Works are oil paintings unless otherwise indicated. Prices recorded are in French francs at around five francs to the U.S. dollar.

Six lithographs, 575ff: 2 [Paul] Cézannes 4 [Pierre-Auguste] Renoirs, A. Vollard[45]

Renoir, 8,500ff, "two heads of girls," Barbazanges [*Two Girls with Hats* (*Jeune filles au chapeau*, BF130)][46]

[Camille] Pissaro [*sic*], 3,000ff, "garden with red roof" [*Jardin à Eragny*], Henry [*sic*] Barbazanges [*Garden* (*Le Jardin au grand soleil, Pontoise*, BF324)][47]

[Eugène Louis] Boudin, 1,500ff, "quai de la Seine, Bruxelles," Barbazanges [traded][48]

Renoir, 16,000ff, "Sortie du bain nude," Durand-Ruel & Fils [inv. 7848; traded][49]

Renoir, 4,000ff, "Montmartre landscape," Durand-Ruel & Fils [inv. 6701; *View from Montmartre* (*Vue de Montmartre*, BF144)][50]

Renoir, 7,000ff, "Girl reading," Durand-Ruel [inv. 8005; *Child Reading* (*Enfant lisant*, BF51)][51]

B[erthe] Morrisot [*sic*], 6,300ff, "portrait of young blonde woman with black lace scarf over hat and under chin," Durand-Ruel [inv. 5176, *Femme au chapeau de paille*; later sold][52]

[Gustave] Loiseau, 1,300ff, "Winter landscape," Durand-Ruel [inv. 8035, *La Neige, environs de Pontoise, 1905*; traded][53]

[Johan Barthold] Jongkind, 6,500ff, "moonlight in Hollande," Durand-Ruel [inv. 9457, *Claire de lune en Hollande*; traded][54]

FIG. 10

Page spread from William Glackens's 1912 notebook (inscribed on cover, "BARNES Pictures [1912] / CONWAY, 1920"), ink on bound notebook paper, 8¼ × 10⅝ in. (21 × 26.2 cm), Museum of Art Fort Lauderdale, Nova Southeastern University, Bequest of Ira Glackens, 92.57

Jongkind, 1,500ff, watercolor, "low hill and tree in for[e] ground," Durand-Ruel [inv. 7346, *La Vieille maison*; traded][55]

[André] Suréda, 800ff, gouache, "Moorish woman portrait," Durand-Ruel [*Femme mauresque*; *Spanish Dancer* (BF461)][56]

Maurice Denis, 1,000ff, "Maternite. Woman with infant," E. Druet [inv. 358, *Maternité*; *Mother and Child* (BF335)][57]

[Vincent] Van Gogh, 8,000ff, "Portrait head of postman," E. Druet [inv. 5512, *Postier (fond aux fleurs)*; *The Postman (Joseph-Etienne Roulin)* (BF37)][58]

[Alfred] Sisley, 6,000ff, "Pont de Sèvres," Durand-Ruel [inv. 8602; *Sèvres Bridge (Le Pont de Sèvres*, BF231)][59]

Sisley, 7,000ff, "Moret le matin. Church in distance up river shed to left," Durand-Ruel [inv. 5712, *Moret le matin*; traded for credit to Durand-Ruel][60]

[Albert] Lebourgh [sic], 1,000ff, "River with boat trees on bank and houses indicated [among?] trees pink cloud," D. Jacobi [traded][61]

Lebourgh [sic], 400ff, *"Rouen with tug boat, bridge, house,"* D. Jacobi [*Along the Seine (Rouen)* (BF563)][62]

Renoir, 300ff, "Tiny sketch of girl with hat on," D. Jacobi [*Woman's Head with Red Hat* (BF63)][63]

[Pablo] Pèccaso [sic], 1,000ff, "Young woman with cigarette," Galerie Vollard [*Young Woman Holding a Cigarette (Jeune femme tenant une cigarette*, BF318)] [fig. 11][64]

Cézanne, 13,200ff, "Mountain in distance green fields and for[e]ground with road," Bernheim-Jeune & Cie. [inv. 17921, *Montagne Victoire et le chemin Aix en Provence*; *Toward Mont Sainte-Victoire (Vers la Montagne Sainte-Victoire*, BF300)] [fig. 12][65]

[Pierre] Bonnard, 800ff, "Portrait of girl in black hat" [*La Femme en noir*], Bernheim inv. 18016 [later sold][66]

[Alfred] Maurer, 1010[ff][67]

[Charles] Dufresne, 5off, "Nude" pastel, [no dealer noted] [*Nude* (BF471)]

Total amount spent: approximately $19,347.00

FIG. 11

Pablo Picasso, *Young Woman Holding a Cigarette (Jeune femme tenant une cigarette)*, 1901, oil on canvas, 29 × 20⅛ in. (73.7 × 51.1 cm), The Barnes Foundation, BF318

FIG. 12

Paul Cézanne, *Toward Mont Sainte-Victoire (Vers la Montagne Sainte-Victoire)*, 1878–79, oil on canvas, 18¼ × 21¾ in. (46.4 × 55.2 cm), The Barnes Foundation, BF300

The paintings were unpacked in Philadelphia on April 2. On April 3, after Barnes had a chance to examine them at home, he wrote to Glackens, "I have examined the paintings which you bought for me in Paris and I am delighted with them. You are to be congratulated upon the selection, and I am sure they do you credit and will be a decided acquisition to my collection."[68]

While Glackens was in Paris in February 1912, Barnes lost no time. He acquired several small oils by the Canadian artist James Wilson Morrice (1865–1924), a longtime friend of Glackens's, from a private dealer in Philadelphia.[69] He also purchased at auction in New York for $250.00 Corot's *Landscape—A Sketch* (BF1035), still in the collection of the Foundation. At the same sale he also bought two other oils.[70] After Glackens's return from Paris, Barnes attended the sale of William Merritt Chase's private collection, where on March 7, he purchased three paintings: a large canvas by Jean Louis Forain, *A Patient Fisherman* (cat. 78, illustrated) for $560.00; a Eugène Louis Boudin, *Harbor Scene* (cat. 46) for $725.00; and a John Henry Twachtman, *World's Fair Exposition Buildings* (cat. 33) for $275.00.[71]

Shortly after Glackens's return home, Barnes purchased Claude Monet's *Madame Monet Embroidering* (*Camille au métier*, BF197) of 1875, which Glackens had seen in Paris.[72] In April 1912, he purchased Renoir's *Before the Bath* (*Avant le bain*, BF9) of c. 1875 and *Girl with Jump Rope* (*Fillette en robe bleu*, BF137) of 1876 from the Durand-Ruel Gallery in New York and negotiated for several works by Degas that Glackens had seen and noted in Paris, as well as others Barnes had looked at in the firm's New York branch.[73] As Barnes's collecting accelerated, Alfred Maurer continued throughout 1912 until mid-1913 to play a significant intermediary role in seeking out and recommending potential acquisitions and negotiating their purchase with Parisian dealers.

After early 1912 Barnes's purchases quickly began to cover the walls of his home and factory. Examples of Glackens, Lawson, Maurer, Henri, Sloan, Prendergast, Luks, Davies, and other American artists were prominent. On the heels of Glackens's buying mission, Barnes himself traveled in June to Paris, where he visited galleries with Maurer. He continued to acquire Modern European paintings throughout 1912, with Maurer as his agent

in Paris. Among these was van Gogh's *The Smoker* (*Le Fumeur*, BF119), bought from Eugène Druet's gallery in July.[74] By August, Barnes had purchased three Bonnards from the Galerie Bernheim-Jeune: *Young Woman Writing* (*Jeune femme écrivant*, BF346) of 1908, *The Ragpickers* (*Les Chiffoniers*, BF309), and *Evening Under the Lamps* (*La Soirée sous les lampes*, BF275).[75] From the spring of 1912 until the summer of 1913, Barnes corresponded intensively with Maurer, to whom he paid a retainer, and expressed interest in acquiring more pictures by van Gogh, Degas, and Cézanne. In addition to visiting the dealers, Barnes urged Maurer to visit collectors such as Théodore Duret and Dr. Paul Gachet to inquire if they would sell works from their collections.

On December 3 or 4, 1912, Barnes arrived in Paris for a major buying campaign at the winter auction sales and at the dealers. On one of his "free" days, he went to London to visit the Second Post-Impressionist Exhibition at the Grafton Galleries, organized by Roger Fry. There he saw for the first time Picasso's *Composition: The Peasants* (BF140) of 1906, which he marked in his catalogue, lent by Ambroise Vollard, and which he bought from the dealer in June 1913.[76] He made his first Paris purchase on December 6, buying six small pictures by Picasso from Daniel-Henry Kahnweiler and a Picasso gouache from Clovis Sagot. At the Leon Hirsch sale on December 7, he purchased Honoré Daumier's *The Hypochondriac* (*Le Malade imaginaire*, BF75), two Renoirs, *Woman Crocheting* (*Femme faisant du crochet*, BF108) and *On the Grass* (*Sur l'herbe*, BF289), and a Pissarro, *Market Scene*, a gouache of 1888 (later traded). At the Henri Rouart sale on December 9 and 10, Barnes bought Daumier's *Water Carrier* (*Le Porteur d'eau*, BF127) and two small Cézanne still lifes, *Grapes and Peach on a Plate* (*Grappe de raisin et pêche sur une assiette*, BF241) and *Three Apples* (*Trois pommes*, BF57), and created a great stir in the salesroom when he successfully bid for Cézanne's *Five Nudes* (*Cinq baigneuses*, BF93).

The foreign correspondent of the *Burlington Magazine* reported at some length on the Rouart sale, the most important sale of the season, and mentioned Barnes: "It was amusing to watch a certain section of those present at the Rouart sale while what they had been accustomed to consider secondary pictures went up to prices hitherto undreamed of. When Cézanne's little *Baigneuses*, measuring only 16 by 17 inches, was put up to 18,000 [francs] (19,800 including charges) [the equivalent of $3,960.00], at which price it was bought by Mr. Barnes, an American collector, there was derisive laughter from some of the worthy dealers and others in my neighborhood. Who, they evidently thought, are the lunatics let loose among us? As the sale proceeded, their derision turned to indignation, for they saw all their standards of value shattered."[77]

On December 9, Barnes visited Leo and Gertrude Stein and purchased his first two paintings by Matisse, *Dishes and Melon* (*Assiettes et melon*, BF64) and *The Sea Seen from Collioure* (*La Mer vue de Collioure*, BF73), both of 1906.[78] On December 10, Barnes bought from Vollard Cézanne's *Portrait of Mme Cézanne* (Rewald no. 607; later traded), *Three Bathers* (*Trois baigneuses*, BF96), *Plate of Fruit on a Chair* (*Assiette de fruits sur une chaise*, BF18), and Emile Bernard's *Self Portrait* (BF2004) of 1888. Following his return home, Barnes wrote to Robert Henri on Christmas day, "I got some important Cézannes and Renoirs a few days ago in Paris. . . . There are 6 Cézannes . . . and four Renoirs . . . I also got two very typical Daumiers, some early Picassos and the Matisse still life & landscape which I believe you saw at Stein's apartment in Paris."[79] A new force had entered the market, a self-made man with substantial intellectual and financial resources, who relished confrontation and who drove hard bargains in business negotiations. As a collector, Barnes revealed himself to be complex and energetic, possessed of a relentlessly curious and disciplined mind. Over the next forty years, the art world learned that to laugh at Albert Barnes of Philadelphia was to provoke an adversarial response of unequaled intensity.

From the standpoint of Barnes's intellectual growth, the most important outcome of this visit to Paris was his first encounter with Leo Stein (1872–1947), who quickly became one of his mentors in matters of art (fig. 13). Stein has been described by a friend who frequented the salon at the Rue de Fleurus in Paris: "A trained and profoundly analytic mind, Leo could, if he chose, discuss theories of esthetics and the history of painting by the hour. But he was also contemplative to a degree that very few connoisseurs of fine art are capable of being. He really looked

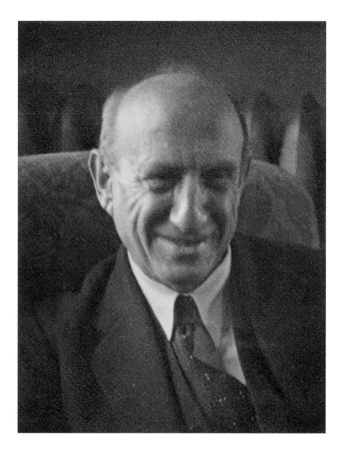

and knowledge to provide the theoretical underpinnings and many of the answers Barnes sought.

In 1913, Barnes began a correspondence with Stein that lasted until the latter's death in 1947. He wrote on March 30, "At New York it [the Armory Show] was the sensation of the generation. . . . Academic art received a blow from which it will never entirely recover. . . . Picasso and the [other] Cubists got more attention than all the rest of the show but the public attitude toward them was largely that of amusement, curiosity and derision. . . . Since I saw you I have bought about a dozen Renoirs—mostly small ones painted recently. I am convinced that I cannot get too many Renoirs."[81]

Leo Stein was one of the few people whose ideas about art Barnes genuinely valued. On July 17, 1914, he wrote to thank Stein for the stimulation provided by their intensive correspondence and reported that his interest in art had become "almost an obsession," manifested in exhaustive reading as an adjunct to visits to innumerable galleries, living with his own collection, and earnest discussions with those he thought were genuinely interested in art. "I have done all these things in an effort to find out what is a good painting; what was the mind behind the painting, what broad principle of psychology would explain those paintings which appealed to me, and tried to figure out in my own mind which painter or group of painters represent what I consider the basic principles of true art. After all this effort I feel that I am still far away from my goal." Barnes continued, "I have never advertised my collection, yet the number of people that besiege me with requests to see my paintings is quite large. Many of these people are prominent, successful men and women, and, therefore, necessarily stupid, and these people I am quite sure think that I am crazy in surrounding myself with such paintings. The American artists, however, seem to get more pleasure and, as many of them have said, inspiration out of my collection than they do from any other group of paintings in this country." As his judgment sharpened, he also remarked, "I find that I am constantly changing: paintings which interested me and which I fairly loved a year or even six months ago now leave me cold. I have in the store-room of my house probably twenty paintings, many of which cost me considerable money and which were discarded because I think the personal message of

at his paintings with a fresh and sensitive eye for longer than the few minutes of concentrated attention that most collectors are able to sustain in front of a favorite masterpiece. . . . The meaning and content of a painting were to him a direct and complete experience. And he could not be bullied by words as most critics and collectors still are."[80]

Barnes and Stein immediately found common ground. Both were Americans of cosmopolitan outlook, and neither thought of pictures as mere possessions, but rather as embodiments of complex human perceptions and values. Stein, who had studied philosophy at Harvard with Santayana and admired William James, had an inquiring mind and a serious interest in science, particularly psychology, making him the ideal interlocutor for his new acquaintance. He looked intensively at pictures and understood the traditions of art both Eastern and Western. The notion of a disciplined, scientific approach to art appealed greatly to Barnes, and Stein had the experience

the painter was either insincere or his presentation so bungling that it is not to be considered a work of art."[82]

Concentrating some of the ideas he had expressed to Stein and for the first time exercising a nascent desire to write about art, in 1915 Barnes published his first signed article, "How to Judge a Painting," which appeared in the April issue of *Arts and Decoration*. In it, he framed some of the intellectual problems he was beginning to grapple with as he pursued his growing preoccupation with Modern pictures and how to assess them:

> Books, the usual means of acquiring elementary knowledge, fail [in any objective attempt to make sense of pictures]. . . . A text book on art is an impossibility. The standard so-called authoritative works are, for the most part, compilations of the traditions . . . written by antiquarians, experts, bad painters, professional writers or plain dunces. . . . With a volume of [Julius] Meier-Graefe in my lap and a Cézanne, Van Gogh or a Bonnard propped on a chair, I have spent months in wading through his verbosity and froth hoping for a ray from it to reflect upon the painting and then to my mind to carry with it the artist's message. . . . [Bernard] Berenson's books on Italian Art are perhaps unique and differ from Meier-Graefe's as does the tropical from the arctic zone. They embody thirty years' continuous research by a scholarly mind that is of the Sherlock Holmes type possessed by the skilled diagnostician in medicine, who observes, reasons, classifies, and then writes concisely and precisely. . . . Good paintings are more satisfying companions than the best of books and infinitely more so than most very nice people. I can talk, without speaking, to Cézanne, Prendergast, Daumier, Renoir, and they talk to me in kind. I can criticize them and take, without offense, the refutation which comes silently but powerfully when I learn, months later, what they mean and not what I thought they meant. That is one of the joys of a collection, the elasticity with which paintings stretch to the beholder's personal vision which they progressively develop. And that is universal, for a painting is justly proportionate to what a man thinks he sees in it. . . . It is more laborious to recognize quality in a painting than to write a popular novel. . . . It puts a man on his mettle. A man with a house full of good paintings needs no subterfuge of excessive heat or cold to drive him north or south to get away from his own wearying self. Golf, dances, theatres, dinners, traveling, get a setback as worthy diversions when the rabies of pursuit of quality in painting, and its enjoyment, gets into a man's system.[83]

The First World War interrupted Barnes's travels abroad. In the spring of 1915, Leo Stein returned to America and intensified his discussions with Barnes. He also published articles in the *New Republic*, which Barnes occasionally criticized in letters to the editor and to their author. In 1918 Leo composed this paean to Renoir: "His every canvas was an experiment . . . because his mind was open to what was growing under his brush. Renoir finds his soul wherever he looks abroad, in the fair faces and in the warm bodies of women, in the delight of children, in the light and life of a field and sky and water, and in the freshness and glow of fruit and flowers. Never has there been a more outward turning mind, a more cheerful and joyous devotion to the visible world. Nor is this visibility a superficial one. With few exceptions every picture of Renoir's is an individual thing. . . . His endless buoyancy thrills through the products of his brush in the flood of an indivisible life." And, surely with Barnes in mind, "Renoir's pictures so wonderfully supplement and sustain each other; and Renoir lovers are insatiable. Collectors of his pictures have them by the scores and find that each accession adds not itself alone but gives addition also to the life of all the others."[84]

Barnes often invited Leo Stein to Merion to discuss his acquisitions, and they maintained a disputatious dialogue about psychotherapy and aesthetics. Writing to Herbert David Croly, editor of the *New Republic*, on February 5, 1919, Barnes called Stein "one of the half dozen men in America who have the keenest personal appreciation of quality in art," but also referred to Stein's "obviously complex-tinged thinking." He continued, "Stein is a great constructive thinker but it is of the kind which Jung, Dewey and men of that class have spent most of their lives in trying to straighten out into sound psychology."[85]

For all their differences, however, they fundamentally concurred on the subject of art.

As the employee seminars in the A.C. Barnes plant expanded and turned to art—during the years in which Barnes had begun to collect and formulate an educational use for his collections—outsiders asked to join them. As a way to further enrich the program, Barnes and his staff constantly sought to expand their own knowledge base. To better prepare to teach aesthetics, Mary Mullen enrolled at the University of Pennsylvania as a part-time student in College Courses for Teachers (CCT) in 1914–15, and both she and Nelle Mullen took CCT courses in 1915–16. The sisters spent five hours a week studying psychology in 1915.[86] Mary Mullen took a course on Poe and Emerson with Professor A.H. Quinn at the university in 1914 and, in 1915, took Ethics of Ibsen, Tolstoy, Nietzsche, and Maeterlinck, given by Louis W. Flaccus, assistant professor of philosophy, whose specialty was aesthetics. Barnes had taken the course the previous term.[87] Barnes

cultivated Flaccus, inviting him to his home to look at his pictures and introducing him to Glackens and Prendergast. In the fall of 1915, Barnes enrolled in History of Modern Philosophy 4, taught by Edgar A. Singer, Jr.[88] He also invited Singer to view his pictures.

Perhaps the most fortuitous and long-lasting consequence of Barnes's study at the University of Pennsylvania was his decision in 1915 to review the history of philosophy and modern psychology with Dr. Laurence Ladd Buermeyer (1889–1970), a student of Louis Flaccus's, who came to play an essential role in formulating and executing the philosophical approach of the Barnes Foundation (fig. 14).[89] Barnes wrote to Buermeyer on July 27, 1915, "I want to get the essence of what Flaccus and Singer teach in aesthetics and philosophy and also study psychology in its modern applications. I have neither the time or inclination to do the great quantity of collateral reading that a comprehensive grasp of these subjects entails. But I can do considerable reading and also take Flaccus's and Singer's courses. My object is to adapt my own, world-experience-acquired, not-very-academic, philosophy to that of the masters. Your function therefore would be that of an expositor. . . . I expect to carry out my plans for study not only for the coming college year but for a long time to come—for I know I have a lot to learn."[90]

Barnes was very pleased with his sessions with Buermeyer and mentioned him frequently in his correspondence. On July 19, 1920, he wrote to Dewey, "Buermeyer is solid, both in mental endowment and culture . . . he is the best posted man on psychology, absolutely without exception, that I've ever met. For five years I've traveled with him from Aristotle to Freud and he's got the whole gamut ready to play without a false note and no over-accentuations—he's *balanced* in psychology. In epistemology, I've seen him put Singer and Flaccus down for the count in casual and systematic discussions in seminar and around a bottle on my library table. He's got both the 'sagacity' and 'fund of information' that Wm. James notes as the essentials."[91] A year later, on October 12, 1921, he reported to Dewey that as a result of two years of intensive work with Buermeyer, "James has crystallized for me into a beautiful gem which I think it would be unwise to redissolve in the water which has flowed under the bridge since then."[92] After the first two years

of tutorials, Barnes wrote Buermeyer on June 23, 1917, "I renew my offer to engage your services at a salary of $125 a month.... It would be better to have you consider the position as that of my secretary, in the sense in which men who have the money and desire have secretaries to carry out work which would otherwise not be possible by lack of time."[93]

Buermeyer suggested that Barnes take the next—and most important—step in his continuing self-education by joining Dewey's postgraduate seminar at Columbia in the fall of 1917. "That Dewey course sounds interesting," he wrote to Buermeyer on September 17. "I wonder if it is too highbrow for me to take one day a week in it. Of course, if it were ... abstruse logic ... I could not touch it; but if it were just straight thinking with a possible application to every day life, I would seriously consider joining the seminar."[94] The yearlong course, The Logic of John Stuart Mill, met every Tuesday afternoon at Columbia. Recalling the class twenty years later, Irwin Edman left this account: "The seminar remains in my memory ... not simply for John Dewey or John Stuart Mill. It consisted ... of a very remarkable group. It included two now well-known professors of philosophy, Brand Blanchard, Paul Blanchard and Albert C. Barnes, the inventor and manufacturer of Argyrol and collector of French paintings, even then a grey-haired man who used to come up from Philadelphia every week with his secretary expressly to study philosophy with his friend John Dewey."[95] Barnes attended Dewey's seminars for two more years, some terms accompanied by Buermeyer, to whom he wrote on February 26, 1918, "I am very sorry that you have dropped Dewey's seminar [Buermeyer was completing his dissertation] because I think it is the most interesting course I have ever taken."[96] On November 2, 1921, Dewey wrote Barnes, "I shall miss you on alternate Tuesdays, but you are right in your decision [not to attend that year because he had covered the same ground on William James with Buermeyer]. If I hadn't been selfish about wanting to see you, I should have advised you not to take it. There is nothing new in it for you—nor for Buermeyer." He added, "Now that your expectations about the immediate possibilities of education and of me are moderated I want to talk to you sometime about the educational situation."[97]

Dewey and Barnes rapidly forged a warm friendship and working relationship that would be sustained for more than thirty years. It would prove to be a fruitful meeting of minds, and in 1945 Dewey remarked that in a lifetime spent with scholars, he had not met Barnes's equal for "sheer brain power."[98] Barnes was attracted to the democratic social vision inherent in Dewey's philosophy and its basis in sound psychological principles. Dewey was impressed by Barnes's grasp of complex intellectual matters and his readiness to apply the ideas to situations in the real world—the essence of Dewey's instrumentalism.

Many writers have been puzzled by the mutual admiration and affection between Dewey and Barnes. While acknowledging the debt Dewey owed Barnes, especially in the field of aesthetics, they cannot understand the rapport that united them. Sidney Hook wrote, "I learned from Dewey the danger of passing final judgments about human beings, their interests, capacities, and characters so long as they were still alive." He continued, "It was almost a relief that I discovered a serious shortcoming in him. That was his indulgent friendship for Albert C. Barnes.... I would challenge Dewey on why he put up with Barnes.... He confessed that he found his company interesting especially when he talked about pictures and that he owed him an intellectual debt."[99]

Dewey, early in their relationship, had answered Hook's question himself. In Barnes, Dewey encountered a self-made man with a powerful intellect who could expound and debate with academics the most complex theories of modern psychology and psychoanalysis and who supported social justice for workers and African Americans; who, in his first letter to Dewey, dated November 7, 1917, wrote, "On my way home from the seminar yesterday, I heard of your plan to organize enlightened liberal thought for the intelligent prosecution of the war.... I presume that your plan embodies some of the ideas set forth in your recent writings looking toward a 'democratic humanitarianism.' I am in sympathy with the movement, and it occurred to me that I might possibly be instrumental in helping by some of the means which college professors do not always have at their disposal—money, business organization and the assistance of practical men of

affairs," and at the same time invited Dewey to his home for the weekend. "That your proposed visit might not be devoid of other interests, I may mention that there will be in Philadelphia on Saturday night a very good symphony orchestra concert, and also theatres and a boxing match, and on Sunday afternoon, I have music at my house with an audience of four people."[100] Dewey was clearly fascinated by this dynamic man of contrasts of whom, as early as 1918, he could say, appreciatively, in a letter to his wife, Alice, "I got so stuffed full in Phila[delphia] that I have tried to keep my mind off from that for fear of nervous prostration. However there are many interesting things there; Mr. Barnes will help keep my backbone stiff, working for him will be a good thing for me practically, as he expects action."[101]

Dewey saw in Barnes a man who was willing to put to a practical test many of the philosopher's social and educational ideas and the values animating them, someone who, because of his financial independence and his confrontational personality, could not be toned down, intimidated, or forced to "behave" for convention's sake. Over the years Dewey winced at some of his friend's blunt tactics and exasperating proclivities for provocation, but although he sometimes urged Barnes to handle people more gently and even to hire a press agent to put across his plans, he not-so-secretly admired him as an individualist who could not be daunted.

Barnes found in Dewey an intellectual mentor who was the outstanding international authority in his profession. As had Barnes's friend and early guide, the attorney and art collector John G. Johnson (1841–1917), who died the year that Barnes met Dewey, the philosopher became a respected father figure, a man who could expand Barnes's intellectual horizons like no other. Barnes's carefully cultivated relationship with John Dewey provided him with ready and sympathetic access to a sounding board for his ideas and plans. Crucially, Dewey confirmed Barnes's educational aspirations and inspired him to act on his convictions. As Barnes wrote to Horace Mann Bond on May 21, 1951, "I never intended to start a foundation until Dewey urged me to after he saw for himself our experiment with a group of mixed white and black people."[102] Given Dewey's sanction for his ideas, Barnes saw no need to bow or be diplomatic to "lesser authorities" such as

professors, administrators, museum directors, and others he regarded as mere functionaries.

Barnes's work with Buermeyer and Dewey, his discussions with Glackens and Stein, and his continued study of psychoanalysis consolidated the intellectual framework for his endeavors as a collector and an educator. On October 23, 1918, in a letter to Herbert Croly, he made a clear statement of his evolving project: "I am afraid that my brief career in international politics and social service has also come to an end. . . . I have decided to cut it all out, and resume a research in the psychology of aesthetics, which I have been doing for about five years, and which is really nearer to my heart than any other interest I have at present."[103]

Barnes was by now becoming more of a public figure. Proof that he was taken seriously in the greater art world had already been registered by a lengthy challenge issued by Forbes Watson, editor of *The Arts*, to the Metropolitan Museum of Art. Published in February 1921 and entitled "Institutional versus Individual Collectors: A Polite Plea for the Abolition of Committee Rule," it questioned the system whereby the museum made decisions on the acquisition of contemporary American art.

There has grown up in America a very different type of collector who is more interested in art as a living issue than as an accomplished fact. The late Henry Havemeyer was such a collector, and today we have among others, such ardent enthusiasts as Mr. John Quinn and Dr. Albert Barnes. If Mr. [Henry Clay] Frick could be described as a dealer-expert's collector, these others might be called artist-collectors. They are the close friends of many artists, and eager students of the art of our day, and, as generally follows in such cases, of the underlying principles of art rather than the great names of art. Comparing what these collectors have achieved with what the Metropolitan Museum has achieved we are brought face to face with the problem, since the word failure is not quite polite, of the museum's purchasing committee. . . . The Museum has lagged far behind the private collectors of America, in the case of modern painting, not because it has not had experts of its

own in this field, but because its experts have been blocked by the purchasing committee. A curator of Far Eastern art or of Egyptian art is not much hindered by the purchasing committee of a museum, because the layman trustees know that they are not experts in these departments. But modern painting—that is a field in which everyone considers himself an expert! In 1920 the Museum did not add a single modern painting of importance to its collection. The management of the Hearn Fund has been at best lamentable. No collector of intelligence would be so timid, and even some of the auction-room speculators, who pose as collectors, have done better. The reason the individual collectors defeat the Museum in the race for modern art is not, as in the case of old masters, because the individual has more money to spend. It is because the museum is hampered by a committee. . . . The museum would do much better to leave modern art in the hands of its very able curator, but if this is against the rules governing public funds, it might at least select a purchasing committee composed of such men as Arthur B. Davies, John Quinn and Albert Barnes, men whose collecting has proved their intelligence and who are known to have vital interest in this vital function of the museum.[104]

For some time, the Deweys had been urging Barnes to reflect on the long-term preservation of his collection and its future role. On October 16, 1922, Barnes wrote Dewey,

I have been trying for ten years to buy the Wilson Arboretum (the finest collection of trees in America) and place therein a gallery for my paintings and turn the whole thing over to the public for educational purposes. I now own the arboretum, the architects are drawing the plans for the gallery, and the lawyers have applied for a charter from the State of Pennsylvania, for the Barnes Foundation. There are assets of about seven million dollars at present and still growing. I thought I'd open the place three days a week to the public, and three days only to such organizations as the Pennsylvania Academy of Fine Arts [sic] for their art students, and to the University of Pennsylvania for their students of

arboriculture; each of those institutions will grab the chance eagerly. . . . How can I cover in a constitution and a set of by-laws explicit statements of those principles of democracy and education . . . that will make my purpose concrete and the futility of the institutions inoperative in the Foundation? If I can get you to draw them, I'll organize to carry them out.[105]

The philosopher replied on the 19th, "It's wonderful, wonderful for the community and public. . . . I shall, of course, be happy and proud to assist in any way."[106]

In fact, the ultimate disposition of his pictures had preoccupied Barnes from the very outset of his collecting, and on several occasions in the past he had written to his attorney, John G. Johnson, himself a world-renowned collector of art, with ideas about bequeathing his Modern paintings to an existing museum or institution in Philadelphia.[107] On June 22, 1912, he had written to Johnson about the need to alter his will, "because my estate is more than double what it was when my present will was drawn, and because a careful inquiry into educational conditions at the University of Pennsylvania, which was made the principal beneficiary under my will, are such that, in my opinion, the status which prevailed when I was a student at the college, does not exist at present."[108] On September 30, Barnes again wrote to Johnson indicating a desire to donate one painting each by Maurer, Lawson, and Glackens to the Wilstach collection owned by the City of Philadelphia: "The Maurer and Glackens are, at first, rather startling in color, but no more so than the modern French works which the Germans and Russians have been buying lately in Paris for some of their public galleries. . . . Glackens has the additional interest of having been a Philadelphian; he was graduated in my [sic] class at the Central High School. If the Wilstach would accept these paintings, I shall be glad to give them. There is no 'hook' in the gift."[109] Johnson responded the same day, pointing out several complicating legal factors, and no gift was made at this time. The correspondence shows that Barnes made a second attempt at a public bequest in 1915, writing to Johnson on January 21 of that year,

For over three years, I've given more time and effort to trying to find out what is a good painting than

I've ever given to any other subject in my life. What I've collected is mostly the works of the French Impressionists; the paintings are fairly representative of the entire movement and the men whose work appeal[s] most to me are represented by numerous good examples—of Renoir's . . . I have fifty, Cézanne fourteen, Van Gogh three, etc.; the total number about two hundred, including the most virile of the Americans. If I live, the collection will undoubtedly be enlarged and improved, and I believe would be worthy of representing, in the Municipal collection, the phase of art that developed between 1870 and the time of my activity in collecting. I would want a separate room and am willing to devise sufficient endowment for its maintenance.[110]

In late September 1922, even before he wrote to Dewey, Barnes had consulted attorney Owen J. Roberts (1875–1955), future associate justice of the U.S. Supreme Court, and asked him to assist with drawing up the by-laws and indenture of an educational institution to be known as the Barnes Foundation. When the work was completed, Roberts wrote Barnes on December 6, "Entirely apart from the monetary compensation involved, it has been a great pleasure to serve you in this connection, and it will be a matter of the keenest interest to me to know how you progress."[111] Barnes, for his part, wrote on December 9, describing his complete satisfaction with Roberts's work: "I felt when I was done with you like I used to when Mr. Johnson was alive and had fixed me up personally. I missed the picturesque, stevedore profanity he practically always handed out to me—but, we can't have everything. In short, I congratulate you on being at the head of something very much to be respected and admired."[112]

In addition to attending to the ultimate disposition of his collection, Barnes was very concerned that provisions be made for the long-term financial security of his African American employees. To that end, in 1917, he had purchased houses for some of his employees. On April 5 he wrote to attorney Raymond W. Rogers, "Please accept my thanks for the list of properties available for my colored men. . . . Those properties upon which I have placed my initials will suit the purpose admirably. . . . I presume in writing the sales agreement and deed, you will exer-

cise your usual careful discernment in seeing that there shall be no difference in opinion as to legality in case we encounter temperamental idiosyncrasies at the time of settlement."[113] The wording indicates Barnes's wish to prevent any discriminatory restrictions that would prevent the purchases. Barnes also sought to ensure that whatever the fate of the company, his employees would receive their pensions. To this end, on November 22, 1922, Barnes sent Roberts a board of directors' resolution to "Remove Pension Fund as an asset of the company, interest to be paid to employees . . . as long as they shall live and to their widows as long as they shall live. At the death of pensioners, fund is to revert to the Lydia A. Barnes Foundation."[114]

Formal titles for the land on which the Foundation was to be constructed were acquired in two parcels, the first on May 4 and the second on October 13, 1922. Barnes immediately set out to realize a program for the Foundation and a project to develop the land around the twelve-acre property on which the Foundation buildings were to be constructed.[115] He was committed by his agreement with the seller of the property, Captain Joseph Lapsley Wilson, to maintain the land as an arboretum, and it was to this project that Mrs. Barnes devoted herself.

Barnes hired Paul Philippe Cret (1876–1945), a French architect and professor of architectural design at the University of Pennsylvania since 1903, to draw up plans for the building that were advanced enough by the end of November 1922 to be submitted to contractors for bids. The gallery and adjoining residence were constructed of two kinds of stone imported from France.[116] The interior eschews rich embellishment that would have detracted from the impact of the works of art. Spacious and elegant in its layout, it provides an intimate setting for the paintings in Barnes's collection (fig. 15). On the ground level a two-story central gallery with a marble floor and three tall French doors looking out on the grounds of the arboretum is flanked on either side by six interconnected rooms of varying dimensions with vaulted ceilings, beige burlap-covered walls, and parquet floors. Each room has at least one large window, placed high, that provides an abundance of natural light, with unobstructed space for pictures on the other three walls. On the second floor, a passage with a balcony overlooks the main gallery and

FIG. 15

The Barnes Foundation Gallery VI, south wall, with Paul Gauguin's *Haere Pape* (BF109), center, flanked by Maurice Prendergast's *Idyl* (BF113), left, and *Beach Scene with Donkeys (or Mules)* (BF116), right

faces three lunettes opposite. Five rooms lead off each end of the corridor, two with skylights and the other eight with flat ceilings, each with windows similar to those on the ground floor. By December 6, 1924, Barnes could write Dewey, "You will be glad to know that all the paintings are in the gallery. . . . It's simply overwhelming—nothing in the world can touch it. I'm ready for you to pick a day and size it up."[117]

Barnes commissioned Jacques Lipchitz (1891–1973) to create seven bas-reliefs and one freestanding figure and base carved from the same limestone to be set into the exterior walls of the north, south, and west facades of the gallery and residence. Another unique feature of the gallery exterior is the decoration of the entrance portico, designed by Barnes in conjunction with Enfield Pottery and Tile Works. The simple entrance proclaimed Barnes's commitment to African art and culture. Prominent three-dimensional terra-cotta-colored tile designs were based on African sculptures in the collection. Six modeled figures are set in the uppermost register above the tablet cartouche reading THE BARNES FOUNDATION MCMXXIII, and below on either side are curvilinear and angular patterns comprising crocodiles, masks, and birds, based upon a carved Baule door from the Ivory Coast in the collection (A238). The motifs, with their rhythmically balanced shapes and textures, welcome visitors as they approach the entrance. Barnes paid exacting attention to each detail, and Lipchitz's reliefs, carved from the same warm Coutarnoux limestone as the ashlar of the exterior, underscore the debt owed by Modern Western art to the art of black Africa. This theme is further reinforced by the cast iron railings with their Baule mask motif on the interior and exterior of the structure.

In his March 1923 article in the *New Republic*, Barnes outlined the objectives of the school and detailed his vision of the Foundation as a force for social action. He underscored the egalitarian conditions underlying the experiment from its inception: "We do not convey the impression that we have developed a crowd of savants, or art connoisseurs, but we are sure that we have stirred an intelligent interest in spiritual things created by living people . . . which has been the means of stimulating business life and affording a sensible use of leisure in a class of people to whom such doors are usually locked."[118] Mary Mullen distilled her years of experience teaching

the seminars in the Foundation's first publication, *An Approach to Art*, which appeared in 1923 and was essentially a primer of the ideas governing the pedagogical approach used at the Foundation.

While all these plans were taking shape, Barnes undertook a major buying trip to Paris in the fall of 1922, during which he purchased a major group of African tribal sculptures, fifty-four canvases by a little-known painter, Chaim Soutine (1893–1943), as well as important paintings by Matisse, Picasso, Amedeo Modigliani, Giorgio de Chirico, and Jules Pascin; lesser-known artists such as Alexis Gritchenko and Robert Lotiron; and little-known figures such as Helène Perdriat and Irène Lagut. Paul Guillaume (1891–1934), the Parisian dealer who had facilitated Barnes's acquisition of most of these works, presented many of them in his gallery in an exhibition entitled Acquisitions Récentes de la Barnes Foundation before they were shipped to Merion.[119]

Barnes arranged to present seventy-five of these new acquisitions in the Exhibition of Contemporary European Paintings and Sculpture held at the Pennsylvania Academy of the Fine Arts from April 11 to May 9, 1923. He well knew that the works would cause an uproar even greater than the Later Tendencies show of Modern paintings at the Academy in 1921, which had elicited a veritable firestorm from aesthetically conservative forces in the city.[120]

Barnes's introduction for the 1923 catalogue includes a synopsis of the psychological basis of his approach to understanding art:

> "Form" is the word used by most critics when they wish to bewilder, mystify or swagger. It is a technical term of psychology and means simply the impression left in the mind by experience, and "forms" are the common possession of every sentient human being. They constitute the essence of experience, education and culture. . . . The important fact about the "form" is that the feelings which were part of the original experience remain with us forever, for life is primarily and chiefly a matter of feeling. An artist is a person who can reproduce forms so that we can perceive them and experience the feelings with which they are loaded. . . . If we can find a response to those "forms" in ourselves, we are kin with that

artist; if we do not respond, it is merely a confession that either the artist has had experiences which we have never had, or of which we cannot construct the "forms" by the exercise of our imagination.[121]

In the early stages of the Foundation, Barnes laid out a number of ideas for his school. He wrote Dewey on September 18, 1923, describing "a plan I have in mind to have a course of lectures delivered under the auspices of our foundation, and then publish them in a book. . . . Lectures by eminent thinkers, at [the] University of Pennsylvania or other place[s], one series each winter, subject, say, Man and His Environment with special reference to what we are trying to do with the Foundation (general ideas about like I set forth in my *New Republic* article). . . . We would select suitable men and then invite them, the fee to be two thousand dollars. If this plan appeals to you, please accept this as the formal invitation to yourself to give the first course during the latter part of 1924. . . . For the course following yours, we would invite Bertrand Russell."[122] Dewey responded on October 10 that he could not accept for the coming year but wrote, "I should not like anything better than to give the lectures at some future time," adding, "Why don't you try to get Santayana for your first course? He is a little sore at American universities, but I am inclined to think he might look with favor upon a proposal coming from your Foundation and that he still has things to say on art and aesthetics that he has not yet said. I hope you will not consider my suggestion impertinent, as it comes from real interest in your project."[123] Barnes, adhering to the ideal of useful individual growth that he had maintained since the earlier factory seminars, also considered other variations such as "lectures to the public, co-operation with existing academies in the hope of bringing about annual exhibitions, and the offering of such financial awards as will enable young artists to maintain life without sacrificing their individuality by submitting to academic or other irrational traditions."[124]

Barnes understood that if he was to succeed in his broader mission to reform aesthetic education in the schools and colleges, it was essential to forge a strong working relationship with a university. To that end, on January 27, 1924,

he wrote Josiah H. Penniman, president of the University of Pennsylvania, proposing just such a partnership:

I would like the action of the Board of Trustees of the University of Pennsylvania upon the following proposition: Establish a Chair of Modern Art at the University of Pennsylvania with Mr. Laurence Buermeyer as full professor. He would give two lectures a week at the university and two practical talks each week at the gallery of the Foundation. . . . He has been associated with me in the study of the psychology of aesthetics and in practical application of those principles to the paintings which I have owned for many years. . . . I think we could make the proposed course unique, beyond comparison with anything available elsewhere in the world. Our buildings will be ready for the practical instruction in art in about a year; but in order to make the course most productive the didactic part should be started at the beginning of the next college year. The Foundation has ample funds to support itself in perpetuity without aid from either the University, the State, or any other source.[125]

Penniman responded positively, but cautiously, on March 18, "The trustees would accept and administer . . . an endowment in amount sufficient to assure the income required permanently to maintain a professorship in Modern Art and to meet other costs incident to its work, such as equipment for intramural use and university overhead. . . . It must also control the selection of the teaching staff. . . . It would be wise . . . to adhere to our established practice . . . of electing to an initial three year period of service as assistant professor. . . . We shall be happy to cooperate in carrying forward to realization what must be a very significant movement toward the better understanding of the nature and purpose of Art."[126]

Barnes replied on March 20, outlining in detail what he foresaw as the essence of the partnership, including the financial arrangements. Predictably, he objected to classifying Buermeyer as an assistant professor. Reacting to the university's willingness to accept an endowed chair whom they would appoint, Barnes redirected Penniman's statement that "the University of Pennsylvania is 'an institution dedicated to the search for the truth,

and, through its dissemination, to the advancement of knowledge,'" and argued that such ends would best be served by allowing the Foundation to retain a degree of autonomy. In closing, he made clear what was at stake for the university: "A minor consideration, at the present status, is that in the deed which Mr. Roberts drew up, the University of Pennsylvania is one of three who control the entire resources of the Barnes Foundation after my death. Naturally, that would have to be changed if some other educational institution should accept the proposal which up to the present has been made to the University of Pennsylvania only."[127]

Thus began the protracted negotiations between Barnes and university officials, in which both sides vied for control of the collaborative venture. Barnes kept Dewey apprised of the details of the proposals and counterproposals. Barnes's immediate objective was to create a course to be taught by Thomas Munro, one of Dewey's students and a member of the Foundation staff, at the University of Pennsylvania and at Columbia University starting in the fall of 1924. The proposed course was to be entitled Applied Aesthetics and given for credit, three hours a week. Students were to be prepared to travel to attend occasional sessions at the Foundation, to be conducted after Munro had laid the philosophical and psychological bases using Mary Mullen's *An Approach to Art* (1923), Buermeyer's *The Aesthetic Experience* (1924), and Barnes's *The Art in Painting* (1925), augmenting the ideas of James, Santayana, and Dewey.[128]

Over the coming months, some steps were taken to implement the sort of collaborative arrangement that Barnes hoped to establish between the Foundation and the university, but progress was slow, and he was impatient with lackluster enrollments in the new courses and what he perceived as a lack of any concerted effort on the part of the university to coordinate the respective resources of the two institutions.

What Barnes earnestly sought to accomplish through the Foundation was nothing less than a fundamental rethinking and reform of art education at every level. In this quest he had Dewey's full support. His ambitious, even idealistic, plan was threefold: First, to transform college-level teaching by establishing courses centered on the psychological principles underlying Modern aes-

thetics and, once these were sufficiently mastered, to introduce students to the works of art in the galleries of the Foundation. Second, Barnes charged Buermeyer with the task of assessing the methods of teacher training used for art instruction in the Philadelphia public schools. Buermeyer taught a course for teachers at the Foundation from October 1925 to January 1926, which he summarized in a report.[129] Third, Munro analyzed teaching methods in the schools in "A Constructive Program for Teaching Art" and traveled to Vienna in the summer of 1925 to observe the classes taught in the Vienna School of Arts and Crafts by Professor Frank Cizek, which he criticized as aimless "free expression" that resulted in "a few years of undirected toying with art materials."[130] Barnes himself wrote a number of articles criticizing various instructional methods that he considered ineffectual or damaging to the application of the scientific method to the study of art.[131]

The formal inauguration of the Barnes Foundation Gallery took place on March 19, 1925. John Dewey gave the dedication address. Leopold Stokowski, conductor of the Philadelphia Orchestra; Laurence Buermeyer; Edgar A. Singer, Jr., standing in for President Penniman; and Barnes also spoke. Dewey declared, "I wish to express my conviction, my most profound conviction, that we are really celebrating here today one of the most significant steps taken in this country for freedom of pictorial or plastic art, for art in education, and also for what is genuine and forward-moving throughout the whole field of education."[132]

Meanwhile, as the time approached to consider renewing the alliance between Penn and the Foundation for the 1926–27 academic year, Barnes's disappointment at what he perceived as inertia on the part of the university had peaked. Accustomed to swift implementation of his executive decisions, he could not fathom the cumbersome structures of academia and the glacial pace of change within them, and he could contain his frustrations no longer. The inaugural (April) issue of the *Journal of The Barnes Foundation* included a blistering attack by Barnes entitled "The Shame in the Public Schools of Philadelphia" and an article by Munro, "A Constructive Program for Teaching Art," criticizing courses in the history of art that emphasized "names, dates and biographies of artists,

the subject-matter, religious, literary and political asso-
ciations of works of art. Rather they should aim to trace
the history of forms and traditions in art, their origin,
development, interaction, combination, differentiation,
decadence, revival and modification, as shown in con-
crete works of art."[133]

Dewey, in reaction, wrote Barnes what were perhaps
the sternest letters of their decades of correspondence. "I
think it is a serious mistake . . . to publish so many nega-
tive articles at once; it will strike the readers you most
need to reach as out of balance," the philosopher wrote
on April 15, adding, "If you pursue a too negative policy
you will find the Foundation isolated for educational
purposes some day."[134] The following day Dewey took an
even more forceful stance:

> A policy of even ten per cent vituperation, to say
> nothing of fifty per cent, will gradually and surely
> alienate, or render access difficult to, the persons
> whom you are concerned to reach. One group
> after another will fall away, and you will [be] left
> with simply a few courses at the Foundation itself
> attended by a comparatively small number of per-
> sons. . . . Supposing that aside from the university
> connection you have broken off by controversial
> methods relations with the state educational peo-
> ple, with the local people, and with Philadelphia,
> besides the incidental effect on their friends, con-
> nections, and the influences which they can set in
> motion, and this procedure goes on. What is the
> outcome to be? With whom and what is the Foun-
> dation to cooperate? I do not know how many let-
> ters of individual approval you get, nor what are the
> motives and standing of those who write them, but
> I have great difficulty in believing that they offset
> the isolation produced by these alienations.[135]

On March 4, 1926, cognizant that his frustration was
becoming counterproductive, Barnes wrote asking Dewey
to intervene and patch things up: "I certainly don't want
to break with Penn because (entre nous) they are one of
three named in our indenture to carry on the work after
I'm gone. . . . So, I was forced to use politics, deception,
notice of quitting, etc., in order to get a working chance to
see what we can do. Hence, I've tried to shift it to you, for

which I apologize. We're in a bad jam and if I talk to them,
I am likely to say something that will obstruct our plan
in its large, general scope."[136] Dewey, nonconfrontational
as was his natural bent, succeeded in smoothing relations
with Penn somewhat and again admonished Barnes on
March 12, "my honest opinion is that with the best will
and efforts in the world, no one can guarantee the size
or the quality of your classes at Penn or the year after;
five years is a fair time in which to form a decision. If you
count on much in the way of tangible results before that
time, it is my judgment it would be better for both you
and the university to sever relations now. . . . Nobody can
shoe students into a new course against competition from
other courses. . . . [I]f you don't find yourself in a position
to give it time, I do not believe there is much use in letting
yourself in for a series of future disappointments—not
that they are certain, but that classes *may* be small and
of no remarkable quality for several years."[137] This was an
accurate prediction of things to come.

In the end, Barnes took Dewey's counsel to heart. On
May 21, 1926, he wrote diplomatically to Penniman, offer-
ing to renew the arrangements with Penn for another
two years on what he described as a quid pro quo basis,
with the Foundation contributing its financial resources
and educational principles and the university lending its
infrastructure and institutional weight. He also proffered
an apology:

> We plead guilty to a militant policy in our Journal
> against people who have publicly assailed us, and
> the articles have no doubt caused Penn officials
> some embarrassment. . . . The Journal has accom-
> plished its intended purpose in answering by logical
> arguments the charges of people who would like to
> push back the clock. We look upon that stage of our
> career as finished . . . [and] we are now proceeding
> in a more conventional, orderly way with the plan of
> education. . . . I understand that there is to be a reor-
> ganization and a Professor of Fine Arts appointed.
> Before you take any decided steps therein, I believe
> it is worth your while to go, with your attorney,
> to the office of our attorney, Mr. Owen J. Roberts,
> and scrutinize the parts of the new Indenture in
> which the name of the University figures. Then, if
> you decide that what you have learned is of value

to the University, kindly make an appointment for me to talk to your Board of Trustees at the earliest moment after I return from Europe on August first.[138]

In what was probably an unintended slight, this conciliatory letter to Penniman went unanswered until Warren P. Laird, dean of the School of Fine Arts, sent Barnes an apologetic letter on December 4, 1926. By then it was too late. In late November, Barnes had already drafted a six-page document, "The Barnes Foundation and The University of Pennsylvania," summarizing his analysis of the two-and-a-half-year experiment:

> As a last resort, the offer of May 21, 1926 . . . was made, whereby the University would have ultimate control of the Foundation and its resources. . . . This letter, containing the offer, criticism and suggestions, was never answered . . . nor was its receipt even acknowledged, until December 1926 one of the faculty, suspecting something was wrong, made inquiry. Perfunctory apologies were then sent . . . but these apologies were unsatisfactory because they exposed a total mishandling of a project involving millions of dollars and the entire future of the Foundation. Not only was no sign indicated of any action to be taken in the near future, but it transpired that the whole proposal had been turned over to the Dean of the School of Fine Arts, whose policy and organization had been the main subject of criticism. . . . Hence the Foundation decided in November 1926, to suspend all formal arrangement with the University.[139]

The prolonged episode probably poisoned the atmosphere for later efforts with Penn and other local colleges. Barnes was destined to be in the isolated position that Dewey had anticipated, even though Dewey understood Barnes's frustration at not being able to get quick results. In this, the experienced philosopher had lower expectations, whereas Barnes, the optimist, thought scientific method as applied to the arts would be welcomed for the promise it held for the education of the common man and not only for an elite stratum of society. The idea that any university would decline such an offer, even with strings attached, was incomprehensible to Barnes.

That the president and the board of the University of Pennsylvania would not consent to meet, with or without Barnes present, with Owen J. Roberts or, despite several invitations, to visit Cret's building and its collections, including a collection of African sculpture comparable to what the University Museum had in its pioneering collection, is unimaginable to us today. One circumstance that perhaps helps to explain this episode as something more than a series of misunderstandings or a battle for control is that in 1920s Philadelphia, Post-Impressionist and Modern art were not considered culturally valuable enough to galvanize Penn's trustees to accept Barnes's offer.

Coincident with his focus on educational logistics, from the moment the Foundation was established in 1922, Barnes had set himself the task of writing a book to put forward his ideas on the aesthetic principles taught in its classes. In this endeavor his approach was discernibly informed by William James, whom Barnes admired greatly and whose works he had read comprehensively. James's *The Principles of Psychology* (1890), in particular, had long been a fundamental influence on Barnes's thinking and had been a core text for the factory seminars. Barnes's ideas on aesthetics, meanwhile, were derived in large measure, but not exclusively, from George Santayana's works. *The Sense of Beauty* (1896), *Reason in Art* (1906), and *Interpretations of Poetry and Religion* (1911) were the philosopher's primary statements on the subject, written with a fluency and subtlety that have rarely, if ever, been equaled in the English language. With respect to the former, Barnes wrote to Thomas Craven on May 21, 1923, "Santayana is to the psychology of aesthetics what Giorgione is to painting; not only is his intellectual endowment of the finest quality but from the time he was a boy he showed extraordinary interest in aesthetics and he was wise enough to master the principles of psychology as far as they had been developed up to that time; and he was genius enough to develop some new concepts in aesthetics. . . . He is the one man whose thinking stands up in the light of daily contact with works of art."[140]

Conceptually, however, Barnes now diverged from these intellectual mentors in one crucial respect—his insistence on analysis and scientific method. James, for instance, had written, "It strikes me that no good will ever

come to Art as such from the analytic study of Aesthetics —harm rather, if the abstractions could in any way be made the basis of practice. We should get stark things done on system with all the intangible personal *je ne scais quaw* left out. The difference between the first and second best things in art absolutely seems to escape verbal definition—it is a matter of a hair, a shade, an inward quiver of some kind . . . verbal formulas are all that your Aesthetics will give."[141] Santayana's consistently held position on the issue is apparent in his comments upon receiving from Thomas Munro a copy of his *Scientific Method in Aesthetics* (1928), which grew out of his theoretical and practical work with Dewey and Barnes:

> It seems pleasantly reasonable and open-minded, and, of course, highly characteristic of the *milieu* in which it has taken shape. In so far as this is academic, philosophical, and American it is not so very different from what it was 35 years ago, when I wrote *The Sense of Beauty*: and I feel for you, caught in the same snags and compelled to thresh the same old straw. . . . Now analysis and psychology seem to stand alone: there is no spiritual interest, no spiritual need. The mind, in this direction, has been *desiccated*: art has become an abstract object in itself, to be studied scientifically as a *caput mortuum*: and the living side of the subject—the tabulation of people's feelings and comments—is no less dead. You are yourself enormously intelligent and appreciative, and so is Dr. Barnes, but like a conservator of the fine arts, as if everything had been made to be placed and studied in a museum. . . . I am far from denying you the possibility of happiness, and wish it for you and Mrs. Munro, with all my heart—even if it be happiness in a museum.[142]

Therefore, it was something of a challenge to James and Santayana—to both of whom Barnes owed so much of his intellectual formation—as well as a response to direct urging from Dewey, that throughout 1924 Barnes, with considerable assistance from Buermeyer and with regard to "the underlying principles of the psychology of aesthetics," gathered his ideas and organized them to put forward "an experiment in the adaptation to plastic art of the principles of scientific method" (fig. 16).[143]

FIG. 16

Page of 1924 draft typescript by Laurence Buermeyer, corrected by Dr. Barnes, for *The Art in Painting*, The Barnes Foundation Archives

Published early in 1925, two months before the March opening of the Barnes Foundation, *The Art in Painting* differs from previous books on aesthetics. Barnes's textbook guides students in conjunction with firsthand encounters with works of art, not through diffuse generalizations, theories, or systems that had rendered abstract and speculative the application of those systems. Based on Dewey's instrumentalism, as expressed in *Democracy and Education* (1916), *Reconstruction in Philosophy* (1920), and *Human Nature and Conduct* (1922), as well as conversations with the philosopher covering a broad spectrum of psychology, the book also encompasses various experimental psychoanalytic approaches of the day.

Barnes sought to provide a practical approach that would be accessible to students, especially young painters, a method enabling them to develop and trust their own judgments over the sometimes impenetrable pro-

nouncements that passed for analyses in virtually all contemporary writing on art. He had concluded that an outline of modern psychology's insights into experience, emotion, perception, and values provided the requisite foundation for a demonstration of how human feelings, interests, preferences, and habits govern behavior. Barnes then applied this knowledge to specific works of art and to the traditions of Western painting so that students at the Foundation, in direct contact with the paintings, could use the book *instrumentally*, as a reference or guide to enlarge and verify their perceptions and personal insight into the aesthetic aspect of art—not the historical, illustrative, symbolic aspects that Barnes considered incidental and not representative of the deepest meanings embodied in pictures. He wrote, "The object in incorporating the analyses in the book is to enable persons who have the opportunity, to learn the method of approach and to test its value with the objective facts in front of them. Nothing is more futile than to discuss a painting without at the same time looking at it."[144]

Barnes encouraged the fledgling percipient to reconstruct the artist's experience to the extent possible, and according to the student's innate sensitivity and capacity to grow with instruction. Students were led to be comfortable with pictures, not to consider them as embodiments of uncontrolled subjectivity or status, financial investments, or playthings. In effect, Barnes was constantly demonstrating the method by means of his evolving collection, which would ultimately be expanded to include furniture, textiles, pottery, Native American jewelry, and metalwork, all selected to demonstrate and underscore the variety of ways in which universal human values were expressed throughout the ages in diverse cultures. Students were constantly faced with new additions and reorganized wall arrangements that changed the locations of well-known works and placed them in completely new contexts. These changes, some of them surprising, were presented for discussion, to gauge students' reactions, engage them, and otherwise challenge them to develop their intellectual horizons and consequently their own perceptions.

An enormous amount of aesthetic theory was published by artists and critics in the early years of the twentieth century, generated in large measure by the advent of Modern painting. In the face of so many conflicting justifications and explanations—offered in a country in which opportunities to see advanced Modern art were rare and critical standards ran to the conservative and academic—the average person was, simply, bewildered. Barnes, in response, made the essential linkage and continuity with the traditions of painting the keystone of his instructional approach. Modern art was not a break with the traditions, an idea that was not widely understood or accepted when Barnes began to think about paintings. Ridicule had been poured on the works in the Armory Show. For Barnes, the nineteenth- and twentieth-century artists that he valued were individualists who creatively adapted plastic ideas from their predecessors and cast them in original forms, thus extending the earlier traditions from which the Modern painters had borrowed. This process was dynamic rather than passive. He wrote,

There is a common misunderstanding of originality which identifies it with complete independence of any other artist's influence. The absurdity of such a view appears as soon as we remember that to see at all requires a background of funded experience, and that no man can build up such a background by his own unaided efforts. An individual completely isolated from the past would have as much chance of developing his own art as he would of discovering his own mathematics and natural science. We see only by utilizing the vision of others, and this vision is embodied in the traditions of art. Each of these . . . represents a systematic way of envisioning the world; taken together, they record the perceptions of the most gifted observers of all generations, and form a continuous and cumulative growth which is one of the most important parts of the heritage of civilization. . . . A painter is an artist . . . only if he is able to select from the work of his predecessors the forms which are adapted to his own designs, modifying them as his individual needs require, and recombining them in a new form which represents his own unique vision. Correspondingly, the observer or critic can only assess the originality of a painting, its artistic importance, if he himself knows the traditions and can judge what the painter has added to them. We can learn

to see the art of the present . . . only by learning to see the art of the past.[145]

His stress was always on what the Modern painters had chosen to draw upon and renew, whereas he considered academic painters the embalmers of the earlier traditions. As with scientists, for whom the discoveries of principles constitute a living fund of knowledge for succeeding generations, artists bring new personal perceptions, unpredictable insights, to bear on the ideas of their forebears rather than merely selecting from a fixed menu of stock effects. Modern painters, because their visual ideas were less dependent on illustrative verisimilitude, required a comprehensive acquaintance with the earlier traditions.

Therefore, before the Foundation was inaugurated in 1925, Barnes, whose approach to understanding Modern and contemporary art had from the beginning been informed by the study of early traditions, extended the range of his collection to include representative early Italian, German, French, Dutch, and Spanish pictures as well as examples of ancient Egyptian, Greek, Roman, Chinese, Japanese, and Persian painting and objects. These works were an integral component of the collection and were selected with a pedagogical purpose. Barnes emphasized firsthand demonstrations in which observations could be verified rather than taken as eternal and codified. In the classes, he put into practice Dewey's precept that "[the teacher's] province is . . . to provide the materials and the conditions by which organic curiosity will be directed into investigations that have an aim and that produce results in the way of increase of knowledge, and by which social inquisitiveness will be converted into ability to ask questions of books as well as of persons. The teacher has to protect the growing person from those conditions which occasion a mere succession of excitements which have no cumulative effect, and which, therefore, make an individual either a lover of sensations and sensationalism or leave him blasé and uninterested. He has to avoid all dogmatism in instruction, *for such a course gradually but surely creates the impression that everything important is already settled and nothing remains to be found out*."[146] Barnes showed students that painting was not a literal translation of something onto a canvas, but rather a complex creative endeavor in which tradition and knowledge

are acted on—and, in successful cases, transformed—by the perception, emotion, and thought of an artist. To understand and evaluate the process at work, Barnes proposed, first, an essential, objective assessment of the formal parameters of a work, carried out with pictures directly in front of the student.

The second tool of Barnes's book was a sequence of demonstrations of the method, applied to specific works of art within those traditions. As early as 1915 he wrote: "The big lesson of the history of art is that the things worth while in the work of the great creators of the past—Giotto, Masaccio, Rubens, Hals, Velásquez—are to be seen by eyes that see . . . Manet, Cézanne, Renoir, Daumier and numerous others, including the best of the Americans. . . . My Picassos . . . show a masterly welding of the essences of Greco and Cézanne."[147] Barnes's method took interest, patience, application, careful firsthand observation, and access to works of art, as well as willingness to ignore what he termed the adventitious and to be guided constantly to refine one's perceptions. For the artist, Barnes held, art was an active process of discrimination, choice, and experimentation. It was therefore instructive to study how the process can lead to the crystallization of the artist's ideas as transmitted into the medium of painting, which Barnes, drawing on his scientific training, sought to break down and elucidate by analysis. Once analyzed, for Barnes it was the unique harmonious fusion of what he termed the "plastic means"—color, light, line, space—into an organized plan or design, a "plastic" form, that constituted a coherent whole. Hence, artists present their individual experience as a fragment of life, of how they perceive the world around them, and translate it into the terms that inhere in art. Today, this is generally accepted for Western art, at least in theory, but a century ago, it was a radical idea.

In his insistence that method could be used to reach a judgment about a specific work of art, Barnes again set himself apart from James and Santayana, who, like most other writers, rarely if ever venture a concrete application of aesthetic theory. Barnes did not deny or eliminate subjective responses to art, but by focusing the student's attention on actual works of art, he sought to reduce subjectivity so that it did not dominate the student's evolving understanding of the masters of Modern painting whose

works hung on the walls of the Foundation. "Perception as a part or phase of the general process of experience, is both subjective and objective: subjective in choosing for attention and emphasis the details in an objective situation which are relevant to feeling or interest; objective, in registering a set or group of details which are present in the environment whether we wish them to be or not. In neither aspect, however, is perception possible without prior experience and training."[148] Barnes saw his school as a laboratory for students' experiments, as participant-observers, in perception and judgment. The Foundation was, as he would tell Dewey on March 14, 1925, "not an entertainment bureau for 'aesthetes.'"[149] Barnes also considered other repositories such as the great museums of Europe to be laboratories of the same kind. Every summer he and his associates held classes in the museums of Paris, London, Madrid, and Italy, and he sent his instructors and students to immerse themselves in the Old Master traditions. Thomas Munro describes these trips:

> Barnes asked . . . Dewey and myself, and our wives, to go with him to Europe several summers. We went to Paris, to several cities in Italy, and I believe to London. Barnes was always the leader on these trips. . . . He guided us through the principal art museums and churches of western Europe and analyzed pictures from the standpoint of his own method, which he was gradually working out, he said, on a basis of Dewey's philosophy. . . . Barnes explained to us, while his secretaries, who were usually along, took ample notes. They did so on the ships going over. Barnes would lecture to his staff and guests on the approach to art in terms of the analysis of form. Dewey on those trips didn't talk too much. He listened. . . . In talking about any art, [Dewey] liked to stress its relation to the life of the people. Whether he was talking about literature, music, or painting, he liked to think that the best art came out of the daily work, occupations, and interests of common people. . . . Both Barnes and Dewey wanted to find an approach to art criticism and art theory which would be scientifically valid and philosophically valid. But Barnes felt the need

of going to the concrete examples and so Dewey and I . . . listened. Barnes would get us up very early. . . . We would climb up the towers and balconies of churches and make notes. When we got done with a long, tiring day's work of looking, he wanted us to make more notes and let him read them. He would criticize them and talk them over. Barnes was indefatigable, tireless mentally and physically in looking, thinking, and arguing. . . . He said what he thought. He was strong-willed and definite in his own beliefs and about people, artists whom he did or didn't like, and he would explain his attitudes toward them. . . . On a more personal basis, I think Dewey enjoyed seeing Barnes in action as a vigorous, colorful, intelligent personality.[150]

By the end of the 1920s he was furnishing paid scholarships to as many as twelve of the Foundation's students—often young painters—each year, and this program continued until, and after, the Second World War.[151]

In early January 1925 the Deweys received their copy of *The Art in Painting*, which was dedicated "to John Dewey whose conceptions of experience, of method, of education, inspired the work of which this book is a part." Dewey wrote to Barnes on the 27th, "It does something which no other book on art criticism with which I am familiar has done and . . . it will be useful, indeed indispensable to those who want to get beyond erudition on one side and sentimentalism on the other."[152]

Reviewers were generally positive in their reactions to *The Art in Painting*. Leo Stein wrote, "There was a need of a book that should make clear to an inquiring student just how the structural elements in painting are related. Painting is a process of relating line and color and light. The process does not, of course, go on in a vacuum for there is always subject matter of some kind. None the less it is possible to make one's studies center on the means by which expression is attained, and this is the principal theme of Mr. Barnes's book on *The Art in Painting*." However, Stein also took issue with a key aspect of the book: "Mr. Barnes is not satisfied to help the student approach all art intelligently; he also insists on telling the student what of good and bad he ought to find in the different works that are studied. . . . The analyses have general significance. They

are specific applications of a general method that is in its essence descriptive. The valuations are not.... Mr. Barnes insistently and not incidentally, offers valuations to the student as though such valuations would mark the successful outcome of the student's observation. I believe that there is in this a serious defect of method. Valuations are personal and not systematic."[153]

Barnes was stung by the criticism and on November 27, 1925, wrote Dewey, who was preparing a response to the review, which he sent to Barnes in advance for comment, "I imagine that what you mean is what I foresaw in that part of the preface to my book which reads, 'It is not assumed that the conclusions reached with regard to particular paintings are the only ones compatible with the use of the method; any one of them is of course subject to revision. What is claimed is that the method gives results as objective as possible within any field of aesthetic experience and that it reduces to a minimum the role of merely personal and arbitrary preference.'"[154] In his response, almost a review in itself, Dewey wrote, "Mr. Leo Stein made an adverse criticism of the book on The Art in Painting written by Mr. A. C. Barnes on the ground that the book was unfavorably affected by Mr. Barnes's interest in education. . . . The book is written from the conviction that art as displayed in painting is inherently educative. But paintings do not educate at present till we are educated to enjoy, to realize their educative potentialities."[155]

Barnes's objective approach struck a chord among some of the leading proponents of Modern expression. Alfred H. Barr, Jr., wrote that he considered Barnes's work to be

> an important book because it presents a systematic and confident statement of what is central in the "modern" attitude toward painting. Its five hundred pages are the expression of an energetic critic, of an experimenter in the education of art-appreciation, and of the owner of the finest collection of modern painting in America. . . . Mr. Barnes will find many, especially among those whom Aldous Huxley terms "the absurd young," who are more or less in sympathy with his position. Among them is the reviewer who has frequently found himself engaged

in a long analysis of a painting without the slightest consciousness of subject matter until some philistine undergraduate brings the discussion to earth by asking why the Madonna has such a funny chin. The undergraduate's impatience is pardonable. His aesthetic illiteracy is shared by all but a few of those who find pictures interesting. Subject-matter has always been of predominant importance to the majority of cultivated people; most of the minority turn their attention to technique or archeology. Only a few are deeply interested in plastic values. Nor has this few up till our own time included many influential critics. Aristotle, Lucian, [Giorgio] Vasari, [Denis] Diderot, [Hippolyte] Taine, and [John] Ruskin, have all helped the public to lose themselves in what Mr. Barnes would term with much good reason irrelevancies. . . . It is refreshing to find no reference to vorticism, futurism, synchromism, and the other ephemeral teapot tempests which though long dead are still made to resound in academic kitchens.[156]

Ezra Pound wrote in praise not only of the substance but of Barnes's spirit: "Mr. Barnes made a laudable effort; In his case we have a man personally concerned with what he is doing, not merely leaving it up to underlings. He has produced by far the most intelligent book on painting that has ever appeared in America. He lives, presumably, in a state of high-tension hysteria, at war with mankind. But he has produced an admirable book, he does know something about Renoir. His book ought to help people to see a picture when they look at it."[157]

In 1925, Barnes hired a new instructor, Violette de Mazia (fig. 17), of whom he later wrote to Dewey, on May 13, 1927, "Early in March I asked you to come to the new Tuesday class and see what Miss de Mazia had to offer. . . . She is a painter, has had two years in our advanced class that studies *Democracy and Education*, and kindred books, with a thoroughness which I doubt is equaled in any college and she has been the most diligent student of our paintings I have ever seen. She had four months last summer in the galleries of Europe. Five days a week, for over a year, she has spent an average of six hours a day in our gallery by

Barnes sold his business in 1929 before the stock market crash, which allowed him to devote all his time thereafter to research, writing, and adding to and refining the collection. As the world economic crisis obliged collectors and dealers alike to relinquish important paintings, Barnes reduced the number of his purchases to focus only on major works that came onto the market. The depression also diminished the ranks of American collectors, as World War I had eliminated the Russian and German collectors who might have competed with Barnes. The process of refining the collection had begun earlier when Barnes acquired Georges Seurat's *Models* (*Poseuses*, BF811) in 1926 from the collection of Count Harry Kessler. In 1929, he bought Renoir's *Leaving the Conservatory* (*La Sortie du conservatoire*, BF862) from Paul Cassirer. He wrote to Dewey on March 5, 1929, "I bought in Berlin the largest Renoir that we have and certainly the finest quality of his early period. The placing of it necessitated a rearrangement with the result that a number of the rooms make ensembles much finer than anything we had before."[160] Barnes began actively to cull from the collection works he no longer deemed essential, including pictures by Cézanne, Degas, Renoir, Matisse, and Soutine. He frequently declined offers to purchase important works, not because they were too expensive, but because, as he explained to art dealer Valentine Dudensing in 1938, such acquisitions threatened to "break up . . . ensembles that are necessary for teaching purposes. The way we hang pictures is not the ordinary way: each picture on a wall has not only to fit in a definite unity but it has to be adapted to our purpose of teaching the traditions."[161] Writing, too, became an increasingly important aspect of Barnes's activities.

In 1931, after four years of intensive research, Barnes's and de Mazia's *The French Primitives and Their Forms* was published. In it the authors apply the method of analyzing the plastic constituents of the pictures, locate their origins in the traditions, and reproduce a considerable number of works never—or rarely—before treated. In 1933 they brought out *The Art of Henri-Matisse*, the first detailed critical study of Matisse's work to appear in any language. It was dedicated "to Leo Stein, who was the first to recognize the genius of Matisse, and who, more than twenty years ago, inspired the study which

herself looking at what is in the paintings. About twice a week, I have listened to what she has herself observed and, while I have helped her, she has made me see things in pictures I never saw before. Next year she is to spend all of her time in our gallery learning and teaching. She has . . . an eye and a focused mind."[158] On October 4, 1930, he wrote to Dr. David Riesman (1867–1940), "[Miss de Mazia] has a mind like John Dewey's and an industry like yours. . . . She is to be co-author with me of our new book on the French primitives which is just about ready to go to press. The preparation of this material has been something awful in its demands on stamina. Miss de Mazia conducts the principal class at the Foundation."[159]

has culminated in this book." Alfred Barr praised the book: "It presents a detailed examination of Matisse's 'plastic means' and formal analyses of particular paintings more thorough and objective than any bestowed upon a living painter before or since. The insistently empirical method results at times in some repetition and tedium but there are many discerning and even eloquent passages."[162]

In 1934, Dewey published *Art as Experience*, dedicating the volume to Barnes. His William James Lectures, originally delivered at Harvard in 1931, were extensively revised and augmented as the result of discussions and correspondence with Barnes and thus transformed into the text for the book.[163] In 1930 the philosopher wrote to Barnes, "I'm having an awful time getting going on the Harvard lectures, tho I still think I shall take art and aesthetics. One thing you will help me out on is the relation between the background affair and objective factors in taste."[164] Barnes responded enthusiastically to this request with a series of letters dealing with the meaning of experience and other subjects covered in detail in the book. Concerning the James Lectures, Dewey stated, "I have been invited to give some lectures at Harvard next spring. . . . I had come down here [Philadelphia] to confer with Doctor Barnes and get his advice and assistance in connection with the plastic and paint subject I was going to lecture on."[165]

Heretofore, it has been commonly accepted that until Dewey met Barnes he was not engaged with the realm of aesthetics apart from his broad knowledge of literature.[166] Jay Martin, however, has convincingly challenged and thereby modified this view of the philosopher's relative indifference to the visual arts, tracing his intellectual engagement with aesthetics back to his days as a student at the University of Vermont (1875–79) and later as an instructor (1884–88) and subsequently Head of the Department of Philosophy at the University of Michigan (1889–94). "From a very early time, Dewey had been interested in aesthetics and tried to acquaint himself with visual art. . . . At Michigan [fall 1891] he designed a course on 'The Philosophy of Beauty.' His field of inquiry had three divisions: '(1) the conditions of (a) nature and (b) society from which aesthetic satisfaction springs; (2) the nature of aesthetic capacity, including "the psychology of aesthetic experience"; and (3) the objective results of aesthetic activity in the individual, society, nature and art.' "[167] The author states,

> Dewey's friend Barnes was more than a collector; he was a true pedagogue. . . . He lectured slowly and patiently and, at least in the instance of art, with genuinely informed intelligence. . . . Albert Barnes introduced him to a whole new area of knowledge. Without Barnes's impetus, Dewey would probably never have written a book on aesthetics. . . . Barnes showed Dewey an approach to artistic productions that stirred his philosophic interest. By temperament, Dewey tended to be interested in naturalistic or realistic literature. But Barnes was not interested in realistic content; rather, he stressed the formal aspects of art. By expanding Dewey's acquaintance with the visual arts and also by emphasizing the power of form in all artistic production, and finally by focusing on the technical aspects of art criticism, Barnes gave Dewey all the material he needed that, added to his own evident interest in artistic production, would lead Dewey to begin to think about writing a book on aesthetics. The book was *Art as Experience*.[168]

In his preface to *Art as Experience*, Dewey acknowledged Barnes's contribution:

> The chapters have been gone over one by one with him, and yet what I owe to his comments and suggestions on his account is but a small measure of my debt. I have had the benefit of conversations with him through a period of years, many of which occurred in the presence of the unrivalled collection of pictures he has assembled. The influence of these conversations, together with that of his books, has been a chief factor in shaping my own thinking about the philosophy of aesthetics. Whatever is sound in this volume is due more than I can say to the great educational work carried on in the Barnes Foundation. That work is of a pioneer quality comparable to the best that has been done in any field during the present generation, that of science not excepted. I should be glad to think of this volume as

one phase of the widespread influence the Foundation is exercising.[169]

In April 1934, the president of Black Mountain College in North Carolina, John Andrew Rice, invited John Dewey to visit and observe the school's educational program. The invitation was also extended to Dr. Barnes. Two accounts of their visit are preserved. According to Martin Duberman, based on interviews with Rice, "Dewey visited twice during the 1934–1935 college year, one time bringing his good friend, Albert Barnes, the art collector. Though Barnes had a notorious reputation for irascibility, Rice, with a young prize fighter's awe of the champ, told me he thought Barnes 'the most charming man you ever saw, utter graciousness, and the most divine whiskey before dinner, with Dewey and two or three other people. Marvelous.'"[170] In Rice's autobiography, he recalled, "John Dewey was . . . the only man I have ever known who was completely fit and fitted to live in a democracy. . . . Another who understood the intention of the college, or perhaps I should say, of the dream, was Dewey's friend, Albert Barnes of Merion, who questioned every man's right to be alive and usually found against the plaintiff. Every night he invited some of us to his room before dinner and measured out with the care of a pharmacist drinks of beautiful whiskey. John Dewey was always there and, following the Socratic tradition, drank with the rest until Barnes said, 'Now John, you've had enough. One more and you'd be drunk,' but he was wrong, for Dewey, upholding the tradition, could stay beyond the rest and lift the last glass with a steady hand."[171]

Published in 1935, *The Art of Renoir* by Barnes and de Mazia is the most substantial analysis of the artist's work and the first comprehensive monograph on the artist to be published in English.[172] The book sums up ideas Barnes had first begun to delineate in his articles of 1920 and 1925, further augmented by intensive research in the intervening years.[173] Barnes sent Dewey the first four chapters to read and requested that the philosopher contribute an introduction. Dewey, who eventually wrote the foreword as well, responded on December 8, 1934, with some minor advice and added, "It isn't true you got your principles from me—re your preface—you've gone too far; my principles were largely derived from you also;

there has been a lot of give and take and as much take as give—at least as much—on my side. I was surprised as well as honored by the suggestion of an Introduction. If I knew just what to say I wouldn't mind critics saying we were scratching each others' backs. But you've said all I could say and much more in terms of experience. If you want to send me your ideas of what should be said I won't use just what you put down but it would give me a start."[174] Barnes replied on December 10, "Believe it or not, what I say about education, science, thinking, unity, experience, *did* come from you, even though it was many years ago. The point in telling you this is that in your introduction you can say to the world 'I told you so many years ago and maybe now, you poor boobs, you may believe it.'"[175]

James Johnson Sweeney, who had known Barnes for a decade, reviewed the book for the *New York Herald-Tribune*:

Today Renoir's place in the great tradition of European painting is acknowledged by even the most conservative tastes. . . . Although not yet sixteen years dead he is practically accorded the respect and position of an "old master." Yet there is one phase of his work, his latest and most vital, which is still unappreciated—in this country at any rate. . . . This so-called "red period" . . . still offers difficulties to the connoisseur as it has been a stumbling block to the critics. But Dr. Albert C. Barnes and Miss Violette de Mazia in their book "The Art of Renoir" make this phase, as it should be, the culmination of their analytic consideration of the painter's work. Their approach is intelligent, workmanlike and informed. And had their book offered no more than this introduction to the maturist flowering of Renoir's genius it would still remain an achievement in America as well as the milestone in the appreciation of Renoir it represents. . . . As a practical stylistic exegesis of Renoir's art Dr. Barnes and Miss de Mazia's book is unique. And as a basis for an approach to painting in general and particularly contemporary work, the introductory chapters propose a method which would eventually eliminate many of the more troublesome misconceptions.[176]

Barnes continued to broaden the scope of his collecting and to implement his experimental, nonhierarchical arrangement of works in the gallery. By the mid-1930s he began acquiring furniture, mainly early American, to complement the wall groupings. These were further augmented by an array of wrought iron utilitarian and decorative objects, both European and American, which were mounted on the walls interspersed with the paintings in the gallery. The ironwork, an intentional counterpoint to the pictures, comprises a collection in itself of the great tradition of the blacksmith's art.[177] In a letter to Clarence J. Bulliet, art critic of the *Chicago Daily News*, Barnes explained, "I have introduced a new element in the Gallery which decreases the width of the gap between 'fine art' and 'industrial art.' I mean the 'industrial art' of two or three hundred years ago in America and Europe."[178]

Dewey took a lively interest in this new direction. In a 1937 article marking the Cooper Union's fortieth anniversary, he wrote,

> One of the most significant phenomena of the present is recognition that art reaches into the lives of people at every point; that material wealth and comfort are in the end a form of poverty save as they are animated by what art and art alone can provide. A necessary part of this changed attitude is the breaking down of the walls that so long divided what were called the fine arts from applied and industrial arts. . . . Design is a matter of composition, of the integrated relation of all constituent parts in forming a whole. To learn to see for artistic purposes is to learn to detect organizing design, whether the object seen be a statue, a picture, a tapestry, a pitcher or a roll of wall-paper. . . . Some museums can put their objects in definite places and keep them there. An educational museum must be able to have them where they are wanted at a given time in relation to other objects in order to meet an educational need when it arises.[179]

In 1939 Barnes and de Mazia published *The Art of Cézanne*, a comprehensive demonstration of Barnes's method coupled with a reliable firsthand detailed exposition of individual works; the ninety pages of analyses are as useful today as a guide to understanding the pictures as they were when they were written.[180] As usual, in addition to demonstrating the artist's creative evolution, the authors are unsparing in criticizing pictures as deficient, even unsuccessful, a constituent of all the Foundation's publications, which puts at the student's disposal what the author believed was an objective tool with which to gauge the success or failure of a given work. Students learned that learning to see is not a form of worship. A particularly instructive feature of the book is the chapter on the artist's impact on such painters as Renoir, Gauguin, Picasso, the Cubists, Matisse, Pascin, Soutine, Prendergast, Modigliani, Demuth, and Maurice Utrillo. Barnes was en route to France to work on the book when he learned of Glackens's death. In his letter of condolence to the artist's wife, written June 3, 1938, he confided, "I came here to finish what I expect to be my last important job of my life—the book on Cézanne."[181]

Following the publication of *The Art of Cézanne*, Barnes wrote a number of articles, reviews, catalogue introductions, and occasional magazine essays that deal with specific subjects, demonstrating the application of scientific method to aesthetics. In 1940, he contributed a brief article, "Method in Aesthetics," to a publication honoring John Dewey's eightieth birthday.[182] In addition to issuing pamphlets and broadsides, Barnes continued to write occasional reviews and organize exhibitions. His focus was, as usual, on art and education. Reviewing Agnes Benedict's *Progress to Freedom: The Story of American Education* in 1942, for example, he wrote, "Miss Benedict's fine touch brings out with force the significant points that characterize the labor of the educational pioneers—from Thomas Jefferson and Horace Mann to John Dewey—in dealing with social conditions that changed with each generation. Her insight, her discrimination, and the manner in which each successive step in the development is proportioned and linked in an unbroken chain, give to the story its unique quality—its novelty, its absorbing interest and its dramatic force. It is obviously a labor of love: love for children, of teaching as a profession, of education as a means of attaining the American conception of democracy or presentation of ideas so interrelated that they constitute real thinking."[183]

By 1940, Barnes's early American collections were so extensive that he was inspired to acquire an eighteenth-

45

century Chester County stone farmhouse surrounded by 137.7 acres, which he named Ker-Feal ("Fidèle's Home" in Breton) in honor of the pet dog he had adopted in Port-Manech, the village in Brittany where he and his associates vacationed and worked on their books. With the coming of World War II, Barnes focused his energies on making additions to Ker-Feal and filling it with antique furniture, pottery, wrought ironwork, pewter, textiles, and other examples of early American craftsmanship.[184] Barnes spent weekends at the Farm, as it was referred to, and Mrs. Barnes landscaped the property, creating formal gardens and natural plantings of rare botanical specimens as well as local flora. That year she had established the Arboretum School of the Barnes Foundation and also brought her students to Merion, where she and a staff of teachers from the faculty of the Department of Botany at the University of Pennsylvania lectured on horticulture, botany, and plant geography as well as the aesthetic values of plants and gardens. At Ker-Feal there were no paintings. However, the arrangements of early Pennsylvania German pottery, furniture, and metalwork carried out the same type of themes as the bold color, pattern, and textural relationships in the arrangements in the gallery. Students from both the art department and the horticulture program had lectures and class work at Ker-Feal. Barnes was sympathetic with the aims of the federal government's Index of American Design program, and a number of objects—notably, but not exclusively, painted furniture—were illustrated in books published during his lifetime.[185]

Early in 1940, the Board of Higher Education of New York appointed Bertrand Russell, who had been teaching philosophy at the University of California, Los Angeles, and was scheduled to deliver the William James Lectures at Harvard in the 1940–41 school year, to lecture at the College of the City of New York on logic and its relations to science, mathematics, and philosophy; relations of the pure to the applied sciences; and the reciprocal influence of metaphysics and scientific theories, beginning in the spring term of 1941. Russell was denounced by several prominent clergymen and a private citizen brought a suit attacking the philosopher's morality and his fitness to teach at the college. A judge of the New York Superior Court voided the appointment on the grounds that it adversely affected public health and morals. On appeal, this ruling was upheld by the Appellate Division of the New York Supreme Court. Russell, who was stranded in the United States during the war, was denounced by a number of civic organizations, religious groups, and individuals. He was stoutly defended by an equal number of intellectuals such as Alfred North Whitehead, John Dewey, Albert Einstein, and many other prominent individuals and organizations. Harvard was pressed to rescind Russell's appointment, but its president and fellows refused to do so.

The "Russell Case" became a cause célèbre. Dewey, who was not personally close to the British philosopher, despite the fact that they agreed on a broad range of social issues, was moved to support him and asked Barnes to take up the cudgels on Russell's behalf, a cause to which Barnes responded eagerly. He had long been an adherent of Russell's approach to social problems and scientific method, and the philosopher's books were read and analyzed in the factory seminars. He now conceived the idea of offering Russell a teaching position at the Foundation and asked Dewey to make the initial overtures. Russell wrote Dewey, "Please accept my warmest thanks for your . . . generous activity on my behalf. The proposal that you transmit is, in principle, all that I could desire and if circumstances permit I shall be most happy to accept it. . . . May I postpone a definite answer for awhile, until the situation is clarified? Please convey my most sincere gratitude to Dr. Barnes."[186] Barnes thanked Dewey for his intermediary efforts and wrote, "We should be glad to take him on. The poor devil must be distressed beyond measure to be practically defenseless under the thunderous onslaught of the concentrated ignorance of some of our prize democratic institutions."[187]

Barnes traveled to California to meet with Russell and extend the offer in person. He also funded the publication of a book, *The Bertrand Russell Case*, edited by John Dewey and Horace M. Kallen, with essays by Dewey, Kallen, Morris R. Cohen, Sidney Hook, and other prominent progressive intellectuals, with a brief foreword by Barnes.[188] Russell was engaged for five years to give a course in the history of philosophy, one lecture per week during the school year, from October 1 to May 31. He started at the Foundation on January 9, 1941. Sixty

students were enrolled in the class, which was devoted to philosophy and cultural development in Europe from the pre-Socratic Greek philosophers to modern times. The original contract stipulated that Russell would receive a salary of $6,000.00 per annum. Russell then informed Barnes that he would like to discontinue his popular lecturing so that he could devote himself exclusively to his philosophical work. Barnes agreed to increase Russell's salary by $2,000.00, Russell's approximate annual income from lecture fees, based upon the understanding that after April 1, 1941, Russell would no longer give such popular lectures excepting an occasional lecture to a university audience, and the contract was amended to reflect the increase. Russell later recalled, "Only one man did anything practical, and that was Dr. Barnes. . . . He gave me a five-year appointment to lecture on philosophy at his Foundation. This relieved me of a very great anxiety. . . . I was saved by Dr. Barnes."[189] In a 1940 letter to Gilbert Murray, then at Harvard, Russell wrote, "My personal problems have been solved by a rich patron (in the eighteenth-century style) who has given me a teaching post with little work and sufficient salary."[190]

Although many of his students enjoyed and profited from the class, Russell did not engage with them or participate in the intellectual life of the Foundation. Further, Barnes observed that his new teacher had not relinquished his outside popular lecturing and writing, which he considered a breach of contract. At the same time, Mrs. Russell, attending her husband's classes in the gallery, acted in ways Barnes considered detrimental to a positive learning atmosphere, such as knitting during class. She insisted on being addressed as Lady Russell and behaved arrogantly to members of the Foundation's board. Barnes informed Russell of his displeasure and they exchanged prickly letters, with the philosopher stoutly, if somewhat disingenuously, defending his spouse. Both men wanted the relationship to continue, but each had a distinctly different view of the situation. Russell sought to keep the post that entailed only "little work," and an uneasy standoff prevailed throughout most of 1942. Attendance in Russell's class dwindled, students found the lectures increasingly perfunctory, the disruptions continued, and Barnes terminated his contract with Russell at the end of December 1942. Russell sued and was awarded $20,000.00,

covering the three remaining years on his contract less what the court considered his outside earnings, which were not affected.[191] Barnes, who had drawn up Russell's contract himself, technically had no legal basis on which to support his argument that the philosopher had broken the agreement in large measure not because he enjoyed lecturing but, doubting that he would be challenged, due to greed.

Dewey felt that Barnes's stance was morally justified and that Russell had taken advantage of him. The disappointment stemming from this episode—in effect, from Barnes's misapprehension of Russell's character and possibly his instinctive resistance to the conventions of the British gentry class as well as his projection onto Russell of the type of friendly, reciprocal intellectual relationship he enjoyed with Dewey—had a deep effect on Barnes and, indirectly, on his subsequent interactions with organizations such as the University of Pennsylvania.[192] After the court's judgment, he reflected on the loss to Dewey, writing, "the ten days since the Court decision have been the most harrowing of my life—trying to reach a rational conclusion of what to do with myself and the Foundation and still maintain self-respect. . . . It was a clean-cut conflict between diametrically opposed systems of thought and morals and we got licked. The law confirms the defeat and an ill-informed press enables Russell to pull off the biggest publicity stunt—and the dirtiest trick—of his entire career."[193]

Overlapping with a disastrous imbroglio with Russell, who had eagerly accepted the offer to teach at the Foundation in early 1941, Barnes took a journalist, Carl W. McCardle, into his confidence, agreeing to have the Foundation, its collections, and its educational work be the subject of a four-part series of articles to be published in the *Saturday Evening Post* and illustrated with color photographs—the first ever published—taken in the gallery by the Pinto brothers, Angelo, Salvatore, and Biagio. The Pintos, all painters, had been students in the Foundation classes and had all received traveling scholarships, and Angelo Pinto had taught classes there since 1935. Dr. Barnes had purchased examples of their work for the collection. The series was announced in the March 14, 1942, issue of the *Post* as follows: "An iron-spiked fence on Philadelphia's fashionable Main Line and a

magnesium-flared temper guard Dr. Albert C. Barnes and the world's greatest modern-art collection from any intrusion whatsoever. The possessor of the most scathing tongue in America."[194]

This florid lead could only have disconcerted Barnes, who had gone to great lengths to cooperate with McCardle in preparation for the articles. He had invited the reporter to attend a preliminary meeting of Russell's class and shortly thereafter to interview the philosopher. He provided access to his personal files, lent the reporter books, and arranged for him to interview John Dewey. McCardle agreed that what he wrote would be submitted to Barnes for approval before publication. In fact, expecting a serious profile, Barnes had left himself open. He had failed to charm the reporter by granting unparalleled access and recounting anecdotes that seemed innocent enough to him, but which the reporter could not resist amplifying and presenting to *Post* readers, who did not want to learn about scientific method and educational reform. Barnes first saw the text in galley proofs and made numerous corrections, including remarks on the Russell situation, which were accepted and incorporated by the editor.[195] But, Barnes wrote, "even if [the editor] publishes the copy as we corrected it, the articles will not come within hailing distance of what the author obligated himself to do."[196] Barnes wrote that the series, entitled "The Terrible-Tempered Dr. Barnes," portrayed its subject "in a breezy, swiftly-moving style that entertains and amuses the reader. . . . Many of the incidents and events, and most of the quotations ascribed to me in McCardle's articles, I learned of for the first time in the galley proofs; indeed, some of the tales and nearly all of the supposedly verbatim reports of my sayings are really whoppers."[197] What upset Barnes most was the title, which he earnestly entreated the *Post* editor to change—to no avail. His very public campaign to counteract the misinformation only served to stoke sales of the series, already substantial owing to the exclusive color reproductions.

Barnes was not unreceptive to the idea of color reproductions of works in the Foundation's collection, as is generally believed. Later that year, on September 17, 1942, Barnes wrote to his old friend Henry McCarter, a longtime teacher at the Pennsylvania Academy of the Fine Arts, "I was very glad to hear from you again and you may be sure that we shall be delighted to have the Pinto colored slides from our collection used for your students. I suppose that you know that we do not have the slides, so that all that remains to be done is for you to get them from the Pintos."[198] A month later, on October 22, Barnes reiterated his offer to McCarter: "You may use the colored slides of our pictures whenever and wherever you wish. The only stipulation we make is that the slides are not to be used to reproduce the pictures either for publication or for sale."[199]

There were two negative consequences of the *Post* articles. The immediate result was that they reinforced Barnes's reputation as an eccentric with whom it was impossible to do business. Much more devastating in the long term was that virtually every article written on Barnes after 1942 has been based in some measure on McCardle's pieces. Coupled with Russell's victory in his lawsuit against Barnes and other public controversies eagerly headlined in a Philadelphia press not known for its sympathy for Barnes, the negative publicity put further on guard the universities with which Barnes tried yet again—and again in vain—to forge alliances in his later years. At a strategic level, the fallout proved to be insurmountable.

In 1944, Barnes drew up his last will and testament, a simple, two-page, five-clause document reaffirming his gift of "almost all of my property to The Barnes Foundation."[200] From that moment onward, he intensified his efforts to establish an affiliation with a university that would preserve the legacy of the Barnes Foundation. This quest—which was to become complicated and fraught with controversy—preoccupied him for the remaining seven years of his life.

On October 31, 1946, Barnes spoke at the funeral of Dr. Nathan F. Mossell, a prominent graduate of Lincoln University whom Barnes admired. At that event Horace Mann Bond, president of Lincoln, also made brief remarks remembering Mossell at the Tindley Temple United Methodist Church, whose programs to feed the poor Barnes had supported for years. Barnes was impressed with Bond and invited him on the spot to Merion for lunch and a tour of the Foundation. Another physician

in attendance at the memorial ceremony was the gyne-cological surgeon DeHaven Hinkson, a longtime friend whose postgraduate work in France had been sponsored by Barnes.[201] Hinkson immediately wrote to Bond, report-ing on Barnes's enthusiasm for Bond's speech and sug-gesting that he should cultivate Barnes.[202]

Bond followed up on his meeting with Barnes, inform-ing him about his plans for Lincoln, but did not press him for money. A lively correspondence ensued, and the two men established a cordial working relationship, just the kind of open communication that had proven so elusive in Barnes's dealings with the University of Pennsylvania. As early as January 1947, after delivering a lecture at Lin-coln, Barnes contributed $1,000.00, as he wrote Bond on the 13th, "to help the neediest of the foreign [African] stu-dents at Lincoln . . . [to] enable them to advance the edu-cation and civilization of their race when they return to their homeland." He concluded, "I enjoyed my stay at Lin-coln and was much impressed not only with the friendly and democratic spirit that prevails but with the eager, alive, intelligent group that surrounded me . . . after my talk."[203] By the summer of 1950, Bond invited Barnes to join the Lincoln faculty as a lecturer in art for the 1950–51 school year, to deliver four to six lectures on art and one or two specifically in the field of African art. On Octo-ber 12, 1950, Barnes made a counterproposal, inviting twelve to fifteen Lincoln students to attend a class at the Foundation. Under the administrative aegis of J. Newton Hill, dean of the college, with whom Barnes also devel-oped good relations, the Lincoln students were enrolled in two courses of study taught by two of the Foundation's instructors in the gallery.[204]

Barnes was drawing closer to Lincoln as a result of both Bond's responsiveness and his own increasing dis-pleasure with the lack of genuine reciprocity from the University of Pennsylvania, which he had made one of his legatees prior to 1912. As if the struggle twenty years earlier with the university had not clinched the case, Barnes again made overtures to his alma mater. His renewed attempts in 1946 to forge a sustainable framework for any future alliance between the Foundation and the university were apparently thwarted by a deep-rooted mutual distrust between Barnes and the Penn administration, although the details are not known. He attempted a variation of

the 1925–26 proposal, but the outcome was reminis-cent of the earlier breakdown. On April 17, 1947, he wrote Justice Horace Stern, a Penn trustee, "Believe me, I am just as much distressed at the outcome of the University affair as you are. . . . It is not disloyalty to the University nor a desire to inflict punishment upon anybody, but a decision based upon a 25-year experiment by scientific method, and under the counsel of very good brains. The stakes are enormous—a conservative estimate of prop-erty values is at least thirty million dollars. . . . To turn this over to a university with such a consistent record of intellectual torpor . . . seems to me just about as stupid a move as could be made."[205] Later that year, on August 7, 1947, Barnes reflected in another letter to Stern, "What a cockeyed world it is and what a damned fool I am to try to change it for the better. And how unhappy I'd be if I stopped!"[206]

Perhaps the union with the University of Pennsylva-nia was ultimately an unattainable match. Although he retained influential friends at the university, includ-ing Justice Stern, John M. Fogg, professor of botany and vice-provost, and Owen J. Roberts, who in 1948 became the dean of Penn's law school (and was also a trustee of Lincoln), Barnes was discouraged. The Russell debacle, his post-trial fulminations, and the coincident *Saturday Evening Post* brawl had been conspicuously conducted in public, and the university had no wish to become mired in similar imbroglios. Penn was a conservative organization; Dewey, whose counsel Barnes had sought in negotiating with the university, was an outsider, a liberal reformer, who could advise but was powerless to assist in any concrete way. Barnes had always been demanding and impatient, but he was older and his health was not alto-gether robust. Whatever the shortcomings of the Penn administration—and they were real: the School of Fine Arts faculty loathed Barnes—the outcome was certain. It is difficult to imagine how Barnes would have behaved if a deal could have been fashioned even partially on his terms. A post-agreement sequel might well have meant a perpetual conflict even worse than the struggle lead-ing up to it. Barnes had always relied on the conviction that the university would assent to an alliance based on its recognition of the unique value of his collection.[207] On November 25, Barnes again wrote to Horace Stern,

referring to Harold Stassen, who had been appointed in 1948: "The President's function seems to be to raise money, and that the attempts to get me into the game were really to further that end. This offends my intelligence. . . . I have written you frankly and with sorrow in my heart, because it is my swan song."[208]

Until October 19, 1950, the by-laws of the Barnes Foundation stipulated, "Upon the death of the survivor of Donor and his said wife the Trustees of Donee to be elected in perpetuity thereafter shall be five in number; two thereof to be chosen by the Board of Trustees of the University of Pennsylvania, and two by such other institution located in Philadelphia, as may be designated by Donor in writing to the corporation. In case the Donor fails to designate such other Philadelphia institution as referred to in the preceding sentence, the third and fourth members of the Board of Trustees of the Barnes Foundation are to be chosen by the Board of Trustees of the University of Pennsylvania. . . . If the University of Pennsylvania becomes affiliated with The Barnes Foundation, either in its art gallery or the Joseph Lapsley Wilson Arboretum, then one of the said Trustees of The Barnes Foundation shall be one of the professors in the School of Fine Arts connected with the said University of Pennsylvania."[209] He wrote to Dewey on April 19, 1950, with Penn in mind, "This is my last fight for democracy and education. If we lose, the Foundation ends its existence, the endowed fund of ten million dollars goes to the extension of a post graduate school of medicine for research and treatment, the paintings will be sold and the proceeds go to the same institution, and the buildings used as research laboratories. . . . I've told you many times that we are as a voice in the wilderness: its parallel is a General fighting without an army of soldiers."[210]

Six months after Barnes had related to Dewey his thoughts on the prospect of a legacy to support medical research, he wrote Roberta L. Dewey (whom Dewey had married in 1946) on October 10, 1950, "We started an experiment in education with classes from Lincoln University comprised of both faculty and students. The first session of the class was a very lively one and I do hope that we will find the much sought connection with a college not completely inadequate."[211] Unbeknownst to Horace Bond, Barnes made a crucial change in the by-

laws of the Foundation. It was formalized well before any possible dissatisfaction with Lincoln might have set in, for the amendment was made at the beginning of the experiment to which Barnes refers. On October 20, 1950, Article IX, Section 2, Paragraph 17, of the Foundation's by-laws was amended to provide that after the death of the donor and his wife, the first vacancy on the board of trustees was to be "filled by the election of a person nominated by the financial institution which shall be Treasurer of Donee, and the next four vacancies which occur by the resignation, incapacity or death of Trustees who were in office at the time of the death of the survivor of Albert C. Barnes and his said wife shall be filled by election of persons nominated by Lincoln University of Lincoln University, Chester County, Pennsylvania. Thereafter vacancies occurring by the expiration of the term, death, incapacity or resignation of the Trustees nominated by the Board of Directors of such financial institution and the Board of Trustees of Lincoln University."[212] This amendment also stated, "no Trustee shall be a member of the faculty or Board of Trustees or Directors of the University of Pennsylvania, Temple University, Bryn Mawr, Haverford or Swarthmore Colleges, or Pennsylvania Academy of the Fine Arts." On November 6, 1950, Barnes wrote Bond, "I spent last Wednesday . . . with John Dewey in New York, and he asked me how the experiment with Lincoln was going. I said I thought it would be a success."[213]

Perhaps health considerations had an effect on the decision, which Barnes wished to settle prior to treatment. He was incapacitated for approximately four months, from November 1950 through February 1951. On January 26, 1951, weeks after his seventy-ninth birthday, Barnes underwent prostate surgery. He was discharged from the hospital on February 13, and his activity was very restricted while he was convalescing.[214]

When he was well enough, Barnes invited Bond to Merion for a meeting on March 1, 1951, to discuss Lincoln's relationship with the Barnes Foundation. He showed Bond the new amendment to the by-laws but did not give him a copy.[215] Barnes wrote to Dean J. Newton Hill on May 24, "You've been so cooperative in our experiment with Lincoln that you are entitled to a frank statement of how I size up the situation. . . . This year the experiment with Lincoln failed . . . in spite of your zeal and intelligent

cooperation, and my efforts to start it right. . . . If Lincoln wants to go on with the course next year, we'll provide the teacher, Paul Moses, and both Miss de Mazia and myself will do our best to help him. . . . I like [the students], and if I had not been taken ill in November, I would have conducted the class."[216]

On June 5, 1951, the Lincoln Board awarded an honorary Doctor of Science degree to Dr. Barnes. The citation reads in part, "You have faith in the capacities of the Negro people, and this faith you have demonstrated in many ways throughout your life."[217] Bond, his wife, and several friends last visited Barnes July 17, 1951. Bond noted that the honorary degree was framed and hung in Barnes's office. Plans had been made for the 1951–52 scholastic year, with fifteen Lincoln students enrolled in three classes, when Barnes died on July 24, 1951.

In May 1951, Barnes met with his friend, the collector Henry Pearlman, who later recalled,

Dr. Barnes and I got along very well together. He invited me to visit the Barnes Foundation . . . where for three hours he described to me where he had purchased various paintings, the prices he paid. . . . When I met Albert Barnes again, he asked me whether I knew of a Rembrandt for sale, as he would like to buy one. Billy Rose had mentioned to me that he had a Rembrandt that he would like to sell, so I told Barnes about it. He said he didn't have the cash just then, so I offered to pay for the Rembrandt and exchange it with him for one of his Cézanne still lives [sic]. Soon thereafter, Barnes came to my office with a colleague [Violette de Mazia]. . . . As the visit by Barnes was for the purpose of going to Billy Rose's home to see the Rembrandt, I made the appointment, Rose rushed home from his office, and the three of us went up to visit him. . . . Billy was waiting for us . . . and as we walked in, he introduced himself by saying, 'So you are the terrible tempered Dr. Barnes!' At that remark Dr. Barnes's hair stood on end, and his face turned colors. I am sure that if there hadn't been a Rembrandt at stake, he would have crushed Billy. . . . Barnes was quite satisfied with the Rembrandt, and asked Billy to get

him an infrared photo of it. Within a week of this date, Barnes was tragically killed in an automobile accident. [218]

American society has from its beginnings been continually, fundamentally transformed and invigorated by its evolving ethnic makeup. The present place of African Americans, Hispanics of many origins, and immigrants from various Asian cultures in American life would have been unimaginable to most Americans of the early twentieth century. Long before Gunnar Myrdal, Barnes clearly comprehended the issues articulated in *An American Dilemma*.[219] Concurrent with the opening of the Barnes Foundation, he wrote, "We have to acknowledge not only that our civilization has done practically nothing to help the Negro create his art but that our unjust oppression has been powerless to prevent the black man from realizing in a rich measure the expressions of his own rare gifts. We have begun to imagine that a better education and a greater social and economic equality for the Negro might produce something of true importance for a richer and fuller American life. . . . This mystic whom we have treated as a vagrant has proved his possession of a power to create out of his own soul and our own America, moving beauty of an individual character whose existence we never knew. . . . He may consent to form a working alliance with us for the development of a richer American civilization to which he will contribute his full share."[220]

Albert Barnes made his presence felt in the worlds of art and education, as he had in chemistry and business. His original application of scientific method to art had as one of its tenets to reduce subjectivity to minimal levels, but it required determined systematic effort and challenged standard historical approaches to the subject. He was a pioneer in analyzing the constituents of emotions and perception in order to probe the mysteries of what Santayana so eloquently characterized when he wrote, "Painting contains . . . an intelligent expression of all those mechanisms, those situations and passions, with which the living world is diversified. It is not a design in spots, meant merely to outdo a sunset; it is a richer dream of experience, meant to outshine the reality."[221] Barnes had a disciplined mind and an imposing work ethic. He took no

prisoners in his many disputes with established authority. He could be impulsive, plainspoken, profane, domineering, even brutal, to adversaries, and he had no illusions that the pretense and deeply rooted inertia he found so discouraging would disappear. He was resolute in refusing to accept the status quo. But then, few of those who endowed our most prestigious institutions—universities, libraries, foundations, and museums—were, in their own spheres of activity, gentle and forgiving men.

Horace Bond, writing to Mary Mullen on November 10, 1951, eulogized Barnes as "a very great American . . . this most extraordinary—and to me, revered—original American personality."[222] It was Barnes's conviction that ordinary people can understand and share in the full range of aesthetic experience, which should and can be a vital part of everyday living. In 1943 Barnes and de Mazia wrote,

> In every age and every culture human beings have the same basic needs, encounter the same world and the same problems, expend time and effort in seeking the same satisfaction. Of these needs, none is more imperative than that for expression. . . . To recognize essential humanity . . . we must look beneath the surface, disregard the adventitious, grasp the essential. . . . Exclusive interest in the art of our own time and civilization is itself a form of parochialism. . . . If we can really grasp, with our imagination and our feelings, the fact that painters who have been dead a thousand years looked upon the same world that we see, were moved by it in the same ways and sought to do the same things with it that we do, then perhaps we may realize our kinship in purpose and aspiration with their descendants.[223]

NOTES

Epigraph. Bernard Bosanquet, *Three Lectures on Aesthetic* (London: Macmillan, 1915), 19. Barnes praises this book in a letter to Thomas Craven, May 21, 1923, ACB Corr., BFA.

1 Letter, Albert C. Barnes to Henry Francis du Pont, May 6, 1948, Courtesy the Winterthur Library: Winterthur Archives, Winterthur, Del. Barnes was responding to a letter from Du Pont dated May 4, 1948. Dr. and Mrs. Barnes were on excellent terms with Henry Francis du Pont, with whom they shared a serious interest in horticulture. J. Stogdell Stokes was president of the Philadelphia Museum of Art. The three men collected early American furniture and decorative arts, including Pennsylvania German art.

2 Letter, Barnes to Alice Dewey, September 20, 1920, ACB Corr., BFA. Roger Baldwin (1884–1981) was founder of the American Civil Liberties Union.

3 Letter, Barnes to John J. Cabrey, November 29, 1950, ACB Corr., BFA.

4 "Barnes Foundation in Merion Has World Renowned Collection of Art" (unsigned interview with Barnes), *News of Bala Cynwyd*, October 1, 1934. Barnes also stated, in testimony given to the Supreme Court of Pennsylvania: "When I was at Central High School one of my classmates was a boy who became one of the most important—recognized as such—American artists. . . . Since then I have painted. I remember my first contact with [Glackens]. He laughed at my trying to paint. I wanted to find out what he was laughing at and I learned a lot from him. Then I always had pictures around me until I had 190 painted." Pennsylvania State Archives, Harrisburg; Record Group 33, Records of the Supreme Court of Pennsylvania; Eastern District; Appeal Papers (series #33.10), January Term 1933, No. 268, "Direct Examination" of Albert C. Barnes in *The Barnes Foundation, Appellee vs. Harry W. Keely et al.*, 143a.

5 G. Y. Loveridge, "Unorthodox Dr. Barnes Explains How He Enjoys Dealing with Arts," *Providence Journal*, January 15, 1943, 1, 8. Barnes's lecture, "Having a Hell of a Good Time Playing with Art, Education, Science and Philosophy," includes a freewheeling extemporaneous recollection of his early years. Barnes had been invited by Curt J. Ducasse, head of the Department of Philosophy at Brown University, to give the annual guest lecture of the Rhode Island Philosophical Society.

6 Letter, Barnes to John Dewey, October 28, 1946, ACB Corr., BFA.

7 Albert C. Barnes, "The Art of the American Negro," Barnwell Address, April 27, 1936, *The Barnwell Addresses*, vol. 2 (1931–36) (Philadelphia: Central High School, 1937), 376.

8 Letter, Barnes to Charles S. Johnson, March 15, 1926, ACB Corr., BFA. Barnes delivered an address at the Women's Faculty Club, Columbia University, New York, March 16, 1926, later published in *Opportunity: Journal of Negro Life* 4, no. 41: 148–49, 168–69. He arranged for the Bordentown singers to present a concert for the audience. Subsequently, on April 19, 1926, Barnes wrote to Dewey, "I have been twice to Bordentown to hear the whole chorus of three hundred and twenty-five young negroes. It was overwhelming—I never heard anything like it in my life." Letter, Barnes to John Dewey, April 19, 1926, ACB Corr., BFA.

9 See John W. Work, Jr., "Introduction," in *Folk Songs of the American Negro*, nos. 1 and 2, Frederick J. Work, ed. (Nashville: Work Bros. & Hart Co., 1907).

10 Letter, Barnes to W. R. Valentine, February 17, 1950, ACB Corr., BFA. See note 220.

11 Archives of Central High School, Philadelphia. See also "Albert C. Barnes Killed in Crash" (obituary), *Philadelphia Evening Bulletin*, July 25, 1951.

12 Almost two years older than Barnes, Glackens entered Central in February 1885 and graduated in February 1890. He contributed to the school magazine, the *Mirror*, gave speeches in the school assemblies,

and was elected vice president of his class in his junior year. See *Mirror* 4, no. 2 (October 1887): 36.

13  Ira Glackens, *William Glackens and the Ashcan Group* (New York: Crown, 1957), 162. He quotes from a typescript by Barnes, "The Art of William Glackens," dated April 1924, in his possession.

14  Letter, Barnes to Alfred Hand, M.D., June 30, 1947, ACB Corr., BFA, published in mimeographed typescript, *Fifty-sixth Anniversary Record Class of 1892 Medical, University of Pennsylvania*, 2–3, London Collection. See also *1902 Decimal Reunion of the 1892 Medical Class, University of Pennsylvania*, July 17, 1902 (Philadelphia: University of Pennsylvania, 1902), in which he states, "summer of '93 visited hospitals of London and Paris" (16). In 1894 and 1895 he worked in clinical medicine and experimental physiology in Berlin, where in 1895 he studied experimental therapeutics (pharmacology) and chemistry.

15  Letter, Barnes to Charles FitzGerald, December 11, 1915, ACB Corr., BFA. FitzGerald was an editorial writer for the *New York Evening Sun*. He also wrote art criticism and on subjects ranging from literature and music to medicine for the paper from 1900 to 1905. Barnes had great respect for his knowledge. Barnes met FitzGerald in 1913 (letter, Barnes to Alfred Maurer, January 27, 1913, ACB Corr., BFA). FitzGerald became Glackens's brother-in-law, married to Edith Dimock's sister, Irene.

16  Letter, Barnes to FitzGerald, December 6, 1915, ACB Corr., BFA. It should be noted that while Freud did not hold American culture in high esteem, he did admire John Dewey. "John Dewey is one of the few men in the world, for whom I have a high regard." Quoted from a conversation in 1926, by Max Eastman, "A Significant Memory of Freud," *New Republic*, May 19, 1941, 694. (Cited in Nathan G. Hale, *Freud and the Americans: The Beginnings of Psychoanalysis in the United States, 1876–1917* [New York: Oxford University Press, 1971], 389 and note 53.)

17  Letter, Barnes to FitzGerald, December 11, 1915, ACB Corr., BFA.

18  Letter, Barnes to Leo Stein, February 26, 1916, ACB Corr., BFA.

19  Barnes matriculated at Ruprecht Karl Universität in Heidelberg as an M.D. and during the summer of 1900 semester took courses in pharmacology under the aegis of Professor Rudolf Gottlieb as well as a philosophy course with Dr. Kuno Fischer.

20  Hermann Hille to William Schack, July 13, 1961, William Schack Papers, Archives of American Art, Smithsonian Institution, Washington, D.C. In November 1960, after his book *Art and Argyrol: The Life and Career of Dr. Albert C. Barnes* (New York and London: Thomas Yoseloff, 1960) was published, in which he had presumed that Hermann Hille was dead, Schack received information that Barnes's early partner was alive and living in Chicago (letter, Julius Frank to Schack, November 5, 1960, William Schack Papers, Archives of American Art, Smithsonian Institution). Schack contacted Hille and began corresponding with him in addition to holding long telephone conversations with him, the handwritten notes and typed transcriptions of which were used for a revised edition of the book published in 1963 by A. S. Barnes and Co., in which he stated: "The Revised Edition is based largely on Dr. Hermann Hille's information." The revisions did not incorporate all of the material provided by Hille, but did rather substantially changed the narrative concerning the invention of Argyrol. Based on Hille's statements and later remarks by Barnes that he had conceived the idea for the drug, Schack accepts that "[Barnes] would furnish the ideas and Hille would come up with the chemical answers" (43). The division of labor between the partners was that Hille synthesized and oversaw production while Barnes handled marketing and sales.

21  Albert C. Barnes, A.M., M.D., and Hermann Hille, Ph.D., "A New Substitute for Silver Nitrate" *Medical Record*, May 24, 1902, 814–15. In the article they describe the new compound as "Silver Vitellin," citing its high silver content and its remarkable solubility. Ongoing trials of the drug in Philadelphia at the Children's and Wills eye hospitals and at the

Royal Westminster Ophthalmic Hospital in London were also cited. Schack, in *Art and Argyrol* (rev. ed.), following his conversations and correspondence with Hille in 1960–62, stated: "Barnes suggested a silver compound for use as an antiseptic. It was hardly an original idea. As far back as 1884, K. S. F. Credé had discovered that a few drops of silver nitrate solution put into the eyes of new-born infants prevented blindness from gonorrheal infection. This immediately led to a search for a form of silver which would be as effective as silver nitrate therapeutically while lacking its caustic quality. . . . Barnes was acquainted with Protargol, a strong silver protein which was gaining considerable acceptance though it was somewhat of an irritant; and what he asked Hille to produce was a superior silver protein, totally without irritant qualities. Hille undertook to make one" (44). Scientists are again experimenting with silver compounds and discovering new therapeutic applications. "Silver, one of humankind's first weapons against bacteria, is receiving new respect for its antiseptic powers, thanks to the growing ability of researchers with its molecular structure. . . . Credé demonstrated that putting a few drops of silver nitrate into the eyes of babies born to women with venereal disease virtually eliminated the high rates of blindness among such infants. But silver's time-tested—if poorly understood—versatility as a disinfectant was overshadowed in the latter half of the 20th century by the rise of antibiotics. . . . It is not entirely clear . . . how silver kills many bacteria at the diluted concentrations considered safe for medical usage." Barnaby J. Feder, "Old Curative Gets New Life at Tiny Scale," *New York Times*, December 20, 2005, Section F, 5. Argyrol's penetrative nonirritant advance over Credé's silver nitrate compound and Protargol is not mentioned.

22  "The books had been kept in Barnes's home and were kept by Mrs. B. in order to save, as B. said, the expense of a bookkeeper. Mrs. B. was, however, paid for her work." Handwritten notes and typescript of a telephone conversation between William Schack and Hermann Hille, undated [1960], William Schack Papers. (See note 20.)

23  See, for example, a letter from Barnes to the firm of Barnes and Hille praising Nelle Mullen's "rare degree of aptitude, reliability and skill" and noting his decision to increase her salary to $35.00 per week. Letter, Barnes to the company, Barnes and Hille, October 26, 1907, ACB Corr., BFA.

24  See Court of Common Pleas no. 4, Philadelphia County, no. 5686 (March Term, 1907), *Albert C. Barnes vs. Hermann Hille*, Bill in Equity, Exhibit "A," 1–7, for the partnership agreement of April 13, 1903 (copy BFA). This contract replaced the original 1902 contract, no copy of which has been located.

25  See *Declarations and Statements: Trade-Marks Registered in the United States Patent Office from June 2–9–16–23 and 30th, 1908*, vol. 127, part 1, 69, 247–69, 499. U.S. Patent Office Report. Trademark registration no. 69,328 for Argyrol was issued to the A. C. Barnes Co. on June 9, 1908.

26  Albert C. Barnes, "Dr. Barnes of Merion Tells His Story," radio address broadcast on station WCAU, Philadelphia, April 9, 1942, transcript, BFA.

27  See University of Pennsylvania CCT transcripts for Mary and Nelle E. Mullen, 1914–15 and 1915–16, University of Pennsylvania Archives, College of General Studies Student Records, 1896–1940 (UPB 2C.45), Box 10. Mary matriculated for two years, 1914–15 and 1915–16, taking five terms of psychology and three terms of English. Nelle was enrolled in 1915–16, taking four terms of psychology. Barnes wrote to Prof. Flaccus, "The young ladies are taking five hours a week in psychology." Letter, October 14, 1915, ACB Corr., BFA.

28  Letter, Barnes to Dewey, March 4, 1927, ACB Corr., BFA.

29  Albert C. Barnes, "The Barnes Foundation," *New Republic*, March 14, 1923, 65–68. See also Laurence Buermeyer, "An Experiment in Education," *Nation*, April 15, 1925, 442, 444. In Hermann Hille's conversations with

William Schack there is no mention that Barnes's partner had any interest in or participated in these sessions. Barnes later stated that "we were having a lot of trouble keeping our help. . . . It brought up basic problems of education, which I had to tackle. . . . We gave them something to do. We organized the work. Ordinarily they spend ten hours in business. We gained the co-operation of these fellows. We all lived together as a family. We developed a personal interest in their affairs. We always had pictures in the building." Pennsylvania State Archives, Harrisburg; Record Group 33, Records of the Supreme Court of Pennsylvania; Eastern District; Appeal Papers (series #33.10), January Term 1933, No. 268, "Direct Examination" of Albert C. Barnes in *The Barnes Foundation, Appellee vs. Harry W. Keely et al.*, 145a.

30 Mary Mullen, "An Experiment in Adult Negro Education," *Opportunity: Journal of Negro Life* 4, no. 41 (May 1926): 160–61.

31 1922–1924 Inventory, BFA. The 1926 List of Paintings includes 143 Renoirs and 46 Cézannes as hanging in the Gallery. See "General Notes on Documentation," pages xix–xxi.

32 "I collected my own pictures when I didn't have any money and when I had money I collected better ones," Pennsylvania State Archives, Harrisburg; Record Group 33, Records of the Supreme Court of Pennsylvania; Eastern District; Appeal Papers (series #33.10), January Term 1933, No. 268, "Direct Examination" of Albert C. Barnes in *The Barnes Foundation, Appellee vs. Harry W. Keely et al.*, 144a.

33 Letter, Barnes to William Glackens, January 19, 1912, London Collection. Ira Glackens (*William Glackens*, 156) states that "Dr. Barnes' original collection of paintings was what one might expect. They were good, but they were not as good as they might have been, consisting of the then accepted painters: Corot, and others of the Barbizon School, etc. W. G. told Barnes that greater painters were more worthy of his attention." Virtually every biography since 1957 has repeated this story, which Ira must have heard in one form or another from his father and/or mother. But, since Ira never saw these pictures himself, he could not substantiate his claim. Financial records in the archives of the Barnes Foundation disclose only that on October 1, 1904, Barnes purchased (an unspecified number of unidentified) paintings from Chas. F. Haseltine, a prominent Philadelphia art dealer (1840–1915) for the amount of $600.00 (Albert C. Barnes check no. 584, BFFR, BFA), and that on the same date he paid McClees Galleries $305.00 (check no. 586), possibly for framing of the pictures purchased from Haseltine. Records in the Barnes Foundation Archives document that Barnes later purchased frames from McClees. See Ira Glackens, *William Glackens*, 160, who relates that the paintings his father purchased for Barnes in February 1912 had "beautiful antique French frames . . . but Dr. Barnes ordered these frames removed and bright new ones substituted. . . . Finally he gave orders to have the new frames taken off and the old ones put back." This part of the story is accurate, and the transactions in 1912 were with McClees. No other record (such as, for example, of deaccessioning by sale or trade) in the archives of the Barnes Foundation refers to or documents the paintings purchased by Barnes from Haseltine. In 1904, net profit of the Barnes and Hille firm was $44,394.74 (document in William Schack Papers, Archives of American Art), half of which was Barnes's. Therefore it is highly unlikely that Barnes collected many paintings at this time, before he and Mrs. Barnes built Lauraston on Latch's Lane in 1905. Dr. Barnes's initial purchases from Glackens and Lawson were made in January (see notes 35 and 36).

34 Letter, Glackens to Barnes, undated [January 1912], London Collection.

35 Letter, Barnes to Glackens, January 24, 1912, London Collection. Glackens's *Mahone Bay* (Sheldon Memorial Art Gallery, University of Nebraska, M. M. Hall Collection) was exchanged with the artist for *Beach at Dieppe* (BF562) in October 1912 (see pages 72–73). On January 30, Barnes purchased Ernest Lawson's *Painting Steam Drill* (later deaccessioned). Albert C. Barnes check no. 2175, $250.00, payable to Ernest Lawson, BFFR, BFA.

36 Letter, Barnes to Glackens, January 30, 1912, London Collection. Glackens sailed instead on February 3, on the French liner *Rochambeau*. Speculation as to the amount Barnes supplied to Glackens to make purchases for him has generally ranged from $20,000.00 to $25,000.00. On February 1, 1912, two days prior to Glackens's departure, Barnes made out a check in the amount of $20,000.00, which he endorsed to Drexel and Company (Albert C. Barnes check no. 2181, BFFR, BFA). Although there is no formal documentation, these funds were transferred to Drexel's partner, Morgan, Harjes & Co., Paris, for Glackens to draw upon in francs for his purchases. Check no. 2182 of the same date (BFFR, BFA) in the amount of $100.00, payable to Glackens, reimbursed the artist for "steamer fare." The exchange rate at this time was just over five French francs to the U.S. dollar. The Moore referred to is James B. Moore, a lawyer and president of the Federal Appraisal Company. The emphasis on Sisley likely stems from conversations with Ernest Lawson, who in 1893 had painted in Moret-sur-Loing and met Alfred Sisley.

37 Letter, Glackens to Barnes, February 3, 1912, London Collection (noted "rec'd Feb 5th, 1912").

38 The two notebooks are in the collection of the Museum of Art Fort Lauderdale, Nova Southeastern University, acc. 92.57, 8¼ × 5¼ in. (21 × 13.3 cm) (with a few summary sketches), and unnumbered, "Shopping" stamped with gold on cover, 3½ × 2⅝ in. (8.9 × 6.7 cm) (no sketches). Gift of Ira Glackens.

39 Ira Glackens, *William Glackens*, 157.

40 Ira Glackens, *William Glackens*, 158–59.

41 Letter, William Glackens to Edith Dimock, February 24, 1912, Ira Glackens Papers, Archives of American Art, Smithsonian Institution, Washington, D.C.

42 Letter, Glackens to Dimock, March 1, 1912, quoted in Ira Glackens, *William Glackens*, 159.

43 Letter, Glackens to Barnes, March 1, 1912, London Collection. Glackens would have seen the Futurist show at the Galerie Bernheim-Jeune, February 5–24. Barnes had authorized Glackens to spend an additional $3,000.00 for a Degas, hence the reference to not needing the money. Ira Glackens, in *William Glackens*, alludes to this without realizing that his father did not make the purchase at this time.

44 The thirty-three works purchased by Glackens comprised twenty-four oil paintings, one gouache (Suréda), one watercolor (Jongkind), one pastel (Dufresne), and six lithographs. Five of the twenty-four paintings are by Alfred Maurer (four landscapes and one still life). Of the total of thirty-three works, at least twelve were traded or given away, some almost immediately. These deaccessions include three Renoir lithographs, one of which cannot be accounted for. It has not been determined if any of the five Maurers that were among this group were sold, exchanged, or given away. At least sixteen of the thirty-three works Glackens purchased remain in the collection today, in addition to an indeterminate number of the five Maurers. Two of the six lithographs—Cézanne's *Bathers at Rest* (*Les Baigneurs*, BF490) and Renoir's *Children Playing Ball* (*Enfants jouant à la balle*, BF493)—are in storage, as are the Suréda and the Dufresne, leaving twelve works, including Cézanne's *Male Bathers* (*Les Baigneurs*, BF699) plus an unknown number of the five Maurers, on display in the gallery.

45 Handwritten receipt, Ambroise Vollard to Glackens, February 27, [1912], for six lithographs, London Collection. The lithographs included Cézanne's *Bathers at Rest* (*Les Baigneurs*, 100 francs) and *Male Bathers* (*Les Baigneurs*, 75 francs) and Renoir's *Children Playing Ball* (*Les Filles jouant à la balle*, 100 francs), all in the collection of the Barnes Foundation, and *The Hat Pin* (*Le Chapeau épinglé*, 100 francs; color) and *Child with a Biscuit* (*L'Enfant au biscuit*, 100 francs; color), both bequest of Laura L.

Barnes to the Brooklyn Museum (acc. nos. 67.29.1 and 67.29.2). The sixth lithograph (unidentified, *Fillette nue* [?]) has not been traced.

46 Handwritten paid invoice, Henry Barbazanges to William Glackens, February 23, [1912], London Collection. The invoice notes the following purchases: "Tableau de Renoir représentant deux petites filles 8500"; "Tableau de Pissaro [*sic*] représentant son jardin à Eragny 3000 fr."; and "Tableau de E. Boudin représentant les quais de la Seine à Bruxelles 1500 fr."

47 See note 46.

48 See note 46. Details of the trade can be found in letter, Barnes to Paul Durand-Ruel, May 29, 1916, ACB Corr., BFA.

49 Handwritten paid receipt, Durand-Ruel & Fils to W. J. Glackens, February 23, [1912], "20000 francs pour deux tableaux de Renoir: no. 7848 Renoir—Sortie du bain; no. 6701 Renoir—Vue de Montmartre," London Collection. Details of the trade can be found in letter, Barnes to Durand-Ruel, August 7, 1912, ACB Corr., BFA.

50 See note 49. Glackens recorded the asking price of 6,000 francs for *View from Montmartre* earlier in his notebook.

51 Paid receipt, Durand-Ruel & Fils to William Glackens, February 14, 1912, "[inv.] 8005 Renoir—Enfant lisent [*sic*] frcs 7000," London Collection. Glackens wrote on the verso, "Young girl reading."

52 Handwritten paid receipt, Durand-Ruel & Fils to W. J. Glackens, February 28, 1912, London Collection. The receipt records four purchases: "15,600 francs pour quatre tableaux: no. 5176 Berthe Morisot—Femme au chapeau de paille, 1887, 6300 frs; no. 8035 Loiseau—La neige, environs de Pontoise, 1905, 1300 frs; no. 9457 Jongkind—Clair de lune en Hollande, 1875, 6500 frcs; no. 7346 Jongkind—Le [*sic*] vielle maison, aquarelle. 1500 fr." See also Alain Clairet, Delphine Monthalant, and Yves Rouart, *Berthe Morisot 1841–1895, Catalogue Raisonné* (Paris: Cerarnrs, 1997), 191, cat. no. 158.

53 See note 52. See also letter, Barnes to Durand-Ruel, July 5, 1913, ACB Corr., BFA: "I have sent [to] your New York address . . . a landscape by Loiseau [for] which I desire you to credit me $260." Glackens indicated elsewhere in his notebook an asking price of 1,800 francs, although he paid only 1,300 francs.

54 See note 52. In his notebook, Glackens recorded the asking price for "Jongkind night effect" as 8,000 francs, although he paid only 6,500 francs. See also letter, Barnes to Durand-Ruel, April 3, 1915: "Jongkind bought of your Paris house in 1912 for $1300"; and "Durand-Ruel Account," appended to letter, Barnes to Durand-Ruel, December 29, 1915, "paintings returned Jonkind [*sic*] $1300," ACB Corr., BFA. This account also lists the Boudin Glackens purchased from Barbazanges for $300.00 (1,500 francs).

55 See note 52. See also letter, Barnes to Durand-Ruel, April 13, 1915, in which he mistakenly lists the work at 1,300 francs, and letter Barnes to Durand-Ruel, December 29, 1915, ACB Corr., BFA.

56 See paid receipt, Durand-Ruel & Fils to W. J. Glackens, February 27, 1912, "800 frcs pour un tableau de Sureda [*sic*] Femme mauresque no. 199 du catalogue de l'Exposition de la Société Moderne" (no Durand-Ruel inv. no.), London Collection.

57 Paid invoice, Galerie Druet to J. [*sic*] Glackens, New York, February 28, 1912, "[inv.] 358, 1 toile Maurice Denis 'Maternité' 1000 frcs," London Collection.

58 Paid invoice, Galerie Druet to G. [*sic*] Glackens, New York, February 19, 1912, "8000 frcs 1 toile Vincent Van Gogh de Postier (fond aux fleurs), [inv.] 5512," London Collection.

59 See handwritten list of seven paintings on Durand-Ruel & Sons stationery, which gives the Durand-Ruel inv. no. 8602, ACB Corr., BFA. In his notebook, Glackens recorded the Durand-Ruel asking price of 8,000 francs for *Sèvres Bridge*, although he paid 6,000 francs.

60 Letters, Barnes to Durand-Ruel, February 28, 1913; Durand-Ruel to Barnes, March 3 and 4, 1913; and Barnes to Durand-Ruel, April 3, 1915, ACB Corr., BFA.

61 Paid invoice, Jacobi Expert to Glackens, February 28, 1912, "1 peinture par Lebourg 1000 frcs; 1 peinture par Lebourg 400 frcs; 1 peinture par Renoir 300 frcs," London Collection.

62 See note 61. Glackens recorded the asking price in his notebook as 500 francs.

63 See note 61.

64 Handwritten receipt, Galerie Vollard to William Glackens, February 28, 1912, "Recu de Monsieur Glackens le somme de *mille francs* pour un tableau de Picasso qui lui a été fourmé: jeune femme tenant une cigarette," London Collection.

65 Paid invoice, Bernheim-Jeune & Cie. to W. J. Glackens, February 28, 1912: "Paul Cézanne, Montagne Victoire et le chemin Aix en Provence 13,200 frcs. [inv.] 17921; Pierre Bonnard, La Femme en noir 800 frcs.," London Collection. See also John Rewald, *The Paintings of Paul Cézanne: A Catalogue Raisonné*, 2 vols. (New York: Abrams, 1996), cat. no. 397. According to Rewald, the canvas, dating to the mid- or late 1870s, was exhibited at the Galerie Bernheim-Jeune in an exhibition in the fall of 1911 (cat. no. 4, ill.). It was reproduced as *La Montagne Victoire et le chemin* in *L'Art décoratif* 3, no. 156 (September 1911): 2 (not cited in Rewald), a copy of which was probably in Barnes's library (London Collection).

66 See note 65. See also Jean Dauberville and Henry Dauberville, *Bonnard, Catalogue Raisonné de l'oeuvre peint*, vol. 2 (1906–19) (Paris: Bernheim-Jeune, 1968), 178, cat. no. 578, *La Femme en noir*, as "sold to W. J. Glackens [*sic*]."

67 See handwritten invoice, Alfred H. Maurer to William Glackens, March 1, 1912, "Maurer: 1 'Still Life,' $60.00; 1 'Landscape,' $60.00; 1 'Small Landscape,' $30.00; 1 'Small Landscape,' $30.00; 1 'Small Landscape,' $30.00." Invoice written on telegram sheet from Morgan, Harjes & Co., 31 Boulevard Haussmann, London Collection.

68 Letter, Barnes to Glackens, April 3, 1912, London Collection. The date the paintings cleared customs in New York is not recorded. Glackens's expedition on behalf of Barnes was a subject of curiosity in New York art circles. On March 14, 1912, Martin Birnbaum, director of the Berlin Photographic Company, wrote John Quinn: "I am asking Mr. Glackens if it would be possible to exhibit Mr. Barnes' pictures in our galleries this Spring before they go to Philadelphia." Quinn replied the following day, "It would be interesting if Glackens could induce his principal to exhibit his things before they go to Philadelphia." Letter, Birnbaum to Quinn, March 14, 1912, John Quinn Memorial Papers: John Quinn Papers, Manuscripts and Archives Division, New York Public Library Astor, Lenox, and Tilden Foundation. It cannot be determined if Birnbaum and/or Quinn actually saw the pictures before they were shipped to Philadelphia, but this is unlikely. No such exhibition occurred.

69 Barnes would have seen a small, six-by-five-inch oil on wood panel by Morrice belonging to Glackens, in the Glackenses' home in New York. That work, *Untitled (Paris Café)*, now in the collection of the Museum of Art, Fort Lauderdale, Bequest of Ira Glackens (acc. no. 91.40.187), is illustrated in R. J. Wattenmaker, *Maurice Prendergast* (New York and Washington, D.C.: Harry N. Abrams in association with The National Museum of American Art, Smithsonian Institution, 1994), 24. Glackens had known Morrice since 1895 when, with Robert Henri, the three artists painted together in France. Glackens saw Morrice in 1906 when he visited Paris and admired his work. (See Ira Glackens, *William Glackens*, 15, 20, 56, and 71.) A letter dated February 14, 1942, from Alfred Henri Peiffer to Barnes, states: "If you will remember you obtained from me several small canvas [*sic*] by 'J.W. Morrice' about forty years ago," ACB Corr., BFA. The purchase is documented by a notation in Barnes's hand reconciling the checkbook balance in his Albert C. Barnes account,

early February 1912: "Outside check Alfred Henry [*sic*] Peiffer [$]425 (2 paintings)," Albert C. Barnes unnumbered check, February 2, 1912; and by a second check, no. 2185, February 5, 1912, in the amount of $135.00, payable to Alfred Henri Peiffer. Both checks BFFR, BFA. The total of $560.00 probably indicates other unspecified purchases, possibly as many as four other Morrices. Today, the Barnes Foundation owns two small oils on panel by Morrice: *Market* (BF776) and *Snow Scene* (BF2053). It is probable that both of these two panels and three or four other works by Morrice were among those purchased from Peiffer, for at least five works by the artist are listed on the 1922–1924 Inventory. (On the 1926 List of Paintings, no. 776, *Market*, and no. 777, *Snow Scene*, are the only two Morrices recorded.) Since 1926, "At Quebec" has been entitled *Snow Scene*, the composition for which is known from an oil on panel, *Winter Street with Horses and Sleighs*, Art Gallery of Ontario (acc. no. 55/21), and a pencil drawing, National Gallery of Canada, Sketchbook 7419, ill. Donald W. Buchanan, *James Wilson Morrice: A Biography* (Toronto: Ryerson Press, 1936), 40, plate IV (as *Street Scene, Montreal*). On the 1922–1924 Inventory, "Street Scene," inv. no. 424, is entitled *Market*, for which there is also a pencil drawing in National Gallery of Canada, Sketchbook 7419.

70 *Collection of the Victor G. Fischer Art Company*, exh. cat. (New York: Anderson Galleries, February 21, 1912), 179, 181, cat. no. 665, *Landscape—A Sketch* (BF1035), as 4¾ × 9½ in., now 4⅞ × 9⅝ in. (12.4 × 24.4 cm); Albert C. Barnes check no. 2200, February 26, 1912, $250.00, payable to "Anderson Auction Co.," BFFR, BFA. At an earlier session of the Fischer Sale, February 20, Barnes purchased a painting by J.C. Cazin, *Landscape*, 111, 113, cat. no. 350; check no. 2194, February 21, 1912, $310.00, payable to "Anderson Auction Co.," BFFR, BFA. A third check indicates that Barnes bought an additional painting at the February 21st session of the Fischer Sale, either Jean-François Raffaëlli's *On a French Roadway*, cat. no. 661, or Boudin's *The Port of Havre*, cat. no. 675; each sold for $275.00. Albert C. Barnes check no. 2195, February 21, 1912, $275.00, payable to "Anderson Auction Co.," BFFR, BFA. Neither of these paintings was illustrated in the catalogue, and, unlike the Corot sketch, the works are not identified in Barnes's checkbook. With the exception of the Corot, all of these paintings were subsequently sold or traded.

71 The three works were noted in "Chase's Collection of Paintings on Sale," *New York Sun*, March 8, 1912, in which Barnes is identified as the buyer. See *The Private Collection of William Merritt Chase*, auction cat. (New York: American Art Galleries, 1912). See also Albert C. Barnes check no. 2221, March 7, 1912, $1,560.00, payable to "American Art Association, Bill March 7, 1912," BFFR, BFA. None of the paintings bought at the Chase sale remain in the collection of the Barnes Foundation. The Forain and Boudin were traded to Durand-Ruel along with the Cazin from the Fischer Sale, a Delacroix purchased from the Galerie Bernheim-Jeune, and $15,000.00 for Renoir's *Reclining Nude* (*Femme nu couché*, BF97). Letters, Barnes to Durand-Ruel, April 3, 1915; May 29, 1916; and June 1, 1916, ACB Corr., BFA.

72 Glackens had seen the painting at the Barbazanges Gallery and written "Woman Embroidering" in his notebook 92.57, Museum of Art, Fort Lauderdale. See Henri Barbazanges to Barnes, March 20, 1912, Levesque & Co. correspondence, ACB Corr., BFA, and Albert C. Barnes check no. 2251, April 17, 1912, $2,320.19, payable to "Drexel Co. Paris draft for 12,000 francs to Henry [*sic*] Barbazanges for Monet painting," BFFR, BFA.

73 See Ira Glackens, *William Glackens*: "After the paintings were all selected and the twenty thousand dollars spent, W. discovered a fine Degas. He cabled Barnes this fact, and Dr. Barnes cabled back the money to buy it" (159). Although Ira was not able to identify the work, the story is accurate. Glackens noted several works by Degas in his

notebook 92.57, "Durand Ruel Degas . . . [D-R inv.] no. 6950 35000 [francs]. [D-R inv.] no. 6802 25000 [francs] dancer in Rose" (Museum of Art, Fort Lauderdale). Ultimately Glackens did not purchase a Degas; however, shortly after his return from France, works by the artist were the subject of extended correspondence between Barnes and Durand-Ruel. After convoluted negotiations with the dealer, Barnes did not purchase any of the Degas seen by Glackens in Paris. See letter from Barnes to Durand-Ruel, March 29, 1912 ("the pastel which Mr. Glackens saw in Paris, and which I am inclined to believe I should prefer to the one you have at your New York store"), and letters from Durand-Ruel to Barnes, April 3, 1912 ("the pastel by Degas which Mr. Glackens saw in Paris"), and April 13, 1912 ("the danseuses roses, pastel by Degas, which Mr. Glackens saw in Paris"). All letters ACB Corr., BFA. However, the Durand-Ruel Archives do not record Barnes's purchase of *Les Danseuses roses*. Barnes did purchase two works he had seen in Durand-Ruel's New York gallery: *La Danse grecque* (pastel) for $3,500.00 and *Foyer de la danse* (oil) for $15,000.00. Letter, Barnes to Durand-Ruel, March 29, 1912; letter, Durand-Ruel to Barnes, April 3, 1912; and invoice/account, Durand-Ruel, April 13, 1912, itemizing two works by Renoir, *Girl with Jump Rope* (*Fillette en robe bleu*, BF137) and *Before the Bath* (*Avant le Bain*, BF9), and two by Degas, "La danse grecque, 1892" and "Foyer de la danse, 1885." Letters and invoice ACB Corr., BFA. See du Bois, "A Modern American Collection," ill. 306, "La Danse Grecque, by Degas." Both Degas works were subsequently sold or traded.

74 Vincent van Gogh, *The Smoker* (*Le Fumeur*, BF119), F534 in J.-B. de la Faille, *The Works of Vincent van Gogh* (New York: Raynal in association with William Morrow, 1970), 229.

75 J. Dauberville and H. Dauberville, *Bonnard, Catalogue Raisonné* (Paris: Bernheim-Jeune, 1965), vol. 1 (1888–1905), 271, cat. no. 287, *La Soirée sous les lampes*, c. 1903; vol. 2 (1906–19), 139, cat. no. 527, *Jeune femme écrivant*, 1908; 160, cat. no. 555, *La Voiture à bras [Les Chiffonniers]*, 1902, purchased August 30, 1912.

76 Barnes's copy of the *Grafton Galleries Second Post-Impressionist Exhibition* (October 5–December 31, 1912) catalogue with notations, 28, cat. no. 46, with Barnes's notation of the price (£240), London Collection. The painting was entitled *Composition*. On this occasion, he also saw a number of Matisses such as *Conversation* (cat. no. 28) and *La Danse* (cat. no. 185), both lent by Sergei Shchukin and today in the State Hermitage Museum, Saint Petersburg.

77 R. E. D. [Robert E. Dell], "Art in France," *Burlington Magazine*, January 15, 1913, 239–42. For further details on bidding by Barnes, see also "Chronique des Ventes: Vente Henri Rouart," *Gazette de L'Hôtel Drouot*, December 10, 1912; *American Art News* X, no. 12 (December 28, 1912) 5, "When the 'Baigneuses' by Cézanne, for which 8000 frs. was asked, fetched in some seconds 18,000 frs., the applause was too spontaneous to have proceeded from other than profound surprise and admiration," naming Barnes as the purchaser; and Rewald 1:242, cat. no. 364.

78 See handwritten receipt from Gertrude Stein: "Painting by Matisse—Still Life Painting 3500 francs, frame 80 francs, Painting by Matisse—Landscape, 900 francs, frame 12 francs, (total) 4492 francs. Received payment." Yale Collection of American Literature, Beinecke Rare Book and Manuscript Library, Yale University (Estate of Gertrude Stein, through its Literary Executor, Stanford G. Gann, Jr., of Levin and Gann, P.A.).

79 See Bennard B. Perlman, *Robert Henri: His Life and Art* (New York: Dover, 1991), 107.

80 Lee Simonson, *Part of a Lifetime* (New York: Duell, Sloan and Pearce, 1943), 14–15.

81 Letter, Barnes to Leo Stein, March 30, 1913, Yale Collection of American Literature, Beinecke Rare Book and Manuscript Library, Yale University.

82 Letter, Barnes to Leo Stein, July 17, 1914, ACB Corr., BFA. It is likely that the paintings purchased at the Fischer and Chase sales in 1912 were among the works no longer valued by Barnes. See notes 70 and 71.

83 Albert C. Barnes, "How to Judge a Painting," *Arts and Decoration*, April 1915, 217–18, 249. He noted, "Matisse's art at his best, as one sees it in [Gertrude and Leo's brother] Michael Stein's house in Paris" (219). By this date, Leo and Gertrude had separated and divided their collection. In 1921, Barnes bought additional paintings by Matisse and Renoir, as well as Cézanne watercolors, from Leo.

84 Leo Stein, "Renoir and the Impressionists," *New Republic*, March 30, 1918, 259–60.

85 Letter, Barnes to Herbert Croly, February 5, 1919, ACB Corr., BFA.

86 See note 26.

87 Barnes, "The Barnes Foundation," *New Republic*: "One or more members of the group have been enrolled frequently in the post-graduate courses of nearby universities, notably Pennsylvania and Columbia. What is studied there is adapted to use in the private [that is, factory] seminars" (66). See note 26.

88 Barnes's matriculation card, BFA. See the College Catalogue 1915–16, BFA, which lists the course as From the Italian Renaissance to the Present Time.

89 Buermeyer was a Phi Beta Kappa graduate of the class of 1912 at the University of Pennsylvania who also attended the Graduate School from 1912 to 1916. He was absent on leave during 1915–16 (University of Pennsylvania Archives). He received his M.A. in 1917 and his Ph.D. in 1919, both from Princeton University. His dissertation was entitled "The Phenomenology of Thought."

90 Letter, Barnes to Laurence Buermeyer, July 27, 1915, ACB Corr., BFA. Barnes was well prepared to study with the younger man. Of his earlier studies Barnes wrote: "I went [to Heidelberg in 1900] to do work in physiological chemistry in accordance with the methods of science that I had picked up by myself and under the best instruction in the world. However, at that time Kuno Fischer, the most brilliant expositor I ever listened to, gave a course in philosophy, including that of [Gottfried Wilhelm] Leibniz, [Johann Gottlieb] Fichte, [Immanuel] Kant, [Georg Wilhelm Friedrich] Hegel, etc. The reason I attended the course was that epistemology purports to be the deepest intellectual penetration of the roots of thinking. . . . My idea in taking Fischer's course was to try to get the habit of that kind of thinking so that I would be able to handle my own problems in science more thoroughly." Letter, Barnes to Roderick M. Chisholm, February 18, 1946, ACB Corr., BFA.

91 Letter, Barnes to Dewey, July 19, 1920, ACB Corr., BFA.

92 Letter, Barnes to Dewey, October 12, 1921, ACB Corr., BFA.

93 Letter, Barnes to Buermeyer, June 23, 1917, ACB Corr., BFA.

94 Letter, Barnes to Buermeyer, September 17, 1917, ACB Corr., BFA.

95 Irwin Edman, *Philosopher's Holiday* (New York: Viking, 1938), 142. See letter, Barnes to Alfred Hand, June 30, 1947, ACB Corr., BFA: "I . . . attended for three years Professor John Dewey's Post-Graduate Seminar in Philosophy at Columbia University."

96 Letter, Barnes to Buermeyer, February 26, 1918, ACB Corr., BFA.

97 Letter, Dewey to Barnes, November 2, 1921, ACB Corr., BFA.

98 Anna Rothe, ed., "Albert C. Barnes," *Current Biography 1945* (New York: Wilson, 1946), 37–39.

99 See Sidney Hook, "Some Memories of John Dewey," and Joseph Waldman, "Letter on Dewey and Barnes," *Commentary*, November 1952, 245–53 and 403–04 (with rejoinder from Hook).

100 Letter, Barnes to Dewey, November 7, 1917, ACB Corr., BFA.

101 Letter, John Dewey to Alice Dewey, July 13, 1918, ACB Corr., BFA. The reference is to the project undertaken in 1918 to study conditions of the Polish American community in Philadelphia suggested to Dewey by Barnes and for which Barnes purchased a house in Philadelphia where several of the graduate students from the seminars attended by Barnes could live and conduct their research. See Harriet Furst Simon, "Note on 'Confidential Report among the Poles in the United States,'" *The Collected Works of John Dewey*, 11 (Carbondale: Southern Illinois University Press, 1982), 398–408.

102 Letter, Barnes to Horace Mann Bond, May 21, 1951, ACB Corr., BFA.

103 Letter, Barnes to Herbert Croly, October 23, 1918, ACB Corr., BFA.

104 Forbes Watson, "Institutional versus Individual Collectors," *Arts and Decoration*, February 1921, 274–75, 340.

105 Letter, Barnes to Dewey, October 16, 1922, ACB Corr., BFA.

106 Letter, Dewey to Barnes, October 19, 1922, ACB Corr., BFA.

107 Johnson, premier corporate attorney in the United States and a fellow graduate of Central High (1857), had represented Barnes in his action against his business partner, Hermann Hille. Johnson had been active as a collector since the 1880s and owned works by Corot, Courbet, Degas, Sisley, Pissarro, Monet, and Manet. Barnes mentions Johnson in several letters to Durand-Ruel at a time when he evidently had not yet had experience with picture dealers or galleries, since in his first letter to Durand-Ruel, March 29, 1912, he refers to "your New York store" and in another letter he terms his purchases "orders" (ACB Corr., BFA). It can be inferred that Johnson counseled Barnes on methods of negotiating with dealers, since he adhered to the same procedures, trading and returning pictures to dealers.

108 Letter, Barnes to Johnson, June 22, 1912, ACB Corr., BFA.

109 Letter, Barnes to Johnson, September 30, 1912, ACB Corr., BFA.

110 Letter, Barnes to Johnson, January 21, 1915, ACB Corr., BFA.

111 Letter, Owen J. Roberts to Barnes, December 6, 1922, ACB Corr., BFA.

112 Letter, Barnes to Roberts, December 9, 1922, ACB Corr., BFA.

113 Letter, Barnes to Raymond W. Rogers, April 5, 1917, ACB Corr., BFA. Rogers was one of two witnesses, with Hermann Hille, on the 1902 trademark documents for Argyrol whom Albert Barnes designated "Proprietor."

114 Letter, Barnes to Roberts, November 22, 1922, ACB Corr., BFA. Originally, Barnes thought to name the Foundation after his mother, Lydia A. Barnes, who died in 1912 (letter, Barnes to the Girard Trust Company, October 23, 1922, ACB Corr., BFA). After the sale of the company in 1929, twenty-eight individuals or their dependents received cumulative payouts ranging from $16.00 to $41,862.30. Total distribution as of the end of 1951 was $232,160.44. Several of the workers originally employed in the chemical plant went on to work at the Foundation but continued to receive monthly payouts from the company in addition to their salaries. See "Account of A. C. Barnes and N. E. Mullen, trustees of pension fund for former employees of A. C. Barnes Company, by N. E. Mullen, surviving trustee," n.d. [fall 1951], BFFR, BFA. See also "Board of Directors' resolution regarding pension," 1922, Barnes Foundation Legal Papers, BFA: "*Board of Directors Resolution* (1) Remove Pension Fund as an asset of the [A. C. Barnes] Company, interest to be paid to employees (other than myself) at discretion of President (myself) with approval of Board of Directors, as long as they shall live and to their widows as long as they shall live. At the death of the pensioners, fund is to revert to the Lydia A. Barnes Foundation." See also letter, Barnes to Dewey, October 21, 1919, ACB Corr., BFA: "I've tried to realize and achieve a concrete instance of industrial democracy. . . . As an earnest of my good intentions, I've placed nearly a quarter of a million in gilt-edged securities where they can reap the eternal benefit and tried to point out a worthwhile plan for their leisure and money."

115 See letter, Barnes to real estate developer John H. McClatchy, November 22, 1922, ACB Corr., BFA. Barnes and McClatchy published a promotional brochure, entitled "The Arboretum, Merion, Penna.," illustrating several existing residences in the neighborhood along with drawings of many of the future residences, with two of the proposed houses to cost $50,000.00 each. The brochure stated: "The properties reproduced here-

with range in value from $100,000 to $350,000. All of them are located on City Avenue or North Latch's Lane. . . ." Barnes, in the same letter, estimated the cost of the Foundation buildings at "more than four hundred twenty thousand dollars" and the current annual income of the Foundation at "about $420,000."

116 See Paul P. Cret, "The Buildings of the Barnes Foundation at Merion, Pa.," *Architecture* LIII, no. 1 (January 1926): 1–6 (ill.). "In its general aspect the exterior of the buildings follows the style of the Italian Renaissance. . . . [I]t is made of stone of two kinds, both . . . imported from France. . . . The trim stone is 'Pouillenay Brun,' of a warm rosy color and granulated texture—a stone with distinct crystalline formation; the ashlar is of 'Coutarnoux,' a limestone" (3–4).

117 Letter, Barnes to Dewey, December 6, 1924, ACB Corr., BFA.

118 Barnes, "The Barnes Foundation," *New Republic*, 63–68.

119 Guillaume kept Barnes apprised of the public reaction, especially the positive response from artists and collectors. For example: "Jacques Doucet came yesterday [January 22], and he stayed a long time. . . . He interrogated me about your personal ideas and came back today with his wife and was particularly intrigued by the place you are giving to African art." Letter, Guillaume to Barnes, January 23, 1923, ACB Corr., BFA.

120 For negative reaction to both shows, see Hamilton Easter Field, "Dr. Barnes Says Modern Artists Are Not Insane," *Brooklyn Daily Eagle*, New York. May 22, 1921, 22; Félix Fénéon, "Dans le ring," *Bulletin de la vie artistique* 2, no. 22 (November 15, 1921): 583–85; and "O Tempora! O Mores!; Without Comment," *Vistas* 3, no. 1 (1984–86): 41–63.

121 Albert C. Barnes, Introduction, in *Exhibition of Contemporary European Paintings and Sculpture*, exh. cat. (Philadelphia: Pennsylvania Academy of the Fine Arts, 1923), 3, 5, 7.

122 Letter, Barnes to Dewey, September 18, 1923, ACB Corr., BFA.

123 Letter, Dewey to Barnes, October 10, 1923, ACB Corr., BFA. Barnes replied on October 12, "Santayana is a regular at the Café Deux Magots where I go also every day I am in Paris. He told a mutual friend there that he hoped never to see America again and left the impression that its institutions were pretty poor. So I never took the trouble to follow up my intention to talk to him about the Foundation."

124 Albert C. Barnes, "The Barnes Foundation," typescript, May 2, 1923, sent to Thomas Craven, ACB Corr., BFA.

125 Letter, Barnes to Josiah H. Penniman, January 27, 1924, ACB Corr., BFA.

126 Letter, Penniman to Barnes, March 18, 1924, ACB Corr., BFA.

127 Letter, Barnes to Penniman, March 20, 1924, ACB Corr., BFA. Despite the "minor consideration" to which Barnes alludes, there was no mention of any previous arrangements in Barnes's will, mentioned in Barnes's letter of June 22, 1912, to John G. Johnson, ACB Corr., BFA.

128 Munro had studied with Dewey from 1915 onward through his B.A. and M.A., received his doctorate in 1920 under Dewey, and taught in the Department of Philosophy at Columbia beginning in 1918. It was Dewey who recommended him to Barnes, and he was appointed Associate Director of Education at the Barnes Foundation in 1924 and worked there through 1927. He and Buermeyer both served as Associate Directors of Education (Dewey was Director of Education for the year 1925–26). Munro acted as an interlocutor between Barnes and Dewey while he was teaching classes of students from the University of Pennsylvania and Columbia. "I ushered them around the Foundation and lectured to them. Barnes and others of the staff talked to my class . . . the main work was done with students of the University of Pennsylvania. . . . The Columbia group met weekly at the Metropolitan Museum . . . and occasionally went over to Philadelphia. The arrangement in Philadelphia was that there should be a professorship of modern art at the University of Pennsylvania, and was affiliated especially with the philosophy department under Professor Singer. He and Professor Flaccus

were much interested in the history of thought including aesthetics. I worked with those men at Pennsylvania and we set up a regular course on aesthetics, in which the students came to the Barnes Foundation gallery for most of their classes and lectures. They received credit toward a degree at the University of Pennsylvania." Munro attests firsthand to the mutual respect between the two men and that they were able to disagree without affecting their friendly relations. "He [Dewey] was one of the few people who could have argued with Barnes without having a conflict." Munro oral history, 1967, 7–9.

129 Thomas Munro, "Results of the Barnes Foundation Course for Teachers," three-page typescript, BFA.

130 Thomas Munro, "Frank Cizek and the Free Expression Method," *Journal of the Barnes Foundation* 1, no. 3 (October 1925): 36–40.

131 Barnes's critiques include "Art Teaching that Obstructs Education," *Journal of the Barnes Foundation* 1, no. 2 (May 1925): 44–47; "Art Teaching that Obstructs Education," *Journal of the Barnes Foundation* 1, no. 3 (October 1925): 41–48; and "Educational Disorder at the Metropolitan Museum of Art," *Journal of the Barnes Foundation* 2, no. 1 (January 1926): 45–48.

132 John Dewey, Dedication Address, the Barnes Foundation, March 19, 1925; text published in *Journal of the Barnes Foundation* 1, no. 2 (May 1925): 3–6.

133 Albert C. Barnes, "The Shame in the Public Schools of Philadelphia," and Thomas Munro, "A Constructive Program for Art," *Journal of the Barnes Foundation* 1, no. 1 (April 1925): 13–17 and 26–38, respectively.

134 Letter, Dewey to Barnes, April 15, 1926, ACB Corr., BFA.

135 Letter, Dewey to Barnes, April 16, 1926, ACB Corr., BFA.

136 Letter, Barnes to Dewey, March 4, 1926, ACB Corr., BFA.

137 Letter, Dewey to Barnes, March 12, 1926, ACB Corr., BFA.

138 Letter, Barnes to Penniman, May 21, 1926, ACB Corr., BFA.

139 Albert C. Barnes, "The Barnes Foundation and the University of Pennsylvania," typescript, dated November 27, 1926, Section 5: "The final attempt, its failure, and the suspension of the arrangement," BFA.

140 Letter, Barnes to Thomas Craven, May 21, 1923, ACB Corr., BFA.

141 William James to Henry Rutgers Marshall, a colleague in the Department of Philosophy at Harvard, January 1899, in *The Correspondence of William James*, vol. 8, 1895–June 1899, ed. Ignas K. Skrupskelis and Elizabeth M. Berkeley (Charlottesville and London: University Press of Virginia, 2000), 475–76. First published in *The Letters of William James*, ed. Henry James [son] (Boston: Atlantic Monthly Press, 1920), 2:86–87 (as February 7, 1899?), which book Barnes had read. See Letter, Barnes to Dewey, October 12, 1920, ACB Corr., BFA.

142 George Santayana, *The Letters of George Santayana, Book Four, 1928–1932: The Works of George Santayana*, vol. 5, ed. William G. Holzberger and Herman J. Saatkamp, Jr. (Cambridge, Mass.: MIT Press, 2003), 4:85, December 13, 1928. First published in George Santayana, *The Letters of George Santayana*, ed. Daniel Cory (London: Constable, 1955), 238–39. *Caput mortuum*, "death's head," refers to the useless residue that remains after an alchemical operation such as distillation or sublimation; and by extension, decline or entropy. Munro and Barnes were not the only scholars to formulate a method on the basis of James's and Dewey's ideas. For example, the Czech writer Karel Čapek (1890–1939) studied philosophy and aesthetics at Charles University, Prague (1909–15). In 1910–11, he visited Paris and Berlin. In Paris he looked at avant-garde art, Cubism, and Futurism, and in 1911 founded a Society of Painters and Artists, which published a magazine, *Art Monthly*. His philosophy was influenced by Pragmatism, and in 1915 he wrote his doctoral dissertation, *The Objective Method in Aesthetics in Relation to the Fine Arts* (not published until 1980). See Jiri Holy, "Karel Čapek," Slavonic Civilization Module 1, http://www.arts.gla.ac.uk/Slavonic/Capek.html (accessed before July 2005); and Leo Carey, "His Own Limitation," *Times*

*Literary Supplement*, August 29, 2003, 3–4: "The greatest philosophical influence on Čapek at this time was American Pragmatism, to which he was introduced by the philosopher (and future President of Czechoslovakia) Eduard Beneš. In 1918, Čapek published a paper entitled, 'Pragmatism, or a philosophy for a practical life.'"

143   Both quotations from Albert C. Barnes, *The Art in Painting*, 1st ed. (Merion, Pa.: Barnes Foundation Press, 1925), xi. Unless otherwise noted, subsequent references to *The Art in Painting* are to this edition. On November 14, 1923, Barnes sent a copy of Mary Mullen's *An Approach to Art* to Scofield Thayer and wrote: "[The book] is the preliminary to a fuller presentation of the subject which Buermeyer and I have been working upon for nearly ten years and which will be in book form within the next few months. That this second book will become a standard in modern universities everywhere is something more than a reasonable hope." Letter, Barnes to Thayer, November 14, 1923, ACB Corr., BFA.

144   Barnes, *The Art in Painting*, xi.

145   Barnes, *The Art in Painting*, 3rd ed. (1937), 19. Barnes frequently wrote about the way in which Modern artists transformed earlier traditions. "Old traditions constantly emerge in even the most recent painting, as, for example, Tintoretto in Soutine, the Persian miniatures in Matisse. One can judge of the individuality and importance of a painter only by referring to the sources of his effects, and by observing how these effects are combined with those from other sources. If the artist is a real creator these effects pass through the crucible of his own personality and emerge as new forms" (111). See also Albert C. Barnes and Violette de Mazia, *The Art of Renoir* (New York: Minton, Balch, 1935), 6: "The traditions of art constitute the working capital of every artist; they are the records of what painters have in the past discovered and revealed as significant; and the ultimate test of any painter's importance is his ability to add contributions of his own, by means of which his successors may carry further the work of discovery." Thomas Munro stressed the accord between Dewey and Barnes on this important issue. "[Barnes] never hesitated to make an evaluation, partly on the basis of whether the work of art is an organic whole, whether the artist has succeeded in unifying and harmonizing his plastic means of line, color, and so on. Partly his evaluations were based on originality, the extent to which an artist has been imitative, merely copied, or has added something new. Barnes and Dewey agreed that all art springs from previous art. Emerson said that too. Nobody is completely original and artists who claim to be purely original are mistaken. No artist should be ashamed to recognize and to admit that he has stood on the shoulders of the past. Both Dewey and Barnes agreed on that." Munro oral history, 1967, 17–18.

146   John Dewey, *How We Think: A Restatement of the Relation of Reflective Thinking to the Educative Process*, 2nd ed. (1st ed., 1910) (Lexington, Mass.: D. C. Heath and Company, 1933), 40 (emphasis added).

147   Barnes, "How to Judge a Painting," 218–19. Writing to Leo Stein thirty years later, Barnes said, "From the first two [Matisses] I bought from Gertrude in 1912 down to the last one I purchased about four years ago [*Figure with Bouquet* (BF980)], I can always find something that is his own, is not a repetition, and is in line with traditions." Letter, Barnes to Leo Stein, April 16, 1946, ACB Corr., BFA.

148   Albert C. Barnes, "Method in Aesthetics," in *The Philosopher of the Common Man: Essays in Honor of John Dewey*, ed. Sidney Ratner (New York: Putnam, 1940), 93.

149   Letter, Barnes to Dewey, March 14, 1925, ACB Corr., BFA.

150   Munro oral history, 1967, 8–12.

151   Letter, Ann Eshner [Jaffe] to William Schack, undated [c. 1955], William Schack Papers, Archives of American Art, Smithsonian Institution. Eshner was a student at the Barnes Foundation from 1933 to 1936. She

wrote a detailed description of the Travel Fellowship she received from Dr. Barnes in 1934. "There'd been twelve of us on that trip (4 girls). While I don't know specifics,—the Foundation did continue to send groups & individuals abroad. . . . All of our transportation tickets were supplied (ships, trains, etc.) & we each received $100 a month for 4 months for just daily expenses. That brought it to well more than $1000 spent for each of us. . . . Back in '34, $100 a month for room & board in Europe was *quite* a different sum than now. . . . For the first time in my young & miserable life, I had PLENTY of everything . . . & no worries of where it was coming from. They were all of them having themselves a Ball buying up European paints & materials. . . . We saw Dr. Barnes on that trip. He took the whole group to a bull-fight in Madrid."

152   Letter, Dewey to Barnes, January 27, 1925, ACB Corr., BFA.

153   Leo Stein, "The Art in Painting," review of *The Art in Painting* by Albert C. Barnes, *New Republic*, Winter Literary Section, December 2, 1925, 56–57.

154   Letter, Barnes to Dewey, November 27, 1925, ACB Corr., BFA.

155   John Dewey, "Art in Education—and Education in Art," *New Republic*, February 24, 1926, 11–13.

156   Alfred H. Barr, Jr., "Plastic Values," review of *The Art in Painting* by Albert C. Barnes, *Saturday Review of Literature*, July 24, 1926, 948. Other reviews appeared in *New York Herald Tribune* (January 31, 1926, 14), *Nation* (March 10, 1926, 259), *New York Times Book Review* (June 20, 1926, 16), *Bookman* (September 1926, 97), and *Times Literary Supplement* (June 30, 1927, 450). These reviewers probably read the edition published by Harcourt, Brace and Company in 1926.

157   Ezra Pound, "Where Is American Culture?" *Nation*, Spring Book Number, April 18, 1928, 443–44. Pound was likely referring to the second, revised edition of *The Art in Painting* (New York: Harcourt, Brace, 1928). Barnes was not sympathetic to Pound, who had written him several letters. In a letter of November 9, 1926, Barnes wrote to Paul Guillaume, "Be careful to ignore Ezra Pound. . . . He . . . is the most egotistic, conceited ass that ever lived. Recently, Munro and I received letters from him making overtures for advising us in art matters. I wrote him a letter that will make him angry. . . . I think his overtures may really mean chantage [blackmail]." Letter, Barnes to Guillaume, November 9, 1926, ACB Corr., BFA.

158   Letter, Barnes to Dewey, May 13, 1927, ACB Corr., BFA. Violette de Mazia was appointed to the Board of Trustees of the Barnes Foundation in 1935 and in 1950 became Director of Education, which position she held until her death in 1988.

159   Letter, Barnes to David Riesman, October 4, 1930, ACB Corr., BFA. David Riesman, M.D., Sc.D., professor of the history of medicine and professor emeritus of clinical medicine, University of Pennsylvania, was a classmate of Barnes's at the University of Pennsylvania Medical School, class of 1892, and for many years his personal physician. They were lifelong friends and Barnes sent, among others, William Glackens, Charles Demuth, and Henri Matisse to consult him. Barnes gave Riesman paintings by Soutine, Glackens, and Moïse Kisling. Riesman was the author of *The Story of Medicine in the Middle Ages* (New York: Hoeber, 1935).

160   Letter, Barnes to Dewey, March 5, 1929, ACB Corr., BFA.

161   Letter, Barnes to Valentine Dudensing, March 28, 1938, ACB Corr., BFA.

162   Alfred H. Barr, Jr., *Matisse: His Art and His Public* (New York: Museum of Modern Art, 1951), 22. Barnes inscribed a copy "To Butts and Edith Glackens, with apologies for presuming to offer to artists a dissertation on Art. A.C.B. 15 Feb. 1933."

163   See typescript, "Excerpts from letters written to John Dewey, Oct. 16th and 19th, 1930, and March 3, 1931," in 1931 Barnes/Dewey correspondence, ACB Corr., BFA.

164   Letter, Dewey to Barnes, August 13, [1930], ACB Corr., BFA. In 1925, Dewey had published "Experience, Nature and Art," an abstract from

*Experience and Nature*, in the *Journal of The Barnes Foundation* 1, no. 3 (October 1925): 4–10.

165 Pennsylvania State Archives, Harrisburg; Record Group 33, Records of the Supreme Court of Pennsylvania; Eastern District; Appeal Papers (series #33.10), January Term 1933, No. 268, Testimony of John Dewey in *The Barnes Foundation, Appellee vs. Harry W. Keely et al.*, 136a. "Paint" is likely an inaccurate transcription of Dewey's remarks, but the meaning is clear.

166 Dewey wrote poetry, only a portion of which is preserved. In his poem "Sorolla," the first stanza reads: "And this is art! / Something / To make us jump and start; / To bring / New thrills to jaded nerves / And break the mind's reserves / Is art." See Jo Ann Boydston, *The Poems of John Dewey* (Carbondale: Southern Illinois University Press, 1977), 63, no. 84. Joaquin Sorolla y Bastida (1863–1923) was a celebrated contemporary Spanish painter whose vivid colorful work was painted in a brisk Manetesque style corresponding to John Singer Sargent's and Anders Zorn's. Three hundred fifty-six paintings were shown February 8–March 8, 1909, in a large exhibition at the Hispanic Society of America, where 160,000 visitors saw the show. Dewey's poem was, therefore, probably written in 1909. This poem documents that well before he met Barnes, Dewey—at least occasionally—looked at pictures on his own and that he was interested enough and prepared to be receptive to the analytical approach that Barnes demonstrated to him.

167 Jay Martin, *The Education of John Dewey: A Biography* (New York and Chichester: Columbia University Press, 2002), 399–400 and 532. Martin also points out that Dewey's first book, *Psychology* (New York: Harper & Bros., 1887), contained a chapter on "aesthetic feeling" and that Dewey reviewed Bernard Bosanquet's *A History of Aesthetic* (1892) in 1893 ("Review of Bernard Bosanquet's *A History of Aesthetic*," *Philosophical Review*, II [January 1893], 63–69). Steven C. Rockefeller, *John Dewey: Religious Faith and Democratic Humanism* (New York: Columbia University Press, 1991), 494, rightly draws attention to "the strong influence of Santayana. . . . [I]t is necessary to consider his [Dewey's] theory of mystical intuition, which deepens his natural piety, taking it beyond anything that one might find in Santayana." Dewey's *A Common Faith* was published the same year (1934) as *Art as Experience*. In it Dewey acknowledges his intellectual debt to Santayana, especially in chapter 1, "Religion versus the Religious." Throughout *Art as Experience* Dewey cites Santayana approvingly, for example, "Every living experience owes its richness to what Santayana well calls 'hushed reverberations'" (18). Barnes, whose aesthetic was steeped in Santayana's ideas, thought that, in general, philosophers had "too little natural reaction to experience." Letter, Barnes to Dewey, September 14, 1923, ACB Corr., BFA. See also Barnes's letter regarding Santayana to Thomas Craven, May 21, 1923, herein quoted on page 35.

168 Martin, *The Education of John Dewey*, 401–03. He continues: "Dewey was not going to be a Barnes epigone but went his own way in accordance with his long-standing convictions. Barnes started with an actual painting and moved to principles of art. Dewey started with experience and moved to aesthetic principles and then to a particular instance. For Barnes 'art' didn't exist until it was realized in an art object. For Dewey, art resided in experience before any concrete expression of it was created. . . . Dewey's view was simpler: experience is itself aesthetic, and art is the consummation of ordinary experience found everywhere. . . . Dewey and Barnes agreed that art did not tell a story, reflect an author's autobiography, or have a moral, any more than experience does. Experience means in its activity, and so does art" (403–04). See also Munro oral history, 1967, 17–18.

169 John Dewey, Preface, in *Art as Experience* (New York: Minton, Balch, 1934), vii–viii. See also *Dialogue on John Dewey*, ed. Corliss Lamont (New York: Horizon Press, 1959), 44–49, in which Herbert W. Schneider (1892–1984) states: "I think that as far as painting goes Barnes's influence was very great" (49). Schneider took his Ph.D. under Dewey at Columbia in 1917 and taught philosophy and religion there from 1918 to 1955. He therefore knew Dewey throughout the entire period in question.

170 Martin Duberman, *Black Mountain: An Exploration in Community* (New York: W. W. Norton, 1993), 94, 469, note 56.

171 John Andrew Rice, *I Came Out of the Eighteenth Century* (New York and London: Harper & Brothers, 1942), 332. During Prohibition, Barnes had made no concessions to the "Noble Experiment"; his wine cellar and supply of pre–World War I Scotch whiskey had been well stocked before the puritanical pall of the Eighteenth Amendment descended.

172 Albert C. Barnes and Violette de Mazia, *The Art of Renoir* (New York: Minton, Balch, 1935), dedicated "to Nelle E. Mullen in gratitude for services of unique value in the creation of the Barnes Foundation and in carrying out its work," London Collection.

173 Albert C. Barnes, "Renoir: An Appreciation," *Dial*, February 1920, 165–67; Albert C. Barnes, "Renoir" and Appendix, "Renoir: The Development of Renoir's Technique" in *The Art in Painting*, 265–71 and 469–84, respectively. On December 8, 1919, Barnes had written to Croly, "The death of Renoir last Wednesday has produced a reaction which is unique in my experience. For many years he has been my God—no religion or no poetry could have so combined value and existence for me. All the free-floating emotion or some damnable complexes—never materially diminished but a rather active objective life—fused into a peaceful adjustment when I got home and literally communed with him. I've written no end of experiential notes on my reactions and, if I can get out of them enough sound universals and put them in a simple language, I'll submit a short appreciation to the N.R. [*New Republic*] in a few days." Letter, Barnes to Croly, December 8, 1919, ACB Corr., BFA.

174 Letter, Dewey to Barnes, December 8, 1934, ACB Corr., BFA.

175 Letter, Barnes to Dewey, December 10, 1934, ACB Corr., BFA.

176 James Johnson Sweeney, "Analytical Study of the Work of Renoir," *New York Herald Tribune*, June 9, 1935, Section 7, 5.

177 This process was well under way no later than 1936, for the frontispiece of the third edition of *The Art in Painting* (New York: Harcourt, Brace, 1937) depicts the north wall of the Main Gallery with ironwork as it was installed at that time.

178 Letter, Barnes to Clarence Bulliet, January 15, 1937, Clarence Bulliet Papers, Archives of American Art, Smithsonian Institution, Washington, D.C. See also Curt J. Ducasse, *Art, the Critics, and You: A Declaration of Independence of Taste in Matters of Art* (New York: Oskar Piest, 1944), 60–63.

179 John Dewey, "The Educational Function of a Museum of Decorative Arts," *Chronicle of the Museum for the Arts of Decoration of Cooper Union* 1, no. 3 (April 1937): 93–99. See also *Guide to the Works of John Dewey*, ed. Jo Ann Boydston (Carbondale and Edwardsville: Southern Illinois University Press, 1970), 179–80. For the influence of John Ruskin and William Morris on Dewey, Boydston writes, quoting Dewey's 1893 review of Bosanquet's *A History of Aesthetic*: "[Dewey] acknowledges 'Ruskin and Morris's insistence upon the place of the individual workman in all art, the necessity that art be a genuine expression of joy of the worker in his work, and the consequent attention to the minor arts, so-called.'" See also note 154. In his published writings, Barnes never mentions Ruskin or Morris.

180 Albert C. Barnes and Violette de Mazia, *The Art of Cézanne* (New York: Harcourt, Brace, 1939). Timed to coincide with the centenary of the artist's birth, the book had been preceded by Barnes's article "Cézanne: A Unique Figure among the Painters of His Time" (*Arts & Decoration*, November 1920) and a longer essay in *The Art in Painting* (1925), 275–80 and 484–98.

181 Letter, Barnes to Dimock, June 3, 1938, Ira Glackens Papers, Archives of American Art, Smithsonian Institution, Washington, D.C.

182 Sidney Ratner, ed., *The Philosopher of the Common Man: Essays in Honor of John Dewey to Celebrate His Eightieth Birthday* (New York: Putnam, 1940), 87–105.

183 Albert C. Barnes, "The History of American Education," review of *Progress to Freedom: The Story of American Education* by Agnes Benedict (New York: Putnam, 1942), *New York Times Book Review*, November 22, 1942, 42.

184 See Albert C. Barnes, "What Ker-Feal Represents," *House and Garden*, December 1942, 45–55, 92–93. See also Kristin Henry, "Progress Report: Ker-Feal and the Pennsylvania Historical and Museum Commission Historic Resource Survey," n.d. [2002].

185 See Virginia T. Clayton, *Drawing on America's Past: Folk Art, Modernism, and the Index of American Design*, exh. cat. (Washington, D.C.: National Gallery of Art; Chapel Hill and London: University of North Carolina Press, 2002). Objects in the Foundation's collection both in color and in black and white appear in Ruth Adams, *Pennsylvania Dutch Art* (Cleveland and New York: World, 1950); Erwin O. Christensen, *The Index of American Design* (New York: Publications Fund, National Gallery of Art, in association with Macmillan, 1950); Henry J. Kauffman, *Early American Copper, Tin and Brass* (New York: Medill McBride, 1950); Frances Lichten, *Folk Art of Rural Pennsylvania* (New York: Scribner's, 1946); Metropolitan Museum of Art, *Emblems of Unity and Freedom, The Index of American Design* (New York: Metropolitan Museum of Art, n.d. [c. 1942]); John Joseph Stoudt, *Pennsylvania German Folk Art: An Interpretation* (Allentown, Pa.: Schlecter's, 1948). See also letters from Barnes to Kauffman, November 3 and 8, 1949, inviting Kauffman to Ker-Feal, ACB Corr., BFA.

186 Letter, Bertrand Russell to Dewey, May 30, 1940, forwarded by Dewey to Barnes, ACB Corr., BFA. A factual synopsis of Dewey's and Barnes's role in the effort to defend Russell is found in Jay Martin, *The Education of John Dewey*, 442–49.

187 Letter, Barnes to Dewey, June 3, 1940, ACB Corr., BFA.

188 John Dewey and Horace M. Kallen, eds., *The Bertrand Russell Case* (New York: Viking, 1941).

189 Bertrand Russell, *The Autobiography of Bertrand Russell, 1914–1944*, vol. 2 (Boston: Little, Brown and Company, 1968), 335.

190 Russell, *The Autobiography of Bertrand Russell*, 381.

191 See Albert C. Barnes, *The Case of Bertrand Russell versus Democracy and Education* (Merion, Pa.: n.d. [1943], copy BFA), a twelve-page account of the events beginning with Barnes's involvement with the Committee for Cultural Freedom and his defense of Russell's constitutional right to a fair trial after his appointment as professor of philosophy at the College of the City of New York (CCNY) was voided by a Justice of the Supreme Court of New York, 3–4, 7. See Martin, *The Education of John Dewey*, 442–49. See also United States Circuit Court of Appeals, No. 8586 (October Term, 1943), *Bertrand Russell v. The Barnes Foundation*, Appendix for Appellant (copy BFA), for the respective testimonies of Barnes and Russell.

192 Russell's *History of Western Philosophy* (London: George Allen and Unwin, 1946) includes an acknowledgment of the lectures at the Barnes Foundation. "This book owes its existence to Dr. Albert C. Barnes, having been originally designed and partly delivered as lectures at the Barnes Foundation in Pennsylvania."

193 Letter, Barnes to Dewey, July 7, 1944, ACB Corr., BFA. Information published since Russell's death in 1970 has shed some new light on the interrelations of the Russell family during the period they lived in California and Pennsylvania. In *My Father Bertrand Russell* (New York and London: Harcourt Brace Jovanovich, 1975), Katharine Tait describes the fissures in her father and stepmother's relations prior to their moving to Pennsylvania. Before they moved east, her father told her: "Peter

(Patricia Spence Russell) has decided to leave us" (144). She describes Peter's highly neurotic behavior after Russell began teaching at the Barnes Foundation: "she was truly pathetic. . . . Like Hitler, she expanded her demands as long as she met no opposition—and, like Chamberlain, he continued to appease her" (157–58). Ray Monk, in *Bertrand Russell: The Ghost of Madness 1921–1970* (London: Cape, 2000), describes one of Lady Russell's periodic suicide attempts during this time (263). Barnes, the psychologist, had doubtless observed her mental problems from the beginning and, though he was not a man to suffer in silence, and because he wanted the class to be a success, restrained himself for nearly two years.

194 Carl W. McCardle, "The Terrible-Tempered Dr. Barnes," *Saturday Evening Post*, March 14, 1942, 6, with photograph of Barnes. The series appeared in the following four issues: March 21, 1942, 9–11, 93–94, 96; March 28, 1942, 20–21, 78, 80–81; April 4, 1942, 18–19, 34–36, 38; April 11, 1942, 20–21, 64, 66, 68.

195 See the April 4 installment in the *Post* series, in which Barnes expatiates on Mrs. Russell's behavior (35–36).

196 Albert C. Barnes, *How It Happened* (Merion, Pa.: n.p., n.d. [1942]), 5.

197 Barnes, *How It Happened*, 7.

198 Letter, Barnes to McCarter, September 17, 1942, ACB Corr., BFA. The Pinto brothers were established in New York as professional photographers. See page 47.

199 Letter, Barnes to McCarter, October 22, 1942, ACB Corr., BFA.

200 In his will, dated October 6, 1944, Barnes specifically placed Ker-Feal under the aegis of the Foundation: "Recently, I undertook at 'Ker-Feal,' a farm in Chester County, Pennsylvania, to create a living museum of art and to develop a botanical garden, both to be used as part of the educational purposes of The Barnes Foundation in my lifetime." He bequeathed real estate consisting of no. 57 Lapsley Road and the adjoining lot to the Foundation. The remainder of the estate was left to Mrs. Barnes, who was appointed executrix, with the Girard Trust Company to succeed her upon her death. Last Will and Testament, Albert C. Barnes, October 6, 1944, Will Book 120, p. 219, Register of Wills, Montgomery County, Pa.

201 In 1931 Barnes arranged to give DeHaven Hinkson a fellowship of $150.00 per month to study abroad the following year with a leading French professor of surgery, Dr. Gosset, in Paris. Letters, Barnes to Hinkson, November 5, 1931, and Hinkson to Barnes, August 18, September 21, and November 2, 1931, ACB Corr., BFA. In the depths of the Depression, Barnes paid for not only Hinkson but also Hinkson's wife and children to accompany him.

202 See Letters, Hinkson to Horace Mann Bond, November 1, [1946], and Bond to Hinkson, March 9, 1968, in which he gives credit to Hinkson for generating the relationship with Lincoln; both letters in Special Collections and Archives, W. E. B. Du Bois Library, Horace Mann Bond Papers (1926–1972), University of Massachusetts, Amherst.

203 Letter, Barnes to Horace Mann Bond, January 13, 1947, ACB Corr., BFA.

204 Letter, Barnes to Bond, October 12, 1950, ACB Corr., BFA. The teachers were graduates of Haverford College who had studied at the Foundation, William D. Wixom, now curator emeritus of the Department of Medieval Art and the Cloisters, Metropolitan Museum of Art, and Paul Moses (1929–1966), an African American art historian who in 1962 joined the faculty of the University of Chicago and was appointed assistant professor of humanities in the Department of Art in 1964. He received his M.A. from Harvard in 1960. A specialist in 19th century French art, he was writing a book on Degas at the time of his death.

205 Letter, Barnes to Horace Stern, April 17, 1947, ACB Corr., BFA.

206 Letter, Barnes to Horace Stern, August 7, 1947, ACB Corr., BFA.

207 Barnes did not ignore or fail to engage with the field of art history. See, for example, "On the Education of Artists in Colleges," *College Art Journal* 14, no. 3 (March 1945): 138–41, and a commentary on the article

in the same issue by Lester D. Longman, "Why Not Educate Artists in Colleges?" 132–36.

208 Letter, Barnes to Horace Stern, November 25, 1950, ACB Corr., BFA.

209 By-laws of the Barnes Foundation, Article IX, paragraph 17, BFA.

210 Letter, Barnes to Dewey, April 18, 1950, ACB Corr., BFA.

211 Letter, Barnes to Roberta Grant (Mrs. John) Dewey, October 10, 1950, ACB Corr., BFA.

212 By-laws of the Barnes Foundation, Article IX, paragraph 17, amended by the Board of Trustees on October 20, 1950, BFA. Barnes was fully aware of the implications of his action. Thomas Munro attests that Barnes was a staunch advocate of civil rights for African American citizens, especially when it concerned education, and that on this issue, as with many other social issues, Dewey and Barnes were in complete accord. "Another contact that Dewey had with Barnes, which I was there to observe, was on the race issue. Barnes was an early energetic advocate of civil rights. . . . He was much interested in Negro education, and in what was later called 'integration' in the schools and colleges. . . . Dewey was also interested in doing away with prejudice and unfairness to minority groups. Barnes was a political and social liberal, just as Dewey was. They had much in common on that in fighting what they considered to be the oppressive power of some institutions in government, the church, big business, and universities. They both wanted to fight the ultra-conservative agencies that prevented people in every field from thinking things out and expressing themselves in original, unconventional ways. It was a difference of manner between Barnes and Dewey rather than any fundamental difference in belief." Munro oral history, 1967, 13–14. See also Gilbert M. Cantor, in *The Barnes Foundation Reality vs Myth*, 2nd ed. (Philadelphia: Consolidated/Drake PRS, 1974), 79–80, who details an incident in 1949 during which Barnes, Munro, Dewey, Max Weber, Rockwell Kent, Harold Ickes, Henry Francis Taylor, and others joined forces to protest a racist event at the University of Alabama, which had refused to allow artists and faculty from Talladega College to attend the opening dinner and be present to hear the keynote speakers—including Munro and Taylor—even though their works were included in the exhibition. The chair of the art department, Claude Clark (1915–2001), had been a student at the Barnes Foundation (confirmed in a conversation with Clark by the author, c. 1985). John Dewey had addressed the first and second National Negro Conference in 1909 and 1910, which led to the founding of the National Association for the Advancement of Colored People, and was a member of its original General Committee.

213 Letter, Barnes to Horace Mann Bond, November 6, 1950, ACB Corr., BFA.

214 Barnes was X-rayed on October 6, 1950, and subsequently entered the Urologic Clinic for five days (December 1–5) and was treated with penicillin and streptomycin (itemized bill, BFFR, BFA). He was admitted to Presbyterian Hospital in Philadelphia (under the pseudonym "Mr. Albert Cross") on January 26, 1951, and was operated on that day. Barnes underwent a second procedure on January 29 and was discharged on February 13.

215 Letter, Bond to Henry Hart, August 15, 1964, Special Collections and Archives, W.E.B. Du Bois Library, University of Massachusetts, Amherst.

216 Letter, Barnes to J. Newton Hill, May 24, 1951, ACB Corr., BFA.

217 See letter, Bond to Barnes, April 28, 1951, ACB Corr., BFA, and citation for Dr. Albert C. Barnes for the honorary doctor of science degree by Lincoln University, June 5, 1951, BFA. Barnes did not attend the ceremony. The text of remarks prepared by Bond and delivered at the commencement by Dr. Walter G. Alexander, Lincoln trustee, is included in a letter from Bond to Alexander, May 27, 1951, Special Collections and Archives, W.E.B. Du Bois Library, University of Massachusetts, Amherst.

218 Henry Pearlman, "Modigliani, Barnes, and Billy Rose," *Reminiscences of a Collector* (Princeton, N.J.: Art Museum, Princeton University, 1995), 25–26. The Rembrandt is *The Apostle James the Major*, dated 1661. See Arthur K. Wheelock Jr., *Rembrandt's Late Religious Portraits* (Washington, D.C.: National Gallery of Art, 2005), 102–05, no. 9, ill. In recollection, Pearlman uses an incorrect date for his approach to Barnes, which occurred in May 1951, several months before Barnes's death (letter, Pearlman to Barnes, May 8, 1951, ACB Corr., BFA). Pearlman called Barnes's attention to a painting by Rembrandt owned by Billy Rose, which Pearlman hoped to incorporate in a three-way transaction whereby he would apparently buy the Rembrandt from Rose and trade it with Barnes for a Cézanne. Barnes and Violette de Mazia visited Rose with Pearlman on May 12, and Barnes responded positively to the picture and requested X-rays and infrared photographs of the canvas. He wrote Pearlman on May 14 suggesting three works, Renoir's *Seated Odalisque* (*Odalisque assise*, BF237) and *Embroiderers* (*Les Brodeuses*, BF239) and Matisse's *Figure with a Persian Robe* (*Figure à la robe persane*, BF954), as a possible exchange. He also stated: "There is only one place on the walls of our twenty-three rooms where the Rembrandt would go harmoniously with the collection as a whole" (letter, Barnes to Pearlman with copy to Rose, May 14, 1951, ACB Corr., BFA). Pearlman visited Merion on May 20 to see the three paintings (letter, Barnes to Pearlman, May 17, 1951, ACB Corr., BFA). The following week, Rose wrote to Barnes indicating that Pearlman was no longer a prospective buyer and offered the Rembrandt to Barnes for $90,000.00. Rose had had the X-rays and infrared photographs as well as a conservation analysis made by Sheldon Keck, conservator of the Brooklyn Museum of Art (letter, Rose to Barnes, May 24, 1951, ACB Corr., BFA). On May 28, Barnes replied, "About your Rembrandt, which I think is tops: there seems to be a misunderstanding that I am after it. The fact is that the incident was stared by Pearlman who asked me what Cézanne or Renoir I would give in exchange. All the paintings I could spare are those I mentioned, and I told him that he would be foolish to take them in even exchange. I advised him to look around in Paris for the Cézanne he craves, and I told him where to look. . . . You may depend on Keck's report—there's none better or more reliable. The only blemish I saw was in the lower part and a man like [William] Suhr could make the two obvious restorations invisible. I'm not buying any old masters" (that is, Barnes was not purchasing old masters but trading pictures in his collection for them) (letter, Barnes to Rose, May 28, 1951, ACB Corr., BFA). There is no record of Keck's conservation report being sent to Barnes, and the correspondence between Barnes and Rose terminates on that date.

219 Gunnar Myrdal, *An American Dilemma: The Negro Problem and Modern Democracy* (New York: Harper, 1944).

220 Albert C. Barnes, "Negro Art and America," *Survey Graphic* 6, no. 6 (March 1925): 669. A longer version of this text was published in *Ex Libris* 1, no. 11 (May 1924): 323–27.

221 George Santayana, *The Life of Reason or the Phases of Human Progress*, vol. 4, *Reason in Art* (London: Constable, 1906), 159.

222 Letter, Horace Bond to "Miss Mary Mullins [sic]," November 10, 1951, ACB Corr., BFA. For accounts of Barnes's relationship with Horace Bond and Lincoln University, see David Levering Lewis, "Albert Barnes and Lincoln University: The First Chapter" (32–49), and Julian Bond, "One Memory of Dr. Barnes" (50–92, 148), both in *The Barnes Bond Connection* (Lincoln University, Pa.: Lincoln University Press, 1995); and Horace Mann Bond, "Dr. Albert C. Barnes: A Lion Among Asses, One of Whom Is a Snide Jackass," typescript (1954), Special Collections and Archives, W.E.B. Du Bois Library, University of Massachusetts, Amherst.

223 Albert C. Barnes and Violette de Mazia, *Ancient Chinese and Modern European Painting*, exh. cat. (New York: Bignou Gallery, 1943), n.p.

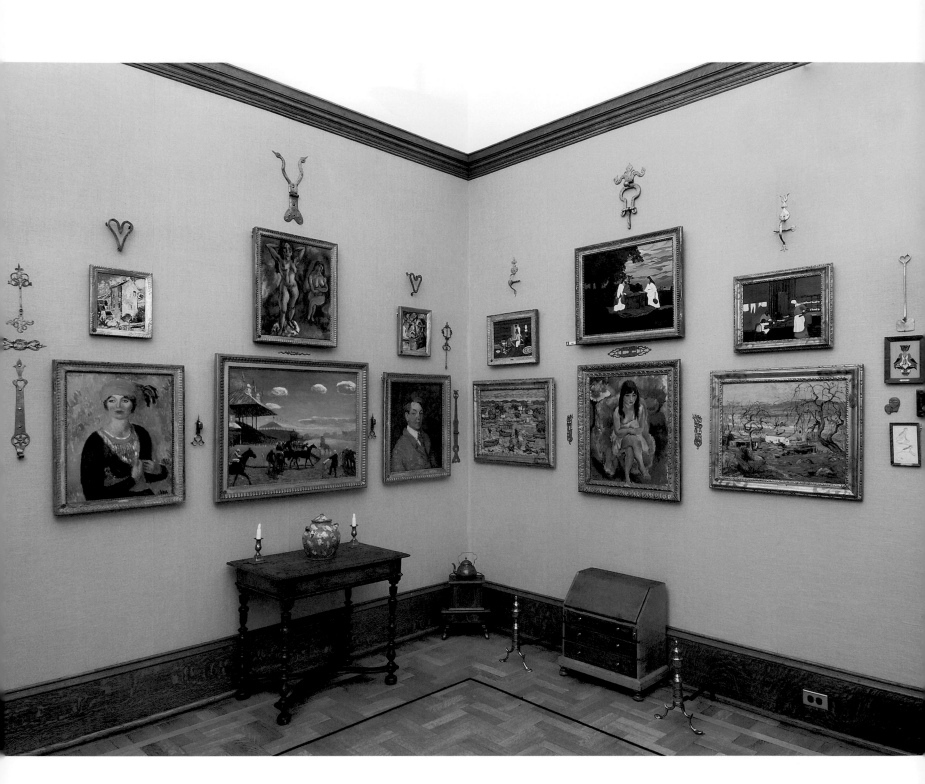

# CATALOGUE

Albert C. Barnes's collection, most fundamentally, is a concrete reflection of his extraordinary mind and his ability to discern subtle affinities and continuities among pictures. This catalogue documents a rich and vital component of that collection—all of the American paintings and works on paper in the Barnes Foundation. The American artists William Glackens, Alfred Maurer, Ernest Lawson, the brothers Maurice and Charles Prendergast, Marsden Hartley, Charles Demuth, Jules Pascin, and Horace Pippin were all instrumental in the development of Barnes's perceptions. In various capacities—painter, friend, interlocutor, agent, protégé—these creative individuals contributed to the education of this pioneer collector.

The Barnes Foundation's holdings of these painters comprise two-thirds of the total of three hundred forty-three paintings, watercolors, drawings, prints, and sculpture by American artists in the collection. In the catalogue that follows, brief essays introduce the entries for works by these nine most significant American artists. Each of these painters had a personal relationship with Dr. Barnes, and in several instances the essays elucidate the artists' influence on Barnes's approach to aesthetics or his understanding of the artists' thought processes, or both. Following the essays, their works are listed by medium—paintings, followed by watercolors, drawings, and, if appropriate, prints—and, within each medium, the entries are generally ordered chronologically, although not every work has a precise date. The fifty-two additional American artists represented in the collection are catalogued alphabetically.

Barnes's correspondence with and writings about artists span different periods in his evolution as a collector and are quoted extensively throughout all of the entries and in the nine introductory essays. The documents are rich in facts pertaining to Barnes's acquisitions and the place of each artist's work in the collection. Barnes's letters convey the tenor of his personal relationships with the nine artists and range from warm and intimate to deliberately formal and businesslike. They document Barnes's efforts to promote the artists' work, and they also provide a glimpse of Barnes's method as a collector: his preoccupation with prices, his treatment of dealers as adversaries, and his occasionally ruthless approach in his negotiations with them. Read in conjunction with other documentation from the period, notably critics' writings and contemporaneous reviews of exhibitions, the correspondence provides an enhanced context for understanding these artists' work within the collection of the Barnes Foundation. Furthermore, the letters contribute to a deeper awareness of heretofore unknown aspects of the American art world in the early decades of the twentieth century, a history that we have yet to fully and adequately understand.

The correspondence and ancillary documents are drawn mainly from the Archives of the Barnes Foundation and are therefore previously unpublished. These documents allow us to revise and reemphasize some ideas about the artists, their sources in the Modern and earlier traditions, and the chronology of their work. For additional information on the abbreviations, primary sources, and inventory numbers referenced in these entries, see "General Notes on Documentation" on pages xix–xxi of the present volume.

FIG. 18

The Barnes Foundation Gallery XII ("American Room"), north and east walls, with works by William Glackens, Maurice Prendergast, Alfred Maurer, Jules Pascin, Ernest Lawson, Horace Pippin, Lenna Glackens, and Albert Nulty

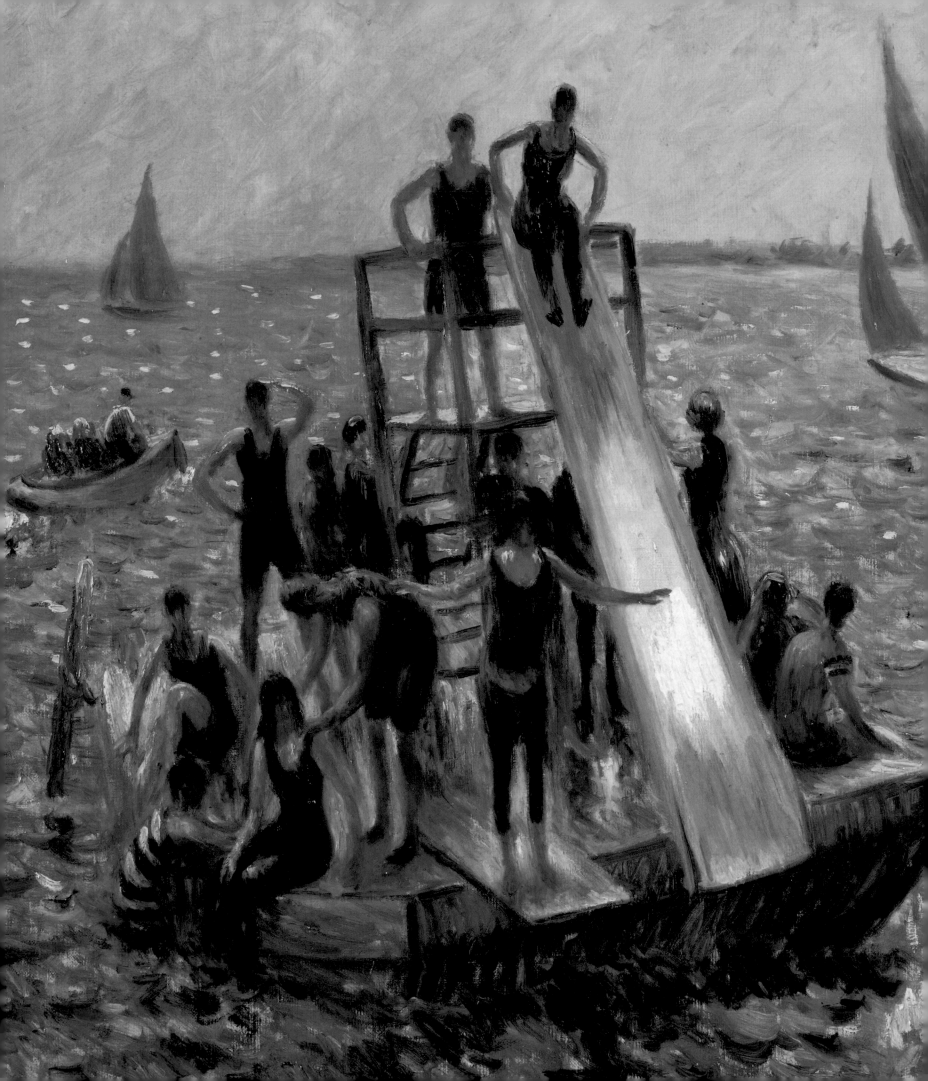

# WILLIAM J. GLACKENS (1870–1938)

If you will read the first article in the copy of "Arts & Decoration" which I am sending you, you will perhaps not be so disappointed next Sunday that I cannot explain to you why Glackens is painting "pink cats". A few years ago I was in the same frame of mind which you have expressed, but I changed when I learned that men like Glackens see in objects colors that for the ordinary person do not exist. One day this summer I was sitting with Glackens on the banks of Lake Ronkokoma, when he pointed out to me in the surface of the water all the colors of the spectrum, and it rather aggravated me because I had been looking at the same water for ten minutes and saw in it only a suggestion of a bluish green color. I have had similar experiences many times with Glackens, who, as [Guy Pène] Du Bois . . . says, has the 'best eyes in America.' . . . I will call for you at about half past eleven Sunday morning, and give you a shock with pink cats, purple cows, cock-eyed houses, and a few other manifestations of artistic genius.

Albert C. Barnes to Edgar A. Singer, Jr., professor of
modern philosophy at the University of Pennsylvania, 1915

*From 1911 until his death in 1938, and beyond,* William Glackens had a profound influence on the direction of Albert Barnes's life. At the time of Glackens's death on May 22, 1938, Barnes wrote Edith Dimock, Glackens's wife, "I was shocked; and not only that but feel a deep sorrow because I loved Butts as I ever loved but a half dozen people in my lifetime. He was so *real,* & so gentle & of a character that I would have given millions to possess. And as an artist, I don't need to tell how I esteemed him: only Maurice, among all the American painters I knew, was in his class. He will live forever in the Foundation collection among the great painters of the past who, could they speak, would say he was of the elect."[1] It would be difficult to imagine what path Barnes's life as a collector, scholar, and educator would have taken had he not had the intelligent guidance of William Glackens to launch his career in the world of art and lead him to the quest that gave overarching purpose and meaning to his life from 1912 onward. It was Glackens who introduced Barnes to the work of Pierre-Auguste Renoir, whose art came to play an essential part in Barnes's collecting and educational enterprise. When Barnes's and Violette de Mazia's *The Art of Renoir* was published in 1935, Barnes sent Glackens a copy, inscribing it "To Butts—who started my interest in Renoir."[2]

Glackens's own exploration of Modern painting took a momentous step forward in 1908, when the artist deliberately relinquished his early style and moved beyond the dark pictures that caused critics to link him with Robert Henri, John Sloan, George Luks, and Everett Shinn, as a so-called urban realist (see, for example, *Beach at Dieppe* [BF562]). That summer he painted on Cape Cod with Maurice B. Prendergast and dramatically brightened the colors of his palette, diminishing the influence of Édouard Manet by virtually eliminating black as a pervasive tonality from his canvases. By 1911, when Barnes and Glackens met in Bellport, Long Island, during the first of Glackens's six

FIG. 19

William J. Glackens, *The Raft*, 1915, oil on canvas, 25 × 30 in. (63.5 × 76.2 cm), The Barnes Foundation, BF701 (detail)

four-month painting campaigns at that summer resort, the artist was at a critical juncture in his development. He had consolidated his transformation into a full-fledged Modern painter, refining his epigrammatic crayon figure sketches into luminously colorful figures set in parks and on the beach, in complex, sparkling multifigure compositions that were his most personal contribution to the Impressionist tradition.

The pivotal work in this radical change of direction is *Race Track* (BF138). Begun in 1907, in Glackens's Manet-esque manner, worked on through 1908, and completed in 1909 under the influence of Maurice Prendergast, Ernest Lawson, Marsden Hartley, and Alfred Maurer, the completely repainted canvas was first publicly shown at the Exhibition of Independent Artists in April 1910 (no. 82).[3] In February 1910, a critic reviewing a show at the National Arts Club had already called attention to Glackens's "brand new manner."[4] Two months later, on April 5, the same writer commented on *Race Track*, "One can fairly wallow in reds and greens in William Glackens' 'Race Track.' If Mr. Glackens thus sees his nature, he must enjoy life far more than the ordinarily equipped human, for there is a riot of tone in his vision."[5] Barnes must have been shocked by the intensely saturated colors and bold chromatic juxtapositions, and he sought to learn why Glackens had painted *Race Track*, beach scenes such as *The Bathing Hour, Chester, Nova Scotia* (BF149) of 1910, and park scenes such as *Street Cleaners, Washington Square* (BF2035) of c. 1910 in just that way.

The world of art was still new, unfamiliar, and somewhat alien to Albert Barnes. But as he began to look at paintings, he found a sphere of activity that was a challenge to his wide-ranging intellect. The budding collector quickly observed that artists, through the medium of paint, tried to express in tangible form a broad range of human emotions. As he became a regular presence at exhibitions of Modern painting—and deeply engaged in his new interest in art—Barnes became known for closely questioning artists as to their precise motives for selecting and placing colors as they did.

The conversations with Glackens about *Race Track* were animated. Glackens was articulate, although by nature he found theorizing uncongenial. Leading Barnes to grasp the meanings painters embodied in the pictorial elements of their compositions must have been taxing, but his explanations—or demonstrations with the pictures—were a revelation to his "student." Above all, the painter stressed observation. "I think the place to see a man's work is the spot in which he does it," he declared in 1917.[6] This method of firsthand analysis became a crucial component of Barnes's approach to art.

Barnes's letter to Edgar Singer (quoted above) touched on only part of what he learned from Glackens about how artists saw the world around them. Barnes's desire to understand *Race Track* and other contemporary American and European works catalyzed his energetic pursuit of a comprehensive knowledge of aesthetics. As he installed more and more pictures in his home and place of business, Barnes put his emerging ideas about how to analyze pictures to the test in give-and-take sessions with his coworkers and guests, many of them artists, and he refined and broadened his ideas in the light of his comprehensive reading in literature, psychology, and philosophy. Influenced by his medical training and early professional experience, he came to treat pictures as explorative experiments not unlike scientific ones—experiments guided by artists' intentions. As he looked and looked, in exhibitions, galleries, museums, and most importantly, artists' studios, Barnes concluded that in each artist's work, failures—or inconclusive results—outnumbered the wholly, or even predominantly, successful embodiments of the artist's conception. Successes, for Barnes, were those instances in which the artist's personal fusion of color, light, line, and space had yielded a distinctive new form expressing that artist's own vision.

Barnes and Glackens often looked at pictures together, following the artist's buying expedition on Barnes's behalf early in 1912, and Glackens periodically came to Philadelphia to see his friend's latest acquisitions. The collector acknowledged his obligation to Glackens in 1915: "The most valuable single educational factor to me has been my frequent association with a life-long friend who combines greatness as an artist with a big man's mind."[7]

When he bought *Race Track* from Folsom Galleries in March 1913,[8] Barnes was expressing his need to possess the talisman that had initiated him into what he came to see as a new world of perception and meaning. *Race Track* was for Barnes always primus inter pares, the

centerpiece of his collection, its indispensability a deeply personal touchstone and perpetual tribute to Glackens.[9] The picture's importance and its acquisition by Barnes were acknowledged in some critical circles. In a long article on Glackens's Folsom Galleries exhibition in April 1913, a reviewer captured its assertiveness: "The 'Race Track!' What fearlessness in the demarcation of color! . . . It is with the greatest interest that we learn that during the recent exhibition five of the eighteen pictures were sold, one to the finest private collection in America, where it has the unique distinction of being the only American canvas."[10] Color and color relationships, indeed, were the keys to Barnes's developing sense of what he admired most in painting.

As Barnes was well aware, Glackens's innovations with color were produced in a critical climate that was competitive if not downright hostile. The reception of Modern art between 1910 and 1920 in the American art world was characterized by controversy and vigorous polemics. Artists, dealers, collectors, and critics alike staked out positions and passionately advocated for "their" artists and points of view. Alfred Stieglitz, John Quinn, Willard Huntington Wright, Charles H. Caffin, James Huneker, A. E. Gallatin, Leo Stein, and Katherine Dreier as well as representatives of the established academic system such as Kenyon Cox, Royal Cortissoz, Frank Jewett Mather, and many others defended their convictions with considerable intensity. Barnes was one of many in this intellectual ferment, and not the only one who relished the give and take. Although Glackens preferred to let his paintings speak for themselves, he was also a participant in these heated debates, and he was unafraid to express his own convictions. Commenting on the Armory Show, Glackens, who was Francophile and staunchly anti-chauvinist, framed the contemporary issues in the clearest of terms:

American art is above everything else skillful. . . . [but] this skill in America is limited . . . by a lack of bravery—a fear of freedom or of honesty. It is a skill enslaved by academies. . . . We have no innovators here. . . . American art is like every other art—a matter of influence. Art, like humanity, every time has an ancestry. You have but to trace this ancestry with persistence and wisdom to be able to build

the family tree. . . . Everything worthwhile in our art is due to the influence of French art. The old idea that American art, that a national art, is to become a fact by the reproduction of local subjects, though a few still cling to it, has long since been put to the discard. . . . I am afraid that the American section of this exhibition will seem very tame beside the foreign section.[11]

The American critics frequently mentioned the relationship between Glackens's work and Renoir's, but no writer during his lifetime ever made an explicit comparison with a specific Renoir such as, for example, his *Madame Charpentier and Her Children*, 1878 (acquired in 1907 by the Metropolitan Museum of Art), which influenced the composition and scale of Glackens's *Family Group* (National Gallery of Art) and one of Glackens's three entries in the Armory Show. This failure to identify exactly what the American had adapted from Renoir is a lacuna that has persisted in Glackens criticism.

As myths about Barnes grew to legendary proportions, Glackens's work, too, met with increasing critical disfavor. Those, like the Modernist critic Henry McBride, who wished to attack Barnes, insulted Glackens. In 1921 McBride wrote, "Mr. Glackens has been trying to paint just like Renoir for years, has been scolded for it, and now doesn't even paint, as the Irish say, like himself."[12] In a similar vein, another critic wrote, "The vigor with which Glackens's admirers defend him against any imputation of imitation seems to show their sensitiveness at this point."[13] An anonymous writer for *American Art News* elaborated the point:

William J. "Renoir," beg pardon, Glackens, is showing a brilliant series of his latest efforts to surpass his ideal. . . . To be sure it is refreshing to find a progressive painter of the younger school who does not strive after [Paul] Cézanne or [Camille] Pissarro, or get on to the band wagon with [Henri] Matisse, [Francis] Picabia, [Pablo] Picasso and the rest of the Armory gang. . . . The funny part of it is that Glackens paints nearly as well as Renoir. . . . But what Glackens lacks is quality, for he does not approach the larger and early nude of Renoir now on view at Durand-Ruel's. In his seated nude, so remarkable

for its color, he rivals, indeed almost excels, similar work by his model. His figures of young girls are charming and his scenes on American beaches, and his morning view on the Marne [*Sunday on the Marne* (BF2033)], have all the spirit and movement of Renoir and more definition.[14]

Certain of Glackens's single figures done between 1913 and c. 1920, for example, *Armenian Girl* (BF176), were influenced by Cézanne's portrait *Madame Cézanne*, c. 1886 (see fig. 50),[15] acquired by Barnes in December 1912, with its patterned background, loosely brushed with a translucency that allows the canvas to show through the paint. Much the same manner had been adopted by Glackens, who had gradually modified and diminished the densely textured paint application seen in such works as *Pony Ballet* (BF340), completed in late 1910–early 1911. Other examples of this adaptation are *Woman in Red Blouse with Tulips* (BF160), c. 1913–14, *Girl in Green Turban* (BF172), c. 1913, and *Julia Reading* (BF487), 1915–early 1916, in each of which Glackens also evinces an important debt to Matisse.

These writers never specify what they assume their readers know, that is, which type of Renoir from which period in his long evolution they reference. Was Glackens looking at the pictures of the mid-1870s, the type represented by Barnes's early purchases, such as *Before the Bath* (*Avant le Bain*, BF9), *Girl with Jump Rope* (*Fillette en robe bleu*, BF137), or *Woman Crocheting* (*Femme faisant du crochet*, BF108), with their blue-green-ivory tonalities; works from the 1880s, such as *Children on the Seashore in Guernsey* (*Enfants au bord de la mer à Guernesey*, BF10), with their brilliant illumination; or the lush landscapes and figures post-1890? For example, if we compare a work such as Glackens's *Woman in Red Blouse with Tulips* (BF160), c. 1913–14, with Renoir's *The Artist's Family* (*La Famille de l'artiste*, BF819), 1896, the blouse front demonstrates clearly the way in which Glackens's color differs from Renoir's and the effect color has on the volume of the figure itself. While the Glackens owes something to Renoir in its overall luminosity, the spontaneously applied strokes of the blouse have a primarily decorative character. In the Renoir, while the pattern is also bright, the richness of the area on Madame Renoir's bodice forms

a decorative adjunct to what is a Venetian composition of opulent three-dimensional volumes in atmospheric space that envelops the ensemble of weighty figures and places them firmly in that setting. In the Glackens, deep space or weighty substantiality is not a factor; the brightness is made up of a color scheme and color relations—the reds, yellows, purples, and greens of the blouse and lurid greens outlining the eyes—that have an acidic bite, revealing Glackens's personal hallmarks of piquant exoticism, tonalities derived from oriental textiles. This pervasively transparent fluidity is carried through in the curtain and flowers, making the Glackens closer to Matisse or Alfred Maurer (see *Tulips in a Green Vase* [BF360]) than to anything found in Renoir's work of any period.

On April 14, 1924, Barnes recorded observations that were more nuanced than those of the *American Art News* critic. In "The Art of William Glackens," written at the time the painter was awarded the Temple Gold Medal by the Pennsylvania Academy of the Fine Arts for his *Nude* (henceforth titled *Temple Gold Medal Nude* and painted c. 1918), Barnes wrote,

> Nobody intelligent disputes that art and life are fundamentally the same, that art is merely a fragment of life presented to us enriched in feeling by means of the creative spirit of the artist. By that token Glackens qualifies for a high place in plastic art. In his scenes on the beach, the street, the café, we see life with a reality and a conviction that our unaided selves would never have experienced. His drawings, pastels and paintings stand out as individual in whatever company they are hung. . . . For color, the skillful, joyous use of brilliant, strong moving color, the only man of this generation who can be said to be his equal was Renoir. His psychology is so near that of Renoir, he saw the world in so nearly the same terms, that he has been much influenced by Renoir, especially in the use of color. But Renoir never had the ability of Glackens to express by drawing some of the things in life which move us most deeply. Renoir seems to us now to be a greater artist than Glackens; but those of us who have lived with the work of both men long enough to know the characteristics of each, would never mistake

one for the other nor admit that Glackens is either an imitator of Renoir or less of an individual artist because he has expressed himself in color which we associate with Renoir's work.[16]

Before he published *The Art in Painting* in early 1925, Barnes sent Glackens his manuscript version of the book's essay on the painter, who in September or October 1924 returned an insightful commentary. "Read your analysis of me and think it most complimentary," he wrote. "I feel a bit out of place however connected up with [Francisco de] Goya, [Honoré] Daumier and [Edgar] Degas, although I appreciate that it is qualified with degree of expressiveness. My early influence (speaking of black and white) was John Leech and Charles Keene both tremendous fellows in dealing with humor. I don't think Degas had much on Keene when it came to actual drawing. . . . My Renoir influence is obvious so I shant mention it—except that I have found out that the pursuit of color is hard on drawing just as the pursuit of drawing is hard on color. Renoir survived but who else?"[17] In the published book, Barnes was clear with respect to their relative merit and standing as artists: "What makes Glackens inferior to Renoir is that he has never been able to use color structurally to give the solidity that makes Renoir's figures so real; consequently, his color-forms are not so active as Renoir's in establishing the dynamic relations between volumes in deep space."[18]

Throughout the years following the establishment of the Barnes Foundation, Barnes and Glackens remained close, continuing to visit each other and spending time together abroad when the Glackens family lived from 1925 to 1932 in France. As further evidence of his consistent support, seven months after Glackens's death on May 22, 1938, Barnes lent three paintings—*Race Track*, *Armenian Girl*, and *The Raft*—to the Glackens Memorial Exhibition at the Whitney Museum of American Art. His ultimate expression of how he felt about Glackens's work was published seven months later in *The Art of Cézanne*, in which Barnes and de Mazia wrote,

We are now in a position to define the academic or eclectic painter. When any technical means or specific esthetic effect is taken over from another painter unchanged, without reference to a new esthetic purpose or design, there is a loss of artistic integrity, and this loss is the essence of academicism. . . . By contrast, the [creative] painter has found real illumination in his sources, he has grasped the relation of technical means to artistic effect, and in the interest of his own specific purposes has converted the borrowed elements into an organic part of a new form. The same authenticity, if not the same magnitude of achievement, is found in such a man as Glackens, whose resemblance to Renoir arises from an actual similarity of temperament and community of interest; their forms are closely akin, but Glackens is differentiated by a very personal type of drawing, and by detailed modifications in the use of all the plastic means which establish the definite individuality of his work.[19]

The assemblage of Glackens's work in the Barnes Foundation, consisting of seventy-one paintings, pastels, sketches, and illustrations, is the standard by which his contributions to American art must be measured. Glackens and Barnes achieved a degree of harmonious intimacy, a friendship singular in its character and duration. Glackens's impact on his former schoolmate transcended the mere accumulation of paintings. Their relationship also rested on mutual values that each expressed in a different form.

In 1935 John Dewey wrote in the foreword to Barnes's and de Mazia's book *The Art of Renoir* that "[t]o learn to see anything well is a difficult undertaking. It requires the activity of the whole personality. Learning to perceive demands the interaction of the whole personality with things about it. This is true whether one is seeing a picture or painting it."[20] In an important sense, Barnes and Glackens each played their own role in the complex challenge to unite what Albert Barnes viewed as the indispensable connection of which the philosopher speaks. The Barnes Foundation is a testament to their relationship.

NOTES

Epigraph. Letter, Albert C. Barnes to Edgar A. Singer, Jr., November 16, 1915, ACB Corr., BFA. The article referred to is Guy Pène du Bois, "William Glackens, Normal Man: The Best Eyes in American Art," *Arts and Decoration* 4, no. 11 (September 1914): 404–06.

1  Letter, Barnes to Edith Dimock, June 3, 1938. Quoted in Ira Glackens, *William Glackens and the Ashcan Group* (New York: Crown, 1957), 259–60.

2  Inscribed copy dated March 18, 1935, in possession of the author. Gift of Ira Glackens. The artist responded, "I wish to thank you for your very handsome Renoir book. I have read Dewey's illuminating fore word [*sic*] which should add a great deal in the understanding of those who don't grasp what you are driving at. Most books on the work of a painter occupy themselves with the more or less interesting gossip about the man and let it go at that. I noted with appreciation your inscription of the fly leaf [*sic*]." Letter, William Glackens to Barnes, March 15, 1935, ACB Corr., BFA.

3  See pages 75–78, entry for Glackens's *Race Track* (BF138).

4  Arthur Hoeber, Art and Artists, *Globe and Commercial Advertiser*, February 7, 1910.

5  Arthur Hoeber, Art and Artists, *Globe and Commercial Advertiser*, April 5, 1910.

6  William Glackens, "The Biggest Art Exhibition in America and Incidentally, War, Discussed by W. J. Glackens," *Touchstone*, June 1917, 166.

7  Barnes, "How to Judge a Painting," *Arts and Decoration* 5, no. 6 (April 1915), 248. For example, in 1914, with an introduction from Durand-Ruel, they visited Louisine Havemeyer's collection, which Barnes admired above all others in America.

8  See page 78, note 1, entry for Glackens's *Race Track* (BF138).

9  See Barnes's analysis of *Race Track* in Albert C. Barnes, *The Art in Painting* (Merion, Pa.: Barnes Foundation Press, 1925), 501.

10  "Art in New York This Season," Notes of General Interest, *Craftsman*, April 1913, 135–36. Unsigned but likely written by Mary Fanton Roberts, who was mistaken about *Race Track* being the only American painting in Barnes's collection.

11  William Glackens, "The American Section, the National Art: An Interview with the Chairman of the Domestic Committee Wm. J. Glackens," *Arts and Decoration* 3, no. 5 (March 1913): 159–64.

12  Henry McBride, "Modern Art," *Dial*, January 1921, 111–14. Many years later, in his review of the Glackens Memorial Exhibition at the Whitney, McBride wrote, "The story of William Glackens is the tale of a natural-born illustrator who turned to painting and plunged deeper and deeper into confusion. . . . Mr. Glackens was not a colorist and it was the desperate effort to correct this defect in his equipment. . . . He . . . became a violent impressionist almost overnight, trailing along abjectly in pursuit of the secrets of Renoir." "The Glackens Memorial," *New York Sun*, December 17, 1938, 8.

13  Catherine Beach Ely, "The Modern Tendency in Lawson, Lever and Glackens," *Art in America* 10, no. 1 (December 1921): 32, 37. In the same article she wrote, "Recent years have emphasized William J. Glackens' mirroring of Renoir, rather unfortunately, unless to be the ablest American imitator of Renoir is in itself a distinction."

14  "Pictures and Sculptures," *American Art News*, January 1917, 3. The exhibition at the Daniel Gallery was held January 13–30, 1917.

15  Detroit Institute of Arts, Gift of Robert H. Tannahill (Rewald cat. no. 607).

16  Barnes, "The Art of William Glackens," BFA. An excerpt from this article was published in French in *Les Arts à Paris*, November 1924, 2–3. Another portion was given to Harry Salpeter, who quoted it in "America's Sun Worshipper: William Glackens Paints the World As He Sees It—on a Perpetual Holiday," *Esquire*, May 1937, 87–88, 190–92.

17  Letter, Glackens to Barnes, undated [September–October 1924], ACB Corr., BFA.

18  Barnes, *The Art in Painting*, 297.

19  Albert C. Barnes and Violette de Mazia, *The Art of Cézanne* (New York: Harcourt, Brace, 1939), 116–17.

20  Albert C. Barnes and Violette de Mazia, *The Art of Renoir* (New York: Minton, Balch, 1935), x.

## NOTE ON GLACKENS SOURCES AND PROVENANCE

Most works by William Glackens in the collection were acquired directly from the artist. Details of provenance and financial data are given only when documentation exists.

In 1943 Albert Barnes sent Glackens's wife, Edith Dimock, a list of sixty-eight Glackens works in his possession, which she passed on to the American Art Research Council at the Whitney Museum of American Art, established by Juliana Force and Lloyd Goodrich to create a reliable compendium of American art. He wrote to Dimock on December 6, 1943: "Enclosed is a list of Glacks' oils owned by the Foundation. Two copies are enclosed: one for you, one for the Whitney Museum. We have a number of drawings and water colors and if you wish a list of them also, please let me know."[1] Barnes was not concerned with titles and frequently referred to pictures by several different names. Between 1943 and 1951, pictures by Glackens were traded and/or given away, in keeping with Barnes's general practice since the outset of his collecting. Although many works on the list remain in the Barnes Foundation, this list is not wholly consistent with the Glackens works today in the collection and has not been referred to in the catalogue entries below.

Two doctoral dissertations have been devoted to Glackens. Vincent J. de Gregorio, *The Life and Art of William J. Glackens* (The Ohio State University, 1955) (hereafter abbreviated as de Gregorio, 1955), contains a catalogue (438–591) that includes seventy-one works in the collection of the Barnes Foundation. No Barnes Foundation inventory numbers are given and in forty-three instances, no dimensions. Descriptions allow identification of some, but not all, works. The catalogue contains numerous errors and includes works that are not presently in or were never in the Barnes collection. Of the seventy-one items, forty-seven are listed by title and medium as "Inaccessible Works" (581–86). Two paintings in the Barnes Foundation are reproduced. The present author has provided references to de Gregorio's text for identifiable works in the Barnes Foundation in the relevant individual entries.

Richard J. Wattenmaker, *The Art of William Glackens* (New York University, 1972) (hereafter Wattenmaker, 1972), reproduces seventeen works in the Barnes Foundation. These are cited below, together with textual references, in the relevant individual entries. Numerous documents have become available in the ensuing years, enabling the author to modify and refine the dating, dimensions, and titles and also, in many instances, to provide acquisition data and bibliographical references for individual works.

Glackens's preferred drawing medium in his freehand sketches and in his sketchbooks was a no. 4 Dixon pencil intended for marking laundry packages, referred to herein as black crayon. See Ira Glackens, "By Way of Background," in Janet A. Flint, *Drawings by William Glackens* (Washington, D.C.: National Collection of Fine Arts, Smithsonian Institution Press, 1972). See also Nancy E. Allen and Elizabeth Hawkes, *William Glackens: A Catalogue of His Book and Magazine Illustrations* (Wilmington: Delaware Art Museum, 1987) (hereafter Allen and Hawkes, 1987).

1 Letter, Albert C. Barnes to Edith Dimock, December 6, 1943, ACB Corr., BFA.

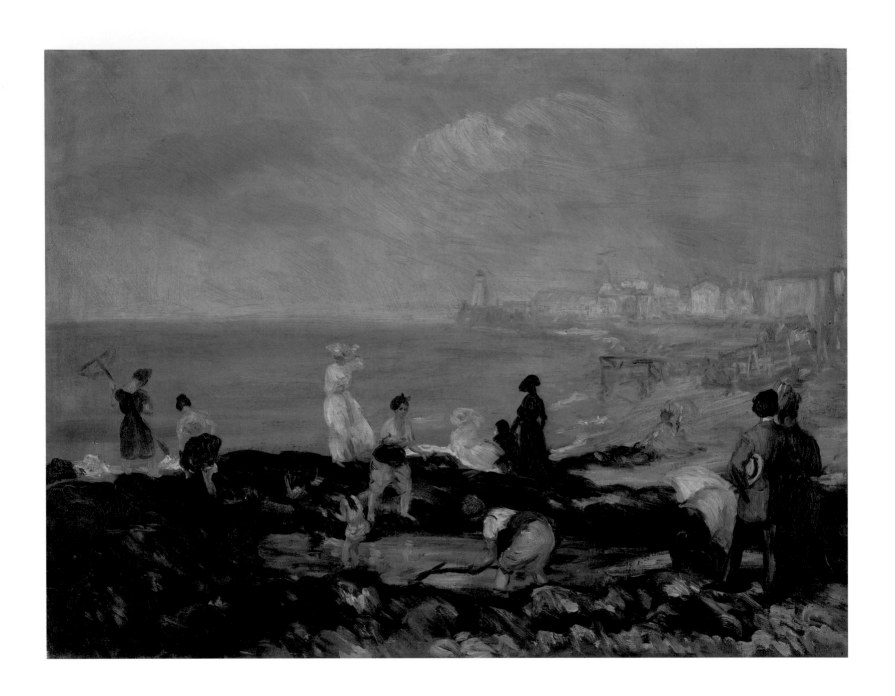

## Beach at Dieppe

Alternate titles: *Dieppe; Dieppe Harbor; Beach Scene at Dieppe*

1906. Oil on canvas, 24 × 32 in. (61 × 81.3 cm). Signed lower left: W. Glackens. BF562

PROVENANCE: Acquired in October 1912 in trade for Glackens's *Mahone Bay* (1910), likely the first Glackens work acquired by Barnes, who had purchased it for $300.00.[1]

EXHIBITION: Kraushaar Galleries, New York, Paintings and Drawings by William Glackens, January 3–29, 1949, cat. no. 6 (as *Dieppe Harbor*, "Lent by the Barnes Foundation").[2]

REFERENCES: De Gregorio, 1955, 386 (as "Dieppe Harbor"); Ira Glackens, *William Glackens and the Ashcan Group* (New York: Crown, 1957), 72, ill. following 112: "The G's chose the Dieppe-New Haven route to England as being the cheapest, but when they reached Dieppe they found the Channel very stormy and the boats not sailing. So they stayed in Dieppe two or three days, and W. sketched. The sketches resulted in 'Dieppe Beach' (Barnes Foundation), in which the artist and his wife may be seen, at the right of the canvas, watching the crowd. . . . These family figures in the Dieppe and other canvases, though small, are always characteristic, and can be identified at once"; Wattenmaker, 1972, 133–34, fig. 116; Violette de Mazia, "The Case of Glackens vs. Renoir," *BFJAD* 2, no. 2 (Autumn 1971): 22, pl. 20; Violette de Mazia, "Creative Distortion: The Case of the Levitated Pear," *BFJAD* 4, no. 1 (Spring 1973): 10; Violette de Mazia, "*E Pluribus Unum*," *BFJAD* 7, no. 1 (Spring 1976): 13, 16.

RELATED WORK: Preparatory crayon drawing in sketchbook 94.82, "W. Glackens Dieppe & Paris," 1906 (also used in New York), Museum of Art Fort Lauderdale, Nova Southeastern University (fig. 20).

1 Letter, Albert C. Barnes to William Glackens, January 24, 1912, London Collection: "I enclose a check for $300.00 in payment for the painting of Mahone Bay, Nova Scotia. When you have had this painting framed, please send it to me by express to my residence, Overbrook, Pa." On January 27, 1912, Barnes sent Glackens a check for the cost of the frame. Albert C. Barnes check no. 2174, January 27, 1912, $17.50, payable to W. J. Glackens, BFFR, BFA.

2 Eleven letters concerning this loan are preserved in the archives of the Barnes Foundation: Antoinette M. Kraushaar (Kraushaar Galleries) to Barnes, October 22, 1948: "Mrs. Glackens tells me that you will consider lending one of your Glackens paintings for the exhibition of his work which we plan to hold from January 3rd to 29th. It is very generous of you, and I hope you will find it possible to arrange it"; Barnes to Kraushaar, November 30, 1948: "Mrs. Glackens appears in the picture and she can tell you the date"; Kraushaar to Barnes, December 7, 1948; Barnes to Kraushaar, December 8, 1948; Kraushaar to Barnes, December 18, 1948; Kraushaar to Barnes, January 2, 1949: "Enclosed is the catalogue of the Glackens exhibition, and also the proof of the excerpt from 'The Art in Painting.' . . . It is very kind of you to give us permission to include this with our catalogue. I like it and feel that it is exactly the explanation required" (the text did not appear in the catalogue but must have been printed as a separate sheet); Barnes to Kraushaar, January 27, 1949, on which is handwritten text of what seems to be a telegram from Kraushaar; Kraushaar to Barnes, January 31, 1949; receipt on Kraushaar stationery, January 31, 1949: "Received from Kraushaar Galleries one package for The Barnes Foundation. Albert Nulty"; Barnes to Kraushaar, January 31, 1949: "I received your letter of this date, stating that the messenger was delivering the Glackens and also the 'Pastel Drawing'; the painting arrived in good condition, but the pastel drawing *was not delivered*" (see *Nude Standing* [BF734]); Kraushaar to Barnes, February 3, 1949. All letters ACB Corr., BFA.

FIG. 20

William J. Glackens, Preparatory drawing for *Beach at Dieppe* (BF562) in "W. Glackens Dieppe & Paris" (sketchbook), 1906, crayon on paper, 5 × 8¼ in. (12.7 × 21 cm), Museum of Art Fort Lauderdale, Nova Southeastern University, Bequest of Ira Glackens, 94.82

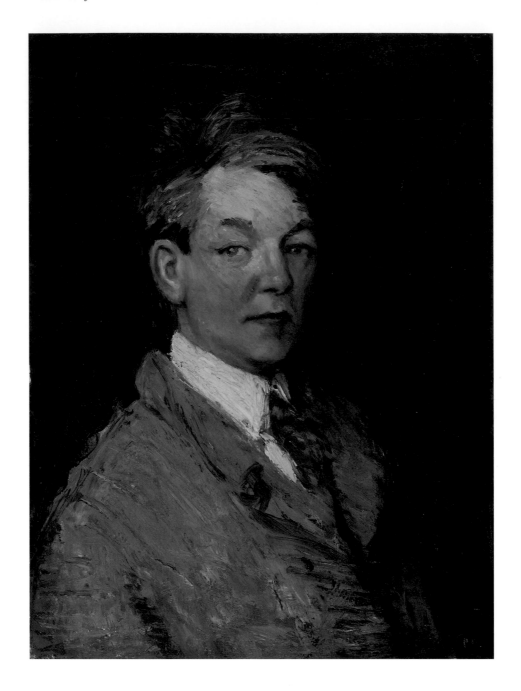

## *Self-Portrait*

Alternate titles: *Portrait of Himself; Portrait of the Artist*

1908. Oil on canvas, 24 × 18 in. (61 × 45.7 cm). Signed lower right: W. Glackens. BF105

PROVENANCE: Acquired from the artist, March 1, 1913.[1]

REFERENCES: De Gregorio, 1955, 552, no. 64 (as c. 1914); Wattenmaker, 1972, 163–65, 171, 195, frontispiece; Albert C. Barnes, *The Art in Painting*, 500; Violette de Mazia, "The Case of Glackens vs. Renoir," *BFJAD* 2, no. 2 (Autumn 1971): 3–30, 12, pl. 8; Violette de Mazia, "Pertinent Portraits," *Vistas* 2, no. 2 (1981–83): 63; Violette de Mazia, "The Barnes Foundation: The Display of Its Art Collection," *Vistas* 2, no. 2 (1981–83): 109 n. 111, pl. 59 (installation view); R.J. Wattenmaker, "Dr. Albert C. Barnes and The Barnes Foundation," in *Great French Paintings from The Barnes Foundation: Impressionist, Post-Impressionist, and Early Modern* (New York: Knopf in association with Lincoln University Press, 1993), 18 and 20.

1 Albert C. Barnes check no. 2565, March 1, 1913, $700.00, for "self portrait," BFFR, BFA.

## Race Track

Alternate titles: *The Race Track; Racetrack*

1908–09. Oil on canvas, 26⅛ × 32¼ in. (66.4 × 81.9 cm).
Signed lower right: W. Glackens. BF138

PROVENANCE: Acquired from the Folsom Galleries, New York, March 12, 1913.[1]

EXHIBITIONS: Macbeth Galleries, New York, Exhibition of Paintings, February 3–15, 1908 (known as the exhibition of "The Eight"), cat. no. 55 (as *Brighton Beach, Race Track*). *Race Track* was withdrawn by the artist and did not travel with the show that toured nine cities.[2] Also New York, Exhibition of Independent Artists, April 1–27, 1910, cat. no. 82 (as *The Race Track*); Folsom Galleries, New York, March 1–17, 1913; Whitney Museum of American Art, New York, William Glackens Memorial Exhibition, December 14, 1938–January 15, 1939, cat. no. 80, ill. (as *Race Track*, 1909, "Lent by the Barnes Foundation").[3]

REFERENCES: Letter, Glackens to A. E. Gallatin, March 18, 1916, Albert E. Gallatin Papers, courtesy of the New-York Historical Society: "Dr. Barnes told me he would send you photographs of 'The Race Track' 1908." *Race Track*'s public debut came in the Exhibition of Independent Artists show, which opened in New York on April 1, 1910. The *New York Mail and Express* (April 2) headlines shrieked, "Panic Averted in Art Show Crowd: Police Preserve Order." Two thousand visitors attended the opening. An anonymous critic wrote: "Another picture by Glackens entitled 'The Race Track,' impresses one with the Matisse effect, and is rather over-accentuated in color" (*World*, April 3, 1910, section II, 7). On April 5, 1910, Arthur Hoeber reviewed the show: "One can fairly wallow in vivid reds and greens in William Glackens' 'Race Track.' If Mr. Glackens thus sees his nature, he must enjoy life far more than the ordinarily equipped human, for there is a riot of tone to his vision" (*Globe and Commercial Advertiser*, 10). *Race Track* was exhibited in the Folsom Galleries, March 1–17, 1913, concurrently with the Armory Show. Unsigned review in *American Art News*, March 8, 1913, no. 22, 7: "The familiar 'Race Track,' brilliant and gaudy in color, also has its say." One critic wrote: "With a sense of wonderful color palpitating about us, we should like to retrace our steps to the Folsom Gallery again and to stay indefinitely . . . with the collection of paintings by William Glackens. A more complete realization of all that color can accomplish on canvas has never been presented, we think, in one private exhibition in New York, and presented with a variety so infinite that it is as though Nature had shared with Mr. Glackens the splendor of her most prodigal moods. . . . And the 'Race Track'! What fearlessness in the demarcation of color!" (*Craftsman*, April 1913, unsigned [Mary Fanton Roberts]). Other references: Guy Pène du Bois, "A Modern Collection: The Paintings of Contemporary Artists," *Arts and Decoration*, June 1914, 304 (ill.), 325–26; Albert C. Barnes, "How to Judge a Painting," *Arts and Decoration*, April 1915, ill. 218; A. E. Gallatin, *Certain Contemporaries* (New York and London: John Lane, 1916), 9: "Race Track, painted in 1908 . . . with horses as alive as those in the pictures of Degas, and painted with at least some of the latter's authority"; Forbes Watson, "William Glackens," *Arts* 3, no. 4, April 1923, 252 (ill.), 249 (drawing, *Racehorses*, Collection of Mr. Albert Gallatin, see fig. 21); Forbes Watson, *William Glackens* (New York: Duffield, 1923), ill. (painting and drawing); Mary Mullen, *An Approach to Art* (Merion, Pa.: Barnes Foundation Press, 1923), ill. 56; Albert C. Barnes, *The Art in Painting*, ill. 295, 501; Guy Pène du Bois, *William J. Glackens* (New York: Whitney Museum of American Art, 1931), ill. following 112 (as 1907); *William Glackens Memorial Exhibition*, exh. cat. (New York: Whitney Museum of American Art, 1938), no. 80 (ill.); *Studio*, March 1939, 132, ill.; *Studio*, September 1940, 72, ill.; de Gregorio, 1955, 350, pl. LXXVIII (as *"The Race Track"*), 348–49, 499, no. 93 (as 1908); Ira Glackens, *William Glackens and the Ashcan Group* (New York: Crown, 1957), 84, 86, 88, ill.; Violette de Mazia, "The Case of Glackens vs. Renoir," *BFJAD* 2, no. 2 (Autumn 1971): 11, pl. 6; Wattenmaker, 1972, 141–42, 154, 212–18, 236–39, 261, 293, 354, fig. 118 (as *The Race Track*); R. J. Wattenmaker, "Dr. Albert C. Barnes and the Barnes Foundation," in *Great French Paintings from the Barnes Foundation* (New York: Knopf in association with Lincoln University Press, 1993), ill. (color), 18, fig. 6, 20.

RELATED WORKS: Seven preparatory crayon drawings for the picture: a single sheet, *Race Track* (alternate title: *Race Horses*), Philadelphia Museum of Art, Gift of Albert Gallatin, 1945–59–1 (fig. 21), and six sketches for figures, horses, and riders as well as the grandstand and infield in a sketchbook used by the artist in 1907, sketchbook 94.85, "W. Glackens Race Track," Museum of Art Fort Lauderdale, Nova Southeastern University (figs. 22–27). All of these drawings were made in 1907. An additional drawing, for which the Gallatin drawing appears to have been a very close preliminary sketch, was made as an illustration for Jacques Futrelle, "When the Flag Falls: Betty Logan, of 'the Track,' Meets the

Queen and Comes a Fall," *Saturday Evening Post*, July 13, 1907 (vol. 180, no. 2), 16, "There You Will Find the 'Wise Ones.'"[4] Further reinforcing the 1907 date is the fact that horse racing was discontinued at the Brighton Beach Race Course in 1908.[5] A similar composition with prominent architectural motifs and figures leaning on an angled fence is found in Glackens's *Captain's Pier*, painted in Bellport, L.I., c. 1911, Bowdoin College Museum of Art, Brunswick, Maine, Gift of Stephen M. Etnier, acc. no. 1957.117.

REMARKS: Glackens worked on *Race Track* in 1907 and 1908, completing it in 1909. Its color scheme was reconceived in a ruggedly textured Impressionist technique influenced by the brushwork of Ernest Lawson, the dense impasto of the Maine mountain scenes of Marsden Hartley, and the dramatically brighter palette and the overall color intensity of Maurice Prendergast's open-air compositions, all of which

FIG. 21

William J. Glackens, Preparatory drawing for *Race Track*, 1907, crayon on paper, 6¾ × 12 in. (17.1 × 30.5 cm), Philadelphia Museum of Art, A. E. Gallatin Collection, 1945, 1945–59–1

FIG. 22

William J. Glackens, Preparatory drawing for *Race Track* (BF138) in "W. Glackens Race Track" (sketchbook), n.d. [1907], crayon on paper, 5¼ × 8⁵⁄₁₆ in. (13.3 × 21.1 cm), Museum of Art Fort Lauderdale, Nova Southeastern University, Bequest of Ira Glackens, 94.85

FIG. 23

William J. Glackens, Preparatory drawing for *Race Track* (BF138) in "W. Glackens Race Track" (sketchbook), n.d. [1907], crayon on paper, 5¼ × 8⁵⁄₁₆ in. (13.3 × 21.1 cm), Museum of Art Fort Lauderdale, Nova Southeastern University, Bequest of Ira Glackens, 94.85

FIG. 24

William J. Glackens, Preparatory drawing for *Race Track* (BF138) in "W. Glackens Race Track" (sketchbook), n.d. [1907], crayon on paper, 5¼ × 8⁵⁄₁₆ in. (13.3 × 21.1 cm), Museum of Art Fort Lauderdale, Nova Southeastern University, Bequest of Ira Glackens, 94.85

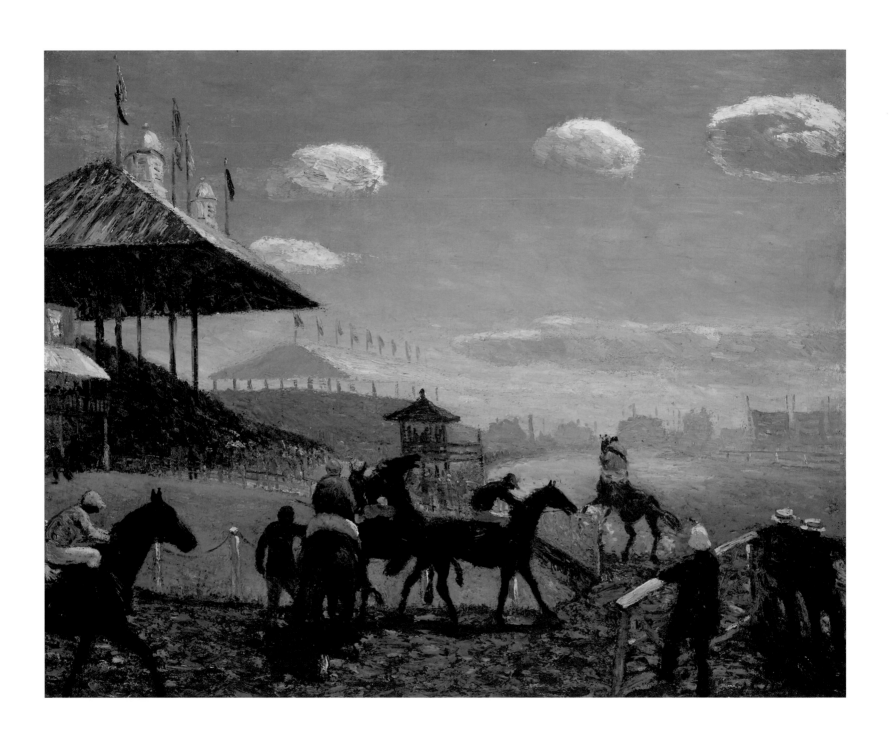

FIGS. 25–26

William J. Glackens, Preparatory drawings for *Race Track* (BF138) in "W. Glackens Race Track" (sketchbook), n.d. [1907], crayon on paper, 5¼ × 8⁵⁄₁₆ in. (13.3 × 21.1 cm), Museum of Art Fort Lauderdale, Nova Southeastern University, Bequest of Ira Glackens, 94.85

FIG. 27

William J. Glackens, Preparatory drawing for *Race Track* (BF138) in "W. Glackens Race Track" (sketchbook), n.d. [1907], crayon on paper, 8⁵⁄₁₆ × 5¼ in. (21.1 × 13.3 cm), Museum of Art Fort Lauderdale, Nova Southeastern University, Bequest of Ira Glackens, 94.85

Glackens had studied at this time and which altered the course of his style. A sense of how much of a transformation had occurred in Glackens's palette is suggested by a description of a beach scene painted in the summer of 1908 on Cape Cod and shown in the Winter Exhibition of the National Academy of Design, December 11, 1908, through January 9, 1909: "In William Glackens' *Beach Scene* it may be said that the painter was striving to get away from the conventional rendering of his confreres. That he succeeded no one will question, perhaps. That he has been wholly successful may be instantly denied even though there is earnest intention. Yet he has failed to arrive at any approximation of nature as it is visible to the majority of eyes, and his values seemed far away from the truth, while the color ended by being aggressively insistent."[6]

1  Albert C. Barnes check no. 2580, March 13, 1913, $800.00, annotated "Payment, 'The Race Track' Glackens," BFFR, BFA. Letter, Barnes to Folsom Galleries, March 13, 1913: "Enclosed check for eight hundred (800) dollars pays for Glackens' painting 'The Race Track.' My name is not [to] figure in the transaction, even in your report to Mr. Glackens, except to state that it was bought by Mr. George Sykes of Philadelphia, a friend of mine. The painting is to be shipped with my others, addressed to me at Overbrook, Pa., and I shall see that Mr. Sykes gets it. If Glackens asks where you are to ship the painting tell him you sent it direct to Mr. Sykes's home in Germantown, Philadelphia. The buyer of Glackens's 'Children on the Beach' desires his identity kept secret and I am sure that neither you or I, the only ones who know it, will ever reveal it to any person." ("Children on the Beach" is likely *Bathing at Bellport*, 1912 [Brooklyn Museum of Art, 67.24.6, Bequest of Laura L. Barnes], which was probably one of the beach scenes exhibited in the Folsom show.) Letter, Thomas Defty of Folsom to Barnes, March 14, 1913 (acknowledging the payment): "The three paintings will be shipped to you right after the close of the exhibition which ends Monday the 17th." Both letters ACB Corr., BFA. The third picture was *Pony Ballet* (BF340).

2  See Judith Zilczer, "The Eight on Tour, 1908–1909," *American Art Journal*, Summer 1984, 21–48, Appendix III, 45–46.

3  On the information form for the loan to the Glackens Memorial Exhibition, Barnes listed the date of the work as 1909. Archives of the Whitney Museum of American Art.

4  Nancy E. Allen and Elizabeth Hawkes, *William Glackens: A Catalogue of His Book and Magazine Illustrations* (Wilmington: Delaware Art Museum, 1987), 34, no. 771, ill. p. 85.

5  Kenneth T. Jackson, ed., *Encyclopedia of New York City* (New Haven, Conn.: Yale University Press, 1995), 558. Gambling was outlawed in New York State in 1908, and that year motorcar racing replaced horse racing at Brighton Beach.

6  Arthur Hoeber, "Winter Exhibition at the National Academy of Design," *International Studio*, February 1909, cxxxv–cxxxviii.

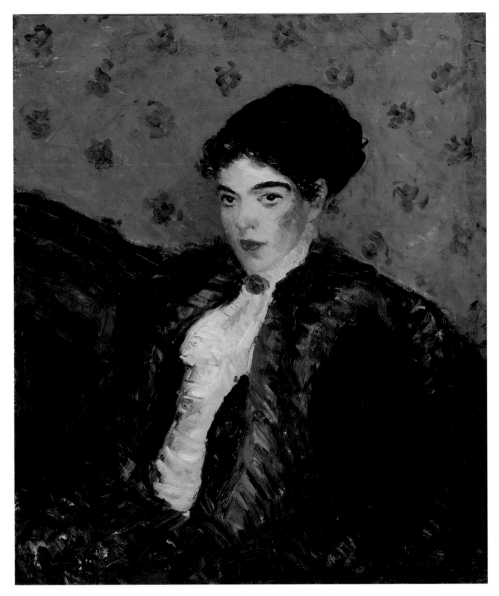

## Girl with Fox Furs

Alternate titles: *Girl with Fox Fur; Portrait of a Woman with Fur Boa; Woman with Fox Furs*

c. 1909. Oil on canvas, 29¾ × 25⅛ in. (75.6 × 63.8 cm). Signed lower left: W. Glackens. BF2000

PROVENANCE: Acquired from the artist no later than early 1917.[1]

EXHIBITION: Daniel Gallery, New York, Recent Paintings by William Glackens, January 1–30, 1917, cat. no. 9 (as *Woman with Fox Furs*).

1 Letter, Albert C. Barnes to William Glackens, January 24, 1917: "Let me know definitely by Saturday if you want me to send my Beach Scene to Daniel for the Chicago show. If that show falls through, please have Daniel send with my Marne picture, the 'Girl with the Fox Furs' and the 'Head of a Girl,' hanging on the wall opposite." Letter, Barnes to Glackens, October 17, 1917: "I made the sale of your paintings, but I had to keep the portrait of Stein for myself (which I am very glad to have), and give in its place the Girl with Fox Furs, and the 18 × 24 Girl in Blue-Green that was reproduced on the cover of Town and Country last spring [*The Brunette* (BF551)]. . . . The transaction is now ended except that I am to return to you the 20 × 24 Girl in Shirt-waist which you agreed to exchange for the Girl in Fox Furs." Letter, Barnes to Glackens, October 18, 1917: "I am sending you to-day by express, charges prepaid, a small box containing the 20 × 24 Shirt-waist girl in exchange for which you gave me the Girl with the Fox Furs." Letter, Glackens to Barnes, undated [c. February 8–14, 1921]: "The price of the head at Daniel is $240." Letter, Mary Mullen or Nelle E. Mullen to Glackens, February 23, 1921: "I asked [Barnes] to get a price for me on the head my sister and I saw at Daniel's gallery [*Head of Girl*, cat. no. 14] and I note in your letter that the price is two hundred and forty (240) dollars. I enclose check for that amount and ask you to kindly send the picture to my residence. . . . The picture is a small one of a girl wearing fox furs." Letter, Glackens to Mullen, February 24, 1921: "I am sending you the picture of *Girl with Fox Furs* today. The price was $240 less 25% so I am sending you a check for $60 as a refund. The price of the head you refer to (Beatrice) is $400 less 25%. It is the same size as 'Girl with Fox Furs' but more important." All letters ACB Corr., BFA. In the Mullen collection, *Girl with Fur Neckpiece*, 13¼ × 10½ in. (33.7 × 26.7 cm), is the painting referred to as "acquired from the artist 1921" (*The Mullen Collection* [Philadelphia: Samuel F. Freeman, 1967], 83, cat. no. 54). The Mullens also owned a painting, *Woman with Fox Furs*, 26 × 21½ in. (66 × 54.6 cm), that is catalogued with no reference to where it was purchased (*The Mullen Collection*, 81, cat. no. 52), hence it was probably one of many pictures owned by Barnes that were given, sold, or traded to the Mullens.

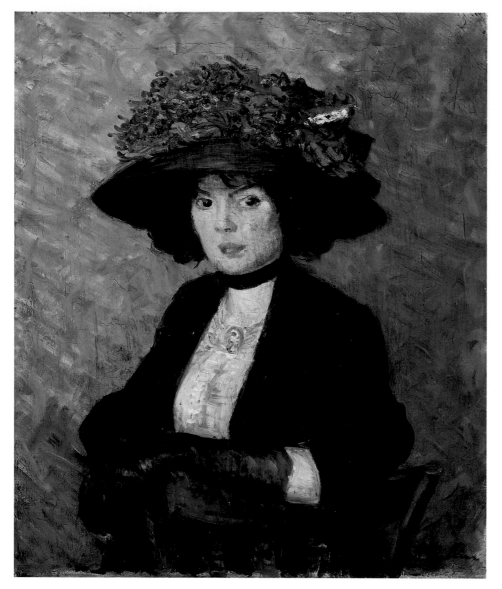

## Woman with Green Hat

Alternate titles: *Woman with Hat; Baroness Seated*

c. 1909. Oil on canvas, 30 × 25 in. (76.2 × 63.5 cm).
Signed lower right: W. Glackens. BF459

PROVENANCE: Acquired from the artist, November 9, 1914.[1]

REMARKS: Barnes wrote to Glackens on October 17, 1917, "I had to keep the portrait of Stein for myself (which I am very glad to have)."[2] The subject can be identified as Zenka Stein. Ira Glackens wrote: "A canvas by William, a portrait of the model Zenka Stein, known as 'Old Stein,' who posed for all the artists of her day—for she was peculiarly paintable—fascinated [Glackens]. Again and again he returned to it, shaking his head and saying 'The Gräfin S.,' though Stein was from Bohemia, and certainly no gräphin."[3] She modeled for John Sloan as early as 1906 and was part of a circle of friends that included the Glackenses, Sloans, and Henris.[4] Stein was also known for weaving hats of raffia. Sloan bought one for his wife in 1907.[5] The elaborate hat in *Woman with Green Hat* could be one of these creations, which appear in several of Sloan's paintings.[6] There is enough of a resemblance between Sloan's images and *Woman with Green Hat* to make this attribution. Barnes wrote on the back of an undated [c. 1920] photograph of BF459 (then BF488): "Glackens: Just a plain American—but it has hung for many years alongside of a fine Manet [*Young Girl on a Bench* (*Fillette sur un banc*, BF162, acquired January 9, 1913)] & a Goya [*Portrait of Jacques (Santiago) Galos* (BF5, acquired February 9, 1914)]—& not one murmur of apology is needed."[7]

1   Albert C. Barnes check no. 3140, November 9, 1914, $500.00, for "Wm J. Glackens Painting 'Baroness Seated,'" BFFR, BFA.

2   Letter, Albert C. Barnes to William Glackens, October 17, 1917, ACB Corr., BFA. For additional text from the letter regarding this acquisition, see entry for *Girl with Fox Furs* (BF2000), note 1.

3   Ira Glackens, *William Glackens and the Ashcan Group* (New York: Crown, 1957), 156.

4   See *John Sloan's New York Scene, from the diaries, notes and correspondence 1906–1913*, ed. Bruce St. John (New York: Harper & Row, 1965): "Zenka Stein, our friend and model" (entry March 3, 1908, 202); "Stein (Zenka) called and we enjoyed her visit as usual. She's a great girl, so ingenious, so paintable, the best professional model in New York probably" (entry January 18, 1908, 185–86).

5   *John Sloan's New York Scene*, entry July 12, 1907, 140.

6   See Rowland Elzea, *John Sloan's Oil Paintings: A Catalogue Raisonné* (Newark: University of Delaware Press, 1991), nos. 60, 68, 72, 583, and 617.

7   William Glackens, *Woman with Green Hat* (BF459), photograph by W. Vivian Chappel, c. 1920s, Photograph Collection, BFA.

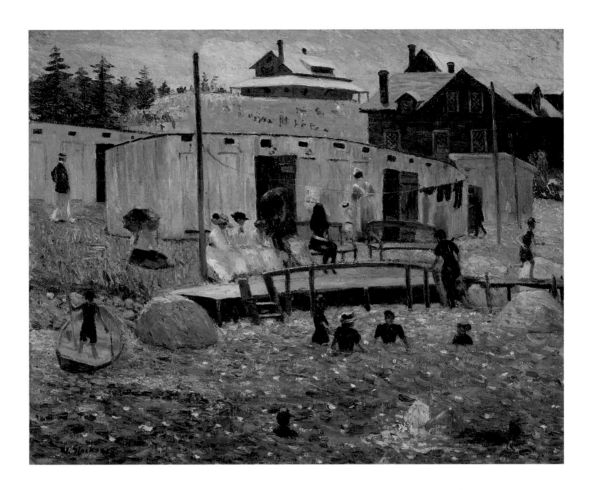

## The Bathing Hour, Chester, Nova Scotia
Alternate titles: *The Bathing Hour; Bathers; Bathers, Bellport; Chester Bathing Hour*

1910. Oil on canvas, 26 × 32 in. (66 × 81.3 cm). Signed lower left: W. Glackens. BF149

PROVENANCE: Acquired from the artist, April 1, 1914.[1]

EXHIBITIONS: 69th Regiment Armory, Lexington Avenue and 25th Street, New York, The International Exhibition of Modern Art (the Armory Show), February 17–March 15, 1913, cat. no. 854 (as *The Bathing Hour*); the Armory Show traveled to the Art Institute of Chicago, March 24–April 16, 1913, where *The Bathing Hour, Chester, Nova Scotia* was Glackens's sole entry, cat. no. 151; Pennsylvania Academy of the Fine Arts, Philadelphia, 109th Annual Exhibition, February 8–March 29, 1914, cat. no. 332, 37 (as *The Bathing Hour*).

REFERENCES: James Huneker, "Seen in the World of Art: William Glackens Shows His Versatility," *New York Sun*, December 18, 1910: "His color grows more harmonious, though it often shocks by its brilliant dissonances. He is pulling up the key year after year, and his studies . . . at Nova Scotia last summer are of exceeding interest because, apart from their technical accomplishment, they begin to show, however dimly, the goal to which this ambitious and gifted young man is steering. Beaches of inland seas, the waters of which are vivid blue; skies as hard blue as Italy's, white cloud boulders that roll lazily across the field of vision and shine on their edges with reflected light; grass so green that you ask yourself if Nova Scotia raises the crop from Celtic seed; nothing tempered as would a less sincere artist, but set forth unmodulated and in audacious oppositions, these waters, skies, beaches, bath houses of uncompromising lines, these drifting or moored boats, with humanity strolling, sitting, bathing, are nevertheless so real, or rather evoke the illusion of reality, that you experience in their presence what Henry James calls 'emotion of recognition' "; W. H. de B.

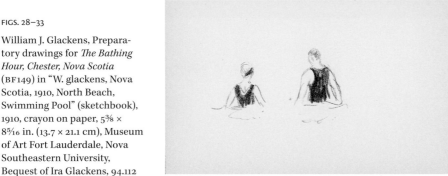
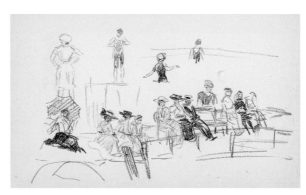

FIGS. 28–33

William J. Glackens, Preparatory drawings for *The Bathing Hour, Chester, Nova Scotia* (BF149) in "W. glackens, Nova Scotia, 1910, North Beach, Swimming Pool" (sketchbook), 1910, crayon on paper, 5⅜ × 8⁵⁄₁₆ in. (13.7 × 21.1 cm), Museum of Art Fort Lauderdale, Nova Southeastern University, Bequest of Ira Glackens, 94.112

Nelson, "Philadelphia's Hundred and Tenth Annual," *International Studio*, March 1915: "His *Bathing Hour* and *The Green Car* are object lessons to those willing to concede a hearing to the ultra-modern school. There is a spontaneity and vigour in the work of these young artists, such as Glackens, Gifford Beal, George Bellows, and others, which cannot fail to upraise American art"; Forbes Watson, "William Glackens," *Arts*, April 1923, 253; Forbes Watson, *William Glackens* (New York: Duffield, 1923), ill.; de Gregorio, 1955, 366, 369–70, 588, no. 8 (as "present whereabouts unknown"), citing letter to the author from Ira Glackens, March 23, 1955, "confirmed loss of picture"; Wattenmaker, 1972, 200–02, 205, 215, 235, 354, fig. 145 (inaccurately as *Bathers, Bellport*); R.J. Wattenmaker,

"William Glackens's Beach Scenes at Bellport," *Smithsonian Studies in American Art* 2, no. 2 (Spring 1988): 77 (as "The Bathing Hour").

RELATED WORKS: Six preparatory drawings in sketchbook 94.112, "W. glackens, Nova Scotia, 1910, North Beach, Swimming Pool," Museum of Art Fort Lauderdale, Nova Southeastern University (figs. 28–33).

1 Albert C. Barnes check no. 2958, April 1, 1914, $500.00, payable to W.J. Glackens, "in payment for 'The Bathing Hour,'" BFFR, BFA. Letter, Barnes to William Glackens, April 1, 1914, ACB Corr., BFA: "I enclose a check for $500.00 in payment for your painting, 'The Bathing Hour,' which, according to our agreement, is to be loaned by me to you for the exhibition in London." The exhibition did not take place.

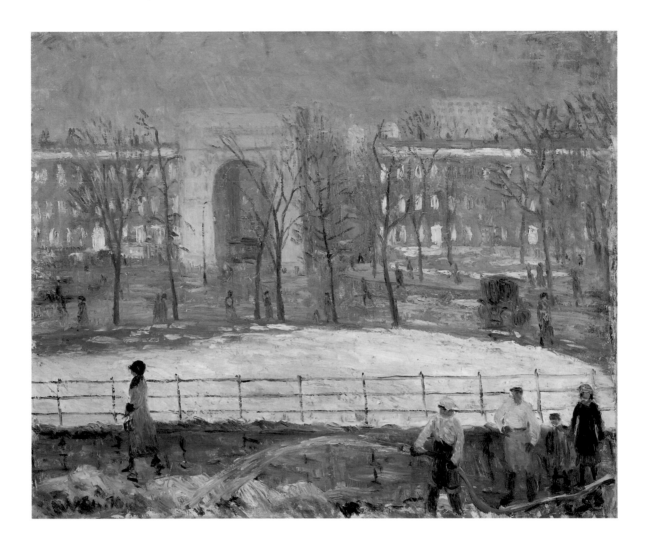

## Street Cleaners, Washington Square
Alternate titles: *Street Cleaners; Washington Square*

c. 1910. Oil on canvas, 25¼ × 30 in. (64.1 × 76.2 cm). Signed lower left: W. Glackens. Frame by Charles Prendergast, signed lower frame member verso: Prendergast. BF2035

PROVENANCE: Acquired from the artist, March 31, 1913.[1]

EXHIBITION: Folsom Galleries, New York, March 1–17, 1913.

REFERENCES: *American Art News*, March 8, 1913, 7: "[In] 'Street Cleaners, Wash'n Sq.,' the artist more worthily expresses himself"; "Art Notes: Paintings by William Glackens," *Evening Post New York*, March 8, 1913, 9: "There are two canvases which have for subject Washington Square, both fine in color"; Charles H. Caffin, "18 Canvases by Glackens on View," *New York American*, March 10, 1913, 8; Wattenmaker, 1972, 188–90, fig. 137.

RELATED WORKS: *March Day, Washington Square*, oil on canvas, 25 × 30 in. (63.5 × 76.2 cm), Private Collection, Washington, D.C.; *Descending from the Bus*, c. 1910, oil on canvas, 25 × 30 in. (63.5 × 76.2 cm), Collection IBM Corporation; *The Green Car*, 1910, oil on canvas, 24 × 30 in. (61 × 76.2 cm), Metropolitan Museum of Art, New York, Hearn Fund, 1937 (37.73). See also *Woman with Umbrella, Washington Square* (BF694) and *Washington Square* (BF696).

1 Albert C. Barnes check no. 2589, March 31, 1913, $400.00, payable to Wm. J. Glackens in "payment for the 'Street Cleaners,'" BFFR, BFA. Letter, William Glackens to Barnes, undated [April 1913], ACB Corr., BFA: "Royal Cortissoz has an exceedingly stupid, for him, article on post-impressionism . . . in this months Century. Received the check for the Street Cleaners O.K."

## *Pony Ballet*
Alternate title: *The Pony Ballet*

1910–early 1911. Oil on canvas, 48 × 30 in. (121.9 × 76.2 cm). Signed lower right: W. Glackens. Frame by Newcomb-Macklin Co., stamped twice, lower frame member verso: Newcomb Macklin Co. / Chicago & New York. BF340

PROVENANCE: Acquired from the artist, January 20, 1913.[1]

EXHIBITION: Folsom Galleries, New York, March 1–17, 1913.

REFERENCES: Listed by Glackens in sketchbook 94.99 ("Bellport 1913") (Museum of Art Fort Lauderdale) in a list of paintings to be included in the artist's Folsom Gallery exhibition, March 1–17, 1913, and probably lent anonymously to that show by Barnes. First described in an unsigned article written by James Huneker, "Seen in the World of Art: William Glackens Shows His Versatility," *New York Sun*, December 18, 1910, Section III, 4: "Glackens has in his studio, South Washington Square, a large canvas, a study of some girls, possibly vaudeville 'artistes,' on which he daily practices his colored scales, trills and arpeggios. He redresses one of the ladies in gorgeous array each day and you watch, with curiosity growing apace, the kaleidoscopic hues that come and go on this canvas. Somehow the picture symbolizes the present state of Glackens' artistic health." Other reviews include "Mr. Glackens' Art Combines Old and New," *New York Herald*, March 3, 1913: "Another figure subject, 'Pony Ballet,' is startling as to color and also as to attitude, emphasizing the forced postures of the ballet"; "Glackens at Folsom's," *American Art News*, March 8, 1913, 7: "'The Pony Ballet,' seen last year at the MacDowell Club, is here with its bad drawing, wooden legs and striped corsages"; "News and Notes of the Art World," *New York Times*, March 9, 1913, 67: "The 'Pony Ballet,' too, so rich in merits of color and placing and so bold in execution, yet again puny and boneless arms too small for the girded figures. Perhaps there is no painter in the present generation who can succeed and fail so courageously in the same moment"; "Art Notes: Paintings by William Glackens," *New York Evening Post*, March, 8, 1913, 9: "If one is at all reminded of Renoir by looking at the collection of Mr. Glackens's work, which is now on view at the Folsom gallery, the thought of slavish imitation never arises, but rather the thought of artistic affinity. . . . In Pony Ballet one meets again with inadequate drawing, but these shortcomings are not sufficient to diminish the rare pleasure which this exhibi-

tion gives. . . . Mr. Glackens is one of the really important figures in American art, and his exhibition should not be missed by those interested in what our more vital artists have to say"; Charles H. Caffin, "18 Canvases by Glackens on View," *New York American*, March 10, 1913, 8: "In this group of eighteen canvases are included two nudes, several studies of the clothed model, a race track, pony ballet"; Guy Pène du Bois, "A Modern American Collection: The Paintings of Contemporary Artists," *Arts and Decoration*, September 1914, 325–26; and Guy Pène du Bois, "William Glackens, Normal Man: The Best Eyes in American Art," *Arts and Decoration*, September 1914, 405, ill. Other references: Mary Mullen, *An Approach to Art* (Merion, Pa.: Barnes Foundation Press, 1923), 55, ill.; de Gregorio, 1955, 585, no. 39; Wattenmaker, 1972, 194–98, 202–03, 261, 295, 354, fig. 141; Ira Glackens, *William Glackens and the Ashcan Group* (New York: Crown, 1957), ill. following 174; Violette de Mazia, "The Case of Glackens vs. Renoir," *BFJAD* 2, no. 2 (Autumn 1971): 12; Violette de Mazia, "Tradition: An Inquiry—A Few Thoughts," *Vistas* 3, no. 1 (1984–86): 78, pl. 68.

RELATED WORK: Preparatory crayon drawing of figure, 8¼ × 5¼ in. (21 × 13.3 cm), in sketchbook 94.112, "W. glackens, Nova Scotia, 1910, North Beach, Swimming Pool," Museum of Art Fort Lauderdale, Nova Southeastern University (fig. 34).

REMARKS: The dating to late 1910–early 1911 is reinforced by a letter from Glackens to A. E. Gallatin, March 18, 1916: "Dr. Barnes told me he would send you photographs of . . . 'Pony Ballet' 1911."[2]

1 Albert C. Barnes check no. 2520, January 20, 1913, $1,000.00, in payment for *Pony Ballet* and "water scene Bellport—Two Girls in Foreground bank" (*Bathing at Bellport*, 1912, Collection the Brooklyn Museum no. 67.24.6, Bequest of Laura L. Barnes), BFFR, BFA. On the check stub is written: "W. J. Glackens 2 paintings, viz: Pony Ballet Bellport scene $1000.00."

2 Albert E. Gallatin Papers, 1898–1951, courtesy of the New-York Historical Society.

FIG. 34

William J. Glackens, Preparatory drawing of figure for *Pony Ballet* (BF340) in "W. glackens, Nova Scotia, 1910, North Beach, Swimming Pool" (sketchbook), 1910, crayon on paper, 8⁵⁄₁₆ × 5⅜ in. (21.1 × 13.7 cm), Museum of Art Fort Lauderdale, Nova Southeastern University, Bequest of Ira Glackens, 94.112

## Sleeping Girl
Alternate titles: *Sleeping Nude; Seated Nude; Nude Figure; Nude Asleep*

c. 1912. Oil on canvas, 32⅞ × 26⅜ in. (83.5 × 67 cm).
Signed lower right: W. Glackens. BF521

PROVENANCE: Acquired from the artist, May 3, 1913.[1]

EXHIBITION: Folsom Gallery, New York, March 1–17, 1913.

REFERENCES: "Mr. Glackens' Art Combines Old and New," *New York Herald*, March 3, 1913: "He Shows Conventional Nude 'Traversed by Blue and Green Lights'"; "Glackens at Folsom's," *American Art News*, March 8, 1913, 7: "'Sleeping Girl' is better drawn, but the flesh is too blue and cold"; Charles H. Caffin, "18 Canvases by Glackens on View," *New York American*, March 10, 1913, 8; "News and Notes of the World," *New York Times*, March 9, 1913, 67: "He does superb things like that richly modeled chest of the sleeping girl, and is suddenly pulled up by getting weak and breathless over the arm"; Guy Pène du Bois, "William Glackens, Normal Man: The Best Eyes in American Art," *Arts and Decoration*, September 1914, ill. 405 (as *A Recent Nude*); Wattenmaker, 1972, 242, 276–77, 295, 447–48, fig. 166 (as *Seated Nude*); Violette de Mazia, "The Case of Glackens vs. Renoir," *BFJAD* 2, no. 2 (Autumn 1971): 12, pl. 11.

1  Albert C. Barnes check no. 2636, May 3, 1913, $500.00, for "W. J. Glackens painting 'Sleeping Nude,'" BFFR, BFA.

## Head of Girl, Feather in Turban
Alternate title: *Portrait in Blue—Miss Clark*

c. 1912. Oil on canvas, 32 × 26 in. (81.3 × 66 cm). Signed lower left: W. Glackens. Frame by Robert Laurent, signed left frame member verso: Laurent. BF355

PROVENANCE: Acquired from the artist.

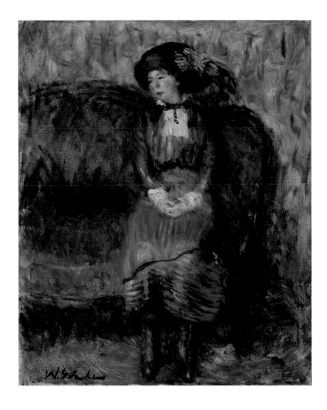

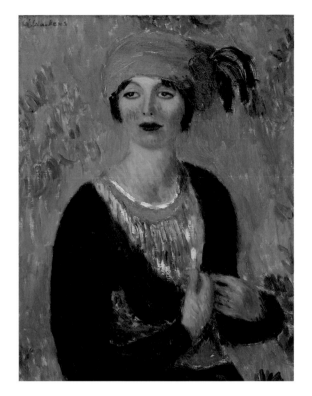

*Woman Seated on Red Sofa*
Alternate titles: *Woman on Sofa; Girl Seated on Sofa*
c. 1912–13. Oil on canvas, 17¾ × 14¼ in. (45.1 × 36.2 cm).
Signed lower left: W. Glackens. BF306

PROVENANCE: Acquired from the artist.

REFERENCES: Albert C. Barnes, *The Art in Painting*, 501;
de Gregorio, 1955, 449, no. 34; Ira Glackens, *William Glackens
and the Ashcan Group* (New York: Crown, 1957), ill. follow-
ing 174 (as 1910); Wattenmaker, 1972, 254.

*Girl in Green Turban*
Alternate title: *Girl with Green Turban*
c. 1913. Oil on canvas, 24 × 18 in. (61 × 45.7 cm).
Signed upper left: W. Glackens. BF172

PROVENANCE: Acquired from the artist.

REFERENCES: Forbes Watson, *William Glackens* (New York:
Duffield, 1923); Forbes Watson, "William Glackens," *Arts*,
April 1923, 254; Albert C. Barnes, *The Art in Painting*, 296;
Wattenmaker, 1972, 250–51, 255, 271, 288, 301, fig. 157; Violette
de Mazia, "The Case of Glackens vs. Renoir," *BFJAD* 2, no. 2
(Autumn 1971): 15; Violette de Mazia, "The Barnes Founda-
tion: The Display of Its Art Collection," *Vistas* 2, no. 2 (1981–
83): 109 n. 111, pl. 59; R. J. Wattenmaker, "Dr. Albert C. Barnes
and The Barnes Foundation," in *Great French Paintings from
The Barnes Foundation: Impressionist, Post-Impressionist, and
Early Modern* (New York: Knopf in association with Lincoln
University Press, 1993), 18 and 20.

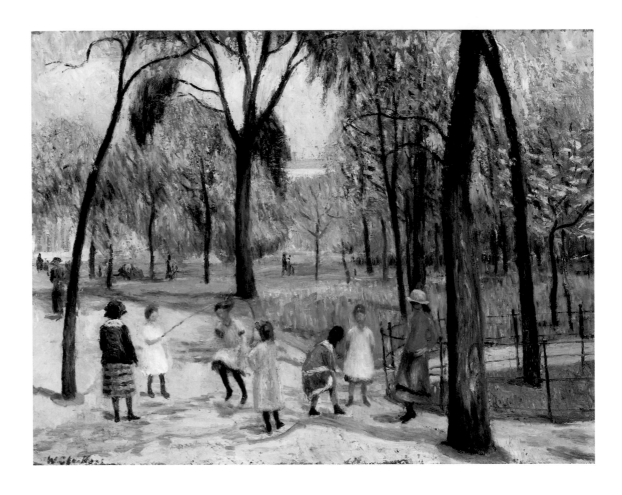

## Children in Washington Square

### Alternate title: *In the Park*

c. 1913. Oil on canvas, 24 × 31⅞ in. (61 × 81 cm). Signed lower left: W. Glackens. Frame by Charles Prendergast. BF485

PROVENANCE: Acquired from the artist.

REFERENCE: Violette de Mazia, "The Case of Glackens vs. Renoir," *BFJAD* 2, no. 2 (Autumn 1971): 23, pl. 37.

RELATED WORKS: Preparatory crayon sketches for composition and figures, signed "W. Glackens N.Y.," n.d. (c. 1913), in sketchbooks 94.90 and 94.107, Museum of Art Fort Lauderdale, Nova Southeastern University (figs. 35 and 36).

## Girl with Flowered Hat

c. 1913. Oil on canvas, 10½ × 6¼ in. (26.7 × 15.9 cm).
Signed lower right: W.G. Frame by Max Kuehne. BF103

PROVENANCE: Acquired from the artist.

REMARKS: The sitter is probably the artist's wife, Edith
Dimock.

## The Brunette

Alternate titles: *Brunette, Girl in Blue-Green;*
*Girl—Green Blouse and Hat*

c. 1913. Oil on canvas, 24¼ × 18⅛ in. (61.6 × 46 cm). Signed
lower left: W. Glackens. Frame by Max Kuehne. BF551

PROVENANCE: Acquired from the artist, October 17, 1917.[1]

REFERENCES: *Town and Country*, April 10, 1917, ill. in color on
cover; "Cover Design," *Town and Country Calendar*, unsigned
text, 8: "The cover of this issue of Town & Country is from
a painting by William J. Glackens which was exhibited at
Mrs. Harry Payne Whitney's studio during the winter season
on one of the three occasions when she had assembled one
of her very interesting 'To Whom Shall I Go for My Portrait'
shows. Everyone who has followed the history of American
art knows Mr. Glackens and realizes his value as a leader
among those who are content not to do the obvious but are
continually experimenting along lines which are certain not
to attain the ready applause provoked by the more obvious
sort of pictures. At the present time Mr. Glackens is conduct-
ing what might be called scientific research in the wide field
of color which at the moment is resulting in a thoughtfully
gorgeous harmony of carefully applied pigment which is in
sympathy with the theories expressed by the French impres-
sionist, Renoir. It is, of course, impossible to give adequate
representation to Mr. Glackens in a reproduction, but Town
& Country feels that not to include so brilliant a painter
among those who have contributed to our covers is to do our
readers a grave injustice." The last three sentences of this text
appear to have been either written by or suggested to the edi-
tor by Barnes. No record of this show has been located, but
the credit for the photograph on the cover reads "Courtesy
of Mrs. H. P. Whitney's Studio." Wattenmaker, 1972, 274–75,
fig. 165 (as *Brunette*).

1  Letter, Albert C. Barnes to William Glackens, October 17, 1917, ACB Corr.,
BFA: "The 18 × 24 [inch] Girl in Blue-Green that was reproduced on the
cover of Town and Country last spring." Albert C. Barnes check no. 4083,
October 17, 1917, $300.00, BFFR, BFA.

## Woman in Red Blouse with Tulips

Alternate titles: *Girl in Red Dress; Girl with Tulips;*
*Girl—Red Dress and Hat*

c. 1913–14. Oil on canvas, 30 × 28 in. (76.2 × 71.1 cm).
Unsigned. BF160

PROVENANCE: Acquired from the artist, September 18, 1915.[1]

REFERENCES: Albert C. Barnes, *The Art in Painting*, 502; Violette de Mazia, "The Case of Glackens vs. Renoir," *BFJAD* 2, no. 2 (Autumn 1971): 11; Wattenmaker, 1972, 243–49, 255, 271, 278–79, 354, 447–50, fig. 153 (as *Woman in Red Blouse*).

1 Albert C. Barnes check no. 3419, September 18, 1915, $500.00, for "Girl with Tulips," BFFR, BFA.

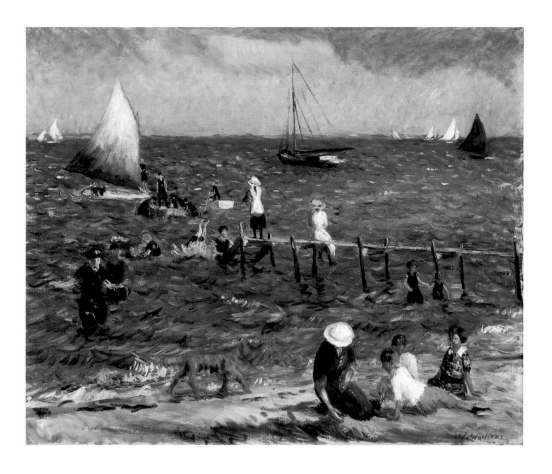

## The Little Pier

*Alternate title: Bathing Scene—Bellport (Red Dog)*

FIG. 37

William J. Glackens, Preparatory drawing for *The Little Pier* (BF497) in "W. Glackens Bellport, 1914" (sketchbook), 1914, crayon on paper, 5 × 8¼ in. (12.7 × 21 cm), Museum of Art Fort Lauderdale, Nova Southeastern University, Bequest of Ira Glackens, 94.83

1914. Oil on canvas, 25 × 30 in. (63.5 × 76.2 cm). Signed lower right: W. Glackens. Frame by Robert Laurent, signed lower frame member verso: Laurent. BF497

PROVENANCE: Acquired from the artist, March 18, 1915.[1]

EXHIBITION: Pennsylvania Academy of the Fine Arts, One Hundred and Tenth Annual Exhibition, February 7–March 28, 1915, cat. no. 527.

REFERENCES: W.H. de B. Nelson, "Philadelphia's Hundred and Tenth Annual," *International Studio*, March 1915: "The American artist yields to nobody in landscape painting optically observed, and here we have the key-note of the exhibition. The visitor who goes with a fresh eye, to whom all the pictures are hitherto unknown quantities, can assuredly come away rejoicing. Why must we forego animal subjects? True, W. Glackens gives us a vermilion dog by the seashore"; Wattenmaker, 1972, 290, 292–94, 301, fig. 180; R.J. Wattenmaker, "William Glackens's Beach Scenes at Bellport," *Smithsonian Studies in American Art* 2, no. 2 (Spring 1988): 89, 90, fig. 20 (as 1915).

RELATED WORK: Preparatory drawing in sketchbook 94.83, "W. Glackens Bellport, 1914," Museum of Art Fort Lauderdale, Nova Southeastern University (fig. 37).

1 Albert C. Barnes check no. 3256, March 18, 1915, $500.00, payable to Wm. J. Glackens, BFFR, BFA, enclosed with letter, Barnes to William Glackens, March 29, 1915: "I enclose check for five hundred dollars for 'The Little Pier,' which I expect to obtain today from the Pennsylvania Academy." Letter, Glackens to Barnes, undated [late March or early April 1915]: "I have instructed the Pennsylvania Academy to deliver 'The Little Pier' to you at your 40th St. place unframed. You can easily take it out [to Merion] in the car. Otherwise they would have had to box it separately at considerable expense to themselves." Both letters ACB Corr., BFA.

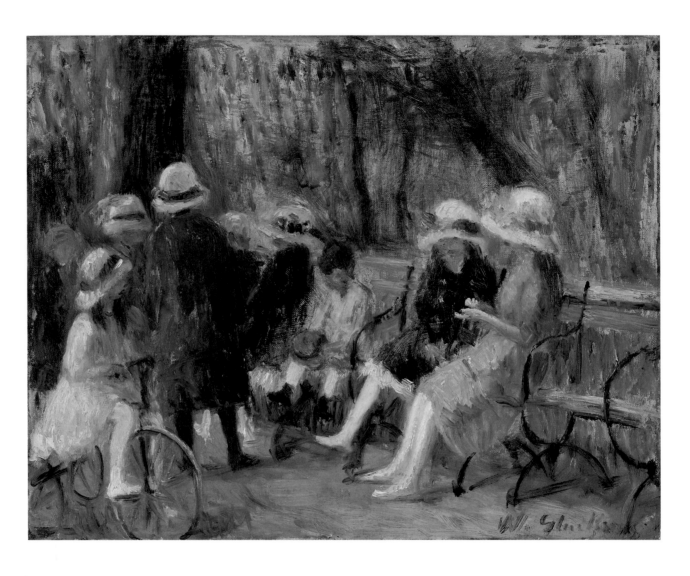

## Children in the Park

Alternate title: *Children in Park*

c. 1914. Oil on canvas, 13¼ × 16⅝ in. (33.7 × 42.2 cm).
Signed lower right: W. Glackens. BF179

PROVENANCE: Acquired from the artist.

REFERENCE: Wattenmaker, 1972, 288–89, fig. 176.

RELATED WORKS: Two preparatory crayon sketches in
unnumbered sketchbook, "New York 1914" (also used at
Bellport, Long Island), 5 × 8¼ in. (12.7 × 21 cm), Museum of
Art Fort Lauderdale, Nova Southeastern University (figs. 38
and 39).

FIGS. 38–39

William J. Glackens, Preparatory drawings for
*Children in the Park* (BF179) in "New York 1914"
(sketchbook), 1914, crayon on paper, 5 × 8¼ in.
(12.7 × 21 cm), Museum of Art Fort Lauderdale,
Nova Southeastern University

## Landscape—Factories
### Alternate title: *The Factories*

FIG. 40

William J. Glackens, Preparatory sketch for *Landscape—Factories* (BF590) in "W. Glackens, Bellport 1914, Staten Island, Skating" (sketchbook), 1914, crayon on paper, 5 × 8¼ in. (12.7 × 21 cm), Museum of Art Fort Lauderdale, Nova Southeastern University, Bequest of Ira Glackens, 94.83

c. 1914. Oil on canvas, 18 × 30 in. (45.7 × 76.2 cm). Signed lower right: W. Glackens. Frame by Charles Prendergast, signed upper frame member verso: Prendergast. BF590

PROVENANCE: Acquired from the artist.

RELATED WORKS: Crayon sketch in sketchbook 94.83, "W. Glackens, Bellport, 1914, Staten Island, Skating" Museum of Art Fort Lauderdale, Nova Southeastern University (fig. 40); *River Factory*, oil on board, 12 × 16 in. (30.5 × 50.6 cm), Shannon's Fine Art Auctioneers, Greenwich, Conn., sale no. 102104, October 21, 2004, lot 36, ill.

## Decoration

Alternate titles: *Krishna and the Foolish Maidens; Krishna; Krishna and the Milkmaids; Hindu Legend; Oriental*

c. 1914. Oil and tempera on canvas, 17½ × 23 in. (44.5 × 58.4 cm). Signed lower left and lower right: W. Glackens. BF256

PROVENANCE: Acquired from the artist, March 18, 1915, for $300.00.[1]

EXHIBITION: Montross Gallery, New York, Exhibition of Paintings, Drawings and Sculpture, March 23–April 24, 1915. Two decorative canvases were included in the show, cat. no. 27 (*Krishna and the Gobis*) and cat. no. 28 (*Hindu Legend*), with no dimensions given. Paper label on left stretcher member of *Decoration* reads "# 28 / Glackens."

REFERENCES: "The 'Very Latest' at Montross Gallery," *American Art News*, March 27, 1915, 2: "William J. Glackens, with curious methods presents some quite well realized illustrations of Hindoo mythology"; de Gregorio, 1955, 256 n. 1, cites a letter from Ira Glackens, February 24, 1955: "About 1916 [*sic*], when we lived at 29 Washington Square, we needed a new lamp shade for a large standing lamp. Shades were very expensive as well as hideous in those days, so father undertook to paint one. I remember he got some books on Hindu mythology out of the library . . . and painted scenes from it around the lamp shade. . . . Father was totally disinterested in religion or theology, and the Hindu [*sic*] subjects were investigated purely for their pictorial possibilities"; Violette de Mazia, "The Case of Glackens vs. Renoir," *BFJAD* 2, no. 2 (Autumn 1971): 17n, pl. 39; Wattenmaker, 1972, 286–87, 286, n. 1 (as "Hindu Legend"); Violette de Mazia, "Subject and Subject Matter: Part II," *Vistas* 2, no. 2 (1981–83): 14n, pl. 87.

RELATED WORKS: Of eight crayon drawings in Glackens's undated sketchbook 94.89, Museum of Art Fort Lauderdale, Nova Southeastern University, one can be considered preparatory for *Decoration* (fig. 41). Six works based on this theme are in the collection of the Museum of Art Fort Lauderdale, acc. nos. 91.40.313, 94.5, 94.71, 94.74, 97.27, and a three-section wood carving designed by Glackens and probably executed by Charles Prendergast (Sansom Foundation, on loan to Museum of Art Fort Lauderdale, no. G12 A-C).[2]

REMARKS: The subject is Buddhist, not Hindu. The exotic motifs found in this series of works, including the carving, were inspired by Vincent A. Smith, *A History of Fine Art in India and Ceylon* (Oxford: Clarendon Press, 1911), with 386 illustrations, which is noted in Glackens's undated sketchbook no. 94.89 (Museum of Art Fort Lauderdale). Glackens probably lent this book to Maurice Prendergast, who also derived motifs for a number of paintings and several watercolors of c. 1912 directly from images reproduced in it. The Prendergast brothers moved to New York by November 1, 1914, renting the entire floor below Glackens's third-floor studio at 50 South Washington Square.[3]

1 Barnes Foundation file card and Albert C. Barnes check no. 3246, March 18, 1915, $500.00, payable to Wm. J. Glackens, BFFR, BFA. Letter, Barnes to William Glackens, March 18, 1915: "I enclose a check for five hundred dollars, which represents as near as I am able to determine, fair payment for the 'Decoration' and the 'Girl with Yellow Shoes.' . . . The 'Decoration' is about 17" × 21", which brings it approximately in the 18" × 24" class, and for three of these which I got from you last summer I paid you two hundred dollars apiece; but for the 'Decoration' I have placed three hundred dollars as the price. . . . I do not consider that sentiment or friendship should cut any figure whatever in the matter. If I did not like your work, the fact that I know you would have absolutely no influence in inducing me to buy your pictures. The fact that you know me should not influence the prices which you feel that you should get for your work. . . . If this check closes the transaction, I would want the 'Decoration' immediately at the end of the present Montross exhibition and not have it sent to any other show." Letter, Glackens to Barnes, undated [c. mid-March, 1915]: "Have received your letter and have noted your remarks on art and business. The amount of the check is O.K. . . . You will get the decoration immediately after the show." Both letters ACB Corr., BFA. *Girl with Yellow Shoes* cannot be identified.

2 See W. H. Gerdts and J. H. Santis, *William Glackens* (Fort Lauderdale: Museum of Art; New York: Abbeville Press, 1996), 129, 132–33, 199.

3 Letter, Charles Prendergast to Edward Root, January 8, 1915, Edward W. Root Papers, Munson-Williams-Proctor Institute, Utica, New York.

FIG. 41

William J. Glackens, Preparatory drawing for *Decoration* (BF256) in untitled sketchbook, n.d., crayon on paper, 8¼ × 5¼ in. (21 × 13.3 cm), Museum of Art Fort Lauderdale, Nova Southeastern University, Bequest of Ira Glackens, 94.89

## The Raft

Alternate titles: *Water Scene; The Sliding Board*

1915. Oil on canvas, 25 × 30 in. (63.5 × 76.2 cm). Signed lower right: W. Glackens. BF701

PROVENANCE: Acquired from the artist, March 28, 1916.[1]

EXHIBITIONS: Pennsylvania Academy of the Fine Arts, Philadelphia, 111th Annual Exhibition, February 6–March 26, 1916, 2nd ed. of catalogue, 34, cat. no. 159 (as *The Sliding Board*); Whitney Museum of American Art, New York, William Glackens Memorial Exhibition, December 14, 1938–January 15, 1939, cat. no. 62, ill. ("Lent by The Barnes Foundation").

REFERENCES: Forbes Watson, "William Glackens," *Arts*, April 1923, 256; Forbes Watson, *William Glackens* (New York: Duffield, 1923), ill. and reproduced on dust jacket cover; Albert C. Barnes, *The Art in Painting*, 500–501; Guy Pène du Bois, *William J. Glackens* (New York: Whitney Museum of American Art, 1931), 38–39; Royal Cortissoz, "The Paintings of William J. Glackens," *New York Herald Tribune*, October 18, 1938, section VI, 8; de Gregorio, 1955, 219, 220, pl. XLVIII, 221, 499, no. 94; Violette de Mazia, "The Case of Glackens vs. Renoir," *BFJAD* 2, no. 2 (Autumn 1971): 24–25; Wattenmaker, 1972, 290–94, 301, fig. 179; Violette de Mazia, "*E Pluribus Unum*," *BFJAD* 7, no. 1 (Spring 1976): 6, 13, 16; Violette de Mazia, "*E Pluribus Unum—*

Cont'd," *BFJAD* 7, no. 2 (Autumn 1976): 23; Violette de Mazia, "Subject and Subject Matter, Part II: Instrumentalism," *Vistas* 2, no. 2 (1981–83): 3–58; R. J. Wattenmaker, "William Glackens's Beach Scenes at Bellport," *Smithsonian Studies in American Art* 2, no. 2 (Spring 1988): 89; Violette de Mazia, "The Form of Seurat's 'The Models': An Analytical Study," *Vistas* 5, no. 1 (Spring–Summer 1990): 15.

RELATED WORKS: Two preparatory crayon sketches in sketchbook 94.46.8, "Bellport, 1915," Snite Museum of Art, University of Notre Dame, Gift of the Sansom Foundation (figs. 42 and 43). See also *The Water Slide*, oil on canvas, 25 × 30 in. (63.5 × 76.2 cm), Herbert F. Johnson Museum of Art, Cornell University, with preparatory drawings in same sketchbook (94.46.8).

1  Albert C. Barnes check no. 3587, March 28, 1916, $500.00, payable to W. J. Glackens, BFFR, BFA. Letter, Barnes to William Glackens, March 28, 1916, ACB Corr., BFA: "I enclose check for five hundred dollars ($500.00) in payment for the 'Sliding Board,' which I got from the Pennsylvania Academy yesterday. I wish you would see Charley [Prendergast] and let me know when I may expect the frame." The painting no longer has a Prendergast frame.

FIGS. 42–43

William J. Glackens, Preparatory sketches for *The Raft* (BF701) in "Bellport, 1915" (sketchbook), 1915, crayon on paper, 5¼ × 8¼ in. (13.3 × 21 cm), The Snite Museum of Art, University of Notre Dame, Gift of the Sansom Foundation, 94.46.8

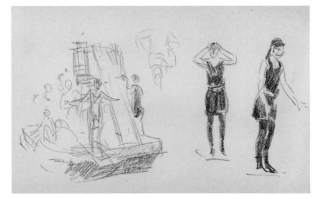

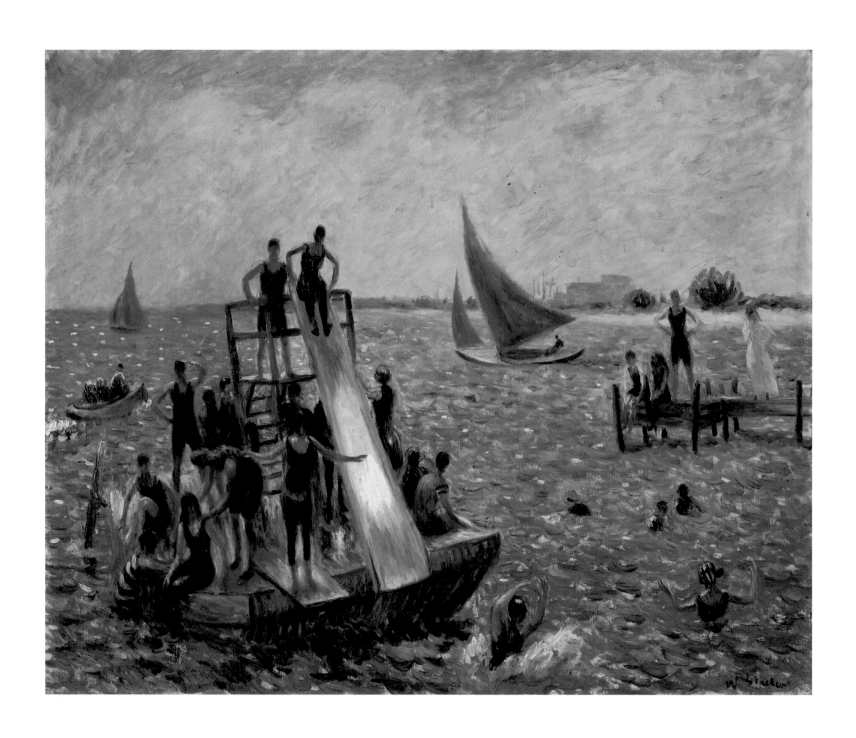

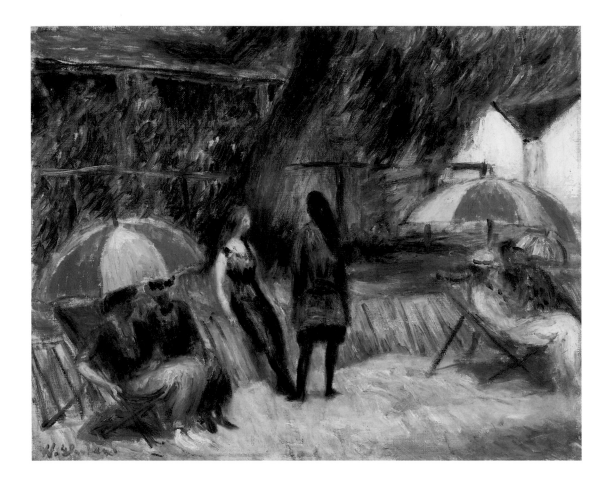

## Beach with Figures, Bellport
Alternate title: *Bathers Resting*

FIG. 44

William J. Glackens, Preparatory sketch for *Beach with Figures, Bellport* (BF175) in "Bellport 1915" (sketchbook), 1915, crayon on paper, 5¼ × 8¼ in. (13.3 × 21 cm), The Snite Museum of Art, University of Notre Dame, Gift of the Sansom Foundation, 1994.046.002

c. 1915. Oil on canvas, 12¼ × 15½ in. (31.1 × 39.4 cm). Signed lower left: W. Glackens. Frame by Charles Prendergast, signed lower frame member verso: Prendergast. BF175

PROVENANCE: Acquired from the artist.

REFERENCES: A. E. Gallatin, "William Glackens," *American Magazine of Art*, May 1916, 261–62, *Beach Scene, Long Island*, crayon and pastel, ill. 261. See also R. J. Wattenmaker, "William Glackens's Beach Scenes at Bellport," *Smithsonian Studies in American Art* 2, no. 2 (Spring 1988): 89–90.

RELATED WORKS: Preparatory crayon sketch in sketchbook 94.46.2, "Bellport 1915," Snite Museum of Art, University of Notre Dame, Gift of the Sansom Foundation (fig. 44). See also *Beach Umbrellas at Blue Point*, c. 1915–16, oil on canvas, 26 × 32 in. (66 × 81.3 cm), National Museum of American Art, Smithsonian Institution, Washington, D.C., acc. no. 1968.1.

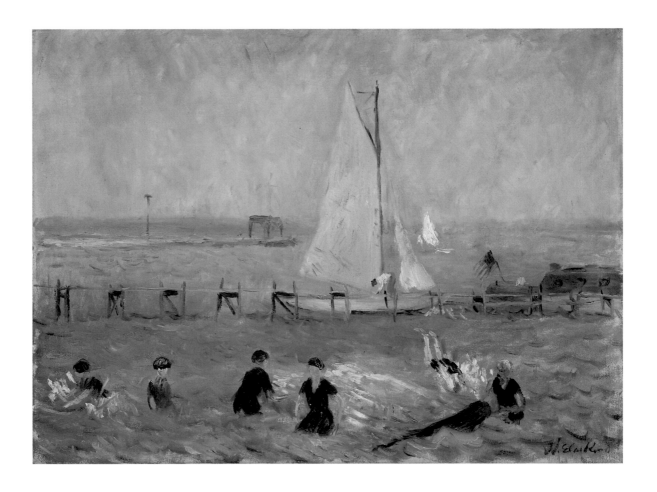

## Seascape with Six Bathers, Bellport

c. 1915. Oil on canvas, 18 × 24⅛ in. (45.7 × 61.3 cm).
Signed lower right: W. Glackens. BF550

PROVENANCE: Acquired from the artist.

RELATED WORK: Preparatory crayon sketch in sketchbook
94.99, "Bellport 1913," Museum of Art Fort Lauderdale, Nova
Southeastern University (fig. 45).

FIG. 45

William J. Glackens, Prepara-
tory sketch for *Seascape with
Six Bathers, Bellport* (BF550)
in "Bellport 1913" (sketch-
book), 1913, crayon on paper,
5⁵⁄₁₆ × 8³⁄₁₆ in. (13.5 × 22.3 cm),
Museum of Art Fort Lauderdale,
Nova Southeastern University,
Bequest of Ira Glackens, 94.99

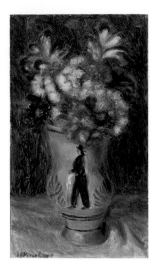

## Flowers in a Quimper Pitcher

Alternate titles: *Flowers in Quimper Vase; Vase of Flowers*

c. 1913–15. Oil on canvas, 15 × 8½ in. (38.1 × 21.6 cm). Signed lower left: W. Glackens. BF247

PROVENANCE: Acquired from the artist.

REFERENCES: Wattenmaker, 1972, 450, 454–57, fig. 225; Violette de Mazia, "The Barnes Foundation: The Display of Its Art Collection," *Vistas* 2, no. 2 (1981–83): 109, 111, pl. 60.

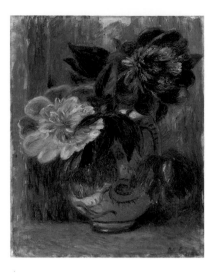

## Tulips and Peonies in Pitcher

Alternate title: *Poppies and Peonies in Pitcher*

c. 1914–15. Oil on canvas, 15½ × 12¼ in. (39.4 × 31.1 cm). Signed lower right: W. Glackens. Frame by Charles Prendergast, signed upper frame member verso: Prendergast. BF178

PROVENANCE: Acquired from the artist.

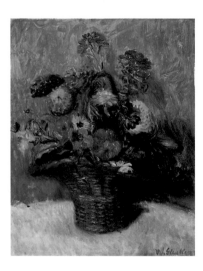

## Red Basket of Zinnias

Alternate titles: *Basket of Flowers; Flowers*

1915. Oil on canvas, 15½ × 12⅜ in. (39.4 × 31.4 cm). Signed lower right: W. Glackens. BF305

PROVENANCE: Acquired from the artist, December 1, 1915, for $200.00.[1]

1 A typewritten account dated January 1, 1916, records Albert C. Barnes check no. 3477, December 1, 1915, $1,000.00, and check no. 3507, January 1, 1916, $650.00, in payment for six pictures and frames ($50.50 of the total), including one entitled *Basket of Flowers* and five other paintings. Account ACB Corr., BFA; checks BFFR, BFA. See also letter, Barnes to William Glackens, December 20, 1915, ACB Corr., BFA: "I have decided to go to New York tomorrow (Tuesday). . . . I shall bring back with me your basket of flowers and its frame."

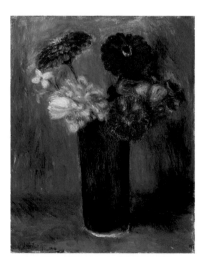

## Flowers in a Blue Vase

Alternate title: *Blue Vase with Flowers*

c. 1915. Oil on canvas, 12⅝ × 9⅞ in. (32.1 × 25.1 cm). Signed lower left: W. Glackens. Frame by Charles Prendergast. BF330

PROVENANCE: Acquired from the artist.

REFERENCE: Violette de Mazia, "The Barnes Foundation: The Display of Its Art Collection," *Vistas* 2, no. 2 (1981–83): 109, 111, pl. 60 (installation view).

## Zinnias in a Striped Blue Vase
Alternate title: *Zinnias*

c. 1915. Oil on canvas, 10⅝ × 7⅛ in. (27 × 18.1 cm).
Signed lower left: W. Glackens. BF2069

PROVENANCE: Acquired from the artist.

REFERENCE: Violette de Mazia, "The Case of Glackens vs. Renoir," *BFJAD* 2, no. 2 (Autumn 1971): 25, pl. 2.

## Flowers

c. 1915–16. Oil on canvas, 12⅝ × 9¾ in. (32.1 × 24.8 cm).
Signed lower left: Glackens. Frame by Charles Prendergast.
BF594

PROVENANCE: Acquired from the artist.

## Flowers in Blue and White Checkered Vase
Alternate title: *Blue Vase with Flowers and Bouquet*

c. 1915–16. Oil on canvas, 12¼ × 9½ in. (31.1 × 24.1 cm).
Signed lower right: W. Glackens. BF2068

PROVENANCE: Acquired from the artist.

REFERENCE: Violette de Mazia, "The Case of Glackens vs. Renoir," *BFJAD* 2, no. 2 (Autumn 1971): 5–6, pl. 5.

## Green Bowl of Flowers
Alternate title: *Bowl of Flowers*

c. 1916. Oil on canvas, 10½ × 13¼ in. (26.7 × 33.7 cm).
Signed lower left: W. Glackens. BF267

PROVENANCE: Acquired from the artist.

REFERENCE: Albert C. Barnes, *The Art in Painting*, 501: "The rendering of the color-values, which make the definition between the flowers, jar and background, is so subtle that it is impossible to say how it is accomplished. The whole painting is of a floating, delicate lightness that can be compared only to a rich foam. Here . . . Glackens has taken Renoir's color forms and rendered them in his own terms, so that something new emerges, reminiscent of Renoir only in the quality of color and its activity in knitting together the whole painting."

## Sunday on the Marne

Alternate titles: *French Open Air Café; Outdoor Restaurant; Outdoor Café—St. Cloud, France; Outdoor Restaurant, St. Cloud*

c. 1915–16. Oil on canvas (later mounted on hardboard), 25¾ × 32¼ in. (65.4 × 81.9 cm). Signed lower right: W. Glackens. Frame by Charles Prendergast, signed upper frame member verso: Prendergast. BF2033

PROVENANCE: Acquired from the artist, January 17, 1917, for $900.00 ($65.00 additional for the frame).[1]

EXHIBITION: Daniel Gallery, New York, January 17–30, 1917, cat. no. 1.

REFERENCES: Catherine Beach Ely, "The Modern Tendency in Lawson, Lever and Glackens," *Art in America*, December 1921, ill. (as "*French Open Air Café* [Collection of Dr. A. C. Barnes]"); Forbes Watson, "William Glackens," *Arts*, April 1923, 260, ill. (as *Outdoor Restaurant*); Forbes Watson, *William Glackens* (New York: Duffield, 1923), ill.; Suzanne LaFollette, *Art in America* (New York and London: Harper and Brothers, 1929), 323–24: "In such pictures . . . as 'Outdoor Restaurant,' or the later beach scenes, the figures are approached in much the same manner as in earlier canvases similar in subject, and . . . the artist retains his amused perception of the individual characteristics and idiosyncrasies which give kaleidoscopic variety to a crowd"; de Gregorio, 1955, 212, 216–17, 496, no. 81 (as "Outdoor Restaurant, St. Cloud"); Wattenmaker, 1972, 282–84, 287–88, 432, fig. 173.

RELATED WORKS: *Outdoor Restaurant*, 1906, oil on wood panel, 10 × 13½ in. (25 × 33.5 cm), unsigned, courtesy Krau-shaar Galleries (fig. 46); study of singer and musician in sketchbook 94.86, "W. Glackens New Castle [Rhode Island] 1909," Museum of Art Fort Lauderdale, Nova Southeastern University (fig. 47); preparatory crayon sketch of composition in sketchbook 94.131, "W. Glackens, Paris & New York," Museum of Art Fort Lauderdale, Nova Southeastern University (fig. 48); *A Café Scene*, c. 1915, pastel and crayon on paper, 10 × 14½ in. (25.4 × 36.8 cm) (sight), unsigned, verso of double-sided pastel, formerly Collection Violette de Mazia (fig. 49), cited in *The Art of William Glackens*, exh. cat., special issue, [Rutgers] *University Art Gallery Bulletin* 1, no. 1 (January 1967): cat. no. 59 (as "Pastel Study for Outdoor Restaurant, St. Cloud," c. 1913). *Sunday on the Marne* is noted by the artist in a list and diagram found in sketchbook 94.94 (1916, Museum of Art Fort Lauderdale) indicating its placement in an exhibition at the Daniel Gallery, New York (Oils by William J. Glackens and Hamilton Easter Field—Sculpture by [Robert] Laurent, January 17–30, 1917). The diagram is a schematic sketch of *Sunday on the Marne* as the center of one wall in the gallery.

REMARKS: *Sunday on the Marne* has a complex evolution. The above-mentioned oil study (fig. 46) dates from 1906, when Glackens was in France visiting Alfred Maurer, who lived in Chézy-sur-Marne, near Château-Thierry. Its paint handling is brisk and summary, the color scheme subdued but enlivened by notes of red and blue and the deep green

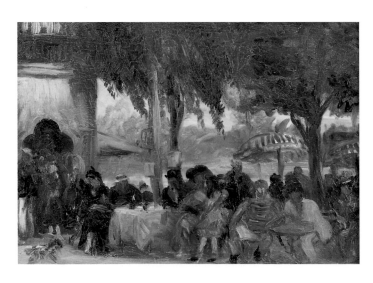

FIG. 46

William J. Glackens, *Outdoor Restaurant*, 1906, oil on wood panel, 10 × 13½ in. (25.4 × 33.3 cm), courtesy Kraushaar Galleries, New York

FIG. 47

William J. Glackens, Preparatory sketch for *Sunday on the Marne* (BF2033) in "W. Glackens, New Castle [Rhode Island] 1909" (sketchbook), 1909, crayon on paper, 8⁵⁄₁₆ × 5¼ in. (21.1 × 13.3 cm), Museum of Art Fort Lauderdale, Nova Southeastern University, Bequest of Ira Glackens, 94.86

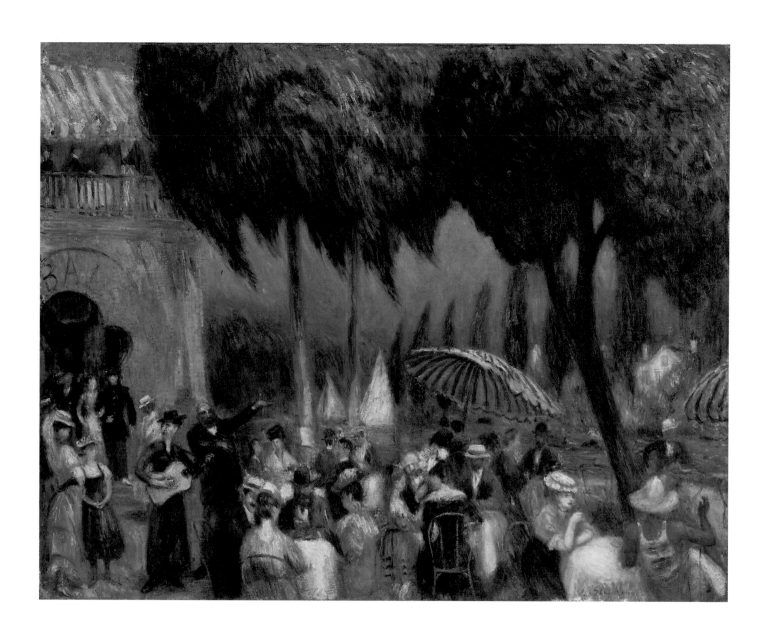

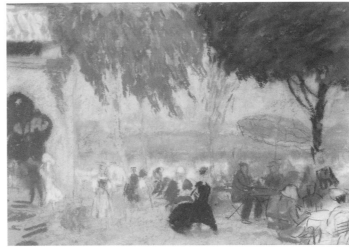

FIG. 48

William J. Glackens, Preparatory sketch for *Sunday on the Marne* (BF2033) in "W. Glackens, Paris & New York" (sketchbook), n.d. [1906], crayon on paper, 5⅛ × 8⁵⁄₁₆ in. (13 × 21.1 cm), Museum of Art Fort Lauderdale, Nova Southeastern University, Ira Glackens Bequest, 94.131

FIG. 49

William J. Glackens, *A Café Scene*, study for *Sunday on the Marne* (BF2033), c. 1915, pastel and crayon on paper, 10 × 14½ in. (25.4 × 36.8 cm) (sight), Private Collection

of the overhanging tree branches. The oil study (fig. 46) and compositional drawing (fig. 48) were not enlarged in format until ten years later, when the artist returned to the composition. At that time, c. 1915, he made a sketchy pastel in bright tonalities very different from his subdued color schemes of 1906 but which retains much of the composition, with overhanging trees and a Moorish-style archway. Glackens introduced a woman wearing a hat and playing guitar, and a male singer in front of the entrance at left based on a sketch in a 1909 sketchbook (fig. 47), and others seated at tables in the foreground under red and white striped umbrellas seen in figure 46. In the final composition, there are numerous standing figures, the guitarist and gesturing singer are reversed, and the entire foreground is animated, almost like a stage or opera set, in its placement of intensely colorful figures from one side to the other across the foreground and middle ground. The dramatic silhouette of the overhanging tree foliage closely resembles that of *From Under Willows*, a canvas of the same dimensions, painted c. 1914–15 (formerly Collection Mary and Nelle E. Mullen).

1 Letter, Albert C. Barnes to William Glackens, January 17, 1917: "I want a Prendergast frame for the painting 'Sunday on the Marne.' Kindly give him the measurements, and ask him to have the frame ready for you to send to me with the painting when your show at Daniel's closes. The price agreed upon is nine hundred ($900) Dollars, net to you for the painting, and I will pay either you or Prendergast whatever he charges for the frame. . . . I do not want that Marne picture to go to the Chicago show, but I am willing to lend you one of your late ones which I have, in case you are short." Letter, Barnes to Glackens, January 24, 1917: "Let me know definitively by Saturday if you want me to send my Beach Scene to Daniel for the Chicago show. If that show falls through, please have Daniel send with my Marne picture, the 'Girl with the Fox Furs,' and the 'Head of a Girl,' hanging on the wall opposite to it. I agree to pay for these pictures Four Hundred Fifty ($450) and Three Hundred Seventy-Five ($375) respectively, including the frames, which are the amounts they would net you if Daniel sold them at the prices which he has upon them. Should Prendergast fail to deliver the Marne frame as promised, send the pictures without waiting for it." (*Girl with the Fox Furs* may be BF2000; *Head of Girl* is unidentified.) Letter, Barnes to Glackens, January 25, 1917: "I received your telegram and am sending to-day to Daniel the Beach Scene without the frame. The frame on the Marne Scene you may use on the picture I am sending you. It is understood that Prendergast is to deliver the frame to Daniel on Monday and that Daniel will send both the frame and the Marne picture to me by express to Overbrook. Tell him to hurry it so that I can receive the picture and close the matter by sending you a check. I hope before the 'Captain's Pier' is sent to the Met that you will have Daniel put a glass on it." (*Captain's Pier*, Collection Mr. and Mrs. Meredith Long, Houston, Texas, which was also in the exhibition, is a Bellport beach scene, painted in 1913, which subsequently belonged to Mary and Nelle Mullen. See *The Mullen Collection* [Philadelphia: Samuel F. Freeman, 1967], 75, no. 46, ill.) Letter, Barnes to Glackens, January 30, 1917: "The framed Marne arrived this morning—thank you for the prompt service." All letters ACB Corr., BFA. Albert C. Barnes check no. 3852, January 30, 1917, $965.00, payable to W. J. Glackens, BFFR, BFA.

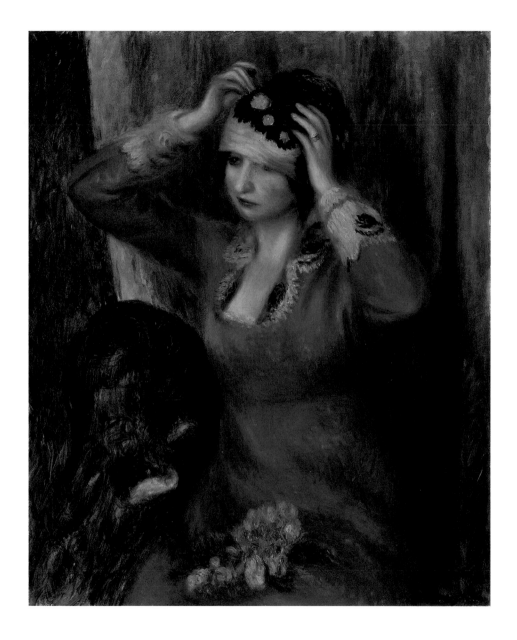

## Girl in Red Dress Pinning on Hat
Alternate titles: *Girl Pinning on Hat; Girl in Red Dress*

c. 1915–16. Oil on canvas, 31¾ × 26 in. (80.6 × 66 cm). Signed lower right: W. Glackens.
Frame by Charles Prendergast. BF174

PROVENANCE: Acquired from the artist.

REFERENCES: *Arts and Decoration*, March 1917, ill. on cover; Forbes Watson, *William Glackens*
(New York: Duffield, 1923), unpaginated (ill. as *Girl Pinning on Hat*); Forbes Watson, "William
Glackens," *Arts*, April 1923, 255; de Gregorio, 1955, 448, no. 28 (as *Girl in Red Dress*, 1917).

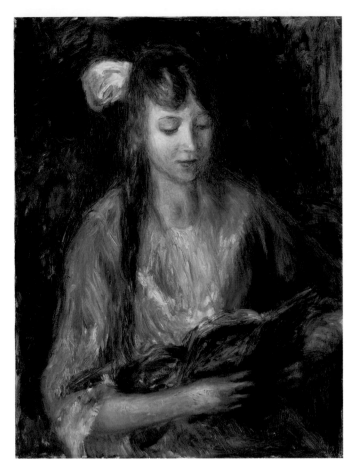

## *Julia Reading*

1915–early 1916. Oil on canvas, 24 × 18 in. (61 × 45.7 cm). Signed upper left: Glackens. BF487

PROVENANCE: Acquired from the artist, February 17, 1916, for $300.00.[1]

REFERENCE: Violette de Mazia, "The Case of Glackens vs. Renoir," BFJAD 2, no. 2 (Autumn 1971): 14, pl. 12.

RELATED WORKS: *Julia*, 1916, oil on canvas, 30 × 25 in. (76.2 × 63.5 cm), London Collection, cited in *William Glackens in Retrospect, 1966–1967*, exh. cat. (Saint Louis: City Art Museum; Washington, D.C.: National Collection of Fine Arts; New York: Whitney Museum of American Art, 1966–67), cat. no. 48, frontispiece (color). *Julia* was also published shortly after it was finished, in A.E. Gallatin, "William Glackens," *Certain Contemporaries* (New York and London: John Lane, 1916), 9: "The Portrait of a Young Girl, also reproduced [property of the artist], was painted early in 1916." The date is confirmed by the artist in a letter to Gallatin, March 18, 1916: "I am sending [a] photograph of one of my latest things Portrait of a Young Girl. 1916."[2] *Head of Julia*, 1916, oil on canvas, 12¾ × 8³⁄₁₆ in. (32.4 × 20.8 cm), Private Collection, is possibly the "Head of Julia" mentioned in a letter from Barnes to Glackens, November 20, 1915, in which he distinguishes between "head of Julia" and "the three-quarter length of Julia," which could refer to *Julia Reading* or to "Julia Holding Flowers," an 18 × 30 in. (45.7 × 76.2 cm) canvas subsequently in the Mullen Collection (now London Collection).[3] "Julia's head" and "Julia Seated" are listed on a January 1, 1916, typewritten account Barnes sent to Glackens with five other pictures including *Red Basket of Zinnias* (BF305).[4] Each of these canvases was painted from the same model, in the same style, and at the same time.

1  Letter, Albert C. Barnes to William Glackens, February 2, 1916, ACB Corr., BFA: "I enclosed check for $321.00 . . . in payment of the 18" × 24" 'Julia reading,' plus the twenty-one dollars for the 26" × 32" frame which you had made for me. The frame on the 18" × 24" I'll return to you as soon as Charley [Prendergast] sends me the one he is making for that picture. At the same time I'll send you a lot of other frames which I have accumulated." Albert C. Barnes check no. 3557, February 17, 1916, for "W. J. Glackens 18 × 24 Julia Reading 26 × 32 frame," BFFR, BFA.

2  Letter, Glackens to A.E. Gallatin, March 18, 1916, Albert E. Gallatin Papers, courtesy of the New-York Historical Society.

3  Letter, Barnes to Glackens, November 20, 1915, ACB Corr., BFA.

4  See entry for Glackens's *Red Basket of Zinnias* (BF305), note 1.

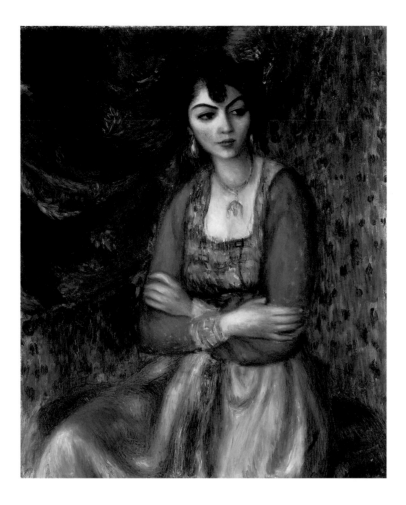

## Armenian Girl

Alternate title: *Girl—Red Sleeves, Green Skirt*

1916. Oil on canvas, 32 × 26 in. (81.3 × 66 cm). Signed lower right: W. Glackens. BF176

PROVENANCE: Acquired from the artist, June 1, 1916, for $500.00.[1]

EXHIBITION: Whitney Museum of American Art, New York, William Glackens Memorial Exhibition, December 14, 1938–January 15, 1939. The painting was not included in the traveling version of the show circulated by the American Federation of Arts.

REFERENCES: *William Glackens Memorial Exhibition*, exh. cat. (New York: Whitney Museum of American Art, 1938), 12, cat. no. 40, ill. ("Lent by The Barnes Foundation"); *Magazine of Art*, January 1939, ill. on cover; Mary Fanton Roberts, "Glackens: Forty Years' Achievement as a Painter of the American Scene Is Presented in This Memorial Show Filling the Entire Whitney Museum of American Art," *Arts and*

FIG. 50

Paul Cézanne, *Madame Cézanne*, c. 1886, oil on canvas, 38¹⁵⁄₁₆ × 30³⁄₁₈ in. (99 × 77 cm), Detroit Institute of Arts, Bequest of Robert H. Tannahill (formerly Collection Albert C. Barnes)

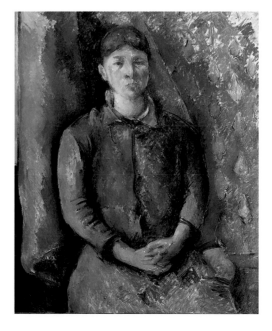

*Decoration*, January 1939, 8–9, 11, 38–39; de Gregorio, 1955, 443, no. 2; Wattenmaker, 1972, 219, 296, 299–301, 311, 314, fig. 184; Ira Glackens, *William Glackens and the Ashcan Group* (New York: Crown, 1957), 257, ill. following 236.

REMARKS: *Armenian Girl* reveals the influence of Paul Cézanne's *Portrait of Madame Cézanne* (fig. 50), acquired from Vollard on December 10, 1912, which Glackens knew from Barnes's collection. Both works depict figures set against patterned walls with a loose, fluid application of paint. For more on Glackens's borrowings from the Cézanne, see page 68.

Edith Dimock wrote to Barnes in 1937: "If you ever decide to liquidate that canvas of Willies, the girl in red jacket with arms folded . . . won't you give me the chance to buy it back?"[2] Barnes expressed his appreciation for the painting, and of Glackens's work as a whole, in his reply on May 14: "Dear Edith, Yes, I'll sell Willie's girl with red jacket for $85,000 cash, and it's cheap for its intrinsic value. About the other numerous canvases of his which we can't hang because of space and necessity of making the collection varied for instructional purposes: none of them are for sale, but as the principles for which we stand expand and become part of the substantial structure of American life, there will be galleries in other cities that need one or more of Willie's pictures, and I shall give them gratis. I expect to give one, and a Prendergast and a Lawson, to the big new museum in Philadelphia next fall. Don't worry that Willie is not yet appreciated: he is in the best company in our gallery and he needs no apology. We talk about him to our students every year, not with emotion as you do, but on the solid rock of permanent place in the great art of all time. A hundred years from now, I'll let you peek down on earth with me and you'll be satisfied with the position he holds with the stars."[3] Additional documentation for *Armenian Girl* is found in correspondence related to the Whitney Museum of American Art for the Glackens Memorial Exhibition in 1938.[4]

1  Albert C. Barnes check no. 3649, June 1, 1916, $800.00, in payment for two paintings, BFFR, BFA. Letter, Barnes to William Glackens, June 1, 1916, ACB Corr., BFA: "If the Armenian Girl does not prove agreeable after I have had it for sometime, I shall ask you to exchange it for one of your other pictures."

2  Letter, Edith Dimock to Barnes, undated [before May 14, 1937], ACB Corr., BFA.

3  Letter (handwritten draft and typed final version), Barnes to Dimock, May 14, 1937, ACB Corr., BFA.

4  See letter, Barnes to Dimock, October 17, 1938, agreeing to lend three paintings, *Race Track*, *The Raft*, and *Armenian Girl*, to the Whitney Museum of American Art for the Glackens Memorial Exhibition; and letter, November 15, 1938, from Hermon More, curator of the Whitney, thanking Barnes for the loan and asking him to complete forms giving the titles and dates of the pictures. More also indicates that Edith Dimock informed him that Barnes was lending three paintings and one drawing to the exhibition, that the drawing had already been delivered to Dimock, and, hence, that it does not appear on the receipt for the three paintings. No drawing was in fact lent to the exhibition. Letter, the Secretary of the Barnes Foundation to the Whitney, November 18, 1938, confirming that the three paintings would be shipped on November 22. All letters ACB Corr., BFA.

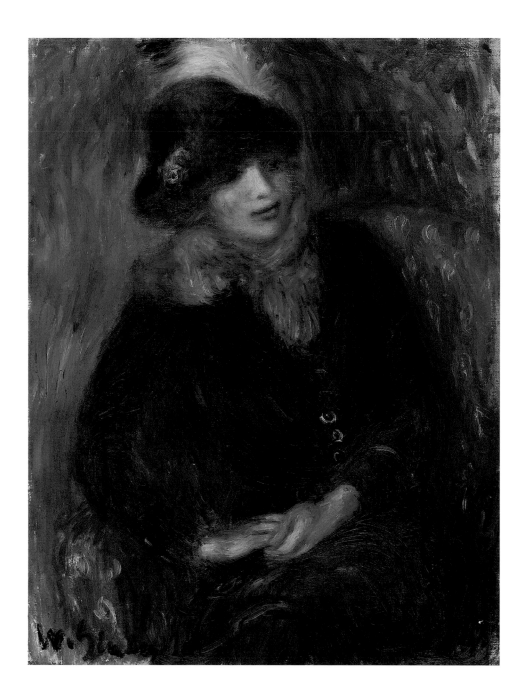

*Seated Woman with Fur Neckpiece
and Red Background*
c. 1916. Oil on canvas, 13¼ × 10 in. (33.7 × 25.4 cm).
Signed lower left: W. Glackens. BF2029

PROVENANCE: Acquired from the artist.

## Lenna with Basket of Flowers
Alternate title: *Lenna and Flowers*

1916. Oil on canvas, 12¾ × 8¼ in. (32.4 × 21 cm). Signed lower left: W.G. Frame by Charles Prendergast. BF338

PROVENANCE: Acquired from the artist.

REFERENCES: De Gregorio, 1955, 546, no. 35 (as c. 1920); Violette de Mazia, "Three Aspects of Art: Their Interrelationships," *BFJAD* 6, no. 2 (Autumn 1975): 18, pl. 64.

RELATED WORKS: Five preparatory drawings in sketchbook 1994.046.001, "Bellport, 1916. Good Harbor Beach, 1919, Gloucester," Snite Museum of Art, University of Notre Dame, Gift of the Sansom Foundation (figs. 51–55).

REMARKS: See entries for two drawings by Lenna Glackens, *Two Figures—Sphinx* (BF758) and *Woman and Dog Under Tree* (BF759).

FIGS. 51–55

William J. Glackens, Preparatory drawings for *Lenna with Basket of Flowers* (BF338) in "Bellport, 1916. Good Harbor Beach, 1919, Gloucester" (sketchbook), 1916, crayon on paper, 8¼ × 5¼ in. (21 × 13.3 cm), The Snite Museum of Art, University of Notre Dame, Gift of the Sansom Foundation, 1994.046.001

## Two Women (One Seated)

c. 1903. Pastel on green wove paper, 13 × 9½ in.
(33 × 24.1 cm). Unsigned. BF2022

PROVENANCE: Acquired from the artist.

RELATED WORK: *Two Women*, pastel on paper, 13 × 9 in.
(32.9 × 22.9 cm), Blanden Memorial Art Museum, Fort Dodge,
Iowa, acc. no. 1952.5, Gift of Albert C. Barnes, the Barnes
Foundation.[1]

REMARKS: Both *Two Women (One Seated)* and the Blanden
pastel are probably related to Glackens's *The Young Bachelor Allowed Himself to Be Led to a Chair*, an illustration for
Charles Paul de Kock, *The Barber of Paris* (Boston: Frederick J.
Quinby, 1903), 1:264.[2]

1 See Margaret Carney Xie, *Handbook of the Collections in the Blanden
  Memorial Art Museum* (Fort Dodge, Iowa: Blanden Charitable Foundation, 1989), ill. 74.
2 See Nancy E. Allen and Elizabeth Hawkes, *William Glackens: A Catalogue of His Book and Magazine Illustrations* (Wilmington: Delaware Art Museum, 1987), 44, no. 991, ill. 96; Ira Glackens, *William
  Glackens and the Ashcan Group* (New York: Crown, 1957), 39–43; Violette de Mazia, "The Case of Glackens vs. Renoir," *BFJAD* 2, no. 2
  (Autumn 1971): 20.

## Nude Standing

Alternate titles: *Standing Nude; Nude*

c. 1909–10. Pastel and charcoal on green wove paper,
14½ × 8¹³⁄₁₆ in. (36.8 × 22.4 cm). Unsigned. BF734

PROVENANCE: Acquired from Kraushaar Galleries, February 12, 1949, for $90.00.[1]

EXHIBITION: Kraushaar Galleries, New York, Retrospective
Exhibition of Paintings and Drawings by William Glackens,
January 3–29, 1949, unnumbered ("A Group of Drawings and
Pastels").

REFERENCES: De Gregorio, 1955, 470, no. 17 (as "Standing
Nude"); Violette de Mazia, "The Case of Glackens vs. Renoir,"
*BFJAD* 2, no. 2 (Autumn 1971): 25, pl. 19.

1 See paid invoice and letter, Albert C. Barnes to Antoinette Kraushaar
  (Kraushaar Galleries), January 31, 1949, and reply from Kraushaar, February 3, 1949, on which is written "CK#16887 2/11/49 $90.00," ACB Corr.,
  BFA. On the back of the secondary support for *Woman in Black Hat
  and Black Skirt* (BF659) is written: "From Kraushaar Galleries / 32 East
  57th Street, New York 22 / 'Nude Standing' / Pastel drawing / by / William Glackens." This label refers to *Nude Standing* (BF734).

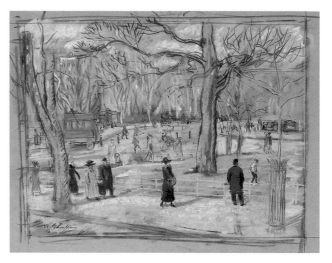

### Woman with Umbrella, Washington Square

c. 1910. Oil pastel and black crayon on brown wove paper, 10¹⁵⁄₁₆ × 13⅞ in. (27.8 × 35.2 cm). Signed lower right: W. Glackens. Inscribed on frame backing board: *Washington Square $75*. BF694

PROVENANCE: Acquired from the artist.

REFERENCES: Violette de Mazia, "The Case of Glackens vs. Renoir," *BFJAD* 2, no. 2 (Autumn 1971): 8n, pl. 42; Wattenmaker, 1972, 72–74, fig. 71.

RELATED WORKS: *Studies from Life*, crayon on brown paper, 17 × 13⅛ in. (42.3 × 32.6 cm), unsigned, Private Collection (fig. 56); *Washington Square*, oil on canvas, 18 × 24 in. (45.7 × 61 cm), signed lower right: W. Glackens, Private Collection (fig. 57).

### Washington Square

c. 1910. Oil pastel and black crayon on brown wove paper, 15¾ × 19⅛ in. (40 × 48.6 cm). Signed lower left: W. Glackens. BF696

PROVENANCE: Probably the picture acquired from the artist, May 12, 1915.[1]

REFERENCE: Violette de Mazia, "The Case of Glackens vs. Renoir," *BFJAD* 2, no. 2 (Autumn 1971): 18.

RELATED WORK: *Street Cleaners, Washington Square*, 1910 (BF2035).

REMARKS: Another pastel, *City Scene (Figures in Washington Square)*, c. 1910–12, was part of the Laura L. Barnes Bequest to the Brooklyn Museum of Art (67.24.3).

1 Albert C. Barnes check no. 3311, May 12, 1915, $40.00, payable to Wm. J. Glackens, BFFR, BFA.

FIG. 56

William J. Glackens, *Studies from Life*, c. 1910–12, crayon on brown paper, 17 × 13⅛ in. (42.3 × 32.6 cm), Private Collection

FIG. 57

William J. Glackens, *Washington Square*, c. 1910, oil on canvas, 18 × 24 in. (45.7 × 61 cm), Private Collection

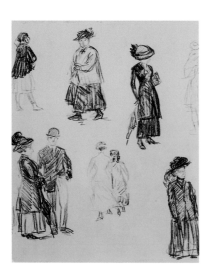

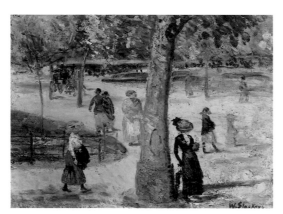

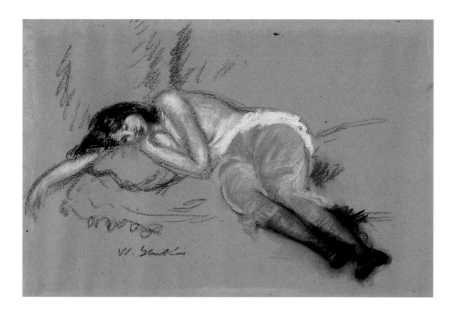

## *Girl Asleep*

c. 1916. Pastel and charcoal on paper, 11¾ × 17¼ in. (29.8 × 43.8 cm). Signed lower left of center: W. Glackens. BF642

PROVENANCE: Acquired from the artist, January 17, 1921, for $75.00.[1]

EXHIBITION: Daniel Gallery, New York, Exhibition: Paintings by Glackens, Lawson, Henri, Prendergast, January 8–February 8, 1921. The catalogue lists five paintings, no graphic work.

REFERENCE: Violette de Mazia, "The Case of Glackens vs. Renoir," *BFJAD* 7, no. 2 (Autumn 1971): 25, pl. 29.

RELATED WORKS: *Nude with Draperies*, c. 1916, oil on canvas, 30 × 25 in. (76.2 × 63.5 cm), Kolodkin Collection (fig. 58), cited or illustrated in *William Glackens Memorial Exhibition*, exh. cat. (New York: Whitney Museum of American Art, 1938), 13, cat. no. 52 (as *Girl with Draperies*); Forbes Watson, "Glackens," *Magazine of Art*, January 1939, 8, ill. (as *Girl with Draperies*); *William Glackens in Retrospect, 1966–1967*, exh. cat. (Saint Louis: City Art Museum; Washington, D.C.: National Collection of Fine Arts; New York: Whitney Museum of American Art, 1966), cat no 53, ill. A similar

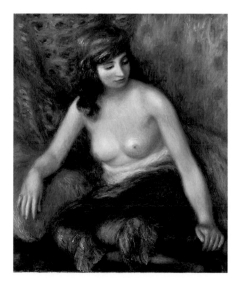

FIG. 58

William J. Glackens, *Nude with Draperies*, c. 1916, oil on canvas, 30 × 25 in. (76.2 × 63.5 cm), Kolodkin Collection

pastel, *Reclining Figure*, 8½ × 13¾ in. (20.2 × 34.2 cm), was included in *The Art of William Glackens*, exh. cat., special issue, [Rutgers] *University Art Gallery Bulletin* 1, no. 1 (January 1967): cat. no. 66 (as c. 1930).

1 Barnes Foundation file card and Albert C. Barnes check no. 4863, January 17, 1921, BFFR, BFA. Letter, Barnes to William Glackens, January 3, 1921: "Let me know the price of that little landscape I saw at your studio last week, and also the price of the pastel which I saw at Daniels. Neither of them is for myself but they would be if I had room to hang them. I have recommended both of them to some friends and if the prices you mention are satisfactory I will try to put the sale over." Letter, Glackens to Barnes, undated [shortly after January 3, 1921]: "I should like to keep the little landscape by me for a time as I have started a larger canvas from it and wouldn't be able to continue without the small picture. The pastel you refer to is a reclining figure I believe. The price is $75. It has a frame I suppose one of those white enameled kind. How I envy your gallons of Hooch!" Letter, Barnes to Glackens, January 7, 1921: "Send the pastel to my office, 24 N. 40th Street, and I'll get the seventy-five dollars before I deliver the picture." Letter, Barnes to Edith Dimock, January 17, 1921: "I had an agreement with Butts to buy a pastel for seventy-five ($75.00) dollars, and I received from him this morning a pastel of a figure, which is not the one I ordered; but the only reason I did not order it was because I understood it had been sold, which it seems was a mistake, so I enclose check for seventy-five ($75.00) dollars in payment for the pastel received today. If it is within your province to act in business matters, which your husband shamelessly neglects, I would like you to find out from Daniels which of the two pastels, he now has at his place, belongs to him, and which one belongs to Butts. I know one of them belongs to Daniels and also that one does belong to Butts. What I want to buy is the one belonging to Butts." All letters ACB Corr., BFA.

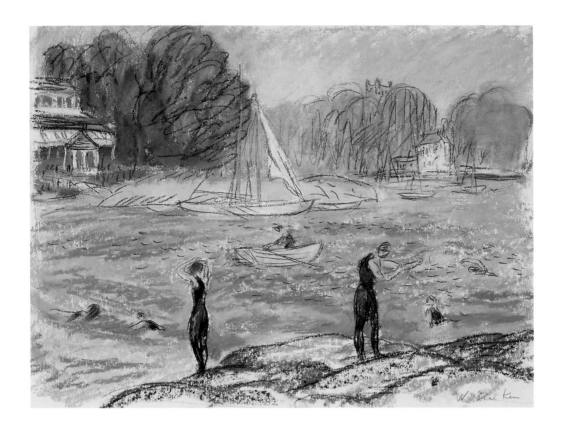

## *Bathers, Annisquam*

Alternate titles: *Bathers, Bellport; Water Scene—Bellport: Two Girls in Foreground Bank*

1919. Oil pastel, black crayon, and graphite on wove paper, 17 × 21 in. (43.2 × 53.3 cm). Signed lower right: W. Glackens. BF503

PROVENANCE: Acquired from the artist.[1]

EXHIBITION: Daniel Gallery, New York, January (?)–February 7, 1920 (including *Annisquam Beach* and *Good Harbor Beach*).

REFERENCE: De Gregorio, 1955, 586, no. 1 (no dimensions given).

RELATED WORK: One crayon drawing in sketchbook 1994 (unlabeled, c. 1919), Delaware Art Museum, Gift of the Sansom Foundation (fig. 59), is a preparatory sketch for *Bathers, Annisquam*. The Glackens family spent the summer of 1919 in Gloucester, Massachusetts, and the artist is known to have worked at nearby Annisquam.

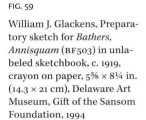

FIG. 59

William J. Glackens, Preparatory sketch for *Bathers, Annisquam* (BF503) in unlabeled sketchbook, c. 1919, crayon on paper, 5⅝ × 8¼ in. (14.3 × 21 cm), Delaware Art Museum, Gift of the Sansom Foundation, 1994

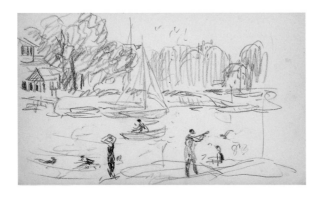

1 Inaccurate information on the Barnes Foundation file card states that the work was bought January 20, 1913, from Wm. J. Glackens for $500.00. The style of the work dates it later than 1912, and pastels by Glackens did not sell for as much as $500.00 in 1913. See also letter, William Glackens to Albert C. Barnes, March 23, 1920, ACB Corr., BFA: "The price of the Annisquam picture is $400 and the Good Harbor Beach $600." The reference to the "Annisquam picture" is not to *Bathers, Annisquam* but confirms the 1919 date. See *Exhibition*.

### Here Are Your Trousers

1903. Black crayon and white gouache on thick illustration board, 15 × 10¾ in. (38.1 × 27.3 cm). Signed lower right: W. Glackens. BF2021

PROVENANCE: Acquired from the artist.

REFERENCES: Allen and Hawkes, 1987, 44, no. 1001, ill. 97; Ira Glackens, *William Glackens and the Ash-can Group* (New York: Crown, 1957), 39–43.

REMARKS: Illustration for Charles Paul de Kock, *Jean* (Boston: Frederick J. Quinby, 1903), i.

### Marceline, the Clown

1905. Brush and ink and black crayon on brown laid paper, 8 × 5 in. (20.3 × 12.7 cm). Signed lower center: W. Glackens. BF661

PROVENANCE: Acquired from the artist.

REFERENCES: Violette de Mazia, "The Case of Glackens vs. Renoir," *BFJAD* 2, no. 2 (Autumn 1971): 18n, pl. 41; Allen and Hawkes, 1987, 14, no. 99, ill. 51.

REMARKS: Illustration for Lindsay Denison, "The Largest Playhouse in the World," *Collier's, The National Weekly*, May 6, 1905, 18.

### Standing Nude Woman

c. 1908–12. Charcoal on tan wove paper, 11⅞ × 8½ in. (30.2 × 21.6 cm). Signed lower left of center: W. Glackens. BF2024

PROVENANCE: Acquired from the artist.

## She Gave Her Darter-in-law a Piece of Her Mind

1909. Brush and ink, charcoal, graphite, black crayon, and white gouache on paperboard, 10 × 7¾ in. (25.4 × 19.7 cm). Signed lower left: W. Glackens. Inscribed: *Gave her daughter in-law a piece / of her mind* [the published caption reads "darter-in-law"]. BF606

PROVENANCE: Acquired from the artist.

REFERENCES: Violette de Mazia, "The Case of Glackens vs. Renoir," *BFJAD* 2, no. 2 (Autumn 1971): 18, pl. 40; Allen and Hawkes, 1987, 27, no. 541, ill. 74.

REMARKS: Illustration for Eden Phillpotts, "The Last Straw," *Putnam's Monthly and The Reader*, August 1909, 580. On May 15, 1943, Edith Dimock wrote Barnes: "In November I shall show some of Willies illustrations for the first time. One of the best stories is the Philpots [*sic*] one of which you have a picture, 'She gave her daughter-in-law a piece of her mind.' No. I am not asking to borrow it. But would you be willing to have a copy of it made at my expense? Some day I hope to get out a book of illustrations and should like to include this one. Most of the illustrations were destroyed alas. But many reproductions remain."[1] The show to which Dimock alludes, Fifth Annual Memorial Exhibition of Works by William Glackens, November 6–December 5, 1943, took place at the Glackenses' home, 10 West 9th St.[2] Barnes replied May 17, 1943: "I quite agree with you that 'She gave her daughter-in-law a piece of her mind' is one of the best and most typical Glackens drawings in existence. Of course, I am willing to have a copy made of it. The question is—who could do justice to the job. I know of nobody living that is in Butt's class as a draftsman. Perhaps you have somebody in mind that will serve the purpose."[3] In an undated letter (mid-May 1943), Dimock answered: "What I want is a photograph of the drawing, same size. I shall mark it so, of course, in the exhibition stating the original is in the Barnes Museum [*sic*]."[4] Barnes sent a photograph (taken by Angelo Pinto) and Edith wrote again that month, "O, Albert, the photograph is perfect, even showing Willies writing on it."[5]

1  Letter, Edith Dimock to Albert C. Barnes, May 15, 1943, ACB Corr., BFA.

2  Postcard announcement, postmarked November 5, 1943, ACB Corr., BFA.

3  Letter, Barnes to Dimock, May 17, 1943, ACB Corr., BFA.

4  Letter, Dimock to Barnes, undated [mid-May 1943], ACB Corr., BFA.

5  Letter, Dimock to Barnes, undated [May 1943], ACB Corr., BFA.

## Then We All Went Home

1909. Black crayon, charcoal, ink washes, and white gouache on wove paper, 9⁷⁄₁₆ × 12⅞ in. (24 × 32.7 cm). Signed lower right: W. Glackens. BF282

PROVENANCE: Acquired from the artist.

REFERENCE: Allen and Hawkes, 1987, 27, no. 547, ill. 74.

RELATED WORK: *On the Town, Homeward Bound*, charcoal (?) on paper, 7⅜ × 9⅜ in. (18.3 × 23.5 cm) (sight), cited in *The Art of William J. Glackens*, exh. cat., special issue, [Rutgers] *University Art Gallery Bulletin* 1, no. 1 (January 1967): 16, cat. no. 43; and *19th/20th Century American and European Art*, auction cat. (Lambertville, N.J.: Rago Arts and Auction Center, January 10–February 10, 2007), 6, no. 8, ill. See also entry for *There Was Edward Bickford's Racing Cup* (BF278).

REMARKS: Illustration for Eden Phillpotts, "The Practical Joke," *Putnam's Monthly and The Reader*, November 1909, 222.

## It Took Four of Us to Keep 'Em Apart

1909. Charcoal, black crayon, pen and ink, graphite, and white paint on thin paperboard, 11¾ × 12¼ in. (29.8 × 31.1 cm). Signed lower right: W. Glackens. BF2020

PROVENANCE: Acquired from the artist.

REFERENCE: Allen and Hawkes, 1987, 27, no. 546, ill. 74.

REMARKS: Illustration for Eden Phillpotts, "The Practical Joke," *Putnam's Monthly and The Reader*, November 1909, 221.

## Never Again, He Remarked Gloomily

1909. Black crayon and white gouache with blue crayon underdrawing on paperboard, 11⅜ × 13⅝ in. (28.9 × 34.6 cm). Signed lower right: W. Glackens. BF2028

PROVENANCE: Acquired from the artist.

REFERENCE: Allen and Hawkes, 1987, 26, no. 535, ill. 73.

REMARKS: Illustration for Elliot Flower, "A Stranger in New York," *Putnam's Monthly and The Reader*, March 1909, 683.

## There Was Edward Bickford's Racing Cup

1909. Black crayon and white gouache on wove paper, 11¼ × 13¼ in. (28.6 × 33.7 cm). Signed lower right: W. Glackens. BF278

PROVENANCE: Acquired from the artist.

REFERENCE: Allen and Hawkes, 1987, 27, no. 548, ill. 74. See also entry for *Then We All Went Home* (BF282).

REMARKS: Illustration for Eden Phillpotts, "The Practical Joke," *Putnam's Monthly and The Reader*, November 1909, 223.

## Woman Waving Flag

c. 1905–10. Graphite on wove paper, 5 × 3 in. (12.7 × 7.6 cm). Unsigned. BF1143

PROVENANCE: Acquired from the artist.

REMARKS: A second figure of a woman to the left of the woman with flag is cropped. Possibly cut from a larger sheet. In the Glackens household, rights and the vote for women were the most important social issues. Edith Dimock marched in suffragist parades. This drawing might have been made during a Fourth of July parade.

## A Party Has a Right to Add More Tong to Their Own Joint

1910. Black crayon on brown wove paper, 8⅝ × 5¼ in. (21.9 × 13.3 cm). Signed lower right: W. Glackens. BF665

PROVENANCE: Acquired from the artist.

REFERENCE: Allen and Hawkes, 1987, 24, no. 473, ill. 70.

REMARKS: Illustration for Helen Green, "In Vaudeville," *McClure's Magazine*, February 1910, 392.

## Eight Figures

Alternate title: *Sketches of Figures*

c. 1910. Black crayon with gouache on brown wove paper, 12⅛ × 14⅜ in. (30.8 × 36.5 cm). Signed lower right: W. Glackens. BF641

PROVENANCE: Acquired from the artist.

REFERENCES: De Gregorio, 1955, 268 n. 1, 469–70, no. 15 (as "Sketches of Figures"); Violette de Mazia, "The Case of Glackens vs. Renoir," *BFJAD* 2, no. 2 (Autumn 1971): 18, pl. 33.

## Woman with Broad-Brimmed Hat

c. 1910. Black crayon on brown wove paper, 7⅛ × 5 in. (18.1 × 12.7 cm). Signed lower right: W. Glackens. BF603

PROVENANCE: Acquired from the artist.

REFERENCE: De Gregorio, 1955, 472, no. 24.

## Woman and Girl

Alternate title: *Trundling a Hoop*

c. 1910. Black crayon on brown wove paper, 6 × 7½ in. (15.2 × 19.1 cm). Signed lower center: W. Glackens. BF693

PROVENANCE: Acquired from the artist.

REFERENCE: Violette de Mazia, "The Case of Glackens vs. Renoir," *BFJAD* 2, no. 2 (Autumn 1971): 18, pl. 43 (detail, as *Girl with Hoop*).

## Five Children

Alternate title: *Children after School*

c. 1910. Black crayon on brown wove paper, 4⅞ × 6⅜ in. (12.4 × 16.2 cm). Signed lower right of center: W. Glackens. BF604

PROVENANCE: Acquired from the artist.

REFERENCE: Violette de Mazia, "The Case of Glackens vs. Renoir," *BFJAD* 2, no. 2 (Autumn 1971): 18, pl. 36.

## Woman Walking to the Left

c. 1910. Black crayon on brown wove paper,
8¾ × 4¼ in. (22.2 × 10.8 cm). Signed lower right:
W. Glackens. BF664

PROVENANCE: Acquired from the artist.

## Man Following Woman

c. 1910. Black crayon on brown wove paper, 9⅛ × 7⅞ in.
(23.2 × 20 cm). Signed lower right: W. Glackens. BF1037

PROVENANCE: Acquired from the artist.

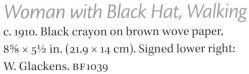

## Woman with Black Hat, Walking

c. 1910. Black crayon on brown wove paper,
8⅝ × 5½ in. (21.9 × 14 cm). Signed lower right:
W. Glackens. BF1039

PROVENANCE: Acquired from the artist.

## Two Women

c. 1910. Black crayon on brown wove paper, 7¾ × 6½ in.
(19.7 × 16.5 cm). Signed upper right: W. Glackens. BF1043

PROVENANCE: Acquired from the artist.

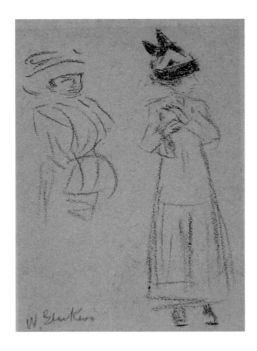

## Two Women

Alternate title: *Two Women (One with Black Hat)*
c. 1910. Black crayon on brown wove paper, 8½ × 6 in.
(21.6 × 15.2 cm). Signed lower left: W. Glackens. BF663

PROVENANCE: Acquired from the artist.

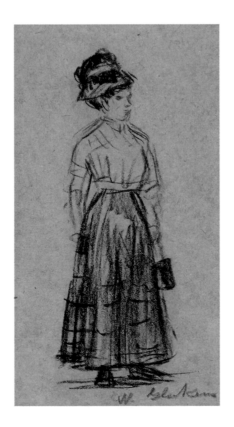

## Woman in Black Hat and Black Skirt

c. 1910. Black crayon on brown wove paper, 7⅞ × 4 in.
(20 × 10.1 cm). Signed lower right: W. Glackens. BF659

PROVENANCE: Acquired from the artist.

## Man with Child

c. 1910. Black crayon on brown wove paper, 8½ × 6 in.
(21.6 × 15.2 cm). Signed lower left: W. Glackens. BF660

PROVENANCE: Acquired from the artist.

REFERENCE: De Gregorio, 1955, 468, no. 9.

RELATED WORKS: The drawing is similar to figures of men
in such paintings as the Pissarro-inspired *Parade, Washing-
ton Square*, c. 1910, oil on canvas, 26 × 31 in. (66 × 78.7 cm),
Whitney Museum of American Art, one of several composi-
tions of the Italian-American parade in Washington Square.

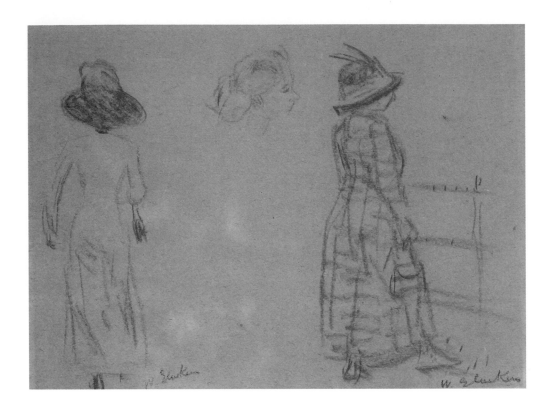

## *Two Women and Head of Woman*

c. 1910. Red chalk on brown wove paper, 9 × 12½ in. (22.9 × 31.8 cm). Signed lower left and lower right: W. Glackens. BF645

PROVENANCE: Acquired from the artist.

REMARKS: This sheet is an example of Glackens's custom of making several—or many—sketches on a single sheet of brown paper with the option to cut the sheet into multiple sheets. Often, these sheets were large and irregularly shaped and were cut into separate smaller sheets by dealers and collectors. In this process, the artist concurred. In at least one instance, Glackens himself assembled a group of small sketches to make an ensemble. In an undated [late 1909–early 1910] letter to A. E. Gallatin, whose article "The Art of William Glackens: A Note" (*International Studio*, May 1910, lxviii) reproduced a grouping of the artist's drawings, Glackens wrote: "I am sending you a number of small sketches pasted together to make a page. They are sketches made from a window; and I think representative of my method of working."[1] The window Glackens refers to is from the vantage point of the second floor of 50 South Washington Square, where Glackens's studio overlooked the park and where he observed the scenes that appear in his drawings and paintings. Many of these small drawings remained unsigned at the time of the artist's death. These were sometimes authen-

ticated by his wife, Edith Dimock Glackens or Ira Glackens and initialed "W. G. per E. G." or "W. G. per I. G."

When the grouping of figures on a page was compositionally coherent, as is the case with *Eight Figures* (BF641), on which there are eight figures disposed horizontally in two registers of four, the sheet was intended to remain a multifigure composition and was signed once. (See also fig. 56, study for *Woman with Umbrella, Washington Square* [BF694].) Otherwise, the large sheets were unsigned. In a letter to Glackens, March 15, 1920, Barnes describes this process: "I cut the sheets of drawings into units so that I can either frame them or put them in an album. I am sending them to you to-day by registered mail and ask you to kindly sign each unit and return them to me immediately. . . . Let me know how much I owe you for the bunch. . . . P.S. I mailed the drawings in two packages—a large envelope and a roll. I enclosed a large envelope to return the loose drawings, but it will be necessary for you to buy a mailing tube at any stationary [*sic*] store so that you may return to me those which I sent to you in the roll."[2]

1   Albert E. Gallatin Papers, courtesy of the New-York Historical Society.

2   Letter, Albert C. Barnes to William Glackens, March 15, 1920, ACB Corr., BFA.

*Two Women Facing in Different Directions*

c. 1910. Black crayon on brown wove paper, 9 × 7⅛ in.
(22.9 × 18.1 cm). Signed lower right: W. Glackens. BF640

PROVENANCE: Acquired from the artist.

*Woman Walking*

c. 1910. Black crayon with gouache on
brown wove paper, 8½ × 4⅜ in. (21.6 ×
11.1 cm). Signed lower right: W. Glackens.
BF633

PROVENANCE: Acquired from the artist.

*Woman Walking*

c. 1910. Black crayon on brown wove paper,
7¼ × 4½ in. (18.4 × 11.4 cm). Signed lower
left: W. Glackens. BF632

PROVENANCE: Acquired from the artist.

*Five Figures*

c. 1910–12. Black crayon on brown wove paper, 9½ × 21⅞ in.
(24.1 × 55.6 cm). Signed lower right: W. Glackens. BF2030

PROVENANCE: Acquired from the artist.

## Barbaro Fats

1912. Black crayon on brown wove paper, 12⅛ × 6½ in. (30.8 × 16.5 cm). Signed lower left: W. Glackens. BF688

PROVENANCE: Acquired from the artist.

REFERENCE: Allen and Hawkes, 1987, 15, no. 129, ill., 53.

RELATED WORK: *Man at Bar*, crayon on paper, 10 × 6½ in. (25 × 16 cm), cited in *The Art of William Glackens*, exh. cat., special issue, [Rutgers] *University Art Gallery Bulletin* 1, no. 1 (January 1967): 16, cat. no. 45; and *19th/20th Century American and European Art*, auction cat. (Lambertville, N.J.: Rago Arts and Auction Center, January 10–February 10, 2007), 6, no. 9, ill.

REMARKS: Illustration for Wallace Irvin, "At the Sign of the Three Rings," *Collier's, The National Weekly*, May 4, 1912, 26.

## Nude

c. 1915. Black crayon on brown wove paper, 12¼ × 10½ in. (31.1 × 26.7 cm). Signed lower left: W. Glackens. BF2027

PROVENANCE: Acquired from the artist.

RELATED WORK: *Study of a Nude*, c. 1915, oil on canvas, 24 × 20 in. (61 × 50.8 cm), illustrated in *William Glackens in Retrospect, 1966–1967*, exh. cat. (St. Louis: City Art Museum; Washington, D.C.: National Collection of Fine Arts; New York: Whitney Museum of American Art, 1966), cat. no. 45. The pose is similar, but the model's left arm is placed differently.

# ALFRED H. MAURER (1868–1932)

Seven years ago Mr. Maurer changed from his harmonies of black, white and gray to lively schemes of primary colors. At the same time he dropped the conventional point of view and took up with what were considered at the time the vagaries of the "Wild Men" [the Fauves]. Like them, he flung over the traditions that a picture must be based on the representation of nature, and ran up the flag of the painter's liberty, if he choose, to emulate the musician in making expression his chief motive.

Charles H. Caffin, "Challenge to Tradition Issued," 1913

*A week after Alfred Maurer's death in 1932,* Alfred Stieglitz wrote to Arthur Dove, "The suicide of Alfy Maurer came as a great shock. . . . What I regret most with his passing are the thousand and one stories about Barnes . . . that are buried with him."[1] Stieglitz could not have known that many of these "stories" are revealed in the Barnes-Maurer correspondence of 1912–13, when the artist became the collector's trusted emissary, retained to seek out prospective paintings for his collection in Paris and to negotiate terms of purchase with such dealers as Ambroise Vollard, the Galerie Bernheim-Jeune, Eugène Druet, Henri Barbazanges, Levesque & Co., Eugène Blot, and Jos Hessel. Maurer shared Barnes's enthusiasm for Modern art. Moreover, he clearly enjoyed the access to pictures he would otherwise not have seen as well as the opportunity to be treated as a knowledgeable, sophisticated person of consequence. "Don't let up on the pictures," he wrote Barnes on October 26, 1912, "I am continually on the look-out, and want you to have them."[2] The dealers were amenable because they understood that Maurer was a friend of Leo and Gertrude Stein's, whom they considered ideal proselytizers for the artists in their inventories, and that he represented a potentially important client.

Maurer's Matisse-influenced work—which is difficult, if not impossible to date precisely—is, at its best, spontaneous and fluid in the application of bright strokes and areas of color. Unlike his early Manet-inspired figure compositions, his decorative style is, for the most part, compositionally simple, consisting primarily of decentralized landscapes, even the largest of which has the character of sketches in order to emphasize their spontaneity. Some of Maurer's still lifes are more compositionally complex, but his small landscapes were deployed by Barnes as accent notes throughout the gallery to complement works by other painters.

Having studied the five Maurer paintings purchased by Glackens in February 1912, Barnes understood that the artist was committed to contemporary art. He encouraged Maurer to exercise his judgment in suggesting prospective acquisitions, and, while the final decision was always Barnes's, the artist and collector worked in concert. Maurer also gave Barnes forthright and astute judgments on dealers and their idiosyncrasies.

FIG. 60

Alfred H. Maurer, *Still Life*, c. 1909–10, oil on canvas, 22 × 18⅜ in. (55.9 × 46.7 cm), The Barnes Foundation, BF525 (detail)

To examine the Barnes-Maurer relationship is to reconstruct the important role the artist played in the early formative stages of Barnes's buying, as he established relations with dealers, some of whom he would conduct business with for as long as thirty years.

"Alfy," as Maurer was known to his friends, was on cordial terms with Leo and Gertrude Stein from the earliest stages of their collecting, which started around 1904. On February 13, 1912, Maurer brought Glackens to see the pictures chosen by the Steins—works by Cézanne, Renoir, Matisse, Picasso, Daumier, Delacroix, Gauguin, Maurice Denis, El Greco, Henri de Toulouse-Lautrec, and Félix Vallotton. While Glackens's selections for Barnes were governed by his predilection for Impressionism, Maurer's preferences were influenced by the Steins' more adventurous taste. Even before Barnes had met the expatriates, his collection was indirectly modeled on theirs.[3] Interwoven throughout the details of Maurer's negotiations with the Parisian dealers on Barnes's behalf is a secondary narrative that traces the collector's role in initiating an exhibition of Maurer's work at the Folsom Galleries in New York in January 1913. In both connections, the Barnes-Maurer letters reveal the extent to which Barnes's early activities were informed by a businessman's mind-set.

In early June 1912, Maurer accompanied Barnes on a brief buying trip to Paris, where they visited a number of galleries and exhibitions. It was at this time that Barnes first met Vollard, the Bernheim brothers, Félix Fénéon, Léon Hodebert, Druet, Levesque, and other dealers from whom he had already purchased paintings, via Glackens, a few months earlier. Following Barnes's sojourn, he and Maurer strategized about how best to approach the sophisticated Parisian dealers, whose practices they considered deceptive and whom Barnes was determined to outwit in his quest to acquire, at the lowest possible prices, important works by the Modern masters. Their letters and telegrams record the feints, parries, and thrusts of offers, counteroffers, completed transactions, and prospective future purchases. In particular, Barnes did not like Vollard's technique of feigning indifference as to whether or not a picture sold. He refused to pay sight unseen for paintings, insisting that they be sent to him on approval before committing to a purchase and telling Maurer to convey these terms to the dealers, stressing that they could consult Durand-Ruel as to his creditworthiness. Maurer apparently shared Barnes's mistrust of the Parisian dealers, writing in one undated letter (late summer 1912), with Vollard in mind, "they all are worse than horse dealers."[4]

On June 25, 1912, after Barnes's return to Philadelphia, he wrote Maurer about a matter they had apparently discussed at some previous time:

Concerning an exhibit of your work in Philadelphia next winter, my plan would be as follows: Rent for a couple of weeks the gallery of the best-known picture dealer—[James] McClees, a man I know well. Send out several hundred announcements to people in this city who are interested in art. Carry good-sized advertisements in the principal daily papers telling of the exhibit. In both the mailed announcements and the newspaper advertisements, there would be a sketch of your artistic career including your list of prize-winnings and the fact that you are permanently represented in the Wilstach collection, and also, a short account of the progressive art which your present work represents.[5] I would write these announcements and would try to make them as productive as the material I've written for the past ten years for our business. . . . It would be necessary for you to have on hand a large number of paintings—not one which must be anything but what you think is entirely worthy of you at your best. . . . Of course, I would loan my examples of your work, and it would look well in the catalogue to have a half dozen or more marked "sold"—it usually makes other people want to buy. Let me hear from you soon and send at the same time the data about your prize-winnings so that I can work it up in shape to use.[6]

Four days later, Barnes wrote,

If you have time, offer Druet twenty thousand (20,000) francs for his Van Gogh [*The Smoker* (*Le Fumeur*, BF119)], providing he can furnish satisfactory documents that it is genuine, can give you a verified pedigree, and will certify that it is over twenty years old and will pay half of the shipping

and transportation charges, his share of which would be about one hundred and twenty-five francs. If the painting is not signed, I would be obliged if you will make inquiry about Van Gogh's habit of signing his work and would get a skilled opinion of a disinterested person on the genuineness of the painting. You know, Mr. [Paul] Durand-Ruel, Sr., told us there are many faked Van Gogh[s] on the market. I received your letter stating that Druet had accepted my offer of nine thousand francs for the small Cézanne [*La Toilette* (BF12)], but I have not yet received any invoice from Druet, and as you know, this will be necessary to have the invoice stating the exact amount paid, and, also, the consular certificate, before I could obtain the painting through the custom house here. I feel under obligations to you in giving you so much trouble concerning the purchase of paintings for me; but I shall be pleased to place this on a business basis, and remunerate you for your services, as soon as we can get together and fix upon the sum which you think such services are worth. I believe you will be interested in knowing that Mr. McClees told me yesterday that we could have his galleries for your exhibit right after the first of January next. Move cautiously about the Van Gogh at Druet's as above mentioned. My recollection of the painting is that it is an extremely strong one . . . however, if there is any doubt in your mind about its authenticity, or if any expert doubts it, or if Druet cannot give you a gilt edge pedigree I, of course, would not want it no matter what the price is.[7]

On July 6, Maurer responded about the prospective show of his work:

Of my smaller canvases that is from No. 10 down you have cleaned me out pretty well. There are a few left and about five or six No. 25. . . . I'm sure you will not need a big stack. Will *bet* you any one of my No. 8 canvases you wish to select to a box of cigars you won't sell three No. 10's. I would not like to see you put much money in this affair because I know they are damned hard to sell. Advertising is very expensive from what I understand, however

you know more about business than I, but you'll see when the exhibition is on. How many canvases would you want? And what do you want to do about frames! My Ballet girl I offered to you for $800. I don't care to let it go for less. The size is 7 ft 2 in. × 4 ft 3 in. . . . Remember what I say, you may sell a number of small ones but not three No 10s. Is the bet good?[8]

In his reply of July 19, Barnes returned to the prospective exhibition: "I accept your bet of a box of cigars against a painting of yours that we will sell more than three No. 10's. I am always optimistic concerning things that most people think can't be done. . . . Don't anticipate difficulties—you go ahead and turn out some damn good work and leave the rest to me. . . . There is one sure thing and this is that the exhibition can do you no harm, while it may be the means of making your work wanted and giving you a decent income. . . . I will finance it and will see that you get an exhibition under good auspices."[9]

On November 15, 1912, Barnes wrote to Maurer,

I have received a letter from Druet in which he states that he is sending me a catalogue for the sale of the Rouart Collection, in which he states there are some fine paintings by Degas, Millet, and other painters. I have not received this catalogue, and, therefore, can tell nothing about whether I would care particularly for any of the paintings offered in that sale. However, it is safe to say that anything by Degas is good enough for my collection, and if he can buy them at a reasonable price, I have no doubt I would be willing to buy them. I do not know how to proceed in this matter because I do not want to give Druet a carte-blanche order to buy some of these paintings for me, but if he is willing to buy them in the expectation that I will take a Degas and a Millet, if after seeing the photographs and the prices of them, I think it would be a good speculation for him to buy the paintings particularly when the market values of the works of these two men are so well established and easily obtained. I shall be obliged if you see Druet and communicate to him these remarks and let me know what he says.[10]

Responding on the 19th, Maurer advised, "The way to do with Druet is when you get the catalogue pick out the pictures you want send him the price you will pay and he will bid up to what you say." He then urged Barnes, "Don't buy a Millet put the money in a Greco. The prices are going to go up after this sale. . . . I'll talk this over when I see you soon. . . . Take a look at some of Renoir's latest things the very red ones some of them are fine and its time to buy them."[11] Maurer met Barnes in Paris for the sale and visits to galleries including those of Vollard, Clovis Sagot, Daniel-Henry Kahnweiler, and Durand-Ruel, from each of whom he purchased pictures. That same month Barnes secured a contract with the Folsom Galleries for an exhibit of Maurer's work, from January 15 through 29, 1913.

Maurer returned to New York and was on hand three weeks before the opening of his show, in time to hang his pictures and make any other necessary arrangements. On December 30, 1912, Barnes wrote to A. H. Folsom, "I have written an introduction, which with the marked passages in Grafton Gallery Catalogue sent you herewith, should be made into a pamphlet and mailed to your usual list. . . . Have your stenographer *copy* from the Grafton Catalogue the articles by Mr. [Roger] Fry and Mr. [Clive] Bell and have them reprinted, with my introduction, in pamphlet form."[12]

In composing his text, Barnes adopted the promotional approach of the ad man that had served him in his marketing of pharmaceutical products. The cover page read: "An Important Art Event of the Season is the Exhibit of the Recent Paintings of Alfred H. Maurer of Paris at the Folsom Galleries, 396 Fifth Avenue, New York, from January 15th to January 29th, 1913. You are cordially invited to view the recent work of a master whose reputation in Europe and America is firmly established, whose work has been awarded numerous prizes of the highest class, and whose paintings are to be found in some of the best private and public galleries of America and Europe." Barnes's unsigned introduction is written in the third person: "At this time at the Grafton Galleries, London, there is being held, under the patronage of men recognized throughout the civilized world as the embodiment of culture, sanity and learning, an exhibition of exclusively post-impressionist paintings. It is not a commercial exhibition having for its object the sale of the works there shown;

but it was originated and is being conducted by public spirited, cultivated people for the purpose of educating the public in this most vital, real and sincere form of art expression. We are exceptionally fortunate in securing for exhibition in the Folsom Galleries the recent work of Mr. Alfred H. Maurer, one of the best-known and most highly esteemed of the Post-Impressionists." The text goes on to cite Maurer's prizes and continues:

> It is an especial pleasure and privilege for us to be able to show also at this time examples of Mr. Maurer's early work; not only because they show his results in what might be termed conventional painting, the rare skill and charm of which will be recognized by all, but because they prove the courage and conviction of the artist who had the temerity to abandon painting of that rarely-skilled character and embark in what he considered the greater, more vital, more sincere and more individual means of expressing himself and the post-impressionistic art to which he became a convert about seven years ago. In order that the recent paintings of Mr. Maurer may be better understood by the general cultivated public, we have reprinted in this booklet an abstract of introductory remarks contained in the catalogue of the Post-Impressionist Exhibit now being held at the Grafton Galleries, London, which introductions were written by Mr. Clive Bell and Mr. Roger Fry, both of London, connoisseurs and art critics of international reputation.

This was followed by more than three pages of text by Bell and five by Fry, excerpted by Barnes, who indicated which passages to print and those to omit.[13]

This effort—Barnes's first published statement on art—was maladroit and far too heavy-handed. Charles Caffin took exception: "The managers have printed an announcement of it, which must hurt the artist's modesty. It is fulsome and misleading. This exhibition, we are told, is 'An important art event of the season.' This smacks of the flub-dub of the theatrical press agent." Instead, Caffin held that "through many years I have watched this artist's evolution, and [in the current show I] congratulate him on the fact that he has made immense progress in solving the difficulties of his later development."[14]

The show was well reviewed in general. An anonymous reviewer for the *New York Times* welcomed the texts by Bell and Fry, writing:

Mr. Maurer has been from his early days given to "schemes" and "arrangements," formerly they were very quiet in color, what would be called Whistlerian harmonies; now they are blazing, what would be called Cézanne harmonies. . . . Mr. Maurer has lived in Paris for about thirteen years and has kept pace with her national dance. Although this art is said to be somewhat on the wane in Paris, it is not so familiar to us that we do not need instruction in its theory. This need has been cleverly met by the republication in a small pamphlet for this occasion of articles by Mr. Fry and Mr. Clive Bell, originally written to help out the English public when it was confronted with the Post Impressionist exhibition at the Grafton Galleries in London. We cravenly fall back upon an extract from Mr. Fry's statement of the qualities that separate Post Impressionist art from other contemporary art. The difficulty of understanding it springs, he thinks, from a mistaken notion of what artists are trying to do, and from a deep-rooted conviction due to long established custom, that the aim of painting is the descriptive imitation of natural forms.

After excerpting Fry's text in the review, the author concludes: "Mr. Maurer has advanced far. In much of his still life he takes magnificent leaps and turns very credible somersaults. Those blue morning glories . . . against a yellow background, and those aureoles of color marching from faint tints to full hues [probably *Still Life* (BF525)]. These pictures have great vitality. They seem to us clumsy at times, but possibly our minds are clumsy."[15]

Another critic wrote in *American Art News*, "For those who are tired of the conventional in art, who find William Glackens, Jerome Myers, George Luks, John Sloan, Robert Henri and George Bellows too 'sane,' the exhibition of 'Post-Impressionist' paintings by Alfred Maurer, now at the Folsom Galleries . . . will doubtless satisfy. The gallery is aflame with brilliant color, and is more than 'up to date.' It goes farther than anything New York has yet seen, in its line. . . . There is beauty and harmony of color here and there, and knowledge and thought in many of the works. Especially good are the still life subjects. 'Old Faience' [no. 12] is a color gem and its arrangement original and effective. 'The Agate Pitcher' [no. 11], 'Dahlias' [no. 26, ex–no. 365 on the 1922–1924 Inventory] and 'Tulips' [no. 6, *Tulips in a Green Vase* (BF360)] are strong works."[16]

On January 25, 1913, Barnes wrote Maurer, carefully avoiding the fact that the show had been, as the artist had predicted, a financial failure: "The close of your exhibit at Folsom brings up for decision some points concerning the financial end. The exhibit has done more in advertising Folsom than anything he can ever do."[17] Two days later, Barnes added, "Even if the show was not successful financially, it was otherwise; and we must work out a plan by which the damned fools who did not buy will be very glad to buy later at higher prices."[18] No mention was made in their letters about the wager or cigars.

Correspondence between Barnes and Maurer about purchasing European paintings ends in mid-July 1913. This is coincident with Barnes's growing friendship with Leo Stein, who also accompanied Barnes to dealers in Paris. After Maurer's return to the United States a year later, following the outbreak of World War I, he and Barnes remained on good terms, and Barnes bought four of his pictures from the Forum Exhibition of Modern American Artists held at the Anderson Galleries from March 13 through April 25, 1916. Barnes's last acquisition of a picture from Maurer was his purchase of *Head: Number Three* (BF2047) from the Paintings and Drawings Showing the Later Tendencies in Art exhibition at the Pennsylvania Academy of the Fine Arts in the spring of 1921.[19]

The approximately twenty-five paintings by Maurer acquired by Barnes between 1912 and 1921, many of which are today untraceable, in effect served as place holders for Matisse during the time when Barnes was buying Renoir, Cézanne, Degas, and Americans such as Glackens, Prendergast, Lawson, Demuth, and Pascin. After his purchase of two works by Matisse in December 1912 (*Dishes and Melon* [*Assiettes et melon*, BF64] and *The Sea Seen from Collioure* [*La mer vue de Collioure*, BF73]), Barnes's next purchases of the Frenchman's work occurred in May 1921. Although he owned most, if not all, of those Maurers at the time the 1922–1924 Inventory was drawn up, during the 1940s he gradually eliminated all but ten pictures

from the collection and began deaccessioning many of them by gift, trade, or sale.[20] Their role in the formative years of his collecting was taken over by Matisse, many of whose major compositions, formerly owned by the Steins, became available on the market in the 1920s. After his 1913 essay, Barnes never again wrote about Maurer's work. On June 7, 1951, he donated one of Maurer's pictures, *French Landscape*, c. 1907, to the Blanden Memorial Art Museum, Fort Dodge, Iowa.[21]

## NOTES

Epigraph. Charles H. Caffin, "Challenge to Tradition Issued: Announcement of Exhibition of Maurer's Paintings Is Declared Fulsome and Misleading," *New York American*, January 20, 1913. See Caffin's article "The Maurers and Marins at the Photo-Secession Gallery," *Camera Work*, July 1909, 41–42.

1 Alfred Stieglitz to Arthur Dove, August 11, 1932, in Ann Lee Morgan, ed., *Dear Stieglitz, Dear Dove* (Newark: University of Delaware Press, 1988), 246. © 2009 Georgia O'Keeffe Museum, Artists Rights Society (ARS), New York.

2 Letter, Alfred H. Maurer to Albert C. Barnes, October 26, 1912, ACB Corr., BFA.

3 This was reinforced by Barnes when in subsequent years he acquired works by Cézanne, Renoir, and Matisse, which either came directly from Leo Stein or had previously been in Leo and Gertrude or Michael and Sarah Stein's collections.

4 Letter, Maurer to Barnes, undated [late summer 1912], ACB Corr., BFA.

5 Maurer's *The Peacock* had been purchased for the Wilstach collection in 1903. *Catalogue of the W. P. Wilstach Collection* (Philadelphia, 1922), 79, cat. no. 199.

6 Letter, Barnes to Maurer, June 25, 1912, ACB Corr., BFA.

7 Letter, Barnes to Maurer, June 29, 1912, ACB Corr. BFA.

8 Letter, Maurer to Barnes, July 6, 1912, ACB Corr., BFA. The numbers refer to the standard stretcher sizes, measured in centimeters, employed in France by artists and framers.

9 Letter, Barnes to Maurer, July 19, 1912, ACB Corr., BFA.

10 Letter, Barnes to Maurer, November 15, 1912, ACB Corr., BFA.

11 Letter, Maurer to Barnes, November 19, 1912, ACB Corr., BFA. Always independent, Barnes also declined to buy paintings recommended by Maurer. See letters, Maurer to Barnes, September 9, 1912: "From Bernheims you will also have quite a number of Van Goghs, a 'Postier' frs

25,000. *Get this* it is fine and very fresh in color"; Maurer to Barnes, September 26, 1912: "Bernheims Post [*Postier*] is the best *figure* piece for the price"; Maurer to Barnes, October 2, 1912: "I . . . asked him [Bernheim] why the 'Post[ier]' was so much more reasonable, his reply was on account of the 'Post' being an ugly picture it was hard to dispose of"; Maurer to Barnes, October 13, 1912: "I am sorry you did not decide on Van Gogh's 'Postier' in spite of the fact you have one." All letters ACB Corr., BFA.

12 Letter, Barnes to the Folsom Galleries, December 30, 1912, ACB Corr., BFA; and Barnes's copy of the Grafton catalogue, with notations in pencil, "Reprint this [excerpt] except those parts marked 'omit'" (London Collection).

13 "An Important Art Event of the Season is the Exhibit of the Recent Paintings of Alfred H. Maurer of Paris at the Folsom Galleries," January 1913, Private Collection. Bell's essay was entitled "The English Group," and Fry's, "The French Group," the titles of which were suppressed in the Folsom pamphlet. The thirteen-page Folsom pamphlet was not illustrated. Supplementary to the pamphlet, Folsom provided a separately printed "List of Paintings," a numbered checklist (1–27) with titles, but no dimensions, entitled on its first page, "Post-Impressionist Paintings: Alfred H. Maurer," Private Collection.

14 Both quotes, Charles H. Caffin, "Challenge to Tradition Issued." See Caffin's article "The Maurers and Marins at the Photo-Secession Gallery," *Camera Work*, July 1909, 41–42.

15 "New of Interest from the Art World: Paintings of Alfred Maurer," *New York Times*, January 26, 1913, X10. See also Harriet Monroe, "Art Lovers Flock to the Morgan Exhibit," *Chicago Daily Tribune*, February 2, 1913, B6.

16 *American Art News*, January 18, 1913, 2.

17 Letter, Barnes to Maurer, January 25, 1913, ACB Corr., BFA.

18 Letter, Barnes to Maurer, January 27, 1913, ACB Corr., BFA. On January 29, 1913, Barnes sent a check in the amount of $400.00 payable to the Folsom Galleries in settlement of the financial obligation for the exhibition. Albert C. Barnes check no. 2524, January 29, 1913, BFFR, BFA.

19 Anderson Galleries, *Forum Exhibition of Modern American Artists*, exh. cat. (New York: Anderson Galleries, 1916), 19, cat. no. 172. Maurer showed two other works in the show, cat. nos. 72 and 167.

20 On the 1926 List of Paintings, only twelve Maurers are included.

21 See Margaret Carney Xie, ed., *Handbook of the Collections in the Blanden Memorial Art Gallery* (Fort Dodge, Iowa: Blanden Charitable Foundation, 1989), 26, ill. (*French Landscape*, c. 1907), which Barnes titled *Landscape (small)* (ex-BF2019). On January 8, 1950, Barnes traded five Maurers to J. B. Neumann for a Paul Klee watercolor, *Historic Ground* (*Historischer Boden*, BF2532), priced at $900.00. Barnes also gave another Maurer, *Landscape—with Bare Trees* (ex-BF1042), to Dr. F. G. Harrison on January 15, 1951.

## Still Life with Jardinière

c. 1909–11. Oil on canvas, 15 × 18⅛ in. (38.1 × 46 cm).
Signed lower right: A. H. Maurer. BF 412

PROVENANCE: Acquired from the artist.

REMARKS: Possibly the *Still Life* chosen by Glackens in Paris
($60.00) in 1912. See provenance for *House* (BF 287).

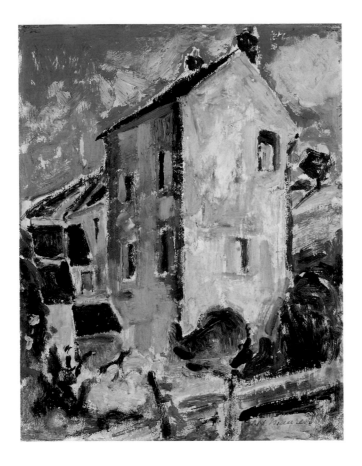

## *House*

c. 1907. Oil on wood panel, 10⅝ × 8⅜ in. (27 × 21.3 cm).
Signed lower right: A. H. Maurer. Frame by Robert Laurent,
signed left frame member verso: Laurent. BF287

PROVENANCE: Likely acquired from the artist in 1912 for
$30.00[1] or, if not, from among the works exhibited in the
Forum Exhibition of Modern American Painters at the An-
derson Galleries, New York, March 13–25, 1916, for $35.00.[2]

EXHIBITION: Anderson Galleries, New York, Forum Exhibi-
tion of Modern American Painters, March 13–25, 1916.

REFERENCES: *Forum Exhibition of Modern American Paint-
ers*, exh. cat. (New York: Anderson Galleries, 1916); Violette de
Mazia, "The Barnes Foundation: The Display of Its Art Col-
lection," *Vistas* 2, no. 2 (1981–83): pl. 59 (installation view);
R. J. Wattenmaker, "Dr. Albert C. Barnes and the Barnes
Foundation," in *Great French Paintings from the Barnes Foun-
dation* (New York: Knopf, in association with Lincoln Univer-
sity Press, 1993), 18 (fig. 6), 20 (text).

1  See Maurer's handwritten invoice dated Paris, March 1, 1912, listing five
paintings by the artist brought home by William Glackens with the
European works purchased for Barnes in February 1912: "Maurer: 1 'Still
Life,' $60.00; 1 'Landscape,' $60.00; 1 'Small Landscape,' $30.00; 1 'Small
Landscape,' $30.00; 1 'Small Landscape,' $30.00. [Total:] $210.00." Invoice
written on telegram sheet from Morgan, Harjes & Co., 31 Boulevard
Haussmann, and signed "Alfred H. Maurer" (London Collection). See
pages 19–20 of the present volume for a transcription of the list of pur-
chases recorded in Glackens's sketchbook, reproduced in fig. 10. Glack-
ens gave the price of the five works as 1,010 francs (approximately
$202.00).

2  See letter, Alfred H. Maurer to Albert C. Barnes, April 8, 1916, ACB Corr.,
BFA: "One of the group of five small pictures you selected at the show
was sold, I have delivered the remaining four to Durand-Ruel [New
York]. Was sorry the show only lasted two weeks. . . . A. H. Maurer 404
West 43rd St." Barnes sent check no. 3602, dated April 11, 1916, in the
amount of $120.00, for the four paintings. Maurer replied on April 12,
1916: "Your letter [not preserved] and draft arrived. You want to know if
the amount is right. These pictures were posted $35.00 at the show. You
will find a pasted [label?] still sticking to the back of one of them. Will
be delighted to come down to see you some week end. I was pleased to
see a group of my work in a show in New York, this is the first lot I have
seen any together since Folsoms." Letter, ACB Corr., BFA. Barnes sent
Maurer a check (no. 3604) dated April 13, 1916, in the amount of $20.00,
to make up the difference for the four pictures. Both checks BFFR, BFA.

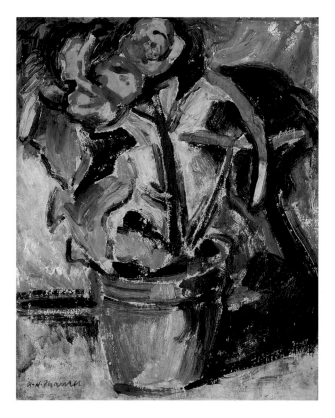

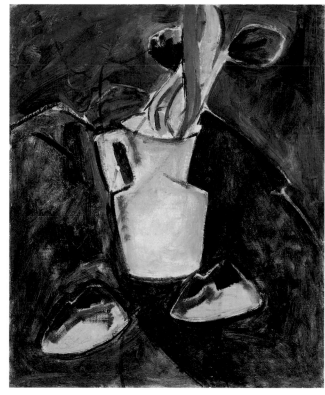

## *Pot of Flowers*

c. 1907. Oil and egg tempera on wood panel, 10⅝ × 8⅜ in. (27 × 21 cm). Signed lower left: A. H. Maurer. Frame by Robert Laurent, signed left frame member verso: Laurent. BF291

PROVENANCE: Acquired from the artist.

REFERENCES: See entry for *House* (BF287).

REMARKS: Since *Pot of Flowers* is not a landscape, it seems likely that the painting was one of the four Barnes acquired from the artist from the Forum Exhibition of Modern American Painters, March 13–25, 1916. See entry for *House* (BF287), note 2.

## *Tulips in a Green Vase*

c. 1910–12. Oil on canvas, 18⅛ × 14⅞ in. (46 × 37.8 cm). Signed lower left: A. H. Maurer. BF360

PROVENANCE: Gift from the artist.[1]

EXHIBITION: Likely Folsom Galleries, New York, Post-Impressionist Paintings: Alfred H. Maurer, January 15–29, 1913, no. 6 (as *Tulips*) in the "List of Paintings," a numbered checklist printed in conjunction with the exhibition.[2]

REMARKS: Barnes traded five pictures by Maurer, including one entitled *Still Life (Vase of Tulips)*, 21½ × 18 in., to J. B. Neumann, January 8, 1950, for a Paul Klee watercolor, *Historic Ground (Historischer Boden*, BF2532), priced at $900.00.[3]

1  See letter, Barnes to Maurer, January 3, 1913, ACB Corr., BFA: "The paintings arrived from Folsom but the one you gave me was not in the box. You know the one I mean, the blue vase and I think it had tulips in it. Please notify Folsom at once, and find out what has become of this painting."

2  See page 132, note 13.

3  Barnes Foundation file card, BFA.

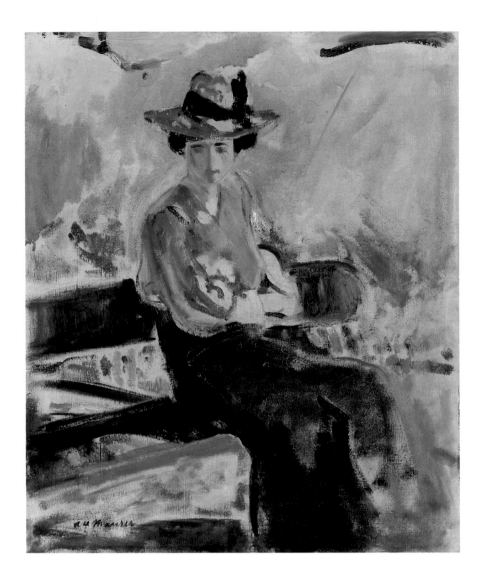

## *Figure on Bench*

c. 1908. Oil on canvas, 21⅝ × 18 in. (54.9 × 45.7 cm).
Signed lower left: A. H. Maurer. BF 499

PROVENANCE: Acquired from the artist.

RELATED WORKS: Probably related to *La Liseuse*, discussed in Peter Pollack, *Alfred Maurer and the Fauves: The Lost Years Rediscovered*, exh. cat. (New York: Bernard Danenberg Galleries, 1973), cat. no. 7, ill. (color).

REMARKS: Barnes wrote to Maurer on June 25, 1912: "Your still-life work would appeal very much, and you should have a number of them ready to sell; also figures, in your present method, along the same lines as the two I bought of you."[1] Since the first five Maurers brought home by Glackens in February did not include a figure, it is logical to conclude that Barnes bought *Figure on Bench* and another figure between April and June 1912. Several figure subjects, including a gouache, *Portrait of Woman*, 25¾ × 18¼ in., were recorded as among those traded to J. B. Neumann on January 8, 1950.[2] A check payable to A. H. Maurer in the amount of $750.00 for unspecified "paintings" was issued June 17, 1912, just after Barnes was in Paris with Maurer.[3] Since the five paintings by Maurer that Glackens had brought from Paris three months earlier cost $210.00, this payment must have been made for a greater number of or for larger works and could have included payment for services rendered by Maurer in visiting dealers and arranging purchases of paintings on Barnes's behalf.

1  Letter, Albert C. Barnes to Alfred H. Maurer, June 25, 1912, ACB Corr., BFA.

2  Barnes Foundation file card, BFA.

3  Albert C. Barnes check no. 2298, June 17, 1912, BFFR, BFA.

## *Still Life*

c. 1909–10. Oil on canvas, 22 × 18⅝ in. (55.9 × 46.7 cm).
Signed lower left: A. H. Maurer. BF525

PROVENANCE: Acquired from the artist in 1912 or 1913.

EXHIBITION: Probably Folsom Galleries, New York, January 15–29, 1913 (as *Still Life*), and referred to on January 26, 1913, by the *New York Times* critic as having "aureoles of color."[1]

RELATED WORKS: Compare *Still Life* (BF525) to *Fauve Still Life*, 18 × 21⅝ in. (Collection Tommy and Gil LiPuma), ill. (color), in Stacey B. Epstein, *Alfred H. Maurer: Modernist Expressions*, exh. cat. (Lancaster, Pa.: Demuth Museum, 2004), for the same table covering, wallpaper, candleholder, and two, rather than three, pears. The "aureole" pattern in *Still Life* is introduced in place of the blue patterned plate in *Fauve Still Life*, and while the two works are similar in size, the format of *Still Life* is vertical. The upward thrust of the table projecting the still life objects forward is similar in each composition as is the juxtaposition of multiple decorative patterns of the table covering, wallpaper, and pottery. Maurer was influenced by Henri Matisse's *Blue Still Life* (*Nature morte bleu*, BF185) of late 1907 and *Harmony in Red* of 1908, both of which were exhibited at the 1908 Salon d'Automne, the former acquired by Michael and Sarah Stein and therefore among many of Matisse's Fauve period paintings readily accessible to Maurer for study in both their as well as Leo's and Gertrude's collections.

1 "New of Interest from the Art World: Paintings of Alfred Maurer," *New York Times*, January 26, 1913, X10.

## *Head: Number Three*

c. 1908. Oil on paperboard, 18 × 15 in. (45.7 × 38.1 cm).
Signed lower right: A. H. Maurer. BF2047

PROVENANCE: Acquired from the Exhibition of Paintings
and Drawings Showing the Later Tendencies in Art in 1921,
together with works by seven other artists.[1]

EXHIBITION: Pennsylvania Academy of the Fine Arts, Phila-
delphia, Exhibition of Paintings and Drawings Showing the
Later Tendencies in Art, April 6–May 15, 1921.

REFERENCES: *Exhibition of Paintings and Drawings Showing
the Later Tendencies in Art*, exh. cat. (Philadelphia: Pennsyl-
vania Academy of the Fine Arts, 1921), 19, cat. no. 172; Sylvia
Yount and Elizabeth Johns, *To Be Modern: American Encoun-
ters with Cézanne and Company*, exh. cat. (Philadelphia:

Museum of American Art of the Pennsylvania Academy of
the Fine Arts, 1996), fig. 18 (as *Head: Number Three*, c. 1906);
Stacey B. Epstein, *Alfred H. Maurer: Aestheticism to Mod-
ernism*, exh. cat. (New York: Hollis Taggart Galleries, 1999),
36–37, fig. 27 (as *Woman*): "*Woman*, a painting from Maurer's
early Fauve period."

REMARKS: Maurer was here influenced by Matisse's *Red
Madras Headdress* (*Tête d'expression*, BF448) of mid-1907,
exhibited at the Salon d'Automne in 1907, and *The Young
Sailor I* (1906), both then owned by Michael and Sarah
Stein.

1 Archives of the Pennsylvania Academy of the Fine Arts and Albert C.
Barnes check no. 4929, May 3, 1921, $200.00, payable to cash, BFFR, BFA.

## Landscape with House

c. 1909–12. Oil and egg tempera on paperboard, 21½ × 18 in.
(54.6 × 45.7 cm). Signed lower right: A. H. Maurer. BF2064

PROVENANCE: Acquired from the artist. See entry for *House*
(BF287).

REMARKS: Possibly one of the paintings brought home from
Paris by Glackens ("'Landscape,' $60.00"). See entry for *House*
(BF287), note 1.

## *Tree and Rock*

c. 1907. Oil on commercial wallboard (later mounted to
hardboard), 10½ × 8⅜ in. (26.7 × 21.3 cm). Signed lower left:
A. H. Maurer. BF2546

PROVENANCE: Acquired from the artist in either 1912 or 1916.
See entry for *House* (BF287).

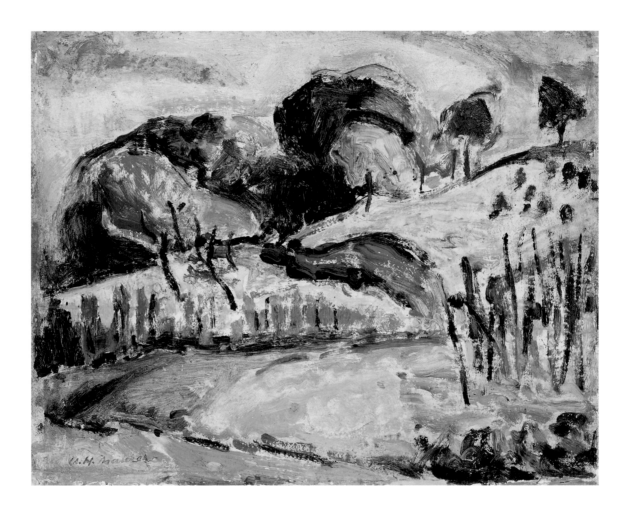

## Hills

c. 1908. Oil on wood panel (later mounted to hardboard),
8⅜ × 10⅝ in. (21.3 × 27 cm). Signed lower left: A. H. Maurer.
BF 2547

PROVENANCE: Acquired from the artist. See entry for *House*
(BF 287).

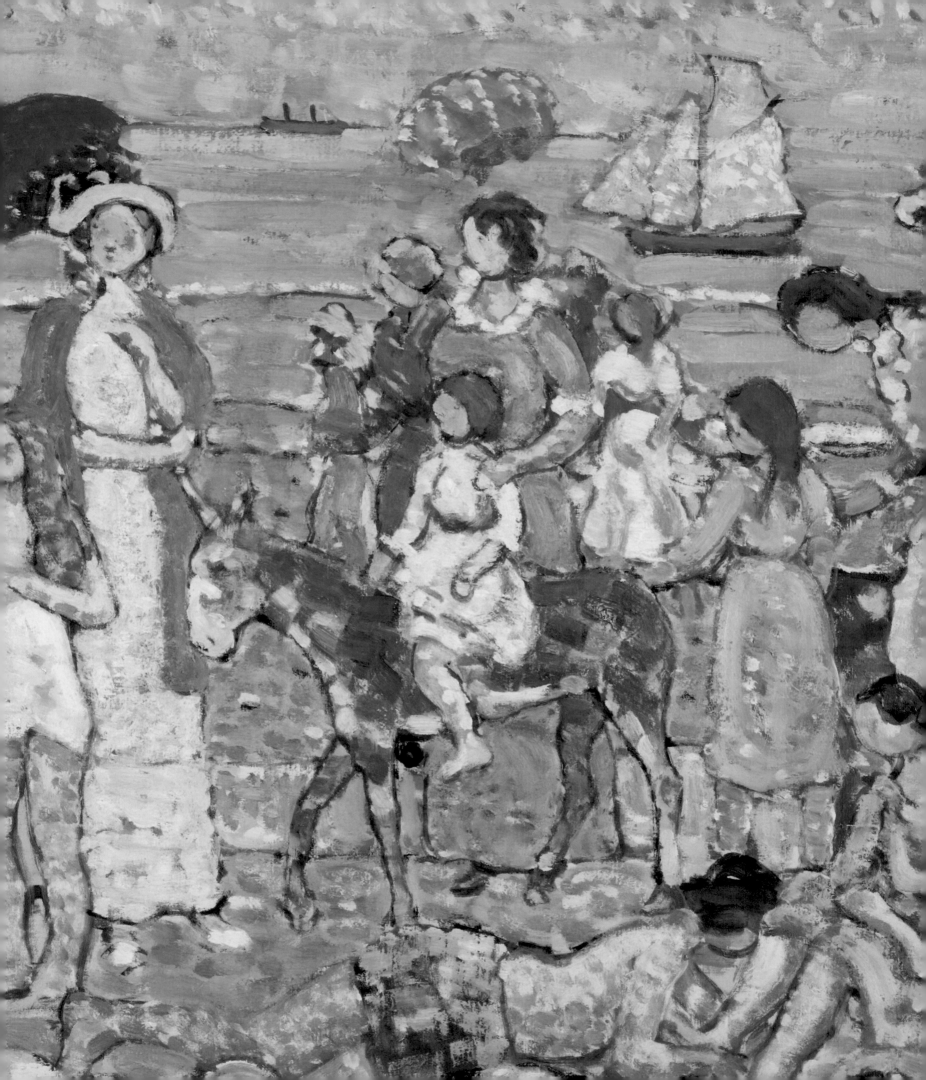

# MAURICE B. PRENDERGAST (1858–1924)

Prendergast founded a technique which differs materially from that of any of the other impressionists. He so modified, amplified and increased the power of color-spots that the effect is totally different from that of any of his prototypes. The manner in which his colors relate themselves gives rise to a great variety of formal relations that constitute his individual note.... The most potent factor in Prendergast's work is color. No painter ever had a finer feeling for its sensuous quality or used it in a greater variety of pure colors. It is rich, juicy and glowing, and he applies it in daring contrasts with harmonious results. It is this staccato use of light and color that makes Prendergast's color-forms powerful and distinctive.

Albert C. Barnes, *The Art in Painting*

*In Albert Barnes's first signed article on art,* published in April 1915, Maurice B. Prendergast's work is acknowledged, alongside that of major Europeans, as a perpetual source of fresh insights. Of all the contemporary American painters Barnes began to collect in 1912, Maurice Prendergast was the eldest and most knowledgeable about French Post-Impressionism. Because his work, by the time Barnes began to acquire it, had already absorbed the influence of Paul Cézanne, Pierre-Auguste Renoir, Camille Pissarro, the pointillists, Paul Gauguin, and other Moderns such as Henri Matisse, he was uniquely respected by his peers (William Glackens, Ernest Lawson, George Luks, Arthur B. Davies, Marsden Hartley). Thus, his paintings were an ideal complement to those of the French masters that Glackens and Alfred Maurer had purchased for the fledgling collector, who was energetically expanding that original ensemble. Like his colleagues, Prendergast was unequivocally enthusiastic about the work of Renoir's later period, which coincided with Barnes's predilection for that artist's work. Maurice's oils, based primarily on subtle color relations, were interspersed throughout Barnes's home and, later, gallery with the best of the French Moderns, exemplifying Barnes's concept of the parity of the Americans who held their own with their French confreres. Maurice's multifigure compositions were also deeply animated by such masters as Vittore Carpaccio, to whose colorful pageantry he was attracted in Venice during an extended stay in that city in 1898–99; Nicolas Poussin, whose complex spacious organizations he studied in the Louvre; and Jean-Antoine Watteau, upon whose *fêtes galantes* he patterned his park by the seashore scenes; as well as by the Byzantine mosaicists, which reinforced Barnes's conviction as to the continuity of Modern art with the Old Master traditions.

Maurice had very sporadic formal art training. Although he studied drawing, both freehand and industrial, he worked as a designer of commercial show cards, which called for knowledge of color mixtures, layout, and lettering. He studied intermittently in Paris at the Atelier Colarossi and the Académie Julian from 1891 to 1894, but his real art education came with his visits to the Museum of Fine Arts, Boston, and in the Louvre. His early (1891–1904) work consisted mainly of colorful watercolors and monotypes, sparkling

scenes of Paris, the Normandy coast, Venice, Rome, and the beaches around Boston, where his remarkable command of that medium received wide acclaim. He focused on oils from around 1904 and it was his work in that medium that attracted the major American collectors of Modern art—Lillie Bliss, John Quinn, Ferdinand Howald, Edward W. Root, Duncan Phillips, and Albert Barnes.

Barnes initially wrote to the artist September 18, 1912, asking him to send examples of pictures that he might consider for purchase.

> Dear Sir:— My life-long friend, W. J. Glackens, said he was going to write you about one or two of your paintings for my collection—but, as he is an artist, it is safe to assume that he has not done so. I have a good collection of the modern leaders— Manet, Renoir, Degas, Monet, Cezanne [*sic*], Van Gogh etc.—and, among other Americans, I would like to have your work represented. I offered Macbeth, the New York dealer, fifty dollars for one of the small sea-coast scenes he has of yours and he said he would write my offer to you; but I would sooner deal with you direct and, if you care to, you might select three or four of what you consider your most characteristic work and send them to me to see. Then, if we can agree on price, I would keep one or more of them [to] hang in my house in very good artistic company. I could not use any very large canvases and would like one or more of the 10 × 12 sizes, like I saw at Macbeth's, and one or more larger ones. No dealer can claim any commission on what I might get from you—long before I saw your work at Macbeth's Galleries, Glackens had told me to see your paintings. If you care to, send the paintings by express to my home address "Dr. A. C. Barnes, Overbrook, Pa.," and write me the prices which I hope will be low enough for us to get together.[1]

Prendergast replied,

> Dear Mr. Barnes, Please accept my apologies for not responding to you before[.] Your letter followed me in the country where I was staying and I postponed answering . . . until my return to the Studio. I find it embarrasing [*sic*] to select anything just now. If you will allow me a little time say three [or] four weeks— when I return for good then I will have leisure to look things over and will select three [or] four pictures and send them to you for your approval. I feel highly complimented by your letter and I hope you will give me an opportunity to be well represented in your collection which contains the works of so many distinguished painters. I hope my arrangement will be satisfactory to you. I remain yours faithfully Maurice B. Prendergast P. S. I will write you again when I am ready to send the pictures M. B. P.[2]

From the outset, their correspondence reveals that Barnes's reflexive, unyielding business tactics in his negotiations for pictures, far from being reserved for his interactions with dealers, were sometimes deployed in transactions conducted directly with artists, even those for whom he had a warm personal regard. Nonetheless, his occasionally bluff letters to the Prendergast brothers over the years never muffled his genuine affection, his concern for their well-being, and his profound respect for their art.

Maurice wrote again to Barnes early in 1913,

> When I decided one morning to select some pictures to send for your inspection I gave up the job as hopeless[;] it is very hard for an artist to select pictures. What he thinks would be suitable for his client[. I]t is all right when he paints a picture and sends it away to an exhibition and someone buys [and] makes it an easy matter. . . . In your letter to me you mentioned so many fine modern names in your collection [that it] was a little discouraging for one would like to be represented with a strong canvas. I have just got back from New York and Glackens gave me a kind of stir so I am writing you to make up for my neglect. I have changed my style completely since you saw those small panels in [William] Macbeth's. When he was here 'Macbeth' . . . selected a canvass [*sic*] to show in his galleries which I like very much[;] it would please me when you are in N.Y. to [go] up there and see it and get Glackens to go with you (for I have a wholesome respect for him in all matters on art). For I

suppose you will be there when our exhibition is on. Mr. Macbeth has marked the canvas 400.00[;] it is a "coast scene" and if he does not sell it by April, I will take it away and send it [to] you and we will get together on a price or any canvas you would care [for] in the exhibition and this will give you some sense of my work also.[3]

The works Barnes had seen when visiting Macbeth's gallery initially were rapid oil sketches, somewhat reminiscent of Manet, on wood panels painted in Paris and St. Malo in 1907. What Maurice meant by "changed my style completely" was that these earlier *pochades* were different from the more complex compositions, with layered built-up paint surfaces made of irregularly shaped patches of color, with which he began to experiment by around 1909.

Barnes responded shortly thereafter, in an undated letter sent to Maurice in January or early February 1913,

I received your letter and I have also seen your painting at Macbeth's, and I am at a loss to understand why you did not send it to me instead of letting it get into a dealer's hands. . . . Inasmuch as I ordered a painting of you more than six months ago, I think that you could conscientiously withdraw the painting from Macbeth's and let me have it, and in exchange for which you could send another one to Macbeth. . . . If, however, you could not get it from Macbeth and if you have one or more paintings of about the same quality and which you like and consider representative of your best work, I suggest that you send them to my address at Overbrook, Pa., and let me select which one I want. I have always felt that an artist knows best what he is trying to do, and on that basis I believe that your selection would probably be better than any other person's no matter how well posted they are on art.[4]

The artist wrote back on February 10, "Your letter received and it pleases me immensely that you like the picture at Macbeth's. As I have to go to New York to stay four or five days to help at the international exhibition and I will see while I am there how matters stand and will write you later on. . . . Mr. Macbeth's price does not include

the frame; it is hand carved and I value [it] highly, but if you insist on it we may come to some arrangements."[5]

A letter from Barnes to Glackens, dated February 12, underscored his determination not to buy from dealers:

I have just received a letter from Prendergast which convinces me that he is so very strange that I do not see how I am going to have him represented in my collection. He writes that he will be in New York . . . to attend to some matters in connection with the International Exhibit, and if you run across him I wish you would prevail on him to send me the painting at Macbeth's. As you know last summer he wrote me that he would send me some of his paintings from which I could make a selection; this he failed to do, and the first thing I heard from him was to tell me to call at Macbeth's and see one of his paintings. I did this and liked the painting very much, but of course, I would not buy it from Macbeth, especially as I surely have first claim upon one of Prendergast's paintings in view of his letter to me, promising to send me one. . . . The painting at Macbeth's is a particularly good one, and I would like to have it, and Prendergast certainly ought to realize that it is to his advantage to be represented in my collection.[6]

On February 14, Maurice wrote again to let Barnes know that the painting had been shipped and that the frame was included in the $400.00 selling price.

The artist accepted Barnes's terms, writing back on the 19th, "I got back from New York this morning and found your letter containing the $300 check. The price it is all right! I am perfectly satisfied. I put my price and you of course yours and that was understood in your first letter to me and I am more than please[d] to be represented by a good picture & frame. Hoping to have the pleasure of seeing your pictures some day."[7]

Maurice and his brother, Charles, moved to New York in early November 1914, settling into studio and living quarters directly below Glackens's studio at 50 S. Washington Square. Shortly thereafter, Barnes invited the brothers to visit and see his collection, writing to Glackens on December 3, "I want the Prendergasts to come over and see my things as soon as they ship the new pictures which

I ordered of them yesterday, and I have written them that I thought perhaps you would come with them. This visit should take place within the next couple of weeks, and I think that you could all manage to spend a day and night very agreeably at my house."[8]

The exhibition Maurice B. Prendergast: Paintings in Oil and Water Colors took place from February 15 through March 6, 1915, at the Carroll Galleries, directed by Harriett C. Bryant and owned by John Quinn. It was Maurice's largest exhibition to date, including twenty-nine paintings and thirty-one watercolors, all painted following the 1908 exhibition at Macbeth's. A brochure-checklist provided dates for all works and was accompanied by a brief essay by Frederic James Gregg, advisor to Quinn, former critic at the *New York Evening Sun*, and publicist for the Armory Show. He lauded Prendergast as "a great master, one of the very few Americans to whom that term may be applied in sincerity and truth," and added, "the work of Prendergast . . . ranks easily with that of the most modern Frenchman."[9] Maurice wrote Quinn, "I am deeply grateful to you for giving my exhibition such a fine start and also for the great interest you have shown in my work right along. . . . Your letter gives me confidence and pleasure and will pave the way for the future."[10] The show was a critical and financial success. Quinn, who had known Maurice since before the Armory Show but had not yet purchased anything from him, bought seven oils and nine watercolors.

The exhibition occasioned a volley of contentious letters between Barnes and Bryant. Barnes, who had been buying Maurice's work for more than two years and by now owned eight of his paintings, visited the show with Glackens on the day after the opening. He showed interest in catalogue no. 14, *The Beach* (1913), and was informed by Bryant on February 17 that it was unsold and available for $500.00. Barnes replied the following day, "I am sorry to learn from your letter of yesterday that the Prendergast panel has not been sold. Several months ago when I told Mr. Prendergast that I would buy it [I] did not take it immediately only because he said he wanted to exhibit it later. . . . Perhaps when your show is over and Mr. Prendergast receives the unsold one, I shall probably go to his studio, have him send the panel to me, and mail him my check to him in the regular way, but I have such a kindly feeling towards him, and such great admiration for his art that I hope that all the paintings in your galleries will have been sold."[11] Bryant riposted on February 27, "I am happy to notify you that I have formal and full authority from Mr. Prendergast in writing to handle all his pictures after the present exhibition closes. . . . During the present exhibition and after it is over, if you wish to secure examples of his work you will do so through my gallery, not through the artist; and you will deliver or send the check to me or my gallery and that will be the only . . . way . . . and will apply right along through the next year and his next exhibition which will also be at my gallery."[12] Barnes realized that Quinn and Bryant were attempting to dupe Maurice into accepting an exclusive contract with Carroll, and that such an arrangement was not in the artist's best interest. He therefore urged Maurice not to make Carroll his exclusive agent, writing him on March 3, "There has been a tempest in a tea-pot, in which your name has been brought. . . . I told Charley yesterday what I thought of him for not giving you the warning expressed to Charley two weeks ago that you should not hypothecate your future by making any entangling alliances with dealers. You have 'arrived' not by any help from dealers, or any other individual, but because of intrinsic qualities of your own. It is most unwise, from a business standpoint, for you to allow any dealer to capitalize, to your disadvantage, your name or your talents."[13] Maurice answered the following day:

I received your letter [of] March the 3rd this morning. This affair about the Carroll Galerie [*sic*] only bores and confuses me. I only want to be let alone and to do the work. I have been wraped [*sic*] up in art all my life and have got along so far O.K. and I would not like to tie myself to any rules now. I appreciate your good intentions but nothing pleases me more than to *sell at a public exhibition* which adds prestige to an artist and creates an independents [*sic*] which benefits his work. There is [are] no cast iron rules between me and the Carroll Galleries, they are interested in my work and with my permission will keep them at the close of the exhibition and try until the end of the season and sell some more. Charlie with me would like to be remem-

bered to Mrs. Barnes and have not forgotten what a fine time we had at your house when you proved a real host and admiring your fine pictures.[14]

Bryant exchanged vituperative letters with Barnes, drafted, possibly with Gregg's help, by Quinn. The outcome of this dispute was that the artist never again exhibited at the short-lived gallery, and he resumed his lifelong policy of being represented by several dealers in addition to independently entering works in museum and art association annual exhibitions throughout the country. The Prendergasts remained on excellent terms with both Barnes and Quinn, Maurice telling Charles Daniel, "They're both my friends, what can I do?"[15]

From time to time, a solicitous personal note appeared in the correspondence. On November 6, 1917, Barnes wrote Charles Prendergast,

You had better take Maurice to a specialist for a regime of daily habits suitable to his present condition. I'll bet a good Renoir against one of your frames that he will confirm my belief that the symptoms which I have observed in Maurice are indicative of a fairly serious disturbance of his circulatory system and, possibly, of his central motor apparatus. . . . I know a very good man in Philadelphia who is also a very warm personal friend and if you would come over here, I shall make an appointment and see that the charge is little or nothing. I feel fairly sure that the specialist will tell Maurice to get a first floor studio somewhere, cut out Barolino, etc., and let those who want to take long walks do it without his company. Of course, I know it's none of my business, and I am so accustomed to being snubbed by butting into other people's affairs that I shall not mind it in the least if you ignore my suggestion; but if you take it seriously, meet me to-morrow night at the Italian Restaurant on Mulberry Street . . . and we can talk it over. If Glack is free, bring him along—it will be a Dutch treat.[16]

After Barnes had gotten to know John and Alice Dewey in the latter part of 1917, he introduced them to several of his artist friends, including the Prendergasts. Mrs. Dewey

wrote to him in May 1919, "I hope you will continue and speak of the American painters you name. I shall never forget that rainy afternoon in the little back shed where the Prendergasts live and work. It was a wonderful experience much as if one found the golden fairy of dreams in the back woodshed on grandpa's farm. In my youth I was stuffed with criticism in my college course, stuffed till nature revolted, and has [sic] never since relaxed to the point of enduring the usual vapidities, uttering adjectives to suggest vague emotions. Getting the real emotions into words, shape, form, is too hard work for the most part, we are too sentimentally inclined I suppose, at least the literary person is. So I hope you will do it for us."[17] Barnes commented on Mrs. Dewey's suggestion a year later, on July 1, 1920, "I can't obligate myself to write even about Prendergast and Glackens because I'm not sure that I would say something really worthwhile; and they are so real, so genuine, so important and I am so in love with them, that detachment would be the hardest part of the job."[18]

On January 31, 1924, William Glackens and Edith Dimock saw Maurice Prendergast for the last time. Glackens wrote Barnes,

Maurice died at 7:30 this morning. Last evening Teed [Edith] and I went to the New York hospital to see him. He appeared to be dozing seated up in his bed but he awoke and saluted us with that Roman salutation of his with his poor thin arm raised high in the air. His eyes were as bright as ever. He spread out his hands and shrugged his shoulders as though saying well you see how it is, there is no help for me. We stayed but a little, he was very weak and when we left he held out his hand and said good bye, and he knew it was a good bye. He had had an attack of asthma which so weakened his heart he couldn't hold out any longer, and it was a good thing for the doctor told us he had a cancer of the prostate gland. . . . Yours, Butts [P.S.] Charles is staying with us.[19]

Barnes replied immediately by telegram to Glackens, "Will call your house tomorrow noon go to Maurice's funeral."[20]

The year of Maurice Prendergast's death, Barnes set down some of his thoughts about the artist's achievement in *The Art in Painting*. With respect to the last canvas he had acquired during the artist's lifetime, Barnes wrote,

> *Marblehead Harbor* [BF216] represents the height of his powers in achieving a design by means of his own technique. . . . As a result the whole canvas is a succession of contrasts of line, color, mass and spatial relations, that give rise to a series of rhythms comparable to those of a Bach fugue. For instance, the horizontal lilac-pink river bank in the middle-ground serves as a starting point for one of the fugues; it first changes its direction to the slightly oblique, then changes in color by interspersions of green which makes a new unit in the fugue; that in turn is modified by line and color, interspersions up to a house with white walls and red roof. . . . In every part there are an infinite number of minor variations of color, line, mass, space and general treatment, which correspond to the internal variations of contrapuntal music.[21]

NOTES

Epigraph. Albert C. Barnes, *The Art in Painting* (Merion, Pa.: Barnes Foundation Press, 1925), 298–99.

1  Letter, Albert C. Barnes to Maurice Prendergast, September 18, 1912, ACB Corr., BFA. See Albert C. Barnes check no. 2457, November 6, 1912, $50.00, payable to William Macbeth, BFFR, BFA. This was Barnes's first purchase of a work by Prendergast, *Seascape—St. Mâlo* (BF561). See also Ira Glackens, *William Glackens and the Ashcan Group* (New York: Crown, 1957), 120 and 171.

2  Letter, Maurice Prendergast to Barnes, undated [fall 1912], ACB Corr., BFA. Written from 56 Mt. Vernon St., Boston, Mass., Maurice and Charles Prendergast's studio and domicile.

3  Letter, Maurice Prendergast to Albert C. Barnes, undated [late January 1913], ACB Corr., BFA. It would appear that Maurice consigned a more recent canvas, representative of his latest style, to Macbeth at a date subsequent to Barnes's earlier visit to the gallery. Prendergast was the only member of the Association of American Painters and Sculptors to serve on both the committees for Domestic and Foreign Exhibits and often traveled to New York.

4  Letter, Barnes to Maurice Prendergast, undated [January or early February (before February 10) 1913], ACB Corr., BFA.

5  Letter, Maurice Prendergast to Barnes, February 10, 1913, ACB Corr., BFA.

6  Letter, Barnes to William Glackens, February 12, 1913, ACB Corr., BFA. Apparently, Barnes's stratagem was successful. See below and note 7.

7  Letter, Maurice Prendergast to Barnes, February 19, 1913, ACB Corr., BFA. Albert C. Barnes check no. 2553, February 17, 1913, $300.00, payable to Maurice Prendergast for "painting," which crossed with Maurice's letter, BFFR, BFA. It is not certain which painting Barnes acquired at this time. See page 152, entry for *Landscape with Figures* (BF480). Maurice was experienced and adept at business negotiations and practical matters, but due to his deafness, this was not always apparent to his patrons. Barnes mistook his impairment for naïveté. See Wattenmaker, *Maurice Prendergast*, 67–70.

8  Letter, Barnes to Glackens, December 3, 1914, ACB Corr., BFA. The Prendergasts and Glackenses were close friends, and Barnes visited the three artists frequently after the Prendergast brothers moved to New York. The familial relationship between the Prendergasts and Glackenses continued after Maurice's death in 1924, and Glackens died, on May 22, 1938, surrounded by a virtual museum of the Prendergasts' work in Westport, Connecticut, while visiting Charles and his wife. See Ira Glackens, *William Glackens and the Ashcan Group*, 116–22.

9  Frederic James Gregg, "Maurice Prendergast," in *Maurice Prendergast: Paintings in Oil and Water Colors* (New York: Carroll Galleries, 1915).

10  Letter, Maurice Prendergast to John Quinn, February 21, 1915, John Quinn Memorial Collection, New York Public Library.

11  Letter, Barnes to Harriet Bryant, February 18, 1915, ACB Corr., BFA.

12  Letter, Bryant to Barnes, February 27, 1915, ACB Corr., BFA.

13  Letter, Barnes to Maurice Prendergast, March 3, 1915, ACB Corr., BFA.

14  Letter, Maurice Prendergast to Barnes, March 4, 1915, London Collection.

15  Charles Daniel, unpublished memoirs, Charles Daniel Papers, Archives of American Art, Smithsonian Institution, Washington, D.C.

16  Letter, Barnes to Charles Prendergast, November 6, 1917, ACB Corr., BFA. Barnes sent three checks to Maurice Prendergast in October and November 1917: Albert C. Barnes check no. 4084, October 22, 1917, $350.00; no. 4089, November 1, 1917, $650.00; and no. 4109, November 20, 1917, $1,400.00, BFFR, BFA.

17  Letter, Alice (Mrs. John) Dewey to Barnes, May 1919 [day illegible], ACB Corr., BFA. The workshop she refers to was the alley behind 50 Washington Square South (subsequently destroyed) adjacent to the Judson Memorial Church. A photograph of the alley is in the Maurice and Charles Prendergast Archives and Study Center, Williams College, Williamstown, Mass.

18  Letter, Barnes to Alice Dewey, July 1, 1920, ACB Corr., BFA.

19  Letter, Glackens to Barnes, February 1, 1924, ACB Corr., BFA.

20  Letter [telegram], Barnes to Glackens, February 1, 1924, ACB Corr., BFA.

21  Barnes, *The Art in Painting*, 502–03.

## NOTE ON MAURICE B. PRENDERGAST SOURCES

Carol Clark, Nancy Mowll Mathews, and Gwendolyn Owens, *Maurice Brazil Prendergast, Charles Prendergast: A Catalogue Raisonné* (Williamstown, Mass.: Williams College Museum of Art; Munich: Prestel-Verlag, 1990), is abbreviated in all entries below as CR, which is followed by the number of the corresponding entry in the *Catalogue Raisonné*. All works from the Barnes Foundation recorded in the *Catalogue Raisonné* are illustrated.

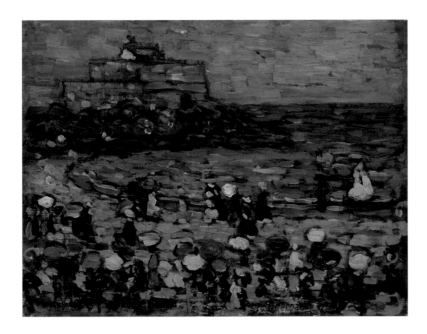

## *Seascape—St. Mâlo*

1907. Oil on wood panel, 10½ × 13¾ in. (26.7 × 34.9 cm). Signed lower right of center: Prendergast; partially signed lower left: Pren. Frame by Charles Prendergast. BF561

PROVENANCE: Purchased from William Macbeth, November 6, 1912.[1]

REFERENCES: CR 79 (reproduced with frame); R.J. Wattenmaker, *Maurice Prendergast* (New York: Abrams in association with the National Museum of American Art, Smithsonian Institution, 1994), 95, 94, pl. 73.

REMARKS: Prendergast exhibited sixteen paintings at Macbeth Galleries' Exhibition of Paintings, February 3–15, 1908, known as The Eight show. Most of the sixteen paintings displayed (cat. nos. 20–36, one of which, no. 24, was not exhibited) were small compositions painted in 1907 during the artist's stay in France, where he painted in Paris and at St. Mâlo. Two of these small compositions (Macbeth nos. 25 and 36) were entitled *Beach, St. Mâlo,* and eight were designated *Study, St. Mâlo.* No dimensions were given, but references in the reviews describe the pictures as small. James Huneker of the *New York Sun,* reviewing the exhibition, wrote: "Prendergast . . . is really a neo-impressionist. He employs the *taches* according to the new men of the Independent Salons. His little panels are cunning mosaics, flowerlike arabesques, delightfully decorative."[2] *Seascape—St. Mâlo,* which is one of four small oils to represent Chateaubriand's Tomb in their backgrounds, is possibly one of those in the show.[3]

1 Albert C. Barnes check no. 2457, November 6, 1912, $50.00, BFFR, BFA. See also letter, Barnes to Maurice B. Prendergast, September 18, 1912, ACB Corr., BFA, quoted on page 144.

2 James Huneker, "Eight Painters," *New York Sun,* February 9, 1908, 8.

3 The three others were CR 80, 81, 82.

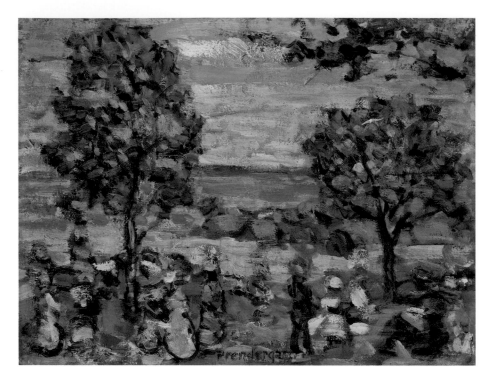

## Beach Scene with Two Trees

c. 1908–10. Oil on wood panel, 10½ × 13¾ in.
(26.7 × 34.9 cm). Signed lower center: Prendergast.
Frame by Charles Prendergast, signed right frame
member verso: Prendergast. BF345

PROVENANCE: Probably acquired from the artist.

REFERENCES: Violette de Mazia, "The Barnes Foundation:
The Display of Its Art Collection," *Vistas* 2, no. 2 (1981–83):
109, 111 (text), pl. 60 (installation); CR 190.

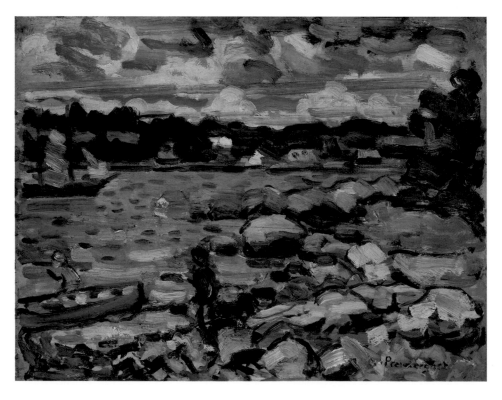

## Brooksville, Maine (River & Rocks)
Alternate title: *Symphony in Blues*

c. 1908–13. Oil on wood panel, 10⅝ × 13¾ in. (27 × 34.9 cm).
Signed lower right: Prendergast. Frame by Charles
Prendergast. BF2078

PROVENANCE: Acquired from Charles Prendergast, May 25,
1948. See entry for *Beach and Village* (BF2077), page 158.

REFERENCE: CR 133 (as c. 1907–10).

REMARKS: Prendergast did not return from a trip to France
in 1907 until early November. He made numerous watercol-
ors and small oils in various locales in New England in the
period c. 1908–13 and is known to have worked in Brooks-
ville, Maine, in the summer of 1913.[1]

1 Letter, Maurice Prendergast to Walter Pach, July 11, 1913, Walter Pach
  Papers, Archives of American Art, Smithsonian Institution: "Both Char-
  lie and I leave for Brooksville, a little place on the Maine coast to stay
  three or four weeks." See also sketchbook, c. 1913, Museum of Fine Arts,
  Boston (1972.1124); CR 1508.

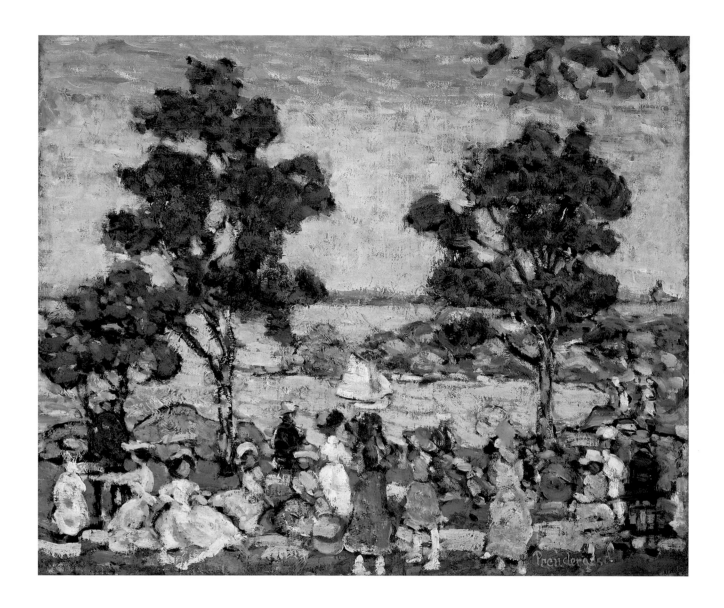

## Landscape (Park Scene)

c. 1910–12. Oil on canvas, 20 × 24⅛ in. (50.8 × 61.3 cm).
Signed lower right: Prendergast. Frame by Charles
Prendergast. BF298

PROVENANCE: Probably acquired from the artist.

REFERENCE: CR 196 (as c. 1907–10).

## Landscape with Figures
Alternate titles: *Landscape with Figures (Park); Park*

c. 1910–12. Oil on canvas, 28 × 34 in. (71.1 × 86.4 cm). Signed lower right: Prendergast. Frame by Charles Prendergast.
BF480

PROVENANCE: Acquired from the artist, February 17, 1913.[1]

EXHIBITION: Whitney Museum of American Art, New York, Maurice Prendergast Memorial Exhibition, February 19–March 22, 1934.[2]

REFERENCES: *Maurice Prendergast Memorial Exhibition*, exh. cat., with introduction by Walter Pach (New York: Whitney Museum of American Art, 1934), cat. no. 32; CR 266 (as c. 1910–13).

1  Albert C. Barnes check no. 2553, February 17, 1913, $300.00, BFFR, BFA. See pages 144–45 and page 148, notes 3–7.

2  Charles Prendergast wrote to Albert Barnes on November 17, 1933: "Dear Dr. Barnes, The Whitney Museum is givin[g] a memorial show to my brother on Feb. 19. Mrs. Force the director told me they were going to devote all the museum to it. I am going to ask you a great favor. I would like to make this a good show. And I know you would too. As they intend to borrow his pictures from different museums and private owners I wonder if you would be willing to let us have one of the oil paintings. As a couple of [possibilities]. One especially. The one painted in Gloucester with the white house in the middle distance [*Landscape* (BF930)]. How-ever I would be glad to have any of them. And would catalogue them (private collection) If you wish to. I know you don't lend pictures. And if you refuse we will be just as good friends as ever. Why don't you and Mrs. Barnes drop in and see us sometime when you are [out] this way. We will be glad to see you." Barnes replied to Charles Prendergast on November 21: "Dear Charlie: I have never loaned a picture in my life to an exhibition and it is my inflexible rule never to do so. You will appreciate my motives, therefore, when I tell you that I will loan two of the best of Maurice's paintings for the Memorial Exhibition to be held at the Whitney Museum, providing you have somebody collect the pictures here, attend to the packing and shipping, and return the paintings to me in good condition immediately after the exhibition is over. I also authorize you to put in the catalogue 'loaned by the Barnes Foundation'. With kind regards." Juliana Force from the Whitney subsequently wrote to Barnes, January 20, 1934: "I am delighted to learn from Charles Prendergast that you will loan to the Museum the two paintings by Maurice Prendergast for our coming Memorial Exhibition this February. It is a concession on your part which I understand and fully appreciate. . . . Thanking you for the great help you have given us in making this exhibition a success." Hermon More, curator, wrote Barnes on January 22, about the arrangements. Nelle Mullen replied on January 25, informing More that the loan form was not enclosed with his letter. Mullen indicated to the Whitney on January 27: "We find that we can lend only one painting by Maurice Prendergast for your exhibition because all of the others are in constant daily use as part of our educational program." More responded to Mullen, January 29, 1934: "We will be very glad to have the painting, 'Landscape with figures' from the collection of The Barnes Foundation for our coming memorial exhibition of the work of Maurice Prendergast." All letters ACB Corr., BFA. See also printed exhibition label attached to upper stretcher member with typewritten additions: DR. ALBERT C. BARNES / Detach and fasten on back of work / WHITNEY MUSEUM OF AMERICAN ART / 10 WEST 8TH ST., NEW YORK CITY / RECEIVING ROOM, 15½ MACDOUGAL ALLEY / PRENDERGAST MEM. EXHIBITION / FEB. 19 to MARCH 22, 1934 / ARTIST: Maurice B. Prendergast / ADDRESS / TITLE Landscape with figures / PRICE [crossed out] Barnes Foundation, Merion / RETURN ADDRESS Montgomery Co., Pa. / INSURANCE VALUATION $3,000.00. The date of the painting was not indicated.

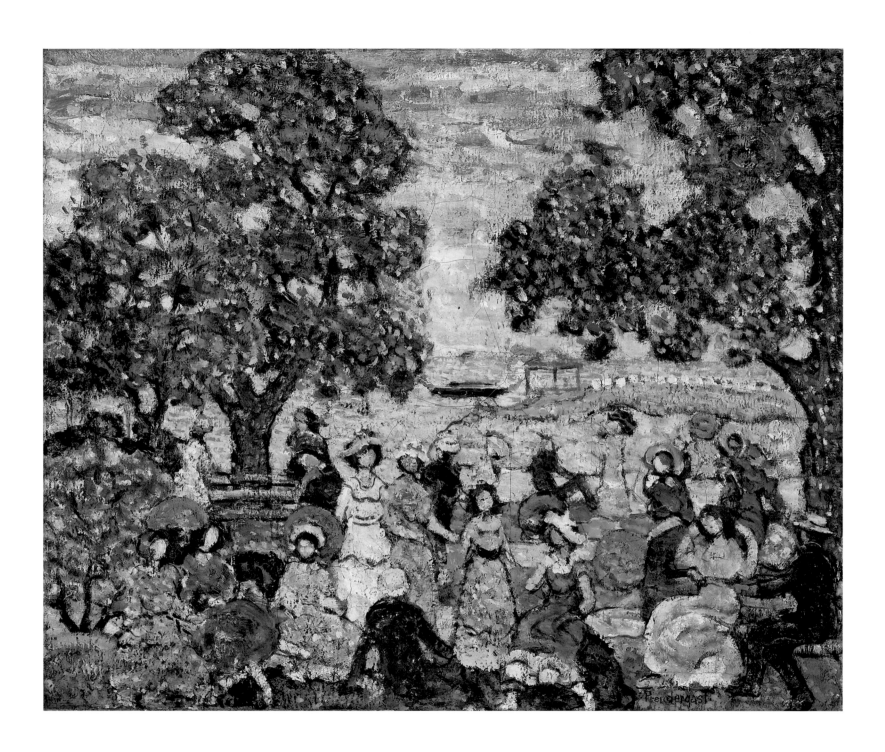

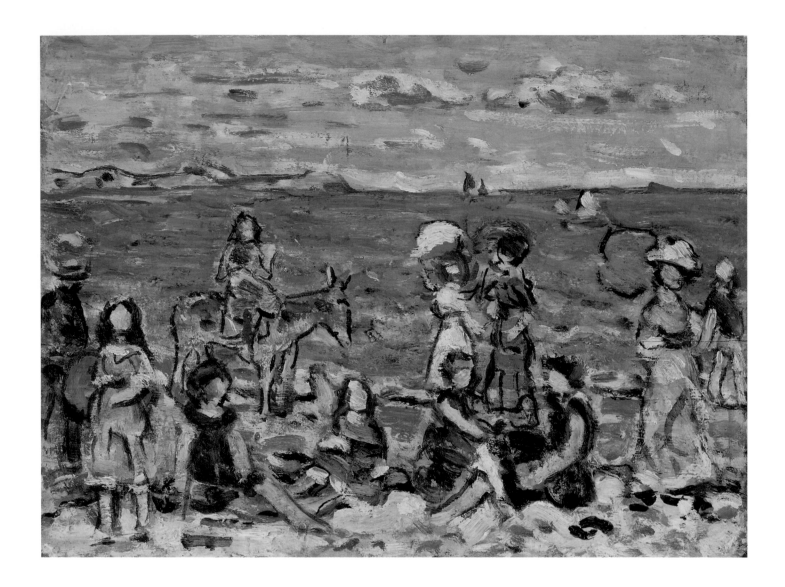

*At the Beach*

c. 1910–13. Oil on wood panel, 10¼ × 13¾ in. (26 × 34.9 cm).
Unsigned. Frame by Robert Laurent, signed upper frame
member verso: Laurent. BF322

PROVENANCE: Probably acquired from the artist.

REFERENCES: Violette de Mazia, "What's in a Frame?" *BFJAD*
8, no. 2 (Autumn 1977): 56n, pl. 135; CR 291.

## Beach Scene

c. 1910–13. Oil on canvas, 18⅜ × 21¾ in. (46.7 × 55.2 cm).
Signed lower left: Prendergast. Frame by Charles Prender-
gast, signed (incised) upper frame member: P.; with
adjacent inscription in graphite: *[P]rendergast*. BF170

PROVENANCE: Probably acquired from the artist.

REFERENCES: Violette de Mazia, "What's in a Frame?" *BFJAD*
8, no. 2 (Autumn 1978): 56, pl. 136; Violette de Mazia, "The
Barnes Foundation: The Display of Its Art Collection," *Vistas*
2, no. 2 (1981–83): 109, 111, pl. 60 (installation); CR 298 (repro-
duced with frame).

## Gloucester Harbor

Alternate titles: *Water Inlet and House; Le Crépuscule (Twilight); Landscape*

c. 1912. Oil on canvas, 19 × 24¼ in. (48.3 × 61.6 cm). Signed lower center: Prendergast. Inscribed canvas verso: *Maurice B. Prendergast / 56 Mt. Vernon St / Boston, Mass*; paper label lower stretcher member: *175* [175 is the number assigned on the 1922–1924 Inventory, as *Landscape—Blues*, 18¼ × 24¼ in.]. Frame by Charles Prendergast. BF930

PROVENANCE: Probably acquired from the artist.

REFERENCES: Forbes Watson, "The Barnes Foundation—Part II," *Arts*, February 1923, 148, ill. (as *Landscape*); Margaret Breuning, *Maurice Prendergast* (New York: Whitney Museum of American Art, 1931), 38, ill. (as *Gloucester Harbor*, with incorrect dimensions); Hedley Howell Rhys, "Maurice Prendergast: The Sources and Development of His Style" (Ph.D. diss., Harvard University, 1952), 156 (as *Gloucester Harbor*); Violette de Mazia, "The Barnes Foundation: The Display of Its Art Collection," *Vistas* 2, no. 2 (1981–83): 109, 111, pl. 60; CR 409 (as c. 1914).

## *Idyl*

Alternate titles: *Landscape; Nudes in Landscape; Summer Idyl*

c. 1912–15. Oil on canvas, 24 × 32⅛ in. (61 × 81.6 cm). Signed lower right of center: Prendergast. Frame by Charles Prendergast. BF113

PROVENANCE: Probably acquired from the artist.

REFERENCES: Mary Mullen, *An Approach to Art* (Merion, Pa.: Barnes Foundation, 1923), 60, ill. (as *Landscape*); Albert C. Barnes, *The Art in Painting*, 191, ill.; Hedley Howell Rhys, "Maurice Prendergast: The Sources and Development of His Style" (Ph.D. diss., Harvard University, 1952), 159; R. J.

Wattenmaker, *Puvis de Chavannes and The Modern Tradition*, exh. cat. (Toronto: Art Gallery of Ontario, 1975), 192 n. 1; Violette de Mazia, "Transferred Values: Part I—Introduction," *BFJAD* 9, no. 2 (Autumn 1978): 7, 31–32, pl. 90; Violette de Mazia, "Subject and Subject Matter: Part II Instrumentalism," *Vistas* 2, no. 2 (1981–83): 14, pl. 86; CR 353 (as 1910–13); R. J. Wattenmaker, *Maurice Prendergast* (New York: Abrams in association with the National Museum of American Art, Smithsonian Institution, 1994), 123, 152 n. 121, ill. 122, pl. 102.

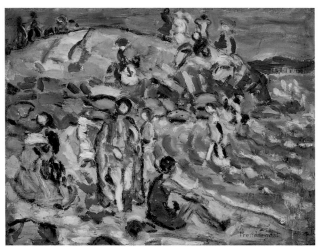

## Beach and Village

c. 1912–15. Oil on wood panel, 10½ × 13¾ in. (26.7 × 34.9 cm).
Signed lower left: Prendergast. Frame by Robert Laurent,
signed lower frame member verso: Laurent. BF2077

PROVENANCE: Acquired from Charles Prendergast, May 25,
1948.[1]

REFERENCE: CR 467.

REMARKS: The *Catalogue Raisonné* gives the date as 1918–23,
but color and facture, especially in the painting of the water
and figures, indicate an earlier date. The artist was not paint-
ing small-scale outdoor oil sketches in his later years but,
rather, painted large-scale oils from drawings made in his
sketchbooks.

1 Albert C. Barnes check no. 3040, May 25, 1948, in the amount of
$2,000.00, BFFR, BFA, in payment for *Beach and Village* and two other
oils (*Beach Scene and Hill* [BF2076] and *Brooksville, Maine (River &
Rocks)* [BF2078]), a watercolor (*Rocks, Waves and Figures* [BF2079]),
and a pastel over watercolor (*Trees, Houses, People* [BF2080]); individ-
ual prices not noted. These five works were purchased during a farewell
visit from Dr. and Mrs. Barnes to Charles and Mrs. Eugenie Prendergast
at their home in Westport, Connecticut, May 25, 1948. Charles Prender-
gast died August 20, 1948. See Barnes Foundation file cards for BF2076,
BF2077, BF2078, BF2079, and BF2080.

## Beach Scene and Hill

c. 1912–15. Oil on wood panel, 10½ × 13¾ in. (26.7 × 34.9 cm).
Signed lower right: Prendergast. BF2076

PROVENANCE: Acquired from Charles Prendergast, May 25,
1948. See entry for *Beach and Village* (BF2077).

REFERENCE: CR 286.

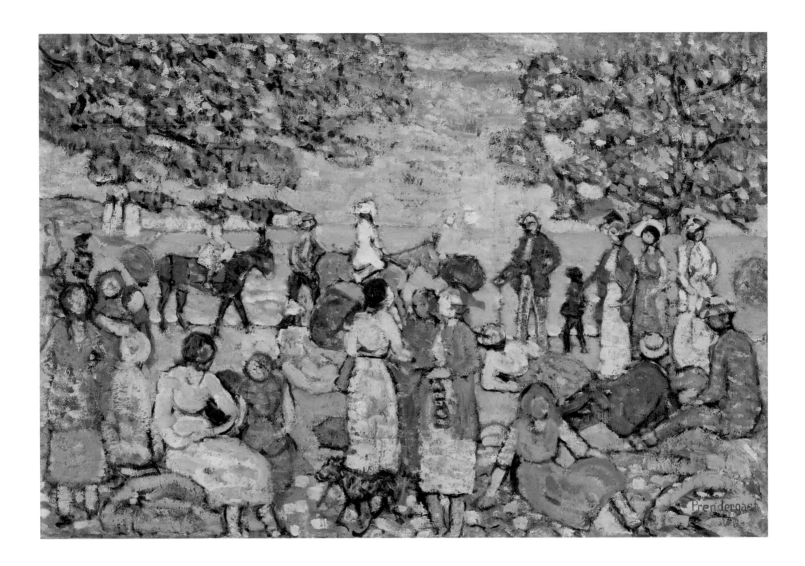

*Beach Scene with Donkeys (or Mules)*

c. 1914–15. Oil on canvas, 22⅛ × 32⅛ in. (56.2 × 81.6 cm).
Signed lower right: Prendergast. Frame by Charles
Prendergast. BF116

PROVENANCE: Probably acquired from the artist.

REFERENCES: CR 426 (reproduced with frame); R.J. Wat-
tenmaker, *Maurice Prendergast* (New York: Abrams in
association with the National Museum of American Art,
Smithsonian Institution, 1994), 132–33, 134, pl. 116.

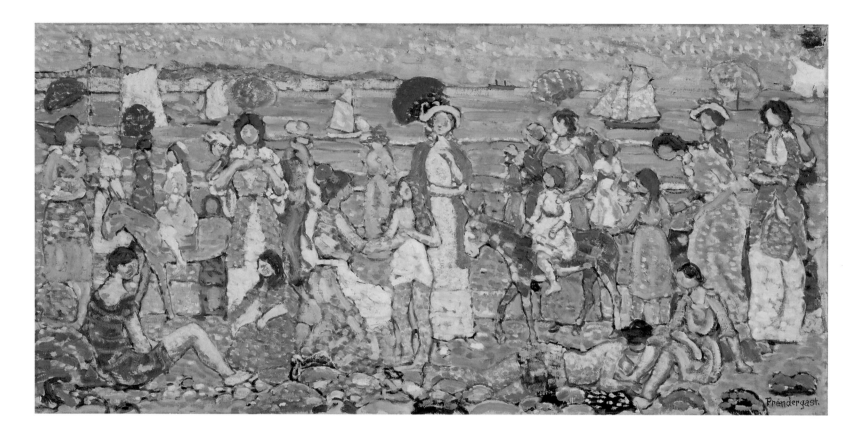

## The Beach "No. 3"
Alternate titles: *Figures at the Beach; Revere Beach*

c. 1914–15. Oil on canvas, 24 × 49⅛ in. (61 × 124.8 cm). Signed lower right: Prendergast. Frame by Charles Prendergast. BF359

PROVENANCE: Probably acquired from the artist.

REFERENCES: Gilbert M. Cantor, "On the Nature of Time," *BFJAD* 3, no. 2 (Autumn 1972): 58, pl. 39; R. J. Wattenmaker, *Puvis de Chavannes and the Modern Tradition*, exh. cat. (Toronto: Art Gallery of Ontario, 1975), 24 n. 27, 191 n. 1; Violette de Mazia, "*E Pluribus Unum*," *BFJAD* 7, no. 1 (Spring 1976): 6–7, pl. 58; Violette de Mazia, "*E Pluribus Unum*—Cont'd," *BFJAD* 7, no. 2 (Autumn 1976): 23, 30, pl. 11; Violette de Mazia, "*E Pluri-* *bus Unum*—Cont'd: Part III," *BFJAD* 3, no. 1 (Spring 1977): 6, 18, pl. 123; Violette de Mazia, "What's in a Frame?" *BFJAD* 8, no. 2 (Autumn 1977): 56, pl. 137; Violette de Mazia, "Transferred Values: Part I—Introduction," *BFJAD* 9, no. 2 (Autumn 1978): 7, pl. 94; Violette de Mazia, "Subject and Subject Matter: Part II," *Vistas* 2, no. 2 (1981–83): 10, 35–38, pls. 109–11; Violette de Mazia, "The Form of Seurat's 'The Models,'" *Vistas* 5, 1 (Spring–Summer 1990): 15, pl. 73; CR 422; R. J. Wattenmaker, *Maurice Prendergast* (New York: Abrams in association with the National Museum of American Art, Smithsonian Institution, 1994), 133–34, 135, pl. 118.

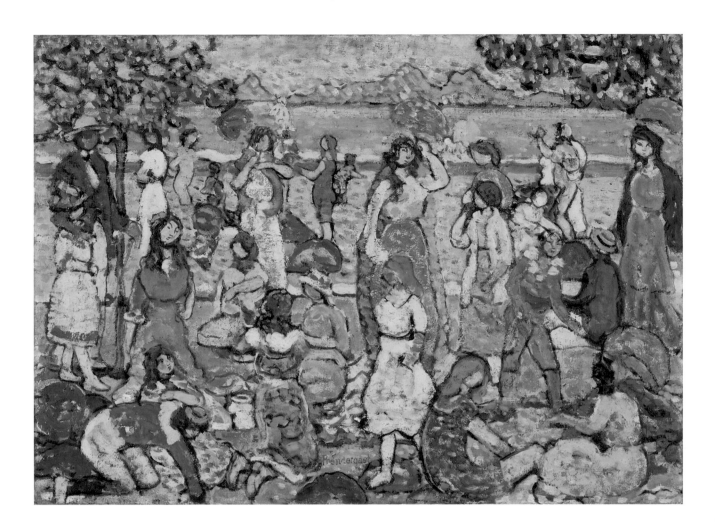

## The Beach

c. 1915. Oil on canvas, 24¾ × 34¼ in. (62.9 × 87 cm). Signed lower center: Prendergast. Inscribed canvas verso: *"The Beach" / Maurice Prendergast / 50 S Washington Sq*. Frame by Max Kuehne, signed left frame member verso: MK. BF319

PROVENANCE: Probably acquired from the artist.

REFERENCES: CR 427 (as c. 1914–15); R. J. Wattenmaker, *Maurice Prendergast* (New York: Abrams in association with the National Museum of American Art, Smithsonian Institution, 1994), 132–33, 134, pl. 117.

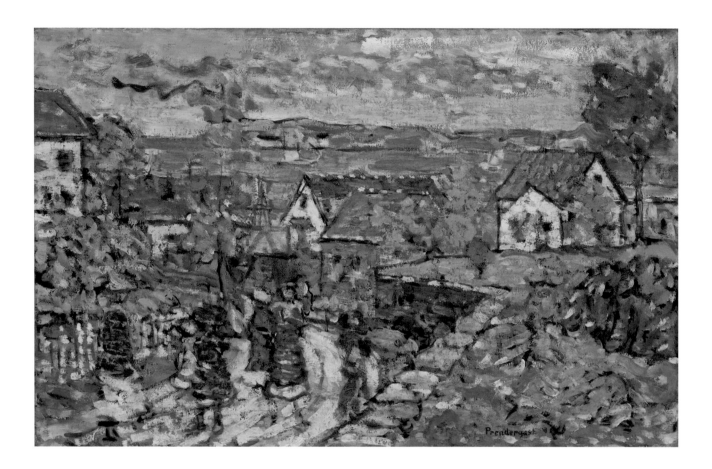

## Landscape (Road & Town)

c. 1915–17. Oil on canvas, 18⅛ × 27¾ in. (46 × 70.5 cm).
Signed lower right: Prendergast. Frame by Charles
Prendergast, signed upper frame member verso:
Prendergast. BF502

PROVENANCE: Probably acquired from the artist.

REFERENCE: CR 403 (as c. 1914–15, reproduced with frame).

REMARKS: The authors of the *Catalogue Raisonné* observe
that *Landscape (Road & Town)* is related to a watercolor,
*South Side Hills*, CR 1198, ill. 503, which they date c. 1912–13.
Because of the prominent role of architectural motifs in a
group of the artist's compositions dating to the latter half
of the decade, both works should be dated slightly later (see
*Beach and Two Houses* [BF557]).

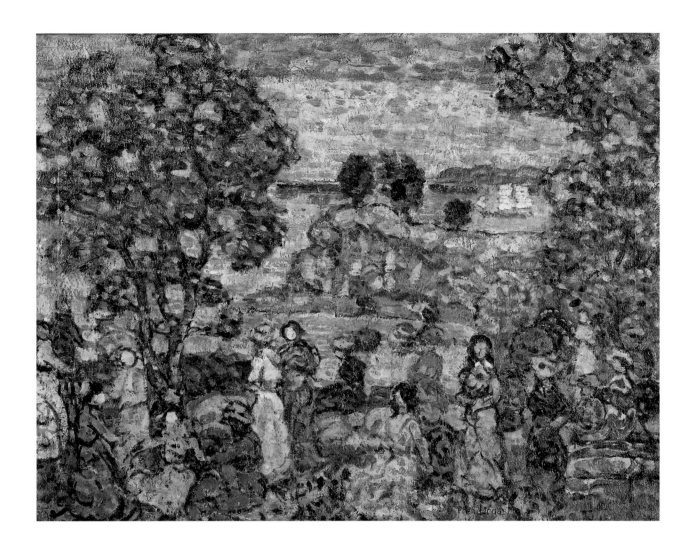

## Landscape (Beach Scene)

c. 1915–18. Oil on canvas, 26 × 34¼ in. (66 × 87 cm). Signed lower right: Prendergast. Frame by Charles Prendergast, signed upper frame member verso: Prendergast. BF514

PROVENANCE: Probably acquired from the artist.

REFERENCE: CR 267 (as c. 1910–13).

REMARKS: The authors of the *Catalogue Raisonné* suggest this canvas was exhibited in the 1915 Carroll Galleries exhibition as *The Headland* (no. 5).[1] The morphology of the composition, its muted color harmonies, predominantly purplish tones, and thick build-up of paint place it in the period of *Beach and Two Houses* (BF557). *Landscape (Beach Scene)* belongs to a group of paintings from the latter part of the decade, for example, CR 430 and 450, each dated c. 1915–18. It is doubtful that Barnes would have purchased anything from the Carroll Galleries, and there is no record of any payment to that gallery.

1  CR 265.

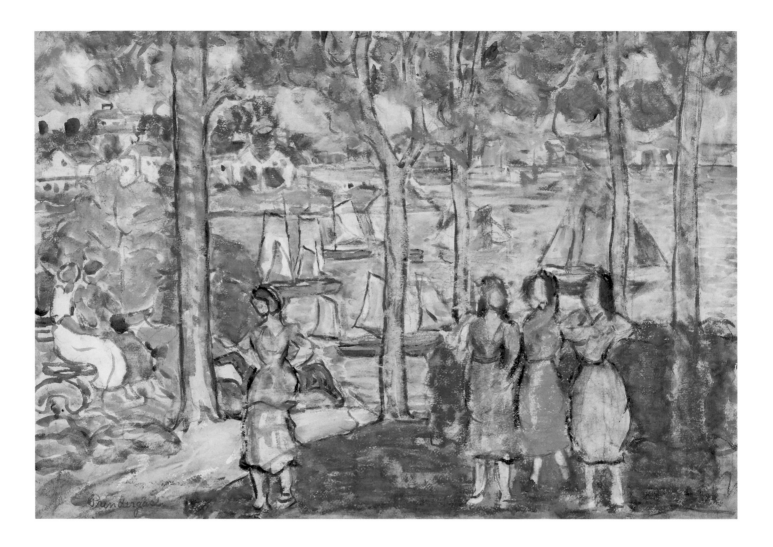

## Trees, Houses, People
Alternate title: *Road to the Beach—Maine*

c. 1916. Watercolor and pastel with graphite on wove paper,
14 × 19¾ in. (35.6 × 50.2 cm). Signed lower left: Prendergast.
BF2080

PROVENANCE: Acquired from Charles Prendergast, May 25,
1948. See entry for *Beach and Village* (BF2077).

REFERENCE: CR 1269.

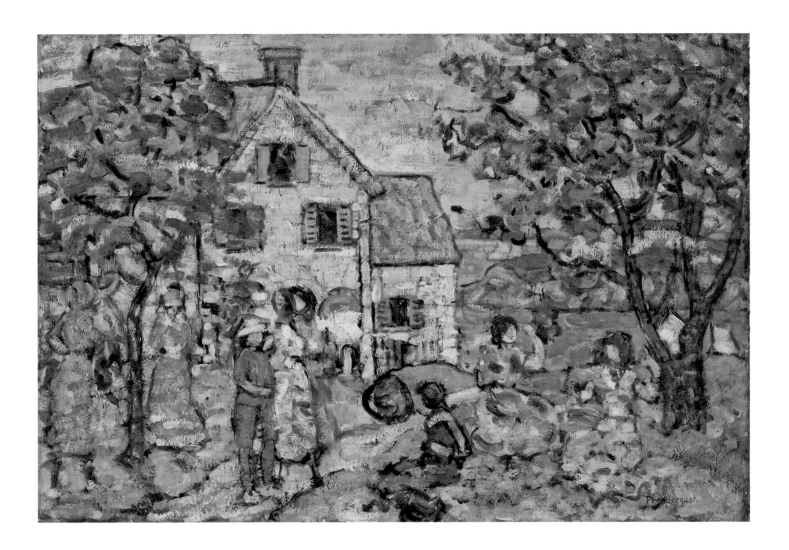

### Beach and Two Houses

c. 1918. Oil on canvas, 24⁵⁄₁₆ × 35⅛ in. (61.8 × 89.2 cm).
Signed lower right: Prendergast. Frame by Charles
Prendergast, signed upper frame member verso:
Prendergast. BF557

PROVENANCE: Probably acquired from the artist.

REFERENCE: CR 462 (as c. 1918–23).

## Marblehead Harbor

Alternate titles: *Landscape—Rowboats; Landscape—Bay*

c. 1918–20. Oil on canvas, 18 × 24⅛ in. (45.7 × 61.3 cm). Signed lower left: Prendergast. Frame by Charles Prendergast, signed upper frame member verso: Prendergast. BF216

PROVENANCE: Maurice Prendergast recorded the sale of this picture twice, on two separate pages of a lined daily calendar from 1918: "Received from Dr. Barnes $600 April 1921 for one oil painting"; "received from Dr. Barnes 1 oil painting $650 April 6, 1921."[1] The discrepancy probably indicates the cost of Charles Prendergast's frame for the painting.[2]

REFERENCES: Albert C. Barnes, *The Art in Painting*, 502–03; CR 458 (as c. 1918–23); R. J. Wattenmaker, *Maurice Prendergast* (New York: Abrams in association with the National Museum of American Art, Smithsonian Institution, 1994), 141, 152 n. 137.

RELATED WORKS: Three watercolors of the composition are related to *Marblehead Harbor:* CR 1331, *Gloucester*, ill. 531; CR 1333, *Gloucester Beach*, ill. 532; and CR 1390, *The Cove*, ill. 543. There are also twelve pencil drawings for *Marblehead Harbor*, seven single pages and five across two pages, several with written color annotations, in CR 1546, "Sketchbook 53," 1916–19, 5¹¹⁄₁₆ × 3¼ in. (15 × 9.5 cm), Museum of Fine Arts, Boston (figs. 62 and 63). Of the sketchbook's contents, CR 1546 states, "These seem to be views on Cape Ann in the vicinity of Gloucester, Marblehead and Salem, and possibly Wiscasset, Maine."[3] (In the 1922–1924 Inventory, no. 216 is entitled *Marblehead Harbor Water Scene*.)

REMARKS: The Exhibition of Works by Maurice B. Prendergast and Charles E. Prendergast at the Joseph Brummer Gallery, New York, April 4–23, 1921, included thirty oils and seven watercolors by Maurice and eight carved panels and

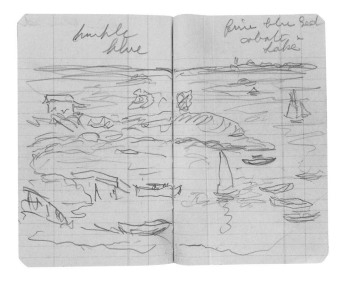

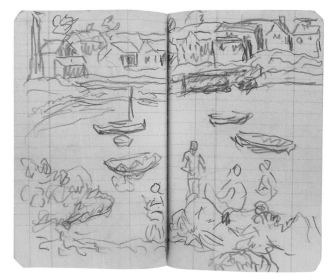

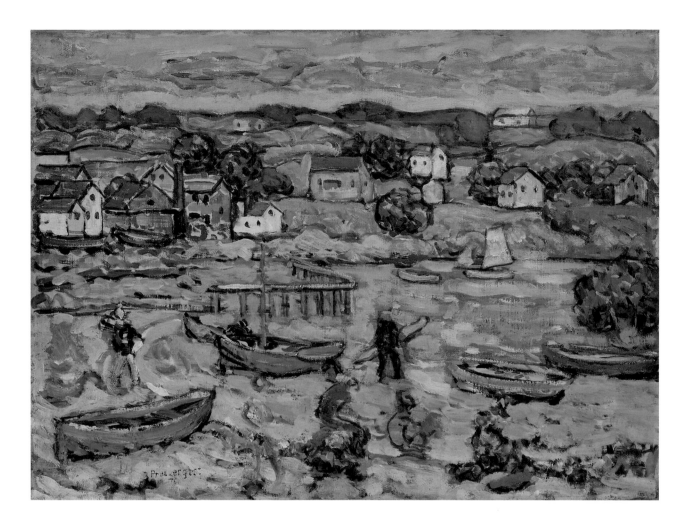

one carved and decorated chest by Charles. Lewis Mumford interviewed Maurice in front of the pictures before the opening and wrote: "As I looked, my . . . spirit lightened as Saul's did at the sound of David's harp. I have been told that Mr. Prendergast is the greatest living American artist; I know that Mr. Brummer . . . considers him so. . . . I have seen no finer work by any contemporary painter."[4]

into the rabbit [*sic*] and that makes the painting stick out behind. If you will furnish a frame of the proper size, and which will fit the painting, I shall be very glad to have you send it to me and I will send you check for the amount. I believe that your show at Brummer's will be a success financially; but don't you let anybody try to give you the impression they discovered you because connoisseurs have known for many years your work is of the finest done by any artist and will live forever." Maurice answered on March 21: "All right! Charley will make a frame and give you a new design. You have been a good friend to us and Charley joins with me in sending a hearty handshake to you and Mrs. Barnes." Prendergast wrote to Barnes, April 1, 1921: "We sent the picture away to your Overbrook address by George Of. I hope you will like the frame. I think it looks better on the picture than the old one. Our exhibition opens on Monday—we were up to see it this afternoon everybody tells us it is going to be a good show but they tell us also the bad news not many pictures have been sold this winter. Wish us 'good luck.'" All letters ACB Corr., BFA.

1  Prendergast Archive and Study Center, Williams College Museum of Art, Williamstown, Mass.

2  Letter, Maurice Prendergast to Albert C. Barnes, March 18, 1921: "After you left last night I thought . . . about selling the canvas and concluded to sell it for $650 which includes the frame which belongs to Charlie. When you spoke about the price it bothered me about taking it out of the exhibition. I think I am going to have good luck with the show. Brummer took away a panel to match his wall and sold the panel to one of his customers." Barnes replied on March 19: "I received your letter stating that the price of the painting is Six hundred fifty ($650.00) dollars, including the frame. But the frame which is on it, while of very fine quality, does not fit the painting because the canvas does not fit

3  CR, "Sketchbooks: Maurice Prendergast," 571.

4  Lewis Mumford [Journeyman, pseud.], "Miscellany," *Freeman*, April 27, 1921, 159–60. See R. J. Wattenmaker, *Maurice Prendergast* (New York: Abrams in association with the National Museum of American Art, Smithsonian Institution, 1994), 145–46, for full text.

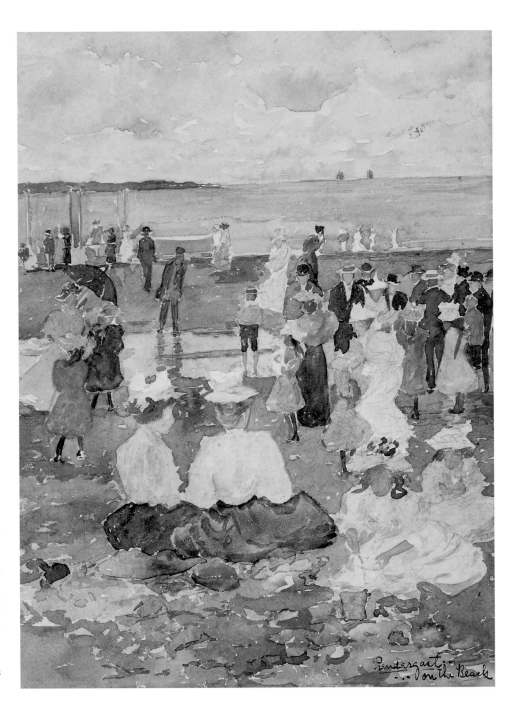

## On the Beach

1896–97. Watercolor with graphite on wove paper, 13¾ × 10 in. (34.9 × 25.4 cm). Signed and inscribed lower right: *Prendergast / on the Beach*. Inscribed verso: *On the Beach*. BF695

PROVENANCE: Acquired from Mrs. Frank S. Collins, February 10, 1923.[1]

REFERENCES: CR 624; Violette de Mazia, "Tradition: An Inquiry—A Few Thoughts," *Vistas* 3, no. 1 (1984–86): 84n, pl. 59; R.J. Wattenmaker, *Maurice Prendergast* (New York: Abrams in association with the National Museum of American Art, Smithsonian Institution, 1994), 34, 36, pl. 20.

1 Note on Barnes Foundation file card: "2/10/23 Mrs. Frank S. Collins 399—Third Avenue West Haven, Conn. $100."

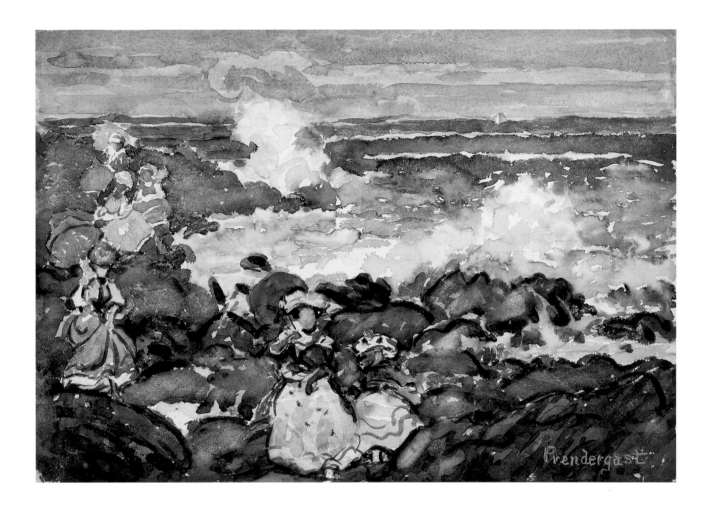

## *Rocks, Waves and Figures*

c. 1902–04. Watercolor with graphite on handmade wove paper, 11⅛ × 15⅝ in. (28.3 × 39.7 cm). Signed lower right: Prendergast. BF2079

PROVENANCE: Acquired from Charles Prendergast, May 25, 1948. See entry for *Beach and Village* (BF2077).

REFERENCES: CR 840, ill. (as 1900–1905); R. J. Wattenmaker, *Maurice Prendergast* (New York: Abrams in association with the National Museum of American Art, Smithsonian Institution, 1994), 79, 76, pl. 54.

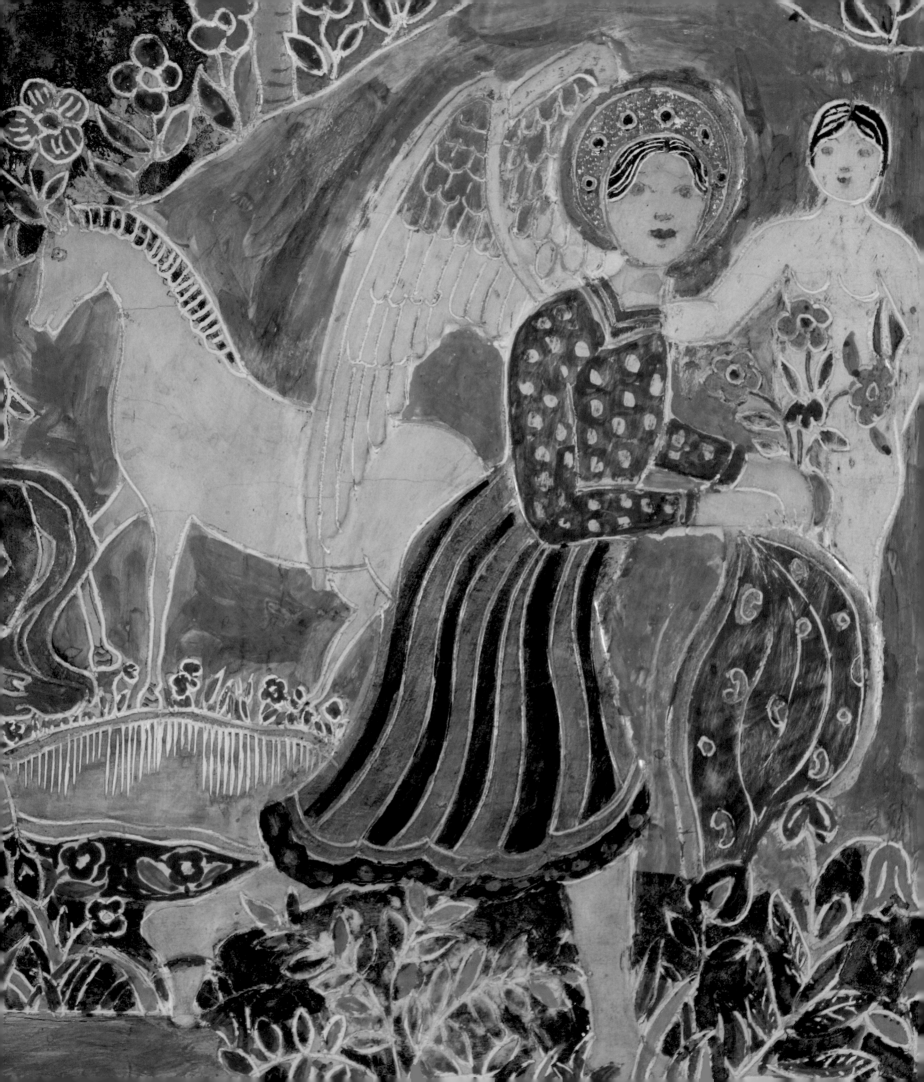

# CHARLES PRENDERGAST (1863–1948)

Every wood-carver should be able to design his own work, for only those who know what can be expressed by the aid of wood and chisels can design work that shall give the carver the greatest scope for the exercise of his skill, and bring out the peculiarities, qualities, and charms in carved wood.... Wood-carving is a beautiful art.... Its beauties are all of a quiet kind.... The craftsman should not try to imitate nature, but must adopt and modify the forms of nature to suit the method of his work ... and experience with tools and will carry out any ideas that take the fancy.

Charles Prendergast, "Revival of Wood-Carving," 1909

*Charles Prendergast, Maurice's younger brother,* was a unique artist-craftsman whose medium of expression set him apart from other artists of his generation. He produced a relatively limited number of panels, screens, chests, and small carved and gilded sculptures, but he is better known for the frames he carved, incised, gilded, and sometimes painted, which he had been fabricating on a commission basis for prominent Boston clients such as Isabella Stewart Gardner and Thomas W. Lawson for more than a decade when his artistic credo (cited above) appeared in *House Beautiful*.[1] A representative of a New England tradition of skilled artisans who created distinctive furniture, architectural woodwork, and ornamental figures, Charles gained the devoted patronage of a small but important group of pioneer collectors, the same group of tastemakers who brought Modern art to the attention of the American public.

Both Charles and Maurice Prendergast were trained craftsmen. In addition to instruction in drawing in the Boston public schools and evening art classes offered by the city, the brothers were likely enrolled in an evening whittling school established in 1871. The curriculum comprised "a course of twenty-four lessons in the use of the flat chisel, the gouge, and the veining tool (or small gouge). The pupils learned to make concave and flat chamfers along the edges of blocks of white wood, to make perfect miters, and to make even gouges. They ... created ornamental figures, fluting, diamond points, and scroll corners. Students trained in industrial drawing were allowed to originate their own designs for carving."[2]

As adults the brothers frequently collaborated on carving and decorating, but it is often impossible to discern precisely the division of labor in their cabinetry, carving, punching, gilding, and painting. Charles designed and fabricated numerous frames in different styles for Maurice's works, but Maurice frequently contributed designs and helped with the carving. On his visits to museums in Italy and France, Maurice made numerous detailed drawings of frame motifs for potential use in their own frames.[3]

In 1911, Charles spent five months (June–October) in Italy. He was joined there by Maurice, who stayed in Venice until the end of January 1912, convalescing from prostate surgery in November, after Charles had returned to Boston. Maurice wrote to Charles,

"It would be so fine if I was home and helping you along with the frames. We together were such a good team."[4] On December 5, 1911, Maurice wrote, "I think I will buy a trunk and invest in some frames. . . . Try and keep the frames back as long as you can and we can put them through during February and March and have all the tools well sharpened."[5] Charles had looked at medieval and early Renaissance Italian art, frescoes and panel paintings, mosaics, wood and stone sculpture, ivories, bronze reliefs, and tapestries in addition to studying frame design, ornamentation and gilding methods.[6] A number of the frames created for clients such as Barnes were adapted from early-eighteenth-century Venetian models, especially the so-called Canaletto type. His pared-down interpretations of these Venetian-style designs bore incised, rather than carved, "C" scrolls in their corners, a design Charles termed his "sausage" pattern. He also made more elaborate versions with raised floral motifs in low relief and carved corners and centers.

Charles began making gessoed panels in 1912. The first compositions were based on religious themes and prototypes: *Madonna and Child* (CR 2214), *Madonna and Child* triptychs (CR 2316 and 2317), other renditions of New Testament themes such as the *Annunciation* (CR 2215 and 2218), *The Calling of Saints Peter and Andrew* (CR 2217), and a carved and painted chest with symbols of the four evangelists (CR 2398). Despite the Christian imagery, the pictorial sources for Charles's panels are found in a broad range of Eastern and Western traditions—Persian, Chinese, Byzantine, Egyptian, Coptic, Roman, and Etruscan —which he freely interpreted according to his "fancy." The technique known as japanning, a specialty of some eighteenth-century Boston cabinetmakers, was another important source for the artist. Japanning was a Western imitation of oriental lacquer work in which figures were modeled in low relief in gesso, with metal (silver and/or gold leaf) subsequently applied on a black or red painted background. While Charles did not imitate the imagery of the early Boston cabinetmakers, he borrowed their geometric patterns in some of his frames. Charles's own technique was characterized in 1919:

> The method employed by Mr. Prendergast in making these panels differs somewhat from the tra-

dition. It is more than merely a flat painting and gilding on plaster. The wood he uses is the sugar pine, or, where possible to procure, fine old white pine. On the surface the outline of his cartoon is transferred with charcoal, and the deeper lines are incised with gouges and chisels. Over this is spread several coats of gesso plaster, and while this is still wet, the more delicate lines are traced with a fine steel point. Over such figures and details as are to be gilded is spread a second coat of special plaster. And when all this has been thoroughly dried and all roughness removed by sandpaper and pumice stone, it is ready for the application of gold and silver leaf and color. Unlike an oil painting, there is little opportunity to correct mistakes in color. The plaster is so absorbent that the artist must be certain of his color scheme before he applies the brush.[7]

One writer who observed the artist at work applying gold leaf described Charles's craft: "Prendergast's strange and ambidextrous performance . . . most nearly resembles that of a harried man simultaneously slicing bread and brushing his hair . . . over and over again."[8]

Charles's initial experiments with panels coincided with Barnes's earliest activity as a collector. Their correspondence indicates that Charles began to make frames for the collector in 1913, the year after Barnes made his first purchase of a painting by Maurice. The collector took an avid interest in the design of Charles's frames as works of art in themselves, frequently specifying their decoration and the tonality of the gilding. He preferred a muted, lustrous finish achieved through application of warm-colored, genuine gold leaf without burnishing. On December 3, 1914, shortly after the Prendergast brothers moved to New York, Barnes wrote to Charles providing details of frames he wanted made for some of Maurice's pictures, adding, "I am sending under separate cover a copy of *Arts & Decorations* [*sic*], containing a brief description of my collection, and I want you and your brother to come over and see my pictures just as soon as you have sent the new frames and canvases. I shall write to Glackens and tell him to come over with you. Perhaps when you see how things are, we could talk more intelligibly

about ordering more frames for other pictures."[9] Barnes thereafter commissioned frames from Charles not only for paintings by Maurice but also for works by Glackens and Ernest Lawson and for many of his European pictures.

Sometime in March 1915 Charles wrote to Barnes, "I am awfully glad you liked my little show at the Montross Gallery."[10] The next month Barnes commissioned eleven frames from Charles totaling $475.00.[11] On April 7, 1915, Barnes wrote Charles, "I enclose check for your bill of Three Hundred and Eighty Dollars ($380) for the nine beautiful frames all of which arrived safely. The color on two or three of them is rather glaring, of natural gold color, and need toning to slightly darker hue. I wonder if you would send a bottle of color to me by express with instructions how to apply it."[12] Several months later Charles made a "sausage pattern" frame for Barnes, who wrote to him on June 19, "the 18" × 25" frame arrived yesterday, but I was very much disappointed to find that you had used on it the same glaring bright color which does not go well with my pictures or the other wood work. You will remember that I complained about this color, and that you told me you would come over and fix them up. I hope you will do so soon, because the color does not do justice to you or to my paintings."[13] Charles answered in an undated letter sent around June 20, "I am afraid to have you touch those frames. You could spoil them very easy. You had better send them back or perhaps I may be down that way sometime and will touch them up."[14] Barnes declined to send back the frames and wrote Charles on October 25, "If you ever feel that you ought to make the color of that last lot of frames according to our agreement, I shall be glad to see you at my house."[15]

In the late autumn of 1919, Barnes invited the Prendergast brothers to spend a few days with him in Philadelphia. Charles especially enjoyed these visits, which typically included hiking with Barnes and dinners with the collector and his wife. After the weekend, Charles wrote, "I wish we were on top of the mountain to day. I will never forget our fine ride last Sunday over the wild Mountains and racing through that bit of fog on our downward course until we struck sunshine again. That's the life all right. . . . And I want to thank you again for one of the more delightful trips ever I had."[16]

On March 1, 1920, Barnes wrote Charles with feigned dismay,

I wonder what is the matter with Maurice that he doesn't want to sell me his pictures? I believe I have more of his pictures than any other collector in the world, nobody more sincerely admired him and his wonderful work, and nobody has ever rooted harder for him as one of the few great painters of our day. Yet, when I try to get a collection of his pictures, I have a hell-of-a-time in separating him from them. The price I offered, Six Hundred Seventy-Five ($675) Dollars, is just what he would get for the picture if Daniels sold it at the price he sells pictures of that size. The only thing I conclude is that he either doesn't want to sell the picture, or else he doesn't want me to have them. However, I suppose I can live without any more of his work, particularly since I have nearly two score of them. Now please push that frame for the Renoir through as quickly as you can, because you know how it is when a fellow has a fine picture that he can't hang until he gets a frame for it.[17]

On March 4 Charles replied, "My brother is trying to get that quality in a larger canvas. As soon as he gets it done you can have the canvas. The one you liked."[18] After the deal was arranged, Barnes wrote Charles on March 15, "I am very anxious to get the picture which I bought of your brother yesterday and ask you to kindly fix up the frame that is on it by engraving a suitable design on the corners, putting gold leaf on it, and toning it the same as the new frame you just made [for the Renoir]. . . . Fix it up for you and Maurice to come over some week-end—I am saving something very nice for dinner on that night."[19]

On July 6, 1920, Barnes wrote Charles of his recent purchase of thirteen Cézannes. Charles replied in an undated letter (July 7 or 8, 1920), "Good for you. That's the way to buy Cézannes. You are a real man. If the old man was alive he would slap you on the back. That will place your collection as a top notcher. I congratulate you."[20] Barnes responded on July 9, "Your letter is like a fragrant, refreshing breeze on a sultry day. If you leave New York . . . tomorrow . . . morning, I will show you the photographs of the wonderful pictures and will take you

for a two-day motor trip in the mountains."[21] On October 11 Barnes extended another invitation: "I hope you and Maurice will find it convenient to come over and see me later this month when the leaves are so beautiful and we can take a ride and a walk through a fine piece of the country."[22] Maurice wrote Barnes on February 9, 1921, "I want to tell you how much I enjoyed that fine wine. I haven't had any wine for six months and when I do get it I appreciate it. We had a chop green peas hash brown potatoes a la francais some Philadelphia cream cheese and bar le duc and the wine was delicious. Thank you for the treat. Charlie joins with [me] in sending our best regards to you and Mrs. Barnes."[23]

The Barneses and Charles continued their friendship after Maurice's death early in 1924. Charles and his wife Eugenie, a Frenchwoman he married in 1926, remained close with William Glackens and Edith Dimock. In 1934, Barnes enthusiastically agreed to Charles's request to borrow a painting for the belated retrospective of Maurice's work organized by Walter Pach for the Whitney Museum of American Art. In 1948, Dr. and Mrs. Barnes traveled to Westport, Connecticut, to see Charles shortly before his death in August that year. On the visit, Barnes bought five works by Maurice to add to his collection. As late as 1951, in one of his last transactions, Barnes exchanged an early Charles Prendergast panel (CR 2234) with Antoinette M. Kraushaar for a later panel, *Central Park* (BF372/CR 2298) dating from 1939.

NOTES

Epigraph. Charles Prendergast, "Revival of Wood-Carving," *House Beautiful*, August 1909, 70.

1   See Nancy Mowll Mathews, "'Beauties . . . of a Quiet Kind': The Art of Charles Prendergast," in *The Art of Charles Prendergast from the Collections of the Williams College Museum of Art and Mrs. Charles Prendergast* (Williamstown, Mass.: Williams College Museum of Art, 1993), 11, 12–13, 36 n. 8.

2   Ellen Glavin, "The Early Art Education of Maurice Prendergast," *Archives of American Art Journal* 33, no. 1 (1993): 7 n. 35, citing Isaac Clarke, *Art and Industry*, vol. 2 (Washington, D.C.: Government Printing Office, 1885–92). The art education of the Prendergast brothers, as reconstructed by Glavin, included carpentry as well as drawing instruction. See also Hamilton Basso, "A Glimpse of Heaven—II," *New Yorker*, August 3, 1946, 28.

3   Most of Charles Prendergast's frames are unsigned. Of the frames that are signed, nearly all of them are signed "Prendergast," occasionally with a date. See Carol Derby, "Charles Prendergast's Frames: Reuniting Design and Craftsmanship," in *Maurice Brazil Prendergast, Charles Prendergast: A Catalogue Raisonné*, by Carol Clark, Nancy Mowll Mathews,

and Gwendolyn Owens (Williamstown, Mass.: Williams College Museum of Art; Munich: Prestel-Verlag, 1990), 95–105; in particular, 98, fig. 2, letter from Maurice Prendergast to Charles Prendergast, June 13, 1907, with drawings of a frame with guilloche (interlacement band) motif and in section. The *Catalogue Raisonné* is abbreviated CR in the body text and in subsequent references. A photograph of Maurice Prendergast working on a frame is reproduced in Hedley Howell Rhys, *Maurice Prendergast 1859–1924* (Cambridge, Mass.: Harvard University Press, 1960), 62. There are approximately two hundred drawings of frame motifs and cross sections throughout Maurice's eighty-eight surviving sketchbooks.

4   Letter, Maurice Prendergast to Charles Prendergast, November 13, 1911, Prendergast Archive and Study Center, Williams College Museum of Art, Williamstown, Mass.

5   Letter, Maurice to Charles, December 5, 1911, Prendergast Archive and Study Center. The reference in these letters is to a large frame commission from the Insurance Company of North America (CIGNA) in Philadelphia. One of these is signed and dated "Prendergast 1912."

6   Charles did not return to Europe until the mid-1920s, so the impressions and photographs brought home from Italy in 1911, supplemented by his visits to the Museum of Fine Arts, Boston, and, after the brothers moved to New York late in 1914, the Metropolitan Museum of Art, supplied ample visual resources for the work of what he termed his "Celestial" or "Oriental" phase (1912–28). See also Mathews, *The Art of Charles Prendergast*, "Appendix B: Books from the Prendergasts' Library," 111–17. These publications make up only a fraction of those consulted by the brothers.

7   M. D. C. Crawford, "The Carved Gesso Panels of Charles E. Prendergast," *Country Life in America*, September 1919, 47. See also Marion M. Goethals, "My Work Is Done in Gesso the Old Italian Method," in Mathews, *The Art of Charles Prendergast*, 41 and 50 n. 17. Charles did not exhibit in the Armory Show, which reinforces the 1912 date for his first experiments creating panels.

8   Hamilton Basso, "A Glimpse of Heaven—I," *New Yorker*, July 27, 1946, 29.

9   Letter, Albert C. Barnes to Charles Prendergast, December 3, 1914, ACB Corr., BFA. The article is Guy Pène du Bois's "A Modern American Collection: The Paintings of Contemporary Arts," *Arts and Decoration*, June 1914, 304–05, 325–26, in which Prendergast is mentioned (305).

10  Letter, Charles Prendergast to Barnes, undated [March 1915], ACB Corr., BFA. The group show, Exhibition of Paintings, Drawings and Sculpture, March 23–April 24, 1915, included works by Maurice, Glackens, and other contemporaries and was Charles's first recorded showing (six panels). A partially illustrated checklist reproduced only one panel, now lost (CR 2216) and one drawing (CR 2318).

11  Itemized invoices from Charles Prendergast, dated March 11, 1915, for two "sausage pattern" frames, and April 6, 1915, for "9 carved frames Italing [sic] gilding," ACB Corr., BFA.

12  Letter, Barnes to Charles Prendergast, April 7, 1915, ACB Corr., BFA.

13  Letter, Barnes to Charles Prendergast, June 19, 1915, ACB Corr., BFA.

14  Letter, Charles Prendergast to Barnes, undated [c. June 20, 1915], ACB Corr., BFA.

15  Letter, Barnes to Charles Prendergast, October 25, 1915, ACB Corr., BFA.

16  Letter, Charles Prendergast to Barnes, undated [first half of November 1919], ACB Corr., BFA.

17  Letter, Barnes to Charles Prendergast, March 1, 1920, ACB Corr., BFA.

18  Letter, Charles Prendergast to Barnes, March 4, 1920, ACB Corr., BFA.

19  Letter, Barnes to Charles Prendergast, March 15, 1920, ACB Corr., BFA.

20  Letter, Charles Prendergast to Barnes, undated [July 7 or 8, 1920], ACB Corr., BFA.

21  Letter, Barnes to Charles Prendergast, July 9, 1920, ACB Corr., BFA.

22  Letter, Barnes to Charles Prendergast, October 11, 1920, ACB Corr., BFA.

23  Letter, Maurice Prendergast to Barnes, February 9, 1921, ACB Corr., BFA.

## NOTE ON CHARLES PRENDERGAST SOURCES

Carol Clark, Nancy Mowll Mathews, and Gwendolyn Owens, *Maurice Brazil Prendergast, Charles Prendergast: A Catalogue Raisonné* (Williamstown, Mass.: Williams College Museum of Art; Munich: Prestel-Verlag, 1990), is abbreviated in all entries below as CR, which is followed by the number of the corresponding entry in the *Catalogue Raisonné*. All works from the Barnes Foundation recorded in the *Catalogue Raisonné* are illustrated.

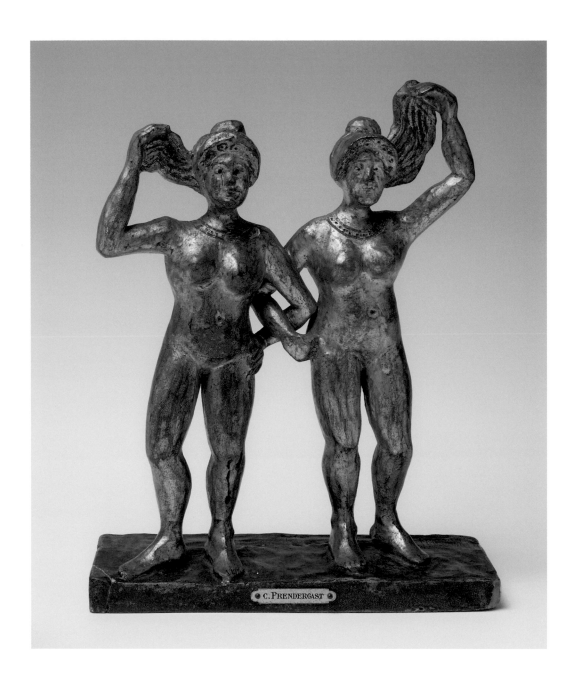

## Two Nudes

c. 1915. Gold leaf and red bole on gessoed wood; base: gold paint and red bole on gessoed wood; overall (including base) 9⅜ × 7⅛ × 2⅞ in. (23.8 × 18.1 × 7.3 cm). Signed (incised in punched pattern on base): CP [monogram]. A5688

PROVENANCE: Acquired from the artist.[1]

REFERENCES: Violette de Mazia, "*E Pluribus Unum—Cont'd*," BFJAD 7, no. 2 (Autumn 1976): 28n, pl. 55; CR 2393: the authors list *Two Nudes* as possibly in an exhibition at the Penguin Club, New York, Exhibition: Contemporary Art, March 16–April 6, 1918, cat. no. 19 (as *Figure Composition [Sculpture]*).

1 Letter, Charles Prendergast to Albert C. Barnes, undated [c. 1915–16], London Collection: "50 Washington Sq. I sent the little gold figures by Parcel Post Sunday afternoon. I didn't care about risking them in the box with the frames. I hope everything got there in good shape." Annotation in Albert C. Barnes checkbook, "Charles E. Prendergast frames and gold figure Bill 2/14/16 $375," probably refers to *Two Nudes*. Albert C. Barnes check no. 3553, February 14, 1916, BFFR, BFA.

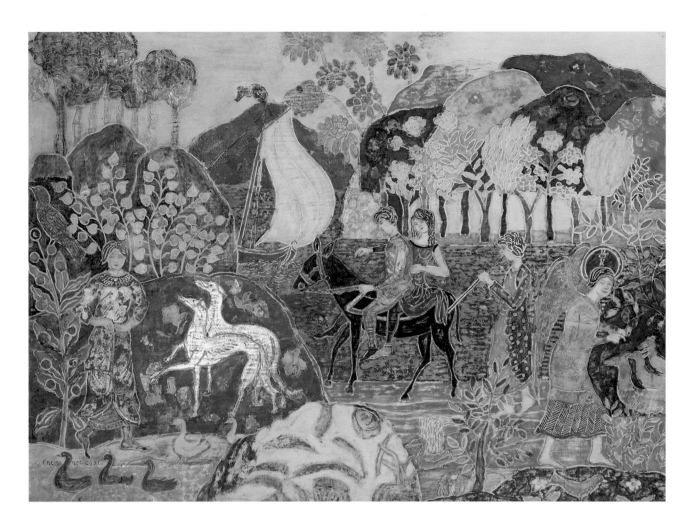

## Two Figures on a Mule
Alternate titles: *Two Figures on Mule; Figures and Mules (or Greyhounds)*

c. 1917–20. Tempera, graphite, gold and silver leaf on incised, gessoed panel, 23 × 31¹⁄₁₆ in. (58.4 × 78.9 cm). Signed (incised) lower left: C. Prendergast. Frame by Charles Prendergast. BF297

PROVENANCE: Acquired from the Society of Independent Artists in 1921.[1]

EXHIBITION: New York, the Society of Independent Artists, Inc., February 26–March 24, 1921, cat. no. 753 or 754.

REFERENCES: *Catalogue of the Society of Independent Artists, Inc., 2/26–3/24/1921*, no. 753 or 754 (as *Carved Wood Panel*); Mary Mullen, *An Approach to Art* (Merion, Pa.: Barnes Foundation Press, 1923), ill. 68 (as *Carved Panel*); Albert C. Barnes,

*The Art in Painting*, ill. 467 (as *Wood Panel*); CR 2256 (as *Figures and Mules [or Greyhounds]*, c. 1921).

REMARKS: In light of the date of the Independents exhibition, and on the basis of style, the date c. 1921 given in CR 2256 is too late. Since there is only one mule, the title has also been adjusted.

1 Letter, Albert C. Barnes to Marsden Hartley, June 2, 1921: "that wonderful Charlie Prendergast panel which was in the Independent show this year." See also page 249. Letter, Charles Prendergast to Barnes, May 19 [1921]: "I will get Of [George F. Of, painter and framemaker, a friend of Michael and Sarah Stein's who, in 1907, was the first person to own a painting by Matisse in America] or somebody to box the panel and send it to 24 North 40th Street. I was very sorry the other morning I couldn't be more hospitable. This bohemian existence has its vantages and disadvantages." Both letters ACB Corr., BFA.

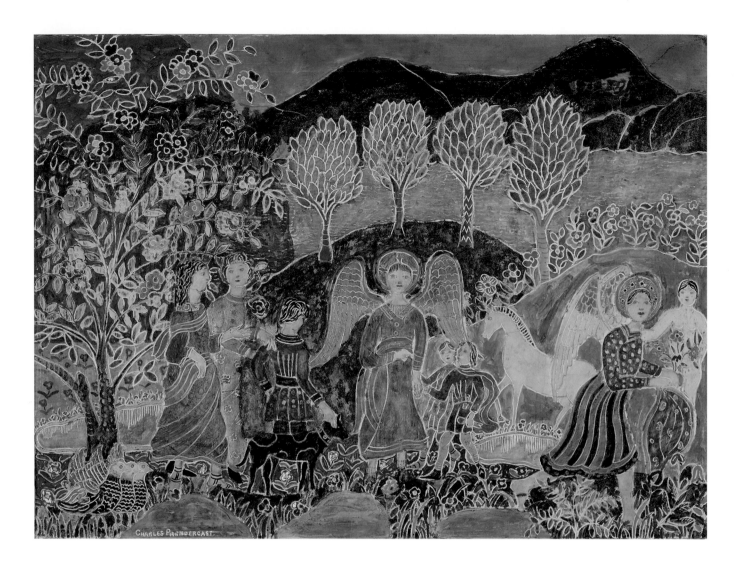

## Angels

Alternate titles: *Angels and Horses in Hilly Landscape—*
*Fantasy; Fantasy*

c. 1917. Tempera, graphite, silver and gold leaf on carved,
incised gessoed panel, 25⅛ × 33½ in. (63.8 × 85.1 cm)
(with engaged frame). Signed (incised) lower left: Charles
Prendergast. Frame by Charles Prendergast. BF520

PROVENANCE: Probably acquired from the artist.

REFERENCES: Forbes Watson, "The Barnes Foundation:
Part II," *Arts*, February 1923, 149, ill. (as *Panel*); Violette de
Mazia, "Naïveté," *BFJAD* 7, no. 2 (Autumn 1976): 63–64, 73,
pl. 18; CR 2236.

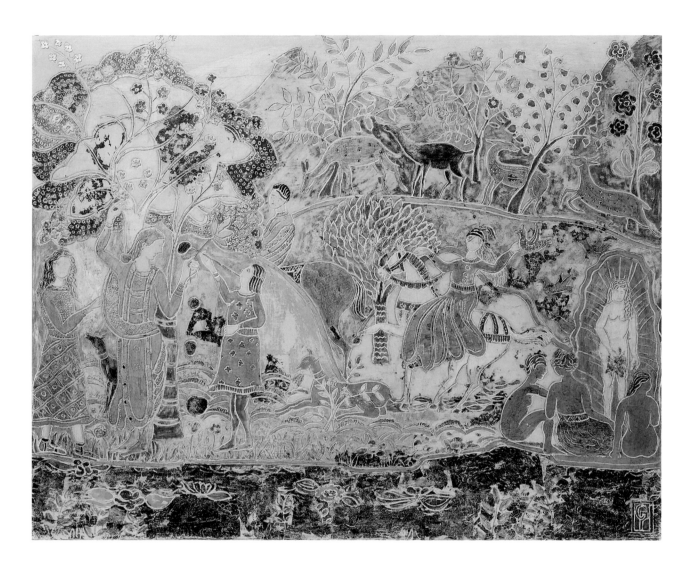

## Figures and Deer

c. 1917. Tempera, gold and silver leaf on incised, gessoed panel, 22¼ × 27¼ in. (56.5 × 69.2 cm). Signed (incised) lower right: CP [monogram]. Frame by Charles Prendergast. BF803

PROVENANCE: Probably acquired from the artist.

REFERENCE: CR 2240, ill. (no Barnes Foundation number cited).

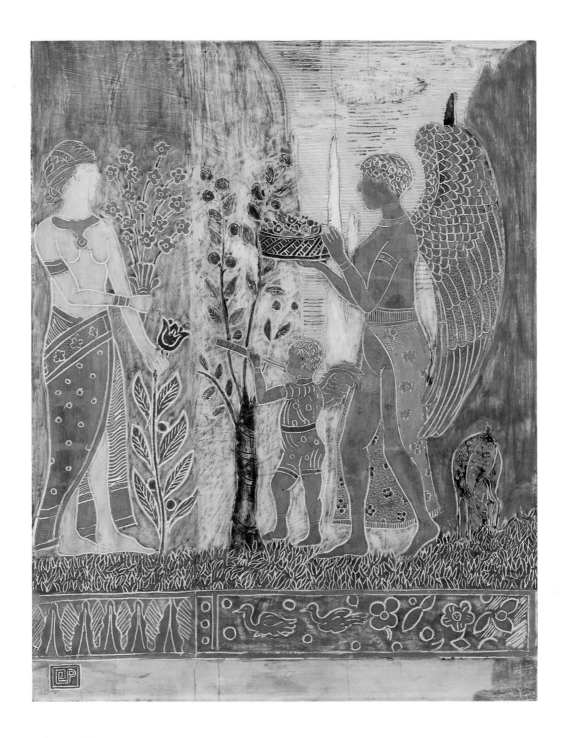

## The Offering

c. 1915–17. Tempera, gold and silver leaf on incised, gessoed panel, 21 × 16¹⁄₁₆ in. (53.3 × 40.8 cm). Signed (incised) lower left: CP [monogram]. Frame by Charles Prendergast. BF467

PROVENANCE: Probably acquired from the artist.

REFERENCE: CR 2245.

REMARKS: On the stub of check no. 3189, January 8, 1915, Barnes recorded the purchase as "Charles E. Prendergast frame & plaque [$]95."[1] While the panel is not specified, it is noteworthy that the term "plaque" must be employed to denote a carved and gessoed panel.

1  Albert C. Barnes check no. 3189, January 8, 1915, BFFR, BFA.

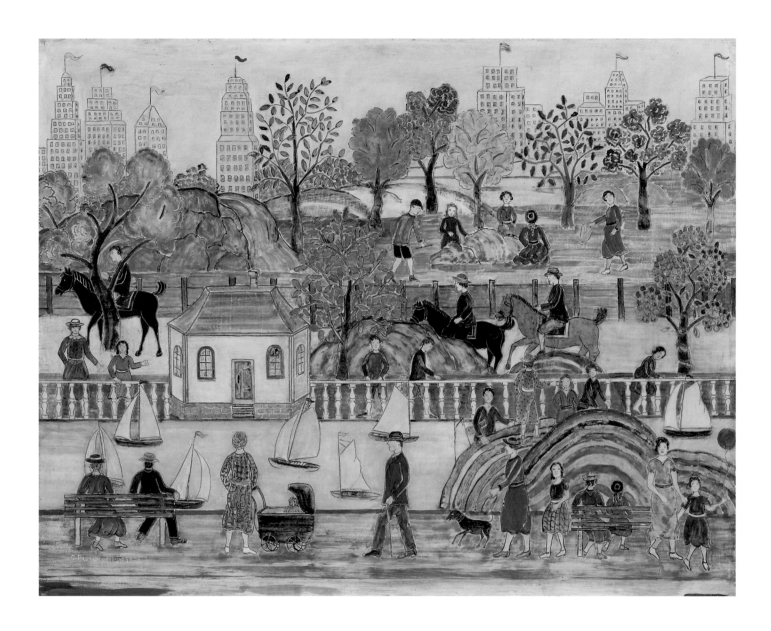

## Central Park

1939. Tempera, gold and silver leaf on incised, gessoed panel, 22 × 28 in. (55.9 × 71 cm). Signed (incised) and dated lower left: C. Prendergast 1939. BF372

PROVENANCE: Acquired by exchange with Kraushaar Galleries, June 12, 1951.[1]

EXHIBITIONS: Kraushaar Galleries, New York, Decorative Panels and Sculpture by Charles Prendergast, December 8–31, 1941, checklist no. 2 (as *Central Park*); Kraushaar Galleries, New York, Charles Prendergast, March 31–April 19, 1947, brochure no. 11 (as *Central Park*).

REFERENCES: Violette de Mazia, "Naïveté," *BFJAD* 7, no. 2 (Autumn 1976): 73, pl. 17; Violette de Mazia, "Subject and Subject Matter: Part II," *Vistas* 2, no. 2 (1981–83): 11n, pl. 85; CR 2298.

1 Letter, Antoinette M. Kraushaar to Albert C. Barnes, May 25, 1951: "We are shipping you by express the Charles Prendergast panel for you to study at your leisure. . . . I would be very glad to come to Merion any Sunday during the coming month or so to see your panel, if the idea of an exchange interests you." (The panel referred to is *Fantasy* [CR 2234].) Letter, Kraushaar to Barnes, June 12, 1951: "According to the arrangement we made, the panel of 'Central Park' is an even exchange for an earlier one which I brought back with me." Both letters ACB Corr., BFA.

# ERNEST LAWSON (1873–1939)

Lawson took over the impressionists' technique in all its phases—divided tones, direct effect of sunlight on objects, atmosphere, and the painting of landscape in which objects are treated chiefly from the standpoint of design. . . . While his best results are comparable to the best of Monet's, they lack the latter's originality and the great variety of color-effects achieved by the use of sunlight and divided tones. Lawson's finer feeling for the plastic function of color is shown by his more accurate placing of deeper tones in areas where they function more strongly in effecting a general harmony throughout the canvas. . . . The successful use of rich, appealing color, a good feeling for space, and the ability to make an ordered sequence of objects in the composition contribute to a plastic design are Lawson's own achievements.

Albert C. Barnes, *The Art in Painting*, 1925

*Ernest Lawson's colorful variations* on the French Impressionist technique had a lasting influence on Barnes's thinking about color as the primary constituent in the artist's repertoire, an idea that he expressed consistently in his writings.[1] Barnes sought to see pictures as a painter saw them, not merely as an inventory of familiar subjects portrayed. When, therefore, Barnes wrote to Lawson on October 27, 1914, "subjects of paintings get less attention from me than color and form,"[2] he was enunciating an attitude he would develop in his collecting, in his research and writing, and in the method of teaching he pursued in factory seminars and later in classes at the Barnes Foundation. By 1925, the collector had more formally articulated his position: "It is no easy task for a person to banish from his mind the subject-matter and concentrate upon a study of the manner in which color, line, space and mass are used, and how they enter into relations with each other. To accomplish the result means the breaking up of a set of old, firmly-established habits and the beginning of new ones."[3]

Barnes bought his first paintings by Ernest Lawson, to whom he was introduced by William Glackens, in January 1912, before Glackens's buying trip to France.[4] Born in Halifax, Nova Scotia, in 1873, Lawson lived and worked in the United States, claiming to have been born in San Francisco. Under the tutelage of J. Alden Weir and especially John Henry Twachtman at their school in Cos Cob, Connecticut, in 1891, the constituents of his Impressionist style were formed.[5] In 1893, during his first stay in France, he sought out Alfred Sisley and painted the landscape around Moret-sur-Loing, where the famous Impressionist lived. He returned to paint in France for two years, 1895 and 1896, moving to New York in 1898.[6] Lawson's richly textured surfaces also reflect the influence of Camille Pissarro and earlier innovators in landscape, notably John Constable. The radical transformation in Glackens's style in 1908, exemplified by his composition *Race Track* (BF138), occurred at the time Glackens and Lawson often painted together. Lawson's technique was catalytic, prompting Glackens's shift toward using strokes of bright color

FIG. 65

Ernest Lawson, *Landscape with Gnarled Trees*, c. 1910, oil on commercial wallboard, 20 × 23⅞ in. (50.8 × 60.6 cm), The Barnes Foundation, BF389 (detail)

to build a sparkling impasto.[7] Glackens in turn transmitted his high regard for Lawson's work to Barnes.

Although he admired Lawson's singular contribution to the Impressionist canon, Barnes never established with Lawson the kind of personal rapport he had with Glackens. Lawson was chronically in need of money, and his repeated requests for funds irritated Barnes, occasionally creating ill will on both sides. The tone of their correspondence is often quarrelsome. Nevertheless, over a period of less than seven years, Barnes purchased approximately fifteen works by the artist, of which six remain today in the Barnes Foundation collection: *River Scene—Boats and Houses* (BF 2046), *Landscape with Gnarled Trees* (BF 389), *Swimming Hole* (BF 496), *River Scene—Boats and Trees* (BF 484), *Graveyard* (BF 528), and *Hot Beds* (BF 173).[8]

At the outset of their relationship, Barnes asked Lawson, as he had done with Glackens and Alfred Maurer, to act as a liaison with other painters and collectors he wished to buy from as his collection began to take shape. He wrote Lawson on January 24, 1912, "I enclose check for $940.00 in payment of the two paintings, 'A Gray Day' and 'Winter Scene on Harlem River,' as per our agreement yesterday.... Let me know what you found out about the 'Sisley.'"[9] Barnes knew that Lawson had met the artist and was knowledgeable about his work, and he was probably influenced to acquire works by Sisley as a result of encouragement from both Lawson and Glackens.[10] On January 31, Lawson wired Barnes that he was sending him three of his pictures.[11] Barnes replied the same day, "If you find that Sisley has been sold, I'd be obliged if you ascertain the name and address of the man who had it for sale so that I can look him up and see if he has any others that might interest me." He then asked Lawson to help locate "a good [Robert] Henri and a good [Arthur B.] Davies at a decent price" and told the artist "I expect to go to New York next Monday or Tuesday and if I do, I'll drop in your studio."[12] By May 15, Barnes had purchased at least four more paintings for $500.00. "It is understood and agreed that if you desire to re-purchase these paintings from me within a reasonable time—say six months from date— you are at liberty to do so by paying me the pro-rata sum for each painting."[13] Barnes's detailed quasi-contractual letters, with their businesslike tone, were uncongenial to Lawson.

Lawson came to visit Barnes in early August 1912. At this formative stage, Barnes's collection included the paintings that Glackens had purchased in Paris in February, including two Sisleys, one Pissarro, and two Albert Lebourgs, as well as works by Glackens and Maurer, plus the Renoirs and Monet purchased later that spring.

Lawson had an exhibition of his work in Paris, Première Exposition d'Art Moderne Américain, at Levesque & Co. from July 3 through October 1, 1914. The catalogue contained a preface by Léonce Bénédite, curator of the Luxembourg Museum, Paris. The show paired Lawson with Bryson Burroughs.[14] The exhibition included thirty-four paintings by Lawson, with an essay on each artist by André Dezarrois, who recounted accompanying Lawson to locales in Washington Heights where he painted and described his working method: "He does not shy away from any means of painting. If the paintbrush does not suffice, he will use a palette knife, or his fingers if need be. The impasto is powerful, but its solidity does not preclude streams of light here and there. He works on unprimed canvases. . . . When he lived in Moret he often met Sisley —who was old, sickly, avoiding artists. That charmer of springtime light had no influence over him. . . . More than any other season, winter has its preferences."[15] The show was reviewed by Robert Dell in the *Burlington Magazine*: "Mr. Lawson is an impressionist; the pictures that he exhibits are all landscapes of America and nearly all views in New York itself, a fact which makes them particularly interesting. Mr. Lawson is a strong painter and an excellent colourist."[16]

Despite the disputatious tone of the correspondence throughout the fall of 1914, Barnes genuinely admired and continued to buy Lawson's work. He wrote to the artist February 24, 1915, "I saw your great show at Daniel's [February 10–March 2, 1915] and feel as happy as you do in the resulting sales. I had Daniel send one of them on approval, to a New York friend and feel pretty sure that a check will follow. One of them—priced at $250—pleases me immensely, and while I said nothing to Daniel about it, I would buy it for $200, including the frame now on it. Daniel knows which one I mean and if you want to tell him to accept my offer, let him send the painting to me. I hope the Metropolitan Museum incident will prove big capital to you—not that it amounts to a damn to the people

who know your work by living with its charm."[17] Barnes sent Lawson his article "How to Judge a Painting."[18] Lawson wrote him on May 5, 1915, "Thank you for sending me a copy of your good article in 'Arts & Decoration.' It is certainly well and vigorously written and is a splendid addition to artistic literature. It is in good contrast to the feeble stuff that passes for art criticism. Hoping to read more."[19] Barnes continued to purchase Lawson's work as late as 1918, including canvases that were shown in earlier Daniel shows.

Lawson's work had a marked impact on some of Barnes's choices over the succeeding four decades. In the examples of the artist's work chosen by Barnes, Lawson used a diversified and ruggedly textured impasto that produced a "rich, appealing color," a "sensuous quality" that according to Barnes made Lawson's "best results . . . comparable to the best of Monet's." Indeed, the first Monet acquired by the collector in April 1912, *Madame Monet Embroidering* (*Camille au métier*, BF197), seen in Paris and recommended by Glackens, has a color texture akin to Lawson's characteristic paint application. Barnes described the Frenchman's work in 1925: "we see

the Monet technique in its most characteristic form. . . . In the woman's gown, the curtain, the two jardinières, the carpet, in fact every object in the canvas, there is a richness of color obtained by the juxtaposition of spots of pure color. It gives not merely the surface effects of stuffs but rather the abstract quality of richness."[20] Such Lawsons as *Landscape with Gnarled Trees* (BF389), *River Scene—Boats and Houses* (BF2046), and *Garden Landscape* (fig. 66) stress rugged application of rich, unctuous pigment, sinuous drawing, especially of trees, and a vivid, light-saturated freshness of color across their built-up surfaces.[21] The presence of these and other Lawsons, hung side by side at Lauraston with the European and American Moderns in the decade 1912 to 1922, struck a responsive chord and opened the way for Barnes's appreciation of the powerful, even explosive, turbulent color rhythms of the Lithuanian artist Chaim Soutine in works such as *Red Church* (*L'Eglise rouge*, BF953) of c. 1919 (fig. 67).

Barnes purchased fifty-four canvases by Soutine, thirty-four of which were landscapes, in 1922.[22] They shared with Lawson's work an energetic manipulation of sensuously variegated strokes, spots, and ribbons and an

FIG. 68

Ernest Lawson, *Country Road— Farm House*, c. 1912, oil on wood panel, 20 × 23½ inches (50.7 × 59.7 cm), London Collection (formerly Collection Albert C. Barnes, subsequently the Mary and Nelle E. Mullen Collection)

FIG. 69

Chaim Soutine, *Landscape with Figure (Paysage avec figure)*, c. 1918–19, oil on canvas, 25⅞ × 32 in. (65.7 × 81.3 cm), The Barnes Foundation, BF315

overall richness of surface. Lawson's *Country Road—Farm House* of c. 1912 (fig. 68), London Collection (formerly Collection Albert C. Barnes, subsequently the Mary and Nelle E. Mullen Collection), depicts curvilinear trees and sweeping drawing with attenuated strokes of color in the broad area of the roadway. [23] Similar use of forceful brush-work, with color patterns made up of irregular patches of individual strokes of varying size and direction, can be seen in a Soutine such as *Landscape with Figure (Paysage avec figure*, BF315) of c. 1918 (fig. 69). Soutine, how-ever, exploited the spontaneity of his sources—Daumier,

Courbet, Van Gogh, Cézanne, and Adolphe Monticelli—to achieve a personal synthesis that lends a rugged, dramatic structural quality to his color that goes far beyond Law-son. Barnes's primary attention to color—expressed as early as 1914 to Lawson—meant that he was not put off by Soutine's images of dead rabbits, splayed beef carcasses, or violently distorted landscapes with twisted trees seen from precipitous vantage points. Lawson's art, then, played an essential, if unacknowledged, role in kindling Barnes's receptivity to Soutine's profound originality and, thus, in shaping his collection.

NOTES

Epigraph. Albert C. Barnes, *The Art in Painting* (Merion, Pa.: Barnes Foundation Press, 1925), 291–92.

1 Barnes's *The Art in Painting* contains many statements of this point. For example, "Color is the most obvious of the plastic means and comes nearest being the raw material of painting, since all the other elements, line, light, etc., may be regarded as modifications or aspects or results of color" (106), and "That color-relations are all-important in the design, in the total form of a picture, that the highest and best form of composition is by means of color, is one of the most weighty facts in aesthetics" (114).

2 Letter, Albert C. Barnes to Ernest Lawson, October 27, 1914, ACB Corr., BFA.

3 Barnes, *The Art in Painting*, 101.

4 Albert C. Barnes check no. 2175, January 30, 1912, BFFR, BFA. The check, payable to Ernest Lawson in the amount of $250.00, was for the "Painting 'Steam drill'" (no longer in the collection; possibly *Excavation for Pennsylvania Railroad Station, New York*, 18 × 24 in. [45.7 × 61 cm], University Gallery, University of Minnesota, extended loan from Mr. Hudson D. Walker).

5 As has been noted, Barnes bought a painting by Twachtman from the W. M. Chase sale, March 7, 1912 (see page 21 and page 55, note 71).

6 There is no comprehensive or reliable monograph on Lawson and relatively few documents to draw upon in researching the artist. Concise factual biographical information is found in Barbara O'Neal, "Introduction," in *Ernest Lawson 1873–1939*, exh. cat. (Ottawa: The National Gallery of Canada, 1967), 8–10. During Lawson's first stay in France in 1893, when he attended classes at the Académie Julian, he shared lodging with W. Somerset Maugham who modeled one of the characters in his novel *Of Human Bondage* (London: William Heinemann, 1915), a young painter named Frederick Lawson, after Ernest Lawson (see pp. 336 ff where Maugham mentions the fictional Lawson painting in Moret). Because Ernest Lawson painted many of the same subjects in and around New York with similar titles over a span of years, the dating of his pictures in exhibition catalogues published during and after his lifetime is imprecise and often speculative; only a general chronology can be estimated.

7 See Ira Glackens, *William Glackens and the Ashcan Group* (New York: Crown, 1957), 156. Glackens's newly adopted Impressionist palette can clearly be seen in *Portrait of Ernest Lawson*, painted in 1909, after Lawson was elected an associate member of the National Academy of Design (Collection of the National Academy of Design).

8 Three paintings by Lawson were bequeathed to the Brooklyn Museum by Laura L. Barnes in 1967: *Winter Landscape: Washington Bridge* (67.24.12), *Garden Landscape* (67.24.10 [ex-BF593, *Landscape—Poppies*]) (see fig. 66), and *Landscape with Stream* (67.24.11), which was deaccessioned in 2006. *Important American Paintings, Drawings and Sculpture*, auction cat. (New York: Christie's, 2006), cat. no. 72, ill. 102.

9 Letter, Barnes to Lawson, January 24, 1912, ACB Corr., BFA. At least one of the paintings purchased from Lawson, *Landscape (Winter)*, also recorded as *Winter Scene*, is noted in the Barnes Foundation's file card

records—together with three other Lawsons, *Boats and House*, *Country House*, and *Landscape*—as sold to Ferargil Galleries, April 9, 1945, by Georges F. Keller of the Bignou Gallery, New York, for $750.00. Barnes bought at least $2,290.00 worth of paintings from Lawson in 1912.

10 See Letter, Barnes to William Glackens, January 30, 1912, page 18.

11 Telegram, Lawson to Barnes, January 31, 1912, ACB Corr., BFA. The Exhibition of Paintings by Sisley, in which twenty-one canvases were shown, was held at Durand-Ruel in New York from April 10 to 27, 1912.

12 Letter, Barnes to Lawson, January 31, 1912, ACB Corr., BFA.

13 Letter, Barnes to Lawson, May 15, 1912, ACB Corr., BFA.

14 Burroughs was a curator at the Metropolitan Museum of Art, where he had been an assistant to Roger Fry from 1906 to 1909, when Fry was curator of paintings. Burroughs was Fry's successor in the position.

15 André Dezarrois, "Ernest Lawson," in *Première Exposition d'Art Moderne Américain*, exh. cat. (Paris: Galerie Levesque, 1914), 15–18, original in French. See also review by Guillaume Apollinaire, "Art Moderne Américain," *Paris-Journal*, July 10, 1914, reprinted in *Œuvres en prose complètes, 2: Chroniques et paroles sur l'art* (Paris: Gallimard, 1991), 818. The Metropolitan Museum of Art purchased *L'Hiver* (Levesque cat. no. 16, possibly the same picture shown in Exhibition of Paintings by Ernest Lawson, February 4–17, 1914, Daniel Gallery, New York, cat. no. 13). Burroughs was probably responsible for this acquisition.

16 Robert E. Dell, "Art in France," *Burlington Magazine*, August 1914, 305. Other critics admired Lawson's work. For example, A. E. Gallatin wrote, "The French Impressionists above all other artists of modern times made the greatest contribution to art. . . . In landscape . . . thanks to the discoveries of the impressionists, something new has been said. Landscape art as we understand it to-day is a modern development. . . . Mr. Lawson, an innovator, like all artists of real genius, has pushed these discoveries and developments even further. There is as much sparkle and sense of outdoors in his picture entitled Winter as there is in an early Monet. . . . His brushwork and his use of the palette knife are forceful and vigorous, full of spontaneity. He has a great sense of color, and there are in his paintings delicious passages of greens and blues." "Ernest Lawson," *International Studio*, July 1916, xiii–xv.

17 Letter, Barnes to Lawson, February 24, 1915, ACB Corr., BFA.

18 Albert C. Barnes, "How to Judge a Painting," *Arts and Decoration*, April 1915.

19 Letter, Lawson to Barnes, May 5, 1915, London Collection.

20 Barnes, *The Art in Painting*, 468–69.

21 One of the three Lawsons bequeathed by Laura L. Barnes to the Brooklyn Museum of Art, *Garden Landscape*, Brooklyn Museum, Gift of Laura L. Barnes, no. 67.24.10 (see fig. 66) is an excellent example of the thick built-up pigment that would have inclined Barnes to appreciate Soutine.

22 1922–1924 Inventory, nos. 558–611, "54 Soutines," BFA.

23 See *New Hope, Pennsylvania*, oil on panel, c. 1914–16, reproduced in *Important American Paintings, Drawings and Sculpture* (New York: Christie's, 2009), cat. no. 28, ill. 35. The buildup of juicy pigment and composition are closely related to *Country Road—Farm House* (fig. 68).

## *River Scene—Boats and Houses*
Alternate title: *Water-Front*

c. 1910. Oil on commercial wallboard, 20 × 23½ in.
(50.8 × 59.7 cm). Signed lower right: E. Lawson. BF2046

PROVENANCE: Possibly purchased as *Along Harlem River*
from the Daniel Gallery together with *Hot Beds* (BF173).[1]

RELATED WORK: *Washington Bridge*, c. 1910, oil on canvas,
25 × 30¼ in. (63.5 × 76.4 cm), Collection Munson-Williams-
Proctor Institute, Utica, Museum purchase 58.42, has a
rugged unctuous surface similar to *River Scene—Boats and
Houses*.

REMARKS: In Barnes's former dining room (now in the Admin-
istration Building of the Barnes Foundation), *River Scene—
Boats and Houses*, with its vigorous manipulation of thick
pigment, layered strokes, and spots of variegated color, hangs
adjacent to Soutine's *Landscape with Houses* (*Paysage avec
maisons*, BF2032) of c. 1919 (fig. 70), where Barnes placed it.

1  Albert C. Barnes check no. 4318, July 23, 1918, $400.00, BFFR, BFA. See
   invoice from Charles Daniel, July 16, 1918, and letter, Barnes to Daniel,
   July 23, 1918. Invoice and letter ACB Corr., BFA.

FIG. 70

Chaim Soutine, *Landscape with
Houses (Paysage avec maisons)*,
c. 1919, oil on canvas, 19¾ ×
24 in. (50.2 × 61 cm), The Barnes
Foundation, BF2032

## Landscape with Gnarled Trees
Alternate title: *Winter*

c. 1910. Oil on commercial wallboard, 20 × 23⅞ in.
(50.8 × 60.6 cm). Signed lower left: E. Lawson. Frame by
Charles Prendergast, signed upper frame member verso:
Prendergast. BF389

PROVENANCE: Probably acquired from the artist.

REMARKS: *Landscape with Gnarled Trees* in its writhing cur-
vilinear trees and animated surface treatment is reminiscent
of such Soutines as *Red Church* (*L'Eglise rouge*, BF953) of
c. 1919 (see page 185) and *Landscape with Figure* (*Paysage
avec figure*, BF315) of c. 1918–19 (see figs. 67 and 69).

## Swimming Hole

Alternate title: *Landscape*

c. 1910. Oil on canvas, 39⅞ × 50 in. (101.3 × 127 cm).
Signed lower center: E. Lawson. BF496

PROVENANCE: Probably acquired from the artist.

REFERENCES: Forbes Watson, "The Barnes Foundation, Part II," *Arts*, February 1923, ill. 147 (as *Landscape*); Mary Mullen, *An Approach to Art* (Merion, Pa.: Barnes Foundation Press, 1923), ill. 74 (as *Landscape*); Albert C. Barnes, *The Art in Painting*, ill. 294 (as *Landscape*).

## River Scene—Boat and Trees

Alternate title: *Snow Storm*

c. 1907–10. Oil on canvas, 25⅛ × 30⅛ in. (63.8 × 76.5 cm).
Signed lower right: E. Lawson. Frame by Robert Laurent,
signed upper frame member verso: Laurent. BF 484

PROVENANCE: Acquired from the Daniel Gallery, Febru-
ary 26, 1915.[1]

EXHIBITION: Daniel Gallery, New York, Landscapes by
Ernest Lawson, February 10–23, 1915.

REFERENCE: "Landscapes by Lawson," *American Art News*
XIII, no. 19 (February 13, 1915): 5: "Ernest Lawson, who is
showing some masterly landscapes . . . at the Daniel Galler-
ies [*sic*]. . . . There are crudenesses here and there and the
facts are sometimes rather arbitrarily stated, but the results
are inspiring artistic truths. . . . Fine in tone is 'Tibbets Creek'
and true the effect of the 'Snow Storm.'"

1 Letter, Albert C. Barnes to Ernest Lawson, February 24, 1915 (without
mentioning specific work). The invoice, dated February 25, 1915, speci-
fies "Sold to Mr. A.C. Barnes Overbrook, Pa 'Snow Storm' by Ernest
Lawson." Letter and invoice, ACB Corr., BFA. Albert C. Barnes check no.
3227, February 26, 1915. $200.00, payable to Charles Daniel ("bill 2/25/15
Lawson painting"), BFFR, BFA.

## Graveyard

Alternate title: *Abandoned Graveyard—"Spring"*

c. 1912. Oil on canvas, 25⅛ × 30¼ in. (63.8 × 76.8 cm).
Signed lower left: E. Lawson. Frame by Max Kuehne,
signed left frame member verso: MK. BF528

PROVENANCE: Unknown.

EXHIBITION: Daniel Gallery, New York, Exhibition of Paintings by Ernest Lawson, February 4–17, 1914.

REFERENCE: *Exhibition of Paintings by Ernest Lawson*, exh. cat. (New York: Daniel Gallery, 1914), cat. no. 5 (as *Abandoned Graveyard—Spring*).

## Hot Beds

Alternate title: *Hot Beds—Spring; The Hot Beds*

c. 1913. Oil on canvas, 18 × 21 in. (45.7 × 53.3 cm). Signed lower right: E. Lawson. Frame by Max Kuehne. BF173

PROVENANCE: Acquired from the Daniel Gallery, July 23, 1918, for $200.00.[1]

EXHIBITION: Daniel Gallery, New York, Exhibition of Paintings by Ernest Lawson, February 4–17, 1914, cat. no. 5 (not purchased by Barnes at this time).

REFERENCES: *Paintings by Ernest Lawson*, exh. cat. (New York: Daniel Gallery, February 4–17, 1914), cat. no. 14 (as *Hot Beds—Spring*); "Landscapes by Lawson," *American Art News* XIII, no. 19 (February 13, 1915): 5: "An unusual subject is made good use of in 'Hot Beds'"; Albert C. Barnes, *The Art in Painting*, 291.

REMARKS: The original stretcher from *Hot Beds* was reused for another work in the Barnes Foundation collection, Henri Matisse, *Nude Standing near Window* (BF184). A number of inscriptions related to *Hot Beds* remain on the verso of the stretcher. Inscribed in blue crayon on upper stretcher member: "13"; inscribed on paper label on right stretcher member: "The Hotbeds / Ernest Lawson / Price 300– / no7–"; stamped on label: "DANIEL GALLERY / 2 WEST 47th ST. / NEW YORK"; inscribed on right stretcher member: "300–"; inscribed on right stretcher member: "The Hotbeds."

1 Invoice from Charles Daniel, July 16, 1918, mentioning Lawson's *Hot Beds* and *Along Harlem River*, and letter, Albert C. Barnes to Charles Daniel, July 23, 1918: "I enclose check for the two Lawsons which arrived this morning." Invoice and letter ACB Corr., BFA. Albert C. Barnes check no. 4318, July 23, 1918, BFFR, BFA.

# JULES PASCIN (1885–1930)

The number, variety, and activity of Pascin's rhythms have rarely been equaled by other painters. His line is not only highly decorative, but also as free, as terse, as varied in expression as that of any of the great illustrators. The distortions in his painting increase the expression of the natural, essential quality of objects or episodes. . . . The dynamic qualities are especially felt: his ability to represent movement is extraordinary; even when a figure is motionless, the effect is not of inertia, but of suspended movement ready at any moment to be resumed. Every unit in his canvas is alive, and so, thanks to the pervasive, delicate, graceful rhythms, is the composition as a whole.

Albert C. Barnes, *The Art in Painting*, 1937

*Jules Pascin, who is represented by fifty-seven works* in the collection of the Barnes Foundation, is one of the underappreciated masters of twentieth-century painting. Because his paintings, drawings, and watercolors are not readily classified under the rubric of a defined group—expressionism, Cubism, Fauvism—he has not received sustained critical attention as one of the creative individualists of the Modern tradition.

Pascin was born in Vidin, Bulgaria, a port on the Danube, in 1885. A precocious draftsman from childhood, he first saw illustrated French comic journals at age fourteen and later, around 1901–02, he visited an exhibition of works by French Impressionists including Henri de Toulouse-Lautrec and Pierre-Auguste Renoir, whose work made the strongest impression on him. By his own account, he studied art for more than seven and a half years in Vienna, Budapest, Berlin, and Munich. In 1904 he was discovered by the Viennese writer Gustav Meyrink (1868–1932), who brought some of Pascin's drawings to the popular German satirical magazine *Simplicissimus*. The nineteen-year-old artist began to supply cartoons to the magazine on a contract basis, then used his earnings to finance a move from Munich to Paris at the end of 1905. By the time he departed for France he had anagrammatically rearranged the letters in his original name—Julius Pincas—to "Jules Pascin," as he was known thereafter.[1]

Studies on Pascin have typically foregrounded his colorful, bohemian lifestyle and overlooked the fact that he was intelligent, articulate, and well read. A close friend noted that Pascin "had a curious mind, and was always asking questions on all sorts of subjects. He was continually seeking knowledge. He had a retentive memory, knew the stories of 'The Thousand-and-one Nights,' and was a good Latin scholar. He could recite Horace in the original."[2] Pascin arrived in Paris at a juncture when the annual salons were exhibiting the latest creations of Modern French art and one could see the work of the Post-Impressionists in profusion. The worldly young artist associated with a circle of German, American, and Scandinavian artists who were exploring the latest discoveries of Henri Matisse.[3] Pascin was included in the 1912 Sonderbund Exhibition in Cologne, the model for the 1913 Armory Show, where he showed twelve drawings, watercolors,

FIG. 71

Jules Pascin, *Woman with Baby Carriage*, 1919, drained oil and pen and ink with graphite on paperboard, 12⅛ × 14⅞ in. (30.8 × 37.8 cm), The Barnes Foundation, BF628 (detail)

and prints. In Paris, prior to World War I, he exhibited at the Salon d'Automne, the Salon des Indépendants, and the Berthe Weill Gallery. After nine years in Paris, in the fall of 1914, Pascin came, via London, to the United States, where he spent six years, becoming an American citizen in 1920.[4]

Albert Barnes purchased his first two drawings by Pascin from Charles Daniel in January 1921. Thereafter, he acquired paintings and drawings in quantity, visited Pascin in his Paris studio, and developed a cordial relationship with the artist. That year in Paris, Barnes received a note from Pascin, "I found your letter at the Café du Dome. I will be very pleased to show you my things. I will be at my studio Tuesday from ½ past 10 AM till 1 o'clock and from 2 to 4 o'clock. Should you prefer to come some other day, please drop me a word."[5] In June 1921 Barnes bought thirteen paintings by Pascin.[6] After the paintings purchased in 1921 arrived, Barnes showed them to William Glackens, who wrote on November 12, "Your two new Cézannes are peaches. Of the Pascins. The nude in the first room and the landscape with crowds of half breeds moving around strike me hardest. The others I like too but these two appeal to me more. He has got imagination."[7] These works, along with Barnes's subsequent purchase from the artist, in January 1923, of twenty-one watercolors, made Pascin one of the most prominently represented artists in his collection.[8]

Barnes was impressed by Pascin's knowledge of the traditions and responded enthusiastically to his creative use of Renoir and Cézanne. In 1925 he wrote, "Pascin's achievements in the line of some of the great traditions of painting make him one of the most important of contemporary artists. The influences of Daumier, Degas, Cézanne and Renoir are seen in his work, but his own contributions converted them into a distinctly personal form."[9]

Pascin's paintings had by 1913 already achieved their characteristic style, in which colorful, robust three-dimensional nudes are made up of planes and patches of color adapted from Cézanne's mature oils and watercolors. The surfaces of Pascin's figures, lighter in weight than Renoir's, stem from François Boucher's mother-of-pearl-ivory handling of flesh. Pascin's luminous, pulsating areas of color are irregular in their outlines and combined with

drawing described by Barnes and Violette de Mazia as "curvilinear, loose and undulating, often made up of a series of curves or scallops, and . . . admirably adjusted to conveying the feeling of active, rhythmic, somewhat swirling movement, both in figures and in the composition as a whole. The swirl of the line is paralleled or otherwise taken up by the numerous areas, bands, patches of color, light and shade, so that the swirl becomes a basic expressive and decorative motif."[10] Pascin's irregularly brushed washes of color, often warm russet or tawny brown-ochre tonalities, in conjunction with his broken linear contours, build the gentle three-dimensionality of his volumes. To these, especially in his watercolors, the artist also brings into play diffuse tinted areas of luminous rose, pale blues, pinks, yellows, and greens reflecting his adaptation of J. M. W. Turner's translucent color application. Subsidiary elements, such as tables, still lifes, and canvases and stretchers in his studio, often enliven his compositions.

Among the diverse sources sought out for study by the young artist were oriental paintings on fine linen. On similar surfaces, Pascin applied delicate washes of color with a fresh translucency that often approximates watercolor and pastel. In each of these media he rhythmically deployed irregular areas of color defined by his sequences of lines in ink as well as in graphite, or both. Summing up Pascin's distinctive line, Barnes wrote that it "evokes a sense of drama and a feeling of extremely animated movement. These short wavy lines, reënforced [sic] by light and color, create a complex series of active, almost quivering, rhythmic units which continuously flow into and link up with each other."[11]

The artist's drawing was also influenced by the prehistoric cave paintings that were brought to the attention of a broad audience as early as 1901, primarily through color drawings of those striking images at Altamira in Spain and Font-de-Gaume in the Dordogne region of France.[12] In these color depictions, the modulations of the figures on the rough surfaces of the cave walls are rendered using discontinuous lines in true-to-life brown pigments. Pascin experimented with similar lines, in concert with patchy areas of warm color, in the multifigure compositions that he began after he came to the United States in 1914.

## *Nude and Books (Nu et livres)*

1906. Oil on canvas, 21¾ × 18 in. (55.2 × 45.7 cm). Signed and
dated lower right: pascin 1906. BF401

PROVENANCE: Unknown.

REFERENCE: *Pascin, Catalogue Raisonné*, 2:98, no. 41, 25, ill.

FIG. 72

Installation photograph showing Jules Pascin's *Les Tunisiennes* (BF2043), *Le petit garçon* (as *Boy*), and *Femme assise* (as *Girl*), Pennsylvania Academy of the Fine Arts, Philadelphia, Exhibition of Contemporary European Paintings and Sculpture, April 11–May 9, 1923. Installation photograph no. 5, Archives of the Pennsylvania Academy of the Fine Arts

A visit must have taken place, for Pascin wrote Barnes again in January 1923: "I am sending you the declaration you asked me for. As I am leaving it at the hotel, you would be very kind to send me a word that you got it all right and that it is the right declaration you wanted."[13] The Declaration of Free Entry of Works of Art, the Production of American Artists Residing Abroad, which Barnes needed to ship his purchases home, is dated January 4, 1923, and signed "Jules Pincas."[14] It declares "21 watercolors $2100"; no titles are indicated. In the margin of the Barnes Foundation 1922–1924 Inventory, which gives these twenty-one works on paper as numbers 537 to 557 inclusive, is the notation "14 @ 100 = [$]1400" and "7 @ 50 = [$]350"; this corresponds to the number (but not the price) of works indicated by Pascin on his declaration of January 4, 1923 (cited above).

According to an invoice dated March 7, 1923, Arthur Lénars & Cie., Paris, shipped Barnes four paintings by Pascin listed as nos. 133, 134, 135, and 136, three of which were exhibited in the Contemporary European Paintings and Sculpture Exhibition at the Pennsylvania Academy of the Fine Arts, April 11–May 9, 1923, confirmed by instal-

lation photographs showing four of Barnes's Pascins in the show (fig. 72).[15] The three recent acquisitions on the Lénars list were *Les Tunisiennes* (BF2043; Lénars no. 134; PAFA cat. no. 67, as *Algerians* [sic]); *Le petit garçon* (Lénars no. 133; PAFA cat. no. 71, as *Boy*), which was later owned by Mary and Nelle E. Mullen; and *Femme assise* (Lénars no. 136; PAFA cat. no. 68, as *Girl*), which was later owned by Violette de Mazia. The fourth Pascin in the PAFA exhibition was *Standing Nude in the Studio* (BF182; PAFA cat. no. 58, as *Nude*).

1 Letter, Charles Daniel to Albert C. Barnes, January 17, 1921, and letter, Barnes to Daniel, January 19, 1921, both ACB Corr., BFA. Invoice from Daniel, January 15, 1921, ACB Corr., BFA. *Horses in Landscape* (BF612) is inscribed on its verso "Havana Suburb," which is one of the titles on the invoice.

2 See letter, Barnes to Pascin, November 8, 1923, and letter, Pascin to Barnes, undated [fall 1922], both ACB Corr., BFA, cited in notes 10 and 12.

3 Letter, Max Kuehne to Barnes, July 1, [1921], ACB Corr., BFA. The numbers mentioned herein do not correspond to the list of works in the consular invoice from Durand-Ruel dated July 21, 1921.

4 Barnes Foundation file cards BF182, BF194, BF198, BF229, BF249, BF276, BF344, BF385, BF401, BF403, BF476, and BF483.

5 Letter, Paul-Louis Durand-Ruel to the author, June 20, 2008. He further added, "On July 20, 1921, D-R New York acknowledged receipt of this letter 'enclosing consular invoice, etc.'" All documents cited in Durand-Ruel's correspondence are held in the Durand-Ruel Archive, Paris.

6 Letter, Paul-Louis Durand-Ruel to the author, June 20, 2008, with copy of page from the Durand-Ruel et Cie. Exportations Book, entry dated July 8, 1921, and a copy of the July 21, 1921, consular invoice. In a letter from Paul-Louis Durand-Ruel to the author dated June 24, 2008, he affirms that "Prov. M. Pascin means that Dr. Barnes purchased the works from Pascin."

7 Letter, Paul-Louis Durand-Ruel to the author, June 25, 2008. Durand-Ruel confirms that although the Exportations Book mentions fourteen works by Pascin ("14 peintures"), "this is obviously a mistake." Numbers B1–B9, B11, B12, B14, and B15 on the list were works by Pascin; B10 was a painting by Maurice Utrillo (*L'Octroi de Saint Germain* [BF188D, deaccessioned in 1935]); and B13 was a painting by Henri Ottmann, *Fish Market, Marseille* (BF406).

8 Letter, Paul-Louis Durand-Ruel to the author, June 24, 2008.

9 At the exchange rate of between 12 and 12.5 francs to the dollar at that time, 838F was approximately $68.00. The reference to the relining of "13 tableaux" in the Durand-Ruel books may be erroneous, as the price suggests and physical examination confirms that only a small number of the thirteen paintings were treated. The relining would not have been mentioned on the consular invoice as were the frames.

10 Letter, Barnes to Jules Pascin, November 8, 1923, ACB Corr., BFA.

11 Barnes Foundation checks no. 33114, 33115, and 33116, January 1, 1923, BFFR, BFA.

12 Letter, Pascin to Barnes, undated [fall 1922], ACB Corr., BFA.

13 Letter, Pascin to Barnes, undated [January 1923], ACB Corr., BFA.

14 Jules Pincas [Jules Pascin], Declaration of Free Entry of Works of Art, the Production of American Artists Residing Abroad, January 4, 1923, Pascin correspondence, ACB Corr., BFA.

15 Invoice, Arthur Lénars & Cie., Paris, March 7, 1923, ACB Corr., BFA. The fourth Pascin in the PAFA show, *Standing Nude in the Studio* (BF182), is visible in another installation photograph.

Durand-Ruel Gallery assigned to each of the thirteen paintings were preceded by "B" for Barnes.[7] Durand-Ruel writes, "We have not found any invoice," and further cites gallery records: "Dû par[t] le Dr. Barnes: Rentoil. de 13 tabl.[eaux] Pascin 838F."[8]

Recent conservation examinations of the paintings at the Barnes Foundation have disclosed that of the thirteen canvases only two (BF198 and BF348) have relinings that could be contemporary to the time of purchase, but it is not possible to determine whether they were treated while in Durand-Ruel's possession. If these two were, this may account for the modest amount Barnes paid to Durand-Ruel for relining work.[9]

The conservation examinations note that Durand-Ruel labels with a blue printed border have been affixed to the stretchers of twelve paintings. The labels are handwritten with numbers B1–B9, B11, B12, and B14; a label for B15 has not been noted on any of the Foundation's paintings and has presumably fallen off. It appears that the labels were affixed at the time the shipment was prepared. With the evidence of the existing Durand-Ruel labels and the documents received from the Durand-Ruel Archive, we can now determine at least twelve of the thirteen pictures purchased by Dr. Barnes from Pascin in 1921. The twelve extant numbered labels appear to have been attached randomly and do not *directly* correspond to the sequence of numbers and titles on the list in the July 21, 1921, consular invoice. Since there are no dimensions recorded on the consular invoice, where possible, identification of the works has been made based on the titles, labels, and subjects of the works in the individual provenances in the entries that follow.

Barnes wrote to Pascin, November 8, 1923:

I think of you often . . . when I see your many paintings and drawings around my house. . . . When I was in Paris last summer [1922] I called at your house with Paul Guillaume and [Jacques] Lipchitz but you were away from the city. . . . I don't know the exact status of the matter which occurred in June, 1921, in reference to some of your drawings. You may remember that I selected a number which I was to buy at the rate of twelve hundred (1,200) francs each [approx. $100.00] for the large ones and six hundred (600) francs [approx. $50.00] each for the small ones. I offered to take them that very day in June, 1921 but you told me you needed them for an atlas to be published in Berlin. You said you would be in America in December, 1921 and that you would deliver the drawings to me at my house. I never saw you again until last Christmas [1922] when Paul Guillaume and I called at your studio. . . . We concluded our meeting amicably and I bought twenty-one of your drawings. Since that day I have not seen you or heard from you.[10]

Pascin did not reside in the United States in 1921. The "Christmas" 1922 purchase of twenty-two (not twenty-one) watercolors and drawings was made directly from Pascin and is documented by three checks, each dated January 1, 1923, drawn on Barnes's French bank account and made out to Pascin: check no. 33114 in the amount of 31,000 francs (approx. $2,600.00), for "12 drawings and water colors"; check no. 33115 in the amount of 3,900 francs (approx. $400.00), for "3 water colors"; and check no. 33116 in the amount of 4,550 francs (approx. $375.00), for "7 water colors."[11] The works are not identified. Pascin had written to Barnes, undated (1922, probably fall, when Barnes was in Paris):

I heard that you were again in Paris. You must excuse me for never having written you to Philadelphia. . . . I expected to go next August to the States, but friends here are very much urging me to make next winter an exhibition of all my work in Paris, so I may still stay till Spring in Europe if I get an extension to my passport. I still got all the drawings you put on side last year. [Julius] Mayer [Meier]-Graefe, the German artwriter, made a choice including many of the ones you wanted. I was supposed to come beginning of this month to Berlin and to bring them with me for publication as a Portfolio of the Maréesgesellschaft, the publishing house who brought out the wonderful reproductions of watercolors and pastels of Cézanne and Renoir, you may have seen in New-York at [dealer and bookseller Erhard] Weyhe's or elsewhere. . . . I hope to have the pleasure of your visit. I am in most of the day till 7 P.M. But perhaps it would be the surest you send me a pneumatique letter, telling me the time you want to come up.[12]

## NOTE ON PASCIN SOURCES AND PROVENANCE

The artist's works are catalogued in Yves Hemin, Guy Krogh, Klaus Perls, and Abel Rambert, *Pascin, Catalogue Raisonné*, 4 vols. (Paris: Abel Rambert, vol. 1, 1984; vol. 2, 1987; vol. 3, 1990; vol. 4, 1991), cited in some cases in the following entries. However, most of the paintings, watercolors, and drawings by Pascin in the Barnes Foundation are not listed in the *Catalogue Raisonné*.

There is scant detailed documentation on Barnes's purchase of the fifty-seven paintings, watercolors, and drawings by Pascin in the collection today. Barnes's first acquisition occurred in January 1921, with the purchase of two drawings from Charles Daniel for $500.00.[1] Barnes made the purchase just prior to Pascin's solo exhibition of twenty landscape and figure drawings, March ?–26, 1921, at the Daniel Gallery. Barnes next selected a group of drawings directly from Pascin in June 1921, but the transaction seems not to have been concluded.[2] Barnes apparently told Max Kuehne about this purchase, for Kuehne wrote Barnes on July 1, 1921: "Aren't you going to tell Daniel you got your Pascins for a third of his prices. Won't he be sore. You must have pretty well cleaned out Pascin 112 Watercolors and 7 oils."[3]

There are nineteen oil paintings by Pascin in the Barnes Foundation. Twelve of these are (erroneously) recorded on Barnes Foundation file cards as having been purchased from the Paris art dealer Durand-Ruel & Cie., September 22, 1921, for a total price of 76,800 francs ($6,400.00, or $533.00 each).[4] There is no documentation in the Foundation's archives to support this claim. In fact, Dr. Barnes did purchase thirteen paintings from the artist in the early summer of that year. Paul-Louis Durand-Ruel has provided the following information from the Durand-Ruel Archive, Paris: "In a letter from D-R Paris to D-R New York on July 8, 1921, it is mentioned that Dr. Barnes came to Paris with his brother, visited the Pellerin, Bernheim and Gangnat collections (but Monet, ailing, could not receive him); he purchased a number of works of art from various parties, and, as usual, asked Durand-Ruel to arrange the shipment to Philadelphia; these purchases included works by Pascin, according to the following excerpt: 'Rapport au certificat que j'ai signé pour Pascin, vous verrez qu'il y a une déclaration faite par Pascin lui-même, comme artiste américain; on nous a dit au Consulat que ces déclarations, faites par des artistes américaines, pour lesquelles on paie 1 dollar, ne font plus foi à la douane de New York; c'est pour cela que j'ai fait une seconde déclaration.'"[5] Durand-Ruel further affirms: "We found three consular invoices relating to these purchases, one of them (dated July 21, 1921) about various paintings . . . and a number of frames . . . for these and other paintings including 13 frames for the following Pascins: *Femme devant la fenêtre* [B1]; *Rue à Tampa* [B2]; *Paysage, Floride* [B3]; *Rue à la Nouvelle-Orleans* [B4]; *Jeune fille au repos* [B5]; *Jeune fille assise* [B6]; *Portrait de jeune fille* [B7]; *Venus et l'Amour* [B8], *Jeune fille et nature morte* [B9]; *Nu debout* [B11]; *Deux nus* [B12]; *Hospitalité créole* [B14]; *Paysage avec figures* [B15]. In our *'Exportations' book*, it is mentioned that these 13 paintings . . . were purchased from Pascin; they are not recorded in the Durand-Ruel stock books, Paris or New York."[6] The consular invoice lists the paintings without dimensions specified. In many instances, the generalized titles are difficult to match with precision to some of the paintings in the Foundation's collection. The non-consecutive numbers the

thousands of prints in the "Druet Process" were sold to painters and collectors, "constituting for a long time an indispensable repository for knowledge and propagation of contemporary art," of which Pascin speaks. See Georges Besson, "Eugène Druet: Photographe et Maître de Maison," *Beaux-Arts*, no. 313 (December 30, 1938): 1, 6. Starting in 1896, Druet became Auguste Rodin's official photographer. In addition to his black-and-white work, Druet also worked in a color process known as *autochrome*, invented by the Lumière brothers, which he applied to paintings, especially those of van Gogh, in whose work his gallery specialized. Thomas Schlesser writes, "Druet invented an extremely effective process that gives results of a remarkable quality, and that enables him to photograph a work of art from very close up, faithfully reproducing the reliefs and relative values of sculptures, the weaving of cloth, and brush strokes" (original in French). See "Le Point sur un outil, un fonds, une recherche: Le Fonds Druet-Vizzavona," *Les Nouvelles de INHA [Institut national d'histoire de l'art]*, no. 17 (April 2004): 22–25.

16  See Nef, *Search for Meaning*, 64. "Pascin told us how Barnes, accompanied by John Dewey, had recently swept through his apartment studio and gone off with several pictures for which he paid cash." Dewey spent a month (late May and June) in 1925 in Europe with Dr. Barnes, attending his friend's lectures in the Louvre, Paris, and the Prado, Madrid. See letter, Dewey to Barnes, September 21, 1925, ACB Corr., BFA. See also Pennsylvania State Archives, Harrisburg; Record Group 33, Records of the Supreme Court of Pennsylvania; Eastern District; Appeal Papers (series #33.10), January Term 1933, No. 268, Testimony of Thomas Munro, in *The Barnes Foundation, Appellee vs. Harry W. Keely et al.*, Brief of Appellants, 37: "I have been present at classes . . . that he was holding in the Louvre in Paris" and "Classes in the summer, abroad—at least I attended one in the Louvre." Thomas Munro describes several trips to Paris, London, and cities in Italy with Barnes, Mr. and Mrs. Dewey, and other members of Barnes's staff, emphasizing that Barnes lectured in the Louvre and other major museums as well as in churches and that Dewey listened. They also frequented Paul Guillaume's gallery and studio, where they met and talked with contemporary critics, including Roger Fry. He also states that they visited artists' studios, confirming Nef's recollection that Barnes took Dewey to see Pascin (and possibly Soutine). He recollected that these trips with Barnes and Dewey took place around 1925, 1926, and 1927. Munro Oral History (8–13).

17  Pascin was considered a French artist in group shows with Charles Daniel in 1919, 1921, and 1922, and in one-man shows with Joseph Brummer in 1923 and Knoedler in 1930, as well as with galleries in Paris. In the Exhibition of Contemporary European Paintings and Sculpture, Pennsylvania Academy of the Fine Arts, April 11–May 9, 1923, Barnes classified Pascin as European. (See entry for *Standing Nude in the Studio* [BF182].) Pascin described Brooklyn in a 1927 letter to Lucy Krogh as "nothing but the Rive Gauche of New York" (original in French). Yves Kobry and Elisheva Cohen, *Pascin 1885–1930* (Paris: Musée Galerie de la Seita and Editions Hoebeke, 1994), 139–40.

18  Letter, Pascin to Barnes, undated [fall 1927], ACB Corr., BFA.

19  Letter, Barnes to Jacques Lipchitz, March 20, 1931, ACB Corr., BFA. For Hermine David, see Mad Benoit, *Hermine David (1886–1970), Peintre-graveur de l'Ecole de Paris* (Paris: Editions Jean-Paul Villain, n.d. [2006]).

such circumstances and I think you are right in deciding not to have anything to do with it. . . . It is most unfortunate because Pascin was such a fine fellow and I am sure that you, as one of his oldest and best friends, would have made something that would have been a credit to him as well as yourself."[19]

NOTES

Epigraph. Albert C. Barnes, *The Art in Painting*, 3rd ed. (New York: Harcourt, Brace, 1937), 375–76.

1 Pronounced Pas-*keen* according to John U. Nef, *Search for Meaning: The Autobiography of a Non-Conformist* (Washington, D.C.: Public Affairs Press, 1973), 62; cited in Tom L. Freudenheim, *Pascin*, exh. cat. (Berkeley: University Art Museum, University of California, 1966). Biographical data on Pascin's early life is drawn from an undated [December 1914] letter from Pascin to Martin Birnbaum, who presented an exhibition of Pascin's work at his Berlin Photographic Company Gallery in January 1915. Martin Birnbaum Papers, microfilm, Archives of American Art, Washington, D.C., original in German.

2 Horace Brodzky, *Pascin* (London: Nicholson and Watson, 1946), 13. The author also writes that Pascin "could discuss Plato, Giordano Bruno, [Jean-Jacques] Rousseau, or [Claude Henri Comte de Saint-]Simon. All this scholarship was hidden behind that simple, somber yet youthful exterior," and that he interested himself in architecture and engineering as well as mathematics (18).

3 Matisse's *Carmelina*, 1903/04, Museum of Fine Arts, Boston, was the source of Pascin's modeling with patches of color in his figures, particularly nudes.

4 Prior to sailing for New York, the artist spent two and a half months in London (July 15–October 1), arriving in New York on October 8, 1914. He spent time in the National Gallery, London, where he was able to study the work of J. M. W. Turner. André Bay, *Adieu Lucy, Le Roman de Pascin* (Paris: Albin Michel, 1984). Although there is considerable literature on Pascin, much of it anecdotal, there is no reliable documentary biography of the artist. Facts presented here have been drawn from the chronologies contained in Freudenheim, *Pascin*, and Yves Hemin, Guy Krogh, Klaus Perls, and Abel Rambert, *Pascin, Catalogue Raisonné*, vol. 1 (Paris: Abel Rambert, 1984).

5 Letter, Jules Pascin to Albert C. Barnes, undated [annotated in another hand, 1921 (probably June)], London Collection. This encounter is documented in a letter dated November 8, 1923, probably in reply to one from Pascin, in which Barnes wrote, "Of course, I think of you often, not only when I see your many paintings and drawings around my house, but also when I recall the numerous tête-à-têtes we have had over a bottle of good wine. When I was in Paris last summer [1922] I called at your house with Paul Guillaume and Jacques Lipchitz but you were away from the city. . . . I don't know the exact status of the matter which occurred in June, 1921 in reference to some of your drawings. You may remember that I selected a number which I was to buy at the rate of twelve hundred (1200) francs each for the large ones and six hundred (600) francs each for the small ones. I offered to take them that very day in June, 1921 but you told me you needed them for an atlas to be published in Berlin. You said you would be in America in December, 1921 and that you would deliver the drawings to me at my house. I never saw you again until last Christmas [1922] when Paul Guillaume and I called at your studio. . . . We concluded our meeting amicably and I bought twenty one of your drawings. Since that day I have not seen you

or heard from you." These drawings must be the group of twelve documented on the declaration cited in note 8. Letter, Barnes to Pascin, ACB Corr., BFA. The works are not identified. A letter from Barnes to Charles Demuth, August 1, 1921, also confirms that the relationship between Barnes and Pascin had been established by 1921: "If you see [Arthur B.] Carles or Pascin [in Paris] remember me to them." ACB Corr., BFA.

6 These Pascin oils are listed in the 1922–1924 Inventory. The thirteen canvases were acquired from the artist and sent to Durand-Ruel in July 1921 to be framed and shipped to Barnes. The Durand-Ruel *livre de exportation* documents that these thirteen oils were not purchased from Durand-Ruel but from another source(s), almost certainly Pascin himself. This purchase was made prior to Barnes's acquisition of works by Chaim Soutine, Amedeo Modigliani, and Jacques Lipchitz.

7 Letter, William Glackens to Barnes, November 12, 1921, ACB Corr., BFA. Glackens had been to Cuba in 1898 as a correspondent covering the Spanish-American War. The two Cézannes are *Portrait of a Woman* (*Portait de femme*, BF164) and *Peasant Standing with Arms Crossed* (*Paysan debout, les bras croisés*, BF209) (Rewald cat. nos. 853 and 787). See letter, Barnes to Max Kuehne, July 26, 1921, ACB Corr., BFA: "I got two very important Cézannes—one of them a woman in red striped gown seated in a chair . . . ; the other Cézanne is a full length portrait of a man standing."

8 Although Pascin was by this time an American citizen, he continued to use the name Pincas on legal documents. See Declaration of Free Entry of Work of Art, the Production of American Artists Residing Abroad, January 4, 1923, for twenty-one watercolors ($2,100.00), signed by the artist three times, "Jules Pincas," ACB Corr., BFA.

9 Albert C. Barnes, *The Art in Painting*, 1st ed. (Merion, Pa.: Barnes Foundation Press, 1925), 343–45. In his review of the book, Alfred H. Barr, Jr., wrote, "Mr. Barnes is right in seeing Pascin [as] a great and very moving draftsman." *Saturday Review of Literature*, July 24, 1926, 948.

10 Albert C. Barnes and Violette de Mazia, *The Art of Cézanne* (New York: Harcourt, Brace and Company, 1939), 134–35.

11 Barnes, *The Art in Painting*, 3rd ed. (1937), 375–76. Pascin's drawing and emphasis on planes, notably in his nude figures, owes a debt to Picasso's nudes of the summer–autumn of 1906, painted less than a year after Pascin arrived in Paris. See, for example, Picasso's *Woman with a Comb*, Walter-Guillaume Collection, Musée de l'Orangerie, Paris, and *Two Nudes*, Cone Collection, Baltimore Museum of Art.

12 See Emile Cartailhac and Henri Breuil, *La caverne d'Altamira à Santillane près de Santander* (Monaco: 1906), and L. Capitan, Henri Breuil, and D. Peyrony, *La caverne de Font-de-Gaume aux Eyzies* (Monaco: A. Chêne, 1910). Breuil discoverered Font-de-Gaume in 1901. He and others had already published illustrated works on prehistoric cave paintings as early as that year. See Jack Flam, *Matisse: The Man and His Art, 1869–1918* (Ithaca and London: Cornell University Press, 1986), 489 n. 23.

13 Barnes, *The Art in Painting*, 1st ed., 344.

14 Letter, Pascin to Barnes, undated [1923], ACB Corr., BFA. Barnes had possibly already met and made purchases from Lipchitz in 1922. Nevertheless, on June 22, 1930, he wrote to a member of the Pascin Memorial Committee, "Pascin was a very good friend to Lipchitz and was the first person to introduce me to him" (original in French). Letter, Barnes to Kurt Mettler, June 22, 1930, ACB Corr., BFA.

15 Letter, Pascin to Paul Guillaume, April (?) 1926, undated [1926] handwritten English translation by Violette de Mazia, Third Party Correspondence, ACB Corr., BFA (uncatalogued). The original letter, possibly solicited by Guillaume, is written in French. Barnes had purchased paintings from Druet as early as 1912 (for example, van Gogh's *The Postman (Joseph-Etienne Roulin)* [BF37] and *The Smoker* [*Le Fumeur*, BF119], and Cézanne's *La Toilette* [BF12]). He made photographs of works of art sold by his gallery as well as those sold through his colleagues, and

papered with these photographs. The artists had portfolios full of them. One often deprived one's self of necessities in order to acquire some of these photographs of one's favorite master. This allowed a thorough study in the calm atmosphere of the studio. The photograph, deprived of color, accentuates more the painter's mannerisms. We can say that Druet was more of a cubist than Cézanne. Some small compositions of nudes, in the master's oldest manner whose drawing is certainly inferior to the color in the sense that one can still separate the drawing from the color—which is impossible in the later works of Cézanne—gave strange result[s]. Many a painter who could have easily carried off a first prize in the most academic schools were working their fingers off to put into their pictures the small women with billiard ball heads and with the line up the middle of their back drawn up to the nape of the neck, which were seen in Cézanne through Druet. These photos had become indispensable in many studios. Just as in certain houses where the girl, whose charms leave her customer indifferent, gives him her photograph album to entice him, the artist had recourse to father Druet's photographs to revive his inspiration before approaching his canvas. . . . Thanks to Mr. Barnes, the American artists will no longer be limited to the study of the reproductions of the great masters, but they will be able to study the originals as one can, in Europe, under the best conditions. I do not mean by this that the destiny of American Art will be an imitation of European art, but I think that, to-day, it is indispensable for an artist to know all that has been produced in Art, to absorb that which can help in the crystallization of his personality, to reject that which can harm him, because it is necessary to have known all in order to be able to forget all. And now, my wishes for a very good journey and my regards to Mrs. & Mr. Barnes and the officers of the Foundation.[15]

Not merely an exercise in flattery, this letter attests to Pascin's intellectual range and the fact that he had a sympathetic grasp of what Barnes was trying to accomplish.

During these years Barnes saw Pascin in Paris, in 1925 taking John Dewey to visit the artist's studio.[16]

Pascin led a peripatetic existence outside conventional cultural norms and was indifferent to domestic comforts. Like Edgar Degas and Henri de Toulouse-Lautrec, he found a ready source of models for his drawings and paintings in bordellos among prostitutes and their milieu. His early illustrative work was somewhat cynical but, atypically for the time, stopped short of caustic moral or political commentary. He frequently portrayed and was at ease among people of color and spent a great deal of his working life in warm climes, ranging throughout the American South, Georgia, Florida, South Carolina, Louisiana, and Texas. He also made two trips to Cuba. Cosmopolitan in every respect, Pascin was a prodigious worker and had a notable capacity for making friends. At the end of 1921 he returned to Paris and resumed his nomadic and somewhat dissolute life. In this period he visited Tunisia, Algeria, Egypt, Spain, Portugal, and Italy. During his last decade, although he exhibited regularly in New York, he returned to the United States only once, residing in Brooklyn Heights for a year in 1927–28.[17]

In the early fall of 1927, Pascin wrote Barnes, accepting an invitation to visit the Foundation: "Your letter was for me one of the biggest pleasures I had since I left France and I would be very delighted to visit you. . . . I am very anxious to do some more paintings, as I had no recent ones to bring to this country. . . . [I] would very much like . . . to come round the end of November for 2 days to Merion."[18] The visit was arranged for November 22. Two years later, in fragile health, the artist killed himself in his Paris studio on June 2, 1930.

Following Pascin's suicide, Barnes accepted the position of honorary president of the Pascin Memorial Committee and donated 25,000 francs (approximately $2,000.00) toward the erection of a commemorative monument in the Cimetière du Montparnasse, urging the committee to commission a stone sculpture by Jacques Lipchitz for this purpose. Quarreling between Pascin's widow, Hermine David, and his mistress, Lucy Krogh, eventually obliged Lipchitz to resign. Barnes wrote a sympathetic letter to the sculptor on March 20, 1931: "No person with any self-respect would work under

In these new departures from his single-figure studies, he integrated ideas borrowed from Cubism and African sculpture. As observed by Barnes, in these canvases, Pascin forged a unique amalgam of "interpenetrating color-planes at all angles. It is used also to indicate movement of voluminal masses in deep space. The second influence of cubism . . . consists in the block-like character of houses and other objects depicted into their constituent planes."[13] These planes, in combination with Pascin's original deployment of the brown tonalities, heightened by brighter hues, also reflect the artist's keen awareness of tradition—namely the figures in motion of Tintoretto and El Greco, in which volumes also emerge and are suffused in dark, but colorful, atmospheric backgrounds—as well as Rubens's swirling compositions. Such compositions as *Cuban Hospitality* (BF344) of 1915, for which several preparatory drawings were made, exemplify Pascin's creative fusion of contemporary and Old Master sources.

In an undated letter from 1923, Pascin, by then an American citizen but residing in Paris, wrote Barnes,

> I have seen the plans for the foundation. I think it will be a great thing for modern art and the artists represented in it can be mighty glad. . . . The great talk at the coffee-houses in Montparnasse right now are the picture sales [purchases] you made. Some way people found out. I know you and as I went yesterday down there I have already be[en] bothered by people who wanted to know your name and address. Some to whom I never talked about you may even, I have no doubt, pretend to come recommended by me. If somebody proposes you some bad stuff you may be sure I didn't tell him to do it. Still one artist I would like to bring to your attention, especially as he didn't ask me ever any service, is the sculptor [Jacques] Lipchitz, who is very appreciated in Paris by some of the foremost connoisseurs and artists but little known yet in America, where, thanks to [John] Quinn and the Washington-Square crowd [Constantin] Brancusi and even [Jacob] Epstein are considered the great sculptors. Lipchitz, who is one of the most serious artists I know is I believe very much [more] important than these men.[14]

Pascin's position as a cultural go-between and his analytic mind made him extraordinarily astute with respect to developments in Modern art. A letter written to Paul Guillaume before the Parisian dealer's April 1926 trip to Merion demonstrates Pascin's sophisticated understanding of the conditions under which Modern painters worked and what they were striving for, and it is worth quoting at some length:

> As for the [my] views on the Barnes Foundation here they are: Some cubists, orphists, futurists and synchromists, who had never seen a Cézanne nor even heard the name of [Georges] Seurat, were swarming in America, just a few years ago. Pictures were seen, whose design, composition and make-up were obviously inspired from Cézanne, but whose colors were those of the [Robert] Henri school— (Henri has "trained" many of the most famous American contemporary painters)—or of some other fashionable professor. Many artists, at that time, had never seen an original picture of Cézanne. This master's pictures which had crossed the Atlantic were in private collections, not easily accessible and the painters knew only the reproductions of them. One has never stressed the enormous influence of reproductions on the evolution of modern art. I often wondered, years ago, how it happened that Cézanne's influence on modern painting was so great, while Renoir,—I am thinking of pre-war times—so much more human, more complete and certainly the greater of the two, was not followed at all. I am convinced that this is due to the fact that the Renoirs do not photograph well, while the Cézannes—especially in those photographs of such beautiful tone & done so artistically by [Eugène] Druet—are reproduced wonderfully well, although they entirely betray the original. And, in general, the artists who have been imitated the most are those whose pictures are the most favorably reproduced. One can easily understand this by measuring those of the young painters who have had followers. We can say that Druet's influence on Modern art has often been greater than that of the painters whose work he reproduced. The studios, at that time, were

## *Two Nudes—One Standing, One Sitting*
Alternate titles: *Nudes (Nus); Deux nus*

1913. Oil on canvas, 21⅝ × 18¼ in. (54.9 × 46.4 cm). Signed and dated lower right: pascin / 1913. BF439

PROVENANCE: Acquired from the artist in 1921. No. B12, *Deux nus*, on Durand-Ruel consular invoice dated July 21, 1921.

REFERENCES: G. Charensol, *Jules Pascin* (Paris: Le Triangle, 1928), no. 2 (as *Nus*), ill.; *Pascin, Catalogue Raisonné*, 1:66, no. 86, ill., 66 (as oil on cardboard); R. J. Wattenmaker, "Dr.

Albert C. Barnes and the Barnes Foundation," in *Great French Paintings from the Barnes Foundation* (New York: Knopf in association with Lincoln University Press, 1993), 18, fig. 6 (color), 20.

REMARKS: Durand-Ruel label: B9; lined with wax and fiberglass.

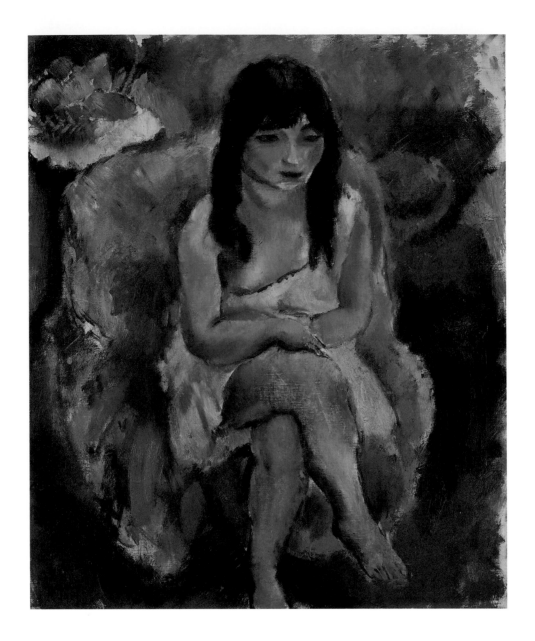

## Seated Figure (Jeune fille assise)

Alternate titles: *Seated Figure with Still-Life;*
*Woman in Dishabille*

1914. Oil on canvas, 25⅝ × 21⅜ in. (65.1 × 54.3 cm).
Signed and dated lower left: pascin / 1914. BF229

PROVENANCE: Acquired from the artist in 1921. No. B9, *Jeune fille et nature morte*, on Durand-Ruel consular invoice dated July 21, 1921.

REFERENCES: Forbes Watson, "The Barnes Foundation—Part I," *Arts*, January 1923, ill. 28; Albert C. Barnes, *The Art in Painting*, 511 (as *Nude*); Albert C. Barnes, *The Art in Painting*, 3rd ed. (New York: Harcourt, Brace, 1937), 478, ill. 473; Albert C. Barnes and Violette de Mazia, *The Art of Cézanne* (New York: Harcourt, Brace, 1939), 135–36: "Pascin's *Seated Figure* illustrates his use of derivations from Cézanne, combined with other traditional features, before the advent of cubism. The unit of still-life at the upper left reveals the influence of Cézanne's technique, drawing, color-form and general feeling, but the picture as a whole is so tempered with delicacy, lightness and a tendency to swirling movement that it is as reminiscent of Renoir as it is of Cézanne"; *Pascin, Catalogue Raisonné*, 2:342, ill. 92.

REMARKS: Durand-Ruel label: B7; unlined.

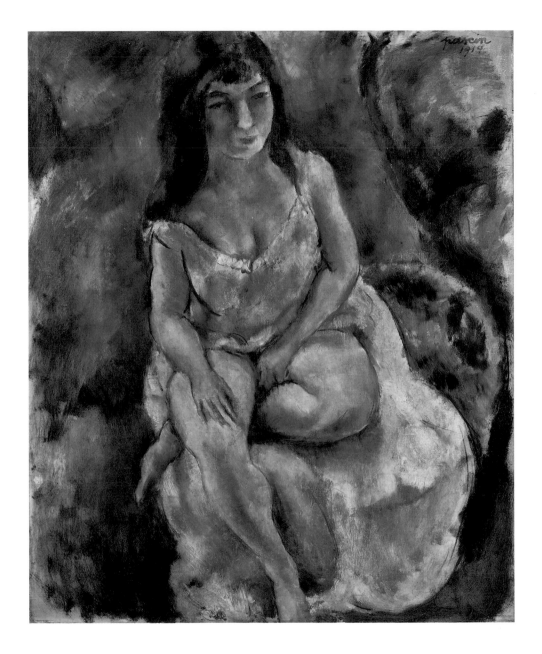

## Seated Girl in Chemise
## (*Jeune fille assise en chemise*)

Alternate title: *Semi-Nude Seated*

1914. Oil on canvas, 28¾ × 23⅝ in. (73 × 60 cm). Signed and
dated upper right: pascin / 1914. BF483

PROVENANCE: Acquired from the artist in 1921. Probably
no. B6, *Jeune fille assise*, on Durand-Ruel consular invoice
dated July 21, 1921.

REFERENCE: *Pascin, Catalogue Raisonné*, 2:187, no. 363, ill.
113.

REMARKS: Durand-Ruel label: B4; lined in 1960.

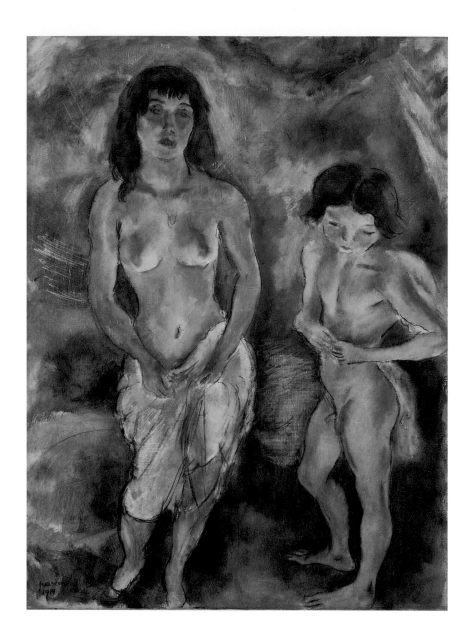

## *Two Standing Nudes (Deux nus debout)*
Alternate titles: *Venus and Cupid (Vénus et l'amour)*;
*Two Nude Figures*
1914. Oil on canvas, 31⅞ × 23½ in. (81 × 59.7 cm). Signed and
dated lower left: pascin / 1914. BF276

PROVENANCE: Acquired from the artist in 1921. No. B8, *Venus
et l'amour*, on Durand-Ruel consular invoice dated July 21,
1921.

REFERENCES: Yvan Goll, *Pascin* (Paris: G. Crès, 1929); Vio-
lette de Mazia, "*E Pluribus Unum*—Cont'd," BFJAD 7, no. 2
(Autumn 1976): 29n, pl. 52; *Pascin, Catalogue Raisonné*, 2:187,
no. 337, ill. 91.

REMARKS: Durand-Ruel label: B3; unlined.

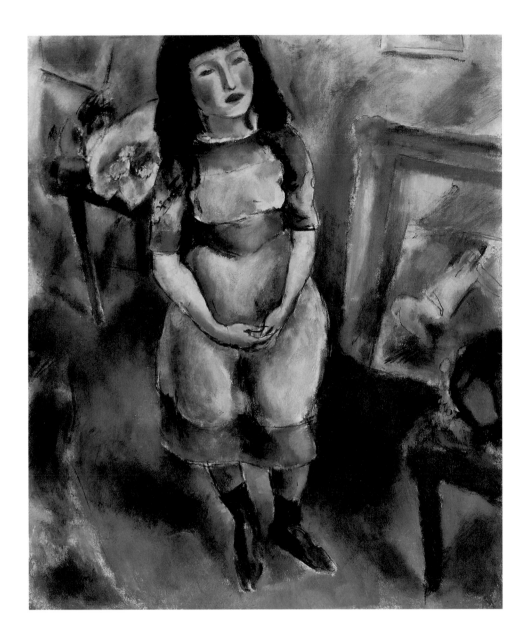

## *Standing Girl in Blue Dress*

Alternate titles: *Girl Standing; Portrait de jeune fille*
1914. Oil on canvas, 28¾ × 23¾ in. (73 × 60.3 cm). Signed and
dated lower left: pascin / 1914. BF943

PROVENANCE: Acquired from the artist in 1921. Probably
no. B7, *Portrait de jeune fille*, on Durand-Ruel consular in-
voice dated July 21, 1921.

REFERENCE: Horace Brodzky, *Pascin* (London: Nicholson
and Watson, 1946), 24, ill.

REMARKS: Durand-Ruel label: B6; lined.

## Standing Nude in the Studio
## (*Nu debout à l'atelier*)

Alternate title: *Nude*

1914. Oil on canvas, 24¼ × 19⅞ in. (61.6 × 50.5 cm).
Signed and dated lower right: pascin / 1914. BF182

PROVENANCE: Acquired from the artist in 1921. Probably
no. B11, *Nu debout*, on Durand-Ruel consular invoice dated
July 21, 1921.

EXHIBITION: Pennsylvania Academy of the Fine Arts, Phila-
delphia, Exhibition of Contemporary European Paintings
and Sculpture, April 11–May 9, 1923, cat. no. 58 (see installa-
tion photograph no. 2, Archives of the Pennsylvania Acad-
emy of the Fine Arts).

REFERENCES: *Exhibition of Contemporary European Paint-
ings and Sculpture*, exh. cat. (Philadelphia: Pennsylvania Acad-
emy of the Fine Arts, 1923), cat. no. 58 (as *Nude*); Albert C.
Barnes, *The Art in Painting*, 512 (as *Nude*); G. Charensol,
*Jules Pascin* (Paris: Le Triangle, 1928), no. 3, ill. (as *Nu*, 1914,
Barnes Foundation); Albert C. Barnes, *The Art in Painting*,
2nd ed. (New York: Harcourt, Brace, 1928), 539; Albert C.
Barnes, *The Art in Painting*, 3rd ed. (New York: Harcourt,
Brace, 1937), 478; *Pascin, Catalogue Raisonné*, 4:101, no. 265,
ill. 82.

REMARKS: Durand-Ruel label: B8; unlined.

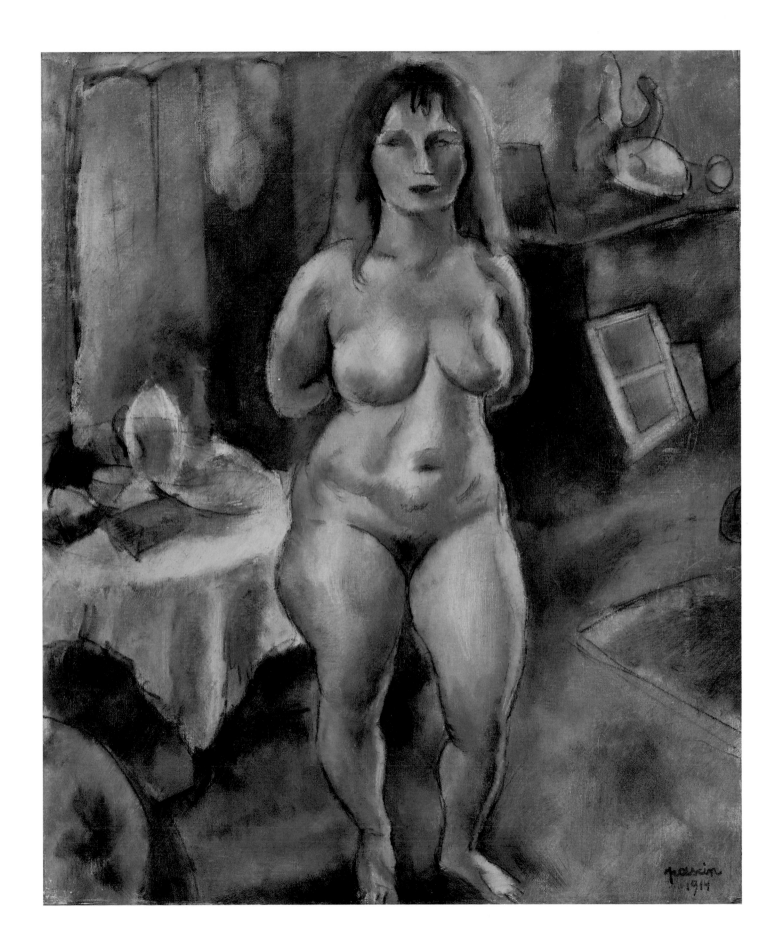

## Cuban Hospitality

Alternate titles: *Creole Hospitality (Hospitalité créole);*
*Return of the Prodigal Son; Picnic*

1915. Oil on canvas, 40 × 35 in. (101.6 × 88.9 cm). Signed and
dated lower left: pascin / 1915. BF344

PROVENANCE: Acquired from the artist in 1921. No. B14,
*Hospitalité Créole*, on Durand-Ruel consular invoice dated
July 21, 1921.

EXHIBITION: Paris, Société des Artistes Indépendants, 1921,
no. 2644 (Pascin classified as American).

REFERENCES: Société des Artistes Indépendants, *Catalogue
de la 32me Exposition*, 1921, 124, no. 2644; G. Charensol, *Jules
Pascin* (Paris: Le Triangle, 1928), no. 4, (as *Hospitalité créole*),
ill.; Gaston Diehl, *Pascin* (New York: Crown, 1968), 70 (noting
Barnes's purchase); *Pascin, Catalogue Raisonné*, 2:187, no. 377,
ill. 115.

RELATED WORKS: *La Fin du déjeuner ou le retardataire*,
1915, watercolor and pen and ink on paper, 8¹¹⁄₁₆ × 13 in. (22 ×
33 cm), signed: Pascin and atelier stamp (inscribed and incor-
rectly dated 1919 in another hand [Lucy Krogh]) (fig. 73), cited
in *Pascin, Catalogue Raisonné*, 1:188, no. 390, ill. 188; *Cuban
Hospitality*, 1915, pen and ink on paper, 15¼ × 13⅜ in. (38 ×
34 cm) (fig. 74), cited in *Pascin, Catalogue Raisonné*, 2:187,
no. 370, ill. 114 (identified as study for *Cuban Hospitality*
[BF344]), and in *International and Israeli Art*, auction cat.
(Tel Aviv: Sotheby's Sale, TA 0029, April 23, 2003), 17, cat.
no. 18, ill. (color), 8⅝ × 13 in. (22 × 33 cm), dimensions given
for image, rather than full sheet.

REMARKS: Durand-Ruel label: B1; unlined.

FIG. 73

Jules Pascin, *La Fin du déjeuner
ou le retardataire*, 1915, water-
color and pen and ink on paper,
8¹¹⁄₁₆ × 13 in. (22 × 33 cm),
Private Collection

FIG. 74

Jules Pascin, *Cuban Hospitality*,
1915, pen and ink on paper,
15¼ × 13⅝ in. (38 × 34 cm),
Private Collection

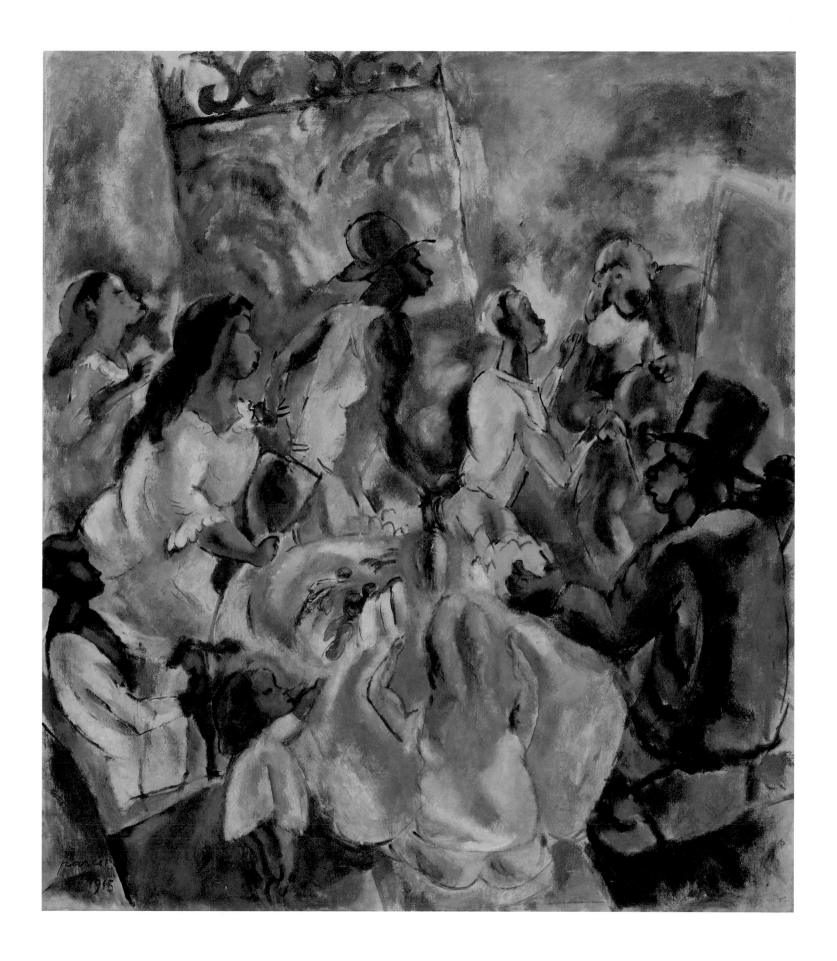

## Landscape with Figures and Carriage

Alternate title: *Southern Scene*

1915. Oil on canvas, 20 × 26⅛ in. (50.8 × 66.4 cm). Signed and dated lower right: pascin / 1915. BF198

PROVENANCE: Acquired from the artist in 1921. Either no. B2, *Rue à Tampa;* no. B3, *Paysage, Floride;* or no. B4, *Rue à Nouvelle-Orléans* on Durand-Ruel consular invoice dated July 21, 1921.

REFERENCES: Mary Mullen, *An Approach to Art* (Merion, Pa.: Barnes Foundation Press, 1923), 66, ill. (as *Landscape*); Albert C. Barnes, *The Art in Painting*, ill. 353 (as *Landscape*); Albert C. Barnes, *The Art in Painting*, 2nd ed. (New York: Harcourt, Brace, 1928), ill. 365 (as *Landscape*); Violette de Mazia, "Subject and Subject Matter," *Vistas* 2, no. 1 (Spring–Summer 1980): 40, pl. 99; *Pascin, Catalogue Raisonné*, 2:187, no. 388, ill. (n.p.).

RELATED WORKS: *Downtown (Street Scene)*, c. 1915, graphite on paper, 6½ × 8 in. (16.1 × 20 cm) (fig. 75); *By the Church*, c. 1915, graphite on paper, 8⅜ × 6¾ in. (21 × 16.8 cm) (fig. 76); and *After School (Home from School)*, c. 1915, graphite on paper, 6⅞ × 8⅜ in. (17.2 × 21 cm) (fig. 77). All three drawings from what is known as Pascin's "Caribbean Sketchbook," an assemblage of drawings compiled by the artist, in the McNay Art Museum, San Antonio. *Landscape with Figures and Carriage* is a composite of these three drawings: the striding woman at left, the mother and child at right, the standing figure seen from the back, and the seated child from *By the Church*; the tree at left, horse and carriage left-center, linear indications of the sky, and the small group of houses to the right with seated man at the extreme right of *Downtown (Street Scene)*; and the series of peaked shanty gables and two seated figures from *After School (Home from School)*. This process of careful selection provides a rare insight into Pascin's approach to composition.[1]

REMARKS: Durand-Ruel label: B12; lined. A collection of drawings done c. 1914–20, when Pascin traveled extensively in the American South, was assembled by the artist into two scrapbooks, of which the McNay compilation is one. The drawings are not dated, but since *Landscape with Figures and Carriage* is dated 1915, they were most likely done at the end of 1914 or 1915, some in Florida. Pascin arrived in the United States in October 1914 and traveled to Florida and Cuba before the end of the year.[2]

FIG. 75

Jules Pascin, *Downtown (Street Scene)* from "Caribbean Sketchbook," c. 1915, graphite on paper, 6½ × 8 in. (16.1 × 20 cm), McNay Art Museum, San Antonio, Bequest of Marion Koogler, 1950.525

FIG. 76

Jules Pascin, *By the Church* from "Caribbean Sketchbook," c. 1915, graphite on paper, 8⅜ × 6¾ in. (21 × 16.8 cm), Collection of the McNay Art Museum, San Antonio, Bequest of Marion Koogler, 1950.573

FIG. 77

Jules Pascin, *After School (Home from School)* from "Caribbean Sketchbook," c. 1915, graphite on paper, 6⅞ × 8⅜ in. (17.2 × 21 cm), Collection of the McNay Art Museum, San Antonio, Bequest of Marion Koogler, 1950.546

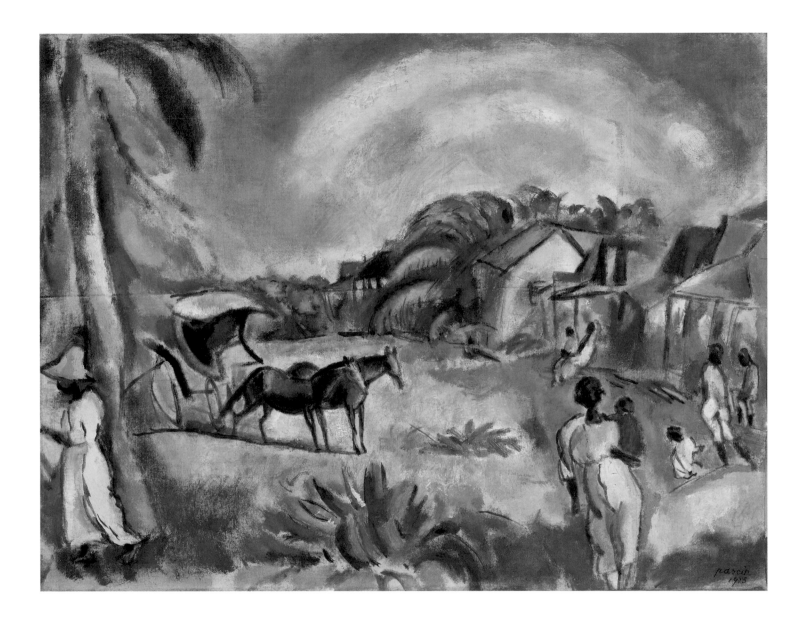

Following the artist's death in 1930, Pascin's American dealer, Edith Halpert, offered at least one of these scrapbooks to Barnes, to whom she wrote: "The high water mark . . . is a scrap book in which Pascin pasted small sketches in pencil, ink, and water color. These sketches were made during his trip through the south, in Havana and Tunis. They represent the handwriting of this great draftsman, and although the works are not 'important' in the American collectors' sense of the word, I am reasonably certain you will appreciate their amazine [*sic*] quality. The book contains 166 such drawings."[3] Barnes declined. John Palmer Leeper notes that "One [scrapbook] containing 116 drawings was purchased by Mrs. John D. Rockefeller, Jr. and subsequently given to the Museum of Modern Art, New York."[4]

1 See John Palmer Leeper, *Jules Pascin's Caribbean Sketchbook* (Austin: University of Texas Press, 1964), 39, *Downtown (Street Scene)*; 43, *After School (Home from School)*; and 82, *By the Church*.

2 See undated letter [late 1914] from Jules Pascin to Martin Birnbaum from Miami, stating that he had been to Havana, providing biographical information to the dealer for his forthcoming exhibition in January 1915. Martin Birnbaum Papers, Archives of American Art, Smithsonian Institution, Washington, D.C.

3 Letter, Edith Halpert to Albert C. Barnes, May 16, 1931, Edith Gregor Halpert Papers, Archives of American Art, Smithsonian Institution, Washington, D.C.

4 Leeper, *Jules Pascin's Caribbean Sketchbook*, 13.

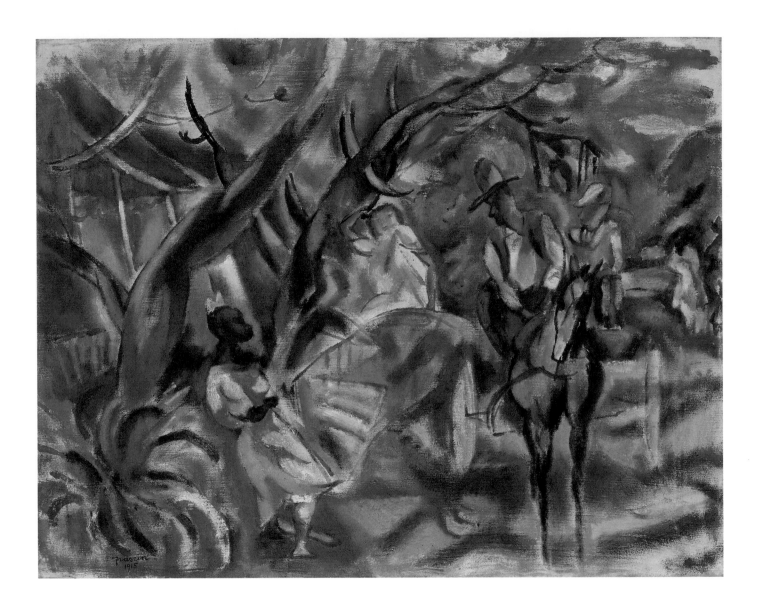

## Southern Scene

Alternate title: *Southern Scene with Man Drawing Carriage*
1915. Oil on canvas, 20¼ × 25¾ in. (51.4 × 65.4 cm).
Signed and dated lower left: pascin / 1915. BF194

PROVENANCE: Acquired from the artist in 1921. Either
no. B2, *Rue à Tampa;* no. B3, *Paysage, Floride;* or no. B4, *Rue
à Nouvelle-Orléans*, on Durand-Ruel consular invoice dated
July 21, 1921.

REFERENCES: Albert C. Barnes and Violette de Mazia, *The
Art of Cézanne* (New York: Harcourt, Brace, 1939), 136: "In his
later *Southern Scene*, Pascin shows an effective adaptation of
cubistic practices: the framework is an accentuated Cézan-
nesque all-over pattern of angles, rectangles, triangles and
other geometrical shapes, with infinitely more varied and
plastically active color than that in actual cubistic painting.
The components of the all-embracing pattern of shapes func-
tion as a series of color-planes which draw and model fig-
ures, houses and trees, locate the masses in clean-cut space,
produce a sense of very active movement, and contribute
enormously to the expressive and decorative values of the
composition"; *Pascin, Catalogue Raisonné*, 2:188, no. 390,
ill. 117.

REMARKS: Durand-Ruel label: B13; unlined.

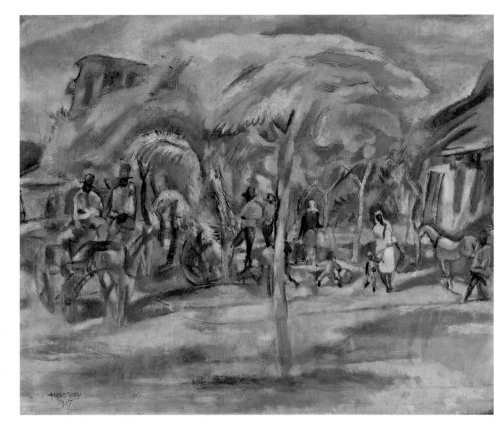

## Southern Landscape

1917. Oil on canvas, 22 × 26 in. (55.9 × 66 cm). Signed and dated lower left: pascin 1917. BF249

PROVENANCE: Acquired from the artist in 1921. Either no. B2, *Rue à Tampa*; no. B3, *Paysage, Floride;* or no. B4, *Rue à Nouvelle-Orléans*, on Durand-Ruel consular invoice dated July 21, 1921.

REMARKS: Durand-Ruel label: B14; unlined.

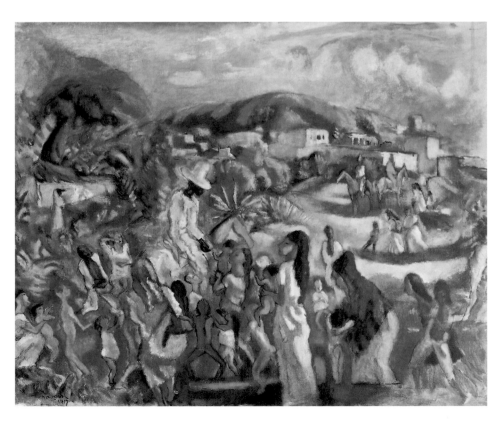

## Landscape

Alternate titles: *Mountain Scene with Figures; Cuban Scene*
1917. Oil on canvas, 32⅛ × 40 in. (81.6 × 101.6 cm). Signed and dated lower left: pascin / 1917. BF413

PROVENANCE: Acquired from the artist in 1921. Probably no. B15, *Paysage avec figures*, on Durand-Ruel consular invoice dated July 21, 1921.

REFERENCE: Horace Brodzky, *Pascin* (London: Nicholson and Watson, 1946), pl. 23 (as *Cuban Scene*).

REMARKS: Durand-Ruel label: B2; unlined.

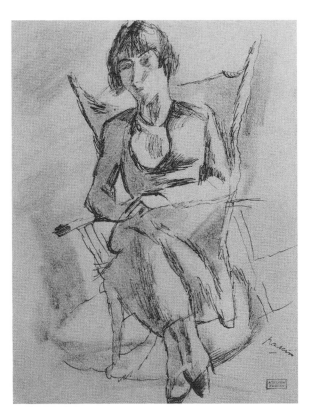

FIG. 78

Jules Pascin, *La Jeune fille au fauteuil*, 1917, pen and ink with charcoal on paper, 10⅛ × 7¾ in. (25.5 × 19.5 cm), Private Collection

## *Girl in Green Reading*

Alternate titles: *Hermine; Woman Reading (Greens); Femme devant la fenêtre*

1917. Oil on canvas, 35⅛ × 27¼ in. (89.2 × 69.2 cm). Signed and dated lower left: pascin / 1917. BF348

PROVENANCE: Acquired from the artist in 1921. No. B1, *Femme devant la fenêtre*, on Durand-Ruel consular invoice dated July 21, 1921.

REFERENCE: Marilyn Bauman, "Informed Perception: A Personal View," *Vistas* 2, no. 2 (1981–83): 101, pl. 23 (as *Hermine*).

RELATED WORK: *La Jeune fille au fauteuil*, 1917, pen and ink with charcoal on paper, 10⅛ × 7¾ in. (25.5 × 19.5 cm) (fig. 78), cited in *Tableaux Modernes: Exceptionnel ensemble de 50 aquarelles et dessins de PASCIN*, auction cat. (Enghien-les-Bains, France, Hôtel des ventes, sale June 21, 1987), 3, no. 3, ill.

REMARKS: Durand-Ruel label: B11; lined. The sitter is French artist Hermine-Lionette Carthan-David (1886–1970), to whom Pascin was married in New York on September 18, 1918. The two had known each other since 1905. Pascin referred to Hermine as "Hermionette."[1]

1  See Mad Benoit, *Hermine David (1886–1970): Peintre-graveur de l'Ecole de Paris* (Paris: Editions Jean-Paul Villain, 2006).

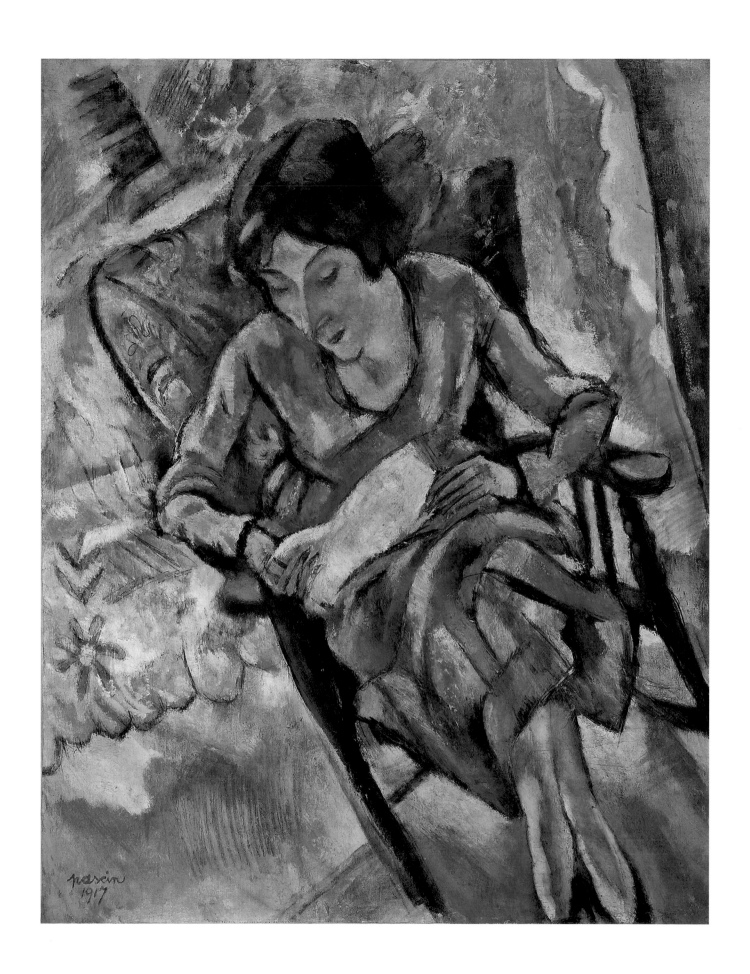

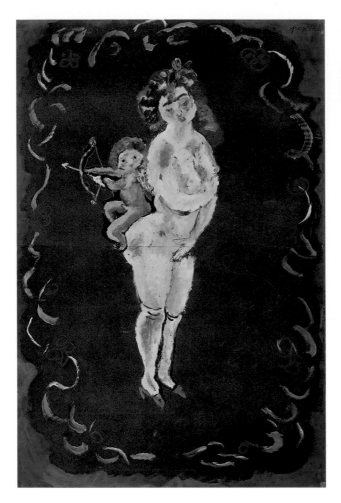

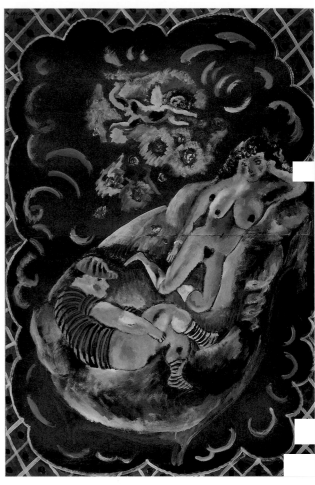

## Nude and Cupid

c. 1920. Oil with graphite on two sheets of gray paper
mounted to canvas, 37⅝ × 25⅛ in. (95.6 × 63.8 cm).
Signed upper right: pascin. BF 473

PROVENANCE: Unknown.

REMARKS: *Nude and Cupid* is a pendant to *Two Figures and
Cupid* (BF 476).

## Two Figures and Cupid

c. 1920. Oil on two sheets of gray paper mounted to canvas,
37¾ × 25⅛ in. (95.9 × 63.8 cm). Signed upper left: pascin.
BF 476

PROVENANCE: Unknown.

REMARKS: *Two Figures and Cupid* is a pendant to *Nude and
Cupid* (BF 473).

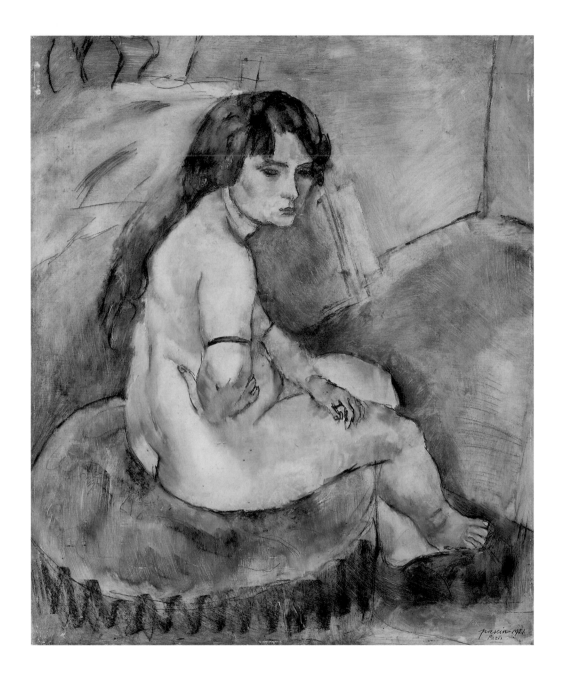

### Nude Seated on Hassock
### (Nu assis sur un pouf)

1921. Oil with graphite and charcoal on fiberboard (later mounted to plywood panel), 25⅝ × 21¼ in. (65.1 × 54 cm). Signed, dated, and inscribed lower right: *pascin 1921 / Paris.* BF385

PROVENANCE: Possibly acquired from the artist in 1921. Possibly no. B5 (no label), *Jeune fille au repos,* on Durand-Ruel consular invoice dated July 21, 1921.

REFERENCE: *Pascin, Catalogue Raisonné,* 2:348, no. 713, ill. 207.

## Les Tunisiennes

Alternate titles: *Two Girls (Tunis); Girls of Tunis*
1921. Oil on canvas, 25¾ × 19⅞ in. (65.4 × 50.5 cm). Signed, dated, and inscribed lower left: *pascin / salammbô 1921.*
BF2043

PROVENANCE: Probably purchased from the artist in 1922 or early 1923.[1]

EXHIBITION: Pennsylvania Academy of the Fine Arts, Contemporary European Paintings and Sculpture, April 11–May 9, 1923, cat. no. 67 (as "Algerians" [*sic*]). See page 203, fig. 72.

REFERENCE: Horace Brodzky, *Pascin* (London: Nicholson and Watson, 1946), 22, ill.

RELATED WORKS: See *Woman and Two Children* (BF731), in which the woman in the center appears to be the same model. See also Florence Gilliam, "Jules Pascin," *The Menorah Journal* XI, no. 3 (June 1925), and Pascin's *Tunisian Jewesses*, watercolor and ink (no dimensions given), reproduced in "Six Sketches by Jules Pascin," *The Menorah Journal* XI, no. 3 (June 1925), in which the seated figure at left is the same model as the seated figure at right in *Les Tunisiennes* (not in the *Catalogue Raisonné*). In *Pascin, Catalogue Raisonné*, 2:234, no. 821, *Les dames de Tunis*, oil on canvas, 10 × 6½ in. (25.4 × 16.5 cm) (ex–Perls Galleries, New York), ill., is incorrectly assigned a date of 1924. The seated woman at left appears to be the same model as the standing figure in *Les Tunisiennes*. (See also *Pascin, Catalogue Raisonné*, 1:260–61, nos. 472, 473, and 475, all assigned a date of 1924.) Since Pascin visited Tunisia in 1908 (together with Hermine), 1921, 1924, and 1926, there is some confusion as to the date of *Les Tunisiennes*. On the back of a black-and-white photograph of the painting in the archives of the Barnes Foundation, in Barnes's hand, is written "*Tunisians*—painted in the fall of 1922."[2] In *Pascin, Catalogue Raisonné*, 1:238, no. 415, an unrelated subject is entitled *A Salammbô*, oil on canvas, 28¾ × 23⅝ in. (73 × 60 cm) (inscribed "*Tunisie* 1921," not visible in illustration). Salammbô is on the outskirts of Carthage. Since *Les Tunisiennes* was exhibited at the Pennsylvania Academy of the Fine Arts in April 1923, it cannot have been painted in 1924.

REMARKS: The works done in Salammbô would appear to have no connection with Gustave Flaubert's novel *Salammbô*, published in 1862, whose exotic and erotic themes would have appealed to Pascin.

1  Arthur Lénars & Cie. customs declaration list, March 2, 1923, no. 134, *Les Tunisiennes* (valued at 2,000 francs; cadre valued at 100 francs), ACB Corr., BFA.

2  Jules Pascin, *Les Tunisiennes* (BF2043), photograph mid-1920s, Photograph Collection, BFA.

## Nude Seated on Chair

Alternate title: *Nude (Nu)*

1922. Oil with black crayon and charcoal on fiberboard
(later mounted to plywood panel), 25¾ × 21⅜ in. (65.4 ×
54.3 cm). Signed and dated at upper right: pascin / 1922.
BF403

PROVENANCE: Possibly no. 135, *Nu*, on invoice from Arthur
Lénars & Cie. dated March 7, 1923.[1]

REFERENCE: G. Charensol, *Jules Pascin* (Paris: Le Triangle,
1928), no. 9, ill. (as *Nu*).

1  Arthur Lénars & Cie. invoice, March 7, 1923, ACB Corr., BFA.

## *Girl in Blue Dress on Sofa, Reading (Jeune fille à la robe bleue lisant sur un divan)*

c. 1922. Oil on fiberboard (later mounted to plywood panel), 25⅝ × 21¾ in. (65.1 × 55.2 cm). Signed upper left: pascin. BF186

PROVENANCE: Probably acquired from the artist c. 1925.

REFERENCES: Horace Brodzky, *Pascin* (London: Nicholson and Watson, 1946), ill. 36; *Pascin, Catalogue Raisonné*, 2:355, no. 956, ill.

## *Two Men in the Park, Havana*

c. 1914–17. Graphite on wove paper, 7⅝ × 9⅝ in. (19.4 × 24.4 cm). Signed lower right: pascin. BF749

PROVENANCE: Unknown.

## Figure Group, Man with Green Plaid Trousers

Alternate title: *Landscape with Figures, Havana*

1915. Watercolor, pen and ink, and crayon on thin paper, 7⅛ × 6⅞ in. (18.1 × 17.5 cm). Signed, dated, and inscribed lower right: *pascin / Havana 1915.* BF608

PROVENANCE: Unknown.

## Siesta

1915. Pen and ink with watercolor on wove paper, 7⅞ × 12 in. (20 × 30.5 cm). Signed and dated lower right: pascin / 1915. Inscribed lower right: *Siesta.* BF617

PROVENANCE: Unknown.

## Three Women and Two Children, Havana

c. 1915. Pen and ink and watercolor on wove paper, 10⅛ × 8⅜ in. (25.7 × 21.3 cm). Signed and inscribed lower right: *pascin / Havana.* BF778

PROVENANCE: Unknown.

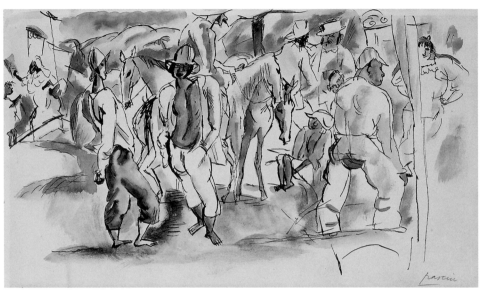

## Two Young Girls

c. 1915. Watercolor, black crayon, graphite, and pen and ink on wove paper, 5 × 4¾ in. (12.7 × 12.1 cm). Signed lower right: pascin. BF610

PROVENANCE: Unknown.

## Figures and Horses

c. 1915. Watercolor and pen and ink on wove paper, 7⁹⁄₁₆ × 12⅞ in. (19.2 × 32.7 cm). Signed lower right: pascin. BF766

PROVENANCE: Unknown.

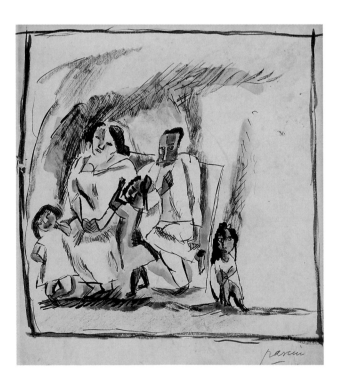

## Father, Mother, and Three Children

c. 1915. Pen and ink, ink washes, watercolor with bodycolor, and yellow crayon on wove paper, 6½ × 5¾ in. (16.5 × 14.6 cm). Signed lower right: pascin. BF697

PROVENANCE: Unknown.

REFERENCE: Violette de Mazia, "The Barnes Foundation: The Display of Its Art Collection," *Vistas* 2, no. 2 (1981–83): 109n, pl. 118 (installation).

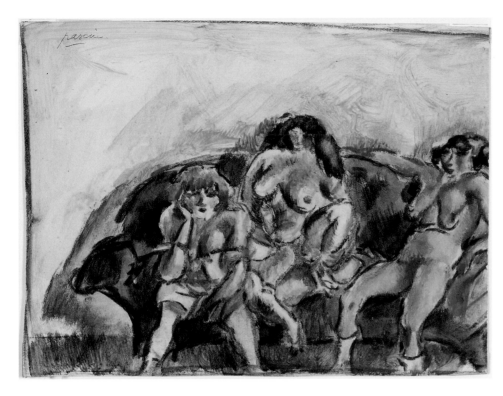

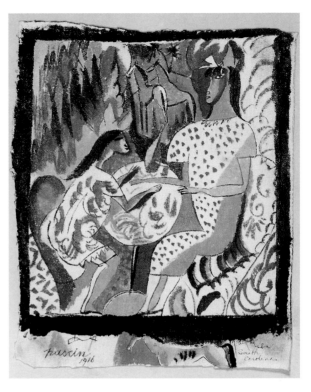

## Three Women on Red Sofa

c. 1915. Water-based paint, charcoal, and graphite on wove paper, 6½ × 8½ in. (16.5 × 21.6 cm). Signed upper right: pascin. BF724

PROVENANCE: Unknown.

RELATED WORK: *The Indecisive Client*, c. 1916, oil on canvas, 18 × 20 in. (45.7 × 50.8 cm), ex–Margit Chanin, Ltd., New York, cited in Tom L. Freudenheim, *Pascin*, exh. cat. (Berkeley: University Art Museum, University of California, 1966), ill.

## Two Women at a Circular Table

1916. Gouache, watercolor, and ink on twill weave fabric, 7⅞ × 6⅜ in. (20 × 16.2 cm). Signed and dated lower left: pascin / 1916. Inscribed lower right: *In / South / Carolina*. BF607

PROVENANCE: Unknown.

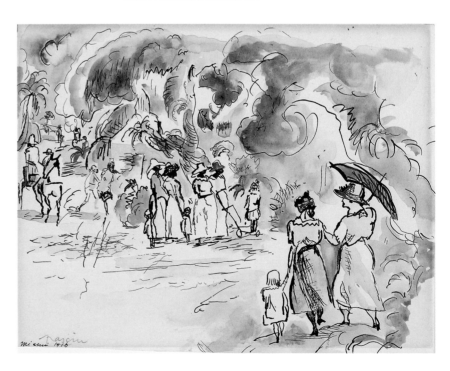

## Figures in Landscape, Miami

Alternate title: *Blue Umbrella Miami*
1916. Watercolor and pen and ink on wove paper, 7½ × 9½ in. (19.1 × 24.1 cm). Signed lower left: pascin. Inscribed and dated lower left: *Miami 1916*. BF623

PROVENANCE: Unknown.

REFERENCE: Violette de Mazia, "The Barnes Foundation: The Display of Its Art Collection," *Vistas* 2, no. 2 (1981–83): 109n, pl. 118 (installation).

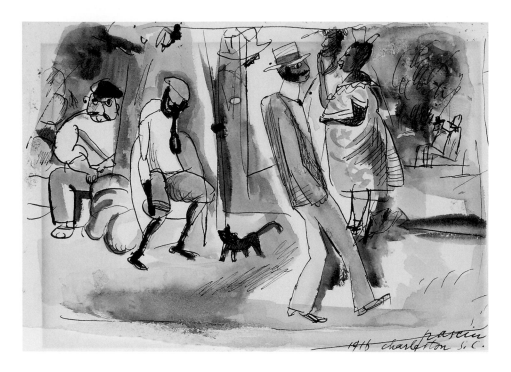

### Figures and Cat in Park

1916. Watercolor and pen and ink on wove paper,
4⅞ × 6⅞ in. (12.4 × 17.4 cm). Signed, dated, and inscribed
lower right: *pascin / 1916 charleston S.C.* BF629

PROVENANCE: Unknown.

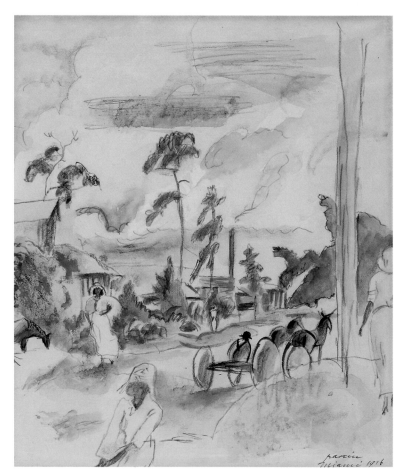

### Landscape with Figures, Miami

1916. Watercolor and graphite on thin wove paper,
9¼ × 7¾ in. (23.5 × 19.7 cm). Signed, dated, and inscribed
lower right: *pascin / Miami 1916.* BF1135

PROVENANCE: Unknown.

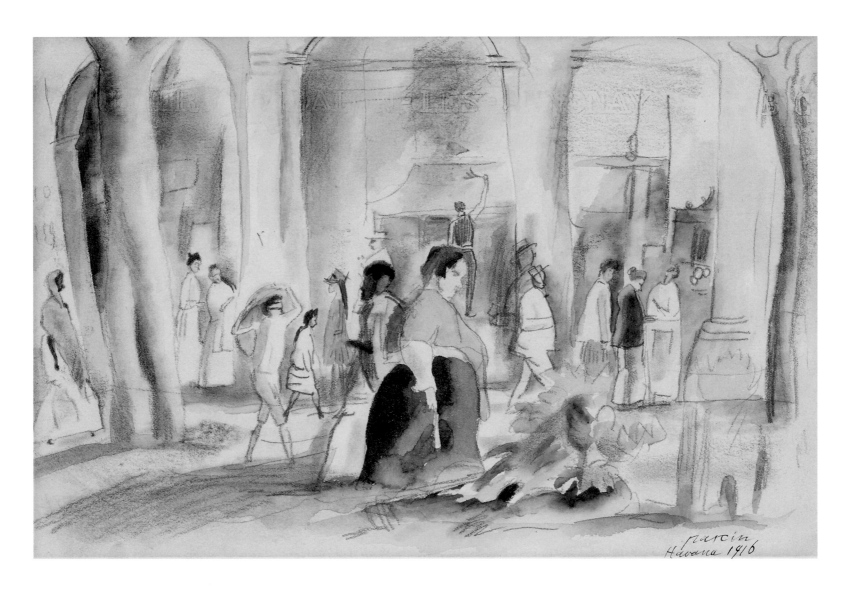

## Figures in Landscape, Havana

1916. Watercolor and graphite on wove paper, 6⅞ × 10½ in.
(17.5 × 26.7 cm). Signed, dated, and inscribed lower right:
*pascin / Havana 1916.* BF624

PROVENANCE: Unknown.

REFERENCE: Violette de Mazia, "Academicism," *Vistas* 4,
no. 2 (1988–89): pl. 96 (installation).

## Southern Scene

Alternate title: *Southern Scene—Four Negroes and Two Children*

c. 1916. Watercolor and brush and ink on wove paper, 8 × 11 in. (20.3 × 27.9 cm). Signed lower right: pascin. BF703

PROVENANCE: Unknown.

## Man, Two Women, Two Children

c. 1916. Watercolor, pen and ink, and black crayon on wove paper, 8½ × 11 in. (21.6 × 27.9 cm). Signed (twice) lower right, in black ink and again below in graphite: pascin. BF727

PROVENANCE: Unknown.

## Southern Landscape with Figures and Horses

Alternate title: *Southern Landscape with Mother and Children*

c. 1916. Watercolor on wove paper, 8 × 9½ in. (20.3 × 24.1 cm). Signed lower right: pascin. BF732

PROVENANCE: Unknown.

## Landscape, Houses and Trees

c. 1916. Watercolor and pastel on wove paper, 8⅜ × 11⅛ in. (21.3 × 28.3 cm). Signed lower right: pascin. BF733

PROVENANCE: Unknown.

## Harvesters

1917. Watercolor and pen and ink with graphite on wove paper, 8¾ × 11¾ in. (22.2 × 29.8 cm). Signed, dated, and inscribed lower right: *pascin / New-Orleans 1917*. BF620

PROVENANCE: Unknown.

## Figures on Beach, Coney Island

1917. Watercolor and pen and ink on wove paper, 7¹³⁄₁₆ × 10⅜ in. (19.8 × 26.4 cm). Signed, dated, and inscribed lower right: *pascin 1917 / Coney-Island*. BF625

PROVENANCE: Unknown.

## Horses in Landscape
### Alternate title: *Havana Suburb*

c. 1917. Watercolor, graphite, and oil pastel on wove paper,
9½ × 12¾ in. (24.1 × 32.4 cm). Signed lower right: pascin.
Inscribed on verso: *Havana Suburb*. BF612

PROVENANCE: One of two works acquired from the Daniel
Gallery, January 21, 1921, for $250.00 each.[1] See also entry for
Pascin's *Group of Figures with Boy Holding Flowers* (BF767).

REMARKS: In the 1922–1924 Inventory, no. 249 is listed as
"Pascin—Watercolor—Horses Grazing 16⅛ × 19¼ [in.]." Given
that these dimensions could have included the mat (that is,
could be sight measurements), the description and title fit
*Horses in Landscape* (BF612). In addition, inventory no. 249
occurs as one in a sequence of thirty-seven pictures hang-
ing in "Dr. Barnes's Sitting Room," works by Degas, Cézanne,
Maurice Prendergast, and Demuth. The fact that twenty-one
other Pascin watercolors are listed later on the inventory as
a contiguous group with no location specified (inventory

nos. 537–57, inclusive) indicates that they were acquired
in a group subsequent to 1921. Since *Horses in Landscape*
does not seem to belong to that group, it is, therefore, likely
that "Horses Grazing" is BF612, one of the two watercolors
acquired from Daniel. That the second watercolor from
Daniel does not appear on the extant copy of the Inventory
may be accounted for by the now missing pages including
nos. 76–100.

1 See invoice from Charles Daniel to Albert C. Barnes, January 15, 1921, for
  two drawings (watercolors) by Jules Pascin, *Colored People* and *Havana
  Suburb*, $500.00, annotated "[check] #4867 1/21/21," ACB Corr., BFA. See
  also handwritten note, Daniel to Barnes, January 17, 1921, ACB Corr.,
  BFA: "Dear Barnes, —I am able to get the Pascins for you for $500.00.
  Am very glad to have him represented in your collection." See also let-
  ter, Barnes to Daniel, January 19, 1921, ACB Corr., BFA: "Dear Sir: In reply
  to your card of yesterday, please send the two (2) Pascin drawings,
  which I selected, to my office, 24 N. 40th Street, Philadelphia. It is
  agreed that the price for the two is Five Hundred (500.00) dollars."

## Shoeshine

Alternate title: *New Orleans Shoeshine*

c. 1917. Watercolor and graphite on wove paper, 8⅛ × 7⅝ in. (20.6 × 19.4 cm). Signed and inscribed lower right: *pascin / New-Orleans.* BF762

PROVENANCE: Unknown.

## Figures in Tropical Landscape

c. 1915–17. Watercolor, drained oil paint, and pen and ink with graphite on thin paperboard, 8¼ × 10 in. (21 × 25.4 cm). Signed lower right: pascin. BF702

PROVENANCE: Unknown.

235

## Figures in Landscape

c. 1917. Pen and ink and watercolor on laid
paper, 7⅝ × 10⅜ in. (19.4 × 26.4 cm). Signed
and inscribed lower left: *pascin / Havana.*
BF615

PROVENANCE: Unknown.

REFERENCE: Violette de Mazia, "Academicism,"
*Vistas* 4, no. 2 (1988–89): pl. 96 (installation).

## Group of Men, New York

1918. Charcoal and watercolor on wove paper,
7¾ × 6¹⁵⁄₁₆ in. (19.7 × 17.6 cm). Signed, dated, and
inscribed lower right: *pascin / New-York / 1918.* BF614

PROVENANCE: Unknown.

## Street Scene, New York

c. 1918. Charcoal and graphite on wove paper, 8¹⁄₁₆ × 10½ in.
(20.5 × 26.7 cm). Signed and inscribed lower right: *pascin /
N.Y.* BF737

PROVENANCE: Unknown.

## Figures with Cab

c. 1918. Pen and ink, ink washes, and watercolor on laid
paper, 6⅜ × 10 in. (16.2 × 25.4 cm). Unsigned. BF740

PROVENANCE: Unknown.

## Negroes and Two Carts

c. 1918. Pen and ink with watercolor on laid paper, 5½ ×
10½ in. (14 × 26.7 cm). Signed lower right: pascin. BF763

PROVENANCE: Unknown.

## *Southern Figures and Goat*

c. 1918. Watercolor, pen and ink, and crayon with graphite
on wove paper, 6⅞ × 12½ in. (17.5 × 31.8 cm). Signed lower
right: pascin. BF764

PROVENANCE: Unknown.

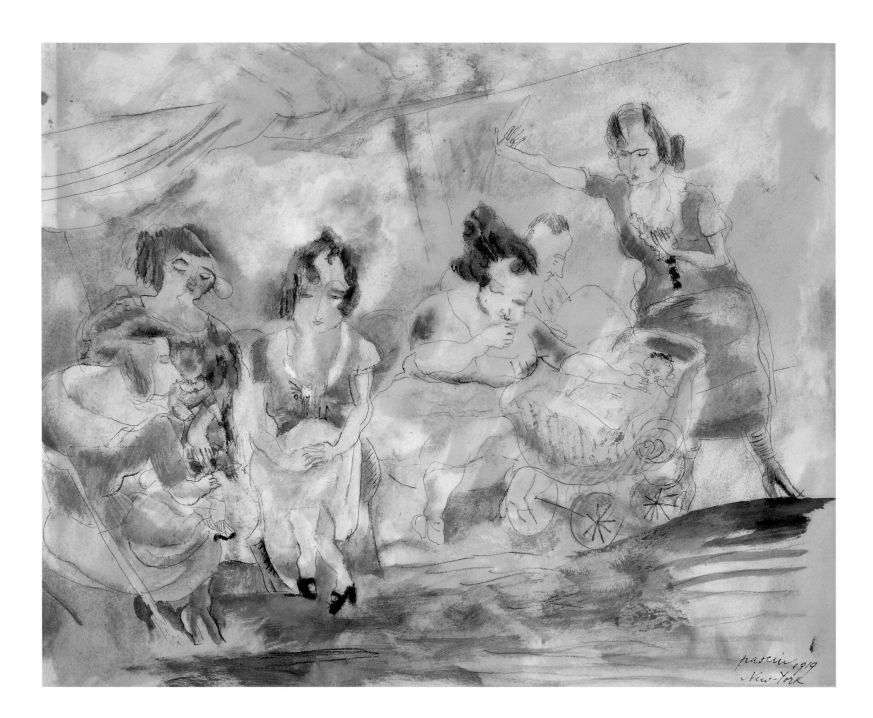

## Woman with Baby Carriage

Alternate title: *Woman with Baby Coach*

1919. Drained oil and pen and ink with graphite on paper-board, 12⅛ × 14⅞ in. (30.8 × 37.8 cm). Signed, dated, and inscribed lower right: *pascin / 1919 / New-York*. BF628

PROVENANCE: Unknown.

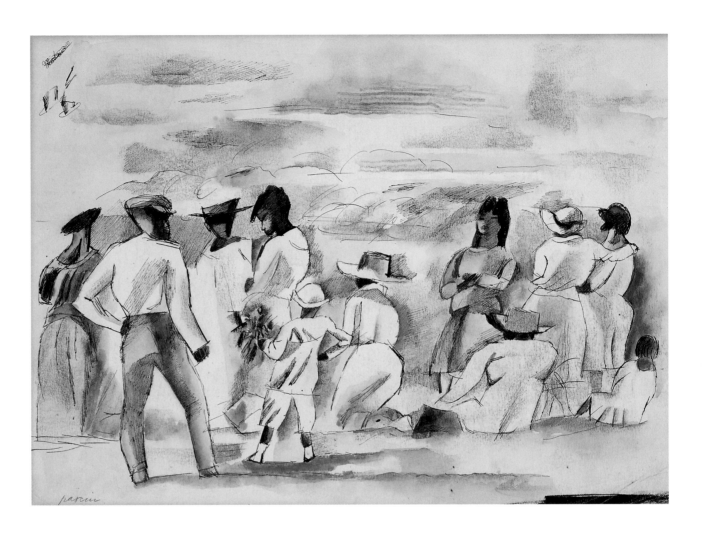

## Group of Figures with Boy Holding Flowers

Alternate titles: *Colored People* (?); *Study—Negroes in Charleston (Etude—Nègres à Charleston)*

1919 (?). Watercolor, pen and ink, and graphite on paper, 9⅞ × 13⅜ in. (25.1 × 34 cm). Signed lower left: pascin. Inscribed upper left: *Mad*[illegible]; three ink markings [sketches of top hats (?)]. BF767

PROVENANCE: Probably one of the two works acquired from the Daniel Gallery, January 21, 1921, for $250.00 each. See entry for Pascin's *Horses in Landscape* (BF612).

REFERENCE: *Pascin, Catalogue Raisonné*, 1:162, no. 317a (as *Etude: Nègres à Charleston*), ill.

REMARKS: *Pascin, Catalogue Raisonné*, 1:162, no. 317, ill. 162, *La visite du dimanche*, oil on canvas, 20⅛ × 16⅛ in. (51 × 41 cm), Collection Josefowitz (also known as *Les fleurs*), depicts the boy with flowers at center left in *Group of Figures with Boy Holding Flowers* and is signed and dated "pascin 1919." In the caption this oil is said to be *Cuba 1919*. *Group of Figures* is mistakenly numbered "317" instead of "317a" as in the caption. In the *Index historique des œuvres* accompanying *Pascin, Catalogue Raisonné*, 1:19, the exhibition history of no. 317, *La visite du dimanche*, is given and *Group of Figures* is listed as 317a.

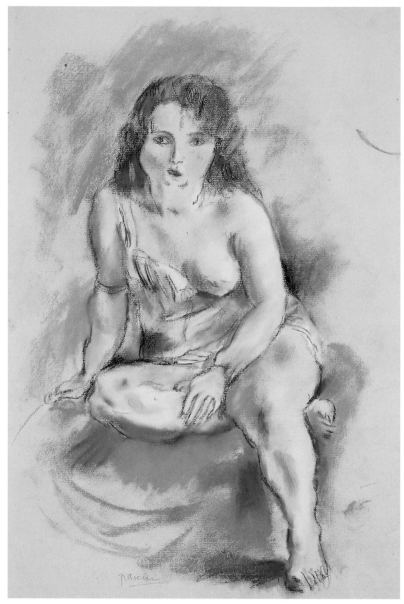

## *Two Men Dining*

c. 1920. Graphite and gouache on wove paper, 8⅞ × 6¹⁵⁄₁₆ in.
(22.5 × 17.6 cm). Signed lower right: pascin. BF718

PROVENANCE: Unknown.

## *Nude*

c. 1920. Pastel and charcoal on blue laid paper, 18½ × 12⅜ in.
(47 × 31.4 cm). Signed lower left of center: pascin. BF609

PROVENANCE: Unknown.

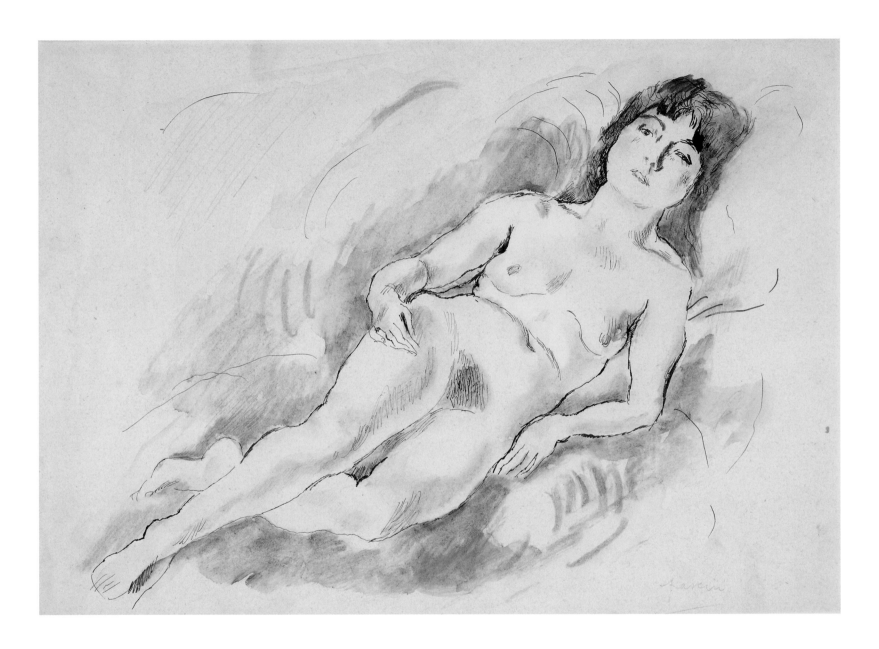

*Reclining Nude*

1920. Watercolor and pen and ink with graphite on wove
paper, 12⅛ × 16¾ in. (30.8 × 42.5 cm). Signed lower right:
pascin. BF631

PROVENANCE: Unknown.

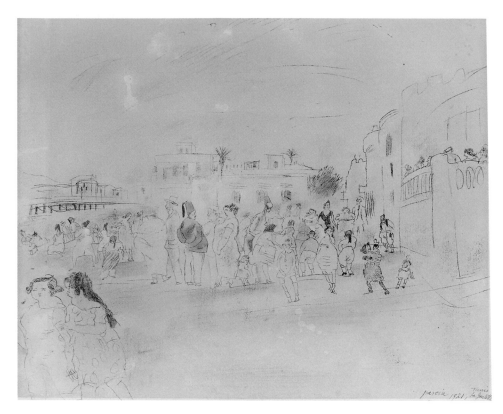

## Tunis

1921. Pen and ink with watercolor on laid paper,
12⅝ × 15⅛ in. (32.1 × 38.4 cm). Signed, dated, and inscribed
lower right: *pascin 1921, Tunis / La Goulette.* BF613

PROVENANCE: Unknown.

REFERENCE: Violette de Mazia, "Academicism," *Vistas* 4,
no. 2 (1988–89): pl. 96 (installation).

REMARKS: La Goulette is a town adjacent to Tunis.

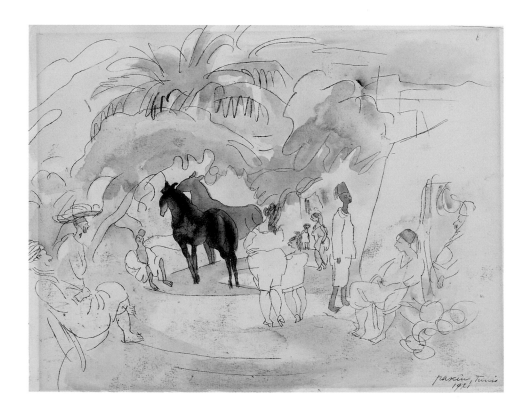

## Figures and Two Horses in Landscape

1921. Pen and brown ink and watercolor on handmade
wove paper, 9⅝ × 12¼ in. (24.4 × 31.1 cm). Signed, dated,
and inscribed lower right: *pascin, Tunis / 1921.* BF630

PROVENANCE: Unknown.

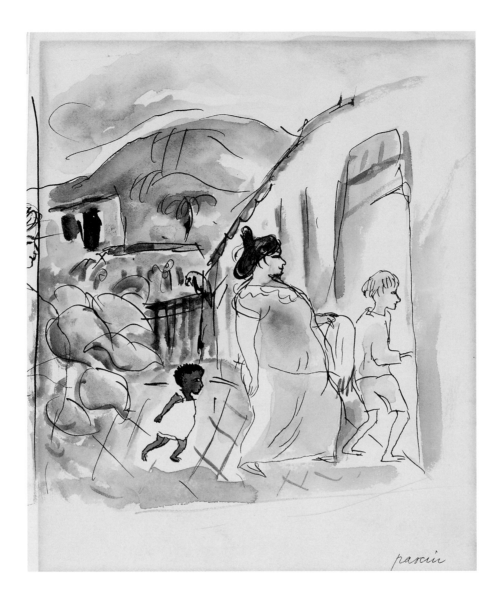

## Woman and Two Children

c. 1921. Watercolor and pen and ink on wove paper, 8⅞ × 7⅜ in. (22.5 × 18.7 cm). Signed lower right: pascin. BF731

PROVENANCE: Unknown.

REMARKS: Probably painted in Salammbô during the artist's trip to Tunis, Tunisia, in 1921. See entry for *Tunisiennes* (BF2043).

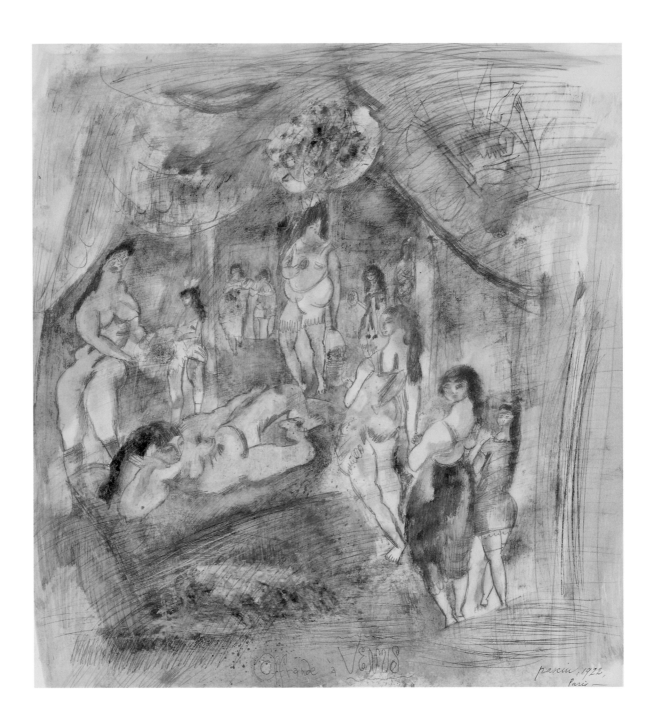

## *Offering to Venus (Offrande à Vénus)*

1922. Watercolor, gouache, graphite, and brown ink on thin paperboard, 18¾ × 16¾ in. (47.6 × 42.5 cm). Signed, dated, and inscribed lower right: *pascin, 1922, / Paris*. Inscribed lower center: *Offrande à Venus*. BF621

PROVENANCE: Unknown.

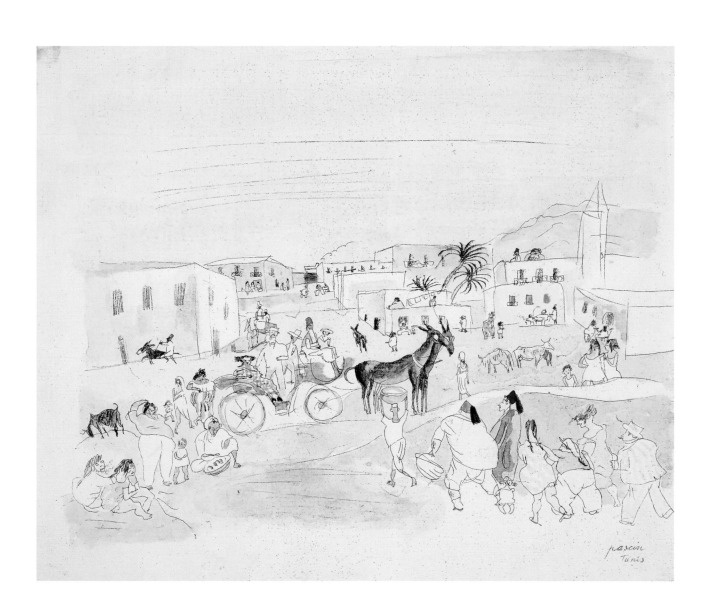

## Landscape with Carriage and Figures, Tunis

1924. Watercolor and pen and ink on primed canvas,
12 × 14⅛ in. (30.5 × 35.9 cm). Signed and inscribed lower right:
*pascin / Tunis*. BF627

PROVENANCE: Unknown.

# MARSDEN HARTLEY (1877–1943)

I have never swallowed the cubist theories whole and six years ago I published an analysis of cubism which made me many enemies. But if a cubist picture moves me aesthetically by means of something more than mere pattern, I shall accept their paintings even if I can't accept their theories.

Albert C. Barnes to Scofield Thayer, editor of the *Dial*, 1923

*In January 1916 Barnes published a strong attack on Cubism* in which he questioned the theoretical underpinnings of the movement, a position shared by William Glackens and Leo Stein: "Three years ago cubism got considerable attention because of the fresh, vivid impressions it brought in the name of art. The parents of sensationalism—a thirst for novelty fostered by curiosity—ensured an unhealthy and short life for its cubic offspring. To-day an exhibition of cubist paintings has even less interest for the educated spectator than have the annual displays of the stagnancies of the art academies. In other words, cubism is academic, repetitive, banal, dead.... [It] is faulty metaphysics in that it takes an abstraction, the planes of objects, and label[s] it the essentials."[1] This stance, however, was at odds with the acceptance of cubism by growing numbers of young American painters, collectors, and critics.[2] By 1921, Barnes himself tempered his opinions and came to acknowledge Cubism's aesthetic merits. The collector's interactions with Marsden Hartley, as well as his relationships with Charles Demuth and Jules Pascin, and his appreciation of these artists' work, were instrumental in stimulating Barnes to see the creative possibilities in Cubism as a living, not exhausted or academic, approach to seeing the modern world.

In mid-July 1916, Hartley went to Provincetown, Massachusetts, to rest and paint for two and a half months, a rare calm interval in a difficult, peripatetic life, which he designated "The Great Provincetown Summer."[3] The artist had just undergone a succession of disruptions, personal and financial, a pattern that would repeat itself in various ways throughout his life. On Cape Cod, Hartley found peace and companionship, painting and socializing with such diverse friends as Charles Demuth, John Reed, George Cram Cook, Susan Glaspell, Eugene O'Neill, and other members of the Provincetown Players theater group.[4] This "exceedingly alive and busy summer" saw a sea change in the painter's work, as Hartley assimilated his observations and experiments from a highly productive period spent abroad from 1912 to the end of 1915.

During his stay in Europe Hartley circulated in advanced art circles in France and Germany. He began his sojourn in April 1912 in Paris, where he remained until the end of the year and was a welcome visitor to Gertrude and Leo Stein's salon. He became

thoroughly conversant with Cubism, including Robert Delaunay's colorful variations on the canonical Analytical Cubism of Pablo Picasso, Georges Braque, and Juan Gris. On a brief trip to Berlin and Munich early in 1913, he met Franz Marc and also Wassily Kandinsky, whose *On the Spiritual in Art* had intensified his interest in mysticism. Hartley then spent April through early November 1913 in Berlin, where he began a series of Cubist-influenced canvases based on the theme of German military regalia. Working with dramatic—even stark—color schemes of predominantly black, white, green, yellow, and red, he developed a personal imagery that stressed patterns of geometric shapes, concentric circles, spheres, and motifs—drawn from banners—depicting helmets, epaulets, medals, and other military paraphernalia, in some cases overlaid with letters or numbers, against a field of intense black. Concurrently, Hartley painted pictures that were based directly on Kandinsky's abstractions, particularly his *Improvisation* compositions, on Bavarian folk painting, including reverse paintings on glass with their primarily religious themes, and on Native American motifs. Although geometric shapes—triangles, circles, eight-pointed stars—were also used here, these paintings were more restrained in their decorative character and were executed in more placid color schemes than were the military subjects.[5] Apart from a brief return to the United States for the winter of 1913–14, Hartley remained in Berlin until after the outbreak of the war. At the end of 1915, circumstances obliged him to return home, where his militaristic German compositions were not well received by critics.[6]

Now, during his brief Provincetown interlude, Hartley conspicuously modulated his palette as he painted a series of small-scale works on fiberboard, to many of which he gave the collective title *Movement*. In these small-scale compositions, motifs drawn from sailboats and flower pieces were rendered as interlocking geometric or curvilinear shapes, executed in muted whites, beiges, pale ochres, grays, and pinks. The gentler tonalities were offset by the artist's signature blacks, now less dominant, yielding a restrained, but nonetheless firm, contrast. The pictures' inherent drama is that of a different range of color relationships. The main theme consists of a pervasive simplicity, achieved by means of the reduction of bright color and elimination of literalistic images such as numbers and letters. The work done in Provincetown, and continued for several months in Bermuda through the spring of 1917, represents a caesura in Hartley's development, after which he returned to the bright color intensity that was an enduring characteristic of his work.

In *Flowerpiece* (BF2072) Hartley sets a russet footed goblet holding a simplified flower, its five white petals emanating from a circular, pupil-like motif, against four bifurcated black and tan leaves of differing lengths that create a spatial setting. These elements are placed on an oval base that in turn is firmly set on a black square, nested slightly askew into a white square that is truncated at the top by the curved bowl of the goblet. The flattened geometry of the tabletop and the leaves is silhouetted against a dappled cream-colored background. *Flowerpiece* is resolutely nonnaturalistic in its color scheme and spatial relations. And yet, in its careful placement and adjustments of shapes, it retains enough naturalism to be convincing. Relying on the restricted means of color and taut geometry, the composition is a tour de force of simplicity. The style of the painting, with its superimposed and truncated geometric shapes, is broadly reminiscent of Picasso's Synthetic Cubist paintings and collages. While Hartley retains a readily, but not insistently, identifiable subject, the pattern formed by the opposing white and black squares of the table and table covering resembles in its pared-down simplicity some of Kasimir Malevich's contemporary Suprematist compositions.[7]

In *Movement, Bermuda* (BF465) and *Movement, Bermuda* (BF466) Hartley simplifies and arranges sails and hulls into compact series of shapes that, as they intersect with or truncate one another, hint at individual planes or spatial recession. The sails, with their delicate geometry, have the effect of placid semaphores, whereas the circular motifs provide a touch of drama that highlights the flat geometry and clean-cut contrast of the sails. The hulls, one at a jaunty angle, serve as containers for the bouquet of sails, just as the goblet and table in *Flowerpiece* function as the base for the flower, petals, and leaves. The pale pink color scheme is a surprising touch against which the round shapes stabilize and pin the shapes of the sails firmly into their close-to-the-surface placement.

Back in New York, Hartley resumed his associations among the city's small avant-garde. He exhibited some of the Provincetown pictures at Alfred Stieglitz's Photo-

Secession Galleries at the end of January 1917.[8] Reviewers responded enthusiastically. Charles Caffin, who had followed the development of Hartley's work, wrote,

Last Summer [he] painted in Provincetown, the results appearing in the present exhibition. Their theme is the shifting aspects of fishing boats and sky and water. The paintings are objective to the point that there is no mistaking what they represent or rather interpret. For the sails and hulls have been simplified until they present only abstractions of the forms in completely flat designs. Yet notwithstanding the flatness, the sense of planes is conveyed by the color contrasts and relations. Simplified also is the range of colors and tones of color; pale, tranquil tones of salmon, light blue, dull red, cream and buff, relieved from tameness by emphatic notes of black, which give pungency to these delicate color schemes, suggest the values of shadow and lock each design into a compact unit. Their unity, at once so simple and equable, seems to me the expression of a temperament, which, for the present at least, has realized itself thoroughly. It has discovered a language in which the flatness of intellectuality can have free play and sensuousness has yielded to spiritual sensations.... They are ahead of, as well as different from, the abstractions of other painters. Their abstraction is sensibly attached to the concrete, their organization grows simply out of objective facts and relations, and their intellectuality is tempered with aesthetic invitation. In a word, they are the offspring of reason that, instead of being intolerant of instinct, has mated with it.[9]

A reviewer for the *New York Times* compared the latest pictures with Hartley's German compositions:

Marsden Hartley's work at the Photo-Secession Galleries needs no book. What "it" means is not of the least importance, but its beauty and sanity are important. Mr. Hartley has been at some seaside town or other where he could see sails and skies and somewhere on the boats the precious bullseye without which, apparently, he cannot quite see pictures. Out of the conventionalized sail and boat forms and sky color and sea color and other kinds of color hidden here and there in nature, as everything is, he has made rather severe little compositions demanding very intelligent exhibition treatment. One canvas drenched with a furious red and blazing with a big patch of white got into conflict with one of the most sensitive and exquisite of the arrangements in green and yellow and gray, and the observer was reminded of an Irish terrier throttling a downy kitten. The main wall of the gallery is beautifully hung with these agreeable abstractions, but the other walls have been sacrificed to this.[10]

In 1921, five years after his published "post-mortem" assessment of Analytical Cubism, Barnes purchased the three Cubist paintings by Hartley at the Anderson Galleries auction. He was delighted with the new pictures and wrote the artist on June 2, 1921, "I want to let off steam generated this morning by placing you[r] two little boats one on each side of that wonderful Charlie Prendergast panel which was in the Independent show this year. Demuth was here while I hung them and he agreed with me that outside of a few spots in my house there is probably nothing in America that can touch the wall in sheer, potent, exquisite, meaningful beauty. The wall is in my private office and is well worth a visit if you happen to be in Philadelphia. The flower piece, which I also got at your sale, gets an important position in my residence and that, too makes a distinctive worth-while addition to my collection."[11]

Barnes's activity in the early 1920s reflected his new attitude toward Cubism. He purchased Cubist paintings by Picasso as well as by Braque and Louis Marcoussis.[12] It is likely that his revised attitude was in part the direct result of buying these three works by Hartley and two temperas by Charles Demuth (*Piano Mover's Holiday* [BF339] and *Masts* [BF343], acquired in December 1921). The most notable expression of Barnes's changed attitude was his 1922 commission to Jacques Lipchitz for seven bas-reliefs and one freestanding sculpture, carved from the same Burgundian limestone as Paul Cret's structure, to decorate the exterior of the Barnes Foundation. Barnes gave the sculptor complete freedom to design the reliefs, just as he would eight years later with Henri Matisse when he commissioned the *Dance* mural for the main gallery of the Foundation. In some respects the sculpture, especially the

FIG. 80

Jacques Lipchitz, *Harlequin with Mandolin in Oval*, 1923, limestone relief, 50 × 42 × 9 in. (127 × 106.7 × 22.9 cm), The Barnes Foundation, 2001.13.04

FIG. 81

Jacques Lipchitz, *Man and Guitar—Black, Gray, Red, and White*, 1918, graphite, brush and black ink, red and white chalks, and embossing on paper, 19⅜ × 12⁷⁄₁₆ in. (49.2 × 31.6 cm), The Barnes Foundation, BF462

FIG. 82

Pablo Picasso, *Still Life: Violin, Sheet Music, and Bottle*, 1914, oil on canvas, 20¹⁄₁₆ × 16⁹⁄₁₆ in. (51 × 42 cm), The Barnes Foundation, BF673

oval vertical *Harlequin with Mandolin in Oval* (2001.13.04) of 1923 (fig. 80) and one watercolor, *Man and Guitar— Black, Gray, Red, and White* (BF462) by Lipchitz (fig. 81), painted in 1918 but acquired at the time of the commission, resemble the two Hartley *Movement* paintings.[13]

On September 17, 1923, while the Lipchitz commission was well under way, Barnes wrote his letter (cited above) to Scofield Thayer, editor of the *Dial*:

I have never seen a non-representative Picasso cubist picture, in the sense that all representation is abolished; for instance, as [Albert] Gleizes and a host of others have abolished it. There is always a clue in Picasso and say, he is painting a bottle, there would be an indication of the front view as well as the side view of the bottle. To make this point clear I'm sending you a photograph of a Picasso which I own and which I think is the best cubist picture ever painted and really justifies their contention that it is a *new end*, not a means to an old end.... This particular Picasso [*Violin, Sheet Music, and Bottle* (BF673) of 1914 (fig. 82)] is a symphony in bright yellow, blue, fawn, grey, white and black and that color, in its ordered sequences, is as clearly a form in an accurate psychological sense as a three-

dimensional Renaissance figure. But Picasso is a big artist and the color, as used in that painting, is merely an adjuvant to the plastic unity (ordered arrangement of lines, spaces, masses) which makes the painting a positive creation in an entirely new field.... I have seen a few [pictures] by Picasso and by Gris that have as positive and demonstrable plastic unity as a Giorgione.[14]

Three days later, on September 20, he followed up, "Keep the Picasso [photograph] I sent you and do anything you want with it. It's [*sic*] real title is 'Still-life.' Picasso prefers to have the space around his ovals reproduced. I was at [his] studio in June and all the cubist paintings he showed me were representative."[15]

The further evolution of Barnes's acceptance of Cubism is evident in his 1925 description of the same Picasso *Violin, Sheet Music, and Bottle*: "The lack of appreciation of this painting by anyone who supposes himself to understand the work of Titian, Velázquez, Cézanne, and Renoir, is a proof that what the person in question likes in the paintings of those great artists is not the art-value, but something else. The only quality in a painting by any one of those great artists that entitles it to be considered as a work of art is precisely what is contained in this cubist

painting by Picasso. . . . This is not to say that this painting by Picasso is as great as a work of art, as one by Titian, Renoir or Cézanne, for Picasso is a lesser artist than any of these. It means merely that Picasso has created a form which has a positive aesthetic value of its own."[16]

NOTES

Epigraph. Letter, Albert C. Barnes to Scofield Thayer, September 17, 1923, ACB Corr., BFA.

1 Barnes, "Cubism—Requiescat in Pace: The Recipes and Their Incidentals Are Fair Subjects for Post-mortem Comment," *Arts and Decoration*, January 1916, 121–24. Marius de Zayas published a rejoinder, "Cubism?" *Arts and Decoration*, April 1916, 284–86, 308. Barnes made no reply. See also Leo Stein, "Introductory to the Independent Show," *New Republic*, April 7, 1917, 288–90, and "Art and Common Sense," *New Republic*, May 5, 1917, 13–15; Harvey M. Watts, "As to Post Mortems on Modernist Art," *Arts & Decoration* XVI, no. 4 (February 22, 1922), 324–26: "In its issue of April [*sic*], 1916, Dr. A. C. Barnes, of Merion, who made one of the largest collections of Modernist works in America . . . made his witty post mortem on the Cubists, and pronounced them dead, and presumably buried." See letters, Barnes to Arthur B. Davies, January 14, 1914, quoted on page 329, and Barnes to Charles Demuth, August 1, 1921, quoted on page 261 and cited on page 264, note 11.

2 See Innis H. Shoemaker, *Mad for Modernism: Earl Horter and His Collection* (Philadelphia: Philadelphia Museum of Art, 1999).

3 Marsden Hartley, "The Great Provincetown Summer," three-page typescript, Norma Berger Papers, Yale Collection of American Literature, Beinecke Rare Book and Manuscript Library, Yale University.

4 See Marsden Hartley, *Somehow a Past: The Autobiography of Marsden Hartley*, ed. Susan E. Ryan (Cambridge, Mass.: MIT Press, 1997), 94.

5 Hartley exhibited forty-five of his German paintings and drawings as well as forty-five drawings of Maine, dating from 1908, in October 1915 at the Münchener Graphik-Verlag, Berlin. See Amy Ellis, "'The Great Provincetown Summer': The Impact of Eugene O'Neill on Marsden Hartley," in *Marsden Hartley*, ed. Elizabeth M. Kornhauser (Hartford, Conn.: Wadsworth Atheneum Museum of Art in association with Yale University Press, 2003), 95–104; Barbara Haskell, *Marsden Hartley* (New York: Whitney Museum of American Art and New York University Press, 1980), 195. For a discussion of Hartley's interest in mysticism, see Charles Eldredge, "Nature Symbolized: American Painting from Ryder to Hartley," in *The Spiritual in Art: Abstract Painting 1890–1985* (New York: Abbeville, 1986), 113–29.

6 Stieglitz exhibited the War Motif series at his Photo-Secession Galleries, New York, Paintings by Marsden Hartley: German Military Series, 1914–1915, April 4–22, 1916.

7 See Michael Taylor, "Marsden Hartley's *Movement* Series and Modern Art in Provincetown in 1916," in *From Hawthorne to Hofman: Provincetown Vignettes, 1899–1945*, exh. cat. (New York: Hollis Taggart Galleries, 2003): "Hartley's *Movement* paintings have no precedent in American art. . . . The degree of abstraction that these panel paintings approach can only be compared to contemporaneous developments in avantgarde painting in Europe. They are especially interesting in relation to Russian modernism, where the non-objective Suprematist paintings of Kasimir Malevich had similarly extended the cubist principle of collage" (34). For specific examples, see Malevich's pencil drawing, *Schneider, Allogismus. Aushang*, c. 1914–15, in Evelyn Weiss, ed. *Russische Avantgarde 1910–1930* (Cologne: Ludwig Museum; Munich: Prestel-Verlag, 1986), 97, no. 89, ill., which resembles Hartley's *Abstraction*, 1916 (where-

abouts unknown; ill. 72 in Bruce Robertson, *Marsden Hartley* [New York: Abrams, 1995]), and 100, nos. 99 and 101, ill.; and Charlotte Douglas, "Beyond Reason: Malevich, Matushin, and Their Circles," in *The Spiritual in Art: Abstract Painting 1890–1985*, 190, nos. 4–8, all dated 1914–c. 1915, but probably unknown to Hartley. Taylor has suggested that Hartley might have seen examples of Suprematist work in Germany before he returned home; personal communication, April 17, 2007.

8 Photo-Secession Galleries, New York, Marsden Hartley's Recent Work, January 22–February 7, 1917 (no catalogue). This was Hartley's last show with Stieglitz.

9 Charles H. Caffin, "A Review of Marsden Hartley," *New York American*, January 29, 1917, 6.

10 "Print Department for Metropolitan Museum: Art at Home and Abroad, Exhibitions of Modern Painting," *New York Times Sunday Magazine*, January 28, 1917, 7.

11 Letter, Barnes to Marsden Hartley, June 2, 1921, ACB Corr., BFA. According to Julie Mellby, Glackens, who had known Hartley since 1909, did the bidding for Barnes. See Mellby, "A Record of Charles Daniel and the Daniel Gallery," M.A. thesis, Hunter College of the City University of New York, 1993, 50. The two Hartleys and Charles Prendergast hung in the arrangement described as listed on the 1922–1924 Inventory, and that installation is maintained in the gallery of the Barnes Foundation today. The June 2, 1921, letter is published in part in Townsend Ludington, *Marsden Hartley: The Biography of an American Artist* (Boston: Little, Brown, 1992), 157. See also Hartley, "Then Came the Auction," in *Somehow a Past*, 102 ff: "The pictures were put on a wall of two or . . . three good size rooms. . . . It was a bit of vaudeville . . . for there was everything I had tried to do and a lot of them not successes. . . . Everybody came to the exhibition—hundreds and hundreds during the almost two weeks. . . . As at all auctions there were certain pictures that many seemed to want and the bidding was keen. Dr. Albert Barnes bought two [*sic*] to his liking and put them in his foundation museum—and has thought them good enough to keep. Not long ago he said to me, 'You'd be surprised how well they look,' which was nice." Barnes purchased four Hartleys and gave one to Demuth. See page 252, entry for Hartley's *Movement, Bermuda* (BF465).

12 Barnes bought "around a dozen pictures out of [Kahnweiler's] sale" in June 1920. Barnes to Charles Demuth, November 1, 1921, ACB Corr., BFA. Braque's *Napkin, Knife, and Pears* (*Serviette, couteau, et poires*, BF437) of 1908 was purchased at the Kahnweiler sale through Durand-Ruel on September 22, 1921. Three reverse paintings on glass by Marcoussis dated 1921 (*Glass and Fruit* [*Verre et fruits*, BF392] and *Fruit Bowl* [*Coupe de fruits*, BF452]) were purchased from Paul Guillaume in 1923. The third, *Glass and Pomegranates*, was donated by Barnes to the Blanden Art Museum, Fort Dodge, Iowa, in 1951.

13 On the Lipchitz-Barnes relationship, see Cathy Putz, "Towards the Monumental: The Dynamics of the Barnes Commission (1922–1924)," in *Lipchitz and the Avant-Garde: From Paris to New York*, ed. Josef Helfenstein and Jordan Mendelson (Urbana-Champaign, Ill.: Krannert Art Museum, 2001), 38–51, and Michael R. Taylor, "Jacques Lipchitz and Philadelphia," *Philadelphia Museum of Art Bulletin* 92, nos. 391–92 (Summer 2004): 13–22, 47–48.

14 Letter, Barnes to Thayer, September 17, 1923, ACB Corr., BFA.

15 Letter, Barnes to Thayer, September 20, 1923, ACB Corr., BFA. The painting was illustrated in Mary Mullen, *An Approach to Art* (Merion, Pa.: Barnes Foundation Press, 1923), 41 (as *Still Life*).

16 Albert C. Barnes, *The Art in Painting* (Merion, Pa.: Barnes Foundation Press, 1925), 510–11, ill. 332 (as *Still-Life*). See also Albert C. Barnes and Violette de Mazia, *The Art of Cézanne* (New York: Harcourt, Brace, 1939), 126–29.

## *Movement, Bermuda*
### Alternate title: *Boat (Black and White Hull)*

1916. Oil on Beaver Board™, 16⅛ × 11⅞ in. (41 × 30.2 cm).
Signed lower right: Marsden Hartley. Inscribed on panel
verso: *H54*. Frame by Max Kuehne. BF465

PROVENANCE: Acquired from the Anderson Galleries Sale,
May 17, 1921.[1]

REFERENCE: *Seventy-five Pictures by James N. Rosenberg
and 117 Pictures by Marsden Hartley*, auction cat. (New York:
Anderson Galleries, Sale number 1586, May 17, 1921), 13,
no. 54.

REMARKS: The 1921 Anderson auction catalogue, which was
hastily drawn up by Alfred Stieglitz for the sale, states that
the picture was done in Bermuda, where Hartley traveled in
December 1916, but in fact it was painted in Provincetown,
Massachusetts, prior to the artist's departure.[2]

1  Letter, Albert C. Barnes to Alfred Stieglitz, May 18, 1921, ACB Corr., BFA:
"I enclose check for one-hundred and seventy-five ($175.00) dollars for
the four Hartley's I bought at last night's sale." Invoice from George F.
Of, May 20, 1921, for "boxing and pack[ing] of 4 Hartley Ptgs Order of
Mr. Stieglitz. $2.50," BFFR, BFA. Albert C. Barnes check no. 4940,

May 24, 1921, BFFR, BFA. Though the payment was made to Stieglitz, the
funds from the sale belonged to Hartley. Despite the mention of four
paintings in both Barnes's letter to Stieglitz and Of's invoice, only three
works are listed in the records of the Barnes Foundation. See letter
Barnes to Marsden Hartley, June 2, 1921, referring only to three paint-
ings (*Movement, Bermuda* [BF465], *Movement, Bermuda* [BF466], and
*Flowerpiece* [BF2072]), ACB Corr., BFA. Barnes Foundation file cards
mistakenly describe BF465 "1912–13–14" as having been bought from
Stieglitz. The 1922–1924 Inventory lists three paintings by Hartley, *Still
Life* (no. 154), *Boat* (no. 447), and *Boat* (no. 449), which correspond to
the three paintings now in the collection. The fourth painting was given
to Charles Demuth, likely on June 2, 1921, at which time Demuth visited
Barnes to see the just-acquired Hartleys. See letter, Barnes to Hartley,
June 2, 1921 (quoted page 249), stating that Demuth was visiting when
the paintings were hung. See letter from Demuth to Barnes, likely writ-
ten following the visit described above, in which the painter wrote: "I
wish that you had taken the drawing [i.e., watercolor] or my check,—
but, do appreciate, as you know, your gift of the Hartley. Thanks very
much." Letter, Demuth to Barnes, undated [June 1921], ACB Corr., BFA.
See also page 264, note 9.

2  See Barbara Haskell, *Marsden Hartley* (New York and London: Whitney
Museum of American Art and New York University Press, 1980), 62,
pl. 24, as *Boat (Black and White Hull)*, 1916; Michael R. Taylor, "Marsden
Hartley's *Movement* Series and Modern Art in Provincetown in 1916," in
*From Hawthorne to Hofmann: Provincetown Vignettes, 1899–1945*, exh.
cat. (New York: Hollis Taggart Galleries, 2003), 37.

## Movement, Bermuda

Alternate title: *Boat (Pink and Black Hull)*

1916. Oil on Beaver Board™, 16 × 11⅞ in. (40.6 × 30.2 cm).
Signed lower right: Marsden Hartley. Inscribed on panel
verso: *H53*. Frame by Max Kuehne. BF466

PROVENANCE: Acquired from the Anderson Galleries Sale,
May 17, 1921. See entry for *Movement, Bermuda* (BF465).

REFERENCES: *Seventy-five Pictures by James N. Rosenberg
and 117 Pictures by Marsden Hartley*, auction cat. (New York:
Anderson Galleries, Sale number 1586, May 17, 1921), 13, no. 53;
*American Art News*, May 21, 1921, 9, identifying A. C. Barnes as
the purchaser of *Movement, Bermuda* for $100.00. Despite its
title, *Movement, Bermuda* (BF466) was painted in Province-
town, Massachusetts. See page 252, Remarks and note 2.

## Flowerpiece

Alternate titles: *Movement, Bermuda; Still-Life*
1916. Oil on commercial wallboard, 20 1/16 × 16 in.
(51 × 40.6 cm). Signed lower right: Marsden Hartley.
Inscribed on panel verso: *H56*. BF2072

PROVENANCE: Acquired from the Anderson Galleries Sale,
May 17, 1921. See entry for *Movement, Bermuda* (BF465).

REFERENCES: *Seventy-five Pictures by James N. Rosenberg
and 117 Pictures by Marsden Hartley*, auction cat. (New York:
Anderson Galleries, Sale number 1586, May 17, 1921), 14, no. 56
(*Movement, Bermuda*) or no. 58 (*Still-Life*), each dated 1916.
See "Artists Will Seek Public at Auction" and "Modernist
Works Sold at Auction," *American Art News*, May 14, 1921, 5;
Violette de Mazia, "Subject and Subject Matter—Part III. In
'Non-Representational' Art," *Vistas* 3, no. 1 (1984–86): pl. 41
and 9–10: "In [Hartley's *Flowerpiece*], there is a good deal left
out of what says objects on table for the sake of a pattern of
contrasting silhouetted shapes, but these shapes are still, to
some extent, clues to what we know as table, vase, flowers,

and, again, it is dramatic contrast *plus*"; Violette de Mazia,
"The Nature of Form," *Vistas* 4, no. 2 (Winter 1988–89): 57,
pl. 20.

REMARKS: The back of the panel is inscribed "H56," which,
in the 1921 Anderson Sale catalogue, is entitled *Movement,
Bermuda*, like the previous seven (nos. 49–55) and the sub-
sequent number, 57. However, there is only one catalogued
*Still-Life*, no. 58, which is likely *Flowerpiece*. No dimensions
are given in the Anderson catalogue. The picture is entitled
*Still Life* in the 1922–1924 Inventory in the Barnes Foundation
Archives. *Flowerpiece* (BF2072) was painted in Provincetown,
Massachusetts. See page 252, Remarks and note 2. Note the
similarity of the black square pattern of the tabletop with
the use of geometric and curvilinear patterns in Charles
Demuth's *In Vaudeville: Two Acrobat-Jugglers* (BF602) of 1916
(see page 283).

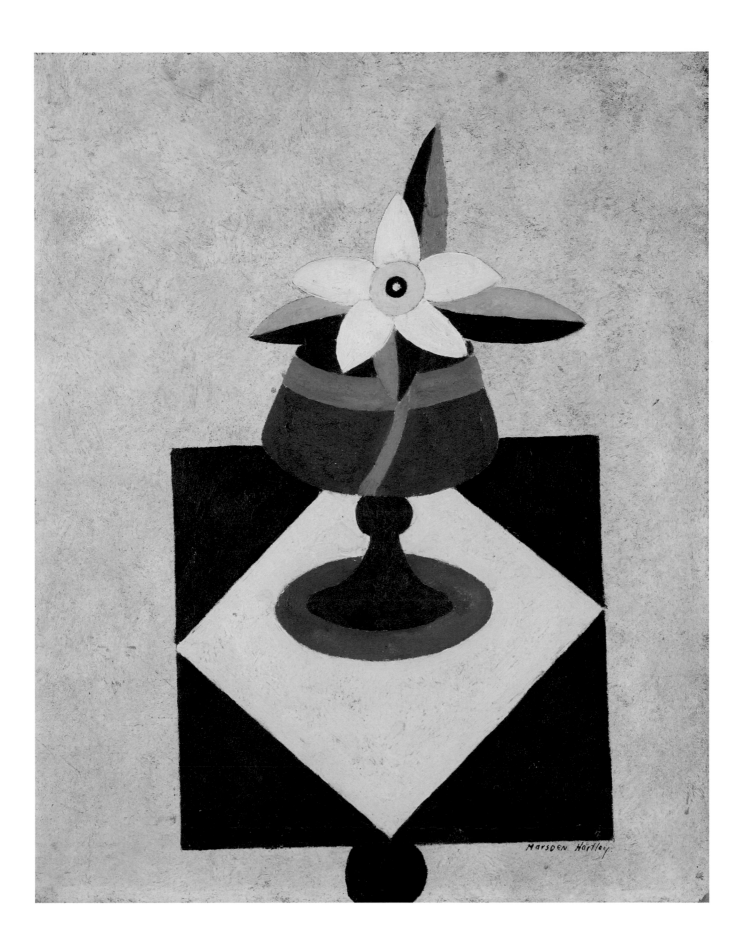

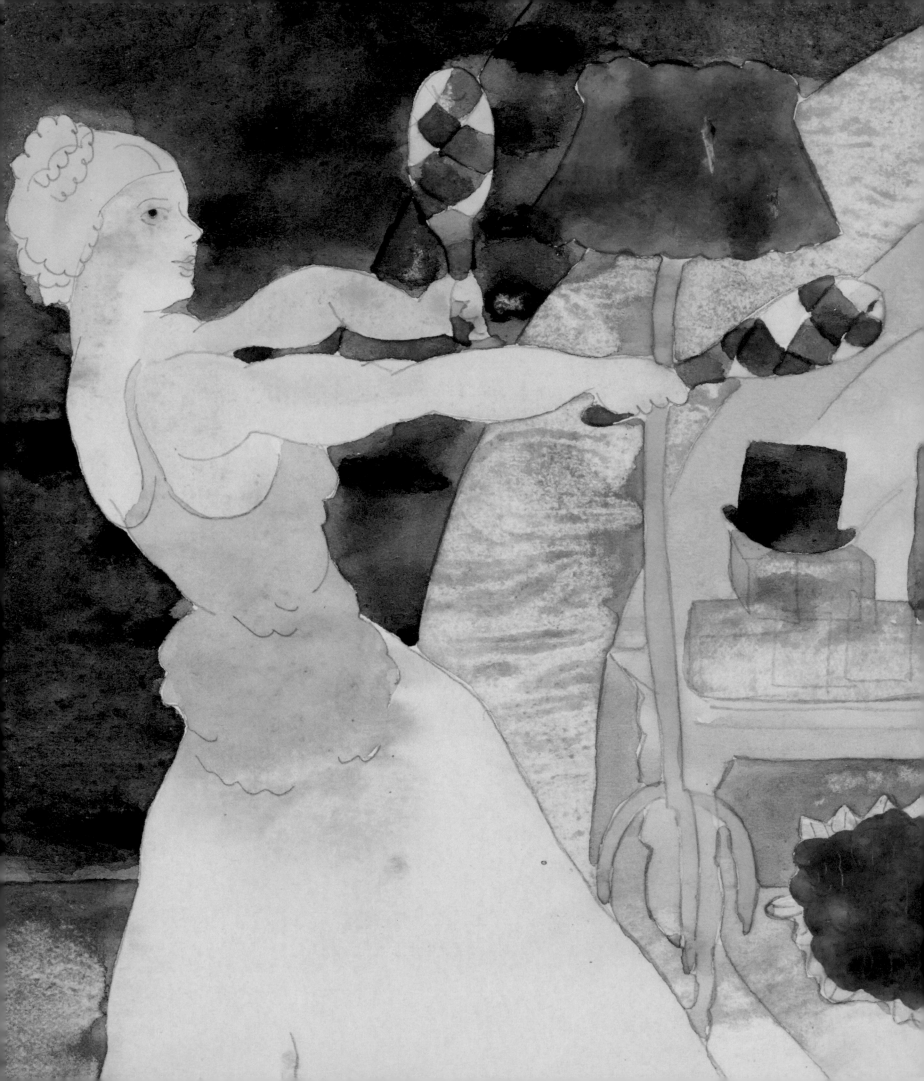

# CHARLES DEMUTH (1883–1935)

Sir Joshua Reynolds never painted a picture that I would accept in exchange for any one of a score of Charles Demuth's water colors which carry personal messages that are as necessary for a satisfactory life to me as my roof or my food.

Albert C. Barnes, Introduction to *Exhibition of Contemporary European Paintings and Sculpture*, 1923

*In 1943, Barnes wrote to John L. Sweeney (1906–1986)* about the work of Charles Demuth, whose work he had been acquiring since late 1916:

> Thank you for the . . . article on Demuth's illustrations of Henry James' stories. You make a credible attempt to establish by objective data an analogy between James and Demuth working in different media and conveying similar human values. Your article brings to mind some very pleasant recollections of Demuth. Just before World War I and during it, Demuth was a frequent week-end visitor at my house, long before the Foundation started. One of the principal things we talked about was the work of Henry James which we both admired intensely. Demuth was extraordinarily sensitive to the subtleties and nuances in James and we both agreed that in, for instance, 'The Golden Bowl,' he was as exquisite an artist as ever lived. I learned much about Henry James in talking with Demuth who I think knew James more intimately and with finer appreciation of the aesthetic values than any literary critic I ever met—not excepting Van Wyck Brooks.[1]

Charles Demuth was born in Lancaster, Pennsylvania, in 1883. In 1903 he matriculated at the Drexel Institute of Art, Science and Industry, Philadelphia, where he followed a program aimed at forming illustrators and commercial artists. After completing his first year, in the summer of 1904, Demuth took a class at the Pennsylvania School of Industrial Art. Resuming his studies at Drexel, he was encouraged to broaden the scope of his training, and by 1905 he had also enrolled at the Pennsylvania Academy of the Fine Arts, studying at both schools. There, for five years, he continued his formal instruction with William Merritt Chase, Thomas P. Anshutz, Hugh Henry Breckenridge, and Henry McCarter.

Like Barnes, Demuth was a prodigious reader with refined literary sensibilities. Among modern writers, the artist especially favored, in addition to Henry James, Walter Pater, Oscar Wilde, Walt Whitman, Marcel Proust, and James Joyce. Throughout his life he wrote plays and brief essays that convey his sophistication and wit. Demuth's initial exposure to Modern art came in 1907, when he first traveled abroad, living in Paris for five months, with a brief trip to Berlin at the end of the year. He readily formed friendships and acquaintanceships among the young Americans in Paris, finding common ground

FIG. 83

Charles Demuth, *Jugglers with Indian Clubs*, 1917, watercolor and graphite on wove paper, 8 × 13 in. (20.3 × 33 cm), The Barnes Foundation, BF2010 (detail)

with artists such as Edward Steichen, Arthur B. Carles, and John Marin, who were determined to break with the kind of academic training they were all receiving.

From 1908 to 1911 Demuth lived in Philadelphia and made frequent trips to New York, where he saw a great deal of contemporary painting by the young generation of American moderns. His developing style was also informed by his visits to shows in New York of the work of important French artists, including Henri Matisse's drawings and watercolors in April 1908 at Alfred Stieglitz's 291 Gallery, Henri de Toulouse-Lautrec's lithographs (December 1909), and watercolors by Auguste Rodin (April 1910) and Paul Cézanne (March 1911).[2]

At the end of 1912, the artist returned to Paris for a year and a half. There he attended life-drawing classes at the Académie Moderne, where models' three-minute poses required students to develop a technique of rapid pencil *croquis* in the manner of Rodin. He also enrolled in sessions at the Atelier Colarossi and the Académie Julian.[3] He became friends with the painter Marsden Hartley, who, like Demuth, was a wide-ranging reader and an incisive writer. During this prolonged stay, Demuth got to know Gertrude and Leo Stein and their collection, which included important works by Matisse and Picasso as well as watercolors by Cézanne that are today in the Barnes Foundation. In Paris Demuth saw Isadora Duncan dance and attended performances of Serge Diaghilev's Ballets Russes. The dancers' striking movements, as well as the exotic stage décors by designers such as Leon Bakst, reinforced a lifelong attraction to cabaret and circus performers—dancers, singers, musicians, acrobats, and jugglers—whose gestures and costumes would become a fertile source of motifs for Demuth's watercolors.

Demuth's distinctive form began to take shape by 1915, coinciding with the influx of French artists into New York after the outbreak of the war. His watercolors possess a remarkable freshness and brilliancy, with their fluid washes of color over summary pencil notations that indicate the scale and positioning of the figures within his compositions. Their bright color schemes suggest an indebtedness to Matisse, while the elastic contours of Demuth's figures recall the lines of Rodin and early Picasso, among others. From 1915 through 1919 the artist painted literary illustrations and theatrical scenes, as well as, beginning in 1916, Cubist-inspired landscapes.

Undertaken on his own initiative and not intended to be published, Demuth's literary illustrations are freely derived from a wide range of texts, including works by such writers as Émile Zola, Honoré de Balzac, Edgar Allan Poe, and the German playwright Frank Wedekind, using excerpts often chosen for their lurid or colorful flavor. He does not use these written sources literalistically, as specific visual templates, but rather as points of departure for interpretation and invention. Sweeney wrote, "Demuth's work is a presentation rather than a representation—a *new* thing in which literal reproduction has been drastically subordinated to a presentation in pictorial terms of the text's supporting structure."[4]

Compositionally, the illustrations are complex, and they share some of the theatricality of Demuth's vaudeville scenes. He employs devices such as screens placed at angles with tables or other geometric props to create intricate mise-en-scènes for the asymmetrical curvilinear and amorphous shapes of the figures. Occasionally, Demuth inserts a performer whose supple, rippling contours clearly echo his vaudeville figures, such as the dramatic, planted central figure in *The Ladies Will Pardon My Mouth's Being Full* (BF1069). In *Count Muffat's First View of Nana at the Theatre* (BF1074) Demuth portrays Zola's courtesan as a Rodinesque nude figure seen from the back before the footlights and audience. He brings an intense focus to these compositional groupings, expressing a breathtaking, even risky, spontaneity while exercising firm control throughout all areas of the pictures' diminutive surfaces. Miniature dramas animated by buoyant color shapes and dynamically expressive lines, the literary illustrations constitute one of Demuth's most original contributions to the modern tradition.

Demuth employs the same vibrant color patterns and crisp planes, sketched outlines, and sinuous shapes in his vaudeville scenes. The performers' rhythmic silhouettes constitute a creative adaptation of those of El Greco, an artist much admired by Demuth and by his contemporary Jules Pascin, whose work in watercolor also influenced Demuth.[5] In *At Marshall's* (BF741), for example, the outlines of Demuth's dancer have a discontinuous, lost-and-found quality. The feet are clearly demarcated, and the left profile of the leg and torso is confidently established by a slender seam of light threaded between the body and adjacent color wash, while no drawn borders

are perceptible in the color shapes that form the arms. Demuth often achieved his varied notations, and the light and dark internal modulations of the color areas superimposed on them, by blotting and freely dabbing water on the surface. This distinctive color application creates a luminous atmospheric shimmer that heightens the drama of the figures. These writhing, undulating shapes, reminiscent of Rodin and Matisse in their elasticity, are organized in compact arrangements far more audacious than the simpler linear compositions of those contemporary French sources.

The figures and backgrounds in many of Demuth's vaudeville compositions display considerable knowledge of the poses and settings in the small-scale illustrations of William Blake. In watercolors such as *Musician* (BF748), *In Vaudeville: Acrobatic Male Dancer with Top Hat* (BF1199), and *Two Women Acrobats* (BF745), the poised silhouetted figures are set against the stage lights—spheres of light-saturated color—that resemble the radiant aureoles or nimbi in Blake's *Albion Rose (Dance of the Albion)* (see fig. 84). The balletic swaying figure in Demuth's *The Masque of the Red Death* (BF2009) is similar to that in Blake's *The Goblin* (see fig. 85).

Demuth's pristine Cubist-inspired Provincetown and Bermuda landscapes, their elegant atmospheric geometry interwoven with asymmetrical organic shapes—tree trunks and foliage—display none of the mechanistic approach of theoretical Cubism. The affinities of the artist's work with Chinese painting were observed by Barnes when, as early as 1925, he compared *Bermuda: Houses Seen through Trees* (BF647) with a fourteenth- or fifteenth-century Chinese figure painted on silk (*Man Seated* [BF86]), illustrating them side by side.[6] Barnes and de Mazia noted the original synthesis of disparate influences in the landscapes: "They differ from typical cubistic pictures in that the color-planes are varied by tonal modulations similar to those in Cézanne's water colors, and they interpenetrate much as the planes do in Cézanne's still-lifes. Frequently, Demuth varies his Cézanne-cubist form by injecting into its rhythm of interpenetrating angular planes an intertwining arabesque movement of various units, thereby giving a Chinese quality to the expression."[7]

Barnes liked Demuth and was enchanted by his work. Between 1919 and 1923 they exchanged letters on a wide range of subjects, and their preserved correspondence discloses an almost paternal solicitude for Demuth's health and welfare. In return, Demuth was forthright, trusting, and, at times, even confessional, expressing his thoughts and feelings on various shared interests. Demuth visited Lauraston to see the constantly growing collection, which he referred to in a letter written in early 1921 as "one of the modern 'seven wonders.'"[8] Dr. and Mrs. Barnes also became friendly with Demuth's mother, Augusta, and wrote to her from time to time and visited her in Lancaster. They were on such cordial terms that Barnes invited the artist and his mother to stay in his house for the month of July 1921, while he was abroad. Demuth wrote in June (undated), "Have been trying to get my mother to come and live with me in your house while you are abroad but she seems to think it too much of a responsibility—of course, I can't see it. I would like to live with the pictures for six weeks, almost as much as I would like going abroad. . . . Sorry about the house.—I would have loved it."[9]

When Demuth was diagnosed with diabetes late in 1920, Barnes reassured the artist about the prognosis and referred him to his friend and colleague Dr. David Reisman for examination. In an undated letter written early in 1921, Demuth told Barnes, "I will see Reisman on Friday, and if he sounds encouraging will go to New York over Sunday. Will take the oil paintings to Daniel's, so, if you want to follow my career as well as my health which I fear I forced on you, a bit, you can see them there."[10]

In August 1921, Demuth undertook what was envisaged as a prolonged stay in Paris. Barnes wrote to him encouragingly on August 1, "By all means go to Paris as soon as you can and stay there, for there is more real spirit of life capable of translation into the terms which you use so well than in any other place. . . . Be sure to go to see the galleries of Léonce Rosenberg where you will find all the best work of the moderns."[11] On August 26, while on a side trip to London, Demuth wrote Barnes a postcard: "Have had some fun in the B[ritish] Museum. Got ahold of a man who had brought some Indian (American) stuff over for it. He can open up all the cases and it's rather fun playing with the things,—some of which are marvelous. [Martin] Birnbaum is bringing over some good [Aubrey] Beardsleys and Blakes, I hear."[12] The artist was enthusiastic, even passionate, in his admiration for El Greco, writ-

ing Barnes soon thereafter, "I had a great time with the Blakes, about thirty of them. And a great time in the Nat. Gallery which really is there for quality of examples. The new El Grecos and,—the old ones which I remembered—[Piero] della Francesca. Oh,—it's been quite wonderful. . . . I think really I could stay on for ever,—maybe not. I suppose if I do anything it must be done in America. But certainly one can understand what kept [Henry] James from being able to live in Boston after some years here. I[t] all seems so difficult, hard, unsympathetic. Still, there does at times seem to be something doing at home."[13]

Demuth's stay in Paris was cut short by his fragile health. Just weeks after arriving he admitted himself to the American Hospital. "I'm giving myself a treat of this for a few weeks," he wrote Barnes in mid-September (undated), adding, "the boat did me up, a bit. I was not very careful. . . . Paris as you told me is really one marvelous place, why don't you come back for a few weeks and see it with me,—or come over when it's time for me to come back and return me to my native province. It has never seemed so beautiful. . . . Have seen one wonderful Matisse [*Tea*, 1919] at Bernheim's; two women in a garden, in green and gray. . . . If you want anything let me know, books, etc. . . . P.S. They are printing Ulysses by James Joyce privately—if you want a copy will get you one. 150 francs is the cheapest. Deem."[14] Barnes replied on September 29,

> Dear Deem: —I think it is the best thing you could have done, to go to the hospital for a while. . . . You must get all right because I think you ought to do some good work while over there. . . . There is nothing I would like better than to accept your suggestion to spend a few weeks with you in Paris, but that is absolutely impossible because of extraordinary demands made upon me . . . in the business. But every time you sit at Rotonde think of me, look them over and drink a demi Vichy. If you stay over until next summer, as I don't see why you should not, I'll join you and we can go off some-where in a motor. I didn't see the Matisse . . . which you tell me is at Bernheim's; but I have such confidence in your judgment that I wrote Durand-Ruel to buy the

picture for me. . . . Let me hear from you occasionally and watch your step in everything.[15]

Demuth was still describing the Matisse when he wrote to Barnes again on October 17: "It is a big canvas,—it will be larger than any picture you have except the Picasso [*Composition: The Peasants* (BF140), 87 × 51¾ in. (221 × 131.4 cm)]. . . . It is really a good late Matisse, and, will be of a quality of your others, and one of the finest Matisse[s] in our country. . . . Paris is really the place,—it is so easy to work if one wants to. . . . If I stay and you come over we will have a grand time, I know. I feel quite fit, and,—maybe I will. Will go to see [Constantin] Brancusi on Sunday. Ezra [Pound] takes me to see the great ones,—he promises to take me to see Marcel Proust. I hope that he does. That will give my French a trial!"[16] Barnes wrote on November 1, "Every letter I get from you makes my mouth water—how I envy you being in a place where one can really live. It is the best thing you ever did in your life, to go abroad at this time, and you would be very foolish if you don't try to stretch it over a couple of years. I am sure it will result in your physical, mental and artistic regeneration. I omitted the moral phase because I know you are irreproachable in that respect—at least I hope you are."[17]

Demuth's fondness for Barnes, as well as his confidence in the collector's insights and acumen, are apparent in his unpublished play, "You Must Come Over," composed some time after his last visit to Paris in 1921. One scene includes a dialogue in which a Frenchman ("V. B.") questions an American ("B.") about American painting. At first B. temporizes, wondering, "Couldn't we talk about American musical shows, revues,—the people who act in them . . . and dance: they really are our 'stuff.' They are our time," adding, a few lines down, "I love Broadway and—well, and vulgarity, and gin. In fact I love my country." V. B. continues to press B. to explain what, for him constitutes great painting. B. replies, "I'll start at what seems to me to be the beginning,—at least it's the earliest painting I've seen that seems to have,—well whatever it is, what ever that quality is which creates between itself and the beholder an understanding, a sympathy,—call it what you like if you know what I'm talking about,—otherwise,—ask Dr. Barnes. He will both tell you what it is and what I'm talking about."[18]

In the spring of 1922, Demuth's health took a serious turn, and he entered Dr. Frederick M. Allen's Physiatric Institute in Morristown, New Jersey, where Barnes's support enabled him to pay for his treatments. Allen's standard treatment at this time was to cut his patients' caloric intake drastically, starving them in order to reduce glucose levels in their blood. Demuth wrote Barnes from the sanatorium sometime in April 1922, "Well, here I am finally put away, by my own hand. . . . Very tiring.—although a wonderful place as to surrounding country. . . . It looks like Versailles in terra cuite! I will do some water colors. . . . In time, I will get everything,—that seems the idea,—even sugar. Of course, so far I've been starved, that is egg and meat in little quantities. . . . Come out to see me,—if you can. I'm bored stiff."[19]

In another undated letter from the same period, Demuth wrote Barnes on a matter of some urgency:

> Got your letter the other day and have tried to get you on the phone twice . . . but failed. I wanted to ask you if you could let me have some money, and,—well, it was easier for me to ask, than to write. You said once on . . . my going abroad, that, you would see me through if I got stuck,—so, I'm, making brave, and asking you now. Could you let me have five hundred dollars, as a loan; a straight loan with interest, or, a "lean" [sic] on any of my work which I might do, with in [sic] a reasonable time, and, which you might want? I will be here for some time,—I don't want to give it up now,—and there is little loose money at my command. If you can do this for me,—I would be very glad, as, it would put me at rest in certain directions. However I will understand,—if you don't, It is rather cheek to ask you I know, you have helped a lot as it is.[20]

Barnes replied on May 1, "I got your note and am very glad to loan you the five hundred ($500.00) dollars you ask for. At this time you don't want to worry about such matters as arranging to see that I get the money back—so we won't say anything about that now, just content yourself and stay there as long as your doctor wants you to."[21] Demuth replied (undated), "You are very good to me,—really. Thank you very, very much. I will do

my part. . . . The treatment has made me very weak,—I do very little. Dr. Allen tells me that I am getting along remarkably well."[22] After leaving the clinic, Demuth stayed on Allen's dietary regimen at home under the close supervision of his mother.

Later in the year Demuth returned to the sanatorium. By now Allen was treating some patients with the experimental drug insulin, despite risks that made Demuth reluctant to join their ranks. In November the artist wrote Barnes with a proposal (undated): "Do you know those Bermuda water-colors of mine? I have a series of 8—would you be interested? . . . Would like to get rid of them. The eight make a group and I've been trying to keep them together—*are going cheap*, as they say at the sales. . . . Allen comes high,—but is worth it. The new serum seems to be working,—I've had none so far. Allen thinks it almost a cure,—I don't want to try it quite yet,—the manufacture of it at present is not very level, as to quality,—some lots are good and others bad."[23] Barnes replied on November 27, "I have been wondering why I haven't heard from you; but your letter . . . explains everything. If Allen thinks that serum is a good thing for you, I think you ought to take that procedure."[24] He and Demuth agreed on the terms of his purchase of the watercolors in early March 1923. Just weeks later, having begun insulin therapy, the artist was able to report good news on two fronts (undated, c. April 21): "I want to tell you, among the first, that the 'Met' [Metropolitan Museum] bought, to-day . . . one of my water-colors. I know you are interested in me and my work so want you to know. Of course, I wired mother! . . . The serium [sic] so far is proving a miracle. It must be magic,—I know that I'll wake up and find it only another dream. Have gained ten pounds and can eat bread!"[25]

The Barnes-Demuth correspondence ends in the fall of 1923. The Barneses remained friendly with Augusta Demuth until her death in 1943.[26] Barnes's enthusiasm for Demuth's work remained undiminished. Their contact receded coincident with a new phase in Barnes's life, as he increasingly focused on the day-to-day work of his school. As with the other American artists—William Glackens, Alfred Maurer, Ernest Lawson, the Prendergast brothers, and Marsden Hartley—Barnes's aesthetic horizons were broadened by Demuth's singular vision.

## NOTES

Epigraph. Albert C. Barnes, Introduction, in *Exhibition of Contemporary European Paintings and Sculpture*, exh. cat. (Philadelphia: Pennsylvania Academy of the Fine Arts, 1923), 6.

1   Letter, Albert C. Barnes to John L. (Jack) Sweeney, October 26, 1943, ACB Corr., BFA. The article referred to is John L. Sweeney, "The Demuth Pictures," *Kenyon Review* 5 (Autumn 1943): 522–32. When Barnes writes "before World War I," that is to say before the United States entered the war in 1917, which corresponds to the time of his initial purchase of the artist's work. Four months earlier Sweeney had written to Barnes, "I have been working on a study of Henry James' stories. In the course of it I have drawn some conclusions from Demuth's illustrations. His compositions and insights have been very helpful to me in an analysis of James' structure . . . I should like to talk with you about Demuth's interest in James. I recall that you introduced him to James' novels." Letter, Sweeney to Barnes, June 29, 1943, ACB Corr., BFA. In a letter accompanying the article, Sweeney wrote: "I have never before attempted to write about painting and I should greatly appreciate your criticism of this effort . . . I hope that you might see, in my analysis, evidence of my debt to your teaching. I acknowledge it with gratitude." Letter, Sweeney to Barnes, October 18, 1943, ACB Corr., BFA. John Sweeney was a scholar and poet who lectured at Harvard on general education and English as well as curator of Harvard Library's Poetry Room and brother of James Johnson Sweeney (1900–1986), art critic, curator, director of the department of painting and sculpture at the Museum of Modern Art, and director of the Guggenheim Museum, with whom Barnes had been friendly since 1925. The earliest recorded acquisition of a Demuth by Barnes is *Flowers*, purchased December 19, 1916, from the exhibition Water Colors and Drawings by Charles Demuth, November 29–December 12, 1916, at the Daniel Gallery, New York. Invoice from Charles Daniel, December 14, 1916, $25.00, ACB Corr., BFA, and Albert C. Barnes check no. 3823, December 19, 1916, BFFR, BFA. (The watercolor is no longer in the collection.) On August 28, 1917, Barnes purchased ten watercolors by Demuth from Daniel for $250.00. Invoice from Charles Daniel, August 23, 1917, ACB Corr., BFA. Barnes purchased one watercolor from the artist on July 8, 1918. Albert C. Barnes check no. 4309, July 8, 1918, BFFR, BFA. Of the fifty-seven Demuths Barnes owned by 1923, forty-four remain in the collection.

2   Demuth was in Paris at the time of Stieglitz's first Rodin watercolor show in January 1908. In addition to a second Rodin drawing exhibition, in March 1911, Stieglitz also published a special Rodin issue of *Camera Work*, no. 34/35 (April–July 1911), with reproductions of nine watercolors. Demuth's watercolors convey none of the repetitive stylizations found, for example, in the small paintings on silk of Charles Conder, or the black-and-white drawings of Aubrey Beardsley, both artists whose work Demuth admired.

3   Emily Farnham, *Charles Demuth: Behind a Laughing Mask* (Norman: University of Oklahoma Press, 1971), 66.

4   Sweeney, "The Demuth Pictures," 531.

5   Demuth was likely familiar with such illustrations by Pascin as those made for *Aus den Memoiren des Herrn von Schnabelewopski von Heinrich Heine*, 1st ed. (Berlin: Cassirer, 1910), especially the drawings reproduced on the cover and pages 12, 19, 20, 23, 27, 31, 36, 40, 70, and 94. He also admired the drawings and watercolors Pascin made and exhibited while in the United States and Cuba (1914–c. 1920). Demuth painted a watercolor portrait of Pascin, *Pascin in New York City*, 10⅝ × 15 in. (27 × 38.2 cm), signed and dated C. Demuth 1916, Collection unknown. Illustrated in *American Watercolors, Drawings, Paintings and Sculpture of the 19th and 20th Centuries*, auction cat. (Christie's, New York, September 28, 1989), 188, lot no. 327. Pascin is depicted with cigarette in his mouth, seated at a café table next to a blond woman. He holds a drawing implement in his right hand. In a mirror directly behind him are reflected his head and shoulders, above which his name is written in block letters. According to Richard Weyand, Demuth owned "a little Pascin drawing of figures on a city street as well as two very small drawings of female heads by Matisse and a tiny Beardsley of two weirdly costumed figures." Interview with Richard Weyand, January 5–18, 1956, in Farnham, *Charles Demuth*, 3:964. Alvord L. Eiseman, "A Study of the Development of an Artist: Charles Demuth" (Ph.D. diss., New York University, 1976), 1:250–51, and Barbara Haskell, *Charles Demuth* (New York: Whitney Museum of American Art in association with H. N. Abrams, 1987), 60, also note Demuth's indebtedness to Pascin.

6   Albert C. Barnes, *The Art in Painting* (Merion, Pa.: Barnes Foundation Press, 1925), 362, 363.

7   Albert C. Barnes and Violette de Mazia, *The Art of Cézanne* (New York: Harcourt, Brace, 1939), 142. See also Barnes and de Mazia, *Ancient Chinese and Modern European Painting* (New York: Bignou Gallery, 1943).

8   Letter, Charles Demuth to Barnes, undated [early 1921], ACB Corr., BFA.

9   Letter, Demuth to Barnes, undated [June 1921], ACB Corr., BFA. Barnes gave Demuth a painting that he purchased at the Hartley auction at the Anderson Galleries, May, 17 1921. See Barnes's letter to Marsden Hartley, June 6, 1921, on which day Demuth visited Barnes and was presented with the Hartley. For the text of the letter, see page 252, note 1, and entry for Hartley's *Movement, Bermuda* (BF465).

10  Letter, Demuth to Barnes, undated [early 1921], ACB Corr., BFA.

11  Letter, Barnes to Demuth, August 1, 1921, ACB Corr., BFA. Léonce Rosenberg's Galerie de l'effort moderne dealt almost exclusively in Cubist and Purist art. Barnes had recently, on July 13, 1921, made purchases there and was intentionally drawing Demuth's attention to a gallery where he could see works that would coincide with his Cubist-influenced style.

12  Postcard with image of Michelangelo's *The Entombment*, National Gallery London, Demuth to Barnes, postmarked August 26, 1921, ACB Corr., BFA.

13  Letter, Demuth to Barnes, undated [late August 1921 (from London)], ACB Corr., BFA.

14  Letter, Demuth to Barnes, undated [mid-September 1921], ACB Corr., BFA. The Matisse is *Tea (Le Thé)*, 1919, 55⅛ × 83½ in. (140 × 212 cm), Los Angeles County Museum of Art.

15  Letter, Barnes to Demuth, September 29, 1921, ACB Corr., BFA. The deal was not consummated because the painting was too large to accommodate in Barnes's house.

16  Letter, Demuth to Barnes, October 17, 1921, ACB Corr., BFA.

17  Letter, Barnes to Demuth, November 1, 1921, ACB Corr., BFA. This letter contains Barnes's only allusion to Demuth's homosexuality in their correspondence.

18  Farnham, *Charles Demuth*, 3:929–30 (from Frank Weyand scrapbook no. 1, 82–83).

19  Letter, Demuth to Barnes, undated [April 1922], ACB Corr., BFA.

20  Letter, Demuth to Barnes, undated [April 1922], ACB Corr., BFA.

21  Letter, Barnes to Demuth, May 5, 1922, ACB Corr., BFA.

22  Letter, Demuth to Barnes, undated [early May 1922], ACB Corr., BFA.

23  Letter, Demuth to Barnes, undated [November 1922], ACB Corr., BFA. For the reaction of patients to treatment with insulin, see Michael Bliss, *The Discovery of Insulin* (Chicago: University of Chicago Press, 1982), Chapter 7, "Resurrection."

24  Letter, Barnes to Demuth, November 27, 1922, ACB Corr., BFA.

25  Letter, Demuth to Barnes, undated [c. April 21, 1923], ACB Corr., BFA.

26  According to Richard Weyand, "She left a Mayan stone toad and a set of dining room chairs to Dr. Albert C. Barnes, who had befriended Charles." Farnham, *Charles Demuth*, 3:964. The Mayan sculpture (a gift from Marsden Hartley) is today not considered authentic.

## NOTE ON DEMUTH SOURCES

Following the death of Demuth's mother, Augusta, in 1943, Richard Weyand, a cousin of Robert Locher, heir to the unsold watercolors and papers left by Demuth, inherited Locher's estate. Weyand compiled a catalogue of Demuth's work, which was never completed or published. Weyand's scrapbooks and research materials were divided among heirs and dispersed following his death intestate, in 1956, several months after the death of Robert Locher. Part of this material is now at the Yale Collection of American Literature, Beinecke Rare Book and Manuscript Library, Yale University, and other papers are dispersed and considered lost. Emily Farnham interviewed Weyand in 1956 and had access to Weyand's material prior to its dispersal. In her doctoral dissertation Farnham catalogues the works by Demuth known to her. Where she references the fifteen works from the Barnes Foundation recorded on Weyand's list (indicated by a "W" followed by his number), it has been included herein following Farnham's catalogue number.

The publications on Demuth listed below are abbreviated in the individual entries. None of these sources records or reproduces all of the forty-four works by the artist in the collection of the Barnes Foundation: Pamela Edwards Allara, "The Water-color Illustrations of Charles Demuth" (Ph.D. diss., Johns Hopkins University, 1970) (hereafter abbreviated as Allara, 1970); Alvord L. Eiseman, "A Study of the Development of an Artist: Charles Demuth," 2 vols. (Ph.D. diss., New York University, 1976) (Eiseman, 1976); Betsy Fahlman, *Chimneys and Towers: Charles Demuth's Late Paintings of Lancaster*, exh. cat. (Fort Worth: Amon Carter Museum; distributed by the University of Pennsylvania Press, 2007) (Fahlman, 2007); Emily Farnham, "Charles Demuth: His Life, Psychology and Works," 3 vols. (Ph.D. diss., Ohio State University, 1959) (Farnham, 1959); Emily Farnham, *Charles Demuth: Behind a Laughing Mask* (Norman: University of Oklahoma Press, 1971) (Farnham, 1971); Albert E. Gallatin, *Charles Demuth* (New York: William Edwin Rudge, 1927) (Gallatin, 1927); Eunice Mylonas Hale, "Charles Demuth: His Study of the Figure," 3 vols. (Ph.D. diss., New York University, 1974) (Hale, 1974); Barbara Haskell, *Charles Demuth* (New York: Whitney Museum of American Art in association with H. N. Abrams, 1987) (Haskell, 1987); Andrew Carnduff Ritchie, *Charles Demuth* (New York: Museum of Modern Art, 1950) (Ritchie, 1950); Jonathan Weinberg, *Speaking for Vice: Homosexuality in the Art of Charles Demuth, Marsden Hartley, and the First American Avant-Garde* (New Haven and London: Yale University Press, 1993) (Weinberg, 1993).

All correspondence from Charles Demuth to Albert C. Barnes quoted herein is courtesy of the Demuth Museum, Lancaster, Pennsylvania.

## NOTE ON DEMUTH SERIES AND PROVENANCE

None of Demuth's watercolor illustrations were commissions or made in anticipation of being published.

Demuth created eleven illustrations for Émile Zola's *Nana*; Barnes purchased eight of these—*Count Muffat's First View of Nana at the Theatre* (BF1074), *Nana Visiting Her Friend Satin* (BF1072), *Nana and Her Men* (BF1073), *Nana at the Races* (BF1068), *Scene after Georges Stabs Himself with the Scissors* (BF1076), *Nana and Count Muffat* (BF1075),

*Count Muffat Discovers Nana with the Marquis de Chouard* (BF1071), and *The Death of Nana* (BF1077)—from the artist on March 3, 1922, for $45.00 each.[1] The other three are in the collections of the Museum of Modern Art, New York, and the Museum of Fine Arts, Boston, and a private collection.

Demuth made a total of six known watercolor illustrations for two plays, *Erdgeist (Earth-Spirit): A Tragedy in Four Acts* and *Pandora's Box: A Tragedy in Three Acts*, by the German playwright Benjamin Franklin (Frank) Wedekind (1864–1918). Barnes acquired all six, later deaccessioning one. Wedekind began writing the plays in 1892 as a single work, *Die Büchse der Pandora (Pandora's Box)*, but the play was so long that it was broken up into two segments, the first of which, *Erdgeist*, was published in 1895 and first produced in 1898. In its sequel, *Die Büchse der Pandora*, published and produced in 1905, the author reorganized and changed much of the dialogue from *Erdgeist*. This overlap between the two plays has caused a considerable amount of confusion for scholars (see below). Collectively, the two plays were known as the "Lulu series," or "Lulu tragedies," based on the name of one of the main characters. Wedekind worked on and revised the plays over a period of nine years. One of their main sources was Émile Zola's *Nana*.

*Erdgeist* was published in an English translation by Samuel A. Eliot, Jr., as *Erdgeist (Earth-Spirit): A Tragedy in Four Acts* (New York: Albert and Charles Boni, 1914). Four years later, *Pandora's Box: A Tragedy in Three Acts*, also translated into English by Samuel A. Eliot, Jr., was published (New York: Boni and Liveright, 1918). *Pandora's Box* Act I consists of a rewritten version of Act IV of *Erdgeist*, a fact acknowledged by Wedekind in the text of the stage direction prior to the opening dialogue. Demuth's illustrations depict scenes from each of the plays, some made up of dialogue from several nonconsecutive lines but always in the same sequence as in the acts. The dialogue, written in graphite in cartoon-like balloons within Demuth's five watercolors, is taken verbatim from the text of Eliot's translations and inscribed by the artist, in roman numerals, with the numbers of the acts in which the dialogue supposedly appears. However, the "act numbers" assigned by Demuth do not correspond to the act numbers in Eliot's texts. All six watercolors are dated 1918, but the order in which they were made is not apparent. Two "illustrations"—*No, No O God!* (BF2011) and *Lulu and Alva Schön at Lunch* (BF1070)—are of scenes from *Earth-Spirit*, and three—*Lulu and Alva Schön* (BF2013), *The Ladies Will Pardon My Mouth's Being Full* (BF1069), and *The Death of Countess Geschwitz* (BF2012)—are of scenes from *Pandora's Box*.

None of the scholars cited in the sources listed above had complete access to the inscriptions found on the individual sheets of Demuth's illustrations or on their secondary supports. Because Wedekind rewrote his material, Act I of *Pandora's Box* can also be considered to be Act IV, making Act II, Act V, and Act III, Act VI. Andrew C. Ritchie (Ritchie, 1950), the first to publish Demuth's illustrations, devised a system that acknowledged the dual act numbers, which he calls a "combined version." Demuth, in 1918, apparently thinking along the same lines, had inscribed these watercolors with adjusted act numbers that do not appear in Eliot's published text. Farnham (1959), in her catalogue, follows Ritchie in referring to two different act numbers, that is, "Act I, or V 'in the combined version.'" Allara (1970, 145, note 52) states: "When labeling these illustrations, Demuth reversed the Act numbers on Acts III and IV." In fact, *none* of Demuth's inscriptions correspond to the published act numbers. Therefore, the act numbers and the pages in the 1914 and 1918 English translations in which the dialogue appears are the act and page numbers given herein in the five entries.

There are nine of Demuth's Bermuda watercolors in the collection of the Barnes Foundation: *Bermuda Landscape No. 2* (BF491), *Bermuda Landscape No. 1* (BF492), *Bermuda: Houses Seen through Trees* (BF647), *Bermuda—Rooftops through Trees* (BF648), *Bermuda—Tree* (BF649), *Bermuda: Stairway* (BF656), *Bermuda: Trees and Architecture* (BF658), *Bermuda, Masts and Foliage* (BF705), and *Bermuda Houses* (BF708). The collector acquired at least eight of the artist's Bermuda watercolors in 1922 and 1923.[2]

Barnes made a payment to the Daniel Gallery of $250.00 on August 23, 1917, for ten unspecified watercolors. In all likelihood this was payment for vaudeville and beach subjects. In addition, Barnes paid Demuth for unspecified works in three other transactions.[3] In the 1940s Barnes

sold or traded or gifted at least thirteen Demuth watercolors, including one of the Wedekind illustrations, "The Animal Trainer Presents Lulu," to Violette de Mazia (see entry for *The Ladies Will Pardon My Mouth's Being Full* [BF1069]). There is, therefore, no way of fully documenting the provenance of the fifty-seven works he purchased.

1 Letter, Albert C. Barnes to Charles Demuth, March 3, 1922, ACB Corr., BFA: "Dear Deem:—I just got back from Florida and found your eight drawings for *Nana*, check for which, at the agreed price of forty-five ($45.00) dollars each is herewith enclosed. They look better to me framed than they did in the original—which is saying a great deal. I like them very much." Albert C. Barnes check no. 5119, March 3, 1922, BFFR, BFA.

2 Albert C. Barnes check no. 25, May 1, 1922, $500.00, payable to Charles Demuth for "5 Bermuda 1917," and Barnes Foundation check no. 52, March 6, 1923, $300.00, payable to Charles Demuth for "3 water colors Bermuda." Both checks BFFR, BFA. The particular works acquired with each purchase are not specified.

3 These consist of Albert C. Barnes check no. 5119, March 3, 1922, in the amount of $360.00, in payment for the eight watercolors from the *Nana* series referred to in Barnes's letter to Demuth of February 26, 1923, in which he mentions buying the "Nana set" for "forty each" (in fact, it was $45.00 each; see note 1 above); and two checks, the first, no. 4881, February 11, 1921, in the amount of $325.00 for "nine drawings [that is, watercolors] $35—$315 [and] Due on drawing left here recently $10= $325," and another, no. 4962, June 2, 1921, in the amount of $250.00. Three checks BFFR, BFA. The latter two checks do not specify the subjects or titles of the works purchased.

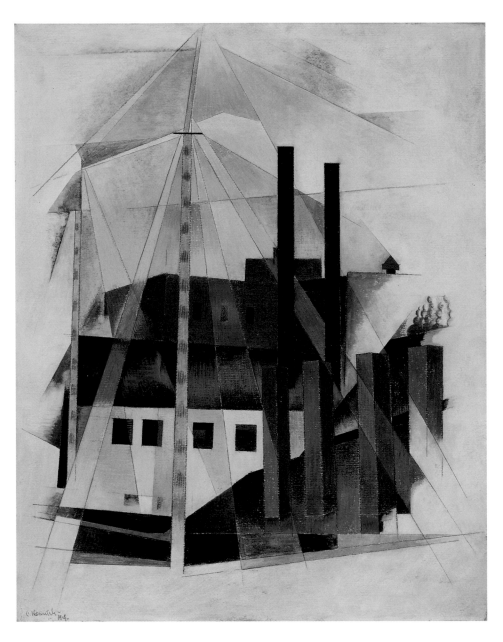

## Piano Mover's Holiday
Alternate titles: *For W. Carlos W.; Factory Tops; Roofs*

1919. Tempera on composition board, 20 × 16 in. (50.8 × 40.6 cm). Signed and dated lower left: C. Demuth 1919. Inscribed verso: *The Piano Movers Holiday / C.D. / 1919.* BF339

PROVENANCE: Acquired from the artist, December 8, 1921, for $150.00.[1]

EXHIBITION: Daniel Gallery, New York, Arrangements of the American Landscape Forms by Charles Demuth, December 1920–January 7, 1921.

REFERENCES: *Arrangements of the American Landscape Forms by Charles Demuth*, exh. cat. (New York: Daniel Gallery, 1920), cat. no. 7 (as *For W. Carlos W.*); Mary Mullen, *An Approach to Art* (Merion, Pa.: Barnes Foundation Press, 1923), 67, ill. (as *Factory Tops*); Gallatin, 1927, ill.; Farnham, 1959, 2:551–52, no. 361 (W 905, as *Piano Mover's Holiday or Factory Tops*); Violette de Mazia, "Subject and Subject Matter," *Vistas* 2, no. 1 (Spring–Summer 1980): 4, 7, pl. 9; Fahlman, 2007, fig. 47, ill. 99.

REMARKS: The playful, somewhat enigmatic, occasionally indecipherable titles of Demuth's Cubist compositions painted in tempera from c. 1919 onward, such as *Piano Mover's Holiday* and *Chiminies, Ventilators or Whatever* (BF343), are often difficult to interpret and perhaps have their sources in those of the "metaphysical" compositions of Giorgio de Chirico. In this instance, however, a transcription of a poem in Nelle Mullen's handwriting (presumably a copy of a document Demuth sent to Barnes) is quite specific:

> Piano Movers Holiday [*sic*]
> The Sky after El Greco
> Pyramids in amythist [*sic*]
> In the Province #7
> The Rise of the Prism
> In the Province #1
> For W. Carlos W. [William Carlos Williams (1883–1963)]
>
> Chimnies [*sic*] Ventilators or whatever
> Rec'd Aug 4—1921 from Chas Demuth[2]

The poem describes *Piano Mover's Holiday*, which has diffuse areas of pale amethyst tints in the pyramid-like shapes and radiating prismatic rays that contrast with the firmly delineated patterns of red and black in the architectural elements of the composition. In the catalogue of the Daniel Gallery exhibition, no. 7 is *For W. Carlos W.* Cat. no. 1 is entitled *Pennsylvania.* Demuth referred to Lancaster, Penn., as "the province."[3]

1　Letter, Albert C. Barnes to Charles Demuth, December 8, 1921, ACB Corr., BFA: "Enclosed is my check for three hundred ($300.00) dollars which I understand is the price of your two paintings, 'The Piano-Mover's Holiday' and 'Roofs, Chimney Tops and Whatever' [BF343]." Nearly three years earlier, Demuth had written Barnes: "I will have some new things in tempera which you might like to see." Letter, Demuth to Barnes, undated [January 1919]. Barnes replied: "I shall be glad to see your new things." Letter, Barnes to Demuth, January 22, 1919. Both letters ACB Corr., BFA.

2　Document transcribed by Nelle Mullen, Demuth correspondence, ACB Corr., BFA.

3　See Fahlman, 2007, 62–63: "[Demuth's] affectionate and ironic term for his hometown."

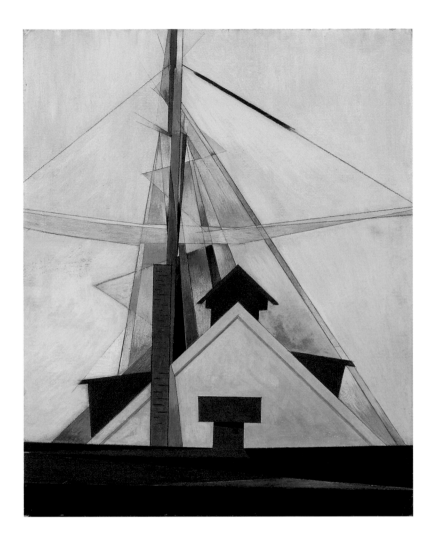

## Masts

Alternate title: *Chiminies, Ventilators or Whatever*

1919. Tempera on composition board, 19⅞ × 16⁵⁄₁₆ in. (50.5 × 41.4 cm). Signed, dated, and inscribed: *C. Demuth 1919 / Gloucester, Mass.* Inscribed on printed paper label verso: *300.– / Return to / The Daniel / Gallery / 2 West 47th St. / New York / Charles Demuth / "Chimnies [sic] Ventilators / or whatever"*; inscribed verso: *Chiminies, Ventilators or whatever. / C. D. 1919—*. BF343

PROVENANCE: Acquired from the artist, December 8, 1921, for $150.00. See entry for *Piano Mover's Holiday* (BF339).

EXHIBITION: Daniel Gallery, New York, Arrangements of the American Landscape Forms by Charles Demuth, December 1920–January 7, 1921.

REFERENCES: *Arrangements of the American Landscape Forms by Charles Demuth*, exh. cat. (New York: Daniel Gal-lery, 1920), cat. no. 11, *Chimnies [sic], Ventilators, or Whatever*; Farnham, 1959, 2:551, no. 360; Fahlman, 2007, 113, fig. 52.

REMARKS: Ira Glackens recalled: "The artist Charles Demuth was spending the summer [of 1919] at Gloucester. The G.'s saw a good deal of him, and more than once had motored with the Barneses to the old Demuth house at Lancaster."[1] Fahlman claims that Glackens introduced Barnes to Demuth but cites no document. She also states "Barnes once owned fifty works by Demuth," whereas by 1943 he owned at least fifty-seven.[2]

1 Ira Glackens, *William Glackens and the Ashcan Group* (New York: Crown, 1957), 189–90.

2 Fahlman, 2007, 69.

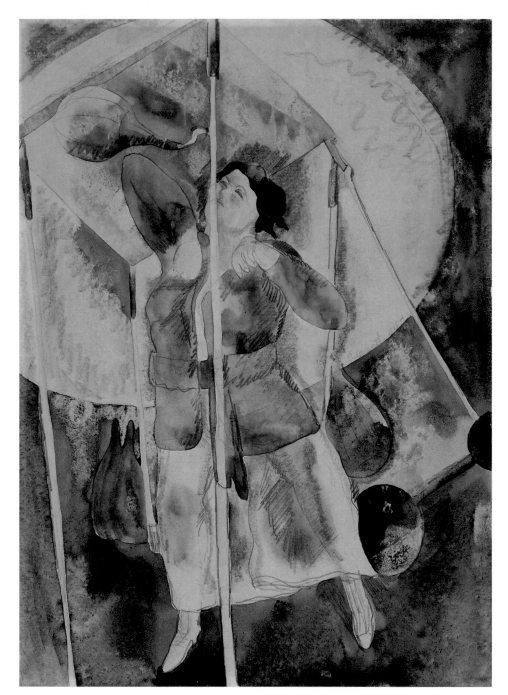

## Woman Punching Bag
Alternate titles: *Woman with Punching Bag; The Bag Puncher*

1915. Watercolor and graphite on laid paper, 11⅜ × 8⅛ in. (28.9 × 20.6 cm). Signed and dated center right: C. Demuth 1915. BF1001

PROVENANCE: Unknown.

EXHIBITION: The Reading Public Museum and Art Gallery, September–October 15, 1939.[1]

REFERENCE: Farnham, 1959, 2:543, no. 343.

REMARKS: In August 1939, Laurence Buermeyer, who was from Reading, asked Barnes to receive Mr. Earl L. Poole, director of the Reading Public Museum and Art Gallery. The visit took place later that month.[2] A loan of pictures from the Foundation to Reading was discussed, as Poole wrote Barnes on September 5, "Would it be satisfactory to you to have our truck call for the pictures that you so kindly set aside on next Monday?"[3] The loan was noted in the *Reading Eagle*, "An exhibition of modern paintings by French and American artists is being shown at the Reading Museum this week and will continue until October 15."[4] Twenty-four works were lent and no catalogue was published. In February 1940, soon after he had purchased Horace Pippin's *Cabin in the Cotton I* (see pages 307 and 309–10, note 11), Barnes wrote to Charles Laughton concerning a loan of nineteen paintings, watercolors, and drawings selected mainly from the twenty-four works lent to Reading. "Last fall I loaned twenty-four pictures to the City Art Gallery of Reading, Pennsylvania, for a loan exhibition and they have not yet been returned. I shall write and ask to have them sent back immediately . . . I enclose a list of the paintings we loaned to the Reading Art Gallery."[5] On the list, eighteen works are identified by BF numbers; *Woman with Punching Bag* has no BF number (although it was no. 497 on the 1922–1924 Inventory). There are no identifying exhibition labels affixed to those works from the Reading loan remaining in the collection, such as *Woman Punching Bag*.

1 "List of Pictures to be Loaned to Reading," no. 24 ("Demuth—Woman with Punching Bag"), in 1940 Barnes–Laurence Buermeyer correspondence, ACB Corr., BFA.

2 Letter, Laurence Buermeyer to Albert C. Barnes, August 28, 1939, thanking Barnes for the visit, ACB Corr., BFA.

3 Letter, Earl L. Poole to Barnes, September 5, 1939, ACB Corr., BFA.

4 "Exhibit of Paintings Planned at Museum," *Reading Eagle*, September 18, 1939, 11.

5 Letter, Barnes to Charles Laughton, February 26, 1940, ACB Corr., BFA. *Woman with Punching Bag* was no. 3 among the seven watercolors and drawings lent to Laughton (AR.ABC. 1940.390). This seems to indicate that the Reading exhibition continued well after October 15, 1939.

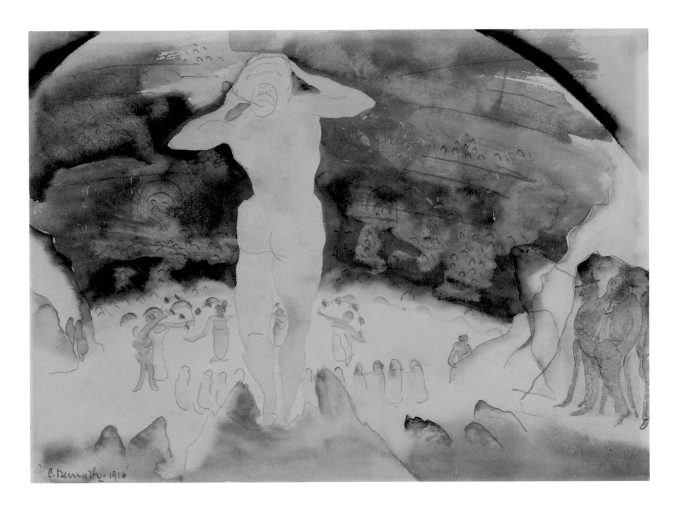

## Count Muffat's First View
## of Nana at the Theatre
Alternate title: *Nana at the Gaiety Theatre*

1916. Watercolor and graphite on wove paper, $7^{15}/_{16} \times 10^{7}/_{8}$ in. (20.2 × 27.6 cm). Signed and dated lower left: C. Demuth 1916. Illustration for Émile Zola's *Nana*, Chapter 5. BF1074

PROVENANCE: Acquired from the artist, March 3, 1922, for $45.00. See "Note on Demuth Series and Provenance," page 267, notes 1 and 3.

EXHIBITIONS: Some of the *Nana* illustrations were shown to private clients by Charles Daniel at the time of Demuth's second exhibition at the Daniel Gallery, New York, November 29–December 12, 1916; and at the Daniel Gallery, New York, Arrangements of the American Landscape Forms by Charles Demuth, December 1920–January 7, 1921.[1] Barbara Haskell states that eight (of eleven) from the *Nana* series were exhibited in March 1921 at the Grafton Galleries, London, as a supplement to the Venice Biennale in 1921. The

exhibition comprised one hundred and fifty works and was organized by Mrs. Harry Payne Whitney.[2]

REFERENCES: Ritchie, 1950, 36, ill. (as 1915–16); Farnham, 1959, 2:449, no. 99 (W 940, as 1915–16); Allara, 1970, 270, cat. no. 7, pl. 21; Hale, 1974, 318, fig. 40; Eiseman, 1976, 1: ill. 179; Haskell, 1987, ill. 100 (as 1915); Weinberg, 1993, 67, fig. 21 (as 1915–16); Robin Jaffee Frank, *Charles Demuth: Poster Portraits 1923–1929* (New Haven, Conn.: Yale University Art Gallery, 1994), 59, fig. 57 (as 1915).

1  See Forbes Watson, "At the Galleries," *Arts and Decoration*, January 1921, 215: "The Daniel galleries are showing an exhibition of paintings by Charles Demuth. . . . Whoever enjoys a whimsical imagination will revel in Mr. Demuth's illustrations of Zola's *Nana* which are exhibited once more in the small anteroom. The man who obtains this group of illustrations will be a lucky man."

2  Haskell, 1987, 111 n. 5. See "London Cool to Whitney Exhibit," *American Art News*, April 9, 1921, 10.

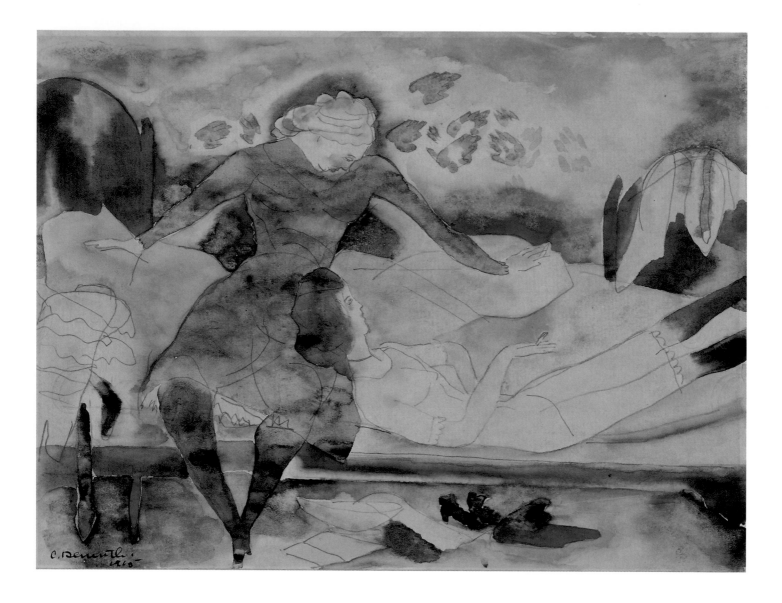

### Nana Visiting Her Friend Satin

1915. Watercolor and graphite on wove paper, 7⅞ × 10⅜ in. (20 × 26.4 cm). Signed and dated lower left: C. Demuth / 1915. Inscribed lower left secondary support: *Drawing for Zola's "Nana"*; lower right secondary support: *Nana and Satin*; secondary support verso: *32*. Illustration for Émile Zola's *Nana*, Chapter 8. BF1072

PROVENANCE: Acquired from the artist, March 3, 1922, for $45.00. See "Note on Demuth Series and Provenance," page 267, notes 1 and 3.

REFERENCES: Ritchie, 1950, 37, ill.; Farnham, 1959, 2:459–60, no. 126 (W 941); Allara, 1970, 269, cat. no. 3, pl. 18; Hale, 1974, 319, fig. 41; Eiseman, 1976, 1:180, ill. 181; Haskell, 1987, ill. 100; Weinberg, 1993, 74, fig. 27.

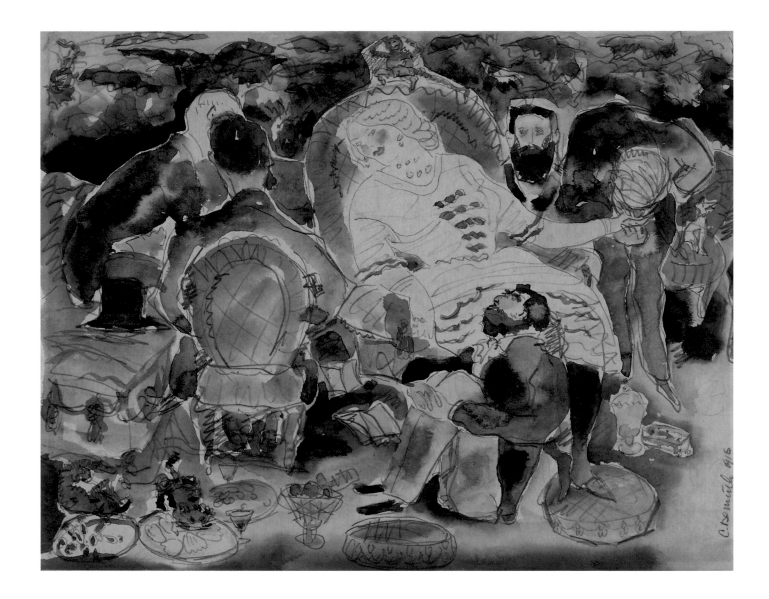

## Nana and Her Men

1915. Watercolor and graphite on wove paper, 7¹⁵⁄₁₆ × 10¼ in. (20.2 × 26 cm). Signed and dated at lower right: C. Demuth 1915. Inscribed lower left secondary support: *Drawing for Zola's "Nana"*; lower right secondary support: *Une Matinée dans le Jardin d'Hiver.* Illustration for Émile Zola's *Nana*, Chapter 10. BF1073

PROVENANCE: Acquired from the artist, March 3, 1922, for $45.00. See "Note on Demuth Series and Provenance," page 267, notes 1 and 3.

REFERENCES: Ritchie, 1950, ill. 39; Farnham, 1959, 2:458–59, no. 124 (W 942, as *Illustration #3 for Zola's Nana*); Allara, 1970, 269, cat. no. 3, pl. 13; Hale, 1974, 325, fig. 51; Eiseman, 1976, 1: ill. 183; Haskell, 1987, ill. 101; Weinberg, 1993, 68, fig. 22; Mark D. Mitchell, "A New Tradition: Cézanne, Demuth, and the Invention of Modern Watercolor," in Joseph J. Rishel and Katherine Sachs, eds., *Cézanne and Beyond*, exh. cat. (Philadelphia: Philadelphia Museum of Art in association with Yale University Press, 2009), 284.

## Nana at the Races

1915–16. Watercolor and graphite on thin wove paper, 10⅛ × 8 in. (25.7 × 20.3 cm). Signed lower left: C. Demuth. Inscribed lower left secondary support: *Le Grand Prix— / Nana! Nana!*; lower right secondary support: *Drawing for Zola's "Nana."* Illustration for Émile Zola's *Nana*, Chapter 11. BF1068

PROVENANCE: Acquired from the artist, March 3, 1922, for $45.00. See "Note on Demuth Series and Provenance," page 267, notes 1 and 3.

REFERENCES: Albert C. Barnes and Violette de Mazia, *The Art of Cézanne* (New York: Harcourt, Brace, 1939), 142n (as *Nana*); Ritchie, 1950, ill. 40; Farnham, 1959, 2:459, no. 125 (W 943); Allara, 1970, 270, cat. no. 6, pl. 15; Hale, 1974, 323, ill., fig. 47; Eiseman, 1976, 1: ill. 184; Haskell, 1987, ill. 102. See Julie Mellby, "A Record of Charles Daniel and the Daniel Gallery" (M.A. thesis, Hunter College of the City University of New York, 1993), 32–33, who details the exhibition history of the *Nana* illustrations, and see also the critical response by critic Henry McBride, "Charles Demuth Exhibition," *New York Sun*, December 3, 1916, Section V, 12: "They are kept in a portfolio, and are only shown to museum directors and proved lovers of modern art upon presentation of visiting cards. They are quite advanced in style."

REMARKS: Allara, 1970, erroneously states that the eight illustrations for Zola's *Nana* were purchased by the Barnes Foundation from the Daniel Gallery in 1922. The Barnes Foundation was not established until December 1922.

## Scene after Georges Stabs Himself with the Scissors

1916. Watercolor and graphite on wove paper, 8⅛ × 10¹¹⁄₁₆ in. (20.6 × 27.1 cm). Signed and dated upper right: C. Demuth / 1916. Inscribed lower left secondary support: *Drawing for Zola's "Nana"*; lower right secondary support: *La fin de Georges Hugon*. Illustration for Émile Zola's *Nana*, Chapter 13. BF1076

PROVENANCE: Acquired from the artist March 3, 1922, for $45.00. See "Note on Demuth Series and Provenance," page 267, notes 1 and 3.

REFERENCES: Ritchie, 1950, ill. 42; Farnham, 1959, 2:489–90, no. 206 (W 944); Allara, 1970, 270, cat. no. 8, pl. 19; Hale, 1974, 322, fig. 45; Eiseman, 1976, 1: ill. 188; Haskell, 1987, ill. 101.

RELATED WORK: A variant version is in the Museum of Fine Arts, Boston (Charles Henry Hayden Fund); Ritchie, 1950, ill. 45. Ritchie, 1950, reproduces both and claims the MFA sheet is the second version; Eiseman, 1976, and Haskell, 1987, follow Ritchie.

## *Nana and Count Muffat*

1916. Watercolor and graphite on thin wove paper, 8 × 10¾ in. (20.3 × 27.3 cm). Signed lower left: C. Demuth 1916. Inscribed lower left secondary support: *Drawing for Zola's "Nana"*; lower right secondary support: *Conte [sic] Muffat du Béville*. Illustration for Émile Zola's *Nana*, Chapter 13. BF1075

PROVENANCE: Acquired from the artist, March 3, 1922, for $45.00. See "Note on Demuth Series and Provenance," page 267, notes 1 and 3.

REFERENCES: Ritchie, 1950, ill. 45; Farnham, 1959, 2:485, no. 196 (W 946), and 1:390, ill., fig. 9; Allara, 1970, 270, cat. no. 9, pl. 22; Hale, 1974, 324, fig. 50; Eiseman, 1976, 1: ill. 187; Haskell, 1987, 103, ill.

*Count Muffat Discovers Nana with the Marquis de Chouard*

1915. Watercolor, graphite, and pen and ink on thin wove paper, 8½ × 10¹⁵⁄₁₆ in. (21.6 × 27.8 cm). Signed and dated lower left: C. Demuth 1915. Inscribed lower left secondary support: *Drawing for Zola's "Nana"*; lower right secondary support: *Le Lit d'Or*. Illustration for Émile Zola's *Nana*, Chapter 13. BF1071

PROVENANCE: Acquired from the artist, March 3, 1922, for $45.00. See "Note on Demuth Series and Provenance," page 267, notes 1 and 3.

REFERENCES: Ritchie, 1950, 46, ill.; Farnham, 1959, 2:448–49, no. 98 (W 947); Allara, 1970, 269, cat. no. 4, pl. 16; Eiseman, 1976, 1: ill. 188; Haskell, 1987, ill. 103 (as 1915); Mark D. Mitchell, "A New Tradition: Cézanne, Demuth, and the Invention of Modern Watercolor," in Joseph J. Rishel and Katherine Sachs, eds., *Cézanne and Beyond*, exh. cat. (Philadelphia: Philadelphia Museum of Art in association with Yale University Press, 2009), 284, ill. 283 with Cézanne's *A Modern Olympia* (Musée d'Orsay, Paris) and *Eternal Feminine* (J. Paul Getty Museum, Los Angeles).

### The Death of Nana

1915. Watercolor and graphite on wove paper, 8½ × 10⅞ in.
(21.6 × 27.6 cm). Signed and dated lower left: C. Demuth /
1915. Inscribed lower left secondary support: *Drawing for
Zola's "Nana"*; lower right secondary support: *La morte /
à Berlin, à Berlin*. Illustration for Émile Zola's *Nana*,
Chapter 14. BF1077

PROVENANCE: Acquired from the artist, March 3, 1922,
for $45.00. See "Note on Demuth Series and Provenance,"
page 267, notes 1 and 3.

REFERENCES: Ritchie, 1950, 47, ill.; Farnham, 1959, 2:450–
51, no. 102 (W 948); Allara, 1970, 269, cat. no. 1, pl. 17; Hale,
1974, 318, fig. 39; Haskell, 1987, ill. 104; Weinberg, 1993, 70–71,
fig. 24.

## Artists Sketching

1916. Watercolor and graphite on thin wove paper, 7⅞ × 9¹⁵⁄₁₆ in. (20 × 25.2 cm). Signed and dated lower right: C. Demuth 1916. BF2039

PROVENANCE: Possibly one of the watercolors purchased from Charles Daniel, August 23, 1917. See "Note on Demuth Series and Provenance," page 265.

REFERENCE: Farnham, 1959, 2:644, no. 580. The author mistakenly speculates that *Artists Sketching* "may be *A Prince of Court Painters #2* (c. 1918), illustration for Walter Pater's *Imaginary Portraits*, section on Watteau." Since no dimensions are given, Farnham did not see the watercolor.

REMARKS: The scene would appear to be an outdoor sketching class observed in Provincetown that summer.

## Two Women and Child on Beach

1916. Graphite and watercolor on wove paper, 8 × 10 in. (20.3 × 25.4 cm). Signed and dated lower left: C. D. 1916. BF704

PROVENANCE: Possibly one of the watercolors purchased from Charles Daniel, August 23, 1917. See "Note on Demuth Series and Provenance," page 265.

REFERENCE: Farnham, 1959, 2:650, no. 598 (no date, no dimensions given).

## Three Figures Sketching

1916. Watercolor and graphite on wove paper, 7⅞ × 9¹⁵⁄₁₆ in. (20 × 25.2 cm). Signed and dated lower left: C. Demuth 1916. BF707

PROVENANCE: Possibly one of the watercolors purchased from Charles Daniel, August 23, 1917. See "Note on Demuth Series and Provenance," page 265.

REFERENCE: Violette de Mazia, "The Barnes Foundation: The Display of Its Art Collection," *Vistas* 2, no. 2 (1981–83): 109n, pl. 118 (installation). Not in Farnham, 1959.

## Three Figures in Water

1916. Watercolor and graphite on wove paper, 8⁵⁄₁₆ × 10⅞ in. (21.1 × 27.6 cm). Signed and dated lower left: C. Demuth 1619 [numbers transposed]. BF1041

PROVENANCE: Possibly one of the watercolors purchased from Charles Daniel, August 23, 1917. See "Note on Demuth Series and Provenance," page 265.

REFERENCE: Farnham, 1959, 2:492, no. 212.

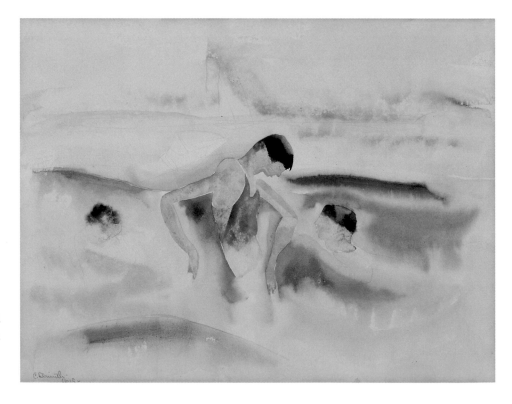

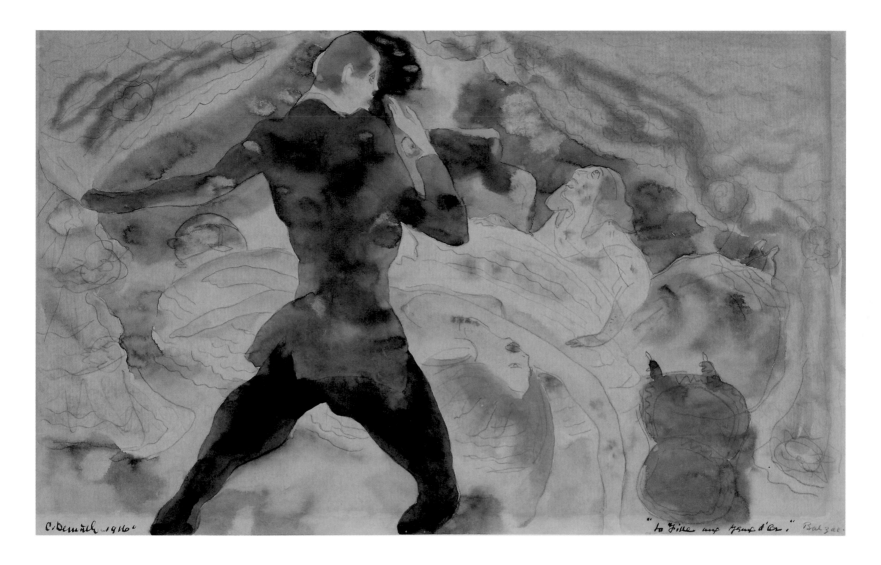

## La Fille aux Yeux d'Or (The Girl with the Golden Eyes)
### Alternate title: *The Death of Paquita*

1916. Watercolor and graphite on wove paper, 8 × 13 in. (20.3 × 33 cm). Signed and dated lower left: C. Demuth 1916. Inscribed lower right: *La Fille aux Yeux d'Or.*; *Balzac.* Illustration for Honoré de Balzac's *La Fille aux Yeux d'Or* from the *Comédie humaine*. BF2008

PROVENANCE: Unknown.

REFERENCES: Ritchie, 1950, 44, ill., mistakenly identifies the subject as "Satin in a Frenzy (?), Illustration no. 9 for Zola's *Nana* Chapter XIII?, 1915–16"; Farnham, 1959, 2:462, no. 132 (W 945), erroneously follows Ritchie, whom she cites; Allara, 1970, 272, cat. no. 13, pl. 27, uses the title *The Death of Paquita* (the specific scene represented); Hale, 1974, 324, fig. 49, erroneously follows Ritchie and Farnham; Eiseman, 1976, 1: ill. 186, erroneously follows Ritchie, Farnham, and Hale; Haskell, 1987, 102–04, ill. 105 (as *Girl with the Golden Eyes*); Weinberg, 1993, 72, fig. 26 (as *The Girl with the Golden Eyes*, 1915).

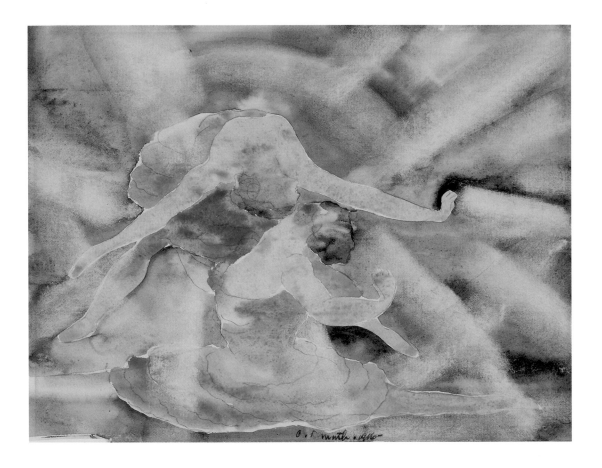

## Two Women Acrobats

1916. Watercolor and graphite on wove paper, 8 × 10⅜ in. (20.3 × 26.4 cm). Signed and dated lower center: C. Demuth 1916. BF745

PROVENANCE: Unknown.

REFERENCE: Farnham, 1959, 2:496–97, no. 225.

REMARKS: William Blake's influence on Demuth's figurative watercolors, especially his vaudeville subjects and illustration, was pervasive. Demuth's adaptations not only are seen in poses and linear elements but are found in the rays of color and light that serve as background settings for these figures, which are reminiscent of Blake's *Albion Rose (Dance of the Albion)* (fig. 84).

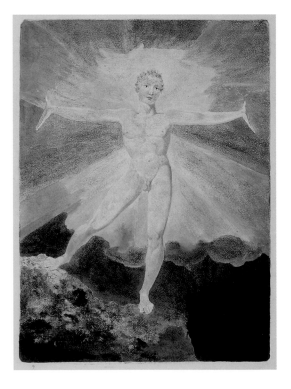

FIG. 84

William Blake, *Albion Rose (Dance of the Albion)*, c. 1794–96, color printed and hand finished with watercolors, 10⅜ × 7⅜ in. (26.4 × 18.7 cm), Huntington Library, Art Collections, and Botanical Gardens, San Marino, California

## In Vaudeville: Two Acrobat-Jugglers
Alternate titles: *Acrobats; In Vaudeville: Two Acrobats*

1916. Watercolor and graphite on wove paper, 11³⁄₁₆ × 8 in. (28.4 × 20.3 cm). Signed and dated lower center: C. Demuth 1916. BF602

PROVENANCE: Acquired from the artist in 1920 for $35.00.[1]

REFERENCES: "Water-color—A Weapon of Wit: Art Critics Dispute the Diabolic Delicacies of Charles Demuth's Brush," *Current Opinion*, January 1919, 51–52, ill. 51 (as *Acrobats*); Albert E. Gallatin, *American Water-Colorists* (New York: Dutton, 1922), no. 25, ill. (as *Acrobats*); "Acrobats by Charles Demuth Property of A.C. Barnes," *The Dial* LXXII, no. 6 (June 1922), frontispiece (facing p. 553); Forbes Watson, "The Barnes Foundation," *Arts*, January 1923, 29, ill. (as *Vaudeville*); Gallatin, 1927, ill. no. 3; William Murrell, *Charles Demuth* (New York: Macmillan/Whitney Museum of American Art, 1931), 52 (as *In Vaudeville 1917*), ill. 53; Ritchie, 1950, 34, ill. (as *Acrobats*); Farnham, 1959, 2:480–81, no. 184 (W 440, as c. 1916, "Unsigned [?] and undated [?]"); Robin Jaffee Frank, *Charles Demuth: Poster Portraits 1923–1929* (New Haven, Conn.: Yale University Art Gallery, 1994), 20, fig. 13 (mistakenly captioned *Cyclamen*).

REMARKS: Albert Gallatin wrote in 1923, "Rumour has it that Demuth may take a set of drawings for a volume dealing with the great vaudeville artists which Marsden Hartley is said to contemplate writing: what a delightful book this would be!"[2] Such a project was never carried out.

1 Letter, Charles Demuth to Albert C. Barnes, undated [1920], ACB Corr., BFA, enclosing clipping with reproduction of *Acrobats* (BF602) from *Current Opinion* (see below): "I have the drawing of which I am enclosing a reproduction. You may remember it. You wanted it at one time. I exchanged with the person who has had it several years. If you want you can have it for 35.—it's framed, and just as you saw it two or three years ago. We had a fine time Sunday,—It was great." The reproduction from *Current Opinion* was one of two watercolors by Demuth reproduced side by side in the publication. The other was a vaudeville scene, *Mademoiselle Fifi*. The caption under both, which was truncated in the clipping sent by the artist to Barnes, reads: "Here are two striking examples of the new language of water-color created by the young American artist Charles Demuth. Even in these half-tone reproductions not quite all of the delicate fluency, the acid-like wit, the Mephistophelian nuances, is lost." *Current Opinion*, January 1919, 51–52.

2 Albert E. Gallatin, *American Water-Colorists* (New York: Dutton, 1922), 24.

## Untitled (Two Women and Three Children on the Beach)

c. 1916. Watercolor and graphite on wove paper, 8⅜ × 10⅞ in. (21.3 × 27.6 cm). Signed lower left: C. Demuth. BF2038

PROVENANCE: Possibly one of the watercolors purchased from Charles Daniel, August 23, 1917. See "Note on Demuth Series and Provenance," page 265.

REFERENCE: Not in Farnham, 1959.

## *Bermuda: Trees and Architecture*

c. 1916–17. Watercolor and graphite on wove paper,
10 × 14 in. (25.4 × 35.6 cm). Unsigned. Graphite sketch
of vase with flowers on verso. BF658

PROVENANCE: See "Note on Demuth Series and Provenance,"
page 267, note 2.

REFERENCE: Farnham, 1959, 2:471, no. 158.

## Bermuda: Tree

1917. Watercolor and graphite on wove paper, 10 × 14 in. (25.4 × 35.6 cm). Signed and dated lower left: C. Demuth 1917. BF649

PROVENANCE: See "Note on Demuth Series and Provenance," page 267, note 2.

REFERENCES: Farnham, 1959, 2:503, no. 243. The author misdescribes the "vertical rose-colored plane symbolizing walls." The rose area is horizontal. See also Eiseman, 1976, 1:172.

## Bermuda: Rooftops through Trees

1917. Watercolor and graphite on wove paper, 10 × 14 in. (25.4 × 35.6 cm). Signed and dated lower left: C. Demuth 1917. BF648

PROVENANCE: See "Note on Demuth Series and Provenance," page 267, note 2.

REFERENCES: Farnham, 1959, 2:503, no. 242; Emily Farnham, "Charles Demuth's Bermuda Landscapes," *Art Journal* (Winter 1965–66): 133–34, ill. 34, fig. 8; Eiseman, 1976, 1:172; Mark D. Mitchell, "A New Tradition: Cézanne, Demuth, and the Invention of Modern Watercolor," in Joseph J. Rishel and Katherine Sachs, eds., *Cézanne and Beyond*, exh. cat. (Philadelphia: Philadelphia Museum of Art in association with Yale University Press, 2009), 283, ill. 288.

## Bermuda Landscape No. 2
Alternate title: *Bermuda: Tree and Houses*

1917. Watercolor and graphite on wove paper, 10 × 14 in. (25.4 × 35.6 cm). Signed and dated lower left: C. Demuth 1917. BF491

PROVENANCE: See "Note on Demuth Series and Provenance," page 267, note 2.

EXHIBITIONS: Pennsylvania Academy of the Fine Arts, The Philadelphia Water Color Club/The Pennsylvania Society of Miniature Painters, Philadelphia, the Eighteenth Annual Philadelphia Water Color Exhibition, and the Nineteenth Annual Exhibition of Miniatures, November 7–December 12, 1920 (presumably lent by the Daniel Gallery).[1] Philadelphia Museum of Art, Philadelphia, Cézanne and Beyond, February 29–May 17, 2009.

REFERENCES: *Catalogue of the Eighteenth Annual Philadelphia Water Color Exhibition, and the Nineteenth Annual Exhibition of Miniatures, November 7 to December 12, 1920*, 2nd ed. (Philadelphia, 1920), 30, cat. no. 228; Mark D. Mitchell, "A New Tradition: Cézanne, Demuth, and the Invention of Modern Watercolor," in Joseph J. Rishel and Katherine Sachs, eds., *Cézanne and Beyond*, exh. cat. (Philadelphia: Philadelphia Museum of Art in association with Yale University Press, 2009), 286, ill., and 536. Not in Farnham, 1959.

1  See exhibition label with return address, the Daniel Gallery.

## Bermuda, Masts and Foliage

1917. Watercolor and graphite on wove paper, 10 × 14 in. (25.4 × 35.6 cm). Signed and dated lower left: C. Demuth 1917. BF705

PROVENANCE: See "Note on Demuth Series and Provenance," page 267, note 2.

REFERENCE: Farnham, 1959, 2:470, no. 155 (as 1916–17, no dimensions given).

## Bermuda Landscape No. 1
Alternate title: *Ships Masts*

1917. Watercolor and graphite on wove paper, 10 × 14 in. (25.4 × 35.6 cm). Signed and dated lower left: C. Demuth / 1917. BF492

PROVENANCE: See "Note on Demuth Series and Provenance," page 267, note 2.

EXHIBITION: Pennsylvania Academy of the Fine Arts, The Philadelphia Water Color Club/The Pennsylvania Society of Miniature Painters, Philadelphia, the Eighteenth Annual Philadelphia Water Color Exhibition, and the Nineteenth Annual Exhibition of Miniatures, November 7–December 12, 1920 (presumably lent by the Daniel Gallery).[1]

REFERENCE: *Catalogue of the Eighteenth Annual Philadelphia Water Color Exhibition, and the Nineteenth Annual Exhibition of Miniatures, November 7 to December 12, 1920,* 2nd ed. (Philadelphia, 1920), 30, cat. no. 229. Not in Farnham, 1959.

1 See exhibition label on verso with return address, the Daniel Gallery.

## *Bermuda: Houses*

1917. Watercolor and graphite on wove paper, 10 × 14 in. (25.4 × 35.6 cm). Signed and dated lower left: C. Demuth / 1917. Graphite sketch of house and trees on verso, study for *Bermuda: Houses*. BF708

PROVENANCE: See "Note on Demuth Series and Provenance," page 267, note 2.

REFERENCES: Farnham, 1959, 2:502, no. 239; Emily Farnham, "Charles Demuth's Bermuda Landscapes," *Art Journal* (Winter 1965–66): 131, fig. 2; Eiseman, 1976, 1:172.

## Bermuda: Houses Seen through Trees

1918. Watercolor and graphite on wove paper, 14¼ × 10 in. (36.2 × 25.4 cm). Signed and dated lower left: C. Demuth 1918. BF647

PROVENANCE: See "Note on Demuth Series and Provenance," page 267, note 2.

REFERENCES: Albert C. Barnes, *The Art in Painting*, 363, ill.; Albert C. Barnes and Violette de Mazia, *The Art of Cézanne* (New York: Harcourt, Brace, 1939) (as *Houses Seen through Trees*), 142n; Farnham, 1959, 2:502, no. 240 (W 965, as 1917?); Fahlman, 2007, fig. 38, ill. 82.

## Bermuda: Stairway

1917. Watercolor and graphite on wove paper, 14¹⁄₁₆ × 10 in. (35.7 × 25.4 cm). Signed and dated lower left: C. Demuth / 1917. BF656

PROVENANCE: See "Note on Demuth Series and Provenance," page 267, note 2.

REFERENCES: Farnham, 1959, 2:471, no. 157 (as 1917 or 1918); Fahlman, 2007, ill. 53, fig. 16.

## Equestrienne and Assistant

1917. Watercolor and graphite on laid paper, 13 × 8 in. (33 × 20.3 cm). Signed and dated lower left: C. Demuth / 1917. BF600

PROVENANCE: Unknown.

REFERENCES: Farnham, 1959, 2:509, no. 257; Violette de Mazia, "The Barnes Foundation: The Display of Its Collection," *Vistas* 2, no. 2 (1981–83): 109n, pl. 118 (installation).

## Bicycle Acrobats

Alternate title: *In Vaudeville: Bicycle Acrobats*

1917. Watercolor and graphite on laid paper, 11 × 8¾ in. (27.9 × 22.2 cm). Signed and dated lower left: C. Demuth 1917. BF643

PROVENANCE: Unknown.

REFERENCES: Albert C. Barnes and Violette de Mazia, *The Art of Cézanne* (New York: Harcourt, Brace, 1939), 142 n. (as *Bicycle Riders*); Farnham, 1959, 2:513, no. 267 (as *In Vaudeville: Bicycle Acrobats*, "Unsigned [?] and undated [?] c. 1917"); Eiseman, 1976, 1:282; Violette de Mazia, "The Barnes Foundation: The Display of Its Art Collection," *Vistas* 2, no. 2 (1981–83): 109n, pl. 118 (installation).

## In Vaudeville: Woman and Man on Stage

1917. Watercolor and graphite on wove paper, 8 × 10 in. (20.3 × 25.4 cm). Signed and dated lower left: C. Demuth 1917. BF601

PROVENANCE: Unknown.

EXHIBITION: Colony Club, New York, Modern Sculpture, Water Colors and Drawings, April 2–13, 1922.

REFERENCES: *Modern Sculpture, Water Colors, and Drawings*, exh. cat. (New York: Colony Club, 1922), cat. no. 50 (as *In Vaudeville*, "Lent by the Daniel Gallery [?]"); Sherman Lee, "The Illustrative and Landscape Watercolors of Charles Demuth," *Art Quarterly* 5, no. 2 (Spring 1942): 158–75; Farnham, 1959, 2:514, no. 270 (mistakenly described as *Jugglers with Dumb-Bells*; see entry for *Jugglers with Indian Clubs* [BF2010], page 297); Eiseman, 1976, 1:282.

## At Marshall's

Alternate title: *Negro Dancing*

1917. Watercolor and graphite on laid paper, 13 × 8 in. (33 × 20.3 cm). Signed lower right: C. Demuth. BF741

PROVENANCE: Acquired from the artist in 1921.[1]

EXHIBITION: New York, First Annual Exhibition of the Society of Independent Artists, April 10–May 6, 1917, cat. no. 52 (as *The Dancer*), ill.

REFERENCES: *Catalogue of the First Annual Exhibition of the Society of Independent Artists* (New York: April 1917), n.p., no. 52; R.J. Coady, "The Indeps," *The Soil: A Magazine of Art* 1, no. 5 (April 1917): 202 ff, 204 (illustrated as *The Dancer* with caption "Copyright by The Society of Independent Artists");[2] William Murrell, *Charles Demuth* (New York: Macmillan in association with Whitney Museum of American Art, n.d. [1931]), 48, ill. 49; Albert C. Barnes, *The Art in Painting*, 3rd ed. (New York: Harcourt, Brace, 1937), 342, ill. (as *Negro Dancing*); Albert C. Barnes and Violette de Mazia, *The Art of Cézanne* (New York: Harcourt, Brace, 1939), 142n (as *Negro Dancing*); Sherman E. Lee, "The Illustrative and Landscape Watercolors of Charles Demuth," *Art Quarterly* 5, no. 2 (Spring 1942): 159, fig. 2, 162, 165; Farnham, 1959, 2:499, no. 231 (W 439) and ill., 1:389, fig. 7; Farnham, 1971, pl. 12; Hale, 1974, 341, fig. 74 (as 1915); Eiseman, 1976, 1: ill. 253, 254–55.

1 Letter, Charles Demuth to Albert C. Barnes, undated [January 1921], ACB Corr., BFA. Eiseman, 1976, 231, mistakenly claims that *At Marshall's* was acquired from Daniel.

2 This reproduction is one of several from the society's exhibition that accompanied Coady's piece on the exhibition. (Coady was publisher and art editor of the short-lived periodical, to which Dr. Barnes was a subscriber.)

## *Two Acrobats in Red Tights*

1917. Watercolor and graphite on laid paper, 13 × 8 in. (33 × 20.3 cm). Signed and dated lower left: C. Demuth / 1917. BF736

PROVENANCE: Unknown.

REFERENCES: Farnham, 1959, 2:522, no. 292; Eiseman, 1976, 1:282; R. J. Wattenmaker, "Dr. Albert C. Barnes and The Barnes Foundation," in *Great French Paintings from the Barnes Foundation* (New York: Knopf in association with Lincoln University Press, 1993), 21.

## Two Trapeze Performers in Red
Alternate title: *Trapeze Performers*

c. 1917. Watercolor and graphite on wove paper, 8 × 13 in. (20.3 × 33 cm). Unsigned. Graphite sketch of trapeze performer on verso. BF644

PROVENANCE: Unknown.

REFERENCES: Farnham, 1959, 2:519, no. 284 (as *Trapeze Performers*); Eiseman, 1976, 1:282; Violette de Mazia, "The Barnes Foundation: The Display of Its Art Collection," *Vistas* 2, no. 2 (1981–83): 109n, pl. 118 (installation).

## *No, No O God!*

1918. Watercolor and graphite on wove paper, 8 × 13 in. (20.3 × 33 cm). Signed and dated right of center: C. Demuth / 1918. Inscribed upper left: *ACT–NO IV* [*sic*]. Illustration for Frank Wedekind's *Erdgeist*, Act III (page 75). Texts of dialogue in balloons:

"O God!"

"No, no. O God! / 'Dr. Ludwig Schön.'"

BF2011

PROVENANCE: Unknown.

REFERENCES: Farnham, 1959, 539, no. 332 (dated c. 1916); Farnham, 1971, pl. 20 (as Act III, but dated c. 1918); Allara, 1970, 274, cat. no. 19; Eiseman, 1976, 1: ill. 202; Haskell, 1987, 104–06, ill. 106.

REMARKS: See "Note on Demuth Series and Provenance," page 265.

## *Lulu and Alva Schön at Lunch*

Alternate title: *Lulu and Alva Schön in the Lunch Room*

1918. Watercolor and graphite on wove paper, 8 × 13 in. (20.3 × 33 cm). Signed and dated lower left: C. Demuth 1918. Inscribed lower right: *ACT NO III* [*sic*]. Illustration for Frank Wedekind's *Erdgeist*, Act IV (pages 76, 79, 80, 85, and 86). Texts of dialogue in balloons:

"You can't / think how glad / I shall be to / see you—."

"I'll / let myself / be hung / on that / statement / any time."

"I shall be expelled / from school."

"My / own / son!"

"Are you / sick?"

"Let him / be!"

"I am a / coachman / usually."

BF1070

PROVENANCE: Unknown.

REFERENCES: Ritchie, 1950, 50, ill; Farnham, 1959, 2:537–38, no. 329 (W 936); Allara, 1970, 274, cat. no. 20, pl. 31; Eiseman, 1976, 1:196–97, ill. 198; Haskell, 1987, ill. 107.

REMARKS: See "Note on Demuth Series and Provenance," page 265.

## Lulu and Alva Schön

1918. Watercolor and graphite on wove paper, 8 × 13 in. (20.3 × 33 cm). Signed and dated lower left: C. Demuth 1918. Inscribed lower right: *ACT–NO V* [*sic*]. Illustration for Frank Wedekind's *Pandora's Box*, Act I (page 28). Texts of dialogue in balloons:

"Is not that / the divan — / —?" [on which your father bled to death?]

"Be still / Be still."

BF2013

PROVENANCE: Unknown.

REFERENCES: Ritchie, 1950, ill. 51; Farnham, 1959, 2:537, no. 326 (W 937); Allara, 1970, 274, cat. no. 21, pl. 32; Hale, 1974, 326, fig. 53; Eiseman, 1976, 1: ill. 199; Haskell, 1987, ill. 107.

REMARKS: See "Note on Demuth Series and Provenance," page 265.

## The Ladies Will Pardon My Mouth's Being Full

1918. Watercolor and graphite on wove paper, 8 × 13 in. (20.3 × 33 cm). Signed and dated lower left: C. Demuth 1918. Inscribed upper left: *ACT–NO VI* [*sic*]. Illustration for Frank Wedekind's *Pandora's Box*, Act II (page 54). Texts of dialogue in balloons:

"How?"

"The / ladies will / pardon my / mouth's / being full."

"Good-night, / children."

BF1069

PROVENANCE: Unknown.

REFERENCES: Farnham, 1959, 2:536, no. 325 (as for *Erdgeist* [?]); Farnham, 1971, 183, pl. 22; Allara, 1970, 275, cat. no. 22; Eiseman, 1976, 1: ill. 195 (mistakenly captioned as "*The Animal Tamer Presents Lulu* from the Prologue to *Erdgeist*" [London Collection; ex–Collection Violette de Mazia]), and 1:204, ill. (correctly) 205; Haskell, 1987, ill., 107.

REMARKS: See "Note on Demuth Series and Provenance," page 265.

## The Death of Countess Geschwitz

1918. Watercolor and graphite on wove paper, 8 × 13 in. (20.3 × 33 cm). Signed and dated lower left: C. Demuth 1918. Inscribed lower right: *ACT–NO VII* [*sic*]. Illustration for Frank Wedekind's *Pandora's Box*, Act III (page 79). Texts of dialogue in balloons:

"I am / a damned / lucky chap!"

"Lulu!—forever!— / O cursed—!!"

BF2012

PROVENANCE: Unknown.

REFERENCES: Ritchie, 1950, ill. 52; Farnham, 1959, 2:526, no. 301 (W 938); Allara, 1970, 275, cat. no. 23, pl. 34; Hale, 1974, 327, fig. 54; Eiseman, 1976, 1:201, ill. 200; Haskell, 1987, 104–06, ill. 108.

REMARKS: See "Note on Demuth Series and Provenance," page 265.

## Jugglers with Indian Clubs

Alternate title: *Jugglers with Dumb-Bells*

1917. Watercolor and graphite on wove paper, 8 × 13 in. (20.3 × 33 cm). Signed and dated lower left: C. Demuth 1917.

BF2010

PROVENANCE: Unknown.

REFERENCES: Farnham, 1959, 2:482, no. 190. Farnham's description, on page 541, of no. 270 confounds *Jugglers with Indian Clubs* (for which no descriptive text is given on page 482) with *In Vaudeville: Woman and Man on Stage* (BF601), to which the subject of *Jugglers with Indian Clubs* is ascribed. See also Violette de Mazia, "The Barnes Foundation: The Display of Its Art Collection," *Vistas* 2, no. 2 (1981–83): pl. 118 (installation).

## *Musician*

1918. Watercolor and graphite on wove paper, 10⅜ × 8 in.
(26.4 × 20.3 cm). Signed and dated lower left: C. Demuth
1918. BF748

PROVENANCE: Unknown.

REFERENCE: Farnham, 1959, 2:538–39, no. 231.

## The Masque of the Red Death
Alternate title: *The Triumph of the Red Death*

FIG. 85

William Blake, *The Goblin*, [17--], watercolor over faint indications in black chalk on paper, 6⁷⁄₁₆ × 4¹³⁄₁₆ in. (16.4 × 12.3 cm), The Morgan Library, New York, Purchased with the assistance of the Fellows with the special support of Mrs. Landon K. Thorne and Mr. Paul Mellon, 1949.4:5

c. 1918. Watercolor and graphite on wove paper, 8 × 11⅛ in. (20.3 × 28.3 cm). Unsigned. Illustration for Edgar Allan Poe's *The Masque of the Red Death*. BF2009

PROVENANCE: Unknown.

REFERENCES: Ritchie, 1950, ill. 62 (as 1918); Farnham, 1959, 2:542–43 (as c. 1918); Allara, 1970, 272, cat. no. 14, pl. 28 (as c. 1918); Hale, 1974, 328, fig. 55; Eiseman, 1976, 1:189, 205, ill. 206; Robin Jaffee Frank, *Charles Demuth: Poster Portraits 1923–1929* (New Haven, Conn.: Yale University Art Gallery, 1994), 91, fig. 84; Haskell, 1987, 104, ill. 105; Weinberg, 1993, 71–72, ill. 71, fig. 25 (as 1918).

REMARKS: In a letter to A. E. Gallatin postmarked June 29, 1926, Demuth enumerated his illustrations, including "Poe. The Masque of the Red Death. One."[1] William Blake's impact on Demuth's style of drawing in the vaudeville and illustration subjects is as pervasive as the influence of Rodin's drawings and watercolors. See, for example, Blake's *The Goblin*, with its tensely balletic body with gracefully outstretched arms and hands (fig. 85).

1 Letter, Charles Demuth to A. E. Gallatin, June 29, 1926, A. E. Gallatin Papers, courtesy of the New-York Historical Society.

## *Interior with Group of People around Red-Headed Woman*

Alternate title: *"Property of the Red Queen"*

1919. Watercolor and graphite on wove paper, 8 × 11 in. (20.3 × 27.9 cm). Signed and dated lower center: C. Demuth / 1919. Painting hanging on wall in background signed "G O Colman." BF2007

PROVENANCE: Unknown.

EXHIBITION: Daniel Gallery, New York, Opening Exhibition, October ?–November 16, 1920, cat. no. 27 (as *"Property of the Red Queen"*) (?).

REFERENCES: Farnham, 1959, 2:533, no. 318 (as *Erdgeist*, c. 1918); Farnham, 1971, pl. 21 (as *Erdgeist*, Act IV, c. 1918); Eiseman, 1976, 1:202–03, ill. 203 (mistakenly as *Erdgeist*, c. 1918, with "balloon shapes" and "G. Coleman [*sic*]"), see Remarks below.

REMARKS: Several authors claim *Interior with Group of People around Red-Headed Woman* as an illustration for Wedekind's *Erdgeist*, despite the fact that there is no dialogue or stage direction in the text linking the watercolor to that or any other play. Unlike the illustrations for the play, all dated 1918, *Interior* is dated 1919. Violette de Mazia wrote to Hugh H. Chapman, Jr.: "The watercolor . . . (of the man's head lying on the woman's lap), has no balloon at all and, therefore, no writing. What gives somewhat the effect of balloons and writing are the lines scratching some of the units. . . . I believe (yet, I am not absolutely positive) that that Demuth is one of the illustrations Demuth did for Nana. A possibly interesting detail is that while the watercolor itself is signed near the lower edge by Demuth, the painting shown as hanging on the background wall of the room is signed E. (or possibly G.) Colman."[1] Ritchie, 1950; Allara, 1970; and Hale, 1974, do not mention this watercolor.

The signature on the picture hanging on the wall is "G O Colman." This denotes Glenn O. Coleman (1887–1932), a contemporary of Demuth's, whose spelling of the last name is idiosyncratic. Coleman had his first solo exhibition, Paintings and Drawings of Old New York by Glenn O. Coleman, November 15–28, 1916, at the Daniel Gallery.[2] During Coleman's show, Demuth's contemporaneous 1915/16 *Nana* watercolors, considered too risqué to hang, were shown privately to potential clients. This exhibition was followed by the exhibition Water Colors & Drawings by Charles Demuth, November 29–December 12, 1916. At the Opening Exhibition of Paintings and Drawings at the Enlarged Daniel Gallery, October 1916, both artists were included (Coleman, cat. 4, and Demuth, cat. 28, drawings). Stuart Davis wrote of Coleman: "Glenn Coleman was a good-humored man. . . . He liked people and had many friends. Parties were agreeable to him. Although it was his habit to retire early he would respond to demands for his presence made by roving bands of artists at odd hours of the morning. He enjoyed jazz piano playing immensely and his taste in speakeasies was simple and correct."[3]

*Interior* compositionally recalls *At the Golden Swan* (Private Collection), also dated 1919, with the painting hanging in the background and the portrait of Marcel Duchamp and self-portrait in profile in the foreground. A similarly positioned head in the center left foreground is possibly a portrait of Glenn Coleman.

1 Letter, Violette de Mazia to Hugh H. Chapman, Jr., October 25, 1962, Central File Correspondence, BFA.

2 See Julie Mellby, "A Record of Charles Daniel and the Daniel Gallery" (M.A. thesis, Hunter College, CUNY, 1993), 32–33, 96–97. According to Virginia M. Zabriskie, Daniel's interest in art was "first sparked" by Coleman. See Zabriskie, "Introduction," in *Charles Daniel and the Daniel Gallery 1913–1932*, exh. cat. (New York: Zabriskie Gallery, 1993), 5. Mellby has written: "Charles Daniel was the son of immigrants who ran a German restaurant . . . . He opened a café with his brother . . . but was dissatisfied with his family's chosen business. It was the café, however, that precipitated Daniel's entry into the New York art scene in 1906, through his friendship with artists such as Glenn O. Coleman and Max Kuehne. . . . Daniel accompanied them to galleries, visited their studios and began to buy their work." Mellby, "Charles Daniel and the Daniel Gallery (1913–1932)," in *Charles Daniel and the Daniel Gallery 1913–1932*, 6. See also statement by Raphael Soyer, quoted on page 15 of *Charles Daniel and the Daniel Gallery 1913–1932*, which reinforces the longstanding connection between Coleman and Daniel.

3 Stuart Davis, in *Glenn O. Coleman Memorial Exhibition*, exh. cat. (New York: Whitney Museum of American Art, October 18–November 16, 1932), 6.

## In Vaudeville: Acrobatic Male Dancer with Top Hat

1920. Watercolor, graphite, and charcoal on wove paper, 13 × 8 in. (33 × 20.3 cm). Signed and dated lower left: C. Demuth 1920. BF1199

PROVENANCE: Unknown.

REFERENCES: Farnham, 1959, 2:580, no. 428; R.J. Wattenmaker, "Dr. Albert C. Barnes and The Barnes Foundation," in *Great French Paintings from the Barnes Foundation* (New York: Knopf in association with Lincoln University Press, 1993), 21.

# HORACE PIPPIN (1888–1946)

Pippin's art is distinctly American; its ruggedness, vivid drama, stark simplicity, picturesqueness and accentuated rhythms, have their counterparts in the Spirituals of the American Negro.... Pippin's closest kinship is perforce with the group of natural, untaught painters to be found at all periods and in all nations, and to which custom has attached the word primitive. America, in the early nineteenth century, produced many such painters, mostly anonymous and a number of them genuine artists endowed with a high degree of esthetic insight and talent for expression.... It is probably not too much to say that he is the first important Negro painter to appear on the American scene.

Albert C. Barnes, "Horace Pippin," 1940

*Horace Pippin was born in West Chester, Pennsylvania, in 1888.* Although he received no formal art instruction, from an early age Pippin evinced an interest in drawing. "When I was a boy I loved to make pictures. No one paid me any mind. But the Sunday school gave a festival; this is in Goshen N.Y., the A.M.E. [African Methodist Episcopal] church for the Sunday school members were to give something to sell. So I went to a store and got a yard of muslin and cut it into six pieces and fringed them. Then I did pictures on them such as Jesus ascending into heaven and so on."[1] Elsewhere Pippin wrote, "One day I got a magazine with a lot of advertisements in it of dry goods. In this magazine there was a sketch of a very funny face. Under this face printed in large letters it said make me and win a prize. And I did and sent it to Chicago, to the address that was given. The following week the prize came. It was a box of crayon pencils of six different colors. Also a box of cold water paint and two brushes. These I were [*sic*] delighted in and used them often."[2]

In July 1917 Pippin enlisted in the 15th Regiment of the New York National Guard, and he shipped out to France at the end of the year. There his unit served under French command in several of the most dangerous sectors at the front, where his activities included volunteer nocturnal patrols in no-man's land, raids on the German trenches, clearing enemy snipers, and generally enduring the hardships of trench warfare. These ghastly experiences are vividly described in a memoir composed in 1920. Recalling his army service, he wrote, "I went overseas with the old 15th N.Y. Fighting no. 369 Inf.; this brought out all of the art in me. I made some scenes of France, something like a hundred of them yet at last I had to burn them up. I can never forget suffering, and I will never forget sunset that is when you could see it, so I came home with all of it in my mind, and I paint from it today.... it came the hard way with me."[3] Pippin was severely wounded in action in October 1918, disabling his right arm. "My right arm was bound to me. I could not use it for anything. But my mind runs back to the sketches I had made

in France which I had to destroy," he recalled. He spent a period recuperating in hospitals both in France and, later, at home and was honorably discharged with a disability pension in May 1919. He was awarded the Croix de Guerre by the French government.[4]

In 1920, Pippin married and returned to West Chester. During his convalescence from his war experiences, he decorated discarded cigar boxes, and in 1925 he began to make burnt-wood panels, a medium known as pyrography. Mark F. Bockrath and Barbara A. Buckley describe the artist's approach to this medium: "Pippin's method of creating the burnt-wood panels was to draw the design in pencil first onto the wooden support, subsequently burning in the line with the hot poker. Probably due to the difficulty of working detailed lines with the poker, there are often more pencil lines than there are burn lines. Sometimes pencil lines used for details were left unburnt. . . . Pippin then painted the panels with a typically restricted palette of white, a few earth colors, and perhaps small amounts or red, blue, or green. The burnt lines are generally left as visible outlines but are sometimes overpainted by the artist."[5] Selden Rodman and Carole Cleaver note Pippin's ingenuity in manipulating his materials despite his disability: "Holding the handle [of the white-hot poker as it lay in the potbellied stove] as firmly as he could in his stiff right hand, and balancing the rod on his knee, he took the extra leaf from the golden oak table, and with his agile left hand he maneuvered the panel against the smoking iron tip."[6] In the latter part of the 1920s Pippin began to paint in oils, devoting three painstaking years to completing *The End of the War: Starting Home*, c. 1930 (Philadelphia Museum of Art), applying multiple layers of paint to achieve a bas-relief effect.[7] He worked in both oils on canvas and burnt-wood panels until around 1940, after which time he devoted himself exclusively to painting on canvas. His total output over a period of less than twenty years was no more than one hundred and forty works.

Barnes's enthusiasm for Pippin's work must be situated within the larger context of his increasing interest in indigenous artistic traditions and the work of self-taught artists. In the early 1920s Barnes had begun to collect African tribal sculpture, appreciating both its intrinsic qualities and the profound influence it had on much of the contemporary art he was purchasing. At the same time, he added examples of ancient Egyptian, Greek, and Roman sculpture to his collection. Barnes's first known acquisition of folk art dates to 1923, when he bought a pair of small portraits in the *peinture paysan* style, one of which, *Peasant Girl in Landscape* (BF134) by an unidentified artist, was reproduced in Mary Mullen's *An Approach to Art*. Also purchased in 1923 were two colorful paintings by Jean-Baptiste Guiraud, *View of Bordeaux* (*Vue de Bordeaux*, BF374) and *Oriental Dancers* (*Danseurs orientaux*, BF371), both 1884, as well as *Child Holding Fruit* (BF554), c. 1840, which he hung in Gallery XI of the Foundation with eight canvases by Henri "le Douanier" Rousseau. A memoir by the painter Alexander Brook (1898–1980), who in 1931 attended a lecture by Barnes, affords insight into the collector's approach to the work of self-taught artists:

Dr. Barnes . . . said that what was called primitive art was not primitive at all. Rousseau had access to and copied postal cards, he was surrounded by all kinds of original paintings in galleries and museums, he saw illustrations in books and magazines; in short he was living in a so called civilized world and was therefore incapable of being a primitive as he was always called. A true primitive, as Dr. Barnes justly and persuasively argued, was a person who lived in a state of complete detachment from other artists save those few who were like himself, who had no other examples of pictures to guide him and who made his scratches on a wall or chipped his stone from a purely compulsive desire to depict animals and in some few cases the people around him. The primitive artists were those who painted the caves of Altamira . . . and [made] the carvings of the Aztecs and Incas. Whatever their motives they had nothing but their own instincts to guide them. Dr. Barnes had brought into the lecture room examples of paintings from his collection done by untutored men. . . . They varied in subject matter that included portraits, landscapes with or without figures, still-lifes and purely imaginative conceptions. They all had a kinship of feeling; an unmistakable aura of an untrained talent that was obvious in

all of them as well as a similarity that could be felt if not seen. These, said Dr. Barnes, were folk artists, not primitives, and, I thought, like all simple ideas embodying flagrant truths, I wished I had thought of it myself.[8]

In 1930 Barnes purchased a number of painted *santos* created in the late eighteenth and the first half of the nineteenth century by artists within the indigenous Hispanic culture of New Mexico, which he integrated with the American and European paintings throughout the gallery. At that time he also introduced dazzling Navajo rugs, Native American pottery, and silver jewelry to intensify further the color and textural impact of the wall arrangements. The next phase of Barnes's explorations into complementary affinities among divergent traditions exemplified by self-taught folk artists was his purchase in 1934 and 1935 of four paintings by the Scottish-born Pittsburgh painter John Kane, about whom he wrote, "[Kane's] commonplace subject-matter is incorporated in a patterned design which is both ingenious and forceful."[9] In the mid-1930s Barnes began to collect early American furniture, pottery, glass, ironwork, and especially Pennsylvania German art, the culture of his maternal grandmother. Barnes's receptivity to Pippin's work may be seen as a culmination of his experience with these various traditions.

Pippin was unknown outside local West Chester art circles until 1937, when his work was seen by critic Christian Brinton and illustrator N. C. Wyeth and was included in group exhibitions, where it was singled out for praise by critics. Thereafter, his reputation progressively burgeoned. In 1938, four of Pippin's paintings were included in the Masters of Popular Painting exhibition at the Museum of Modern Art, New York, which subsequently traveled to museums across the country.[10]

In December 1939 the Philadelphia art dealer Robert Carlen became Pippin's agent and organized the artist's first solo show, Horace Pippin Exhibition, January 19–February 18, 1940, comprising twenty-two paintings and five burnt-wood panels. Barnes saw Pippin's work before the show opened and purchased one painting, *Abraham Lincoln and His Father Building Their Cabin on Pigeon Creek* (cat. no. 1). He also bought *Cabin in the Cotton Field* (cat. no. 2), 1935, for his friend, the actor Charles Laugh-

ton.[11] Violette de Mazia purchased *Birmingham Meeting House* (cat. no. 3), 1940.[12] Barnes invited Pippin to visit the Barnes Foundation, and early in 1940 the artist joined Violette de Mazia's class, which he attended for several months. In a letter to Irene Culhane dated March 15, 1944, Barnes wrote, "Although a totally uncultivated man as far as knowledge of traditions of painting is concerned, I think he learned more at our place than any student we ever had. He seemed to know instinctively what made a painting good and his work shows that he not only grasped the essence of the forms of the great painters but he was able to interpret it in his own terms."[13]

In October 1940 Pippin submitted a grant proposal to the Solomon J. Guggenheim Foundation to enable him to travel in the South, "to paint landscapes and the life of the Negro people. At work and at play, and all other things that happen in their everyday living."[14] Barnes wrote a letter of reference that stated in part, "Mr. Pippin is a sincere, talented, individual, creative artist, worthy of the support of a fellowship. His capacity for growth is revealed in his recent work and I believe that, given the opportunity, he will become one of the most important painters of our age."[15] In January 1941 Carlen took a number of Pippin's paintings to show to the Guggenheim jury, among which were *Abraham Lincoln and His Father Building Their Cabin on Pigeon Creek* (BF978) and *Birmingham Meeting House*, on loan from Violette de Mazia. He wrote to Barnes, "I returned the Horace Pippin paintings you were kind enough to lend for the purpose of showing to the Guggenheim Foundation on Saturday. I also delivered the burnt wood panel at the same time."[16]

The artist's second exhibition at Carlen Galleries, Recent Paintings by Horace Pippin, took place March 21–April 20, 1941. It consisted of thirteen paintings and eight burnt-wood panels. Barnes wrote an introduction for the catalogue, "Horace Pippin Today," in which he implicitly noted the fact that the artist had attended classes at the Barnes Foundation and had therefore been exposed to the Western traditions: "The plenitude of ideas that made his early work embrace a wide range of compositional organizations, have been fertilized by a more comprehensive knowledge of how to apply paint and how to coordinate color, line, light, space, pattern, to make his compositions more fully expressive."[17] A month before the show opened,

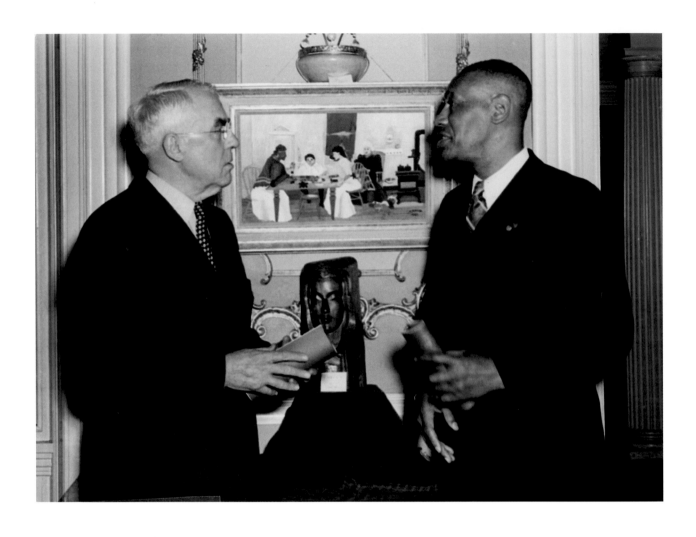

Barnes bought *Christ and the Woman of Samaria* (BF986), 1940, which was lent to the exhibition (cat. no. 1, "Acquired by Barnes Foundation"). The picture shocks by its drama, which is due primarily to Pippin's original use of color. The intense gradations of fuchsia and gray in the sky meet dramatically at the horizon with an intense purplish red against the green-blacks of the foliage. The placement of Christ's crisp, silhouetted purple cloak, firmly situated as if in a niche between the well and stones and the dark foliage behind, is a powerful color statement as bold as any color juxtaposition of Henri Matisse, while the carpet-like effect of the stones in front of the well, with its fringe of deep green-on-black grass on their border, is as subtle a color ensemble as any found in the work of Henri Rousseau. Barnes believed that Pippin had been influenced by the composition of a painting formerly attributed to Tintoretto (*Christ and the Woman of Samaria* [BF823])

of the same subject in the Foundation. However, Selden Rodman wrote in 1947, "'The Woman at [*sic*] Samaria' is said to owe its composition to a Tintoretto in the Foundation, but the design appears to have been taken directly from an old book-engraving found among the artist's papers after his death."[18] The painting conceivably has another source rooted in African American experience, specifically, Pippin's deep religious faith. Rodman and Cleaver note, "[Pippin and his wife, Ora,] both sang in the choir, and Pippin began again to play the organ, perhaps with the exercise restoring some life to the wounded arm. He also played the mandolin, the guitar, and drum."[19] One of the fundamental aspects of Barnes's attraction to Pippin's work and his reference to its "counterparts in the Spirituals of the American Negro" was their shared love for the powerful emotions evoked by the simplicity, directness, and rhythms of that indigenous music.

It is likely that Pippin, familiar with a wide repertoire of accompanied and a cappella songs, knew the traditional spiritual "Jesus Met the Woman at the Well."[20]

In 1943 Pippin exhibited two paintings at the Pyramid Club, an African American organization founded in 1941 and dedicated to the promotion of civic, social, and cultural pursuits, including American art dealing with Negro subjects (fig. 87). At the club's third annual exhibition, Barnes presented an informal lecture, "Art of Negro Africa and Modern Negro America." Although its text is not preserved, Barnes had on many other occasions expressed his admiration for the artistic contributions of African Americans. In a 1936 lecture presented in conjunction with a performance by the Bordentown Singers, for example, he affirmed,

> The Negro spirituals represent the greatest art America has produced, because they came out of the soil and, like the greatest artistic achievements of the Middle Ages—the Cathedrals—they are an outgrowth of community life inspired by religion. Like the Homeric poems, these spirituals are also the work of generations of singers, so that they represent the collective griefs and aspirations of a race. The spirituals have their roots in the tribal chants of Africa, but their content is an accurate reflection of the sufferings . . . and hopes of the slaves. . . . In the poetry of Angelika Grimke, Langston Hughes, Claude MacKay and others, we find, in the highest degree, an exemplification of [John] Milton's rule for great poetry that it must be "simple, sensuous and passionate." The images are vivid and full of color, expressive of the personal sorrows, hopes and aspirations, transfigured by images and given universal significance. They have the harmony, the rhythmic surge, the poignancy and rapture, which are the authentic qualities of poetic inspiration. . . . In such men as Eric Walrond and Jean Toomer the connoisseur recognizes an equality with the work of the best white writers in America or Europe.[21]

Pippin's work, for Barnes, embodied an innovative fusion of the verbal, visual, and musical aspects of indigenous black American culture, earning him a place among the nation's greatest artists.

NOTES

Epigraph. Albert C. Barnes, "Horace Pippin," in *Horace Pippin Exhibition*, exh. cat. (Philadelphia: Carlen Galleries, 1940).

1   Horace Pippin, undated memoir, Horace Pippin War Notebooks and Letters, c. 1920, 1943. Archives of American Art, Smithsonian Institution, Washington, D.C. (grammar, spelling, and punctuation edited). For additional biographical information, see Selden Rodman and Carole Cleaver, *Horace Pippin: The Artist as a Black American* (Garden City, N.Y.: Doubleday, 1972); Anna Rothe, "Horace Pippin," in *Current Biography, 1945* (New York: Wilson, 1946), 470–73; Theodore Stanford, "Call Pippin Greater Painter Than Tanner," *Afro American*, May 13, 1944, 5; Judith Stein, *I Tell My Heart: The Art of Horace Pippin* (Philadelphia: Pennsylvania Academy of the Fine Arts, 1993); Joseph W. Woods, "Modern Primitive: Horace Pippin," *Crisis*, June 1946, 178–79, 189.

2   Horace Pippin, "My Life's Story," in Selden Rodman, *Horace Pippin: A Negro Painter in America* (New York: Quadrangle, 1947), 77–80.

3   Pippin, undated memoir.

4   The U.S. government did not decorate Pippin, who applied for and was granted only in 1945 the Purple Heart medal he had earned in World War I.

5   Mark F. Bockrath and Barbara A. Buckley, "Materials and Techniques," in Stein, *I Tell My Heart*, 170–72.

6   Rodman and Cleaver, *Horace Pippin*, 62 (cited by Bockrath and Buckley).

7   I have drawn upon Bockrath and Buckley, "Materials and Techniques," 167. Barnes in "Horace Pippin," his introduction to the catalogue for the 1940 Horace Pippin Exhibition at Carlen Galleries, wrote, "A crude, bald, starkness of statement, and a thick, semi-sculptural use of paint, all combining to yield the effect of power, link Pippin's early work with the first efforts of Cézanne."

8   Alexander Brook, "Dr. Barnes," in "Myself and Others," typescript of an unpublished memoir, Alexander Brook Papers, Archives of American Art, Smithsonian Institution, Washington, D.C. See also Alexander Brook to Albert C. Barnes, February 17 and 20, 1931, and Barnes to Brook, February 18, 1931, signaling his talk on Rousseau, which Dewey attended. The terms *folk art* and *folk artists* had been applied to self-taught artists before this time, for example, *American Primitives: An Exhibit of the Paintings of Nineteenth Century Folk Artists*, November 4, 1929–February 1930, organized by the Newark Museum, to which Brook lent five early American pictures.

9   Albert C. Barnes, *The Art in Painting*, 3rd ed. (New York: Harcourt, Brace and Company, 1937), 346.

10  Dorothy C. Miller, "Horace Pippin," in *Masters of Popular Painting: Modern Primitives of Europe and America*, exh. cat. (New York: Museum of Modern Art, 1938), 125–26. The exhibition traveled to six museums throughout the United States and the Musée des Beaux-Arts, Grenoble, which was co-organizer.

11  Now known as *Cabin in the Cotton I* (Art Institute of Chicago). Although many accounts (for example, Stein, *I Tell My Heart*, 40 n. 59) erroneously claim that Laughton purchased the painting in Philadelphia on Barnes's advice, in fact, Barnes purchased the painting as a gift for Laughton and so informed him in a letter the day before the opening, on January 18, 1940: "Dear Buster: Don't be surprised if you read in the paper that Charles Laughton has acquired a painting by Horace Pippin, one of the most distinctive artists that has appeared on the scene in recent years. He is a Negro, fifty years old, crippled by shrapnel in the shoulder in the last world war, and only began to paint a few years ago. I saw his work for the first time the other day and I immediately bought . . . one painting for the Foundation and one to send to you after the exhibition is over in about a month. Inasmuch as the man is totally unknown as a painter I consented to the use of the Barnes Foundation

and Mr. Charles Laughton as purchasers of two of the best of the works." Letter, Barnes to Laughton, January 18, 1940. Laughton replied on February 1, "I am very much indeed looking forward to seeing the Horace Pippin canvas. It is really most generous of you and most kind." Letter, Laughton to Barnes, February 1, 1940. Both letters ACB Corr., BFA. See also Romare Bearden and Harry Henderson, *Six Black Masters of American Art* (Garden City, N.Y.: Doubleday, 1972): "Enormously impressed and believing Pippin was America's first Black artist, Dr. Barnes immediately bought some of the paintings on the spot, including one for actor Charles Laughton" (62). *Cabin in the Cotton I* was one of the four pictures included in the Masters of Popular Painting exhibition in 1938. The painting had figured in the Sixth Annual Exhibition, Chester County Art Association, May 23–June 6, 1937, cat. no. 21. See the *Coatesville Record*, May 29, 1937: "a painting of a negro cabin with the family at the door, behind which is a great field of snow white cotton, with snow white clouds rising above it. in producing this picture Pippin has violated just about every rule of good painting, but the result, despite all this, is something that has county art circles talking." The author states that the judges for the show say the painting "has a touch of genius." See also *Chester County Daily Local News*, May 21, 1937: "One of the surprises of the exhibition is a unique painting by Horace Pippin, a West Chester Negro laborer, called 'Cabin in the Cotton.' N.C. Wyeth has called this contribution the most original individual picture of the whole show. It is executed in a modern primitive style, which, according to Dr. Christian Brinton, corresponds to the style of Henri Rousseau, the great French primitivist."

12  Now known as *Birmingham Meeting House I* (Regis Collection, Minneapolis, Minn.). See Violette de Mazia, "Expression," *BFJAD* 5, no. 2 (Autumn 1974): 5–7, 31–32, pl. 16.

13  Letter, Barnes to Irene Culhane, March 15, 1944, ACB Corr., BFA.

14  See Stein, "An American Original," in *I Tell My Heart*, 20–21 and 40–41 nn. 76–81. References included Holger Cahill, Alain Locke, Barnes, Max Weber, Dorothy C. Miller, and the Philadelphia painter Julius T. Bloch, a former student at the Barnes Foundation and friend of Pippin's.

15  Copy of Barnes's reference for Pippin, "Confidential Report on Candidate for Fellowship," Carlen Galleries, Inc., Records, Archives of American Art, Smithsonian Institution, Washington, D.C. Pippin did not receive the grant.

16  Letter, Robert Carlen to Barnes, February 16, 1941, Carlen Galleries, Inc., Records. See also Carlen to Barnes, January 23, 1941, Carlen Galleries, Inc., Records. Barnes had acquired the burnt-wood panel *Supper Time* (BF985) on February 17, 1941. On October 18, 1940, Barnes had purchased

from Carlen Pippin's *Six O'Clock*, 1940, a night interior scene of a woman, child, and dog in front of a hearth, reminiscent of the seventeenth-century Dutch tradition mentioned in Barnes's article for the 1940 Carlen exhibition. See Stein, "An American Original," 40 n. 59, fig. 150. It was the largest of the Pippins bought by Barnes, measuring 25 × 28 in. (65.5 × 71.1 cm). Barnes sold it on April 4, 1946, to David Y. Ellinger for $300.00. Barnes to Ellinger, April 2, 1946, ACB Corr., BFA. See also entry for Thomas Hart Benton's *Figure and Boats* (BF2014), remarks and note 4.

17  Albert J. Barnes, "Horace Pippin Today," in *Recent Paintings by Horace Pippin*, exh. cat. (Philadelphia: Carlen Galleries, 1941). The exhibition traveled to the Arts Club of Chicago, May 23–June 14, 1941 (thirty-nine works). Barnes helped arrange for two other exhibitions of Pippin's work. The first, Paintings by Horace Pippin, September 30–October 12, 1940, Bignou Gallery, New York (twenty-four paintings), and the second, also called Paintings by Horace Pippin, in conjunction with Douglas MacAgy, a former Barnes Foundation student and newly appointed curator at the San Francisco Museum of Art, April 14–May 3, 1942 (thirty-one paintings). See MacAgy's letter to Barnes, June 3, 1941, and Barnes to MacAgy, June 12, 1941: "The difficulty with [the possibility of a Pippin show] is that he had exhibitions in Philadelphia, New York and Chicago and sold everything that was any good. However, he is a very diligent worker and I think by the early winter he can have enough to make a credible showing." Both letters ACB Corr., BFA.

18  Rodman, *Horace Pippin: A Negro Painter*, 14–15. Rodman reproduces the print by an unknown artist, 15. The sixteenth-century Venetian painting referred to is no longer attributed to Tintoretto. Rodman continues: "The blood-red sky, according to Robert Carlen, was inspired by a sunset observed while crossing the Pulaski Skyway after Pippin's trip to New York for the opening of his third show, at the Bignou Gallery." The sky in the painting is not "blood-red."

19  Rodman and Cleaver, *Horace Pippin*, 60–61.

20  Performed by three children from Tupelo, Mississippi, May 8, 1939, Folklife Field Recording Index, Library of Congress, AFS 2960, and subsequently by many other artists, including Mahalia Jackson, Reverend Gary Davis, and Bob Dylan.

21  Barnes, "The Art of the American Negro," *The Barnwell Bulletin*, "The Barnwell Addresses," 13, no. 54 (May 1936), 15–26, lecture presented in conjunction with a performance by the Glee Club of the Manual Training and Industrial School for Youth of Bordentown, New Jersey, at Barnes's alma mater, April 27, 1936.

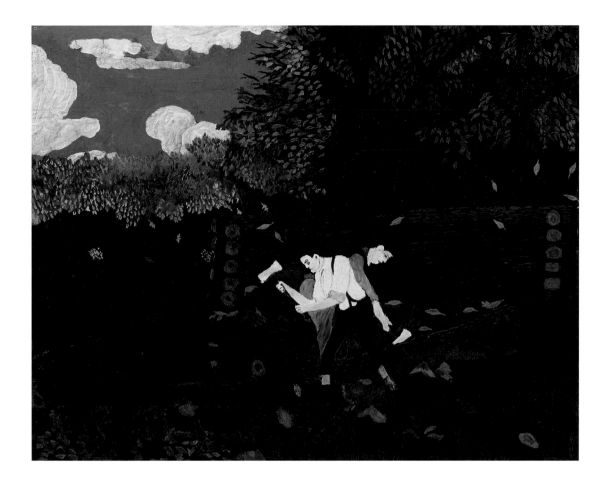

## *Abraham Lincoln and His Father Building Their Cabin on Pigeon Creek*

c. 1934. Oil on fabric (later mounted to composition board), 16¼ × 20¼ in. (41.3 × 51.4 cm). Unsigned. BF978

PROVENANCE: Acquired from Carlen Galleries, January 18, 1940, for $150.00.[1]

EXHIBITIONS: Chester County Art Association and the West Chester Community Center, Pa., June 8–July 5, 1937, cat. no. 8; Carlen Galleries, Philadelphia, Horace Pippin Exhibition, January 19–February 18, 1940.

REFERENCES: *Horace Pippin Exhibition*, exh. cat. (Philadelphia: Carlen Galleries, 1940), cat. no. 1 ("Lent by [the] Barnes Foundation"); Albert C. Barnes, "Horace Pippin," introduction to *Horace Pippin Exhibition*, 1940; Selden Rodman, *Horace Pippin: A Negro Painter in America* (New York: Quadrangle Press, 1947), 13, 33, pl. 5, and 82, cat. no. 10; Selden Rodman and Carole Cleaver, *Horace Pippin: The Artist as a Black American* (Garden City, N.Y.: Doubleday, 1972), 66, 68, stating that the composition was "suggested if not copied directly from life insurance calendars" (70); Judith E. Stein, *I Tell My Heart: The Art of Horace Pippin* (Philadelphia: Pennsylvania Academy of the Fine Arts, 1993), 40 n. 59, "Chronology," 187, and "List of All Known Pippin Works," 194; Richard Powell, "Re-Creating American History," in Stein, *I Tell My Heart*, 72, ill. 75, pl. 51; Mark F. Bockrath and Barbara A. Buckley, "Materials and Techniques," in Stein, *I Tell My Heart*, 171, 173, and 175.

1 Letter from the Barnes Foundation Secretary to Robert Carlen, January 18, 1940, enclosing a check in the amount of $150.00 in payment for *Abraham Lincoln* and a second check in the amount of $100.00 for *Cabin in Cotton Field*, which Barnes purchased as a gift for Charles Laughton. Letter, ACB Corr., BFA. Barnes Foundation check no. 12662, January 18, 1940, $150.50; and Albert C. Barnes check no. 2264, January 18, 1940, $100.00, BFFR, BFA.

## Supper Time

Alternate title: *Cabin Interior*

c. 1940. Oil on burnt-wood panel, 12 × 15⅛ in. (30.5 ×
38.4 cm). Signed lower right: H. Pippin. Frame by Charles
Prendergast, signed upper frame member verso:
Prendergast. BF985

PROVENANCE: Acquired from Carlen Galleries in February
1941.[1]

REFERENCES: "Museums Buy Pippin," *Art Digest*, March 1,
1941; Selden Rodman, *Horace Pippin: A Negro Painter in
America* (New York: Quadrangle Press, 1947), 16–17, 87, cat.
no. 113 (as *Cabin Interior*, 1941?), ill. 76, pl. 48; R.J. Watten-
maker, "Dr. Albert C. Barnes and the Barnes Foundation,"
in *Great French Paintings from the Barnes Foundation* (New
York: Knopf in association with Lincoln University Press,
1993), 24, 25, fig. 11 (color); Judith E. Stein, *I Tell My Heart: The
Art of Horace Pippin* (Philadelphia: Pennsylvania Academy of
the Fine Arts, 1993), 40 n. 59, pl. 152, "Chronology," 188, "List of
All Known Pippin Works," 197.

1  Letter, Albert C. Barnes to Robert Carlen, February 17, 1941, enclosing
   Albert C. Barnes check no. 418, February 17, 1941, $50.00, ACB Corr., BFA.

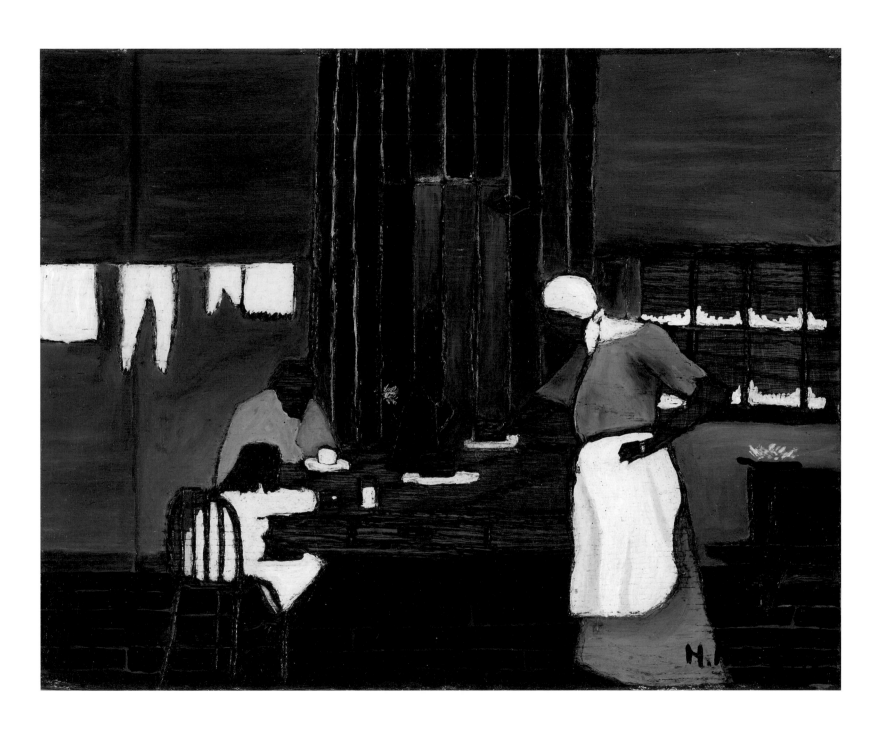

## *Christ and the Woman of Samaria*

Alternate titles: *Woman of Samaria; The Woman at Samaria*
1940. Oil on canvas, 19¾ × 24¼ in. (50.2 × 61.6 cm).
Signed and dated lower right: H. Pippin, / 1940. BF986

PROVENANCE: Acquired from Carlen Galleries in February 1941.[1]

EXHIBITION: Carlen Galleries, Philadelphia, Recent Paintings by Horace Pippin, March 1–April 20, 1941.

REFERENCES: Albert C. Barnes, "Horace Pippin Today," introduction to *Recent Paintings by Horace Pippin*, exh. cat. (Philadelphia: Carlen Galleries, 1941), cat. no. 1 (as *Woman of Samaria*, "Acquired by [the] Barnes Foundation"); Sidney Janis, *They Taught Themselves: American Primitive Painters of the 20th Century* (New York: Dial Press, 1942), 186 (photograph with caption, "Horace Pippin painting *Woman of Samaria*. Now in the Collection of the Barnes Foundation, Merion"); Selden Rodman, *Horace Pippin: A Negro Painter in America* (New York: Quadrangle Press, 1947), 14–15, 83,

cat. no. 26, pl. 12; Violette de Mazia, "What to Look for in Art," *BFJAD* 1, no. 2 (Autumn 1970): 20–22, pl. 12; Selden Rodman and Carole Cleaver, *Horace Pippin: The Artist as a Black American* (Garden City, N.Y.: Doubleday, 1972), 76–77; Violette de Mazia, "Naïveté," *BFJAD* 7, no. 2 (Autumn 1976): 63, 69, pl. 14; Violette de Mazia, "Academicism," *Vistas* 4, no. 2 (Winter 1988–89): 14, 23–34, pls. 104 and 106; Judith Stein, *I Tell My Heart: The Art of Horace Pippin* (Philadelphia: Pennsylvania Academy of the Fine Arts, 1993), 20, 39 n. 43, 40 n. 59, "Chronology," 188, "Exhibition History of Horace Pippin," 196; Richard Powell, "Biblical and Spiritual Motifs," in Stein, *I Tell My Heart*, 126, 127, fig. 121; Mark F. Bockrath and Barbara A. Buckley, "Materials and Techniques," in Stein, *I Tell My Heart*, 174, 180.

REMARKS: This painting was completed late in the year (fig. 88). See pages 307–08 and page 310, notes 17 and 18.

1  Letter, Barnes Foundation Secretary to Robert Carlen, February 20, 1941, with Albert C. Barnes check no. 421, February 20, 1941, $150.00, ACB Corr., BFA.

FIG. 88

Horace Pippin (1888–1946) painting *Christ and the Woman of Samaria* (BF986), 1940, Whitney Museum of American Art, New York, Library Archives

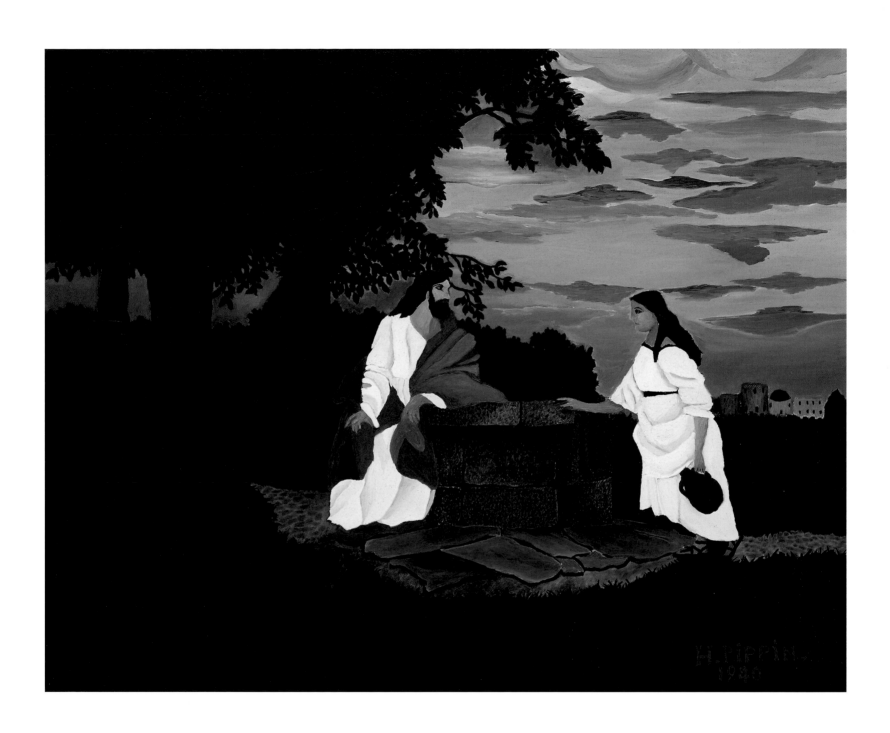

## *Giving Thanks*

1942. Oil on canvas (later mounted to composition board), 11 × 14⅜ in. (27.9 × 36.5 cm). Signed lower right: H. Pippin. BF990

PROVENANCE: Acquired from Carlen Galleries, September 22, 1942, for $175.00.[1]

REFERENCES: Selden Rodman, *Horace Pippin: A Negro Painter in America* (New York: Quadrangle Press, 1947), 84, no. 48 (as 1942?); Judith Stein, "An American Original," in *I Tell My Heart: The Art of Horace Pippin* (Philadelphia: Pennsylvania Academy of the Fine Arts, 1993), 40 n. 59; Mark F. Bockrath and Barbara A. Buckley, "Materials and Techniques," in Stein, *I Tell My Heart*, 167, fig. 169; "Chronology," 188, and "List of All Known Pippin Works," 198 (as c. 1942), in Stein, *I Tell My Heart*.

1 Albert C. Barnes check no. 1986, September 22, 1942, $175.00, BFFR, BFA.

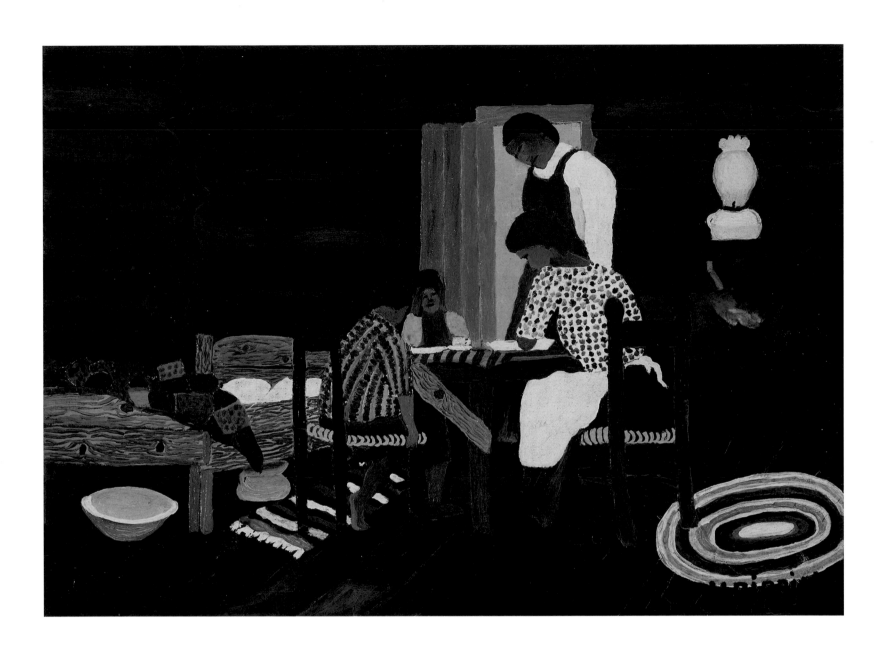

# ADDITIONAL WORKS BY AMERICAN ARTISTS

# MILTON AVERY (1885–1965)

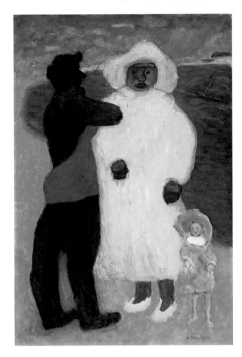

FIG. 89

Milton Avery, *Study for "The Nursemaid"* (BF961), c. 1934, watercolor on paper, 21¼ × 15 in. (53.2 × 37.3 cm), Makler Family Collection

## The Nursemaid
Alternate title: *Nursemaid*
1934. Oil on canvas, 48 × 32 in. (121.9 × 81.3 cm). Signed lower right: Milton Avery. Frame by Sally Michel Avery (the artist's wife). BF961

PROVENANCE: Acquired from Valentine Gallery, New York, March 20, 1935.[1]

EXHIBITION: Valentine Gallery, New York, first one-man show, March 1935.

REFERENCES: Harry Salpeter, "Art Career in Two Keys," *Esquire*, July 1945, 160–62: "Concerning Albert C. Barnes' acquisition of *Nursemaid* for the Barnes Foundation, there is a curious story: the dealer had refused to hang it on the wall, fearing that some people might be offended at the artist taking seriously the subject of a colored nursemaid; observing it on the floor in a back room, Barnes bought it on the spot, on condition that the full purchase price be transmitted to the artist" (162); Barbara Haskell, *Milton Avery* (New York: Whitney Museum of American Art in association with Harper and Row, 1982), 188.

RELATED WORK: *Study for "The Nursemaid,"* c. 1934, watercolor on paper, 21¼ × 15 in. (53.2 × 37.3 cm), signed lower right: Milton Avery, Makler Family Collection (fig. 89). Acquired in 1957 by gift from the artist and his wife. See Paul Todd Makler, *Prometheus (Bound)*, Annex C, September 1961, 21–24.

1 Invoice from Valentine Gallery, March 14, 1935, ACB Corr., BFA. Barnes Foundation check no. 8110, March 20, 1935, $150.00, payable to Milton Avery, BFFR, BFA. Letter, Valentine Dudensing to Albert C. Barnes, March 18, 1935: "This is to confirm our sale to you of the painting by Milton Avery, *The Nursemaid*. Avery was very thrilled at the event. Unlike many of these so-called artists, he has a sense of appreciation." Letter, Milton Avery to Barnes, March 16, 1935: "Mr. Valentine Dudensing has informed me that you have acquired one of my paintings. Would like you to know that I consider it an honor to be included in your collection." © 2009 Milton Avery Trust/Artist Rights Society (ARS), New York. Letter, Barnes to Dudensing, March 20, 1935: "The day before your letter arrived I got a note from Mr. Avery expressing great satisfaction that his picture is to be in our collection. I thought that the painter might be in need of money so I am enclosing check for one hundred and fifty ($150.00) dollars. Inasmuch as you told me the full amount goes to him I have made the check payable to his order." All letters ACB Corr., BFA.

## ELAINE BAILEY (1914–1995)

## *Hallyjuliah!*

1945. Colored pencil on thin wove paper, 11 × 8⁹⁄₁₆ in. (27.9 × 21.7 cm). Signed and inscribed lower center: *Dr. Barnes, Mrs. Barnes and colleagues of the / Barnes Foundation. / Joy to you for 1945 and 1946. / Elaine.* Inscribed lower center: *Hallyjuliah on high*; inscribed upper left: *Dr. Albert C. Barnes / The Barnes Foundation*; inscribed upper center: *Decembre.* BF432

PROVENANCE: Gift from the artist, December 1945.

REMARKS: Bailey was a student at the Barnes Foundation from 1937 to 1939.

## *Dancing Figures*

1940. Four drawings: graphite and crayon on five leaves of thin wove paper (including signature leaf) displayed in multi-opening mat, overall with mat, 14 × 11 in. (35.6 × 27.9 cm); sheet, upper left, 5¹⁄₁₆ × 4½ in. (12.9 × 11.4 cm); sheet, upper right, 3¾ × 3¾ in. (9.5 × 9.5 cm); sheet, lower left, 5¼ × 3¾ in. (13.3 × 9.5 cm); sheet, lower right (figure), 3¼ × 3½ in. (8.3 × 8.9 cm); sheet, lower right (signature), ¾ × 1⅝ in. (1.9 × 4.1 cm). Signed lower right: Elaine Bailey. BF1192

PROVENANCE: Gift from the artist, June 1940.[1]

1 Letter, Albert C. Barnes to Elaine Bailey, July 5, 1940, ACB Corr., BFA: "Not the least interesting part of your nice letter of June 29th was the colorful drawings that show that you can create art as well as study and understand the art of others. We are all delighted to learn that you have got a job that gives you an opportunity to eat as well as to enjoy your work. . . . This is a strange summer for me, the first one I have spent in America in more than twenty years. It fills me with grief to think of the terrible fate of France, the country I love so much and in which I have spent so much time. I hope everything goes well with you and that you will be successful not only in your teaching but also in your painting."

## THOMAS HART BENTON (1889–1975)

### Figure and Boats

c. 1920. Charcoal on laid paper, 15¾ × 18¼ in. (40 × 46.4 cm). Signed lower right: Benton. BF2014

PROVENANCE: Acquired from the artist, May 26, 1923.[1]

REFERENCES: Violette de Mazia, "Creative Distortion IV: Portraiture II," BFJAD 5, no. 1 (Spring 1974): 23, pl. 66; Violette de Mazia, "Academicism," *Vistas* 4, no. 2 (Winter 1988–89): 18, 25, pl. 120.

REMARKS: On April 4, 1946, Barnes sold a drawing by Benton to David Y. Ellinger.[2] Ellinger was a dealer from whom Barnes purchased a number of Pennsylvania German antiques beginning in 1946. He also was a painter and was a student at the Barnes Foundation from 1950 to 1951.[3]

1 *Figure and Boats* is one of several works purchased by Barnes May 26, 1923. Barnes Foundation check no. 93, May 26, 1923, $300.00, payable to "Thomas H. Benton [3? Illegible] pictures," BFFR, BFA.

2 Letter, David Y. Ellinger to Nelle E. Mullen, November 19, 1955: "In 1946 or 1947 I purchased a charcoal and crayon drawing from Dr. Barnes by Thomas Hart Benton. The subject was a nude woman with fruit. I now have a chance to sell this Benton which is unsigned. Could you . . . send me a note to verify the fact that this I purchased from Dr. Barnes and that he acquired it from Benton." Letter, Mullen to Ellinger, November 22, 1955: "This is to verify that on April 4 1946, Mr. David Y. Ellinger bought from The Barnes Foundation the charcoal and crayon drawing by Thomas Hart Benton. This drawing was bought directly from Mr. Benton by The Barnes Foundation in May of 1923." Both letters Central File Correspondence, BFA.

3 See Nelson M. Williams, "Love David," *Pennsylvania Folklife* 41, no. 3 (Spring 1997): 112–13, 117 n. 40.

### Waves

Alternate title: *Study for a Decoration*

1920. Charcoal on laid paper, 17¾ × 21¾ in. (45.1 × 55.2 cm). Unsigned. BF2015

PROVENANCE: Acquired from the Pennsylvania Academy of the Fine Arts, May 12, 1921.[1]

EXHIBITION: Pennsylvania Academy of the Fine Arts, Philadelphia, Exhibition of Paintings and Drawings Showing the Later Tendencies in Art, April 16–May 15, 1921.

REFERENCES: *Exhibition of Paintings and Drawings Showing the Later Tendencies in Art*, exh. cat. (Philadelphia: Pennsylvania Academy of the Fine Arts, 1921), cat. no. 166 (as *Study for a Decoration*); Henry Adams, *Thomas Hart Benton, An American Original* (Kansas City, Mo.: Trustees of the Nelson Gallery Foundation, 1989), 106–07, ill. 101: "Benton exhibited this drawing, made during his first summer at Martha's Vineyard, at a modernist exhibition [Later Tendencies] in Philadelphia in spring 1921. There it was spotted by Dr. Albert C. Barnes, who purchased it for his foundation."

REMARKS: Benton served on the selection and hanging committees for the Exhibition of Paintings and Drawings Showing the Later Tendencies in Art at the Pennsylvania Academy of the Fine Arts.

1 Letter, Albert C. Barnes to the Pennsylvania Academy of the Fine Arts, May 12, 1921, ACB Corr., BFA, mentions payment of $1,125.00 covering eight works, including two by Benton, sent May 3.

## MORRIS BERD (1914–2007)

## *Nature Study*

1947. Oil on canvas, 24 × 20 in. (61 × 50.8 cm). Signed and dated lower left: Berd / '47. BF2084

PROVENANCE: Acquired from the artist's first one-man exhibition at the School of Industrial Arts, Philadelphia, June 23, 1948, for $100.00.[1]

EXHIBITION: Contemporary Art Association, School of Industrial Art, Philadelphia, 1948.

REFERENCES: C. H. Bonte, "Morris Berd's Solo Show," *Philadelphia Inquirer*, May 3, 1948: "This small group of oils at the School of Industrial Art . . . constituting the first one-man show held by Morris Berd, contains much that is colorful, lively and engaging . . . *Nature Study* is perhaps the most direct in statement"; Don Fairbairn, "In Our Town," *Philadelphia Evening Bulletin*, June 25, 1948, 4: "Dr. Albert C. Barnes, who has the world's greatest collection of French moderns, bought a painting at new Contemporary Art Assoc. Gallery, 'Nature Study,' by Morris Berd, School of Industrial Art teacher."

1 Barnes Foundation check no. xx [from a series of unnumbered checks], June 23, 1948, payable to the Contemporary Art Association, Barnes Foundation Ledger, P–Z, 1922–1950, BFFR, BFA.

## JOHN BOSWORTH [RYBCZYK] (1934–2006)

## *Bedroom*

1951. Oil on canvas panel, 20 × 16 in. (50.8 × 40.6 cm). Signed lower right: JR. BF2556

PROVENANCE: Acquired from the Friends' Neighborhood Guild, Philadelphia, June 26, 1951, for $10.00.[1]

REMARKS: See also entry for Francis McCarthy's *Still Life* (BF2059).

1 Invoice, Friends' Neighborhood Guild to the Barnes Foundation, June 21, 1951, ACB Corr., BFA. Barnes Foundation check no. 19655, June 26, 1951, payable to the Friends' Neighborhood Guild, BFFR, BFA.

## KRONA BRONSTEIN (B. 1925)

*Seated Figure*

c. 1946. Oil on paperboard, 11 × 9 in. (27.9 × 22.9 cm). Signed lower left: K. C. Bronstein. Frame by Robert Laurent, signed left frame member verso: Laurent. BF2060

PROVENANCE: Acquired from the Friends' Neighborhood Guild, Philadelphia, June 6, 1946, for $30.00.[1]

EXHIBITION: Friends' Neighborhood Guild, Philadelphia, June 5–9, 1946, cat. B.

REMARKS: Bronstein was a student at the Barnes Foundation from 1944 to 1947.

1 Letter, Nelle. E. Mullen to the Friends' Neighborhood Guild, June 6, 1946, enclosing Barnes Foundation check no. 13854, June 6, 1946, $110.00, in payment for Bronstein's *Seated Figure* (BF2060) as well as Priscilla Heacock, *Composition* (BF2061), Francis McCarthy, *Still Life* (BF2059) and another work by McCarthy no longer in the collection, and Florence Shubert, *Color Movement Inspired by "Joie de vivre"* (BF2057), along with a check from Violette de Mazia in the amount of $15.00 in payment for a work by Shubert. Letter ACB Corr., BFA; check BFFR, BFA.

## MYRA BUTTERWORTH (1899–2002)

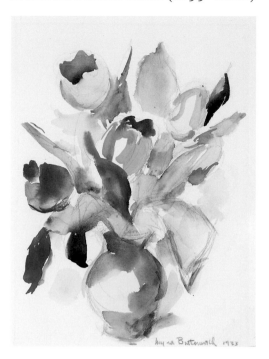

*Tulips (Flower Study)*

1933. Watercolor with graphite on wove paper, 11½ × 9 in. (29.2 × 22.9 cm). Signed and dated lower right: Myra Butterworth 1933. BF2006

PROVENANCE: Acquired from the Newman Galleries, Philadelphia, June 1, 1933, for $15.00.[1]

REFERENCE: See Cynthia A. Hummel, "A Trove of Amish Art and History," *Maine Antique Digest* XXXV, no. 2 (February 2007): section 1, 11.

1 Invoice from the Newman Galleries, April 27, 1933, ACB Corr., BFA. Barnes Foundation check no. 6560, June 1, 1933, $17.50 (incl. $2.50 for frame), BFFR, BFA. Barnes Foundation Ledger, P–Z, 1922–1950, BFA.

## MARY CASSATT (1844–1926)

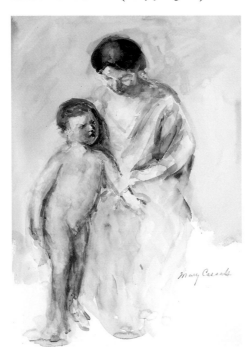

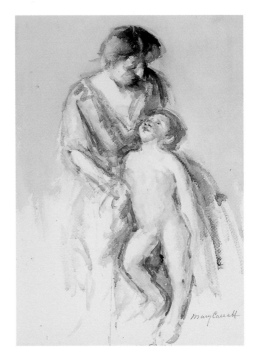

### Woman with Nude Boy at Her Right

Alternate title: *Woman and Child (Femme et enfant)*
c. 1911–13. Watercolor on thick wove paper, 20 × 14 in.
(50.8 × 35.6 cm). Signed lower right: Mary Cassatt. Inscribed
verso: *No 10744 / Cassatt—Femme et enfant.* BF 321

PROVENANCE: Acquired from Durand-Ruel, April 22, 1915,
for $250.00.[1]

REFERENCE: Violette de Mazia, "The Barnes Foundation:
The Display of Its Art Collection," *Vistas* 2, no. 2 (1981–83):
109n, pl. 118 (installation).

RELATED WORKS: See Adelyn D. Breeskin, *Mary Cassatt: A
Catalogue Raisonné of the Oils, Pastels, Watercolors, and Draw-
ings* (Washington, D.C.: Smithsonian Institution Press, 1970),
nos. 649–51 and 687–89, for similar watercolors. *Woman with
Nude Boy at Her Right* was not included in Breeskin.

1 Invoice from Durand-Ruel, April 22, 1915, $500.00 for two water-
colors by Mary Cassatt, Durand-Ruel nos. 3841 (*Femme et enfant—
aqua[relle]*) and 3846 (*Femme et enfant—aqua[relle]*), ACB Corr., BFA.
Information with respect to dates from Durand-Ruel stockbooks cour-
tesy of Dr. Nancy Mowll Mathews, letter to the author, May 30, 2007.

### Woman with Nude Boy at Her Left

Alternate title: *Woman and Child (Femme et enfant)*
c. 1911–13. Watercolor on thick wove paper, 20⅞ × 13⅞ in.
(53 × 35.2 cm). Signed lower right: Mary Cassatt. Inscribed
verso: *No 10739 / Cassatt—Femme et enfant.* BF 323

PROVENANCE: Acquired from Durand-Ruel, April 22, 1915,
for $250.00.[1]

REFERENCE: See entry for Cassatt's *Woman with Nude Boy at
Her Right* (BF 321); not in Breeskin.

1 Invoice from Durand-Ruel, April 22, 1915, $500.00 for two watercolors
by Mary Cassatt, Durand-Ruel nos. 3841 (*Femme et enfant—aqua[relle]*)
and 3846 (*Femme et enfant—aqua[relle]*), ACB Corr., BFA. Informa-
tion with respect to dates from Durand-Ruel stockbooks courtesy of
Dr. Nancy Mowll Mathews, letter to the author, May 30, 2007.

## MARY CHALMERS (B. 1927)

### My Portrait

Alternate title: *Head—Self-Portrait*
c. 1949. Drypoint on wove paper, sheet 6 × 5 in. (15.2 × 12.7 cm), plate 4⅞ × 3⅞ in. (12.4 × 9.8 cm). Signed lower right: Mary Chalmers. Inscribed lower left: *My portrait.* BF657

PROVENANCE: Acquired from the artist at the Rittenhouse Square, Philadelphia, Annual "Clothesline" Exhibition, June 24, 1949, for $12.00.[1]

EXHIBITION: Rittenhouse Square, Philadelphia, Annual "Clothesline" Exhibition, 1949.

REMARKS: Chalmers was a student at the Barnes Foundation from 1948 to 1950.

1 Barnes Foundation Cash Journal, 1947–1950, BFFR, BFA.

## JOSEPH GOODHUE CHANDLER (1813–1884) [attributed to]

### Portrait of a Man

c. 1845–50. Oil on canvas (later mounted to fiberboard), 28¼ × 25⅝ in. (71.8 × 65.1 cm). Unsigned. BF993

PROVENANCE: Acquired from Clarence Johnson, August 24, 1944, for $25.00.[1]

RELATED WORKS: *Portrait of a Man* may be compared to portraits by Chandler recorded in the Catalogue of American Portraits (CAP), National Portrait Gallery, Smithsonian Institution, Washington, D.C., such as MD990101, *Portrait of Samuel Austin* (1808–1876), dated 1846 (Private Collection). Chandler's drawing of hands with elongated fingers is characteristic of his signed and documented work.

REMARKS: Attribution to Chandler suggested by Susan Foster Garton, Catalogue of American Portraits, National Portrait Gallery, Smithsonian Institution. The assistance of Ellen G. Miles, curator of Painting and Sculpture, is also gratefully acknowledged.

1 Barnes Foundation Cash Journal, 1941–1946, BFFR, BFA.

## BARTON CHURCH (B. 1926)

FIG. 90

*Seated Couple,* Dogon Peoples, Mali, late 19th–early 20th century, H 27⅜ × W 11 × D 10½ in. (69.5 × 27.9 × 26.7 cm) (with base), The Barnes Foundation, A197

### *Girl in a Chair*
Alternate title: *Seated Figure*

1951. Oil on canvas, 20½ × 13⅛ in. (52.1 × 33.3 cm). Signed and dated on canvas verso: B. Church 51. Frame by Alfred Maurer. BF616

PROVENANCE: Acquired from the artist, June 27, 1951.[1]

REFERENCES: Barton Church, "A Sonata—A Painting," *BFJAD* 3, no. 1 (Spring 1972): 59–71. See Violette de Mazia, "What's in a Frame?" *BFJAD* 7, no. 2 (Autumn 1977): 56n, pl. 65 (as *Seated Figure*). The painting sent to de Mazia as a replacement for *Girl in a Chair* (BF616, see note 1), *Girl in Trolley Car,* 1951, is discussed in Violette de Mazia, "Transferred Values," *BFJAD* 9, no. 2 (Autumn 1978), 5, pl. 64 (Collection Violette de Mazia Trust). See also *Barton Church: Paintings,* exh. cat., special issue, [Rutgers] *University Art Gallery Bulletin* 1, no. 4 (1967): cat. no. 9; Violette de Mazia, "Subject and Subject Matter," *Vistas* 2, no. 1 (Spring–Summer 1980): 5, 6, pls. 46, 61, and 95; Ralph Blumenthal, "Arts in America: Imparting the Vision Behind an Idiosyncratic Collection," *New York Times,* November 12, 2002, B2.

RELATED WORK: *Seated Couple* (A197), Dogon Peoples, Mali, late 19th–early 20th century, H 27⅜ × W 11 × D 10½ in. (69.5 × 27.9 × 26.7 cm) (with base), The Barnes Foundation (fig. 90).

REMARKS: Church was a student at the Barnes Foundation from 1949 to 1951. In 1952 he was appointed a faculty member in the Art Department of the Barnes Foundation, where he continues to teach. He received a traveling scholarship from the Foundation in 1953. Maurer carved the frame from a stretcher; it was sized and retouched by Albert Nulty.

1 Barnes Foundation check no. 19557, June 27, 1951, $100.00, payable to Barton Church, BFFR, BFA. Letter, Albert C. Barnes to Church, June 27, 1951, ACB Corr., BFA: "The painting you gave to Miss de Mazia has gotten me into trouble. I liked the painting and asked Miss de Mazia to donate it to the Foundation, but she refused. I asked her to sell it to me and she got mad. She asked to have Albert [Nulty] make a frame for it and when the frame was finished, I hung the painting in the Foundation Gallery. Of course, she can have me arrested for theft, but if I pay you some money, keep the painting, and ask you to give her another painting to replace the one you had already given her, I may be able to stay out of jail. So, I send herewith a check payable to you for one hundred (100) dollars."

## LIZ CLARKE (1906–1967)

### *The Balloon Man*

Alternate title: *Man with Balloon*

c. 1942. Oil with sand on paper mounted to canvas,
12 × 10 in. (30.5 × 25.4 cm). Unsigned. BF992

PROVENANCE: Acquired from the Bignou Gallery, New York,
March 30, 1943.[1]

EXHIBITIONS: Bignou Gallery, New York, Paintings by Liz
Clarke, January 11–30, 1943 (cat no. 6); Phillips Memorial Gallery, Washington, D.C., Liz Clarke: An Exhibition of Recent
Paintings, February 21–March 7, 1943.

REFERENCE: Peggy Preston, "She Ventures into 'Sheer
Abstractionism' with Her Exhibit of Playful Paintings," *Washington Post*, February 21, 1943: "Her first exhibition in the
United States was held in 1928. . . . The Barnes Foundation
in Philadelphia recently purchased her *Man With Balloon*,
which is to be included in the show here."

1 Barnes Foundation check no. 2518, March 30, 1943, $25.00, signed N. E.
Mullen, payable to Georges Keller, BFFR, BFA. Invoice from Bignou Gallery, March 31, 1943: "One original painting by Liz Clarke ANYC457 [Bignou inventory no.] *Man with a Balloon* $25.00." Letter, Albert C. Barnes
to Keller, March 30, 1943: "The enclosed check for twenty-five dollars
($25.00) pays for the small painting which just arrived from the Phillips
Memorial Gallery of Washington. Please send me the *name* of the
painter so that we might complete our records." Letter, Keller to Barnes,

March 31, 1943: "Thank you very much for your letter of March 30, which
has been duly received, together with check in the amount of Twenty-five Dollars, in payment for the painting by Liz Clarke, *Man with Balloon*, for which I am sending you enclosed the receipted invoice. I am
also enclosing herewith the catalogue of the Show, in case you can use
some of the information contained therein." Both letters ACB Corr.,
BFA.

## ANDREW DASBURG (1887–1979)

### *Landscape (Mountain in the Southwest)*

c. 1920. Oil on canvas, 16 × 20 in. (40.6 × 50.8 cm). Signed
lower right: Dasburg. Inscribed on upper stretcher
member: *Andrew Dasburg*; on lower stretcher member:
*This Dasburg was painted in Taos [New Mexico]*. BF592

PROVENANCE: Acquired from the Exhibition of Paintings
and Drawings Showing the Later Tendencies in Art, Pennsylvania Academy of the Fine Arts, 1921, for $215.00.[1]

EXHIBITION: Pennsylvania Academy of the Fine Arts, Philadelphia, Exhibition of Paintings and Drawings Showing the
Later Tendencies in Art, April 16–May 15, 1921.

REFERENCES: *Exhibition of Paintings and Drawings Showing
the Later Tendencies in Art*, exh. cat. (Philadelphia: Pennsylvania Academy of the Fine Arts, 1921), cat. no. 101 (as *Landscape*); Van Deren Coke, "Works of Andrew Dasburg, Other
Than Prints, in Public Collections" (as *Mountain Landscape*,
late 1920s, oil, Barnes Foundation), *Andrew Dasburg* (Albuquerque: University of New Mexico Press, 1979), 136; Sylvia
Yount and Elizabeth Johns, *To Be Modern: American Encounters with Cézanne and Company* (Philadelphia: Museum of

American Art of the Pennsylvania Academy of the Fine Arts, 1996), fig. 17.

REMARKS: In 1930–32, Barnes corresponded extensively with Dasburg, then residing in Santa Fe, New Mexico, and purchased New Mexican *santos*, Navajo blankets, turquoise and silver jewelry, and Southwestern Pueblo pottery from him.[2] Barnes wrote a letter of recommendation in support of Dasburg's application for a fellowship to the Guggenheim Memorial Foundation, September 18, 1931: "I have known Mr. Andrew H. Dasburg for about fifteen (15) years and I share the general opinion of special students of paintings that he is one of the most competent and broadly educated of progressive American painters. He is one of the pioneers of that phase of modern painting which is now accepted as one of the distinct contributions to American culture. . . . He is an assiduous worker and his integrity is of the best."[3]

1  Andrew Dasburg to Albert C. Barnes, undated [1921]: "Eugene Speicher read me your letter to him inquiring for the prices of certain canvases— I believe the New Mexican one of mine you refer to is a 16 × 20 greyer in tone than the smaller ones—with a foreground of reddish fields against a range of hills—my lowest price on this is 175.00 dollars (unframed)." Letter, Dasburg to Barnes, undated [April 21, 1921]: "Mr. Arthur B. Carles communicated to me your offer to buy one of my canvases in the present exhibition at the Pennsylvania Academy of Fine Arts—I told him that I will be pleased to accept your offer of 200—dollars, and asked him to remind you that there is probably a commission to be paid to the academy and that I wondered whether you would care to share this with me in consideration for the reduction of 100—dollars that you ask for—If not—I will be glad to pay all of it, and let you have it on your own terms. It pleases me greatly that you like this picture of mine. Cordially yours." Letter, Barnes to Dasburg, April 22, 1921: "In reply to your letter of yesterday, I shall accept your proposition to pay one-half of the commission on the sale of your painting. I understand the commission is 15% which would make $15.00 for me to pay over and above the $200.00; but to keep the matter business-like it would be better for me to send you a check for $15.00 for my share of the commission, and I shall do that when the transaction is completed. I like the painting very much—in fact, better every time I see it." All letters ACB Corr., BFA. Albert C. Barnes check no. 4930, May 3, 1921, $15.00, payable to Andrew Dasburg, BFFR, BFA, with a letter, Barnes to Dasburg, May 3, 1921, confirming the transaction, ACB Corr., BFA.
2  See Lara Kaplan, "Conservation of Southwest Pueblo Ceramics at the Barnes Foundation," The Barnes Foundation *Newsletter* (Summer 2009), 2–3.
3  Letter, Barnes to the Guggenheim Memorial Foundation, September 18, 1931, ACB Corr., BFA.

## ARTHUR B. DAVIES (1862–1928)

## Music in the Fields
Alternate title: *Music*
Early 1890s. Oil on canvas, 8⅛ × 20¼ in. (20.6 × 51.4 cm). Unsigned. BF817

PROVENANCE: Acquired from William Macbeth, January 4, 1913.[1]

REFERENCE: In *Photographic Record of Paintings Sold*, William Macbeth recorded the sale of *Music in the Fields* as to Dr. A. C. Barnes, 12/18/1912 (p. 29, ill.) [handwritten under image]. See *Macbeth Gallery Records*, Archives of American Art, Smithsonian Institution, Microfilm Reel NMc 80, frames 85 (handwritten index) and 101 (photograph).

REMARKS: Barnes had considerable interaction with Davies between 1912 and 1914. Davies contacted Barnes about lending to the Armory Show. Barnes wrote to Davies, February 4, 1913: "I received your telegram requesting the loan of paintings by Cézanne and Gauguin for the International Exhibit. If you knew what those paintings meant to me, I am sure you would not put me in the position where I appear selfish or unsympathetic in refusing the loan. They are with me not an incident or pieces of furniture—they are simply my daily life itself and I could no more be without them for a month than I could go without food for a like period. I hope, when you are over the rush of the show that you will come over and see them."[2] Davies replied to Barnes, February 5, 1913: "Your kindly letter has just been received. Your point of view—the joy of living with your new pictures I can readily understand. Also I can say with certainty you will have intensified pleasure in seeing our great exhibition, the side lights of the modern movement, its very real signification as a stimulus to our modern life. These are busy days, and when I can arrange an appointment later, which you may find agreeable, I shall be only too happy to accept your cordial invitation, believe me."[3] After the show closed, Barnes

wrote Davies: "At the recent international show in New York, I bought a painting by Vlaminck [*Les figues*, cat. no. 191], I have heard nothing from this painting: can you tell me what has become of it and when I may expect it?"[4] (Barnes had seen the Vlaminck in London at the Grafton Gallery Second Post-Impressionist exhibition in December 1912 [cat. no. 17, lent by Daniel-Henry Kahnweiler].) Davies and Barnes corresponded about the artist's recent Cubist-inspired work. Barnes wrote to Davies, January 14, 1914: "I have looked at many canvases in the dealers in the last two years, and my appreciation of your work has increased as my apparent knowledge of art has developed. I still feel that I would like to make a more careful study of that phase of your art represented by your old work, by living with what you consider one of your best canvases for at least a few months. This scheme would fit in with the plan which I have followed from the start, of forming my own judgment of paintings by living with them and uninfluenced by what other critics or artists may say of the particular paintings. I cannot tell you how much I enjoyed my all too short visit with you yesterday. I saw, after talking with you, more what the new movement in art means than I had been able to see heretofore, from seeing recent paintings in Paris, and from talking with the Steins and other people who share your views as to the importance of the essence of this movement. Heretofore, I have been in a wholly receptive, but totally unappreciative, mode towards the work represented by Picasso's recent paintings, and refrained from rejecting them because I had lived with Cézanne's sufficiently long to see the origin of the new phase, and because I know that Picasso is an earnest, sincere and exceptionally gifted artist. I am going to study the thing now with a better vision than I had before yesterday, although, I must confess that at this moment the importance given by you, Picasso and other gifted men, to what you consider the essence of all vital art, does not carry conviction to me—but that is, in all probability, due to my ignorance."[5]

1 Albert C. Barnes check no. 2507, January 4, 1913, $200.00, payable to William Macbeth, in payment of invoice dated December 31, 1912, BFFR, BFA. Letter, R. W. Macbeth to Barnes, October 30, 1912, ACB Corr., BFA: "We shipped you last night . . . the larger of the two paintings by Davies, and the smaller will go to you on Friday. It is understood that these are to go to you on approval. . . . The prices of these . . . are $650 for the larger, and not more than $200 for the smaller, the definite price of the latter to be fixed by my father."
2 Letter, Barnes to Arthur B. Davies, February 4, 1913, ACB Corr., BFA.
3 Letter, Davies to Barnes, February 5, 1913, ACB Corr., BFA.
4 Letter, Barnes to Davies, May 13, 1913, ACB Corr., BFA. Albert C. Barnes check no. 2668, June 20, 1913, $162.00, inscribed "Vlaminck's Les Figues," payable to Association of American Painters & Sculptors, BFFR, BFA.

The 24 × 28⅞ in. (61 × 73.3 cm) canvas depicting a plate of figs and objects on a table with drawer is a virtual imitation of a Cézanne still life. Subsequently sold to Bignou Gallery, New York, in 1945 for $350.00 (as *Still Life*). See typewritten list "Pictures sold to Bignou Gallery, 23 March, 1945," and letter, Georges Keller to Barnes, March 28, 1945, with list of twenty-two pictures sold to Bignou Gallery, including "Vlaminck Nature Morte," ACB Corr., BFA.
5 Letter, Barnes to Davies, January 14, 1914, ACB Corr., BFA, sending payment for two canvases. Albert C. Barnes check no. 2883, January 14, 1914, $450.00, payable to Arthur B. Davies, BFFR, BFA.

## Flora

Early 1890s. Gouache and graphite on heavy wove paper, mounted to paperboard, 10½ × 6¼ in. (26.7 × 15.9 cm). Signed lower right: AB Davies. Inscribed on verso: *661*; *Flora*; *Macbeth #661*. BF527

PROVENANCE: Acquired from William Macbeth, January 6, 1914 (? see references below).

REFERENCES: In *Photographic Record of Paintings Sold*, William Macbeth recorded the sale of *Flora* as "w.c. [watercolor] to Dr. A. C. Barnes 1/6/ [no year]," 1914 (?), "p. 8 [handwritten under image]." See *Macbeth Gallery Records*, Archives of American Art, Smithsonian Institution, Microfilm Reel NMc 80, frames 138 (handwritten index) and 147 (photograph).

## VIOLETTE DE MAZIA (1899–1988)

### A Necklace of Boats

Alternate title: *Concarneau*

1949. Oil on wood panel, 4½ × 8 in. (11.4 × 20.3 cm). Signed lower right: V. D. Frame by Charles Prendergast. BF1195

PROVENANCE: Acquired from the artist, November 28, 1949.[1]

REFERENCE: Violette de Mazia, "Subject and Subject Matter," *Vistas* 2, no. 1 (Spring–Summer 1980): 4–5, pl. 63.[2]

1  Barnes Foundation check no. 3207, November 28, 1949, $290.75, payable to Violette de Mazia, BFFR, BFA.
2  See letter, Violette de Mazia to Mrs. Morris Klein, December 2, 1955, Central File Correspondence, BFA: "I feel flattered that you noticed the small panel of boats, which I sketched in Brittany a few years back."

### Head

Undated. Graphite on wove paper, 5 × 5 in. (12.7 × 12.7 cm). Unsigned. BF768

PROVENANCE: Unknown.

REFERENCE: Violette de Mazia, "The Barnes Foundation: The Display of Its Art Collection," *Vistas* 2, no. 2 (1981–83), 109n, pl. 118 (installation).

## MILDRED MURPHY DILLON (1907–1992)

### Yes! Madame

c. 1948. Etching on laid paper, sheet 5⅝ × 4⅜ in. (14.3 × 11.1 cm), plate 4⅞ × 3¹⁵⁄₁₆ in. (12.4 × 10 cm). Signed lower right: Mildred M. Dillon. Inscribed lower left: *Yes! Madame*. BF2088

PROVENANCE: Acquired from the artist at the Rittenhouse Square, Philadelphia, Annual "Clothesline" Exhibition, May 1948, for $0.75.[1]

EXHIBITION: Rittenhouse Square, Philadelphia, Annual "Clothesline" Exhibition, 1948.

REMARKS: Dillon was a student at the Barnes Foundation from 1929 to 1931.

1  Barnes Foundation file card.

## EDITH DIMOCK (1876–1955) (MRS. WILLIAM J. GLACKENS)

### Country Girls

Alternate title: *Three Girls*

c. 1905–12. Watercolor, gouache, and black crayon on wove paper, 7¹⁵⁄₁₆ × 9³⁄₁₆ in. (20.2 × 23.3 cm). Signed lower right: E. Dimock. BF352

PROVENANCE: Acquired from the artist, January 24, 1913, for $25.00.[1]

RELATED WORKS: See "An Extraordinary Opportunity" (advertisement for Barnard Goldberg Fine Arts, New York), *The Magazine Antiques*, CLXXIV, no. 1 (July 2008): 13, which reproduces (color) six of the eight watercolors by Dimock in the Armory Show with Armory Show label, identical in style to *Country Girls* (BF352), *Country Girls Carrying Flowers* (BF353), and *The Sunday Walk* (BF354). On September 12, 2006, Christie's, New York (Sale no. 1699, Lot no. 126), sold three of these watercolors that were in the Armory Show. The watercolors were framed in the same "Taos" style molding as two of those in the Barnes collection, underscoring the fact Barnes selected *Country Girls* and *Country Girls Carrying Flowers* from a group just prior to the Armory Show. (All three of these watercolors are among the six reproduced in the above-mentioned advertisement.) For other comparative examples of Dimock's watercolors, see Jorge H. Santis, *Catalogue of the Collection*, in William H. Gerdts and Jorge H. Santis, *William Glackens* (Fort Lauderdale: Museum of Art; New York: Abbeville Press, 1996), 241–43, cat. nos. 301–22. Like her

husband, Dimock also illustrated a number of books. The color illustrations for Grace Van Rensselaer Dwight, *The Yellow Cat and Her Friends* (New York: D. Appleton, 1905), are watercolors similar in style and technique to *Country Girls*, *Country Girls Carrying Flowers*, and *The Sunday Walk*.

REMARKS: Edith Dimock exhibited eight watercolors (cat. nos. 114–21) in the Armory Show. Two of these, *Sweat Shop Girls in the Country* (no. 114) and *Mother and Daughter* (no. 115), were purchased by John Quinn from the show. Nos. 116–21 (collectively entitled "Group") were purchased by G. E. Marcus, New York. See *1913 Armory Show 50th Anniversary Exhibition* (Utica, N.Y.: Munson-Williams-Proctor Institute, 1963), 188. Edith Dimock's work was mentioned in several of the reviews of the Armory Show, for example, Harriet Monroe, "Art Show Open to Freaks," *Chicago Tribune*, February 17, 1913: "Some watercolors by E. Dimock are clever studies of sweatshop workers"; and Harriet Monroe, *Chicago Tribune*, February 23, 1913: "Other more or less unfamiliar Americans who make one pause along these walls are Messrs. [*sic*] [Howard] McLean, Dimock, [Abraham] Walkowitz . . ." Dimock also exhibited twelve works (cat. nos. 102–13) in the Exhibition of Independent Artists, April 1–27, 1910, including cat. no. 108 (*Village Girls*), possibly synonymous with *Country Girls*.

1 Albert C. Barnes check no. 2522, January 24, 1913, $50.00 (including $25.00 for *Country Girls Carrying Flowers* [BF353]), payable to "E.D. Glackens 2 water-colors," BFFR, BFA.

## Country Girls Carrying Flowers

c. 1905–12. Watercolor and black crayon with graphite on thick wove paper, 9½ × 10⅜ in. (24.1 × 26.4 cm). Signed lower right: E. Dimock. Inscribed on label on backboard: *Vacation Girls / E. Dimock /* [Price?] *$40.* BF353

PROVENANCE: Acquired from the artist, January 24, 1913, for $25.00. See entry for Dimock's *Country Girls* (BF352).

REFERENCES: Violette de Mazia, "Three Aspects of Art," *BFJAD* 6, no. 2 (Autumn 1975): 27–30, 31n, pls. 35 (detail) and 36; Violette de Mazia, "*E Pluribus Unum*—Cont'd: Part III," *BFJAD* 8, no. 1 (Spring 1977): 37, pl. 113.

## The Sunday Walk
Alternate title: *Three Women*
c. 1905–12. Watercolor, gouache, and black crayon with charcoal and graphite on wove paper, 7⅞ × 9⅛ in. (20 × 23.2 cm). Signed upper right: E. Dimock. BF354

PROVENANCE: Acquired from the artist, June 11, 1915.[1]

REFERENCE: Ira Glackens, *William Glackens and the Ashcan Group* (New York: Crown, 1957), ill. following 174.

1  Albert C. Barnes check no. 3342, June 11, 1915, $25.00, payable to Edith D. Glackens, BFFR, BFA.

## Women with Eggs
1928. Watercolor, gouache, and black crayon on thick wove paper, 9⅛ × 12½ in. (23.2 × 31.8 cm). Signed and dated upper left: E Dimock 1928. BF784

PROVENANCE: Acquired from the artist.

REMARKS: Watercolor painting on verso (zoo scene), partially trimmed. *Women with Eggs* was painted in France, where the Glackens family lived from 1925 to 1932.

## GUY PÈNE DU BOIS (1884–1958)

## The Politician
Alternate title: *Politician*
c. 1912. Oil on academy board, 12¼ × 9¼ in. (31.1 × 23.5 cm). Unsigned. Inscribed upper frame member verso: *1039* [catalogue number in the Armory Show, 1913]; right frame member verso: *DuBois frame*. BF270

PROVENANCE: Acquired from the artist, September 10, 1914.[1]

EXHIBITIONS: 69th Regiment Armory, New York, International Exhibition of Modern Art (the Armory Show), February 17–March 15, 1913; the exhibition traveled to the Art Institute of Chicago, March 24–April 16, 1913.

REFERENCES: *Catalogue of International Exhibition of Modern Art, Association of American Painters and Sculptors: At the Armory of the Sixty-ninth Infantry*, exh. cat. (New York: Vreeland Advertising Press, 1913), cat. no. 1039 (AIC, cat. no. 104); William B. McCormick, "Guy Pène du Bois—Social Historian: The Similarity of the Spirit Animating the Paintings of du Bois and Daumier," *Arts and Decoration*, November 1913, 13–16, ill. 16; Guy Pène du Bois, *Artists Say the Silliest Things* (New York: American Artists Group, 1940), 268, ill. (as 1914); Betsy Lee Fahlman, *Guy Pène du Bois: Painter, Critic, Teacher* (Ph.D. diss., University of Delaware, 1981), 54–55 (as 1913), 65 n. 7; Betsy Fahlman, *Guy Pène du Bois: Painter of Modern Life* (New York: James Graham, 2004), 26, fig. 30 (as c. 1912), 28.

1   Albert C. Barnes check no. 3101, September 10, 1914, $300.00, payable to Guy Pène du Bois, "for painting 'the Politician,'" BFFR, BFA.

## NANCY MAYBIN FERGUSON (1872–1966)

### The Red Banner
Alternate title: *Carnival*

c. 1913. Oil on canvas, 24⅞ × 36 in. (63.2 × 91.4 cm). Signed with monogram lower left: N. M. F. Frame by Newcomb-Macklin Co., stamped upper and left frame member verso: *Newcomb-Macklin Co. / Chicago & New York*. BF317

PROVENANCE: Acquired from the Pennsylvania Academy of the Fine Arts, March 23, 1914, for $150.00.[1]

EXHIBITION: Pennsylvania Academy of the Fine Arts, Philadelphia, One Hundred and Ninth Annual Exhibition, February 8–March 29, 1914.

REFERENCES: *Catalogue of the One Hundred and Ninth Annual Exhibition of the Pennsylvania Academy of the Fine Arts*, exh. cat. (Philadelphia: Pennsylvania Academy of the Fine Arts, 1914), no. 202; Victoria Donohoe, "Nancy Ferguson's Paintings Show Pleasant People Having Fun," *Philadelphia Inquirer*, September 6, 1970, 7: "Even Dr. Albert C. Barnes purchased a Ferguson painting. That picture, though not exhibited at [the] Barnes Foundation, is used for instruction purposes to compare with [Maurice] Prendergast when his work is under discussion"; Page Talbot and Patricia Tanis Sydney, *The Philadelphia Ten: A Women's Artist Group, 1917–1945* (Philadelphia: Galleries at More and American Art Review Press, 1998), 94.

REMARKS: Painted in Provincetown, Massachusetts.

1   Albert C. Barnes check no. 2948, March 23, 1914, $4,505.00, payable to the Pennsylvania Academy of the Fine Arts, for three paintings: "The Red Banner 150, Study for Agnew Clinic 4000 [Yale University Art Gallery, deaccessioned by Barnes in 1944], The Blue Churn, 355" (see entry for George Luks, *The Blue Churn* [BF391]), BFFR, BFA. Invoice from the Pennsylvania Academy of the Fine Arts, March 5, 1914, ACB Corr., BFA.

## CHARLES HENRY FROMUTH (1861–1937)

### An Evening Glow with a Rose Trail in the Shadow (Boats Concarneau)

1905. Oil pastel on brown wove paper mounted to paperboard, 18 × 13 in. (45.7 × 33 cm). Signed and dated lower left:

CH Fromuth 1905. Inscribed lower left: *Sep 11 – 1905*; artist's monogram stamped lower right: *CHF*. Paper label on tertiary support verso: *23-8-cc–9* / *"An evening glow with a / rose trail in shadow"* / *Charles H. Fromuth* / *Concarneau France 1905.* BF481

PROVENANCE: Acquired from the Folsom Galleries, New York, October 26, 1912, together with a second pastel, *Snow Falling in Brittany Harbor*, for $250.00.[1]

1 Invoice from the Folsom Galleries, October 23, 1912, ACB Corr., BFA. Albert C. Barnes check no. 2436, October 26, 1912, $250.00, payable to "The Folsom Galleries [for] Snow Falling in Brittany Harbor" (no longer in collection) and "An Evening Glow with a Rose Trail in the Shadow," BFFR, BFA.

## LENNA GLACKENS (1913–1943)

## Two Figures—Sphinx

1922. Graphite and watercolor on two leaves of wove paper, 7 × 4 in. (17.8 × 10.2 cm). Signed and dated under each figure lower left: Lenna / 1922. BF758

PROVENANCE: Gift from the artist.

REMARKS: Lenna Glackens was born December 6, 1913. See Ira Glackens, *William Glackens and the Ashcan Group* (New York: Crown, 1957), 179, for a photograph of Lenna with her father c. 1914.

## Woman and Dog Under Tree

1922. Crayon with graphite on tan wove paper, 3⅜ × 7¼ in. (8.6 × 18.4 cm). Signed and dated lower left: Lenna / 1922. BF759

PROVENANCE: Gift from the artist.

REFERENCE: Ira Glackens wrote in *William Glackens and the Ashcan Group*: "Lenna was a small baby and grew slowly. She did not walk until she was two, but she began to talk at an unusually early age, and by the time she could walk was carrying on lengthy conversations with a large vocabulary. Her interests and sympathies early turned to animals. At six she was dictating stories in long, measured sentences to her mother . . . who had a scramble keeping up with her without shorthand. 'Her style,' it was said of her then, 'would make Dr. Johnson's skip.' She drew all the time. Through no fault of theirs, the Dimocks had another artist in the family. When he looked down at his strange little granddaughter, not yet three, sitting up in her crib busily drawing horses with her left hand, Ira Dimock, who was nearly ninety, chuckled and said, 'A regular little Rosa Bonheur!' "[1] He continued: "Lenna was a young art student, studying awhile with Guy Pène du Bois. Having posed so often for her father, she turned the tables and produced a little study, 'William and Imp [the family French Poodle],' a characteristic scene witnessed every day at 10 West Ninth Street. Jerome Myers, gentle painter of street children, taught her the technique of etching, and Lenna's friendship with Jerome and Ethel Myers was close."[2]

REMARKS: A posthumous collection of Lenna Glackens's poems and essays, several illustrated, was published in a volume, *I Want to be a Columnist*, with biographical note by Mary Fanton Roberts (New York: Exposition Press, 1947). An exhibition of her drawings and paintings was shown in 1947 at the Glackens residence, Tenth Memorial Exhibition of Paintings by William Glackens; Also a Group of Drawings and Paintings by Lenna Glackens, November 2–30, 1947. Five

works, including *William Glackens and Imp* (acc. no. 91.40.12) in the collection of the Museum of Art Fort Lauderdale, are nos. 328–31 in Jorge H. Santis, *Catalogue of the Collection*, in William H. Gerdts and Jorge H. Santis, *William Glackens* (Fort Lauderdale: Museum of Art; New York: Abbeville Press, 1996), 244–45.

1 Ira Glackens, *William Glackens and the Ashcan Group* (New York: Crown, 1957), 172–73.
2 Ira Glackens, *William Glackens and the Ashcan Group*, 235.

## JUNE GERTRUDE GROFF (1903–1974)

## *Head of Chef*

c. 1938. Oil on canvas (later mounted to hardboard), 6⅜ × 6⅜ in. (16.2 × 16.2 cm). Unsigned. BF1154

PROVENANCE: Acquired from the A.C.A. Gallery, Philadelphia, May 2, 1939.[1]

REMARKS: Groff was a student at the Barnes Foundation from 1936 to 1939.

1 Barnes Foundation check no. 11010, May 2, 1939, $30.00, and Barnes Foundation Ledger, P–Z, 1922–1950, BFFR, BFA.

## ABRAHAM P. HANKINS (1900–1963)

## *Ocean*

Alternate title: *The Ocean*

Late 1940s. Oil on academy board (later mounted to hardboard), 8¾ × 11¾ in. (22.2 × 29.8 cm). Signed with monogram lower right: APH. BF2507

PROVENANCE: Acquired from the artist, March 23, 1949.[1]

REFERENCE: Violette de Mazia, "Subject and Subject Matter," *Vistas* 2, no 1. (Spring–Summer 1980): 5–6, 7, pl. 64.

REMARKS: Hankins was a student at the Barnes Foundation from 1937 to 1939 and 1949 to 1951. See photograph (fig. 91).

1 Barnes bought a Hankins monotype the same day, March 23, 1949, from the Philadelphia Print Club for $12.00. However, a letter from Barnes to Hankins, March 23, 1949, states: "The enclosed check for $150.00 is for the following purchases, made today: 4 monotypes @ $25.00 $100.00; 1 Oil $50.00 TOTAL $150.00 CK # 17024." Letter, Albert C. Barnes to Abraham P. Hankins, March 23, 1949, ACB Corr., BFA. Barnes Foundation check no. 17024, March 23, 1949, and Barnes Foundation Cash Journal, 1947–1950, BFFR, BFA.

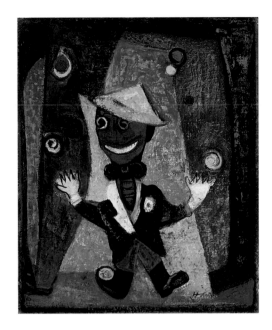

## Juggler

Alternate title: *The Juggler*

1949–50. Oil on academy board (later mounted to
hardboard), 16 × 13 in. (40.6 × 33 cm). Signed lower right:
Hankins. Inscribed by Albert Nulty upper left verso:
*AN / 1950.* BF2550

PROVENANCE: Acquired from the artist, March 22, 1950, for
$100.00.[1]

EXHIBITION: Philadelphia Art Alliance, Abraham Hankins
Oils, May 16–June 4, 1950.

REFERENCE: *Abraham Hankins Oils*, exh. cat., special issue,
*Philadelphia Art Alliance Bulletin*, May 1950, 5, cat. no. 24,
*Juggler*, listed as "Acquired by Dr. Albert C. Barnes."

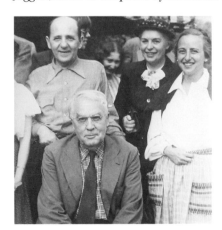

FIG. 91

Dr. Barnes, Abraham P. Han-
kins, and Violette de Mazia (in
the background) at Ker-Feal,
May 1951

REMARKS: Violette de Mazia acquired two works from the
Philadelphia Art Alliance exhibition, cat. nos. 25 (*Stranger
Than Fiction*) and 26 (*Abstraction*). Barnes also purchased
several color monotypes by Hankins. At the time of the
Charles Demuth exhibition at the Museum of Modern Art,
New York, March 7–June 11, 1950, to which Violette de Mazia
and the Mullen sisters lent watercolors, Barnes allowed
fourteen watercolors from the Foundation's collection to
be reproduced in the catalogue for the show by organizer
Andrew Carnduff Ritchie.[2]

See Hankins, *The Way to Art* (Philadelphia: Copyright
Dorothy Morgan Levin, 1979), a book of the artist's ideas and
observations on art, illustrated with his own diagrams and
drawings.

1 Barnes Foundation check no. 18219, March 22, 1950, $100.00, BFFR, BFA.
Letter, Nelle E. Mullen to Abraham P. Hankins, March 22, 1950: "The
enclosed check for $100.00 pays for your painting, *The Juggler*, which we
got from you today. Miss de Mazia's check for $100.00, enclosed here-
with, pays for the two small paintings which she just got from you." Let-
ter, Albert C. Barnes to Georges Keller, Carroll Carstairs Gallery, New
York, March 22, 1950: "I strongly urge you to arrange to come to Phila-
delphia . . . to look at a large number of paintings done by Hankins, one
of whose pictures you saw hanging in our gallery and liked. He is the
most exciting painter I have seen anywhere in the past several years—
exciting because he is not only a real painter but as individual an artist
as Matisse, Klee or Miró. He is also as definitely modern as any of these
contemporaries, and I believe he is destined to go places. He is Russian,
worked in France for several years, has been living in Philadelphia since
the first world war, and has studied at the Foundation. He is to have a
show at the Philadelphia Art Alliance beginning May 15, but I believe it
would be worthwhile to have a show at your gallery sometime in
April. . . . I went to his studio today with the idea of bringing a few pic-
tures out to show to you on Sunday, but he had so many—at least a
score—that are far superior to anything I have seen at the dealers for
several years, that not any six of them would adequately represent what
he is doing. I'll tell you more about it when I see you on Sunday." Letter,
Barnes to Hankins, March 27, 1950: "Mr. Georges Keller, owner of the
Carroll Carstairs Gallery in New York, will come to your studio with me
on Thursday afternoon of this week, March 30th, to look at your paint-
ings and arrange for an exhibition of them at his gallery." Letter, Han-
kins to Barnes, June 5, 1950: "When shall I bring your painting and the
two belonging to Miss de Mazia? . . . My show is over. Concerning sales
your prediction was correct, almost none. I cannot complain however,
you bought a painting, Miss de Mazia two, the Art Alliance sold one for
$60.—. I got favorable write ups and comments and now I have hopes
for a show in New York." All letters ACB Corr., BFA.

2 Letter, Andrew Carnduff Ritchie to Barnes, March 9, 1950, ACB Corr.,
BFA: "Mr. Hankins came in to see me today at your recommendation.
He was only able to show me his prints. We purchased two of them
from him for the Museum Collection. His work, I think, is very imagina-
tive and technically quite outstanding. Thank you for introducing him
to me."

## PRISCILLA HEACOCK (1884–1969)

## *Composition*

1946. Oil on canvas mounted to fiberboard, 12⅝ × 9⅞ in. (32.1 × 25.1 cm). Signed and dated lower right: Heacock / 46. BF2061

PROVENANCE: Acquired from the Friends' Neighborhood Guild, June 1946, for $30.00.[1]

EXHIBITION: Friends' Neighborhood Guild, Philadelphia, June 5–9, 1946, cat. F.

REMARKS: Heacock was a student at the Barnes Foundation from 1950 to 1951.

1 Letter, Nelle E. Mullen to the Friends' Neighborhood Guild, June 6, 1946, enclosing Barnes Foundation check no. 13854, June 6, 1946, $110.00, in payment for Heacock's *Composition* (BF2061) as well as works by Krona Bronstein (*Seated Figure* [BF2060]); Francis McCarthy (*Still Life* [BF2059] and another work no longer in the collection); and Florence Shubert (*Color Movement Inspired by "Joie de vivre"* [BF2057]); along with a check from Violette de Mazia in the amount of $15.00 in payment for a work by Shubert. Letter ACB Corr., BFA; check BFFR, BFA.

## ROBERT MORRIS HERVEY (1913–1990)

## *Summer Light*

1940. Lithograph on wove paper, sheet 11½ × 16¾ in. (29.2 × 42.5 cm), plate 9⅛ × 11¾ in. (23.2 × 29.8 cm). Signed lower right: Morris Hervey ['40 erased]. Inscribed lower left: *Summer Light 11/14*. BF507

PROVENANCE: Acquired from the artist, June 10, 1946.[1]

REMARKS: Hervey was a student at the Barnes Foundation from 1941 to 1942.

1 Barnes Foundation check no. 13863, June 10, 1946, $27.38, BFFR, BFA. This amount includes $12.00 for *Summer Light*, $5.00 for two works by Barbara Reiff, *Still Life Abstraction ("Cheese and Crackers")* (BF2056) and *Still Life with Jug* (BF2058), and $10.38 (misc. expenses and travel).

## ARISTODIMOS KALDIS (1899–1979)

### *Absorbing Art*
Alternate title: *The Gallery*
1941. Oil on canvas, 30⅛ × 25⅛ in. (76.5 × 63.8 cm).
Signed lower left: Ari Kaldis. BF988

PROVENANCE: Acquired from the Artists' Gallery, New York, December 4, 1941, for $100.00.[1]

EXHIBITION: The Artists' Gallery, New York, Aristodimos Kaldis, November 25–December 8, 1941, cat. no. 3.

REFERENCES: *Aristodimos Kaldis*, exh. cat. (New York: Artists' Gallery, 1941), cat. no. 3. An unidentified handwritten note on the exhibition flyer in the National Portrait Gallery–Smithsonian American Art Museum Library, Washington, D.C.: "Sold to the Barnes Foundation $100—(price was $150—) Mr. Barnes bought it personally in 3 minutes leaving it up to Kaldis to accept the lower offer or not. Kaldis and Miss Beer [Frederica Beer-Monti] were not present. Miss Mary Pritz effectuated the sale very much against her wish. Kaldis accepted the $100 when told about it."[2] Article (in Greek), *National Herald*, June 15, 1947; *Reunion on Lexington Avenue*, exh. cat. (New York: The Artists' Gallery, 1956), cat. no. 13 (as *The Gallery*), ill.; Violette de Mazia, "*E Pluribus Unum*—Cont'd: Part IV," *BFJAD* 8, no. 2 (Autumn 1977): 29–30,

30n, 31, pl. 23; *Aristodimos Kaldis: Early Paintings, 1939–51, The Barnes Years*, exh. cat. (New York: Lori Bookstein Fine Art, 2002), cover: *Absorbing Art*, color ill.

REMARKS: The Artists' Gallery was a nonprofit organization supported by contributions. It exhibited artists not represented by a commercial dealer. Kaldis's first name was spelled Aristodemos or Aristodimos; the artist's spelling has been adopted here.

1  Barnes Foundation check no. 1214, December 4, 1941, $100.00, payable to Aristodemos [*sic*] Kaldis, and Barnes Foundation Ledger, P–Z, 1922–1950, BFFR, BFA.
2  Letter, Aristodimos Kaldis to Albert C. Barnes, December 3, 1941: "I was very glad to accept your offer and yesterday afternoon a sign was placed next to my painting 'Acquired by the Barnes Foundation.' It is needless for me to express in words the great joy that I felt in learning of your decision to buy one of my paintings. I wish to assure you that this purchase not only will assist me materially, but what is more important to me is the moral encouragement from a collector whose pioneer work in modern art I always admired." Barnes to Kaldis, December 4, 1941: "I am very glad to write you that your paintings, which I saw at the Artists' Gallery the other day, represent a personal expression of definite aesthetic value. The picture which I acquired from the exhibit was bought for the purpose of further study by myself and colleagues. We think it will be valuable to show to the scores of young painters who attend our classes as an example of what we consider good work. . . . The enclosed check for one hundred dollars ($100.00) pays for the picture which I purchased." Kaldis to Barnes, December 5, 1941: "I wish to thank you so much for the check for my painting. . . . I will be delighted to come to the Foundation on December 9 . . . and I am looking forward with much pleasure to my visit. I will bring the painting with me to Merion." All letters ACB Corr., BFA.

## JOHN KANE (1860–1934)

## Along the Susquehanna

c. 1928. Oil on canvas, 19 × 27⅛ in. (48.3 × 68.9 cm).
Signed and inscribed lower right: *Along the Susquehanna / John Kane*. BF946

PROVENANCE: Acquired from the Valentine Gallery (together with *The Farm* [BF947]), December 26, 1934, for a total of $1,000.00.[1]

EXHIBITIONS: Carnegie Institute Galleries, Pittsburgh, Associated Artists of Pittsburgh, Nineteenth Annual Exhibition, February 15–March 14, 1929; Valentine Gallery, New York, Memorial Exhibition of Selected Paintings by John Kane, January 26–February 16, 1935.

REFERENCES: *Associated Artists of Pittsburgh, Nineteenth Annual Exhibition*, exh. cat. (Pittsburgh: Carnegie Institute Galleries, 1929), cat. no. 5, ill. 19; *Memorial Exhibition of Selected Paintings by John Kane*, exh. cat. (New York: Valentine Gallery, 1935); C. J. Walter, "The Associated Artists of Pittsburgh," *Carnegie Magazine* 2, no. 9 (February 1929): ill. 259; *Art News*, January 26, 1935, ill. 61; John Kane, *Sky Hooks, The Autobiography of John Kane, As Told to Marie McSwigan* (Philadelphia and New York: Lippincott, 1938), ill. 131; Leon Anthony Arkus, *John Kane, Painter: A Catalogue Raisonné of Kane's Paintings* (Pittsburgh: University of Pittsburgh Press, 1971), 159, no. 84, ill. 262. Another version of *Along the Susquehanna*, dated 1928 (ex–Collection William S. Paley), appears in Arkus, *John Kane, Painter*, no. 85.

1 Barnes Foundation check no. 7894, December 26, 1934, BFFR, BFA. Invoice from the Valentine Gallery, New York, December 24, 1934, $1,000.00, for *Along the Susquehanna* and *The Farm* (BF947). Letter, Val-

entine Dudensing (Valentine Gallery) to Albert C. Barnes, December 24, 1934: "The two Kane paintings were shipped to you to-day prepaid express . . . I am pleased and proud that these go into the foundation collection. I believe Kane himself would have been surprised, to say the least. I have done a very interesting business since your visit. Six other pictures were sold. S. S. White [a Philadelphia collector] is very keen to get one. I do not believe I'll have any more bargains. I am taking your advice." Barnes to Dudensing, December 26, 1934: "The enclosed check for one thousand ($1,000.00) dollars pays for the two (2) pictures by John Kane which arrived today. The smaller of the two pictures [*The Farm*], because of its color-scheme, is difficult to place harmoniously with other pictures on the wall. . . . [It was eventually placed over a door in the gallery.] I think you are wise in not making the announcement of our purchases until the time of your show [Memorial Exhibition of Selected Paintings by John Kane, Valentine Gallery, New York, January 26–February 16, 1935]. It will get more attention and serve better to sell some others." Both letters and invoice ACB Corr., BFA.

## Farm

Alternate title: *The Farm*

c. 1928. Oil on canvas, 15⅞ × 20½ in. (40.3 × 52.1 cm).
Signed lower left: John Kane. BF947

PROVENANCE: See entry for Kane's *Along the Susquehanna* (BF946).

REFERENCES: Albert C. Barnes, *The Art in Painting*, 3rd ed. (New York: Harcourt, Brace, 1937), 346–47, ill. 284: "John Kane was modern in the sense that his usually trite, romantic, or commonplace subject-matter is incorporated in a patterned design which is both ingenious and forceful. . . . He was primarily concerned in constructing a firm framework of patterns consisting of a well-balanced interrelation of units of line, space, light, and color"; Leon Anthony Arkus, *John Kane, Painter: A Catalogue Raisonné of Kane's Paintings* (Pittsburgh: University of Pittsburgh Press, 1971), 169, cat. no. 100, ill. 277.

## Girl Coming Down Garden Steps

Undated. Oil on canvas (later mounted to hardboard), 13¹⁄₁₆ × 10 in. (33.2 × 25.4 cm). Signed lower right: John Kane. BF1150

PROVENANCE: Acquired from Valentine Gallery, New York, January 3, 1935, for $300.00.[1]

REFERENCE: Leon Anthony Arkus, *John Kane, Painter: A Catalogue Raisonné of Kane's Paintings* (Pittsburgh: University of Pittsburgh Press, 1971), 136, cat. no. 30, ill. 215.

1 Invoice from Valentine Gallery to Albert C. Barnes, January 3, 1935, ACB Corr., BFA: "Painting by John Kane, *Girl Coming down Garden Steps*, canvas, mounted on board, 13 × 10 in. $300." Barnes Foundation check no. 7922, January 4, 1935, $300.00, BFFR, BFA. Letter, Valentine Dudensing (Valentine Gallery) to Barnes, January 3, 1935, ACB Corr., BFA: "The small Kane painting goes forward, express prepaid to you to-day. It was mounted and finished as you suggested. I think it looks very good."

## Children Picking Daisies

1931. Oil on canvas (later mounted to hardboard), 10 × 16⅛ in. (25.4 × 41 cm). Signed lower right: John Kane. BF1151

PROVENANCE: Acquired from the Valentine Gallery, New York, February 18, 1935, for $400.00.[1]

REFERENCES: Leon Anthony Arkus, *John Kane, Painter: A Catalogue Raisonné of Kane's Paintings* (Pittsburgh: University of Pittsburgh Press, 1971), 135, cat. no. 23, ill. 209; Violette de Mazia, "Learning to See," *BFJAD* 3, no. 1 (Spring 1972): 13, pl. 15; Violette de Mazia, "Naïveté," *BFJAD* 7, no. 2 (Autumn 1976): 64, 69–70, pl. 12; Violette de Mazia, "Transferred Values: Part I—Introduction," *BFJAD* 9, no. 2 (Autumn 1978): 12, pl. 92; Violette de Mazia, "Academicism," *Vistas* 4, no. 2 (Winter 1988–89): 32, pl. 99.

1 Barnes Foundation check no. 8036, February 19, 1935, $400.00, BFFR, BFA. Invoice from Valentine Gallery, Inc., New York, February 18, 1935: "*Children Picking Daisies*, 1931, Painting on canvas mounted 10 × 16 in. $400," ACB Corr., BFA. Letter, Valentine Dudensing to Albert C. Barnes, February 18, 1935, ACB Corr., BFA: "I shipped today, express prepaid, the painting of John Kane, *Children Picking Daisies*. I trust it will reach you immediately and in good condition. I enclose invoice for same. . . . Sold the 16th Kane Saturday."

## MAX KUEHNE (1880–1968)

## *Granada*

1920. Oil on wood panel, 6 × 8 in. (15.2 × 20.3 cm). Signed and dated lower right: Kuehne / 1920 [paint damage obscures lower portion of date]. BF518

PROVENANCE: Acquired from the artist, April 14, 1920, for $15.00.[1]

REMARKS: In 1920, Kuehne was commissioned by Barnes to make an incised silver gilt chest, at a cost of $600.00, and numerous frames in various styles ("Italian," "Spanish," "Plain") for both European and American paintings in the Barnes Foundation collection. The collector purchased a second chest in 1921 for the same amount.[2] Barnes would sometimes specify a Kuehne frame when purchasing a painting from Durand-Ruel—paying for both painting and frame together—and have Kuehne bill the dealer directly, as he did with Charles Prendergast. Kuehne also sold the collector a number of textiles (brocade, lace) that he had acquired during his prolonged stays in Spain. Between January 21 and November 29, 1921, Barnes disbursed $2,689.00 to the artist for these purchases. On occasion, according to William Adair, Charles Prendergast would subcontract frame commissions to Kuehne.[3] The Mullen sisters also ordered a chest as well as frames from Kuehne.[4] A detailed record of these transactions with Barnes is contained in Kuehne's Order (Account) Books (Collection William B. Adair) and in the extensive correspondence between Barnes and Kuehne, 1920–22, in the Barnes Foundation Archives.

1  Letter, Albert C. Barnes to Max Kuehne, April 14, 1920, ACB Corr., BFA: "I enclose my check for thirty ($30.00) dollars in payment of the two small pictures which arrived today." Albert C. Barnes check no. 4716, April 14, 1920, $30.00, payable to Max Kuehne, "Payment for two small Kuehne pictures," BFFR, BFA. See also Kuehne's Order (Account) Books, Collection William B. Adair, entry for January 1921: "one picture 20 × 24 (in.) $300" and "2 small pictures $80," Barnes. Letter, Barnes to Kuehne, February 2, 1923, ACB Corr., BFA: "It ought to interest your painter friends, who look down on you, to know that your 20 × 24 Spanish landscape & two small ones, will hang in the gallery of the Foundation holding its own with some good paintings by men internationally famous." In the Barnes Foundation's 1922–1924 Inventory, four paintings are listed. Barnes is referring to the large *Spanish Landscape*, 20 × 24 in. (50.8 × 61 cm), inv. no. 451, no longer in the collection. None of the three small paintings on that list (inv. nos. 248, 253, and 265), all subsequently deaccessioned, conform to the dimensions of *Granada*. Kuehne spent the years 1914–17 in Spain, eighteen months of that time in Granada. He returned there in 1920, 1922, and 1923.

2  Both chests now in the Brooklyn Museum of Art, acc. nos. 67.271.1 and 67.271.2. The two chests owned by Barnes were not bequeathed to the Brooklyn Museum of Art by Mrs. Laura L. Barnes in 1967, as with other works of art, but were offered for sale by her estate. The Museum purchased both, with the Dick S. Ramsay Fund, for $400.00 each.

3  William Adair, "Max Kuehne Frames," in *Max Kuehne: Artist and Craftsman* (New York: Hollis Taggart Galleries, 2001), 45.

4  See *The Mullen Collection* (Philadelphia: Samuel F. Freeman, 1967), cat. no. 44, *Romantic Fantasy*, ill. 73.

## ROBERT LAURENT (1890–1970)

## *Princess*

Alternate title: *Standing Nude*

c. 1914. Wood (walnut), 42¹⁵⁄₁₆ × 14 × 1³⁄₁₆ in. (109 × 35.5 × 3 cm). Signed (carved) lower right verso: Laurent. Inscribed upper center verso: 5. A427

PROVENANCE: Acquired from the Daniel Gallery, April 15, 1915, for $100.00.[1]

EXHIBITION: Daniel Gallery, New York, Recent Paintings by Hamilton Easter Field—Carvings in Wood by Robert Laurent, March 24–April 6, 1915, cat. no. 5 (*Princess*).

REFERENCES: *Recent Paintings by Hamilton Easter Field—Carvings in Wood by Robert Laurent*, exh. cat. (New York: Daniel Gallery, 1915), cat. no. 5 (as *Princess*); "Pictures and Carvings at Daniels' [*sic*]," *American Art News*, March 27, 1915, 2: "The nude figures of *The Slave*, *The Nile Maiden*, and *The Princess*, are attractive though nakedly ugly rather than beautifully made"; Roberta K. Tarbell, *Robert Laurent and American Figurative Sculpture 1910–1960*, exh. cat. (Chicago: David and Alfred Smart Museum of Art, University of Chicago, 1994), 4, 6, fig. 4 (mistakenly as *Standing Nude [Priestess]*), and 46 nn. 15 and 16.

REMARKS: Following his acquisition of the two carvings by Laurent on March 31, 1915, Barnes wrote to Laurent, "I congratulate you upon the artistic excellence of your sculpture now on exhibition in the Daniel Galleries. They seem to me to be, in their grasp and rendering of the essence of form, as great in art as the works which noted men from the earliest times have produced."[2] Laurent replied to Barnes, April 1, 1915: "I should like to thank you for your very kind letter. . . . It is indeed pleasant to have received as much praise as I have during the last week—but nothing [h]as given me more pleasure than your letter."[3] There follows a letter dated March 31, 1915, from Barnes to Laurent, concerning waterproofing and waxing of the panels. In an undated, but contemporary, note, Laurent wrote Barnes, "Would it not be possible to come on to Philadelphia Sunday and see samples of toning and at the same time have a view of your art treasures? We would bring the 'Princess' with us entirely finished."[4] Beginning at this time Barnes commissioned numerous frames from Laurent; they corresponded about the design and gilding of these frames, which are found today on paintings by such American and European artists as Alfred Maurer, Ernest Lawson, Maurice Prendergast, Pierre Bonnard, Jean Hugo, and many others in the collection.

At the time Barnes acquired by trade Charles Prendergast's panel *Central Park* (BF372) from Kraushaar Galleries, he was exploring the possibility of selling at least one of the two Laurent carvings. Antoinette M. Kraushaar (Kraushaar Galleries) wrote to Barnes, June 12, 1951: "I have looked up my records on Laurent, and I would think that your early panel might sell for around $450.00 to $500.00 retail. I doubt very much that we could do anything with it over the Summer but if I can find some interest early next fall, I will let you know. I am very glad to know about it, and hope that I can work out something with you on it."[5]

1 Albert C. Barnes check no. 3283, April 15, 1915, $175.00, annotated "two Laurent carvings, bill April 7, 1915," BFFR, BFA. Invoice from Charles Daniel, April 7, 1915: "Carvings by Laurent, *Princess*, $100, *Nile Maiden*, $75," ACB Corr., BFA.

2 Letter, Albert C. Barnes to Robert Laurent, March 31, 1915, ACB Corr., BFA.

3 Letter, Laurent to Barnes, April 1, 1915, ACB Corr., BFA.

4 Letter, Laurent to Barnes, undated [early–mid-April 1915], ACB Corr., BFA.

5 Letter, Antoinette M. Kraushaar (Kraushaar Galleries) to Barnes, June 12, 1951, ACB Corr., BFA.

## Nile Maiden

Alternate title: *Head*

1914. Wood (walnut), overall 25³⁄₁₆ × 11⁷⁄₁₆ × 1³⁄₁₆ in. (64 × 29 × 3 cm). Signed (carved) lower right verso: Laurent. A428

PROVENANCE: Acquired from the Daniel Gallery, April 15, 1915, for $75.00.[1]

EXHIBITION: Daniel Gallery, New York, Recent Paintings by Hamilton Easter Field—Carvings in Wood by Robert Laurent, March 24–April 6, 1915, cat. no. 1 (*Nile Maiden*).

REFERENCES: *Recent Paintings by Hamilton Easter Field—Carvings in Wood by Robert Laurent*, exh. cat. (New York: Daniel Gallery, 1915), cat. no. 1 (*Nile Maiden*); "Pictures and Carvings at Daniels' [sic]," *American Art News*, March 27, 1915, 2: "The nude figures of *The Slave*, *The Nile Maiden*, and *The Princess*, are attractive though nakedly ugly rather than beautifully made"; Roberta K. Tarbell, *Robert Laurent and American Figurative Sculpture 1910-1960*, exh. cat. (Chicago: David and Alfred Smart Museum of Art, University of Chicago, 1994), 4, 6, fig. 3 (as *Head [Nile Maiden]*).

1  Albert C. Barnes check no. 3283, April 15, 1915, $175.00, annotated "two Laurent carvings, bill April 7, 1915," BFFR, BFA. Invoice from Charles Daniel, April 7, 1915: "Carvings by Laurent, *Princess*, $100, *Nile Maiden*, $75," ACB Corr., BFA.

## TILLY LOSCH (1907–1975)

## Creek

Alternate title: *The Creek*

c. 1943. Oil on canvas (later mounted to fiberboard), 10¾ × 8⁵⁄₈ in. (27.3 × 21.9 cm). Signed lower right: T. Losch. BF1196

PROVENANCE: Acquired from Bignou Gallery, New York, May 24, 1944, for $180.00.[1]

EXHIBITIONS: Bignou Gallery, New York, Romantic Paintings by Tilly Losch, April 25–May 12, 1944; Robert Carlen Gallery, Philadelphia, Romantic Paintings by Tilly Losch (travel venue), June 7–30, 1944 (including loan of *Creek* from the Barnes Foundation).[2]

REFERENCES: *Romantic Paintings by Tilly Losch*, exh. cat (New York: Bignou Gallery, 1944), cat no. 1; "Tilly Losch," in Anna Rothe, ed., *Current Biography* (New York: Wilson, 1944), 424–26: "The success of the exhibit and the fact that one of her paintings, *Creek*, was bought by the noted art collector Alfred [sic] Barnes for exhibition at the Barnes Foundation restored her confidence"; Naomi Jolles, "Youth, Love and Rhythm Blended on Canvas," *New York Post*, May 3, 1944: "on the first day eight of her paintings were sold, including one to the Barnes Foundation, which amounts to practically an accolade professionally"; "Losch Launched," *Time*, May 15, 1944, 37: "Collector Alfred [sic] (Argyrol) Barnes promptly

snapped up *Creek*, a small painting of two dancing girls in sweeping skirts, one red, one blue, beside a pastoral stream in a green landscape"; Violette de Mazia, "Naïveté," *BFJAD* 7, no. 2 (Autumn 1976): 66, 69, pl. 76.

REMARKS: On May 29, 1944, Tilly Losch wrote to Dr. Barnes: "Thank you for letting me come and see your wonderful collection. It was a great experience. . . . It meant a great deal to me. . . . I started to read The Art in Painting . . . what I have read makes me feel I shall learn a great deal from it. I am extremely proud and happy to occupy a small place in your unique collection."[3] In 1947, Losch wrote Barnes: "As guardian Angel won't you come and see what progress I have made! You where [*sic*] so kind and gave me so much confidence the last time."[4]

1 Barnes Foundation Ledger, P–Z, 1922–1950, BFFR, BFA.
2 See letter, Robert Carlen (Robert Carlen Gallery) to Albert C. Barnes, [illegible] 10, 1944, ACB Corr., BFA: "I am grateful to you for the loan of the Tilly Losch painting for the show."
3 Letter, Tilly Losch to Barnes, May 29, 1944, ACB Corr., BFA.
4 Letter, Losch to Barnes, May 11, 1947, ACB Corr., BFA.

## GEORGE B. LUKS (1867–1933)

## *The Blue Churn*
Alternate titles: *Churn; Woman with a Churn; Woman and Goose in Interior*
c. 1908–10. Oil on wood panel, 20⅛ × 16⅛ in. (51.1 × 41 cm). Signed lower right: George Luks. BF391

PROVENANCE: Acquired from the Pennsylvania Academy of the Fine Arts, March 24, 1914, for $355.00.[1]

EXHIBITION: Pennsylvania Academy of the Fine Arts, Philadelphia, One Hundred and Ninth Annual Exhibition, February 8–March 29, 1914.

REFERENCES: *Catalogue of the One Hundred and Ninth Annual Exhibition of the Pennsylvania Academy of the Fine Arts* (Philadelphia: Pennsylvania Academy of the Fine Arts, 1914), 29, cat. no. 254; Guy Pène du Bois, "George B. Luks and Flamboyance," *Arts* 3, no. 2 (February 1923): 107–18, ill. (as *Woman with a Churn*); Forbes Watson, "The Barnes Foundation—Part II," *Arts* 3, no. 2 (February 1923): 149: "George Luks is represented by *The Woman with a Churn*, which is Luks at his best"; Albert C. Barnes, *The Art in Painting*, 301–02, analysis 503–04: "The general feeling is that of the best of the genre-painters who used an adaptation of Rembrandt's chiaroscuro. In this painting, chiaroscuro has been so successfully adapted that the essentially somber character of

the colors is illuminated by the use of rich, juicy tones in the face, gown, churn and objects in the foreground. . . . Everything in the painting glows, even the dark background. The drawing is loose and vigorous and is done with paint in a manner which is a combination of the Dutch tradition with Manet's broad brush-strokes."

1 Documentation in the Archives of the Pennsylvania Academy of the Fine Arts. Albert C. Barnes check no. 2948, March 23, 1914, $4,505.00, payable to the Pennsylvania Academy of the Fine Arts, "The Blue Churn 355," as part of transaction for purchase of Nancy Ferguson, *The Red Banner* (BF317) and Thomas Eakins, "Study for Agnew Clinic" (deaccessioned in 1944), BFFR, BFA.

## FRANCIS MCCARTHY (1921–2005)

## Still Life

c. 1945–46. Pen and ink and yellow gouache on wove paper, 6¹⁄₁₆ × 11⁵⁄₁₆ in. (15.4 × 28.7 cm). Signed lower right: Francis McCarthy. BF2059

PROVENANCE: Acquired from the Friends' Neighborhood Guild, Philadelphia, June 6, 1946, for $10.00.[1]

EXHIBITION: Friends' Neighborhood Guild Annual Exhibition, June 5–9, 1946, cat. K.

REFERENCE: Violette de Mazia, "The Barnes Foundation: The Display of Its Art Collection," *Vistas* 2, no. 2 (1981–83): ill. 118 (installation).

REMARKS: The Friends' Neighborhood Guild was a Quaker settlement school established in the 1870s as Quaker Mission No. 1 to provide instruction in domestic housekeeping, sewing, and religious instruction. McCarthy was a student and subsequently art instructor at the school, which held

art exhibitions by young artists and children enrolled in the classes. Its director was Francis Bosworth, a playwright who also helped refugees and displaced persons during and following World War II. He initiated the Guild's art program, of which McCarthy became the director. Barnes was a regular visitor to the exhibitions and purchased numerous works from its shows.[2] McCarthy was a regular exhibitor at the Friends' Neighborhood Guild from 1946 and was a student at the Barnes Foundation from 1947 to 1949. He was awarded a scholarship to study at the Foundation in 1947 and a traveling scholarship to study in France in the summer of 1948, when he was enrolled in the Atelier de La Grande Chaumière, Paris.[3] At the suggestion of Horace Bond, president of Lincoln University, with Barnes's concurrence, McCarthy taught a class at Lincoln in 1951–52 and a seminar in the fall of 1952.

1 Letter, Barnes Foundation to Friends' Neighborhood Guild, June 6, 1946, enclosing Barnes Foundation check no. 13854, June 6, 1946, $110.00, in payment for McCarthy's *Still Life* (BF2059) as well as Krona Bronstein, *Seated Figure* (BF2060), Priscilla Heacock, *Composition* (BF2061), Florence Shubert, *Color Movement Inspired by "Joie de vivre"* (BF2057), and another work by McCarthy no longer in the collection along with a check from Violette de Mazia in the amount of $15.00 in payment for a work by Shubert. Letter ACB Corr., BFA; check BFFR, BFA.
2 See McCarthy, *Mexican Landscape* (BF619), John Bosworth, *Bedroom* (BF2556), Krona Bronstein, *Seated Figure* (BF2060), Priscilla Heacock, *Composition* (BF2061), and Florence Shubert, *Color Movement Inspired by "Joie de vivre"* (BF2057).
3 Letter, Albert C. Barnes to Francis McCarthy, June 30, 1947, ACB Corr., BFA: "$100 a month scholarship we have awarded you for a year." Barnes Foundation check no. 16145, June 25, 1948, $500.00, for travel in Europe, BFFR, BFA.

## Still Life

Alternate titles: *Garden Implements; Garden Tools*
c. 1948. Oil on paper (later mounted to panel),
11¼ × 20¼ in. (28.6 × 51.4 cm). Unsigned. BF2085

PROVENANCE: Acquired from the artist, June 23, 1948, for
$50.00.[1]

1 Barnes Foundation Ledger, P–Z, 1922–1950 (entered June 24, 1948), and
Barnes Foundation check no. xx [from a series of unnumbered checks],
June 23, 1948, $90.00, BFFR, BFA.

## Girl in Red Spotted Skirt

1949. Watercolor and pen and ink on laid paper, 12 × 9⅛ in.
(30.5 × 23.2 cm). Signed and dated lower right: McCarthy 49.
BF2542

PROVENANCE: Acquired from the Robert Carlen Gallery,
Philadelphia, January 24, 1950, for $8.00 (one of two pur-
chases, with *Girl Seated in Room* [BF2543]).[1]

REMARKS: Created in what the artist termed the "wet paper
technique" learned from his instructor, Paul Wieghardt
(1897–1969), when McCarthy studied with him at the Art In-
stitute of Chicago in 1949. The same method was employed
for McCarthy's *Girl Seated in Room* (BF2543).

1 Invoice from Robert Carlen Gallery, January 24, 1950, ACB Corr., BFA.
Barnes Foundation check no. 18034, January 24, 1950, BFFR, BFA.

## Girl Seated in Room

1949. Watercolor and pen and ink on laid paper, 12¹/₁₆ ×
9⅛ in. (30.6 × 23.2 cm). Signed and dated lower right:
McCarthy 49. BF2543

PROVENANCE: Acquired from the Robert Carlen Gallery,
January 24, 1950, for $8.00 (with *Girl in Red Spotted Skirt*
[BF2542]). See entry for *Girl in Red Spotted Skirt* (BF2542).

## Mexican Landscape

1950. Watercolor and pen and ink on wove paper,
9⁷⁄₁₆ × 12⅜ in. (24 × 31.4 cm). Signed and dated lower left:
McCarthy 50. Inscribed verso: *3 Landscape near Cuautha 12.*
BF619

PROVENANCE: Acquired from the Friends' Neighborhood
Guild, June 26, 1951, for $10.00.[1]

1 Invoice, Friends' Neighborhood Guild to the Barnes Foundation, June
   21, 1951, ACB Corr., BFA. Barnes Foundation check no. 19655, June 26,
   1951, BFFR, BFA.

## HUGH MESIBOV (B. 1916)

## Byzantine Figure

1945–46. Oil pastel over black ink on cardstock mounted to
multi-ply paperboard, 14 × 11 in. (35.6 × 27.9 cm). Unsigned.
BF2073

PROVENANCE: Acquired from the artist, February 24, 1947.[1]

EXHIBITION: Chinese Gallery, New York, January 4–24, 1947.
(Only oils were listed in the catalogue. *Byzantine Figure*, a
crayon drawing, was in the exhibition, hors catalogue, and
is based on the oil *Girl with Necklace*, cat. no. 14.)

REFERENCES: *MKR's art outlook*, January 13, 1947: "Hubert
Mesibov, 30–year old Philadelphian, makes his 57th Street
debut at the Chinese Gallery with an exhibition of oils,
watercolors, pen and ink drawings and crayon compositions.
The canvases immediately postwar have a somber brooding
quality, but the later ones have a more buoyant mood and
key. All of them deal with people. And each is firmly com-
posed. The feeling here is of quiet and repose. The colors,
with their softly shifting tones, are as tenderly melodious as
Modigliani's. The design as simple and telling as that of the
Italian artist. Mesibov has several crayon compositions the
technique of which will probably puzzle and intrigue his fel-
low artists. They have a similarity to oil painting except for
that thick tactile texture achieved by heavily applied crayon.

*Byzantine Figure*, a small gem of a work, is a prime example of this medium. The artist adds more appeal to his work by an occasional dash of humor"; Hugh Mesibov, *arte: International art review directed by Carlo E. Bugatti*, 1973, 7, *Byzantine Figure* (crayon and ink), Collection Albert C. Barnes Foundation, ill.; R. J. Wattenmaker, "Dr. Albert C. Barnes and The Barnes Foundation," in *Great French Paintings from The Barnes Foundation* (New York: Knopf in association with Lincoln University Press, 1993), 21, fig. 8.

REMARKS: Mesibov was a student at the Barnes Foundation from 1936 to 1940. On December 4, 1946, Barnes wrote a recommendation in support of a Guggenheim fellowship application by the artist. "Mr. Mesibov was a student at the Barnes Foundation for a period of three [*sic*] years. He . . . showed a quick intelligence in grasping the principles involved in our course in the study of the traditions of painting. He is a painter of individuality and his work shows a grasp of the principles of the traditions of painting and ability to use them creatively. . . . We cannot speak too highly of Mr. Mesibov's qualities of character."[2]

The artist asked Barnes to write a foreword for his then-forthcoming exhibition at the Chinese Gallery in 1946. Barnes wrote to Mesibov, December 6, 1946: "Thank you for sending me the information about your show at the Chinese Gallery. . . . I'll do my best to try and see it. . . . I am not sure that I would have time to see your work before then, which would be necessary in order to write the foreword. If I find that I can get to New York between Christmas and New Year's, I'll write you so that you could have your paintings all in one place for me to see and form my opinion. I wish you the best of luck with the exhibition, but you know how it is with both critics and the public—their lack of interest and knowledge about such things is about the only positive quality they have. Enclosed is a copy of what I wrote the John Simon Guggenheim Memorial Foundation when they asked me for a report on you."[3] When Barnes visited the show, he selected a painting to purchase. However, as he wrote Mesibov on February 4, 1947, after the show had closed, "Yesterday I received from the Chinese Gallery the crayon portrait with a break in the cardboard that extends all the way across. . . . Of course I don't want a picture that has been damaged, so I returned it to The Chinese Gallery. In your exhibit you had a small crayon somewhat in the Byzantine style. I wish you would send me that in place of the one I have returned and I'll send you a check for the price."[4]

1 Barnes Foundation check no. 14639, February 24, 1947, $45.00, payable to Hubert Mesibov, BFFR, BFA. Barnes Foundation Ledger, P–Z, 1922–1950, BFFR, BFA. Typewritten account with the Chinese Gallery, April 25, 1947: "Sale to Barnes Foundation *Byzantine Figure*—Crayon, 28 February 1947, $45.00." (Courtesy of the artist.)

2 Letter, Albert C. Barnes to the Guggenheim Foundation, December 4, 1946, ACB Corr., BFA.

3 Letter, Barnes to Hugh Mesibov, December 6, 1946, ACB Corr., BFA. Barnes also wrote to Mesibov, January 27, 1947, ACB Corr., BFA: "I am very glad to learn from your letter of January 24 that your show has been a success, at least with painters. . . . In reply to your query, you may use my name as reference in connection with your application for a teaching job."

4 Letter, Barnes to Mesibov, February 4, 1947, ACB Corr., BFA.

## RANDALL MORGAN (1920–1994)

## *Ponte Vecchio*

c. 1950. Oil on hardboard, 15⅝ × 20⅝ in. (39.7 × 52.4 cm). Unsigned. BF2537

PROVENANCE: Acquired from the artist, January 16, 1950, for $100.00, with Morgan's *Amalfi: Moonlight Pattern* (BF2538).[1]

REFERENCE: Violette de Mazia, "*E Pluribus Unum*," BFJAD 7, no. 1 (Spring 1976): 6n, pl. 62.

1 Barnes Foundation check no. 18002, January 16, 1950, $200.00 (including payment for BF2538), BFFR, BFA.

## *Amalfi: Moonlight Pattern*

1950. Oil pastel on hardboard, 14 × 18 in. (35.6 × 45.7 cm).
Signed lower right: Morgan. BF2538

PROVENANCE: Acquired from the artist, January 16, 1950, for
$100.00. See entry for Morgan's *Ponte Vecchio* (BF2537).

## JEROME MYERS (1867–1940)

## *Street Shrine*

Alternate title: *The Street Shrine*
1915. Oil on canvas, 18 × 22 in. (45.7 × 55.9 cm). Signed
and dated lower left: Jerome Myers 1915. Frame by Robert
Laurent, signed lower frame member verso: Laurent. BF526

PROVENANCE: Acquired from the Daniel Gallery, January 17,
1916, for $300.00.[1]

EXHIBITION: Daniel Gallery, New York, Special Exhibition:
American Art of Today, January 1–24, 1916.

REFERENCE: *Special Exhibition: American Art of Today*, exh.
cat. (New York: Daniel Gallery, 1916), cat. no. 14, Jerome Mey-
ers [*sic*], *The Street Shrine*.

REMARKS: See letter, Barnes to Robert Laurent, January 7,
1916, referring to "the frame for the painting by Jerome Myers,
which I recently bought at Daniel's with the request that they
have you make a frame for it of the same design and width
of those ordered today. On this painting by Myers there is, at
present, an old molding which I would like to have you match
in color for all of these frames." Laurent replied (undated,
early January 1916): "The frame for the Jerome Myers is just
about finished. Daniel will have it Thursday."[2]

1   Invoice from Charles Daniel, January 5, 1916, ACB Corr., BFA. Albert C.
Barnes check no. 3527, January 17, 1916, $300.00, payable to Charles Dan-
iel; on the check stub is written "Street Shrine Myers Bill 1/5/16," BFFR,
BFA.
2   Letters, Barnes to Jerome Myers, January 7, 1916, and Myers to Barnes,
undated [early January 1916], ACB Corr., BFA.

## ALBERT H. NULTY (1886–1957)

### Mother and Child

c. 1940. Wood relief, 3 × 2½ × ¼ in. (7.6 × 6.4 × 0.6 cm).
Unsigned. BF2553

PROVENANCE: Unknown.

REMARKS: In 1913 Albert Nulty joined the Narberth Vol-
unteer Fire Company, where he held the position of Fire
Chief. Barnes was elected a life member of the Company in
1924. Nulty first worked for Barnes as his chauffeur in 1917.
He received instruction in conservation techniques from
Thomas H. Stevenson, conservator for the John G. Johnson
Collection, as well as from Barnes. Nulty served as curator
for the Foundation's collection and trained for a short period
in April 1928 with William Suhr, paintings conservator at the
Detroit Institute of Arts, who cleaned and restored a num-
ber of the Barnes Foundation's Old Masters and nineteenth-
century paintings.[1] Nulty provided the measurements for
the *Dance* mural Henri Matisse created for the Foundation,
and, with Barnes and the artist, supervised its installation
in 1933.[2] Matisse presented Nulty with his etching *Girl with
Goldfish*, 1931, illustrated in Barnes and Violette de Mazia,
*The Art of Henri-Matisse* (New York: Charles Scribner's Sons,
1933), no. 218. A talented craftsman, Nulty also worked on
frames and the early American furniture Barnes began to
collect in the mid-1930s in a workshop housed in the lower

level of the Gallery. He regularly accompanied Barnes on
buying trips to examine potential purchases. At the time
of Barnes's death in 1951, Nulty was elected to the board of
trustees of the Barnes Foundation, on which he served until
his death in 1957.

1  See page 61, note 218.
2  See "Henri Matisse—*The Dance*," *Vistas* 2, no. 1 (Spring–Summer 1980):
   53 (photo) "Installation of *The Dance*," and 55 (photo) "April 1933 Matisse
   and Albert Nulty, Curator at The Barnes Foundation."

### Pennsylvania Dutch Motif

1940s. Reverse painting on glass, 6½ × 4½ in.
(16.5 × 11.4 cm) (sight). Unsigned. BF2554

PROVENANCE: Unknown.

## ANGELO PINTO (1908–1994)

*Interior with Bouquet*

1933. Oil on canvas, 15⅞ × 19¹⁵⁄₁₆ in. (40.3 × 50.6 cm).
Signed and dated lower left: Angelo Pinto 33. BF434

PROVENANCE: Acquired from the artist, March 3, 1934, for
$50.00.[1]

EXHIBITION: The Reading Public Museum and Art Gallery,
September–October 15, 1939.[2] See also entries for Angelo
Pinto, *Fort, Corsica* (BF924), and Charles Demuth, *Woman
Punching Bag* (BF1001).

REFERENCES: See Helen McCloy, "Human Values in the
Art of the Pinto Brothers," *Parnassus* 7, no. 1 (January 1935):
4–6; Albert C. Barnes, *The Art in Painting*, 3rd ed. (New York:
Harcourt, Brace, 1937), 347: "The work of the three Pinto
brothers—Salvatore, Angelo, and Biagio . . . is entitled to
respect because it represents personal visions embodied
in individual plastic forms"; Angelo Pinto, "The Light of
Vermeer adapted to Photographic Studies," *BFJAD* 3, no. 1
(Spring 1972): 49–57; *Reverse Painting on Glass: The Mildred
Lee Ward Collection* (Lawrence, Kans.: Helen Foresman Spen-
cer Museum of Art, University of Kansas, 1978), 62.

REMARKS: Angelo Pinto was one of five brothers (with Sal-
vatore, Biagio, Joseph, and Dominic), each of whom studied
at the Barnes Foundation. He was awarded traveling schol-
arships in 1931, 1932, and 1933 and traveled with his brothers
Salvatore and Biagio to study in the museums of Europe and
to paint. He painted in Italy, France, Morocco, and Corsica,

the latter two locales suggested to him by Henri Matisse, who
befriended Angelo and invited him to visit him in his studios
in Nice, where the Frenchman was painting his *Dance* mural
for the Barnes Foundation, and in Paris. Angelo, Biagio, and
Salvatore shared an exhibition at the Bignou Gallery, Paris
(Trois Peintres Américains, October 20–November 4, 1933);
Barnes wrote the preface for the exhibition catalogue. Barnes
began acquiring paintings by the Pinto brothers by 1932. On
March 7, 1933, Nelle Mullen wrote to the three brothers while
they were abroad: "Dear Boys: The most important news we
have for you is that Boyer [C. Philip Boyer, director, Mellon
Galleries, Philadelphia] sold one of Angelo's pictures . . . to
Mrs. [Edith] Halpert of the Downtown Galleries. . . . Since
Doctor has come home from Europe we have been very
busy . . . with hanging the new pictures Doctor bought this
winter. Not only the pictures he bought in Europe but the
four he bought in Philadelphia. Angelo's and Biagio's hang
in the Glackens room, the large one of Salvatore's over the
door in the [Matisse] 'Music Lesson' room and the small one
over the Renoir *Embroiderers* [BF239] in the room where the
Renoir *Sailor Boy* [BF325] and *Girl with Parasol* [ex-BF189] are.
They all look very well and have been very much admired. All
the new pictures have made so many changes in the hanging
of the pictures that you will hardly know the Gallery when
you next see it."[3]

For an exhibition at the Valentine Gallery, New York,
March 29–April 17, 1934, Paintings by the Three Pinto Broth-
ers, Barnes wrote in his foreword to the catalogue: "Color is
the primary means by which each of the Pintos effects the
unity of his compositions. They all use bright color; but with
that, their identity as artists and colorists ceases. The meth-
ods of making color serve as the unifying factor differ essen-
tially in each of the three painters: the relationships of color,
its participation in drawing and modeling, its emphasis on
geometrical pattern and decorative quality, its function in
illustration or fuller plastic expression—all these differenti-
ate the work of each man from the fact that they resort to
simplifications and technical devices introduced by Manet
and Cézanne, and to the emphasis upon bright exotic color
and upon pattern which, as in most contemporary painting,
reflect the influences of Matisse and Picasso."

In 1933 Angelo began work on wood engravings, and in
1935 he was appointed to the faculty of the Barnes Founda-
tion. In 1937, with his brother Salvatore, he designed sets
and costumes for productions of the Philadelphia Ballet
Company directed by Catherine Littlefield (including *Barn
Dance* and *Terminal*, which were performed at the 1937

353

Paris Exposition). He and his brothers Salvatore, Biagio, and Joseph established a commercial photography enterprise, specializing in color photography. In 1941 Angelo Pinto and his brothers were granted permission to use the Gallery for their experiments in color photography. Their work was featured in the four-part series of articles on the Barnes Foundation published in the *Saturday Evening Post* in 1942,[4] and their color photography appeared in the first color features for *Town & Country* and *Life*. Angelo Pinto was subsequently appointed by Barnes as the official photographer of the Barnes Foundation, in which capacity he served until his death in 1994. Angelo Pinto also gained considerable recognition for his paintings in the age-old tradition of reverse painting on glass, which he began making in 1942, five of which were purchased for the collection (*Bathtub and Cat* [BF723], *Icarus* [BF744], *Seashells* [BF1002], *Bathers on Boardwalk* [BF1042], and *David and Goliath* [BF1190]). Angelo Pinto was a student at the Barnes Foundation from 1928 to 1932, from 1934 to 1939, and in 1941. He was a member of the faculty from 1935 to 1992.

1 Barnes Foundation Ledger, P–Z, 1922–1950, BFFR, BFA.
2 "List of Pictures to be Loaned to Reading," no. 16 ("Flowers in Window # [BF]434"), Laurence Buermeyer Correspondence, 1940, ACB Corr., BFA.
3 Letter, Nelle E. Mullen to Salvatore, Angelo, and Biagio Pinto, March 7, 1933, ACB Corr., BFA.
4 Carl W. McCardle, "The Terrible-Tempered Dr. Barnes," *Saturday Evening Post*, March 21, 1942; March 28, 1942; April 4, 1942; and April 11, 1942.

## Fort, Corsica

Alternate title: *Fortress*
c. 1931–32. Oil on canvas, 12 × 15 in. (30.5 × 38.1 cm).
Signed lower left of center: Angelo Pinto. BF924

PROVENANCE: Acquired from the artist, December 4, 1934.[1]

EXHIBITION: The Reading Public Museum and Art Gallery, September–October 15, 1939.[2] See also entries for Angelo Pinto, *Interior with Bouquet* (BF434), and Charles Demuth, *Woman Punching Bag* (BF1001).

1 Barnes Foundation check no. 7845, December 4, 1934, $125.00, payable to Salvatore Pinto for three paintings (individual prices not indicated): Biagio Pinto's *Domino Players* (BF1148), Angelo Pinto's *Fortress* (BF924), and Salvatore Pinto's *Road with Houses* (no longer in the collection), BFFR, BFA. Barnes Foundation Cash Journal, 1922–1940, BFFR, BFA.
2 "List of Pictures to be Loaned to Reading," no. 15 ("Corsican Landscape," no BF number), 1940 Barnes–Laurence Buermeyer correspondence, ACB Corr., BFA.

## Two Figures

1933. Oil on canvas, 14⅞ × 12 in. (37.8 × 30.5 cm). Signed and dated lower left: Angelo Pinto 33. BF1147

PROVENANCE: Unknown.

EXHIBITION: Bignou Gallery, Paris, Trois Peintres Américains, Angelo, Biagio, Salvatore Pinto, October 20–November 4, 1933.

REFERENCE: *Trois Peintres Américains, Angelo, Biagio, Salvatore Pinto*, exh. cat. (Paris: Galerie Etienne Bignou, 1933), cat. no. 5, *Les Guitaristes* (?), no dimensions given.

REMARKS: Painted in Morocco.

## Balcony Scene

Alternate title: *Landscape from Balcony*

1933. Oil on canvas, 12 × 15 in. (30.5 × 38.1 cm). Signed and dated lower left: Angelo Pinto 33. BF2002

PROVENANCE: Acquired from the artist, March 3, 1934, for $50.00.[1]

1  Barnes Foundation Ledger, P–Z, 1922–1950, BFFR, BFA.

## David and Goliath

1942. Reverse painting on transparent support mounted on paperboard, image 7⁷⁄₁₆ × 5½ in. (18.9 × 14 cm). Signed lower right: A. Pinto. BF1190

PROVENANCE: Acquired from the artist, November 16, 1942, for $25.00.[1]

1 Barnes Foundation Ledger, P–Z, 1922–1950, BFFR, BFA.

## Icarus

c. 1944. Reverse painting on glass, 7¾ × 9⅞ in. (19.7 × 25.1 cm) (sight). Unsigned. BF744

PROVENANCE: Acquired from the artist, January 17, 1945, for $40.00. See entry for Angelo Pinto, *Bathtub and Cat* (BF723).

REMARKS: See frontispiece of the present volume: Dr. Barnes holding *Icarus* in Gallery XIX, photographed c. 1945 by Angelo Pinto.

## Bathtub and Cat

Alternate title: *Bathtub*

c. 1944. Reverse painting on glass, 7¾ × 9¾ in. (20 × 24.8 cm) (sight). Signed lower right: A. Pinto. BF723

PROVENANCE: Acquired from the artist, January 17, 1945, for $40.00 (with *Icarus* [BF744], *Seashells* [BF1002], and *Bathers on Boardwalk* [BF1042], each also priced at $40.00).[1]

REFERENCE: Violette de Mazia, "*E Pluribus Unum*—Cont'd: Part IV," *BFJAD* 8, no. 2 (Autumn 1977): 20, pl. 131.

1 Barnes Foundation Cash Journal, 1941–1946, BFFR, BFA.

## Seashells

c. 1944. Reverse painting on glass, 7¾ × 9¾ in. (19.7 × 24.8 cm) (sight). Unsigned. BF1002

PROVENANCE: Acquired from the artist, January 17, 1945, for $40.00. See entry for Angelo Pinto, *Bathtub and Cat* (BF723).

## Bathers on Boardwalk

c. 1944. Reverse painting on glass, 7⅞ × 9¹³⁄₁₆ in.
(20 × 25 cm) (sight). Signed: A. Pinto. BF1042

PROVENANCE: Acquired from the artist, January 17, 1945, for
$40.00. See entry for Angelo Pinto, *Bathtub and Cat* (BF723).

---

## BIAGIO PINTO (1911–1989)

## Domino Players

1934. Oil on canvas, 12⅛ × 20¼ in. (30.8 × 51.4 cm).
Signed and dated upper right: Biagio Pinto / 34. BF1148

PROVENANCE: Acquired from the artist, December 4, 1934.[1]
See entry for Angelo Pinto, *Fort, Corsica* (BF924).

REFERENCE: Albert C. Barnes, *The Art in Painting*, 3rd ed.
(New York: Harcourt, Brace, 1937), 347.

RELATED WORK: *Checker Players* (Private Collection), repro-
duced in Albert C. Barnes, *The Art in Painting*, 3rd ed. (New
York: Harcourt, Brace, 1937), ill. 341.

REMARKS: Biagio Pinto was a student at the Barnes Founda-
tion from 1928 to 1932 and from 1934 to 1937. He was awarded
traveling scholarships to study in Europe in 1932, 1933, 1934,
and 1935.

1 Barnes Foundation check no. 7845, December 4, 1934, $125.00, payable
to Salvatore Pinto for three paintings (individual prices not indicated).
Barnes Foundation Cash Journal, 1922–1940, BFFR, BFA.

## Flower Piece

Alternate title: *Still-Life*

1933. Oil on canvas, 10 × 8 in. (25.4 × 20.3 cm).
Signed and dated upper left: Biagio Pinto 33. BF1146

PROVENANCE: Acquired from the artist, April 18, 1934, for
$25.00.[1]

EXHIBITION: Valentine Gallery, New York, March 29–April
17, 1934, no. 18.

1 Barnes Foundation check no. 7238, April 18, 1934, $25.00, BFFR, BFA.
Barnes Foundation Cash Journal, 1922–1940, BFFR, BFA.

is made aware through the choice and arrangement of the pigments of a genuine delight in the earth and its savor. The color range is from light yellow to deep green, back to yellow, and on to orange, brown, and to blue of sky. Much the same earthy emotionalism adheres to Biagio's 'Landscape, Venice [*sic*]', purchased by the Barnes Foundation and developed in segments of brown, burnt orange, dull red, dull yellow, dull green, dark blue and gray"; Violette de Mazia, "Transferred Values: Part I," BFJAD 9, no. 2 (Autumn 1978): 7, pl. 89 (as *Landscape*).

1 Barnes Foundation check no. 6151, November 16, 1932, $100.00, BFFR, BFA. Barnes Foundation Cash Journal, 1922–1940, BFFR, BFA.

## Landscape—Vence

1932. Oil on canvas, 20 × 24 in. (50.8 × 61 cm). Signed lower left: Biagio Pinto. Frame by Charles Prendergast, signed lower frame member verso: Prendergast. BF927

PROVENANCE: Acquired from the artist, November 16, 1932, for $100.00.[1]

EXHIBITION: Mellon Galleries, Philadelphia, Exhibition: Angelo Pinto, Biagio Pinto, Salvatore Pinto, November 23–December 15, 1932, cat. no. 27, lent by the Barnes Foundation.

REFERENCES: *Exhibition: Angelo Pinto, Biagio Pinto, Salvatore Pinto*, exh. cat. (Philadelphia: Mellon Galleries, 1932), essay (untitled) by Albert C. Barnes (essay subsequently published in French in *Trois Peintres Américaines: Angelo, Biagio, Salvatore Pinto*, October 20–November 4, 1933, Bignou Gallery, Paris), cat. no. 27 (as *Landscape, Vence*); "3 Brothers' Art in Barnes Gallery," *Evening Bulletin-Philadelphia*, November 18, 1932, D3; "3 Pinto Brothers Win Art Honors," *Public Ledger—Philadelphia*, November 18, 1932, 2 (as *Landscape Venice [*sic*]*); "3 Young Phila. Brothers Win Fame as Dr. Barnes Buys 4 of Their Paintings," *Philadelphia Record*, November 18, 1932, 14; "Three Brothers, Phila. Artists, Win Places in Noted Collection," *Philadelphia Inquirer*, November 18, 1932, 18 ("Biagio's landscape culled in Southern France near Vence"); D. G. [Dorothy Grafly], "Philadelphia Art News," *Christian Science Monitor*, December 3, 1932, 10: "Biagio . . . has his own color range. . . . From his brush comes one of the most individual and compositionally satisfying canvases in the exhibition, an improvisation upon a landscape theme. . . . One

## SALVATORE PINTO (1905–1966)

## Ajaccio, Corsica

Alternate title: *Landscape—Corsica (Red Mountain)*
c. 1932–33. Oil on canvas, 11⅞ × 15 in. (30.2 × 38.1 cm). Signed lower left: Salvatore Pinto. BF380

PROVENANCE: Possibly acquired from the artist, March 3, 1934, for $25.00.[1]

REFERENCES: Albert C. Barnes, *The Art in Painting*, 3rd ed. (New York: Harcourt, Brace, 1937), 347; Margaret Breuning, "Pinto, Pinto & Pinto," *Magazine of Art*, May 1937, 330.

REMARKS: Salvatore Pinto was awarded three consecutive European traveling scholarships by Barnes in 1931, 1932, and 1934. He worked in oil, printmaking—etching and wood engraving—and, with his brother Angelo, designed sets

and costumes for productions of the Philadelphia Ballet Company, directed by Catherine Littlefield (including *Barn Dance* and *Terminal*, which were performed at the 1937 Paris Exposition). In 1941 he and his brothers Angelo and Joseph established the Pinto Brothers Photography Studio, where they specialized in color photography. Salvatore Pinto was a student at the Barnes Foundation from 1927 to 1932 and from 1934 to 1938.

1 Barnes Foundation check no. 7122, March 3, 1934, BFFR, BFA. Barnes Foundation Cash Journal 1922–1940, BFFR, BFA. Barnes Foundation Ledger, P–Z, 1922–1950, BFFR, BFA.

## JAMES PRESTON (1873–1962)

## *Trumbull, Connecticut*

c. 1912. Watercolor, gouache, and black crayon on paperboard, 7¹⁄₁₆ × 10⅛ in. (17.9 × 25.7 cm). Signed and inscribed lower right: *Trumbull Conn. / James Preston*. BF747

PROVENANCE: Acquired from the artist, February 1, 1913.[1]

1 Albert C. Barnes check no. 2528, February 1, 1913, $50.00, check stub annotated, "James Preston landscape," BFFR, BFA.

## *Marrakech*

Alternate title: *Landscape—Marrakech*

1933. Oil on canvas, 12 × 14⅞ in. (30.5 × 37.8 cm). Signed and dated lower right: S. Pinto 33. BF2071

PROVENANCE: Possibly acquired from the artist, March 3, 1934, for $25.00.[1]

1 Barnes Foundation check no. 7122, March 3, 1934, BFFR, BFA. Barnes Foundation Cash Journal 1922–1940, BFFR, BFA. Barnes Foundation Ledger, P–Z, 1922–1950, BFFR, BFA.

## *Chartres*

Undated. Gouache and black crayon on gray wove paper, 8⁵⁄₁₆ × 9¾ in. (21.1 × 24.8 cm). Signed and inscribed lower right: *Chartres / James Preston*. BF887

PROVENANCE: Acquired from the artist, June 8, 1915.[1]

REMARKS: Barnes bought two other works by Preston, *Winter Scene*, 13¼ × 17¼ in. (33.7 × 36.2 cm), given in March 1947 to Henry Francis du Pont's daughter on the occasion of her marriage, and a watercolor, *Old Paris Street*, 8 × 5¾ in. (20.3 × 14.6 cm), lent to Dr. W. Wallace Dyer, July 20, 1951.[2]

1 Albert C. Barnes check no. 3337, June 8, 1915, $37.50, payable to James Preston, possibly represents payment for *Chartres*, BFFR, BFA.
2 Albert C. Barnes checks no. 9, January 30, 1912, $125.00, for *Winter Scene*; no. 2190, February 19, 1912, $15.00, for *Old Paris Street*, BFFR, BFA.

## MAY WILSON PRESTON (1873–1949)

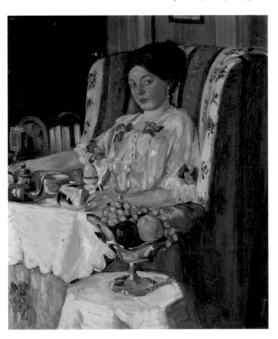

## *Déjeuner*

c. 1910. Oil on canvas, 30 × 25 in. (76.2 × 63.5 cm).
Signed lower right: May Wilson Preston. BF408

PROVENANCE: Acquired from the artist, February 24, 1912, for $300.00.[1]

1 Albert C. Barnes check no. 2199, February 24, 1912, $300.00, payable to "May Wilson Preston painting." Albert C. Barnes check no. 2225, March 22, 1912, $16.00, payable to May Wilson Preston (annotated "May Wilson Preston Frame"), is probably for the frame for *Déjeuner*. Both checks BFFR, BFA.

## *Hunting the Fashions*

Alternate title: *Couturier*
c. 1910–12. Charcoal, watercolor, and gouache with graphite on paperboard, 13¾ × 14½ in. (34.9 × 36.8 cm). Unsigned. Inscribed verso: *Hunting the Fashions / Preston; and for you Madame— / a little touch of violet—*. BF488

PROVENANCE: On March 6, 1912, Dr. Barnes paid May Wilson Preston $83.00 for an unspecified picture or pictures, possibly several drawings including *Drama in the Living Room* (BF519) and *The Confidantes* (BF984) as well as *Hunting the Fashions*.[1]

REMARKS: Drawing for an unidentified illustration.

1 Albert C. Barnes check no. 2217, March 6, 1912, $83.00, payable to May Wilson Preston, BFFR, BFA. The odd sum of check no. 2217 may connote payment for several works.

## Drama in the Living Room

1910. Watercolor, charcoal, and graphite on paperboard, 17⅛ × 14⅛ in. (43.5 × 35.9 cm). Signed and dated lower left: May Wilson Preston 10. Inscribed verso: *Mr. Pottle's Passengers*; *Preston*; *1st installment / Page 2 / I have with me an Indian / rajah, a Russian countess / a priest of the Greek church— / + a Bengal tiger=*. BF519

PROVENANCE: See entry for May Wilson Preston's *Hunting the Fashions* (BF488).

REMARKS: Drawing for an unidentified illustration. Title probably not the artist's.

## The Confidantes

Alternate title: *Conversation*

1907. Graphite, charcoal, watercolor, and white gouache on paperboard, 8¾ × 13⅝ in. (22.2 × 34.6 cm). Signed and dated

lower right: May Wilson Preston 07. Inscribed verso: *"The cousin[s'] love intensified itself / with every nightly confession"*; *The Confidantes*; *Mrs. Preston*. BF984

PROVENANCE: See entry for May Wilson Preston's *Hunting the Fashions* (BF488).

REMARKS: Drawing for an unidentified illustration.

## Woman and Man

1911. Charcoal, watercolor, and white gouache with graphite on paperboard, 17⅝ × 13⅞ in. (44.8 × 35.2 cm). Signed and dated lower right: May Wilson Preston 11. Inscribed verso: *The Shanghaied Son-in-Law / Preston / No. 1— / Its.—Its Algernon said Elizabeth with a little sob.* BF2026

PROVENANCE: Unknown.

REMARKS: Drawing for an unidentified illustration.

## KARL PRIEBE (1914–1976)

## Miss Chalfont

Alternate title: *Girl with Birds*

1947. Casein on cardboard, 12 × 12⅝ in. (30.5 × 32.1 cm).
Signed and dated lower left: Karl Priebe 3/47. Paper label
on verso: *Perls Galleries / 32 East 58th St., New York 22, N.Y.
No. 2894 Artist Priebe Miss Chalfont*. BF1144

PROVENANCE: Acquired from Perls Galleries, New York, February 6, 1948.[1]

EXHIBITION: Perls Galleries, New York, Priebe: Recent Paintings, January 5–31, 1948, cat. no. 5.

REFERENCES: "Karl Priebe, Young Midwest artist lives and paints in an odd world of fantasy," *Life* 23 (November 24, 1947), 60–71; Arnold Newman, "Portrait Assignment," *Photo Arts* 2 (Spring 1948): 70–73, 106, 108, 110; Kit Basquin, *Karl Priebe: A Look at African Americans*, exh. cat. (Milwaukee: Haggerty Museum of Art, Marquette University, 1990); Curtis L. Carter, "Karl Priebe," in Basquin, *Karl Priebe*, n.p.

REMARKS: On the verso of *Miss Chalfont* is a pencil sketch of a woman. On February 3, 1948, Klaus Perls wrote to Priebe: "During the show . . . Dr. Barnes of the Barnes Foundation came in with his whole retinue, attracted by the *Life* publicity which we had sent him. He was very much intrigue[d] with your paintings and made some extremely curious remarks concerning them, comparing them mostly with Seurat and Toulouse-Lautrec. And then he left. But today he offered me through his agent [Georges Keller] $200.– for the Juice-Head, to be bought for the Barnes Foundation, and I couldn't refuse the offer, because it's worth so very much to be able to say he bought one of your paintings. So I let it go at the price, but it's more important to be represented there than even in the Metropolitan or the Museum of Modern Art. So it's really quite wonderful."[2] On February 18, 1948, Perls wrote to Priebe: "Dr. Barnes came back today to say that he'd rather have 'Miss Chalfont' than 'The Juice-Head,' and I made the exchange. As 'Miss Chalfont' was listed during the show at $200.– and the other at $400.–, we did well in that even swap. He has invited me to come over and see his collection and pick up the Juice-Head at the same time. I'll do that next Thursday, and it will be a pleasure, because I've wanted to see that collection for fifteen years now."[3]

1  Barnes Foundation check no. 15705, February 6, 1948, $200.00, BFFR, BFA. On the reverse of the check, typed by the Barnes Foundation: "Painting—'The Juice-Head' by Karl Priebe: 'The Juice-Head,' casein on beaver-board, signed and dated 1946, 20 × 16 inches, Ref. #2587 . . . $200.–net. In accordance with arrangements made through Mr. G. Keller, the above painting is being shipped to you [Dr. Barnes], unframed, by Railway Express, prepaid and fully insured by us."

2  Letter, Klaus Perls to Karl Priebe, February 3, 1948, Perls Galleries Records, 1935–1997, Archives of American Art, Smithsonian Institution.

3  Letter, Perls to Priebe, February 18, 1948, Perls Galleries Records, 1935–1997, Archives of American Art, Smithsonian Institution. In a letter from Perls to Priebe, November 19, 1947, prior to the exhibition, *Miss Chalfont*, #2894, is recorded as no. 19, 12 × 12⅝ [in.], on a list entitled "PRIEBE PAINTINGS AVAILABLE FOR 1948 SHOW."

## HOWARD RACKLIFFE (1917–1987)

### Winter Wharf

1947. Opaque paint and crayon on tan wove paper, 21⅜ ×
17 in. (54.3 × 43.2 cm). Signed and dated lower right on mat:
H. Rackliffe 47. Inscribed lower left on mat: *Winter Wharf.*
BF523

PROVENANCE: Acquired from the artist, June 30, 1948.[1]

1 Barnes Foundation check no. xx [from a series of unnumbered checks],
June 30, 1948, $50.00, payable to Howard Rackliffe, BFFR, BFA. Barnes
Foundation Ledger, P–Z, 1922–1950, BFFR, BFA.

## BARBARA REIFF (B. 1926)

### Still Life Abstraction ("Cheese and Crackers")

1946. Oil on paper, 5¾ × 8 in. (14.6 × 20.3 cm). Signed and
dated lower right: Reiff 46. BF2056

PROVENANCE: Acquired from the artist, June 10, 1946, for
$2.50.[1]

EXHIBITION: Rittenhouse Square, Philadelphia, Annual
"Clothesline" Exhibition, 1946.

REFERENCE: *Philadelphia Record*, Jeff Keen Says, June 13,
1946: "Barbara Reiff, local artist, made one of the most impor-
tant sales of the Rittenhouse Square clothesline exhibition.
The buyer was Dr. Albert S. [*sic*] Barnes of [the] Barnes Foun-
dation, who purchased two of her canvases for $2.50 each."

REMARKS: Reiff was a student at the Barnes Foundation
from 1945 to 1947.

1 Barnes Foundation check no. 13863, June 10, 1946, $27.38, BFFR, BFA.
This amount includes $12.00 for Morris Hervey, *Summer Light* (BF507),
and $5.00 for two works by Reiff, *Still Life Abstraction ("Cheese and
Crackers")* (BF2056) and *Still Life with Jug* (BF2058), plus $10.38 (misc.
expenses and travel).

## *Still Life with Jug*

1946. Oil on paperboard, 6½ × 7 in. (16.5 × 17.8 cm).
Signed and dated lower left: Reiff 46. BF2058

PROVENANCE: Acquired from the artist, June 10, 1946, for
$2.50. See entry for Reiff's *Still Life Abstraction ("Cheese and
Crackers")* (BF2056).

EXHIBITION: Rittenhouse Square, Philadelphia, Annual
"Clothesline" Exhibition, 1946.

## PAUL ROHLAND (1884–1953)

## *Flower Piece (Zinnias)*

c. 1920. Monoprint in opaque paint on Japanese paper,
sheet 12⅛ × 10⅛ in. (30.8 × 25.7 cm), plate 9½ × 7½ in.
(24.1 × 19.1 cm). Signed lower left: Rohland. BF721

PROVENANCE: Acquired from the artist, 1920.

REMARKS: Barnes wrote to Rohland, September 7, 1920: "I've
just as vivid a sense of your monotypes this morning as I
had when I saw them on Sunday and I'd hang some of them
among my pictures at home if I had a few inches of wall space
left. The next best thing is to hang them in my offices where
there are already some of the best things that some of the best
Americans ever did. So I enclose a check for one hundred and
twenty-five ($125) dollars, leaving it to you whether you send
me five or six of them including the two flower pieces in your
studio on the wall toward [Leon] Kroll's house and the one
with the houses in [it] that hangs in the room just opposite
the entrance door."[1] Among the other monotypes by Rohland
is *Spanish Houses* (alternate title: *Spanish Landscape*), 11¼ ×
14½ in. (28.6 × 36.8 cm), which was donated to the Blanden
Memorial Art Museum, Fort Dodge, Iowa, on June 7, 1951.[2]

1  Letter, Albert C. Barnes to Paul Rohland, September 7, 1920, ACB Corr.,
   BFA. There is no record of the check Barnes refers to in BFA.
2  See Margaret Carney Xie, *Handbook of the Collections in the Blanden
   Memorial Art Museum* (Fort Dodge, Iowa: Blanden Charitable Founda-
   tion, 1989), 12.

## HARRY SEFARBI (1917–2009)

*Interior: Jim*

1949. Oil on canvas, 24 × 20 in. (61 × 50.8 cm). Signed lower left: Sefarbi. Frame by Charles Prendergast. BF2540

PROVENANCE: Acquired from the artist, February 17, 1950, for $100.00.[1]

EXHIBITION: Pennsylvania Academy of the Fine Arts, Philadelphia, Annual Exhibition, 1950.

REFERENCES: Harry Sefarbi, "The Clue to Klee," *BFJAD* 3, no. 1 (Spring 1972): 27–44; Harry Sefarbi, "Vincent van Gogh: A Fiction," *BFJAD* 6, no. 1 (Spring 1975): 42–63; Harry Sefarbi, "Henri Rousseau: From 'primitive' to Primitive," *Vistas* 4, no. 1 (1988): 3–24. See also Randy Kennedy, "After 50 Years, Still Teaching It the Barnes Way," *New York Times*, July 22, 2007, Section 2, 1, 20.

REMARKS: Sefarbi, who for some years painted under the name Harry Smith, was a student at the Barnes Foundation from 1947 to 1949. In 1953 he was appointed a faculty member in the Art Department of the Barnes Foundation, where he taught until 2007. Sefarbi spent three and a half years painting in Paris, where, in 1950–51, he studied at the Académie de la Grande Chaumière. Barnes wrote to Yvon Bizardel, director of Fine Arts, City of Paris, February 16, 1950:

"One of our best graduates, Mr. Harry Smith, a painter who has also been engaged in teaching art, has gone to Europe to study. . . . I told Mr. Smith that if he wanted any information and advice, the best person he could apply to is yourself."[2] Barnes subsequently wrote to Sefarbi, April 4, 1951: "Miss de Mazia and I often talk about you and wonder what you are doing, how you are getting along. . . . Your letter of March 20 answers our questions very thoroughly, and you size it up very well in the sentence—'Thus far it has been a pleasant, rewarding and happy time.' What more could a human being ask of this world. . . . When you get home, Miss de Mazia and I are looking forward to the pleasure of having a good talk with you. She asked me to answer your letter for both of us and, like myself, she joins in sending you cordial greetings."[3]

1 Barnes Foundation check no. 18101, February 17, 1950, payable to Harry Smith, BFFR, BFA. Barnes Foundation Cash Journal, 1947–1950, BFFR, BFA. Letter, Albert C. Barnes to Harry Sefarbi, February 17, 1950, ACB Corr., BFA: "Your painting at the Academy struck me as one of the three or four in the show that is really a picture—i.e., it carries out an idea, accomplished by intelligent use of the plastic means that gives it an individuality. I like it better at a distance than I did at close view, particularly because, when looked at from afar, the color functions as color, but when closely examined the color has too much the quality of paint. I suppose you know that, and also know that to put quality in color is the most difficult job of all. The painting has a few other minor defects—but so do a number of great painters, including Cézanne. If you want to sell it, the enclosed check for one hundred dollars is offered. I can't hang it, but Miss de Mazia can use it in classes when she talks about what to look for in a painting that makes it a work of art."
2 Letter, Barnes to Yvon Bizardel, February 16, 1950, ACB Corr., BFA.
3 Letter, Barnes to Sefarbi, April 4, 1951, ACB Corr., BFA.

# LUIGI SETTANNI (1908–1984)

## Two Figures

1935. Pen and ink with pastel on wove paper, 10⅝ × 8¼ in. (27 × 21 cm). Signed, dated, and inscribed lower right: *To / Albert C. Barnes / from / Luigi Settanni / Marrakech 1935.* BF2017

PROVENANCE: Gift from the artist, 1935.

## Russian Ballet

Alternate title: *Ballet Dancers*

1934. Oil with graphite on wove paper (later mounted to fiberboard), 16⁵⁄₁₆ × 12⅝ in. (41.4 × 32.1 cm). Signed and dated lower right: Luigi Settanni 1934 XX. BF1152

PROVENANCE: Acquired from Gimbel Brothers Galleries, Philadelphia, January 16, 1935, for $50.00.[1]

EXHIBITION: Gimbel Brothers Galleries, Contemporary Art, Philadelphia, 1934 or 1935, cat. no. 128.

REFERENCES: Albert C. Barnes, *The Art in Painting*, 3rd ed. (New York: Harcourt, Brace, 1937), 347: "The work of . . . Settanni . . . is entitled to respect because it represents [a] personal vision embodied in individual plastic form," ill., 343; Violette de Mazia, "Transferred Values: Part III," *Vistas* 1, no. 2 (Autumn–Winter 1979–80): 38, pl. 38.

REMARKS: Settanni was a student at the Barnes Foundation from 1933 to 1941.

1 Barnes Foundation check no. 7963, January 16, 1935, $33.33, payable to Luigi Settanni for "2/3 of price 'Dancers' @ $50.00"; check no. 7964, January 16, 1935, $16.67, payable to Gimbel Bros. for "1/3 price of Luigi Settanni 'Dancers' @ $50.00."

## Marrakech

Alternate title: *Interior with Figures at Marrakech*

1935. Oil on canvas, 16⅛ × 14 in. (41 × 35.6 cm). Signed and dated lower right: L. Settanni 35 / XX. BF308

PROVENANCE: Acquired from the artist, December 23, 1935, for $50.00.[1]

REMARKS: Settanni was in Marrakech, Morocco, in early 1935 on a Barnes Foundation scholarship awarded him in February 1935.

1 Barnes Foundation check no. 8775, December 23, 1935, BFFR, BFA. Barnes Foundation Cash Journal, 1922–1940, BFFR, BFA.

## Port-Manech

1939. Oil on canvas, 10½ × 15⅝ in. (26.7 × 39.7 cm). Signed and dated lower right: Luigi Settanni / 39 XX. Frame by Charles Prendergast. BF168

PROVENANCE: Acquired from the artist, May 13, 1940, for $150.00.[1]

EXHIBITION: Bignou Gallery, New York, Paintings by Luigi Settanni, April 22–May 4, 1940.

REFERENCES: *Paintings by Luigi Settanni*, exh. cat. (New York: Bignou Gallery, 1940), cat. no. 3; Albert C. Barnes, foreword, in *Paintings by Luigi Settanni*: "Since 1933, Settanni has devoted his entire time to painting, in France, Morocco, Corsica, Mexico and Florida. . . . The present exhibition represents work done on the Coast of Brittany during the past two years. One is struck immediately by the quality, variety and individuality of Settanni's color. Its sensuous quality is unusually pleasing, its combinations are harmonious, and its contrasts are highly dramatic. The most significant characteristic of his color, however, is that it penetrates into and becomes an integral part of the total form; it determines the character of the linear elements, suffuses light and illuminates space, and is the dominant factor in the drawing and modeling. . . . His color is . . . highly expressive as well as strikingly decorative. . . . In these respects, he belongs to that rare class of painters represented at the best by Renoir."

REMARKS: Port-Manech is a village in Brittany (Finistère), where Barnes spent part of his summers in the 1930s.

1 Letter, Albert C. Barnes to Luigi Settanni, May 13, 1940, ACB Corr., BFA.: "Our enclosed check. 12889 for four hundred ($400) dollars pays for nos. 3 [*Port-Manech* (BF168)], 6 [*Three Women at Port-Manech* (BF2045)] and 17 [*Fisherman and Wife, St. Guénolé* (BF981)] in the catalogue of the Bignou show, held April 22nd to May 4, 1940, listed under the names of no. 3, *Port-Manech, Fisherman*; no. 6, *Three Women at Port-Manech*; and no. 17, *Fisherman and Wife, Saint Guénolé*." Barnes Foundation check no. 12889, August 13, 1940, $400.00, BFFR, BFA. Barnes also acquired no. 14, *Spreading Nets, Douarnenez* (BF983), for $150.00 and no. 16, *Kerdruc*, for Charles Laughton, for $250.00. "Luigi Settanni 3 paintings," May 13, 1940, $400.00, Barnes Foundation Cash Ledger, BFFR, BFA.

## Fisherman and Wife, St. Guénolé

1939. Oil on canvas, 13 × 18 in. (33 × 45.7 cm). Signed and dated lower right: Luigi Settanni / 39 XX. BF981

PROVENANCE: Acquired from the artist, May 13, 1940, for $150.00. See entry for Settanni's *Port-Manech* (BF168).

EXHIBITION: Bignou Gallery, New York, Paintings by Luigi Settanni, April 22–May 4, 1940.

REFERENCE: *Paintings by Luigi Settanni*, exh. cat. (New York: Bignou Gallery, 1940), cat. no. 17.

## Three Women at Port-Manech

1938. Oil on canvas, 21⅛ × 25½ in. (53.7 × 64.8 cm). Signed and dated lower left: Luigi Settanni / 1938 XX. Label on upper stretcher member: *6. Port-Manech*. BF2045

PROVENANCE: Acquired from the artist, May 13, 1940, for $100.00. See entry for Settanni's *Port-Manech* (BF168).

EXHIBITION: Bignou Gallery, New York, Paintings by Luigi Settanni, April 22–May 4, 1940.

REFERENCE: *Paintings by Luigi Settanni*, exh. cat. (New York: Bignou Gallery, 1940), cat. no. 6.

## Spreading Nets, Douarnenez

1939. Oil on canvas, 15 × 23⅞ in. (38.1 × 60.6 cm). Signed and dated lower right: Luigi Settanni / 39 XX. Label on upper stretcher member: *14. Spreading Nets, Douarnenez*. BF983

PROVENANCE: Acquired from the artist, May 13, 1940, for $150.00. See entry for Settanni's *Port-Manech* (BF168).

EXHIBITION: Bignou Gallery, New York, Paintings by Luigi Settanni, April 22–May 4, 1940.

REFERENCE: *Paintings by Luigi Settanni*, exh. cat. (New York: Bignou Gallery, 1940), cat. no. 14.

## Landscape in Brittany (Pont l'Abbé Figure)

1939. Oil on canvas (later mounted to fiberboard), 18¾ × 26 in. (47.6 × 66 cm). Signed and dated lower right: Luigi Settanni 1939. BF979

PROVENANCE: Gift from the artist, April 1940.

## Woman in Hammock

1936. Oil on canvas, 12⅛ × 17⅞ in. (30.8 × 45.4 cm).
Signed and dated lower right: L. Settanni 36 / XX. BF446

PROVENANCE: Probably acquired from the artist.

## Negro Figure

Alternate title: *Topsy*

c. 193[9?]. Oil on canvas, 34¼ × 24½ in. (87 × 62.2 cm).
Signed and dated lower left: Settanni / 19[damaged].
BF2037

PROVENANCE: Unknown.

REMARKS: Probably painted in New Orleans in 1939.[1]

1 See letter, Albert C. Barnes to Elaine Bailey, July 5, 1940, ACB Corr., BFA:
"It will interest you to know that Luigi [Settanni] sold six paintings of
those exhibited in New York and for the first time in his life has a sub-
stantial bank account running into four figures. He is now painting in
New Orleans which, as you know, is a very picturesque and colorful
place."

## FLORENCE SHUBERT (1920–2004)

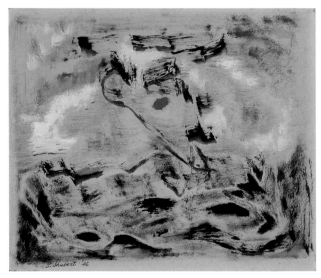

## Color Movement Inspired by "Joie de vivre"

1946. Oil on tan wove paper, 9¼ × 10¾ in. (23.5 × 27.3 cm).
Signed and dated lower left: F. Shubert '46. BF2057

PROVENANCE: Acquired from the Friends' Neighborhood
Guild, Philadelphia, June 6, 1946, for $20.00.[1]

EXHIBITION: Friends' Neighborhood Guild, Annual Exhibi-
tion, June 5–9, 1946, cat. O.

REMARKS: Shubert was a student at the Barnes Foundation
from 1945 to 1947. "Joie de vivre" refers to Henri Matisse's *Joy
of Life* (*Le Bonheur de vivre*, BF719).

1 Letter, Nelle. E. Mullen (Barnes Foundation) to the Friends' Neighbor-
hood Guild, June 6, 1946, ACB Corr., BFA, enclosing Barnes Foundation
check no. 13854, June 6, 1946, $110.00, in payment for Shubert's *Color
Movement Inspired by "Joie de vivre"* (BF2057) as well as Krona Bron-
stein, *Seated Figure* (BF2060), Priscilla Heacock, *Composition* (BF2061),
Francis McCarthy, *Still Life* (BF2059), and another work by McCarthy no
longer in the collection, along with a check from Violette de Mazia in
the amount of $15.00 in payment for a work by Shubert.

## JOHN SLOAN (1871–1951)

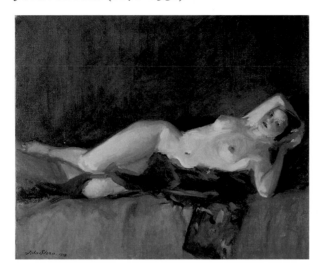

## Nude, Green Scarf

Alternate titles: *Green Scarf; Reclining Nude*

1913. Oil on canvas, 20 × 24 in. (50.8 × 61 cm). Signed and dated lower left: John Sloan 1913. BF524

PROVENANCE: Acquired from the artist in 1913 or early 1914.[1]

REFERENCES: Grant Holcomb III, *A Catalogue Raisonné of the Paintings of John Sloan, 1900–1913* (Ph.D. diss., University of Delaware, 1972), 578, cat. no. 190, cites J[ohn] S[loan]: Inventory of Works of Art Ledger (1944), no. 503. Holcomb writes: "The selling of [*Nude, Green Scarf*] was Sloan's first major sale," having noted (118) that the artist had sold *The Shooting Gallery* in 1903 (actually in 1904, according to entry in Sloan's Ledger [DAM]). Rowland Elzea, *John Sloan Oil Paintings: A Catalogue Raisonné* (Newark: University of Delaware Press, 1991), 127, cat. no. 220, states that *Nude, Green Scarf* "appears in the literature on Sloan as being the first canvas he sold. . . . This is not the case since Sloan sold *Targets* [*The Shooting Gallery*; Elzea no. 43] in 1902 [*sic*] and the portraits of Mr. and Mrs. Storz [Elzea nos. 187 and 188] in 1912." John Loughery, in *John Sloan: Painter and Rebel* (New York: Henry Holt, 1995), 191, states that Barnes's purchase of *Nude, Green Scarf* was Sloan's fourth sale, following two portraits and *The Shooting Gallery*, observing that "most of the literature on Sloan for some reason records it as his first, and certainly Sloan himself preferred that notion as he got older."[2] See also Violette de Mazia, "Creative Distortion IV: Portraiture II," *BFJAD* 5, no. 1 (Spring 1974): 14, pls. 69 and 71 (detail); Violette de Mazia, "The Decorative Aspect in Art,"

*BFJAD* 6, no. 1 (Spring 1975): 33, pls. 48 and 49 (detail); Violette de Mazia, "*E Pluribus Unum*—Cont'd: Part III," *BFJAD* 8, no. 1 (Spring 1977): 17n, pl. 100; Violette de Mazia, "Tradition: An Inquiry—A Few Thoughts," *Vistas* 3, no. 1 (1984–86): 84n, pl. 101; Violette de Mazia, "Academicism," *Vistas* 4, no. 2 (Winter 1988–89): 27, pl. 119; Janice M. Coco, *John Sloan's Women: A Psychoanalysis of Vision* (Newark: University of Delaware Press, 2004), 113 n. 7.

1 Albert C. Barnes check no. 2869, January 2, 1914, $150.00, payable to Sloan, probably in payment for *Nude, Green Scarf*, BFFR, BFA. Recorded in Sloan's Inventory of Works of Art Ledger (1944), no. 503: "*Nude, Green Scarf* 20 × 24 1913 [sold] Dec. 1913 Dr. Albert C. Barnes 150.00," John Sloan Manuscript Collection, Delaware Art Museum. See also entry for John Sloan, *Seated Nude* (BF192).

2 The author notes the assistance of Heather Campbell Coyle, Associate Curator, Delaware Art Museum, in clarifying the documentation on these purchases.

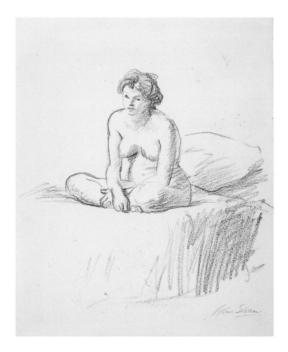

## Seated Nude

c. 1913. Black crayon on wove paper, 12¹³⁄₁₆ × 9⅞ in. (32.5 × 25.1 cm). Signed lower right: John Sloan. BF192

PROVENANCE: Acquired from the artist, January 26, 1914, for $25.00, together with twenty-two etchings created by Sloan (see list of etchings below).[1]

1 Invoice January 22, 1914, ACB Corr., BFA. Albert C. Barnes check no. 2892, January 26, 1914, $200.00, payable to John Sloan, BFFR, BFA.

JOHN SLOAN ETCHINGS

The twenty-two etchings in the collection of the Barnes Foundation are documented in A. E. Gallatin, "John Sloan: His Graphic Work," in *Certain Contemporaries: A Set of Notes in Art Criticism* (New York and London: John Lane, 1916), 29–30; and Peter Morse, *John Sloan's Prints: A Catalogue Raisonné of the Etchings, Lithographs, and Posters* (New Haven and London: Yale University Press, 1969). Morse examined the prints in the Barnes Foundation and states, "Another significant early sale was a group of prints to Dr. Albert C. Barnes in 1913 [*sic*], for $175.00, works now in the Barnes Foundation, Merion, Pennsylvania" (17). Morse's titles are used in the following list.

*Girl in Kimono* (working proof), 1913 (Gallatin no. 87, Morse 164), BF2578

*The Serenade* (Alternate title: *The Laggard in Love*) (first state), 1912 (Gallatin no. 80, Morse 159), BF2579, frontispiece for T. A. Daly, *Madrigali* (Philadelphia: David McKay, 1912)

*Combing Her Hair*, 1913 (Gallatin no. 84, Morse 161), BF2580

*Rag Pickers*, 1913 (Gallatin no. 83, Morse 166), BF2581

*Head with Necklace*, 1913 (Gallatin no. 86, Morse 163), BF2582

*Fun, One Cent*, 1905 (Gallatin no. 65, Morse 131), BF2583

*Girl and Beggar*, 1910 (Gallatin no. 70, Morse 150), BF2584

*Connoisseurs of Prints*, 1905 (Gallatin no. 66, Morse 127), BF2585

*The Show Case*, 1905 (Gallatin no. 64, Morse 129), BF2586

*Roofs, Summer Night*, 1906 (Gallatin no. 68, Morse 137), BF2587

*Swinging in the Square (In the Park)* (working proof), 1912 (Gallatin no. 81, Morse 156), BF2588

*Swinging in the Square (In the Park)*, 1912 (Gallatin no. 81, Morse 156), BF2589

*Turning Out the Light*, 1905 (Gallatin no. 61, Morse 134), BF2590

*Prone Nude*, 1913 (Gallatin no. 85, Morse 162), BF2591

*Night Windows*, 1910 (Gallatin no. 69, Morse 152), BF2592

*The Little Bride*, 1906 (Gallatin no. 67, Morse 138), BF2593

*Fifth Avenue Critics*, 1905 (Gallatin no. 59, Morse 128), BF2594

*Man, Wife and Child*, 1905 (Gallatin no. 63, Morse 135), BF2595

*Memory*, 1906 (Gallatin no. 73, Morse 136), BF2596

*The Picture Buyer*, 1911 (Gallatin no. 71, Morse 153), BF2597

*Man Monkey*, 1905 (Gallatin no. 62, Morse 130), BF2598

*The Women's Page*, 1905 (Gallatin no. 60, Morse 132), BF2599

## MAURICE STERNE (1877–1957)

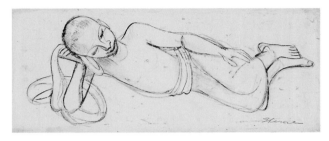

### Reclining Figure
Alternate title: *Reclining Child*
c. 1913. Black crayon on Japanese paper, 7¼ × 17⅞ in.
(18.4 × 45.4 cm). Signed lower right: Sterne. BF669

PROVENANCE: Acquired from the Berlin Photographic
Company.[1]

EXHIBITION: Berlin Photographic Company, March 1915.

REFERENCES: Martin Birnbaum, *The Last Romantic: The
Story of More Than a Half-Century in the World of Art* (New
York: Twayne, 1960), 96–97; Violette de Mazia, "*E Pluribus
Unum*—Cont'd: Part III," *BFJAD* 8, no. 1 (Spring 1977): 21n,
pl. 101 (as *Arab Boy*).

1 Albert C. Barnes check no. 3308, May 6, 1915, $50.00, payable to Berlin
Photographic Co., for "Sterne drawing Bill Mat 5th, 1915"; the check stub
is annotated "Fo[r] one drawing 'Reclining Child' $50," BFFR, BFA.

### Deer
c. 1913. Black crayon on wove paper, 9⅛ × 12⁹⁄₁₆ in.
(23.2 × 31.9 cm). Unsigned. BF646

PROVENANCE: Acquired from the artist, February 1, 1919.[1]

1 Albert C. Barnes check no. 4451, February 1, 1919, $125.00, payable to
Maurice Sterne, BFFR, BFA.

## LYND WARD (1905–1985)

### Two Figures
1932. Wood engraving on Japanese paper, sheet 8⅞ × 6⅝ in.
(22.5 × 16.8 cm), plate 6⅛ × 3¾ in. (15.6 × 9.5 cm). Signed
and dated lower right: Lynd Ward / 1932. Inscribed lower
left: *19 / 20*. BF320

PROVENANCE: Acquired as one of five wood engravings
by the artist from Robert Carlen Gallery, April 1, 1938, for
$35.00.[1]

REMARKS: Dr. Barnes donated two of Ward's wood engrav-
ings to the Blanden Memorial Art Museum, Fort Dodge,
Iowa, on June 7, 1951.[2]

1 Itemized invoice, March 31, 1938, ACB Corr., BFA. Barnes Foundation
check no. 10927, April 1, 1938, payable to Carlen Galleries, BFFR, BFA.
Barnes Foundation Ledger, P–Z, 1922–1950, BFFR, BFA.
2 See Margaret Carney Xie, *Handbook of the Collections in the Blanden
Memorial Art Museum* (Fort Dodge, Iowa: Blanden Charitable Founda-
tion, 1989), 12.

## Figure and Skulls

1932. Wood engraving on Japanese paper, sheet 8 × 5½ in. (20.3 × 14 cm), plate 6⅛ × 3¾ in. (15.6 × 9.5 cm). Signed and dated lower right: Lynd Ward / 1932. Inscribed lower left: *19 / 20*. BF495

PROVENANCE: See entry for Ward's *Two Figures* (BF320).

## E. AMBROSE WEBSTER (1869–1935)

## Sunlit Landscape

Alternate title: *Jacob's House Montego Bay Jamaica*

1911. Oil on canvas, 19⅞ × 24 in. (50.5 × 61 cm). Signed and dated lower right: E. A. Webster / 1911. BF2558

PROVENANCE: Acquired from the artist, July 10, 1918.[1]

1 Letter, E. Ambrose Webster (in Provincetown, Massachusetts) to Albert C. Barnes, July 4, 1918, ACB Corr., BFA.: "Dear Mr. Barnes—Am sending by Adams Express prepaid your picture. Subject: Jacob's House Montego Bay Jamaica. I thank you very much for your encouragement." Albert C. Barnes check no. 4310, July 10, 1918, $200.00, payable to E. A. Webster, BFFR, BFA.

# INDEX

*Page numbers in italics indicate photographs and illustrations.*

A.C. Barnes Company, xix, xxi, 14–15, 25, 29
Académie Moderne, 260
Adair, William, 342
*The Aesthetic Experience* (Buermeyer), 33
aesthetic values, 3, 24, 32, 51, 66. *See also The Art in Painting* (Barnes)
    course entitled Applied Aesthetics, 33
    Dewey on, 42
African Americans, 4, 12, 16–17, 26, 29, 50, 307–09
African art, 31, 197, 306, 326
Allara, Pamela Edwards, 274
Allen, Frederick M., 263
American art
    American artists visiting Barnes's collection, 23
    in Barnes Foundation, 63
    Barnes's purchasing of, 21
    Barnes's role in promoting, 2
    early American crafts, 45
    Glackens on, 67
*American Art News*
    on Glackens, 67–68
    on Maurer, 131
Anderson Galleries, 131
Apollinaire, Guillaume, 187
*An Approach to Art* (M. Mullen), 31, 33, 306
Arboretum School of the Barnes Foundation, 28, 29, 45, 49
Argyrol, 13, *14*
Armory Show, 67, 328, 332
art, Barnes approach to, 66, 183. *See also* aesthetic values; scientific method
    display of, 2–3, 44, 249, 352
*Art as Experience* (Dewey), 42
art critics, 3, 67, 130–31, 349
art education, reform of, 33
*The Art in Painting* (Barnes), 36–40
    art education, purpose of, 33
    criticism of, 39–40
    Dewey on, 2, 39, 40
    draft page, *36*
    on Glackens, 101
    Glackens's reading of draft of, 69
    on Kane, 340
    on Lawson, 183
    on Luks, 345
    on Pascin, 195
    on Prendergast, M., 143, 148
    on Settanni, 365
Artists' Gallery, 339
*The Art of Cézanne* (Barnes and de Mazia), 44, 69
*The Art of Henri-Matisse* (Barnes and de Mazia), 41–42, 351
"Art of Negro Africa and Modern Negro America" (Barnes), 309
*The Art of Renoir* (Barnes and de Mazia), 7, 43–44, 65, 69
"The Art of William Glackens" (Barnes), 68
*Arts and Decoration* article by Barnes, 24, 185
Avery, Milton
    *The Nursemaid*, *319*

Bailey, Elaine, 320
    *Dancing Figures*, *320*
    *Hallyjuliah!*, *320*
Ballets Russes, 260
Balzac, Honoré de, 260, 281
Barnes, Albert Coombs. *See also* Barnes Foundation; Barnes Foundation Gallery
    *For his relationships with artists, other individuals, and organizations, see their individual names.*
    on aesthetic experience, 51, 66
    arrangement of art by, 2–3, 44, 249, 352
    art critics and, 67, 130–31, 349
    black culture, influence of, 12, 16, 17, 50, 309
    Black Mountain College visit, 43
    business ventures of, 13–15, 41. *See also* A.C. Barnes Company
    correspondence of, 4, 5, 6, 23, 24, 27–29, 34–35, 44, 63. *See also specific correspondents with Barnes*
    death of, 50
    early life of, 12
    education of, 4, 12–13
    European summer classes led by, 39
    family background, 11–12
    on folk art, 306–07
    negativity engendered by, 6–7
    notoriety of, 2, 4, 47
    portraits and photographs of, *ii, xxii, 5, 14*
    psychological approach to art, 12–16, 23–25, 27, 31–32, 37, 42, 45
    scientific approach of, 7

scientific articles in German by, 13
temperament of, 4, 6, 7, 12, 29, 43, 47, 51,
    130, 144
will of, 28, 47
writings by, 41–44, 65, 69, 309, 351. *See also*
    *specific titles*
wrought iron objects, collecting of, 44–45
Barnes, John J. (father of Albert C. Barnes), 11
Barnes, Laura Leggett (Mrs. Albert C. Barnes),
    *14*, 29, 45
Barnes, Lydia A., *see* Lydia A. Schaffer
Barnes and Hille Company, 14
Barnes Foundation
    approach of, 3, 25
    Arboretum School, 28, 29, 45, 49
    Archives, 63
    Barnes on, 2, 15–16
    by-laws, 49
    development of, 1, 14–17, 28–29, 31, 32
    Dewey on, 42–43
    faculty of Art Department, xiii, *10*, 11, 35,
        40–41, 326, 352–53, 364
    formal inauguration of, 33
    Lincoln University and, 47–50
    Matisse on, 3
    move into central Philadelphia, ix
    Munro on, 7
    Pascin on, 197
    publications of, 31, 33
    University of Pennsylvania and, 28, 31–35,
        45, 46, 48, 49
Barnes Foundation Gallery
    construction of, 28, 29–31
    front entrance, *viii*
    Gallery VI, *30*
    Gallery XII "American Room," *62*
    Gallery XXIII, *10*
    inauguration of, 33
    Main Gallery, *xii*, *xviii*, *15*, 249
Barr, Alfred H., Jr., 40, 42
Bell, Clive, 130–31
Benedict, Agnes, 44
Benton, Thomas Hart, 321
    *Figure and Boats*, *321*
    *Waves*, *321*
Berd, Morris
    *Nature Study*, *322*
Berenson, Bernard, 24
Bernard, Emile, 22
*The Bertrand Russell Case* (Dewey and Kallen,
    eds.), 45
Black Mountain College, 43
Blake, William
    influence on Demuth, 261, 262, 282, 299
    works:
        *Albion Rose (Dance of the Albion)*, *282*
        *The Goblin*, *299*
Blanden Memorial Art Museum, 132, 363, 371
Bockrath, Mark F., 306
Bomgardner, Renee, xiv, xv
Bond, Horace Mann, 47–48, 49–50, 51, 346

Bonnard, Pierre, 22
Bosanquet, Bernard, 11
Bosworth, Frances, 346
Bosworth, John [Rybczyk]
    *Bedroom*, *322*, 346
Boucher, François, 196
Braque, Georges, 248, 249
Bronstein, Krona, 323
    *Seated Figure*, *323*
Brook, Alexander, 306
Brummer, Joseph, 166–67
Bryant, Harriett C., 146, 147
Buckley, Barbara, xiv, xv, 306
Buddhist art, 94
Buermeyer, Laurence Ladd
    assessment of teacher training for Philadel-
        phia public schools art instruction, 33
    Barnes and, 25–26, 27, 32–33, 36
    draft page *The Art in Painting*, *36*
    introduction of Poole to Barnes, 270
    photograph of, *25*
    as University of Pennsylvania professor,
        25–26, 32
Butterworth, Myra
    *Tulips (Flower Study)*, *323*

cabinetmakers, 11, 172
Caffin, Charles H., 127, 130, 249
Camp, Kimberly, x, xiv
Canaletto type of frames, 172
Cantor, Gilbert M., 6–7
Carlen, Robert, 307
Carpaccio, Vittore, 143
Carroll Galleries, 145, 163
Cassatt, Mary
    *Woman with Nude Boy at Her Left*, *324*
    *Woman with Nude Boy at Her Right*, *324*
Cézanne, Paul
    *The Art of Cézanne* (Barnes and de Mazia),
        44, 69
    Barnes on, 38, 328–29
    in Barnes's collection, 19, 68, 129, 173, 260
    Barnes's desire to purchase, 22
    Hartley on, 3
    influence of, 38, 44, 186
    influence on Demuth, 260, 261
    influence on Glackens, 68, 108
    influence on Pascin, 196–98, 206
    works:
        *Card Players*, *xviii*
        *Large Bathers*, *xii*
        *Madame Cézanne*, 68, *107*, 108
        *Toward Mont Sainte-Victoire*, *21*
Chalmers, Mary, 325
    *My Portrait*, *325*
Chandler, Joseph Goodhue, 325
    *Portrait of a Man*, *325*
Chase, William Merritt, 21
Chinese art, 261
Chinese Gallery, 349

Church, Barton, xiii, 326
    photograph of, *10*
    work: *Girl in a Chair*, *326*
Cizek, Frank, 33
Clarke, Liz
    *The Balloon Man*, *327*
Cleaver, Carole, 306, 308
Coleman, Glenn O., 300
Collections Assessment Project (CAP), xiv
color photography, 47, 48, 353, 358
Columbia University
    Barnes's proposal for course at, 33
    Dewey's seminars at, 26
Constable, John, 121, 183
"A Constructive Program for Teaching Art"
    (Munro), 33–34
Cooper Union's fortieth anniversary article
    (Dewey), 44
Courbet, Gustave, 186
Cret, Paul Philippe, 29, 35
Cubism, 23, 195, 197, 247–51, 260, 261, 268,
    285–90, 329
Culhane, Irene, 307

Daniel, Charles (Daniel Galleries), 147, 184, 196,
    201, 271, 279–80, 343, 350
Dasburg, Andrew, 327–28
    *Landscape (Mountain in the Southwest)*, *327*
Daumier, Honoré, 22, 186, 196
David, Hermine (Carthan-David, Hermine-
    Lionette), 198, 218
Davies, Arthur B., 28, 184, 328–29
    *Flora*, *329*
    *Music in the Fields*, *328*, 329
de Chirico, Giorgio, 268
Degas, Edgar, 21, 22, 69, 129, 196
de Gregorio, Vincent J., 71
Delaunay, Robert, 248
Dell, Robert, 184
de Mazia, Violette, 40–44, 58
    on aesthetic experience, 51
    Barnes Foundation faculty member, xiii,
        40–41, 50
    on Demuth, 300
    Hankins and, 337
    photographs of, *10*, *41*, *337*
    Pippin and, 307
    visit to Billy Rose, 61
    works:
        *Head*, *330*
        *A Necklace of Boats*, *330*
    writings with Barnes, ix
        *Ancient Chinese and Modern European
            Painting*, 51–61
        *The Art of Cézanne*, 44, 69
        *The Art of Henri-Matisse*, 41–42, 351
        *The Art of Renoir*, 7, 43–44, 65, 69
        *The French Primitives and Their Forms*, 41
*Democracy and Education* (Dewey), 15, 36
Demuth, Augusta, 261, 263

Demuth, Charles, 259–303
    Barnes on, 259
    birth and education of, 259
    correspondence with Barnes, 261, 262, 263
    Cubist-inspired landscapes by, 260, 261, 268,
        285–90
    development as artist, 259–60
    display of paintings by Barnes, 3
    health of, 262, 263
    influences on, 260–61, 299
    literary illustrations by, 260, 271–78, 299
    literary knowledge of, 259
    relationship with Barnes, 63, 247, 261–64
    works:
        Artists Sketching, 279
        Bermuda: Houses, 266, 289
        Bermuda: Houses Seen through Trees,
            261, 266, 290
        Bermuda, Masts and Foliage, 266, 287
        Bermuda: Rooftops through Trees,
            266, 286
        Bermuda: Stairway, 266, 290
        Bermuda: Tree, 266, 286
        Bermuda: Trees and Architecture,
            266, 285
        Bermuda Landscape No. 1, 266, 288
        Bermuda Landscape No. 2, 266, 287
        Bicycle Acrobats, 291
        Chiminies, Ventilators or Whatever,
            see Masts
        Count Muffat Discovers Nana with the
            Marquis de Chouard, 266, 277
        Count Muffat's First View of Nana at the
            Theatre, 260, 265, 271
        The Death of Countess Geschwitz, 266, 297
        The Death of Nana, 266, 278
        Equestrienne and Assistant, 290
        Interior with Group of People around
            Red-Headed Woman, 300, 301
        In Vaudeville: Acrobatic Male Dancer with
            Top Hat, 261, 302, 303
        In Vaudeville: Two Acrobat-Jugglers,
            256, 283
        In Vaudeville: Woman and Man on Stage,
            291
        Jugglers with Indian Clubs, 258, 297
        The Ladies Will Pardon My Mouth's Being
            Full, 260, 267, 296
        La Fille aux Yeux d'Or (The Girl with the
            Golden Eyes), 281
        Lulu and Alva Schön, 266, 296
        Lulu and Alva Schön at Lunch, 266, 295
        At Marshall's, 260–61, 292
        The Masque of the Red Death, 261, 299
        Masts, 268, 269
        Musician, 261, 298
        Nana and Count Muffat, 265, 276
        Nana and Her Men, 265, 273
        Nana at the Races, 265, 274
        Nana Visiting Her Friend Satin, 265, 272
        No, No O God!, 266, 295

        Piano Mover's Holiday, 268
        Scene after Georges Stabs Himself with the
            Scissors, 265, 275
        Three Figures in Water, 280
        Three Figures Sketching, 280
        Two Acrobats in Red Tights, 293
        Two Trapeze Performers in Red, 294
        Two Women Acrobats, 261, 282
        Two Women and Child on Beach, 279
        Untitled (Two Women and Three Children
            on the Beach), 284
        Woman Punching Bag, 270
Dewey, Alice (Mrs. John Dewey), 6, 11, 147
Dewey, John
    at Barnes Foundation Gallery inauguration,
        33
    on Barnes's contribution to his work,
        42–43
    on Barnes's falling out with University of
        Pennsylvania, 34, 35, 48–49
    on Barnes's The Art in Painting, 2, 39, 40
    Black Mountain College visit, 43
    correspondence with Barnes, xiii, 4, 5, 6, 25,
        31, 32, 34, 39, 40, 46
    on education, 1
    Munro and, 5–7, 39
    portrait of, 5
    relationship with Barnes, 4, 5–7, 12, 15–16,
        26–27, 32, 33–34, 36, 39, 42, 147, 196
    Russell and, 45–47
    on understanding art, 69
Dewey, Roberta L. (Mrs. John Dewey), 49
Dezarrois, André, 184, 187
Dillon, Mildred Murphy, 331
    Yes! Madame, 331
Dimock, Edith (Mrs. William J. Glackens), 65
    correspondence with Barnes, 65, 71, 108, 116,
        122
    as illustrator, 332
    as model for Glackens, 89, 118
    works:
        Country Girls, 331, 332
        Country Girls Carrying Flowers, 331, 332
        The Sunday Walk, 331, 333
        Women with Eggs, 333
diversity, 15, 37, 38, 50, 306–07. See also African
    Americans
Dogon Peoples, Mali
    Seated Couple, 326
Druet, Eugène, 54, 127, 128–29, 197, 198
Duberman, Martin, 43
du Bois, Guy Pène, 65, 335
    The Politician, 333
Durand-Ruel, Paul, 129, 130, 201–02, 342

educational philosophy, 1, 15, 32. See also
    Dewey, John
"The Eight," ix, 149
El Greco, 130, 197, 260, 262
Ellinger, David Y., 321

Enfield Pottery and Tile Works, viii, 31
Erdgeist (Wedekind play), 266, 295, 296, 300
European summer classes led by Barnes, 39

Fahlman, Betsy, 269
Farnham, Emily, 265, 266, 279
Ferguson, Nancy Maybin, 334
    The Red Banner, 334
file cards kept by Barnes Foundation, xxi, 201
Flaccus, Louis W., 25
folk art, 45, 60, 306, 309
Folsom Galleries, 66, 67, 84, 128, 130
Forum Exhibition of Modern American Artists
    (Anderson Galleries), 131
frames, xxi, 171–73, 331, 342, 343, 350
Free Man's Worship (Russell), 16
French Impressionists, 29, 183, 195. See also
    specific artists by name
The French Primitives and Their Forms (Barnes
    and de Mazia), 41
Freud, Sigmund, 13
Frick, Henry Clay, 27
Friends' Neighborhood Guild, 322, 323, 346
Fromuth, Charles Henry
    An Evening Glow with a Rose Trail in the
        Shadow (Boats Concarneau), 334
Fry, Roger, 22, 130–31
furniture as part of Barnes's collection, 44, 45,
    342, 351

Gallatin, Albert, 75–76, 84, 98, 106, 122, 283, 299
Garton, Susan Foster, 325
Gauguin, Paul, 3, 19, 44, 128, 144, 328
    Haere Pape, 30
gessoed panels, 172, 180
Gillman, Derek, ix–x
Glackens, Edith, see Edith Dimock
Glackens, Ira, xiv, 2, 55, 73, 80, 94, 148, 269, 335
Glackens, Lenna, 110, 335–36
    Two Figures—Sphinx, xxi, 335
    Woman and Dog Under Tree, xxi, 335
Glackens, William J.
    on American art, 65, 67
    "The Art of William Glackens" (Barnes), 68
    Asian influence and, 94
    Barnes on, 65, 66, 68–69, 101, 108
    black crayon, use of, 71
    Cézanne, influence of, 68, 108
    display of paintings by Barnes, 3
    donation by Barnes to Wilstach, 28
    Hartley, influence of, 66, 76
    Lawson and, 66, 76, 183–84
    notebook of acquisitions records, 18, 19, 20
    on Cubism, 247
    on Pascin's work, 196
    photograph of, 17
    Prendergast brothers and, 76, 94, 144,
        145, 147
    purchasing art for Barnes, 18–21, 66

relationship with Barnes, 2, 12–13, 17–21, 27, 46, 63, 69
Renoir, influence of, 19, 65, 67–68, 101
sketches grouped on a page, 122
works:
  *Albert C. Barnes, xxii*, 1
  *Armenian Girl, 107*, 108
  *Barbaro Fats, 125*
  *Bathers, Annisquam, 114*
  *The Bathing Hour, Chester, Nova Scotia, xii, 66, 81–82*
  *Beach at Dieppe,* 65, *72, 73*
  *Beach with Figures, Bellport, 98*
  *The Brunette, 89*
  *Children in the Park, 92*
  *Children in Washington Square, 88*
  *Decoration, 94–95*
  *Eight Figures, 119, 122*
  *Five Children, 119*
  *Five Figures, 124*
  *Flowers, 101*
  *Flowers in a Blue Vase, 100*
  *Flowers in a Quimper Pitcher, 100*
  *Flowers in Blue and White Checkered Vase, 101*
  *Girl Asleep, 113*
  *Girl in Green Turban,* 68, *87*
  *Girl in Red Dress Pinning on Hat, 105*
  *Girl with Flowered Hat, 89*
  *Girl with Fox Furs, 79*
  *Green Bowl of Flowers, 101*
  *Head of Girl, Feather in Turban, 86*
  *Here Are Your Trousers, 115*
  *It Took Four of Us to Keep 'Em Apart, 117*
  *Julia Reading,* 68, *106*
  *Landscape—Factories, 93*
  *Lenna with Basket of Flowers, 110*
  *The Little Pier, 91*
  *Man Following Woman, 120*
  *Man with Child, 121*
  *Marceline, the Clown, 115*
  *Never Again, He Remarked Gloomily, 117*
  *Nude, 125*
  *Nude Standing, 111*
  *Nude with Draperies, 113*
  *Outdoor Restaurant, 102*, 104
  *A Party Has a Right to Add More Tong to Their Own Joint, 118*
  *Pony Ballet,* 68, *84–85*
  *Race Track,* 66–67, 69, *75, 76–78,* 183
  *The Raft, xii,* 64, 69, *96–97*
  *Red Basket of Zinnias, 100,* 106
  *Seascape with Six Bathers, Bellport, 99*
  *Seated Woman with Fur Neckpiece and Red Background, 109*
  *Self-Portrait, 74*
  *She Gave Her Darter-in-law a Piece of Her Mind, 116*
  *Sleeping Girl, 86*
  *Standing Nude Woman, 115*
  "Staten Island, Skating" (sketchbook), *93*

  *Street Cleaners, Washington Square,* 66, *83*
  *Studies from Life, 112*
  *Sunday on the Marne, 102–04*
  *Then We All Went Home, 117*
  *There Was Edward Bickford's Racing Cup, 118*
  *Tulips and Peonies in Pitcher, 100*
  *Two Women, 120*
  *Two Women (One Seated), 111*
  *Two Women (One with Black Hat), 121*
  *Two Women and Head of Woman, 122*
  *Two Women Facing in Different Directions, 123*
  *Washington Square, 112*
  *Woman and Girl, 119*
  *Woman in Black Hat and Black Skirt, 121*
  *Woman in Red Blouse with Tulips,* 68, *90*
  *Woman Seated on Red Sofa, 87*
  *Woman Walking (BF632), 123*
  *Woman Walking (BF633), 123*
  *Woman Walking to the Left, 120*
  *Woman Waving Flag, 118*
  *Woman with Black Hat, Walking, 120*
  *Woman with Broad-Brimmed Hat, 119*
  *Woman with Green Hat, 80*
  *Woman with Umbrella, Washington Square, 112,* 122
  *Zinnias in a Striped Blue Vase, 101*
Grafton Galleries, 130–31, 329
Gregg, Frederic James, 146, 147
Gris, Juan, 248
Groff, June Gertrude, 336
  *Head of Chef, 336*
Guggenheim Foundation, 307, 328, 349
Guillaume, Paul, 31, 112, 197, 202
Guiraud, Jean-Baptiste, 306

Halpert, Edith, 215, 352
Hankins, Abraham P., 336–37
  photograph of, *337*
  works:
    *Juggler, 337*
    *Ocean, 336*
Hartley, Marsden, 247–57
  on Barnes's collection, 3
  Caffin on, 249
  Demuth and, 260
  European travel of, 247–48
  Glackens and, 66, 76
  "The Great Provincetown Summer," 247, 248
  relationship with Barnes, 63, 247
  reviews of work by, 249
  works:
    *Flowerpiece, 246,* 248, *256, 257*
    *Movement, Bermuda (Boat, Black and White Hull),* 248, 252, *253*
    *Movement, Bermuda (Boat, Pink and Black Hull),* 248, 254, *255*
Haskell, Barbara, 271
Havemeyer, Henry O. and Louisine, 27

Heacock, Priscilla
  *Composition, 338*
Henri, Robert, 17, 22, 65, 184
Hervey, Robert Morris, 338
  *Summer Light, 338*
Hill, J. Newton, 48, 49
Hille, Hermann, 13–14, 15
Hinkson, DeHaven, 48
Hispanic *santos* from New Mexico, 307, 328
*A History of Fine Art in India and Ceylon* (Smith), 94
H. K. Mulford & Company, 13
Hook, Sidney, 26
"Horace Pippin Today" (Barnes), 307
"How to Judge a Painting" (Barnes), 24, 185
*How We Think* (Dewey), 16
Huneker, James, 67, 149

Index of American Design program, 45
"Institutional versus Individual Collectors: A Polite Plea for the Abolition of Committee Rule" (Watson), 27–28
insulin, 263
inventory of Barnes Foundation collection
  1922–1924 Inventory, xix–xx, 17, 131
  1926 List of Paintings, xx–xxi
  post-1926 acquisitions, xxi
ironwork, 44, 45
*I Want to be a Columnist* (L. Glackens), 335

James, Henry, 81, 259
James, William
  Barnes's admiration for, 15–16, 25, 35–36
  Dewey and, 42
  Stein, L., and, 23
  use of his writings in Barnes's classes, 16, 33
japanning, 172
Johnson, John G., 27–29
Joseph Brummer Gallery, 166
*Journal of The Barnes Foundation,* 33

Kaldis, Aristodimos, 339
  *Absorbing Art, 339*
Kandinsky, Wassily, 248
Kane, John, 307, 340
  *Along the Susquehanna, 340*
  *Children Picking Daisies, 341*
  *Farm, 340*
  *Girl Coming Down Garden Steps, 341*
Keck, Sheldon, 61
Ker-Feal (the farm), 45, 182
Kraushaar Galleries, 343
Krogh, Lucy, 198
Kuehne, Max, 342
  as framemaker, xxi, 342
  on Pascin, 201
  work: *Granada, 342*

labor movement, 4, 16, 332
Laird, Warren P., 35
Laughton, Charles, 307
Laurent, Robert, 343
    as framemaker, xxi, 343, 350
    works:
        *Nile Maiden*, 344
        *Princess*, 343
Lawson, Ernest, 53, 183–93
    art training of, 183
    Barnes on, 183
    Glackens and, 66, 76, 183–84
    nationality of, 183
    relationship with Barnes, 17, 63, 183, 186
    works:
        *Country Road—Farm House*, 186
        *Garden Landscape*, 185
        *Graveyard*, 192
        *Hot Beds*, 193
        *Landscape with Gnarled Trees*, 182, 183,
            185, *189*
        *River Scene—Boats and Houses*, 185, *188*
        *River Scene—Boats and Trees*, *191*
        *Swimming Hole*, *190*
Leeper, John Palmer, 215
Levesque & Co., 184
Lincoln University, 47–50, 346
Lipchitz, Jacques
    gallery reliefs, ix, 31, 249–50
    Pascin and, 197, 198
    works:
        *Harlequin with Mandolin in Oval*, 250
        *Man and Guitar—Black, Gray, Red, and
            White*, 250
Losch, Tilly, 345
    *Creek*, 344
Luks, George B., 65, 345–46
    *The Blue Churn*, 345

Macbeth, William, 144–45, 146, 149
Malevich, Kasimir, 248
Manet, Édouard, 65, 66, 80, 127, 145
Marc, Franz, 248
Marcoussis, Louis, 249
Martin, Jay, 42
Matisse, Henri
    *The Art of Henri-Matisse* (Barnes and
        de Mazia), 41–42, 351
    Barnes purchasing art of, 22, 131, 249
    on Barnes's approach to displaying art, 3
    influence of, generally, 195
    influence on Demuth, 260, 261, 262
    influence on Glackens, 68
    influence on Maurer, 127–28, 137, 138
    influence on Pinto brothers, 352
    relationship with Barnes, 41 42, 131 32
Maurer, Alfred H., 127–41
    Barnes and, 18, 21–22, 63, 127–28, 130, 136
    in Barnes Foundation, 131–32
    Caffin on, 127, 130

exhibition of works of, 128–30
    as framemaker, 326
    Glackens and, 18, 66, 128
    influence of Matisse on, 127–28, 137, 138
    as purchasing agent for Barnes, 127–29,
        136
    Steins and, 127, 128
    suicide of, 127
    works:
        *Figure on Bench*, 136
        *Head: Number Three*, 131, *138*
        *Hills*, *141*
        *House*, *134*
        *Landscape with House*, *139*
        *Pot of Flowers*, *135*
        *Still Life*, 126, 131, *137*
        *Still Life with Jardinière*, *133*
        *Tree and Rock*, *140*
        *Tulips in a Green Vase*, 68, 131, *135*
McBride, Henry, 67
McCardle, Carl W., 46–47
McCarter, Henry, 47
McCarthy, Francis
    Barnes Foundation student, 346
    Friends' Neighborhood Guild school and,
        346
    "wet paper technique," 347
    works:
        *Girl in Red Spotted Skirt*, 347
        *Girl Seated in Room*, 347
        *Mexican Landscape*, 348
        *Still Life*, 346
        *Still Life (Garden Implements)*, 347
McClees, James, 128, 129
Meier-Graefe, Julius, 24
Mesibov, Hugh, 348–49
    *Byzantine Figure*, 348
Metropolitan Museum, 263
Meyrink, Gustav, 195
Mill, John Stuart, 26
Millet, Jean-François, 129, 130
Modern art
    aesthetic theory and, 37–39
    African influence on, 31
    Barnes on, 17–18, 24, 143
    Glackens and, 65–70
    museum vs. private collection of, 27–28
    Pascin on, 197
    Prendergast and, 144
Monet, Claude, 19, 21, 184, 185, 201
Morgan, Randall
    *Amalfi: Moonlight Pattern*, 350
    *Ponte Vecchio*, 349
Morrice, James Wilson, 21
Morse, Peter, 370
Moses, Paul, 60
Mossell, Nathan F., 47
Mullen, Mary
    *An Approach to Art*, 31, 33, 306
    on Barnes Foundation classes, 16–17
    as Barnes's associate, 14

education of, 25, 52
    as factory seminar instructor, 15, 16, 25
    Kuehne and, 342
    photograph of, *15*
Mullen, Nelle E.
    Barnes Foundation and, 14
    as Barnes's associate, 14
    Barnes's estimation of, 52
    education of, 25, 52
    Kuehne and, 342
    photograph of, *15*
    Pinto brothers and, 352
Munro, Thomas, 5–6, 7, 33–34, 36, 39
Museum of Modern Art, 215, 307, 337
Myers, Jerome, 335
    *Street Shrine*, 350

*Nana* (Zola), 260, 265, 271–78, 300
Navajo blankets and jewelry, 307, 328
New Republic
    articles by Barnes, 15, 31, 32
    articles by Stein, L., 24
*New York Times* reviews
    of Hartley exhibition, 249
    of Maurer exhibition, 131
Nulty, Albert H., 351
    *Mother and Child*, 351
    *Pennsylvania Dutch Motif*, 351
numbering system for works, xx

Old Masters, 38, 39, 143, 197, 351
*Opportunity: Journal of Negro Life*, 12, 16
*Outline of History* (H. G. Wells), 16

Pach, Walter, 174
Paintings and Drawings Showing the Later
    Tendencies in Art (Pennsylvania
    Academy of the Fine Arts), 131, 321
*Pandora's Box* (Wedekind play), 265, 296–97
Parisian art dealers, 127, 128, 130
Pascin, Jules (Jules Pincas), 195–245
    Barnes on, 195, 196
    Cézanne's influence on, 196–98, 206
    early life of, 195
    Glackens and, 196
    immigration to U.S., 196
    influence on Demuth, 260
    as "Julius/Jules Pincas," 195, 203
    relationship with Barnes, 63, 202–03, 247
    suicide of, 198
    temperament of, 195
    works:
        *After School (Home from School)*, 214
        *By the Church*, 214
        "Caribbean Sketchbook," 214–15
        *Cuban Hospitality*, 197, *212–13*
        *Downtown (Street Scene)*, 214
        *Father, Mother, and Three Children*, 226

*Figure Group, Man with Green Plaid Trousers*, 225
*Figures and Cat in Park*, 228
*Figures and Horses*, 226
*Figures and Two Horses in Landscape*, 242
*Figures in Landscape*, 235
*Figures in Landscape, Havana*, 229
*Figures in Landscape, Miami*, 227
*Figures in Tropical Landscape*, 234
*Figures on Beach, Coney Island*, 232
*Figures with Cab*, 236
*Girl in Blue Dress on Sofa, Reading*, 224
*Girl in Green, Reading*, 218, 219
*Group of Figures with Boy Holding Flowers*, 239
*Group of Men, New York*, 235
*Harvesters*, 232
*Horses in Landscape*, 233
*La Fin du déjeuner ou le retardataire*, 212
*La Jeune fille au fauteuil*, 218
*Landscape*, 217
*Landscape, Houses and Trees*, 231
*Landscape with Carriage and Figures, Tunis*, 245
*Landscape with Figures, Miami*, 228
*Landscape with Figures and Carriage*, 214, 215
*Les Tunisiennes*, 203, 210, 222
*Man, Two Women, Two Children*, 230
*Negroes and Two Carts*, 236
*Nude*, 240
*Nude and Books*, 204
*Nude and Cupid*, 220
*Nude Seated on Chair*, 223
*Nude Seated on Hassock*, 221
*Offering to Venus*, 244
*Reclining Nude*, 241
*Seated Figure*, 206
*Seated Girl in Chemise*, 207
*Shoeshine*, 234
*Siesta*, 225
*Southern Figures and Goat*, 237
*Southern Landscape*, 217
*Southern Landscape with Figures and Horses*, 231
*Southern Scene*, 216, 230
*Standing Girl in Blue Dress*, 209
*Standing Nude in the Studio*, 203, 210, 211
*Street Scene, New York*, 236
*Three Women and Two Children, Havana*, 225
*Three Women on Red Sofa*, 227
*Tunis*, 242
*Two Figures and Cupid*, 220
*Two Men Dining*, 240
*Two Men in the Park, Havana*, 224
*Two Nudes—One Standing, One Sitting*, 205
*Two Standing Nudes*, 208
*Two Women at a Circular Table*, 227
*Two Young Girls*, 226

*Woman and Two Children*, 243
*Woman with Baby Carriage*, 194, 238
Pascin Memorial Committee, 196
Pearlman, Henry, 50, 61
*peinture paysan* style, 306
Penniman, Josiah H., 32, 34–35
Pennsylvania Academy of the Fine Arts, 26, 28, 31, 47, 49, 68, 131, 203, 222, 259, 321
Pennsylvania German, 12, 45
Perls, Klaus, 361
Philadelphia Art Alliance, 337
Philadelphia arts community, ix
Philadelphia Ballet Company, 352, 358
Philpotts, Eden, 116–18
Picasso, Pablo
    Barnes on, 38, 329
    Barnes purchasing work of, 22, 249
    Cubism of, 248, 249, 250–51, 329
    influence on Demuth, 260
    works:
        *Still Life: Violin, Sheet Music, and Bottle*, 250, 251
        *Young Woman Holding a Cigarette*, 21
Pinto, Angelo, 46, 352–53
    influence of Matisse, 352
    photograph of, 10, 15
    works:
        *Balcony Scene*, 354
        *Bathers on Boardwalk*, 353, 356
        *Bathtub and Cat*, 353, 355
        *David and Goliath*, 353, 354
        *Fort, Corsica*, 353
        *Icarus*, ii, 353, 355
        *Interior with Bouquet*, 352
        *Seashells*, 353, 355
        *Two Figures*, 354
Pinto, Biagio, 46, 352–53
    *Domino Players*, 356
    *Flower Piece*, 356
    *Landscape—Vence*, 357
Pinto, Dominic, 352
Pinto, Joseph, 352, 353
Pinto, Salvatore, 46, 352–53
    *Ajaccio, Corsica*, 357
    *Marrakech*, 358
Pippin, Horace, 304–17
    attending classes at Barnes Foundation, 307
    Barnes on, 305, 307
    burnt-wood panels of, 306, 307
    disabled in World War I, 305–06
    early life of, 305
    exhibition and sale of work of, 307
    photograph of, 308, 314
    relationship with Barnes, 63, 307, 309
    self-taught, 305–07
    works:
        *Abraham Lincoln and His Father Building Their Cabin on Pigeon Creek*, 307, 311
        *Christ and the Woman of Samaria*, 307–08, 314–15

*Giving Thanks*, 304, 317
*Supper Time*, 313
Pissarro, Camille, 121, 183, 184
"plastic means," 38, 41, 250
Poe, Edgar Allan, 25, 260, 299
Poole, Earl L., 270
Post-Impressionist art, 130–31, 143, 195
Pound, Ezra, 40
Poussin, Nicolas, 143
*Pragmatism* (W. James), 16
prehistoric cave paintings, 196
Première Exposition d'Art Moderne Américain (Levesque & Co.), 184
Prendergast, Charles, 171–81
    dealing with brother on behalf of Barnes, 173
    education and craftsmanship of, 171–73
    framemaking of, xxi, 171–73, 342
    Glackens and, 145, 147, 174
    Kuehne and, 342
    move to New York with brother, 145
    relationship with Barnes, 63, 147, 173–74
    works:
        *Angels*, 170, 178
        *Central Park*, 174, 181, 343
        *Figures and Deer*, 179
        *The Offering*, 180
        *Two Figures on a Mule*, 177
        *Two Nudes*, 176
Prendergast, Maurice B., 143–69
    art training of, 143–44
    Asian influence and, 94
    Barnes Foundation classes using works of, 334
    Barnes on, 143, 148
    death of, 147
    Glackens and, 65, 66, 76, 144, 145, 147
    move to New York with brother, 145
    relationship with Barnes, 63, 144–46
    Renoir and, 143
    works:
        *At the Beach*, 154
        *The Beach*, 161
        *Beach and Two Houses*, 162, 163, 165
        *Beach and Village*, 158
        *The Beach "No. 3,"* xviii, 142, 160
        *Beach Scene*, 155
        *Beach Scene and Hill*, 158
        *Beach Scene with Donkeys (or Mules)*, 30, 159
        *Beach Scene with Two Trees*, 150
        *Brooksville, Maine (River & Rocks)*, 150
        *Gloucester Harbor*, 156
        *Idyl*, 30, 157
        *Landscape (Beach Scene)*, 163
        *Landscape (Park Scene)*, 151
        *Landscape (Road & Town)*, 162
        *Landscape with Figures*, 152, 153
        *Marblehead Harbor*, 148, 166–67
        *On the Beach*, 168
        *Rocks, Waves and Figures*, 169

*Seascape—St. Mâlo*, 149
*Trees, Houses, People*, 164
Preston, James, 359
*Chartres*, 358
*Trumbull, Connecticut*, 358
Preston, May Wilson
*The Confidantes*, 360
*Déjeuner*, 359
*Drama in the Living Room*, 360
*Hunting the Fashions*, 359
*Woman and Man*, 360
Priebe, Karl, 361
*Miss Chalfont*, 361
primitive style, 306–07
*The Principles of Psychology* (W. James), 16, 35
*Progress to Freedom: The Story of American Education* (Benedict), 44
psychology
of aesthetics, 31, 33, 36
Barnes's study of, 13, 25, 26, 27
Stein, L., and, 23, 24
purchases
documentation of, xxi
of American art, timing, 2
Pyramid Club, 308

Quakers, 11, 346
Quinn, John, 146, 147

racism, 4. *See also* African Americans
Rackliffe, Howard
*Winter Wharf*, 362
*Radical Empiricism* (W. James), 16
Ratner, Joseph, 4
Rawdon, Katy, xiv
Reading Public Museum and Art Gallery, 270
*Reason in Art* (Santayana), 16
Reiff, Barbara, 362
*Still Life Abstraction ("Cheese and Crackers")*, 362
*Still Life with Jug*, 363
Reisman, David, 261
religious themes, 172, 307–08
Rembrandt, 50, 345–46
Renoir, Pierre-Auguste
*The Art of Renoir* (Barnes and de Mazia), 7, 43–44, 65, 69
Barnes and, 21, 43, 184
Glackens and, 19, 65, 67–68, 101
Pascin and, 196
Prendergast, M., and, 143
Stein, L., on, 24
work: *The Artist's Family*, *xii*, 68
reverse painting on glass, 353
Rice, John Andrew, 43
Ritchie, Andrew Carnduff, 337
Roberts, Owen J., 29, 34, 35, 48
Rockefeller, Steven C., 6
Rodin, Auguste, 260, 261, 299

Rodman, Selden, 306, 308
Rohland, Paul, 363
*Flower Piece (Zinnias)*, 363
Rose, Billy, 50
Rouart Collection, 22, 129
Rousseau, Henri "le Douanier," 306
*The Canal*, *xviii*
*Unpleasant Surprise*, 10
Rubens, 197
Russell, Bertrand, 16, 45–47

Salon des Indépendants (1912), 196, 268
Santayana, George
on Barnes, 50
Barnes on, 35
influence of, 16, 23, 36, 38
on Munro's *Scientific Method in Aesthetics*, 36
*Sense of Beauty*, 16, 35, 36
use of writings in Barnes Foundation classes, 16, 32, 33, 35
*santos*, 307, 328
*The Saturday Evening Post* series, 46–47, 48, 353
Schaffer, Lydia A. (mother of Albert C. Barnes), 11, 56
scientific method
application to art, 16, 34, 36, 37, 44, 47, 50
application to education, 5
*Scientific Method in Aesthetics* (Munro), 36
sculpture, 343
Secession Galleries, 249
Sefarbi, Harry ("Harry Smith")
Barnes on, 364
Barnes Foundation faculty member, xiii, 364
Barnes Foundation student, 364
photograph of, 10
work: *Interior: Jim*, 364
self-taught artists, 306–07
*Sense of Beauty* (Santayana), 16, 35, 36
Settanni, Luigi, ix, 365, 366, 368
*Fisherman and Wife, St. Guénolé*, 366
*Landscape in Brittany (Pont l'Abbé Figure)*, 367
*Marrakech*, 365, 366
*Negro Figure*, 368
*Port-Manech*, 366
*Russian Ballet*, 365
*Spreading Nets, Douarnenez*, 367
*Three Women at Port-Manech*, 367
*Two Figures*, 365
*Woman in Hammock*, 368
Seurat, Georges, 361
*Models*, *xviii*, 41
"The Shame in the Public Schools of Philadelphia" (Barnes), 33
Shubert, Florence, 368
*Color Movement Inspired by "Joie de vivre,"* 368
*Simplicissimus* (magazine), 195
Singer, Edgar A., Jr., 25, 33, 65, 66

Sisley, Alfred, 183, 184
Sloan, John, 17, 65, 80, 370
etchings, 370
*Nude, Green Scarf*, 369
*Seated Nude*, 369
Smith, Vincent A., 94
Sonderbund Exhibition (Cologne), 195
Soutine, Chaim, 31, 185–86
*Landscape with Figure*, 186, 189
*Landscape with Houses*, 188
*Red Church*, 185, 189
spirituals, 308–09
Stassen, Harold, 49
Stein, Leo, 55–56, 58
on Barnes's *The Art in Painting*, 39–40
on Cubism, 247
as mentor to Barnes, 13, 22–24, 27, 41–42, 128, 131
photograph of, 23
on Renoir, 24
Stein, Leo and Gertrude
collection of, 18, 127, 128, 132, 137, 260
salon of, 247–48
Stein, Michael and Sarah, 137, 138
Stein, Zenka, 80
Stern, Horace, 48
Sterne, Maurice
*Deer*, 371
*Reclining Figure*, 371
Stieglitz, Alfred, 67, 127, 248, 252, 260
Stokowski, Leopold, 33
Suhr, William, 61, 351
Sweeney, James Johnson, 43, 176, 259, 260

*Talks to Teachers* (W. James), 16
*Three Lectures on Aesthetic* (Bosanquet), 11
Tintoretto, 197, 308
Toulouse-Lautrec, Henri de, 111, 128, 195, 198, 260, 361
*Town and Country*
cover by Glackens, 89
Pinto brothers photography in, 353
Turner, J. M. W., 196

University of Pennsylvania
Barnes and Mullen sisters studying at, 25
Barnes's proposal of partnership with, 32–35
as beneficiary of Barnes's will, 28, 48
Department of Botany, 45
Medical School, 13
revision of Barnes Foundation by-laws to exclude, 49

Valentine Gallery, 352
Van Gogh, Vincent, 22, 128–29, 186
*Varieties of Religious Experience* (W. James), 16
vaudeville, 256, 258, 260–61, 282–83, 293–94, 297, 299, 302. *See also* Demuth, Charles

Venetian model frames, 172
Vienna School of Arts and Crafts, 33
Vlaminck, Maurice de, 329
Vollard, Ambroise, 19–20, 22, 53–54, 127, 128, 130

Ward, Lynd, 371
   *Figure and Skulls*, 372
   *Two Figures*, 371
Watson, Forbes, 27–28
Watteau, Jean-Antoine, 143
Wattenmaker, Richard, ix–x, xiii–xvi, 71
*The Way to Art* (Hankins), 337
Webster, E. Ambrose
   *Sunlit Landscape*, 372
Wedekind, Frank, 260, 265, 295–97, 300
Westbrook, Robert B., 6

Weyand, Richard, 265
Whitney Museum of American Art, 69, 71, 174
*Why Men Fight* (Russell), 16
Wieghardt, Paul, 347
Wilson, Joseph Lapsley, 28, 29, 45, 49
Wilson Arboretum, 28, 29
Wilstach collection, 28–29, 128
Wixom, William D., 60
wood engravings, 351, 352
Work, Frederick J., 12
World War I, 24, 41, 305
Wyeth, N. C., 307

"You Must Come Over" (Demuth play), 262

Zola, Émile, 260, 265, 266, 271–78

## CREDITS

Effort has been made to credit sources and/or right holders of images, where such information is available. If there are omissions, please contact the Barnes Foundation.

The copyright in reproductions of works in the Barnes Foundation collection, unless otherwise indicated, are "Copyright 2010 The Barnes Foundation. All Rights Reserved." The Barnes Foundation and the publisher wish to thank the following individuals and organizations, who have supplied images and/or have granted licenses for the reproductions included in this catalogue.

Frontispiece: Courtesy Pinto Family

Fig. 1: Courtesy Violette de Mazia Foundation

Fig. 4: Courtesy London Collection

Fig. 8: Courtesy Archives Matisse, Paris, © 2010 Pierre Matisse/ Artists Rights Society (ARS), New York

Fig. 10: Courtesy Museum of Art Fort Lauderdale, Nova Southeastern University

Fig. 11: © 2010 Estate of Pablo Picasso/Artists Rights Society (ARS), New York

Fig. 13: Courtesy the van Vechten Trust

Fig. 17: Courtesy Violette de Mazia Foundation

Fig. 20: Courtesy Museum of Art Fort Lauderdale, Nova Southeastern University

Fig. 21: Courtesy Philadelphia Museum of Art

Figs. 22, 23, 24, 25, 26, 27, 28, 29, 30, 31, 32, 33, 34, 35, 36, and 37: Courtesy Museum of Art Fort Lauderdale, Nova Southeastern University

Figs. 38 and 39: Courtesy Sansom Foundation

Figs. 40 and 41: Courtesy Museum of Art Fort Lauderdale, Nova Southeastern University

Figs. 42, 43, and 44: Courtesy Snite Museum of Art, University of Notre Dame

Fig. 45: Courtesy Museum of Art Fort Lauderdale, Nova Southeastern University

Fig. 46: Courtesy Kraushaar Galleries, New York

Figs. 47 and 48: Courtesy Museum of Art Fort Lauderdale, Nova Southeastern University

Fig. 49: Courtesy Private Collection

Fig. 50: Photograph © 1995 The Detroit Institute of Arts

Figs. 51, 52, 53, 54, and 55: Courtesy Snite Museum of Art, University of Notre Dame

Fig. 56: Courtesy Private Collection

Fig. 57: Courtesy Kraushaar Galleries, New York

Fig. 58: Courtesy Alan and Elaine Kolodkin

Fig. 59: Courtesy Delaware Art Museum

Figs. 62 and 63: Photographs © 2009 Museum of Fine Arts, Boston

Fig. 66: Courtesy Brooklyn Museum of Art

Fig. 67: © 2010 Artists Rights Society (ARS), New York/ADAGP, Paris

Fig. 68: Courtesy London Collection

Fig. 69, 70: © 2010 Artists Rights Society (ARS), New York/ADAGP, Paris

Fig. 72: Courtesy Archives of the Pennsylvania Academy of the Fine Arts

Fig. 73: Courtesy Rosenfeld Gallery, Tel Aviv

Fig. 74: Reproduced from *Pascin, Catalogue Raisonné*, vol. 2 (Paris: Abel Rambert, 1987)

Figs. 75, 76, and 77: Courtesy McNay Art Museum, San Antonio

Fig. 78: Reproduced from *Tableaux Modernes: Exceptionnel ensemble de 50 aquarelles et dessins de PASCIN*, auction cat. (Enghien-les-Bains, France, Hôtel des ventes, sale June 21, 1987)

Figs. 80 and 81: Courtesy Estate of Jacques Lipchitz

Fig. 82: © 2010 Estate of Pablo Picasso/Artists Rights Society (ARS), New York

Fig. 84: Courtesy Huntington Library, Art Collections, and Botanical Gardens, San Marino, California

Fig. 85: Courtesy Morgan Library, New York

Fig. 87: Courtesy Charles L. Blockson Afro-American Collection, Temple University, Philadelphia

Fig. 88: Courtesy Whitney Museum of American Art, New York

Fig. 89: Courtesy Makler Family Collection, © 2010 Milton Avery Trust/Artists Rights Society (ARS), New York

Fig. 91: Courtesy London Collection

BF961, page 319: © 2010 Milton Avery Trust/Artists Rights Society (ARS), New York

BF2556, page 322: Courtesy Melissa Bosworth

BF2006, page 323: Courtesy of son, Peter T. Cox, and Family

BF657, page 325: Courtesy Mary Chalmers

BF2507, page 336 (right), BF2550, page 337 (top): Reproduced with permission of Dorothy Levin

BF988, page 339: Courtesy Estate of Aristodimos Kaldis, represented by Lori Bookstein Fine Art, 138 Tenth Avenue, New York, N.Y. 10011, 212.750.0949

BF2553, BF2554, page 351: Courtesy Family of Albert H. Nulty

BF434, BF924, BF1147, BF2002, BF1190, BF723, BF744, BF1002, BF1042, pages 352–356: Courtesy The Pinto Family

BF1148, BF1146, BF927, pages 356–357: Courtesy Ruth and Gina Pinto

BF380, page 357 (right), BF2071, page 358 (left): Courtesy J. Bleakney Savage

BF1152, BF2017, BF308, BF168, BF981, BF2045, BF983, BF979, BF446, BF2037, pages 365–368: Reproduced with permission of the Settanni Family

BF320, page 371 (right), BF345, page 372 (left): Reproduced with permission of Robin Ward and Nanda Weedon Ward